ADVERTISING NOW. TV COMMERCIALS

ED. JULIUS WIEDEMANN

ADVERTISING NOW. TV COMMERCIALS

TASCHEN

HONG KONG KÖLN LONDON LOS ANGELES MADRID PARIS TOKYO

ESSAYS

Date R'D 28/06/11 Price £24.99
Control
Item H511032510
Class 659.143
Cllctn NHH BusIT H&
Loan 4 Week Loan

CHAPTERS

INTRODUCTION

CHRIS WALL & DAVID APICELLA
CHIEF CREATIVE OFFICERS, OGILVY & MATHER NEW YORK

David Apicella joined Ogilvy & Mather as a copywriter after graduating from law school. Since then he has worked with nearly every agency client, both large and small. During his long tenure at Ogilvy, David rose through the creative ranks before his appointment as Executive Creative Director in 1996 and Chief Creative Officer in 2002. In addition to his role as a leader of the agency's integrated creative department, he oversees such accounts as American Express, Foster's, DHL, Time Warner Cable, Tribeca Film Festival, Kraft, Unilever and the New York Mets. His work has been showered with some of the most important awards in the industry.

Chris Wall stands head and shoulders above all creative leaders in advertising today (quite literally, as he's six feet ten). However, he does have a smattering of accomplishments to his credit, besides his towering height. A copywriter by trade, he's written for print, TV and multimedia campaigns that have won most of the awards there are to win: Cannes Lions, Clios, One Show, Communication Arts, Andys, Addys and Effies. His work has appeared frequently in the annuals of *Communication Arts* and *Graphis*, the One Show and the Art Director's Club. He's either written or

David Apicella stieg nach Abschluss seines Jurastudiums als Texter bei Ogilvy & Mather ein. Seitdem hat er mit nahezu allen Agenturkunden gearbeitet, darunter sowohl große als auch kleine Accounts. Im Laufe seiner langen Karriere bei Ogilvy bewährte David sich in verschiedenen Kreativpositionen, bevor er 1996 zum *Executive Creative Director* und 2002 zum *Chief Creative Officer* ernannt wurde. Zusätzlich zu seiner Rolle als Leiter der integrierten Kreativabteilung der Agentur betreut er Accounts wie American Express, Foster's, DHL, Time Warner Cable, Tribeca Film Festival, Kraft, Unilever und die New York Mets. Für seine Arbeit erhielt er bereits viele bedeutende Auszeichnungen der Werbebranche.

Chris Wall überragt alle kreativen Leiter der heutigen Werbebranche (dies kann man wörtlich nehmen, denn er ist über zwei Meter groß). Doch abgesehen von seiner beeindruckenden Größe kann er auch noch einiges mehr vorweisen. Als Texter hat er Print-, TV- und Multimediakampagnen mitgestaltet, die nahezu alle Preise abgeräumt haben, die es zu gewinnen gibt: Cannes Lions, Clios, One Show, Communication Arts, Andys, Addys und Effies. Seine Arbeiten erscheinen häufig in den Jahrespublikationen von *Communication Arts*, *Graphis*, One Show und Art Director's Club. Für einige der weltweit größten Marken hat er schon die inhaltliche oder gestalterische Leitung übernommen: IBM, Apple, Nike, Coca-Cola, Microsoft, Pepsi, Kodak, American Express und Motorola. Zudem wurden seine Arbeiten für IBM, Microsoft, Kodak und Apple von Adweek als „Best Spot of the Year" ausgezeichnet.

David Apicella entre chez Ogilvy & Mather en tant que rédacteur publicitaire après avoir obtenu un diplôme de droit. Depuis lors, la quasi-totalité des clients de l'agence, qu'ils soient petits ou grands, sont passés entre ses mains. Depuis qu'il a pris ses fonctions, David a gravi tous les échelons du service de la création et a été nommé directeur exécutif de la création en 1996, puis directeur général de la création en 2002. Outre son rôle de leader du service de la création intégrée de l'agence, il supervise certains clients, tels qu'American Express, Foster's, DHL, Time Warner Cable, Tribeca Film Festival, Kraft, Unilever et les Mets de New York. Son travail a décroché quelques-unes des récompenses les plus importantes du monde publicitaire.

Chris Wall dépasse largement tous les directeurs de création de publicité d'aujourd'hui (au sens propre, puisqu'il mesure 2 mètres). En dehors de sa taille, il a également à son actif une multitude de réussites. Rédacteur publicitaire de formation, il a été le rédacteur de campagnes de presse, de TV ou multimédia qui ont remporté la plupart des prix qui existent : les Lions de Cannes, les Clios, le One Show, le Communication Arts, les Andys, les Addys et les Effies. Son travail a régulièrement été publié dans les revues annuelles *Communication Arts* et *Graphis*, au One Show, ainsi qu'à l'Art Director's Club. Il a assuré la rédaction ou dirigé la création de grandes campagnes pour quelques-unes des marques les plus importantes au monde : IBM, Apple, Nike, Coca-Cola, Microsoft, Pepsi, Kodak, American Express et Motorola. Chris a également décroché un Adweek dans la catégorie « Meilleur film

creative-directed major campaigns for some of the biggest brands on earth: IBM, Apple, Nike, Coca-Cola, Microsoft, Pepsi, Kodak, American Express and Motorola. Chris has also had an Adweek "Best Spot of the Year" for IBM, Microsoft, Kodak and Apple.

T: In light of the Internet boom, how would you generally evaluate the state of commercial films in the last five years?

CW: A lot more experimentation. Clients realize you can't bore people into buying your products; you can only interest them… just as David Ogilvy said forty years ago.
DA: Besides a broad range of forms and styles, the biggest change I see is that a spot shot with a camera phone and distributed on YouTube can be better received than a multi-million dollar epic. Production values, once a hallmark of great commercials, are almost irrelevant.

T: What was it like before?

CW: A lot of formulaic garbage dictated by testing.
DA: There were always style trends, but things were much more uniform.

T: Has storytelling changed in recent years?

CW: Not as much as it should have. Most storytelling is still quite conventional.
DA: I think there is less storytelling and fewer people who do it well or care to try.

T: Wie würden Sie vor dem Hintergrund des Internetbooms die Entwicklung des Werbefilms in den letzten fünf Jahren allgemein beurteilen?

CW: Es wird wesentlich mehr experimentiert. Den Werbekunden wird immer klarer, dass sie die Leute nur dann dazu bringen können, ihre Produkte zu kaufen, wenn es ihnen gelingt, sie wirklich dafür zu interessieren… worauf David Ogilvy ja schon vor vierzig Jahren hinwies.
DA: Abgesehen davon, dass es inzwischen eine riesige Vielfalt an Formen und Stilen gibt, besteht die größte Veränderung in meinen Augen darin, dass ein Spot, der mit einem Kamerahandy aufgenommen und auf YouTube veröffentlicht wird, unter Umständen viel besser ankommt als ein Multi-Millionen-Dollar-Epos. Die Höhe der Produktionskosten, früher ein Meilenstein für erfolgreiche Werbung, spielt inzwischen fast gar keine Rolle mehr.

T: Wie war es denn früher?

CW: Jede Menge formelhafter Müll, diktiert von Tests.
DA: Es gab immer bestimmte stilistische Trends, aber alles war viel gleichförmiger.

T: Hat sich das Storytelling in den letzten Jahren verändert?

CW: Nicht so viel, wie man hätte erwarten können. Die meisten Geschichten werden immer noch sehr konventionell erzählt.
DA: Ich denke, es gibt weniger Storytelling und weniger Leute, die es gut können oder es wenigstens versuchen.

publicitaire de l'année » pour IBM, Microsoft, Kodak et Apple.

T : Compte tenu du boom qui s'est produit sur Internet, quelle évaluation faites-vous des films publicitaires des cinq dernières années ?

CW : On expérimente beaucoup plus. Les clients se rendent compte qu'on ne peut plus forcer les gens à acheter un produit en les martelant de messages publicitaires. Il faut capter leur attention, comme le disait David Ogilvy il y a quarante ans.
DA : Outre un éventail bien plus large de formes et de styles, pour moi, le plus grand changement, c'est qu'un spot tourné avec un téléphone portable et publié sur YouTube peut être bien mieux reçu qu'un film à grand spectacle de plusieurs millions de dollars. Les coûts de production, qui autrefois étaient un point de référence pour les grands spots publicitaires, sont devenus quasiment insignifiants.

T : C'était comment, avant ?

CW : Il y avait beaucoup de verbiage vide de sens, dicté par des tests.
DA : Il y avait des tendances, mais tout était bien plus standardisé.

T : Raconte-t-on les histoires différemment depuis quelques années ?

CW : On devrait le faire plus souvent. On raconte encore les histoires de façon très conventionnelle.
DA : Je pense qu'on raconte moins d'histoires et que peu de gens savent le faire ou en ont envie.

„DURCH DIE TECHNOLOGIE KANN NAHEZU DER GESAMTE KREATIVE PART AM COMPUTER ERLEDIGT WERDEN. FRÜHER MUSSTE MAN NACH CHINA REISEN, WENN MAN DIE GROSSE MAUER HABEN WOLLTE.“

T: TV is still the biggest media driver of the advertising industry. What are its biggest benefits?

CW: The biggest audience and it has the most immediate impact.
DA: I think you still get a lot of buzz when you've got something good. And there's always the Super Bowl.

T: What do you think has been the impact of technology on producing commercial films today?

CW: Technology is making it possible to produce commercials faster and theoretically cheaper – although the actual cost of film is a tiny part of production.
DA: Technology is making it possible to create just about anything without leaving your desk. You used to have to go to China if you wanted the Great Wall.

T: How do you see television interacting with the Internet today and in the future?

CW: From now on, all TV will be instant response. That is, viewers will have the ability to find out more immediately – and they will do so. So TV becomes a sort of movie trailer for deeper content.
DA: I think in the very near future it will all be one.

T: Are TV spots being used more and more to drive consumers to websites, where people would spend more time engaging in a longer story?

CW: Is this the future for CMs? It isn't just the future – it's the present. The ability to respond to something you've just seen is a huge opportunity for marketers and creative people to extend the stories we tell on TV.
DA: I think it's a future, not the only future. Some products don't have a longer story.

T: What are your top three spots of all time?

CW: "1984" Apple Computer. A big, dramatic, daring, brilliantly executed campaign, and all with a product that paid it off. "1948 Auto Show" Volkswagen (VW).

T: Das Fernsehen ist noch immer das wichtigste Medium in der Werbebranche. Worin liegen seine größten Vorteile?

CW: Das größte Publikum und die unmittelbarste Wirkung.
DA: Ich denke, man kann immer noch eine große Wirkung erzielen, wenn man etwas Gutes anzubieten hat. Und der Super Bowl ist natürlich unschlagbar.

T: Welchen Einfluss hat heute Ihrer Meinung nach die technologische Entwicklung auf die Produktion von Werbefilmen?

CW: Die Technologie macht es möglich, Werbefilme schneller und theoretisch billiger zu produzieren – allerdings machen die tatsächlichen Kosten eines Films nur einen Bruchteil der Produktionskosten aus.
DA: Durch die Technologie kann nahezu der gesamte kreative Part am Computer erledigt werden. Früher musste man nach China reisen, wenn man die Große Mauer haben wollte.

T: Welche Interaktion sehen Sie heute und in Zukunft zwischen Fernsehen und Internet?

CW: In Zukunft wird auf alles, was im Fernsehen zu sehen ist, unmittelbar reagiert werden. Das heißt, die Zuschauer werden die Möglichkeit haben, sofort mehr zu erfahren – und sie werden diese Möglichkeit nutzen. Das Fernsehen verwandelt sich also mehr und mehr in eine Art Filmtrailer für weitergehende Inhalte.
DA: Ich denke, in naher Zukunft wird beides miteinander verschmelzen.

T: Werden TV-Spots zunehmend dazu eingesetzt, Konsumenten auf Internetseiten zu leiten, wo sie theoretisch mehr Zeit mit längeren Geschichten verbringen könnten?

CW: Ist das die Zukunft für Werbefilme? Das ist nicht nur die Zukunft – das ist schon die Gegenwart. Indem man auf etwas reagieren kann, was man gerade erst gesehen hat, bekommen Marketingexperten und Kreative eine Riesenchance, die im Fernsehen erzählten Geschichten noch weiter auszubreiten.

T : La télévision est encore le principal média du monde de la publicité. Quels en sont les plus grands avantages ?

CW : C'est celui qui recueille le plus grand nombre de spectateurs et qui a l'impact le plus immédiat.
DA : Quand un film est de qualité, sa répercussion demeure importante. Et puis, il y a toujours la finale du championnat de football américain.

T : Comment la technologie a-t-elle influencé la production des films publicitaires aujourd'hui ?

CW : La technologie permet de produire des films plus vite et à un moindre coût théoriquement, mais le coût du film ne représente qu'une partie infime de la production.
DA : La technologie permet de créer pratiquement n'importe quoi depuis son bureau. Autrefois, il fallait aller en Chine pour filmer la Grande muraille.

T : Comment pensez-vous que la télévision et l'Internet agissent l'un sur l'autre aujourd'hui et comment agiront-ils dans un avenir proche ?

CW : À partir de maintenant, la télévision apportera des réponses instantanément. En d'autres termes, les téléspectateurs pourront obtenir des informations plus détaillées sur ce qu'ils verront, et ils en tireront parti. La télévision deviendra ainsi une sorte de bande-annonce pour des contenus plus approfondis.
DA : Dans un futur proche, télévision et Internet ne feront plus qu'un.

T : Les spots publicitaires vont-ils servir de plus en plus à conduire les consommateurs sur Internet, où l'on peut leur raconter des histoires plus longues ?

CW : Il s'agit non seulement de l'avenir des spots publicitaires, mais aussi de leur présent. Il a été donné une occasion inouïe aux marketeurs et aux créatifs de poursuivre les histoires qu'ils racontent à la télévision, en les prolongeant sur Internet.
DA: C'est une possibilité, mais pas la seule. Certains produits n'ont pas besoin d'une histoire plus longue.

The smartest and wittiest of thousands of brilliant ads done by Bernbach in the 60s. "Bo Knows" Nike. A brilliant mash-up of culture and sport to launch cross training. It's brilliant, elegantly simple and witty writing.

DA: The VW "Snow Plow", "1984" Apple and the Miller "High Life" campaign by Wieden+Kennedy.

T: Now choose your top three from your own repertoire.

CW: My best work is defined more by series than single spots: a series of spots for Apple PowerBook based on the theme "What's on Your PowerBook?". Another Apple series would be the one with people trying to make Windows work. And the IBM campaign that featured *faux* business technology: pixie dust, the business reality detector, the business time machine and a bunch of other silly contraptions.

DA: Hershey Kisses "Christmas Bells"; American Express "Gas Station" with Jerry Seinfeld; Jaguar "At Last."

DA: Ich denke, das ist eine der Entwicklungen, die zukünftig möglich sind, doch nicht die einzige. Einige Produkte haben einfach keine längere Geschichte.

T: Was sind für Sie die besten drei TV-Spots aller Zeiten?

CW: „1984", Apple Computer. Eine großartige, dramatische, gewagte, brillant ausgeführte Kampagne für ein Produkt, das jeden Werbepenny wert war. „1948 Auto Show" VW. Die cleverste und witzigste unter den tausenden von brillanten Werbungen, die Bernbach in den 1960ern machte. „Bo Knows" Nike. Eine brillante Mischung aus Kultur und Sport, um Cross-Trainingsschuhe einzuführen. Eine brillante, witzig geschriebene Werbung von eleganter Einfachheit.
DA: Der VW „Snow Plow", Apple „1984" und die Miller-Kampagne "High Life" von Wieden+Kennedy.

T: Wählen Sie jetzt Ihre Top 3 aus Ihrem eigenen Repertoire.

CW: Meine beste Arbeit ist eigentlich kein einzelner Spot, sondern eine Serie: eine Reihe von Spots für das Apple PowerBook, basierend auf dem Slogan „What's on Your PowerBook?" (Was ist auf deinem PowerBook?) Dann wäre da noch die andere Apple-Serie mit den Leuten, die versuchen, Windows zum Laufen zu bringen. Und die IBM-Kampagne mit all diesen unsinnigen Technologieerfindungen: Feenstaub („Pixie Dust"), Business-Lügendetektor („Reality Detector"), universeller Business-Adapter („Universal Business Adapter") und so weiter.
DA: Hershey Kisses „Christmas Bells"; American Express „Gas Station" mit Jerry Seinfeld; Jaguar „At Last".

T : Quels sont vos trois films publicitaires favoris de tous les temps ?

CW : « 1984 », Apple Computer. Une campagne gigantesque, spectaculaire, audacieuse, et réalisée à la perfection avec un produit qui a donné ses fruits. « 1948 Auto Show » Volkswagen (VW). La plus astucieuse et la plus intelligente des milliers de publicités géniales que Bernbach a créées dans les années 1960. « Bo Knows » Nike. Un mélange exquis de culture et de sport pour lancer le « cross training ». L'écriture du film est géniale, astucieuse et simple, tout en restant élégante.
DA : VW « Snow Plow », « 1984 » Apple, et la campagne de Miller « High Life » par Wieden+Kennedy.

T : Citez les trois meilleurs films que vous ayez écrits.

CW : Mon meilleur travail se définit mieux en termes de séries de spots qu'en termes de films pris séparément. Il y a la série du PowerBook d'Apple, basée sur le thème « Qu'est-ce qu'il y a sur votre PowerBook ? ». Il y a une autre série Apple, où des gens essaient de faire marcher Windows. Et il y a la campagne IBM qui présentait de faux nouveaux produits technologiques pour les entreprises : la poudre à réparer les serveurs, le détecteur de réalité commerciale, la machine à remonter le temps de l'entreprise, ainsi que toute une série d'engins ridicules.
DA : Hershey Kisses « Christmas Bells », American Express « Station-service » avec Jerry Seinfeld et Jaguar « At Last ».

BE LOVED, BE POWERFUL!

AL MOSELEY & JOHN NORMAN
EXECUTIVE CREATIVE DIRECTORS OF WIEDEN+KENNEDY AMSTERDAM

Al Moseley joined Wieden + Kennedy Amsterdam in the beginning of 2005, where, alongside John Norman, he is responsible for the agency's creative output on a broad range of accounts including Nike, Coca-Cola, Electronic Arts, Procter & Gamble, and Carlsberg. After studying film at Epsom College of Art and Design, Al fell into advertising whilst working at a production company in 1993. Since then he has gained a wide range of experience working on campaigns for Sony PlayStation, Apple, Orange, and high street retailer Boots. He also worked as creative director for the Labour Party, helping to win the general election in 1997. In addition to his advertising duties he has also worked as a television script-writer for stand-up comedian Jack Dee, as well as a more sobering BBC fundraising documentary on the aftermath of the war in the Balkans. Originally, Al had never intended to work in advertising, favoring a career as a professional chess player.

Like creative partner Al Moseley, John Norman joined Wieden + Kennedy Amsterdam in 2005, employing his talents to lead campaigns for Nike, Coca-Cola, Electronic Arts and HypoVereinsbank. John is a classically trained

Al Moseley kam Anfang 2005 zu Wieden +Kennedy Amsterdam. Zusammen mit John Norman ist er dort für die kreativen Arbeiten der Agentur für zahlreiche Kunden verantwortlich, darunter Nike, Coca-Cola, Electronic Arts, Procter & Gamble und Carlsberg. Nach seinem Studium der Filmwissenschaften am Epsom College of Art and Design landete Al während seiner Tätigkeit für eine Produktionsgesellschaft 1993 mehr oder weniger per Zufall in der Werbung. Seitdem konnte er sich durch seine Arbeit an Kampagnen für Sony PlayStation, Apple, Orange und die britische Handelskette Boots einen großen Erfahrungsschatz aneignen. Zudem unterstützte er die Labour Party als Kreativdirektor bei ihrem Wahlsieg 1997. Neben seiner Tätigkeit in der Werbung hat er auch schon TV-Drehbücher für den britischen Stand-up-Comedian Jack Dee und das Script für eine BBC-Dokumentation über die Folgen des Balkankrieges geschrieben. Ursprünglich hatte Al gar nicht vor, in der Werbung zu arbeiten, sondern wollte professioneller Schachspieler werden.

Wie sein Kreativpartner Al Moseley kam auch John Norman 2005 zu Wieden + Kennedy Amsterdam, wo er seine Talente einsetzte, um Kampagnen für Nike, Coca-Cola, Electronic Arts und die HypoVereinsbank zu leiten. John ist ein klassisch ausgebildeter Grafikdesigner und kann als Art Director umfangreiche Erfahrungen in der Kommunikationsbranche vorweisen. Seine hoch gelobten Arbeiten in den Bereichen Grafikdesign, TV- und Printwerbung erhielten zahlreiche internationale Auszeichnungen, und er wurde in nahezu allen renommierten Designpublikationen porträtiert. Er vertritt nicht nur die grundsätzliche

Début 2005, Al Moseley entre chez Wieden + Kennedy Amsterdam où, aux côtés de John Norman, il est responsable de la création de l'agence pour un large éventail de clients, tels que Nike, Coca-Cola, Electronic Arts, Procter & Gamble et Carlsberg. Après ses études de cinéma à l'Epsom College of Art and Design, Al avait découvert la publicité en travaillant dans une société de production en 1993. Depuis lors, il a gagné une longue expérience en œuvrant notamment sur des campagnes pour Sony PlayStation, Apple, Orange et Boots, le détaillant pharmaceutique britannique. Il a également travaillé en tant que directeur créatif pour le parti travailliste et l'a aidé à remporter les élections législatives en 1997. Outre ses activités publicitaires, il a également été scénariste de télévision pour le comique Jack Dee, et pour un documentaire plus sérieux, visant à collecter des fonds, sur les conséquences de la guerre des Balkans. À l'origine, Al n'avait jamais eu pour objectif de travailler dans le monde de la publicité, il pensait plutôt à une carrière de joueur d'échec professionnel.

Tout comme son compagnon de création Al Moseley, John Norman entre chez Wieden + Kennedy Amsterdam en 2005 et emploie son talent à mener des campagnes pour Nike, Coca-Cola, HypoVereinsbank ou Electronic Arts. Graphiste de formation, Al est devenu un directeur artistique confirmé dans le domaine de la communication. Son travail dans le graphisme, la publicité télévisée ou l'affichage a été largement applaudi. Il s'est vu remettre de nombreux prix internationaux et a fait l'objet d'articles dans la

graphic designer and an art director with extensive experience in the communication industry. His work in graphic design, television and print advertising has been widely acclaimed, receiving a host of international accolades, and he has been featured in almost every design publication. He fundamentally believes that all communication has roots in design; moreover that the best advertising and design contains a strong concept and a simple form. Previously, John was design director for Benetton in Italy (where he also served as director of the international design school Fabrica). He also did an earlier stint at W+K Amsterdam as creative director on Coca-Cola, Microsoft, and the award-winning Nikepark soccer experiential environment for the 1998 World Cup.

The adage says "There is no surer way to a man's heart than through his stomach". We would argue that unless you get into the heart you'll never get near the stomach.

TO BE A SUCCESSFUL FOOD BRAND YOU HAVE TO BE LOVED, BECAUSE NO OTHER RELATIONSHIP IN LIFE HAS AS MUCH EMOTIONAL RESONANCE ON A DAILY BASIS THAN THAT OF US AND OUR FOOD.

It can make us feel nostalgic, it can make us feel happy and it can console us when we are sad. People are passionate about food. It is a seemingly simple, yet ultimately complex experience.

Ansicht, dass Kommunikation ihre Wurzeln im Design hat, sondern dass die beste Werbung und das beste Design immer durch ein starkes Konzept und eine einfache Form überzeugen. John war zuvor als Design Director für Benetton in Italien tätig (wo er auch die internationale Designschule Fabrica leitete). Zudem war er bereits früher als Kreativdirektor für W+K Amsterdam im Einsatz, wo er Kampagnen für Coca-Cola, Microsoft und den preisgekrönten „Nike Park" für die Fußball-WM 1998 leitete.

Ein altbekanntes Sprichwort sagt: „Liebe geht durch den Magen" – mit anderen Worten: Das Herz eines Menschen lässt sich am besten durch gutes Essen erobern. Wir dagegen glauben, dass zuerst das Herz erobert werden muss, sonst nützt auch das beste Essen nichts.

EINE NAHRUNGSMITTELMARKE KANN NUR DANN ERFOLGREICH SEIN, WENN SIE GELIEBT WIRD. NUR WENIGE BEZIEHUNGEN IN UNSEREM LEBEN SIND TÄGLICH VON SO GROSSER EMOTIONALITÄT GEPRÄGT WIE DIE BEZIEHUNG ZWISCHEN UNS UND UNSERER NAHRUNG.

Nahrung kann uns glücklich machen, sie kann Sehnsucht in uns wecken und uns Trost spenden, wenn wir traurig sind. Der Mensch isst und trinkt mit Leidenschaft. Essen und Trinken ist nur scheinbar ein ganz simpler Vorgang; bei näherer Betrachtung erweist es sich als äußerst komplexer Prozess.

quasi-totalité des revues sur le design. Il est convaincu que toute communication provient du design, et que c'est avec un concept puissant et une forme simple que l'on vend et l'on conçoit le mieux un produit. John a aussi été directeur du design chez Benetton en Italie (où il dirigeait également l'école internationale de design Fabrica) et avait déjà travaillé en tant que directeur créatif chez W+K Amsterdam sur Coca-Cola, Microsoft et Nikepark, l'environnement expérientiel footballistique primé pour la Coupe du monde 1998.

Selon le vieil adage : « Le meilleur moyen d'atteindre le cœur de l'homme, c'est à travers son estomac ». Nous pensons, nous, qu'à moins d'atteindre le cœur de l'homme, on ne parvient jamais à son estomac.

POUR QU'UNE MARQUE ALIMENTAIRE FONCTIONNE, ELLE DOIT ÊTRE AIMÉE. CAR, DANS LA VIE, AUCUN AUTRE RAPPORT N'A DE RÉPERCUSSIONS AUSSI ÉMOTIVES AU QUOTIDIEN QUE NOTRE RAPPORT À LA NOURRITURE.

Elle nous rend nostalgiques ou heureux. Elle peut nous consoler quand on est triste. Quand on parle d'elle, il arrive qu'on s'enflamme. Simple en apparence, c'est en définitive une expérience complexe.

La nourriture que l'on mange au quotidien ne procure pas uniquement du plaisir. Elle nous définit, tout comme la voiture que l'on conduit ou le type de vacances que l'on prend. En d'autres termes, on se

The food we choose to consume daily not only gives us a lot of pleasure, but actually defines who we are, as much as the car we drive or the holidays we take. In other words, you can probably find out just as much about someone by looking through their shopping basket as looking in their underwear drawer, because so many food and beverage brands in the shopping basket are imbued with emotional resonance.

This is partly because the relationship people have with these brands is pretty constant and long-lasting: Coca-Cola is 120 years old and completely ubiquitous, seen by the average person almost 2000 times a day. Other great brands have this same quality—Heinz Tomato Ketchup, Nescafé, Cadbury's chocolate, to name a few.

Our brief was to choose the best television advertising from the food and beverage category in the last three years. It's worth stopping to consider what this actually means for our selection. The fact that they are all on television means they have money behind them. It also means they have excellent distribution, which in turn tells us that they are owned by some of the biggest companies in the world. So, no local wine producer or organic bread maker gets a look in… until of course, they become the next big brand.

WORKING WITHIN THESE PARAMETERS, WE END UP WITH A SNAPSHOT OF OUR MASS CONSUMPTION, AND A VERY SPECIFIC ONE AT THAT.

Our shopping basket resembles a late night supermarket sweep after happy hour: lots of beer, crispy snacks, sweets, fizzy drinks and burgers. Food that's enjoyable at the moment of consumption.

Radical thinking behind some of the work—even on campaigns which have been around for a number of years—is striking: Marmite celebrates how the taste polarizes people to extremes; Stella Artois tells us how expensive (and thus valued) a beer is; and Guinness says you'll have to stand there and wait at the bar (but it'll be worth it). These are all rational reasons told to us in a connective emotional way.

Skittles, on the other hand, throws rational thinking entirely out of the window and succeeds brilliantly,

Das Essen, das wir zum täglichen Verzehr auswählen, bereitet uns nicht nur Wohlempfinden: es definiert, wer wir sind – genauso wie das Auto, das wir fahren, oder der Urlaub, den wir machen. Mit anderen Worten: Wer den Leuten in den Einkaufswagen schaut, kann genauso viel über sie erfahren wie bei einem Blick in ihren Wäscheschrank, denn viele der Marken im Einkaufswagen liegen nur deshalb dort, weil sie einen emotionalen Wert haben.

Dies lässt sich zum Teil darauf zurückführen, dass die Beziehung, die ein Mensch zu einer Marke hat, oft konstant und langlebig ist. Die 120 Jahre alte Marke Coca-Cola ist auch heute noch allgegenwärtig: Jeder Mensch begegnet ihr im Durchschnitt mehrere Male pro Tag. Auch andere führende Marken zeichnen sich durch ihre enorme Präsenz aus, darunter z.B. Heinz Ketchup oder Nescafé.

Unser Auftrag bestand darin, die besten TV-Werbespots der letzten drei Jahre in der Kategorie „Speisen und Getränke" auszuwählen. Was heißt das für unsere Auswahl? Die Tatsache, dass es sich um TV-Spots handelt, bedeutet, dass die darin beworbenen Marken viel Geld im Rücken haben. Außerdem verfügen diese Marken über eine ausgezeichnete Distribution, was wiederum vermuten ließ, dass ihre Eigentümer zu den weltweit führenden Unternehmen zählen. Der örtliche Weinhändler oder Biobäcker wird sich kaum eine TV-Werbekampagne leisten können.

WENN WIR MIT DIESEN PARAMETERN ARBEITEN, ERHALTEN WIR EINE SEHR SPEZIFISCHE MOMENTAUFNAHME UNSERES MASSENKONSUMS.

Unser Einkaufswagen sieht aus wie bei einem abendlichen Supermarktbummel: jede Menge Bier, Snacks, Süßigkeiten, Softdrinks und Burger – also Nahrungsmittel, die viel Spaß machen.

Bemerkenswert ist der radikale Denkansatz, der hinter manchen Werbekampagnen steckt – und dies trifft sogar auf Kampagnen zu, die bereits seit vielen Jahren laufen. Die Werbung für den Brotaufstrich Marmite zielt ganz bewusst darauf, dass die Leute den Geschmack entweder lieben oder hassen. Stella Artois informiert darüber, wie teuer (und begehrt) die-

fait autant une idée de quelqu'un en regardant dans son panier à commissions qu'en fouillant dans son tiroir secret, car le panier à commissions renferme un nombre extraordinaire de marques de produits alimentaires et de boissons empreintes d'émotions.

Cela s'explique en partie par le caractère relativement constant et durable que les gens entretiennent avec ces marques : la marque Coca-Cola a 120 ans et elle est complètement omniprésente – une personne la voit en moyenne 2 000 fois par jour. D'autres grandes marques partagent cette qualité : le ketchup Heinz ou Nescafé par exemple.

On nous a demandé de choisir la meilleure publicité télévisée des trois dernières années dans la catégorie Produits alimentaires et boissons. Analysons quel est le sens réel de cette requête. Si ces marques se voient à la télévision, c'est qu'elles sont portées par de gros capitaux et qu'elles bénéficient d'un excellent réseau de distribution, ce qui indique qu'elles sont détenues par l'une des plus grandes sociétés au monde. Par conséquent, ni le producteur de vin local ni le fabricant de pain bio ne figureront parmi les candidats… À moins que son produit ne devienne la prochaine grande marque à succès.

SUR LA BASE DE CES PARAMÈTRES, ON ARRIVE À UN APERÇU DE LA CONSOMMATION DE MASSE. UN APERÇU, QUI PLUS EST, TRÈS PRÉCIS.

Notre panier à commissions ressemble au sol d'un bar à la fermeture après le « happy hour » : de la bière, des biscuits apéritifs, des bonbons, des boissons gazeuses et des hamburgers. Des produits que l'on apprécie au moment où on les consomme.

Certaines campagnes (dont quelques-unes existent depuis de nombreuses années) sont le fruit d'un mode de pensée très radical. Marmite célèbre la capacité du goût à diviser les gens en deux camps. Stella Artois nous explique à quel point la bière est chère (et donc valorisée). Et Guinness nous invite à attendre notre bière debout, sagement au bar (car elle en vaut la peine). Il s'agit de justifications rationnelles, qui nous sont expliquées de manière connective et émotionnelle.

because you shouldn't have to stop and think. If you did, you probably wouldn't eat the brightly colored, sugary chewy confection. The work's irrationality stays true to the brand.

Burger King feeds us rationally—big patties, lots of choice, innovative servings—all presented with a big dollop of humor.

WHAT'S SO INTERESTING ABOUT THE BURGER KING WORK IS HOW DIFFERENT EACH EXECUTION IS FROM THE LAST BUT CLEARLY IS COMING FROM THE SAME BRAND, WHAT WE CALL SPEAKING WITH THE SAME VOICE.

The two Miller campaigns and Smirnoff's "Tea Partay" all trade off a lifestyle, real or imagined. "Man Law" and "Tea Partay" are both very knowing. Even though we're meant to identify with the consumer they portray, we laugh at them. "High Life", on the other hand, is sincere and real (but still funny) with a much more wise, honest tone.

Johnnie Walker and Coke's "Parade" commercial both tackle weightier themes such as that of human progression and the cultural make-up of the American people, themes that only truly established brands dare comment on.

ULTIMATELY, A TELEVISION COMMERCIAL, FOR BRANDS WITH SO MUCH HISTORY, CAN ONLY ENHANCE WHAT IS ALREADY BELIEVED SOMEWHERE IN SOMEONE'S SUBCONSCIOUS, RATHER THAN CHANGE SOMEONE'S PERCEPTION ENTIRELY.

But the inherent potency of that subconscious can be very persuasive. It can mean that under the right circumstances, buying a Coke for someone can be a more intimate, generous and loving act than buying someone a diamond.

Maybe the adage is true.

se Biermarke ist, während Guinness darauf hinweist, dass man eine Weile an der Bar warten muss, um dieses Bier zu bekommen (aber das Warten lohnt sich natürlich). Diese rationalen Fakten werden in einer emotional ansprechenden Weise vermittelt.

Burger King füttert uns mit rationalen Argumenten (große Happen, große Auswahl, innovative Geschmacksvarianten), die alle mit einer großen Portion Humor serviert werden.

WAS DIE WERBUNG VON BURGER KING SO INTERESSANT MACHT IST, DASS SICH JEDE NEUE KAMPAGNE VON IHREM VORGÄNGER UNTER- SCHEIDET, ABER DENNOCH KLAR ERKENNBAR ZU EIN- UND DERSELBEN MARKE GEHÖRT. ANDERS AUSGEDRÜCKT: ALLE KAMPAGNEN DIESER MARKE SPRECHEN DIESELBE SPRACHE.

Die zwei Kampagnen von Miller und die „Tea Partay"-Kampagne von Smirnoff spielen mit einem entweder realen oder imaginären Lifestyle. Bei „Man Law" und „Tea Partay" sollen wir uns eigentlich mit den Verbrauchern in diesen Spots identifizieren, lachen aber zugleich über sie. Die Werbung für „High Life" dagegen kommt real und authentisch daher, wodurch sie viel lebensnäher und ehrlicher wirkt (ohne dabei an Witz zu verlieren).

In der Kampagne für Johnnie Walker und in der „Parade"-Werbung von Coca-Cola hingegen werden „intellektuellere" Themen, wie der menschliche Fortschritt oder die amerikanische Kultur inszeniert. Nur wirklich etablierte Marken können es wagen, solche Themen aufzugreifen.

Letztlich kann ein TV-Spot für eine so etablierte Marke nur eine Meinung unterstreichen, die bereits irgendwo im Unterbewusstsein verankert ist. Sie wird allerdings niemals eine totale Meinungsänderung bewirken können. Die Macht des Unterbewussten kann jedoch sehr stark sein. Wenn die Umstände stimmen, kann es also sein, dass jemandem eine Coke zu kaufen, großzügiger, liebevoller und intimer wirkt als der Kauf eines Diamanten.

Vielleicht trifft das alte Sprichwort also doch zu?

Skittles, en revanche, fuit complètement ce mode de pensée rationnel et y parvient à merveille. Heureusement, car il ne faut pas trop réfléchir au produit. Sinon, vous ne mangeriez certainement pas ces friandises sucrées aux couleurs vives, difficiles à mâcher. L'irrationalité de la campagne est fidèle à la marque.

Burger King nous sert de la rationalité : de gros steaks hachés, un choix varié, des présentations innovantes, le tout avec une bonne dose d'humour.

CE QUI EST INTÉRESSANT DANS LE TRAVAIL DE BK, C'EST QUE CHAQUE FILM DIFFÈRE DU PRÉCÉDENT, MAIS PROVIENT CLAIREMENT DE LA MÊME MARQUE. C'EST CE QU'ON APPEL- LE PARLER D'UNE SEULE VOIX.

Les deux campagnes Miller et le « Tea Partay » de Smirnoff vendent un mode de vie, qu'il soit réel ou imaginaire. « Man Law » et « Tea Partay » rendent le spectateur très complice. Bien qu'on soit censé s'identifier avec le consommateur dépeint, on se moque de lui. « High Life », en revanche, est sincère et réaliste (tout en étant drôle). Son ton est bien plus sage et honnête.

Johnnie Walker et le spot publicitaire « Parade » de Coca-Cola s'attaquent à des sujets bien plus profonds, tels que la progression de l'humanité ou la diversité culturelle du peuple américain, des sujets que seules des marques bien établies osent aborder.

ENFIN, UN SPOT TÉLÉVISÉ, POUR DES MARQUES AUSSI ANCRÉES DANS L'HISTOIRE, NE PEUT QUE METTRE EN EXERGUE CE QUE L'ON CROIT QUELQUE PART DANS NOTRE INCONSCIENT. IL NE CHANGERA JAMAIS COMPLÈTE- MENT NOTRE PERCEPTION.

Mais la force inhérente à ce subconscient peut être puissante. À tel point, que dans de bonnes circonstances, offrir un Coca à quelqu'un peut devenir un acte plus intime, plus généreux et plus affectueux que de leur offrir un diamant.

Peut-être que l'adage est vrai.

001

FOOD & BEVERAGE

TITLE: Breeze. **CLIENT:** Diageo. **PRODUCT:** Gordon's Gin. **AGENCY:** Bartle Bogle Hegarty. **COUNTRY:** United Kingdom. **YEAR:** 2005. **CREATIVE DIRECTOR:** Alex Grieve, Adrian Rossi. **COPYWRITER:** Matt Waller, Dave Monk.
ART DIRECTOR: Dave Monk, Matt Waller. **PRODUCTION COMPANY:** Passion Pictures. **DIRECTOR:** John Robertson. **AWARDS:** Cannes Lions (Bronze).

Enter an animated world of painting-by-numbers. The digits swarm and swirl their way through the city street, into a pub and a glass of Gordon's Gin and Tonic. /// Wir befinden uns in einer animierten „Malen nach Zahlen"-Welt. Die Zahlen wirbeln ihren Weg durch die Straßen einer Stadt, sausen in einen Pub und landen dort in einem Glas mit Gordon's Gin und Tonic. /// Entrez dans un monde de dessins animés faits de coloriage par numéros. Les numéros fourmillent dans la rue et entrent dans un pub, puis dans un verre de Gin and Tonic de Gordon.

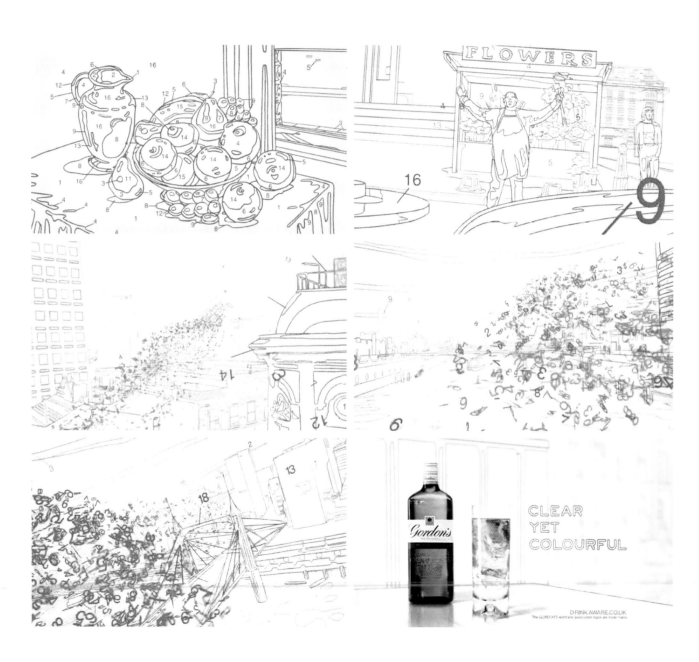

TITLE: Tea Partay. **CLIENT:** Smirnoff. **PRODUCT:** Smirnoff Raw Tea. **AGENCY:** Bartle Bogle Hegarty. **COUNTRY:** USA. **YEAR:** 2006. **CREATIVE DIRECTOR:** Kevin Roddy. **COPYWRITER:** Matt Ian, Clay Weiner. **ART DIRECTOR:** Amee Shah. **PRODUCER:** Melissa Bemis, Lisa Gatto. **DIRECTOR:** Julian Christian Lutz.

A spoof style hip hop video shows a bunch of rich college preppies gangsta rapping the exclusive taste of Smirnoff Raw Tea line. The boys are encouraged by their debutante girlfriends. /// Ein Ulk-Hip-Hop-Video zeigt eine Gruppe reicher adretter College-Studenten, die zu dem exklusiven Geschmack der Reihe Raw Tea von Smirnoff rappen. Die Jungs werden von ihren Freundinnen angefeuert, die als Debütantinnen auftreten. /// Cette parodie de clip hip-hop montre une bande d'étudiants BCBG faisant du rap « gansta » sur le goût exclusif de la ligne Raw Tea de Smirnoff. Les garçons sont encouragés par leurs copines très comme il faut.

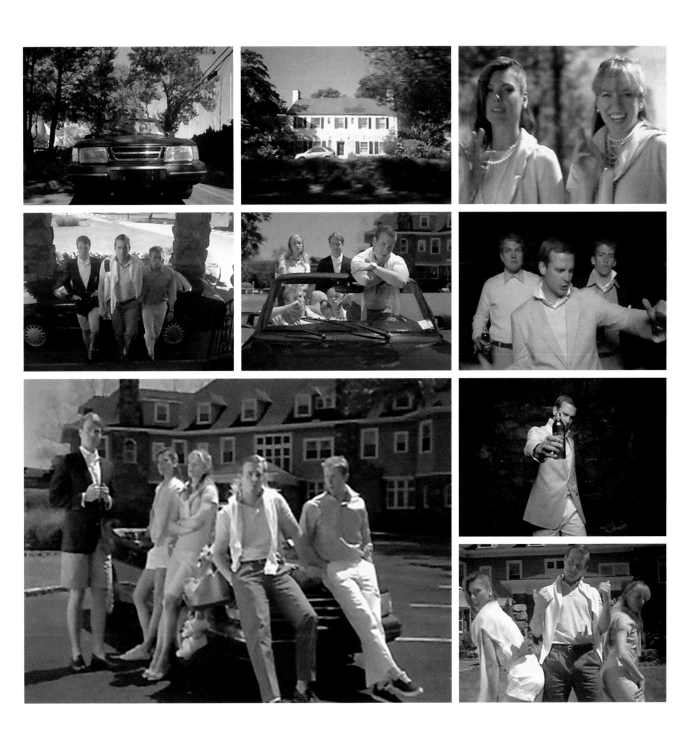

TITLE: Swear Jar. **CLIENT:** Anheuser-Busch. **PRODUCT:** Bud Light. **AGENCY:** DDB Chicago. **COUNTRY:** USA. **YEAR:** 2008. **EXECUTIVE CREATIVE DIRECTOR:** Paul Tilley. **GROUP CREATIVE DIRECTOR:** Mark Gross. **CREATIVE DIRECTOR:** Chuck Rachford, Chris Roe. **COPYWRITER:** Jason Karley. **ART DIRECTOR:** Galen Graham. **PRODUCTION COMPANY:** Hungry Man. **DIRECTOR:** David Shane.

A bored office worker discovers that the proceeds of a swear jar will go towards buying the office a case of Bud Light. This triggers off a whole sequence of antics as the entire office goes swear-happy. The ad ends with the CEO swearing his congratulations to his team as they enjoy their well-deserved case of Bud Light. /// Ein gelangweilter Büroangestellter findet heraus, dass die Einnahmen einer Fluchkasse dafür gedacht sind, der Abteilung einen Kasten Bud Light zu kaufen. Dies löst eine ganze Bildfolge witziger Szenen aus, in denen die gesamte Abteilung flucht, was das Zeug hält. Der Werbespot endet mit einer Einstellung des Geschäftsführers, der fluchend sein Team beglückwünscht, während alle ihr wohlverdientes Bud Light genießen. /// Un employé de bureau désœuvré découvre le fonctionnement d'un « pot à jurons », dont le contenu doit servir à acheter une caisse de Bud Light pour le personnel. Suit une série de gags où les employés jurent à qui mieux mieux. La pub s'achève sur le chef de bureau : à grand renfort de gros mots, il félicite son équipe, qui savoure sa caisse de Bud Light bien méritée.

TITLE: Big Ad. **CLIENT:** Foster's Australia. **PRODUCT:** Carlton Draught Beer. **AGENCY:** George Patterson Y&R. **COUNTRY:** Australia. **YEAR:** 2006. **CREATIVE DIRECTOR:** James McGrath. **COPYWRITER:** Ant Keogh. **ART DIRECTOR:** Grant Rutherford. **PRODUCTION COMPANY:** Plaza Films. **PRODUCER:** Peter Masterton. **DIRECTOR:** Paul Middleditch. **AWARDS:** Cannes Lions (Gold).

A parody of epic proportions sends up the big budget commercial, with song lyrics like "It's a big ad, expensive ad! This ad better sell some bloooooody beer." /// Diese Parodie epischen Ausmaßes nimmt die teuren Werbespots mit Songs wie „Dies ist eine großartige Werbung, eine teure Werbung! Diese Werbung muss unbedingt viiiiiiiel Bier verkaufen!" auf den Arm. /// Cette publicité à gros budget est une parodie aux proportions épiques, avec les paroles suivantes : « C'est une grande publicité/un spot très cher/il a intérêt à vendre un saaaaaaaacré nombre de bières ! »

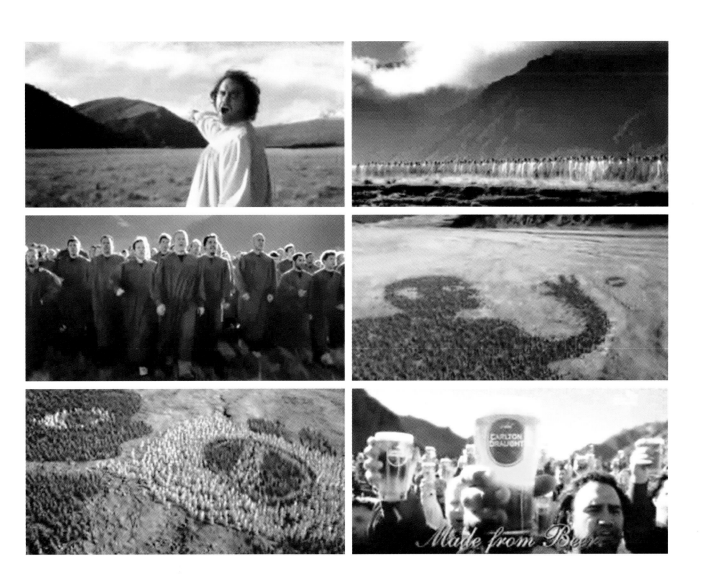

TITLE: Noitulove. **CLIENT:** Guinness & Co. **PRODUCT:** Guinness Beer. **AGENCY:** Abbott Mead Vickers BBDO. **COUNTRY:** United Kingdom. **YEAR:** 2006. **CREATIVE DIRECTOR:** Paul Brazier. **COPYWRITER:** Ian Heartfield. **ART DIRECTOR:** Matt Doman. **PRODUCTION COMPANY:** Kleinman Productions. **PRODUCER:** Jonnie Frankel. **DIRECTOR:** Danny Kleinman. **AWARDS:** Cannes Lions (Grand Prix).

Three guys take a sip of Guinness at a bar. All of a sudden the action plays in reverse. The three men walk out backwards and travel back in time through millions of years of evolution. Three mudskippers take a sip of sludge on a primeval shore. The tagline reads: "Guinness. Good things come to those who wait." /// Drei Männer nippen in einer Bar an ihrem Guinness. Plötzlich kehrt sich die Zeit um, die drei Männer laufen rückwärts aus der Bar und reisen Millionen von Jahren in der Evolution zurück. Drei Schlammspringer genießen an einem urzeitlichen Strand einen ordentlichen Schluck Schlamm. Der Slogan lautet: „Guinness. Was lange währt, wird endlich gut." /// Trois hommes boivent une Guinness dans un bar. Tout d'un coup, l'action se déroule à l'envers. Ils sortent du pub en marche arrière et remontent le temps à travers des millions d'années d'évolution. Trois poissons-amphibiens préhistoriques boivent de la vase sur une rive primitive. Le slogan s'affiche : « Guinness. Les bonnes choses arrivent à ceux qui savent attendre ».

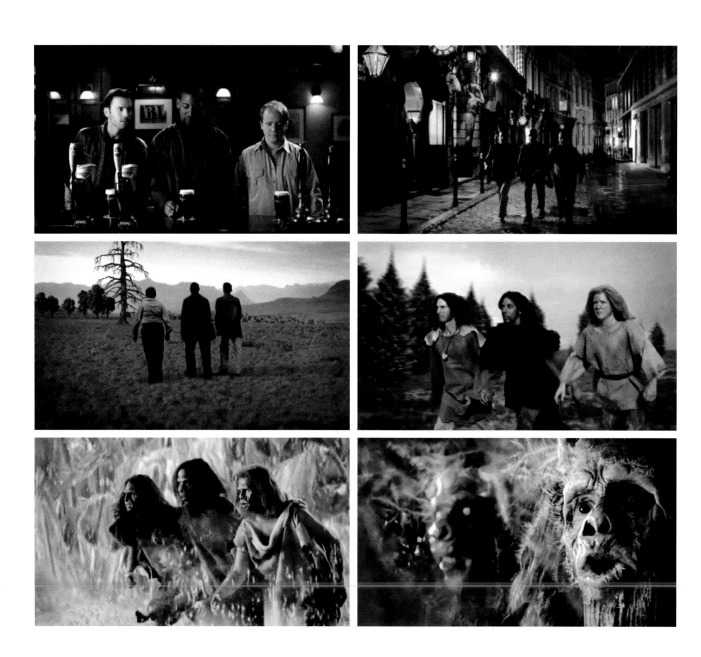

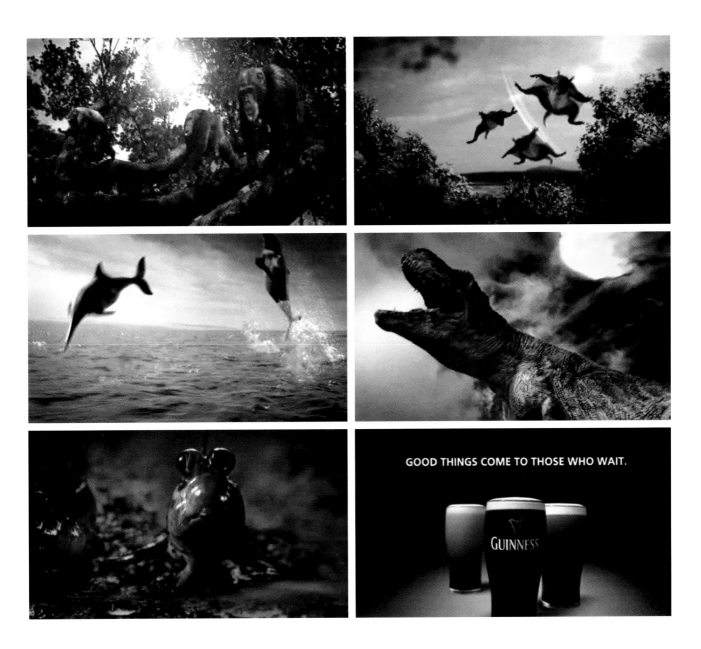

TITLE: Foxhole. **CLIENT:** Miller Brewing Company. **PRODUCT:** Miller High Life Light. **AGENCY:** Wieden+Kennedy Portland. **COUNTRY:** USA. **YEAR:** 2003. **CREATIVE DIRECTOR:** Roger Camp, Susan Hoffman. **COPYWRITER:** Jed Alger, Jeff Kling. **ART DIRECTOR:** Jeff Williams. **PRODUCTION COMPANY:** Moxie Pictures. **PRODUCER:** Jeff Selis. **DIRECTOR:** Errol Morris. **AWARDS:** ANDY Awards (Silver).

This tongue-in-cheek spot pokes fun at women's obsession with weight loss. While her partner tucks into his wholesome plate of meat and potatoes, a woman pokes at a green salad. As he drinks his Miller High Life, he feels proud of his sensitivity to her goals. /// Dieser ironische Spot macht sich darüber lustig, wie sehr Frauen aufs Abnehmen fixiert sind. Während sich ihr Partner über sein ordentliches Gericht mit Fleisch und Kartoffeln hermacht, stochert sie nur in einem grünen Salat herum. Als er sein Miller High Life trinkt, ist er stolz darauf, so einfühlsam auf ihre Ziele einzugehen. /// Ce spot ironique se moque de l'obsession des femmes pour les régimes. Pendant que son compagnon attaque une belle assiette de viande et de pommes de terre, elle touche à peine sa salade verte. Il boit sa Miller High Life, et se sent fier de la soutenir dans ses objectifs.

 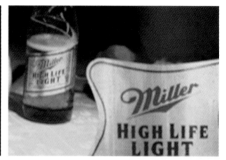

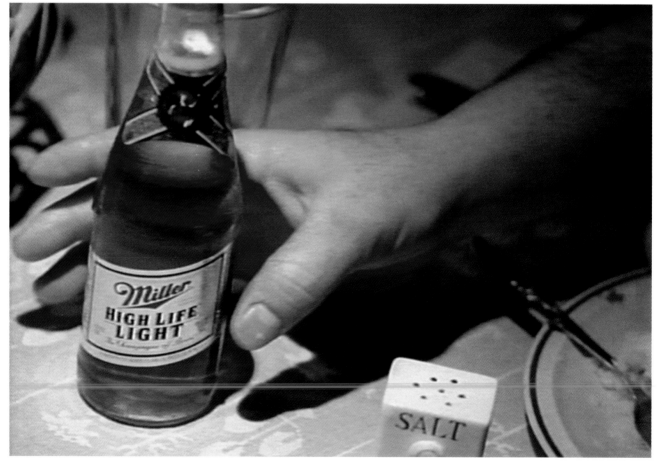

TITLE: Penguin. CLIENT: Miller Brewing Company. PRODUCT: Miller Lite Beer. AGENCY: Y&R Chicago. COUNTRY: USA. YEAR: 2006. CREATIVE DIRECTOR: Mark Figliulo, Dave Loew, Jon Wyville. COPYWRITER: Ken Erke, Pete Figel. ART DIRECTOR: Corey Ciszek, Mark Figliulo. PRODUCTION COMPANY: MJZ. PRODUCER: Vince Landay, David Zander, Jeff Scruton. DIRECTOR: Spike Jonze. AWARDS: Cannes Lions (Bronze).

In this pastiche send-up of Reality TV, talent searches, and online public voting, a casting director boasts about her successes in finding animal actors. The scene is cleverly intercut with real animals auditioning with human voices. /// In dieser Mischung aus Reality TV, Talentshow und Online-Wahl prahlt eine Casting-Chefin über ihre Erfolge im Aufspüren von tierischen Schauspielern. In der Szene werden echte Tiere geschickt mit den Stimmen von Menschen unterlegt, die für ein Casting vorsprechen. /// Dans ce pastiche de la télé-réalité et des émissions de télécrochet soumises au vote du public, une directrice de casting se vante de son talent pour trouver des animaux acteurs. La scène est entrecoupée d'auditions de vrais animaux avec des voix humaines.

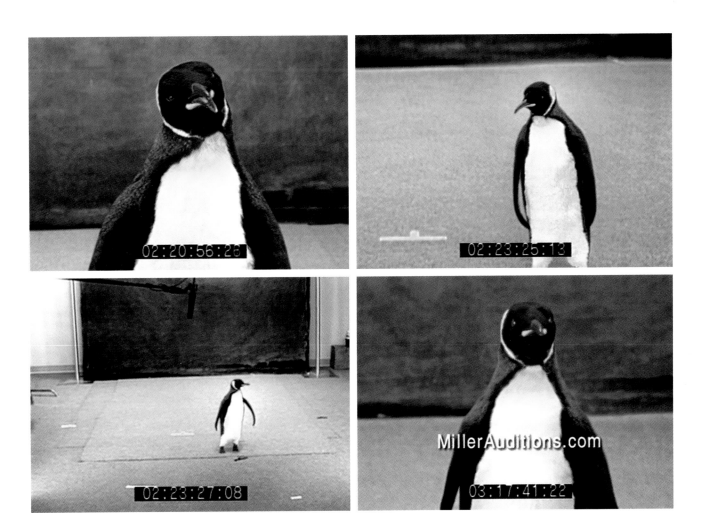

TITLE: Off Limits. **CLIENT:** Miller Brewing Company. **PRODUCT:** Miller Lite Beer. **AGENCY:** Crispin Porter + Bogusky. **COUNTRY:** USA. **YEAR:** 2006. **CHIEF CREATIVE OFFICER:** Alex Bogusky. **CREATIVE DIRECTOR:** Paul Keister, Bill Wright. **COPYWRITER:** Franklin Tipton. **ART DIRECTOR:** Geordie Stephens. **PRODUCTION COMPANY:** Villains. **EXECUTIVE PRODUCER:** Robin Benson, Richard Goldstein. **DIRECTOR:** Peter Farrelly.

A group of men sit around a table drinking Miller Lite and debating the length of time a woman is 'off limits' after dumping their best friend. "When she's breaking up with your best friend she's breaking up with you." Unless she happens to be 'drop dead gorgeous', that is. /// Mehrere Männer sitzen um einen Tisch herum, trinken Miller Lite und debattieren darüber, wie lange eine Frau „tabu" ist, nachdem sie deren besten Freund verlassen hat. „Wenn sie deinen besten Freund verlässt, dann hat sie dich verlassen." Es sei denn natürlich, sie wäre „umwerfend schön". /// Plusieurs hommes sont assis autour d'une table et boivent de la Miller Lite tout en débattant de la période pendant laquelle une femme est « hors limite » après qu'elle ait quitté un ami proche. « Si elle quitte ton meilleur ami, elle te quitte aussi. » Sauf s'il se trouve qu'elle est « canon », bien sûr.

TITLE: Last Orders. **CLIENT:** Whitbread Beer Company. **PRODUCT:** Stella Artois. **AGENCY:** Lowe Howard-Spink. **COUNTRY:** United Kingdom. **YEAR:** 1999 **CREATIVE DIRECTOR:** Paul Weinberger. **COPYWRITER:** Paul Silburn. **ART DIRECTOR:** Vince Squibb. **PRODUCTION COMPANY:** Academy Commercials. **PRODUCER:** Nick Morris. **DIRECTOR:** Jonathan Glazer. **AWARDS:** Cannes Lions (Bronze).

A son asks his dying father for his last three wishes. He fulfils the first two but is unable to keep himself from drinking the third, a Stella Artois. When the village priest arrives, the son hands him the empty glass whilst taking his coat. /// Ein Sohn fragt seinen sterbenden Vater nach seinen letzten drei Wünschen. Er erfüllt die ersten beiden, doch er kann sich nicht zurückhalten, den dritten Wunsch, ein Stella Artois, selbst zu trinken. Als der Dorfpfarrer ankommt, überreicht ihm der Sohn das leere Glas und nimmt seine Jacke. /// Un fils demande à son père mourant de lui dire ses trois dernières volontés. Il accomplit les deux premières mais est incapable de se retenir de boire la dernière, une Stella Artois. Lorsque le prêtre du village arrive, le fils lui tend le verre vide pendant qu'il prend son manteau.

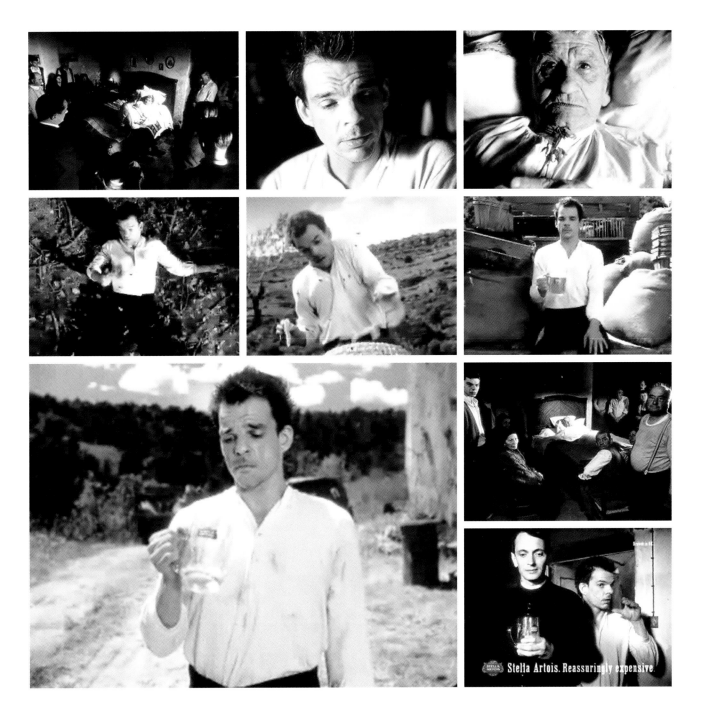

TITLE: Taste it in this Life. **CLIENT:** DB Breweries. **PRODUCT:** Tiger Beer. **AGENCY:** Saatchi & Saatchi. **COUNTRY:** New Zealand. **YEAR:** 2006. **CREATIVE DIRECTOR:** Mike O'Sullivan. **COPYWRITER:** Jay Benjamin, Andy DiLallo, Cameron Harris, Tom Hazeldine. **ART DIRECTOR:** Andy DiLallo, Jay Benjamin Cameron Harris. **PRODUCTION COMPANY:** Film Construction. **POST PRODUCTION:** Digipost. **DIRECTOR:** Jesse Warn.

An old man sees a younger man sitting at a bar with his girlfriend drinking a bottle of Tiger Beer. He walks across the road and is knocked over and killed by a bus. He goes through various reincarnations until he becomes a man again. Just as he is about to claim his long awaited prize, he is squashed by a falling Panda. /// Ein alter Mann sieht einen jüngeren Mann, der mit seiner Freundin in einer Bar sitzt und eine Flasche Tiger Beer trinkt. Er überquert die Straße und wird dabei von einem Bus überfahren und getötet. Er durchlebt verschiedene Reinkarnationen, bis er schließlich als Mann wiedergeboren wird. Gerade, als er dabei ist, sein lang erwartetes Bier zu genießen, wird er von einem fallenden Pandabären erschlagen. /// Un vieillard regarde un jeune homme qui boit une bouteille de Tiger Beer à la terrasse d'un café en compagnie de sa petite amie. Il traverse la rue, se fait renverser par un bus et meurt. Après plusieurs réincarnations, il retrouve enfin apparence humaine. Il est sur le point de recevoir la récompense tant attendue, lorsqu'un panda tombe du ciel et l'écrase.

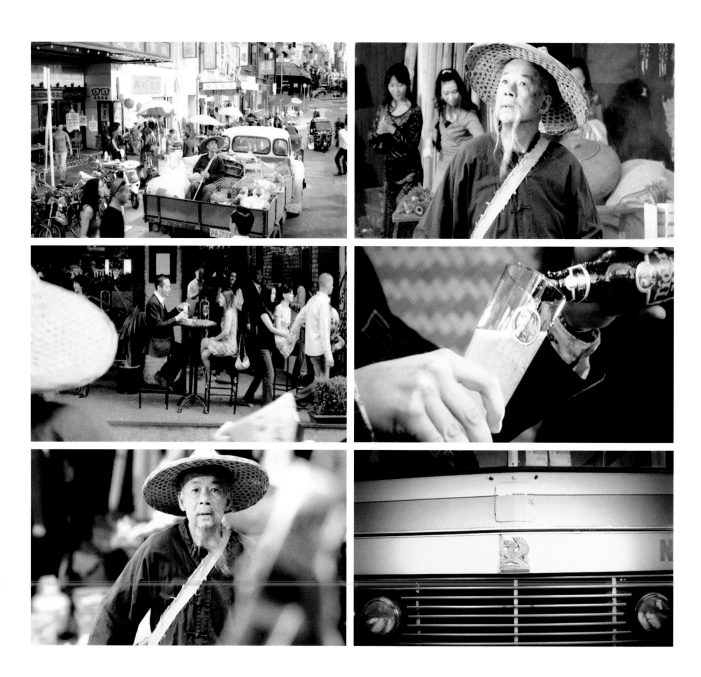

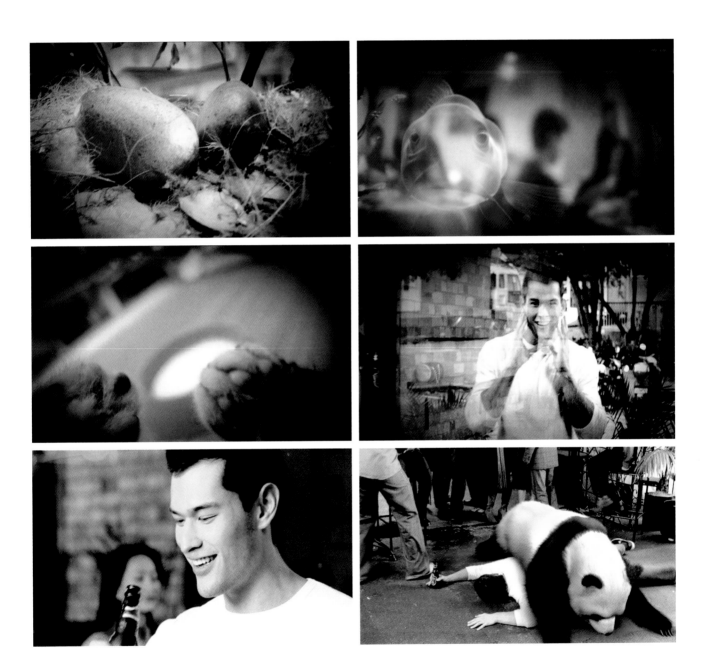

FEATURED ON THE DVD **TITLE:** Happiness Factory. **CLIENT:** Coca-Cola Co. **PRODUCT:** Coca-Cola. **AGENCY:** Wieden+Kennedy Amsterdam. **YEAR:** 2006. **EXECUTIVE CREATIVE DIRECTOR:** Al Moseley, John Norman. **CREATIVE DIRECTOR:** Rick Condos, Hunter Hindman. **EXECUTIVE PRODUCER:** Justin Booth Clibborn. **PRODUCER:** Tom Dunlap, Darryl Hagans, Boo Wong. **DIRECTOR:** Todd, Kylie Mueller, Matulick.

A guy slots a coin into a vending machine to reveal "The Coke Side of Life". The giant coin rolls down into a fantasy land where Coke is bottled. /// Ein Mann wirft eine Münze in einen Getränke-automat, um „Die Coke-Seite des Lebens" zu entdecken. Die Riesenmünze rollt hinunter in ein Fantasieland, wo Coke in Flaschen abgefüllt wird. /// Un homme met une pièce de monnaie dans un distributeur de boissons et cet évènement dévoile « Le côté Coca de la vie ». La pièce de monnaie géante tombe dans le monde imaginaire où le Coca est mis en bouteille.

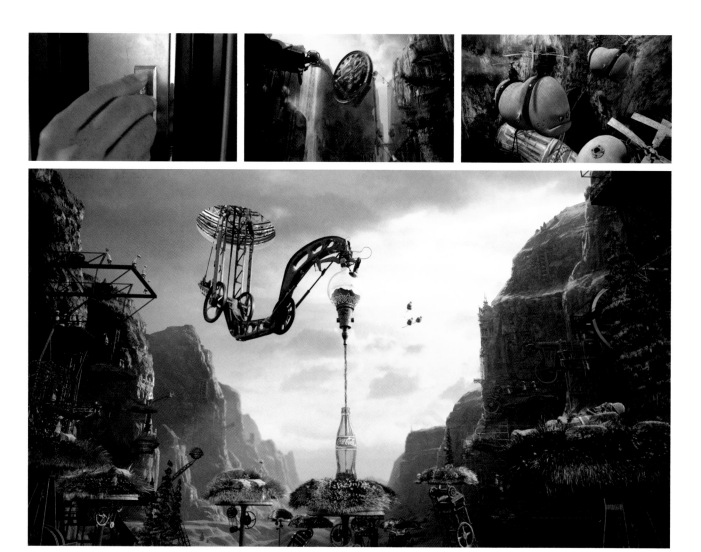

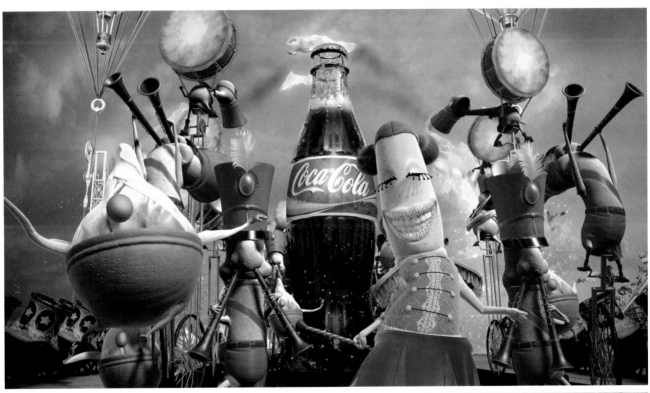

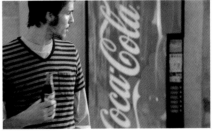

TITLE: Parade. CLIENT: Coca-Cola Co. PRODUCT: Coca-Cola. AGENCY: Wieden+Kennedy Portland. COUNTRY: USA. YEAR: 2006. CREATIVE DIRECTOR: Mark Fitzloff, Hal Curtis. COPYWRITER: Sheena Brady. ART DIRECTOR: Shannon McGlothlin. PRODUCTION COMPANY: MJZ.

A young boy buys a bottle of Coke and cycles down an empty city street. As if in a daydream he finds himself pedaling through a parade of marching bands, baton twirlers, and war veterans – out of the city and into the country. All of a sudden he is back at the corner store. /// Ein kleiner Junge kauft sich eine Flasche Coke und fährt mit dem Rad durch eine leere Straße weg. Wie in einem Tagtraum findet er sich auf einmal in einer Parade wieder und radelt durch Spielmannszüge, wirbelnde Taktstöcke und Kriegsveteranen aus der Stadt heraus und aus offene Land hinaus. Plötzlich landet er wieder vor dem kleinen Laden. /// Un jeune garçon achète une bouteille de Coca et descend une rue vide en vélo. Comme dans un songe, il se retrouve en train de pédaler à travers une parade d'orchestres, de majorettes et de vétérans, qui va de la ville à la campagne. Il se retrouve tout d'un coup au magasin de quartier où tout avait commencé.

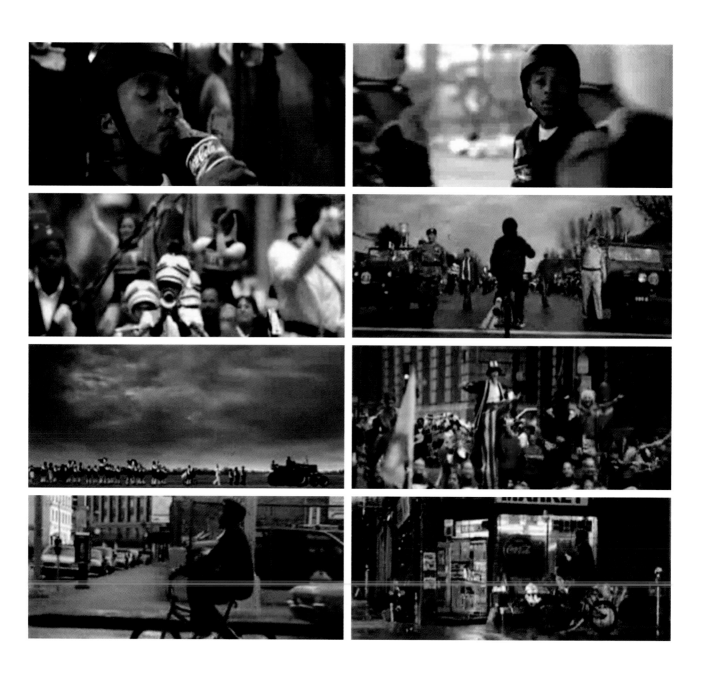

TITLE: Jim K., Rob C.. CLIENT: Coca-Cola Co. PRODUCT: Coke Zero. AGENCY: Crispin Porter + Bogusky. COUNTRY: USA. YEAR: 2008. ASSOCIATE CREATIVE DIRECTOR: Alex Burnard. COPYWRITER: Erkki Izarra. ART DIRECTOR: Dayoung Ewart. EXECUTIVE PRODUCER: Richard Goldstein. DIRECTOR: Fred Goss

Two Coca-Cola executives are secretly being filmed meeting with a lawyer to discuss suing Coke Zero for taste infringement. The baffled lawyer asks why they would want to sue themselves. One of the executives replies, "…but they're on a different part of our floor." /// Zwei Führungskräfte von Coca-Cola werden heimlich gefilmt, wie sie sich mit einem Rechtsanwalt treffen und besprechen, Coke Zero wegen Geschmacksverletzung zu verklagen. Der perplexe Rechtsanwalt fragt, warum sie das eigene Unternehmen verklagen wollen. Einer der Führungskräfte antwortet: „…aber die arbeiten doch auf unserer Etage in einem anderen Bereich." /// Deux cadres de Coca-Cola sont filmés à leur insu en train de consulter un avocat: ils envisagent de faire un procès à Coke Zero pour contrefaçon du goût. Déconcerté, l'avocat demande à quoi rime de se poursuivre soi-même. Et l'un des cadres répond: « …mais ils occupent une partie différente de notre étage. »

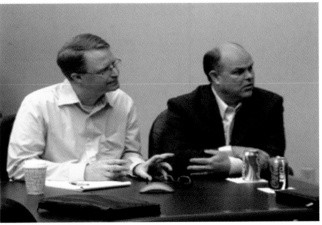

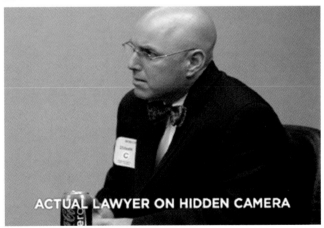

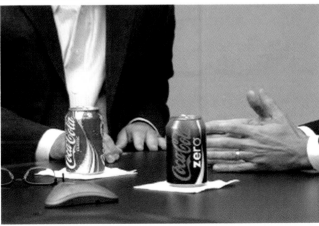

FEATURED ON THE DVD **TITLE:** Amoeba. **CLIENT:** GlaxoSmithKline. **PRODUCT:** Lucozade Energy. **AGENCY:** Ogilvy & Mather. **COUNTRY:** United Kingdom. **YEAR:** 2005. **CREATIVE DIRECTOR:** Malcolm Poynton. **COPYWRITER:** Dale Winton. **ART DIRECTOR:** Hamish Pinnell. **PRODUCTION COMPANY:** Passion Pictures. **AWARDS:** Cannes Lions (Shortlist).

A delightful animation shows a group of scientists looking into their microscopes. One of them turns the radio on and the microorganisms start dancing to a funky groove. The closing shot shows a Lucozade bottle as a transmitter. The slogan reads "Move It!" /// Eine bezaubernde Animation zeigt eine Gruppe von Wissenschaftlern an ihren Mikroskopen. Einer von ihnen schaltet das Radio ein, und die Mikroorganismen beginnen, zu einem funky Groove zu tanzen. Die Schlusseinstellung zeigt eine Flasche Lucozade als Sendemast. Der Slogan lautet „Bewege dich!" /// Une charmante animation montre un groupe de scientifiques qui regardent dans leurs microscopes. L'un d'eux allume une radio et les microorganismes commencent à danser au rythme effréné de la musique. Le dernier plan montre un émetteur radio en forme de bouteille de Lucozade. Le slogan affiche : « Bougez ! »

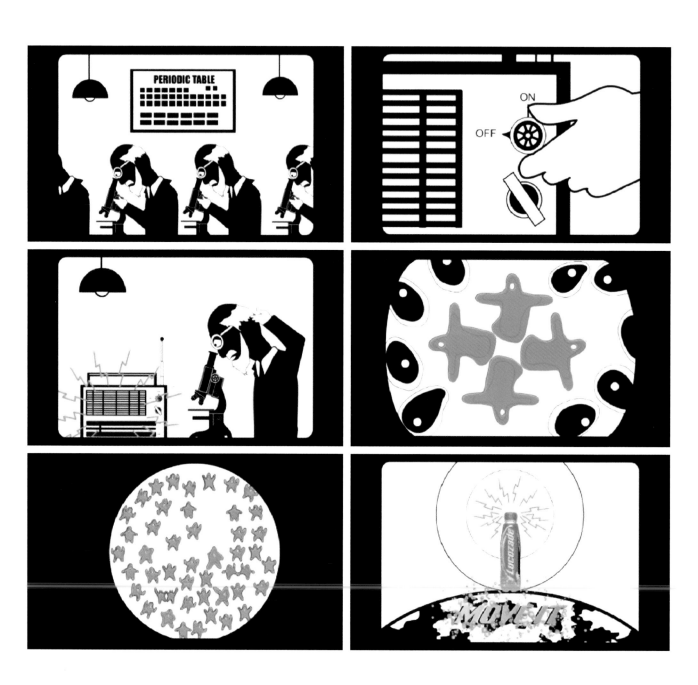

TITLE: Waterboy. **CLIENT:** Saeme. **PRODUCT:** Evian Mineral Water. **AGENCY:** BETC Euro RSCG. **COUNTRY:** France. **YEAR:** 2004. **CREATIVE DIRECTOR:** Rémi Babinet. **PRODUCTION COMPANY:** Quad Productions, Wizz. **DIRECTOR:** Soandsau. **AWARDS:** Cannes Lions (Gold).

Follow the little waterboy character as he journeys through different scenarios which show water in its different elemental states. He puts out fires, turns to ice and evaporates into steam. Two thunderclouds rumble and he rains down to earth and meets a little watergirl. Together they have waterbabies. /// Begleiten Sie die kleine Figur des Wasserjungen auf ihrer Reise durch verschiedene Szenarien, die Wasser in seinen elementaren Zuständen zeigt. Der Junge löscht Feuer, verwandelt sich in Eis und löst sich in Dampf auf. Zwei Gewitterwolken grollen, und er kommt als Regen wieder auf die Erde, wo er ein kleines Wassermädchen trifft. Zusammen bekommen sie Wasserbabys. /// Suivez le personnage du garçon-eau dans son voyage à travers des scénarios qui montrent l'eau dans ses différents états élémentaires. Il éteint des incendies, se transforme en glace et s'évapore. Deux nuages d'orage grondent et il tombe sur la Terre sous forme de goutte de pluie, et rencontre une fille-eau. Ils tombent amoureux et font des bébés-eau.

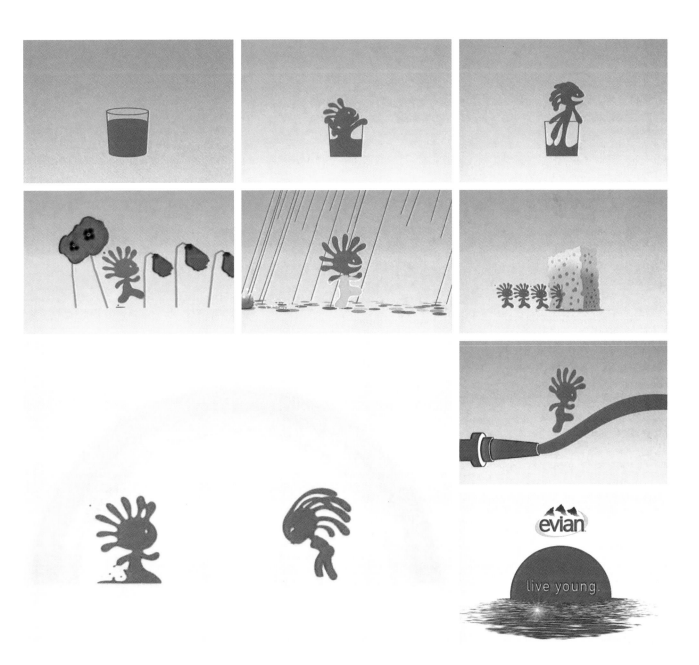

TITLE: Desert. **CLIENT:** PepsiCo. **PRODUCT:** Pepsi. **AGENCY:** Almap BBDO. **COUNTRY:** Brazil. **YEAR:** 2007. **CREATIVE DIRECTOR:** Marcello Serpa. **COPYWRITER/ART DIRECTOR:** Renato Simões, Bruno Prosperi. **PRODUCTION COMPANY:** Ilegal FX. **PRODUCER:** Margarida Flores e Filmes. **DIRECTOR:** Pedro Becker.

An Arab comes across an unplugged Pepsi vending machine in the desert. He puts it on his camel's back and takes it to a tent with electricity, where he pays the owner to plug it in. Unfortunately, he has no money left. Both traveller and camel look on helplessly as the owner slots a coin in and gets a cold can of Pepsi. /// Ein Araber findet zufällig einen Pepsi-Automaten in der Wüste. Er lädt ihn auf den Rücken seines Kamels und bringt ihn zu einem Zelt. Dort bezahlt er den Besitzer des Zeltes für den Strom, um den Automaten anzuschließen. Leider hat er nun kein Geld mehr übrig. Der Araber schaut mit seinem Kamel hilflos zu, wie der Zeltbesitzer eine Münze einwirft und eine kalte Dose Pepsi zieht. /// En plein désert, un Arabe tombe sur un distributeur de Pepsi débranché. Il le charge sur son chameau et le transporte jusqu'à une tente équipée de l'électricité, dont il paye le propriétaire pour brancher la machine. Malheureusement, il n'a plus de monnaie. Le voyageur et le chameau, aussi dépités l'un que l'autre, regardent le propriétaire insérer une pièce et obtenir une boîte bien fraîche de Pepsi.

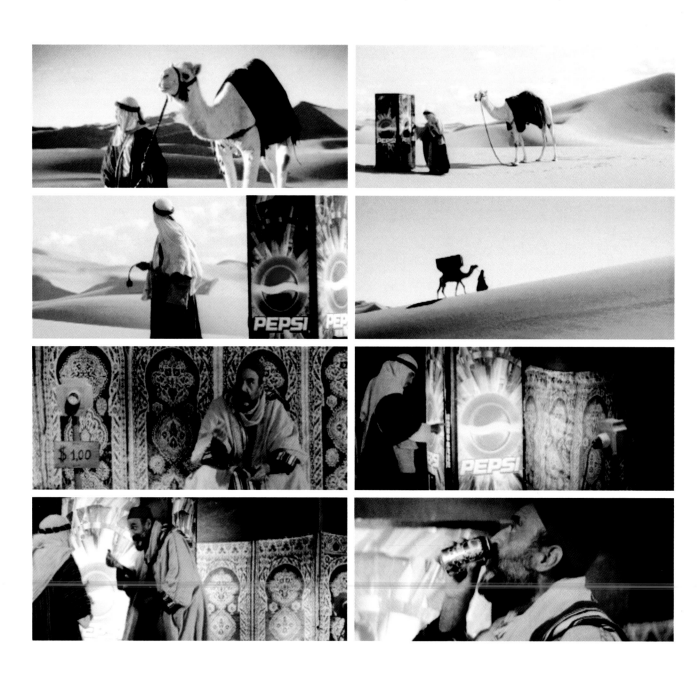

TITLE: Bravo. **CLIENT:** Tango. **PRODUCT:** Tango Soft Drink. **AGENCY:** Clemmow Hornby Inge. **COUNTRY:** United Kingdom. **YEAR:** 2006. **CREATIVE DIRECTOR:** Ewan Paterson. **COPYWRITER:** Micky Tudor. **ART DIRECTOR:** Micky Tudor. **PRODUCTION COMPANY:** Thomas Thomas Films. **PRODUCER:** Billy Jones. **DIRECTOR:** Jim Gilchrist. **AWARDS:** Cannes Lions (Silver).

This clever send-up of another famous spot shows thousands of pieces of fruit dumped down a descending street in slow motion. A woman emerges from under the huge pile in a euphoric daze with her bottle of Tango Clear. /// Diese schlaue Anspielung auf einen anderen berühmten Werbespot zeigt Tausende von Früchten, die in Zeitlupe eine abschüssige Straße hinunterkullern. Eine Frau taucht unter dem enormen Früchteberg auf – vor Begeisterung wie betäubt – und hält eine Flasche Tango Clear in der Hand. /// Cette parodie ingénieuse d'un autre spot célèbre montre des milliers de fruits qui descendent une rue en pente au ralenti. Une femme émerge de sous l'énorme tas de fruits, stupéfaite et euphorique, une bouteille de Tango Clear à la main.

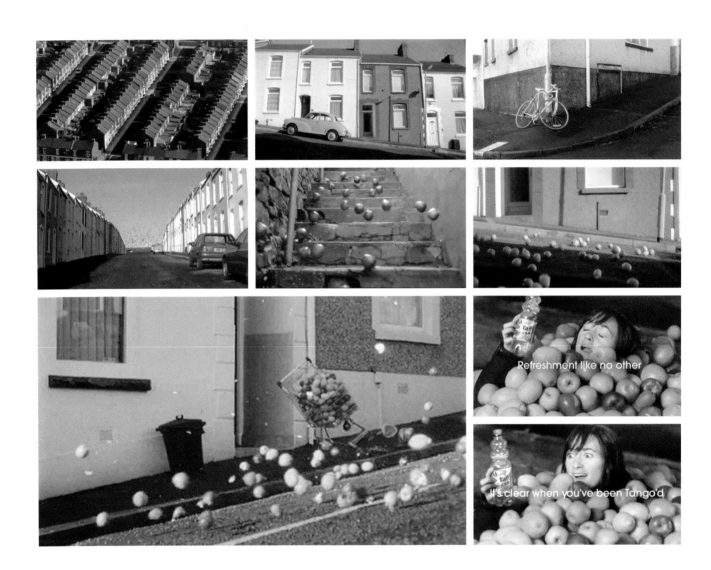

TITLE: BBQ. / Manual. **CLIENT:** Cadbury Schweppes. **PRODUCT:** Solo Man Cans. **AGENCY:** Euro RSCG. **COUNTRY:** Australia. **YEAR:** 2008. **CREATIVE DIRECTOR:** Rob Martin Murphy. **COPYWRITER:** Sean Birk. **ART DIRECTOR:** Chad Mackenzie. **PRODUCTION COMPANY:** Plaza Films. **PRODUCER:** Peter Masterton, Susan Wells. **DIRECTOR:** Paul Middleditch. **EDITOR:** Peter Whitmore.

This short spot shows three guys tucking into some corn on the cob around a barbecue. One of them looks down and sees a female cleavage inflate under his shirt. He drops his corn in astonishment. A voiceover announces, "Man Cans. Don't say we didn't warn you!" /// Dieser kurze Werbespot zeigt drei junge Männer, die sich neben einem Barbecue-Grill über ihre Maiskolben hermachen. Einer der Männer blickt nach unten und sieht, dass sich unter seinem T-Shirt ein weibliches Dekolleté aufbläht. Vor Überraschung lässt er seinen Maiskolben fallen. Eine Hintergrundstimme sagt: „Man Cans. Sag nicht, wir hätten dich nicht gewarnt!" /// Ce spot rapide montre trois hommes en train de s'empiffrer de maïs grillé autour d'un barbecue. L'un d'eux baisse les yeux et voit son tee-shirt s'enfler d'une poitrine féminine. Stupéfait, il en laisse tomber son épi de maïs. En voix off, on entend : « Man Cans. On vous aura prévenus ! »

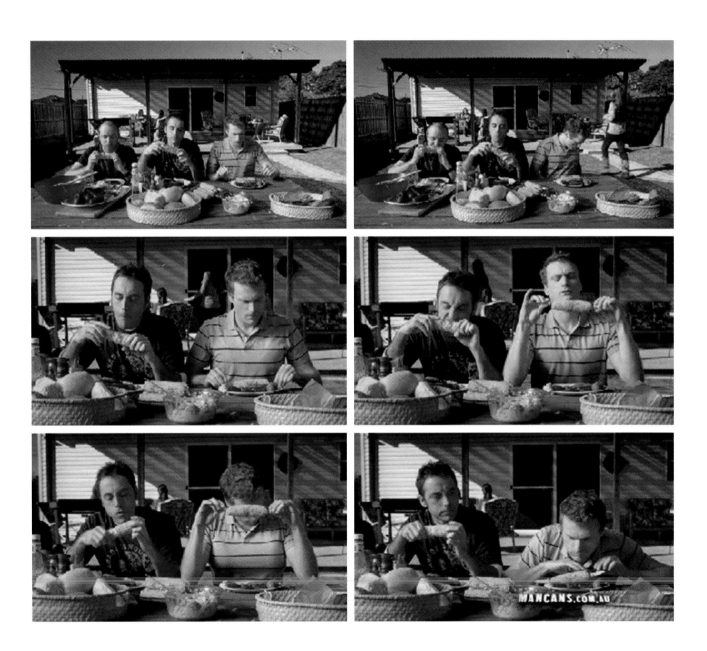

A guy shows off his new pick-up to his friends. He gives one of them his keys so he can take it round the block. His friend looks inside and says nervously, "It's a manual!" The owner looks across and cringes when he sees that his friend has suddenly developed a cleavage. /// Ein Mann zeigt seinen Freunden seinen neuen Pickup. Er gibt einem von ihnen seinen Autoschlüssel, sodass dieser eine Runde um den Block drehen kann. Sein Freund schaut in das Innere des Fahrzeugs und sagt nervös: „Der hat ja eine Handschaltung!" Der Besitzer sieht zu seinem Freund hinüber und zuckt zusammen, als er sieht, dass dieser plötzlich ein Dekolleté entwickelt hat. /// Un homme montre son nouveau pick-up à ses amis. Il donne ses clefs à l'un d'entre eux pour qu'il puisse faire le tour du pâté de maisons avec. Son ami regarde à l'intérieur et dit nerveusement : « Ce n'est pas une boîte automatique ! » Le propriétaire le regarde et a un mouvement de recul lorsqu'il s'aperçoit qu'une poitrine de femme vient de pousser sur le torse de son ami.

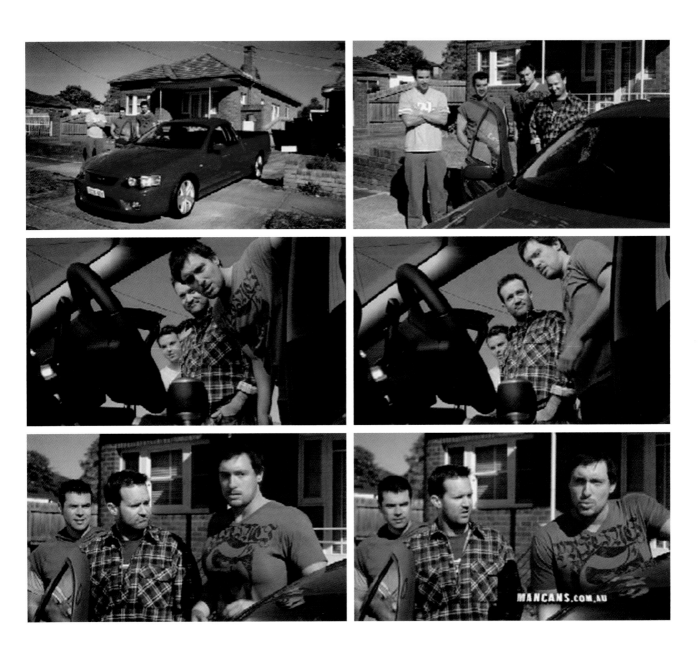

TITLE: Cinema. CLIENT: Cadbury Schweppes. PRODUCT: Solo Man Cans. AGENCY: Euro RSCG. COUNTRY: Australia. YEAR: 2008. CREATIVE DIRECTOR: Rob Martin Murphy. COPYWRITER: Sean Birk. ART DIRECTOR: Chad Mackenzie. PRODUCTION COMPANY: Plaza Films. PRODUCER: Peter Masterton, Susan Wells. DIRECTOR: Paul Middleditch. EDITOR: Peter Whitmore.

A man and his girlfriend are watching a tearjerker at the cinema. The woman looks across to see the man weeping at the same time as his chest expands. /// Ein junger Mann sitzt mit seiner Freundin im Kino und genießt eine Filmschnulze. Die Freundin schaut zu ihm hinüber und beobachtet, wie seine Brust immer größer wird, je mehr er weint. /// Un homme et sa petite amie sont au cinéma en train de voir un mélodrame. La femme regarde son compagnon et le voit pleurer, pendant que son torse s'orne d'une poitrine de femme.

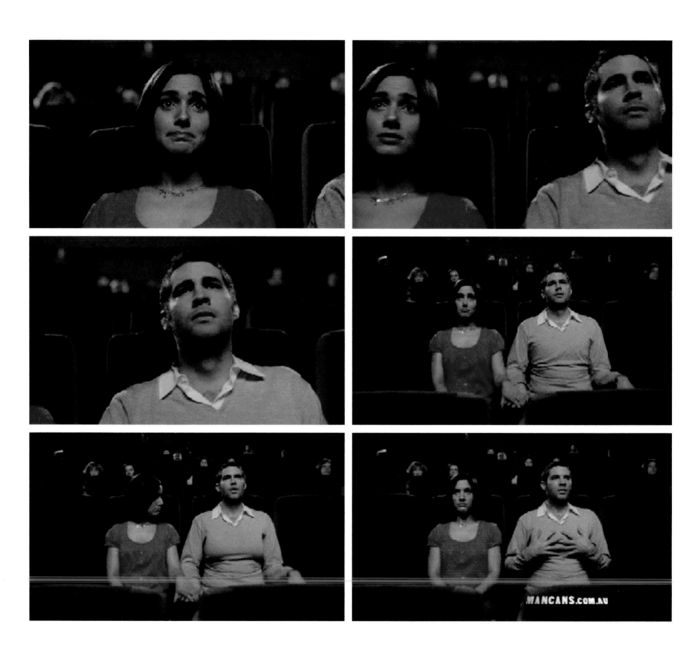

TITLE: Glen. CLIENT: Starbucks Corporation. PRODUCT: Starbucks Doubleshot Espresso. AGENCY: Fallon New York. COUNTRY: USA. YEAR: 2005. CREATIVE DIRECTOR: David Lubars, Ari Merkin. COPYWRITER: Allon Tatarka. ART DIRECTOR: Rob Baird. PRODUCTION COMPANY: Biscuit Filmworks. PRODUCER: Shawn Lacy Tessaro. DIRECTOR: Noam Murro. AWARDS: Cannes Lions (Shortlist).

Glen is in his kitchen drinking a can of Starbucks Doubleshot Espresso. He looks on as legendary rock band Survivor begins singing a spoof of their classic hit "Eye of the Tiger". The band then follows him to work. The closing shot shows Survivor singing to a new guy named Roy. /// Glen trinkt in seiner Küche eine Dose Starbucks Doubleshot Espresso. Er schaut zu, als die legendäre Rockband Survivor beginnt, ihren Klassiker „Eye of the Tiger" zu verulken. Die Band begleitet ihn sogar bis zur Arbeit. Die Schlussszene zeigt, wie die Band nun vor einem anderen Mann namens Roy singt. /// Glen est dans sa cuisine et boit une canette de Doubleshot Espresso de Starbucks. Il regarde impassible le groupe de rock légendaire Survivor qui lui chante une parodie de leur grand classique « Eye of the Tiger ». Le groupe le suit jusqu'à son travail. Le dernier plan montre Survivor qui commence à chanter pour un certain Roy.

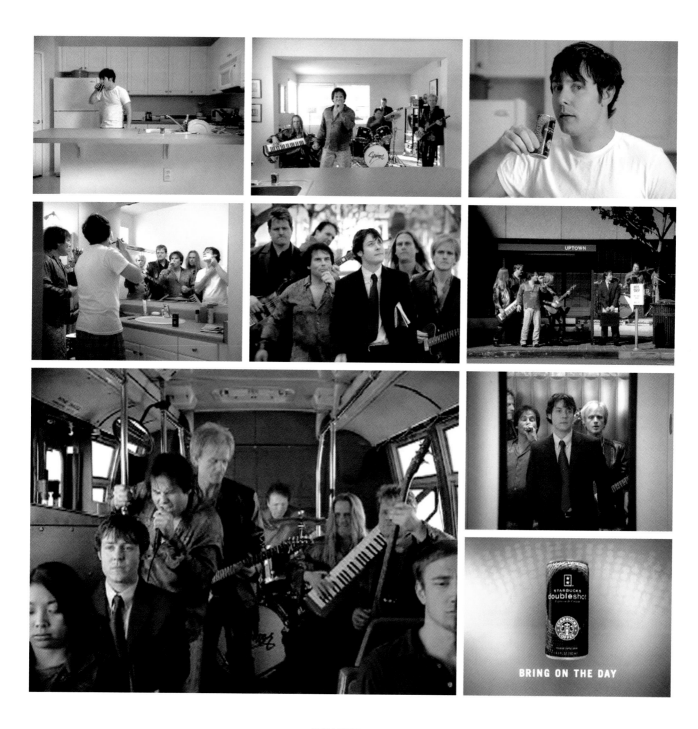

TITLE: America's Favorite. **CLIENT:** Burger King. **PRODUCT:** Burger King. **AGENCY:** Crispin Porter + Bogusky. **COUNTRY:** USA. **YEAR:** 2006. **CHIEF CREATIVE OFFICER:** Alex Bogusky. **EXECUTIVE CREATIVE DIRECTOR:** Andrew Keller. **CREATIVE DIRECTOR:** Rob Reilly. **ART DIRECTOR:** John Parker, Mark Taylor. **COPYWRITER:** Bob Cianfrone, Evan Fry. **DIRECTOR OF PRODUCTION:** Rupert Samuel. **EXECUTIVE PRODUCER:** Matt Bonin . **PRODUCTION COMPANY:** Hungry Man (New York and Rio de Janeiro). **DIRECTOR:** Bryan Buckley. **EXECUTIVE PRODUCER:** Thomas Rossano, Alex Mehedff, Steve Orent.

Inspired by the famous Busby Berkeley dance routines of the 1930s, Burger King celebrates "America's Favorite" hamburger with The Whopperettes and the "Creepy King". /// Inspiriert durch die berühmten Tanzchoreographien von Busby Berkeley in den 30er Jahren feiert Burger King den „berühmtesten Hamburger Amerikas" mit den Whopperettes und dem „Creepy King". /// Inspiré par les fameuses chorégraphies des années 1930 de Busby Berkeley, Burger King célèbre « le hamburger que l'Amérique préfère » avec les Whopperettes et « Creepy King » (le roi qui donne la chair de poule).

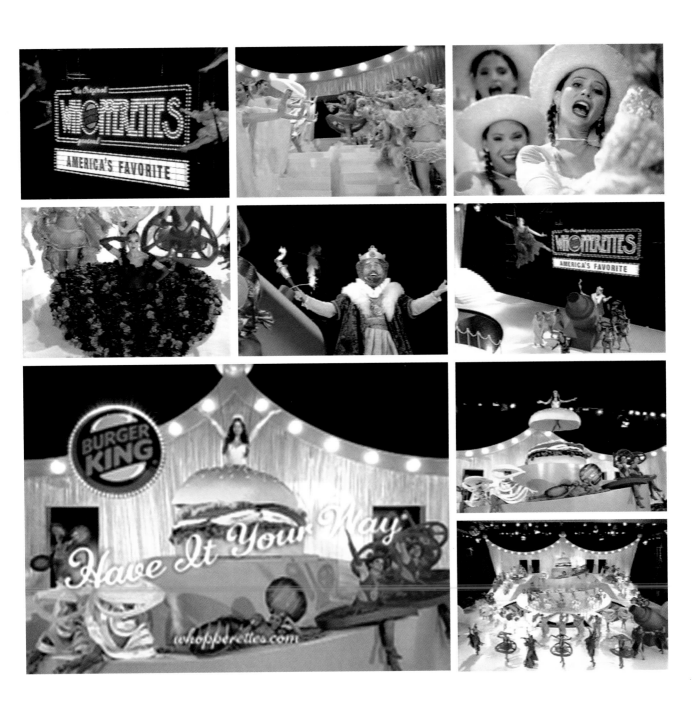

TITLE: Fantasy Ranch. CLIENT: Burger King. PRODUCT: Burger King Chicken Bacon Ranch. AGENCY: Crispin Porter + Bogusky. COUNTRY: USA. YEAR: 2005. EXECUTIVE CREATIVE DIRECTOR: Alex Bogusky. CREATIVE DIRECTOR: Andrew Keller. ASSOCIATE CREATIVE DIRECTOR: Rob Reilly. COPYWRITER: Evan Fry, Brian Tierney. ART DIRECTOR: Ben James, John Parker. PRODUCTION COMPANY: HSI. PRODUCER: David Rolfe, Rupert Samuel. DIRECTOR: David Lachapelle. AWARDS: AICP.

When he feels hungry, a cowboy closes his eyes and sings a song about Burger King's Tender Crisp Bacon Cheddar Ranch, where chicken breasts grow on trees and the stream is made of bacon ranch dressing; all because "the King wants you to have it your way." /// Ein hungriger Cowboy schließt die Augen und singt ein Lied über die „Tender Crisp Bacon Cheddar"-Ranch von Burger King, wo Hühnerbrüste auf Bäumen wachsen und der Fluss aus Bacon Ranch-Dressing besteht – und alles nur, weil „der König will, dass du es wie gewünscht bekommst." /// Un cow-boy qui a faim ferme les yeux et chante une chanson sur le ranch « Tender Crisp Bacon Cheddar » de Burger King, où les blancs de poulet poussent sur les arbres et de la sauce bacon ranch coule dans la rivière, tout cela parce que « Le Roi veut que vous l'ayez comme vous l'aimez ».

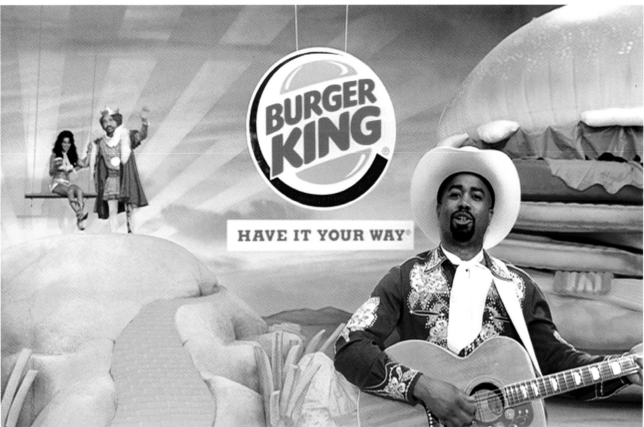

TITLE: Manthem. CLIENT: Burger King. PRODUCT: Burger King Texas Double Whopper. AGENCY: Crispin Porter + Bogusky. COUNTRY: USA. YEAR: 2006. CHIEF CREATIVE OFFICER: Alex Bogusky. EXECUTIVE CREATIVE DIRECTOR: Andrew Keller. CREATIVE DIRECTOR: Rob Reilly. COPYWRITER: Bob Cianfrone. ART DIRECTOR: James Dawson Hollis. PRODUCTION COMPANY: Hungry Man. PRODUCER: Steve Orent, Tom Rossano, Alex Mehedff. DIRECTOR: Bryan Buckley.

Men unite in the streets to form a parade. In a testosterone driven show of strength they sing the "Manthem" for the Texas Double Whopper. /// Männer versammeln sich in den Straßen zu einer Parade. Bis obenhin voll mit Testosteron singen sie als Demonstration männlicher Stärke den „Manthem" (Lobgesang der Männer) auf den Texas Doppelwhopper. /// Des hommes se rassemblent dans la rue pour former une parade. Dans une démonstration de force injectée de testostérone, ils chantent le « Manthem » (hymne viril) du Texas Double Whopper.

TITLE: Wake up with the king. **CLIENT:** Burger King. **PRODUCT:** Burger King. **AGENCY:** Crispin Porter + Bogusky. **COUNTRY:** USA. **YEAR:** 2005. **EXECUTIVE CREATIVE DIRECTOR:** Alex Bogusky. **CREATIVE DIRECTOR:** Andrew Keller. **COPYWRITER:** Bob Cianfrone. **ART DIRECTOR:** Mark Taylor. **PRODUCTION COMPANY:** Moxie Pictures. **PRODUCER:** Tony Cantale. **DIRECTOR:** Martin Granger.

It's the morning after the night before. Just as the guy begins to wonder what happened to him, the King averts innuendo by offering him a Double Croisandwich. /// Es ist der Morgen „danach". Gerade als der Kerl anfängt, sich zu wundern, was mit ihm passiert ist, verhindert der König anzügliche Anspielungen, indem er ihm ein „Double Croisandwich" anbietet. /// C'est le matin après LA nuit. Au moment où le jeune homme commence à se demander ce qui est arrivé, le Roi évite tout malentendu en lui proposant un Double Croisandwich.

TITLE: Tiny Hands. **CLIENT:** Burger King. **PRODUCT:** Burger King Double Cheeseburger. **AGENCY:** Crispin Porter + Bogusky. **COUNTRY:** USA. **YEAR:** 2008. **VP CREATIVE DIRECTOR:** Rob Reilly, Bill Wright. **COPYWRITER:** Michael Craven. **ART DIRECTOR:** David Steinke. **PRODUCTION COMPANY:** HSI. **EXECUTIVE PRODUCER:** Chris Kyriakos. **PRODUCER:** William Green. **DIRECTOR:** Paul Hunter.

Two friends are walking off a football field. One suggests they go for a Burger King Cheeseburger. Worried, the other shows him his tiny hands. To save him from embarrassment, his buddy offers to hold the burger for him. A Double Cheeseburger appears and a voiceover announces, "… 30 % more meat than the McDonald's Double Cheeseburger… and only a buck!" /// Zwei Freunde verlassen einen Fußballplatz. Einer der beiden schlägt vor, bei Burger King Cheeseburger essen zu gehen. Besorgt zeigt ihm der andere seine winzigen Hände. Um ihm diese Peinlichkeit zu ersparen, bietet ihm sein Freund an, den Cheeseburger für ihn zu halten. Ein Double Cheeseburger erscheint, und aus dem Off sagt eine Stimme: „… 30 % mehr Fleisch als der McDonalds Double Cheeseburger… und nur ein Dollar!" /// Deux amis quittent un terrain de foot. L'un d'eux propose d'aller manger un Burger King Cheeseburger. Très embêté, l'autre montre ses toutes petites mains. Pour lui éviter de l'embarras, son pote propose de tenir le burger à sa place. Un double cheeseburger apparaît, tandis qu'une voix off annonce : « … 30 % de viande en plus que le double cheeseburger de McDonald's … et pour seulement un dollar ! »

TITLE: Whopper. CLIENT: Burger King. PRODUCT: Burger King. AGENCY: Crispin Porter + Bogusky. COUNTRY: USA. YEAR: 2008. VP CREATIVE DIRECTOR: Rob Reilly, Bill Wright. ASSOCIATE CREATIVE DIRECTOR/COPYWRITER: Ryan Kutscher. SR. ART DIRECTOR: Paul Caiozzo. ART DIRECTOR: Andy Minisman, Dan Treichel, Julia Hoffman. PRODUCTION COMPANY: Smuggler. EXECUTIVE PRODUCER: Patrick Milling Smith, Brian Carmody, Lisa Rich. PRODUCER: Drew Santarsiero. DIRECTOR: Henry-Alex Rubin.

At a Burger King restaurant an experiment is taking place. A Whopper has been deliberately swapped for a Wendy's burger. The customer immediately notices the difference and demands his Whopper. Suddenly the King appears with the Whopper and the customer realises he's been the victim of a prank. A voiceover announces, "Whopper. Anything else is a freakin' disappointment." /// In einem Burger King Restaurant findet ein Experiment statt. Ein Whopper wurde absichtlich durch einen Wendy's Burger ersetzt. Der Kunde bemerkt sofort den Unterschied und verlangt seinen Whopper. Plötzlich erscheint der King mit dem Whopper, und der Kunde erkennt, dass man ihm einen Streich gespielt hat. Eine Hintergrundstimme sagt: „Whopper. Alles andere ist die totale Enttäuschung." /// Une expérience a lieu dans un restaurant Burger King. On substitue délibérément un Whopper par un Wendy's burger. Le client s'en rend immédiatement compte et exige son Whopper. Soudain, le Roi apparaît avec le Whopper, et le client réalise qu'il a été victime d'un canular. Une voix off avertit : « Whopper. Rien d'autre. Tout le reste est atrocement décevant. »

[LAS VEGAS, NV - 10/30/07 - 3:30PM]

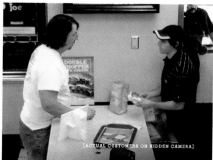
[ACTUAL CUSTOMERS ON HIDDEN CAMERA]

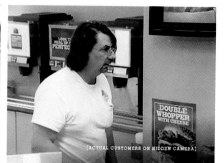
[ACTUAL CUSTOMERS ON HIDDEN CAMERA]

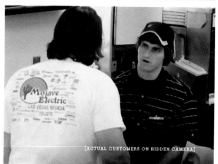
[ACTUAL CUSTOMERS ON HIDDEN CAMERA]

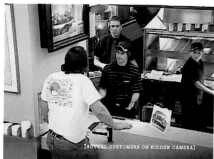
[ACTUAL CUSTOMERS ON HIDDEN CAMERA]

[ACTUAL CUSTOMERS ON HIDDEN CAMERA]

WHOPPERFREAKOUT.COM

[ACTUAL CUSTOMERS ON HIDDEN CAMERA]

WHOPPERFREAKOUT.COM

TITLE: Girl. CLIENT: McDonald's Australia. PRODUCT: McDonald's. AGENCY: Leo Burnett Australia. COUNTRY: Australia. YEAR: 2005. CREATIVE DIRECTOR: Glen Ryan. COPYWRITER: Tim Bishop, David Smith. ART DIRECTOR: David Smith, Tim Bishop. PRODUCTION COMPANY: FAT. PRODUCER: Nicci Lock. DIRECTOR: Ned Wenlock.

A sequence of children's flashcards shows words and images associated with a girl growing up: dollhouse/school/mascara/bikini/boyfriend. A flashcard hangs on the word 'botox'. The phrase "Life's complicated enough" appears before the cards display the ingredients of a cheeseburger. The solution is "Simple." /// Eine Reihe von Leselernkarten für Kinder zeigen Wörter und Bilder in Zusammenhang mit einem aufwachsenden Mädchen: Puppenhaus/Schule/Maskara/Bikini/Freund. Eine Karte zeigt das Wort „Botox". Der Satz „Das Leben ist kompliziert genug" erscheint, bevor die Karten die Zutaten eines Cheeseburgers zeigen. Die Lösung ist „Simple." /// Une série de cartes pour enfants montre des mots et des images associés à l'idée d'une petite fille qui grandit : maison de poupée / école / mascara / bikini / petit ami. Une carte s'arrête sur le mot « botox ». La phrase « La vie est déjà assez compliquée » apparaît, puis les cartes se mettent à afficher les ingrédients d'un cheeseburger. La solution est « Simple ».

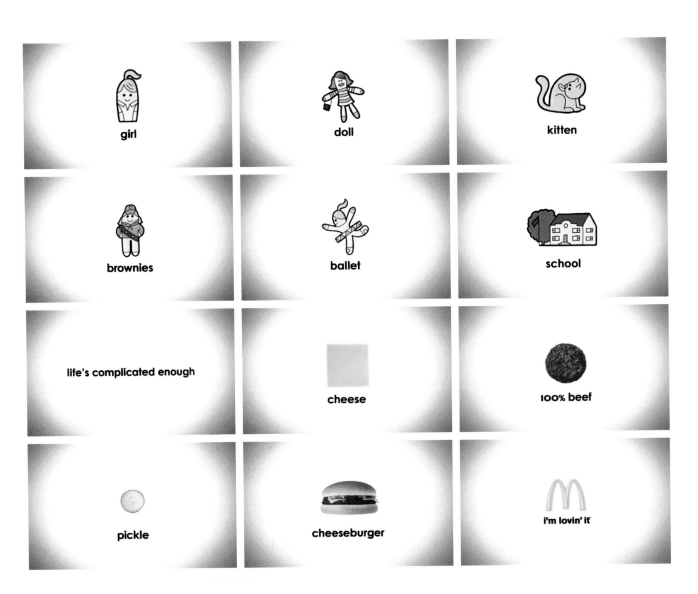

TITLE: Buy your own private island. **CLIENT:** McDonald's. **PRODUCT:** McDonald's McSnack. **AGENCY:** Kitchen Leo Burnett. **COUNTRY:** Norway. **YEAR:** 2005. **COPYWRITER:** Bendik Romstad. **ART DIRECTOR:** Anne Gravingen. **PRODUCTION COMPANY:** Video Workshop. **DIRECTOR:** Anne Gravingen, Bendik Romstad.

A slideshow is accompanied by a voiceover who lectures on the cost effectiveness of going to McDonald's. The theory is you can save money and buy your own private island. /// Eine Diashow wird von einem Sprecher begleitet, der darüber doziert, wie wirtschaftlich es ist, bei McDonald's zu essen. Der Theorie zufolge kann man so Geld sparen und dann seine eigene private Insel kaufen. /// Une présentation accompagnée d'une voix off explique qu'aller chez McDonald's vous fera économiser de l'argent. D'après cette théorie, vous pourrez même vous acheter une île avec vos économies.

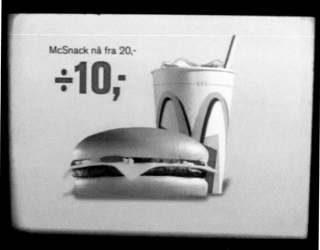

TITLE: Victory. CLIENT: McDonald's. PRODUCT: McDonald's. AGENCY: DDB Chicago. COUNTRY: USA. YEAR: 2007. GROUP CREATIVE DIRECTOR: Bill Cimino. CREATIVE DIRECTOR/ART DIRECTOR: Tim Souers. ASSOCIATE CREATIVE DIRECTOR/COPYWRITER: David Oif. GROUP EXECUTIVE PRODUCER: Marianne Newton. PRODUCTION COMPANY: PYTKA. DIRECTOR: Joe Pytka.

A kids' game of football in the park can only yield victory for one team. As the winners taunt their defeated rivals with their trophy, the losers cheer themselves up with McDonald's Happy Meals. Who's the winner now? The spot ends with the McDonald's logo and the tagline, "I'm lovin' it." /// Bei einem Fußballmatch unter Kindern im Park trägt ein Team den Sieg davon. Während die Gewinner die geschlagenen Rivalen mit ihrer Trophäe verhöhnen, muntern sich die Verlierer mit McDonald's Happy Meals auf. Wer ist nun der Gewinner? Der Werbespot endet mit dem Logo von McDonald's und dem Slogan „Ich liebe es." /// Au terme d'une partie de foot dans le parc, il ne peut y avoir qu'une seule équipe gagnante. Alors que les vainqueurs narguent leurs malheureux rivaux en brandissant le trophée, les perdants se requinquent avec des McDonald's Happy Meals. Qui c'est qui gagne maintenant? Le spot finit sur le logo de McDonald, avec cette accroche, « J'adore. »

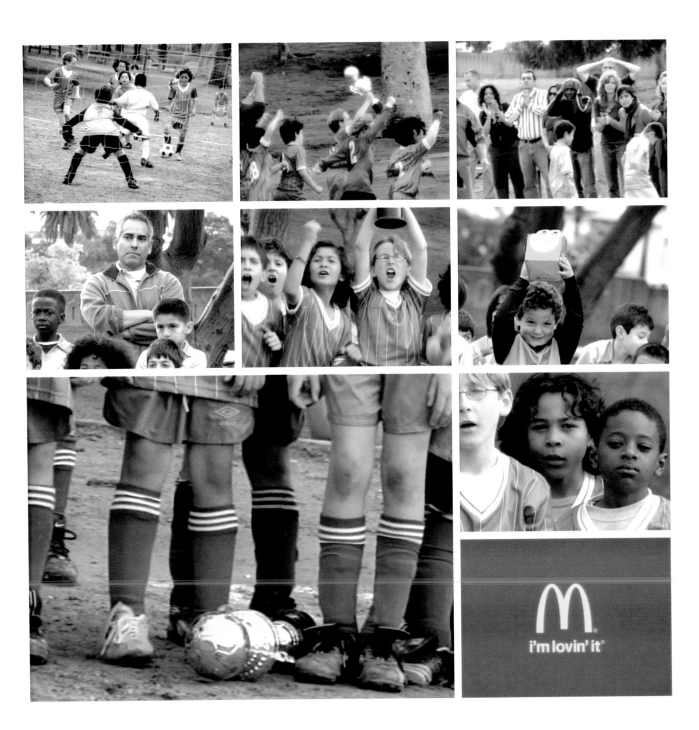

FEATURED ON THE DVD **TITLE:** Jumper. **CLIENT:** ConAgra Foods. **PRODUCT:** Chef Boyardee Canned Food. **AGENCY:** Leo Burnett USA. **COUNTRY:** USA. **YEAR:** 2006. **CREATIVE DIRECTOR:** Paul Hirsch, Josh Denberg. **COPYWRITER:** Josh Denberg. **ART DIRECTOR:** Paul Hirsch. **PRODUCTION COMPANY:** Biscuit Filmworks. **DIRECTOR:** Steve Rogers.

A boy with an amazing ability to jump high leaps over walls and rescues a cat stuck in a tree before springing up to the pick up a can of Chef Boyardee from the top shelf of the kitchen pantry. /// Ein Junge kann sehr hoch und gar über Wände springen. Mit dieser erstaunlichen Fähigkeit rettet er eine ängstliche Katze von einem Baum. Zu Hause dann springt er hoch, um eine Dose Chef Boyardee vom obersten Regal eines Küchenschranks zu holen. /// Un garçon qui a le don de sauter très haut bondit par-dessus les murs et sauve un chat coincé dans un arbre avant de sauter pour attraper une boîte de Chef Boyardee sur l'étagère la plus haute du placard de la cuisine.

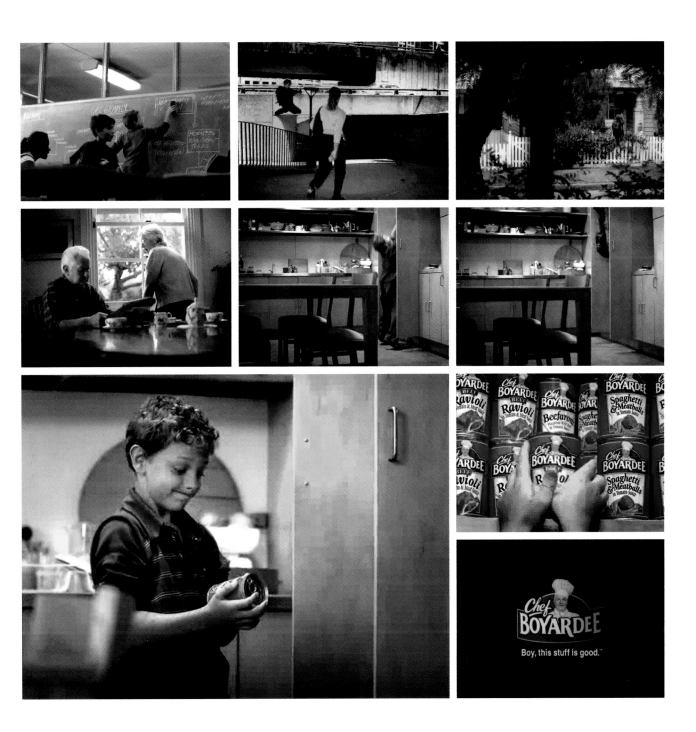

TITLE: Pourable Sunshine. **CLIENT:** H.J. Heinz Co. **PRODUCT:** Heinz Salad Cream. **AGENCY:** McCann Erickson London. **COUNTRY:** United Kingdom. **YEAR:** 2007. **COPYWRITER:** Neil Clarke. **ART DIRECTOR:** Jay Phillips. **PLANNER:** Peter Wilson. **PRODUCTION COMPANY:** Gorgeous Films. **POST PRODUCTION:** The Mill. **DIRECTOR:** Vince Squibb.

People of all ages enjoy a summer's day in a city park. A child sits on a squeezy bottle of Heinz Salad Cream. A pair of sneakers dangles from a tree with the Heinz Salad Cream logo on-screen and the tagline, "Pourable Sunshine." /// Menschen jeden Alters genießen einen Sommertag im Stadtpark. Ein Kind setzt sich auf eine Drückflasche mit Heinz Salad Cream. Ein Paar Turnschuhe baumeln von einem Baum herunter. Auf dem Bildschirm erscheinen das Heinz Salad Cream-Logo sowie der Slogan „Flüssiger Sonnenschein." /// Des gens de tous âges pique-niquent dans le parc municipal un beau jour d'été. Un gamin s'assoit sur une bouteille de sauce de salade Heinz. Une paire de baskets pend à un arbre ; le logo de Heinz Salad s'affiche sur l'écran, avec l'accroche « Du soleil en flacon. »

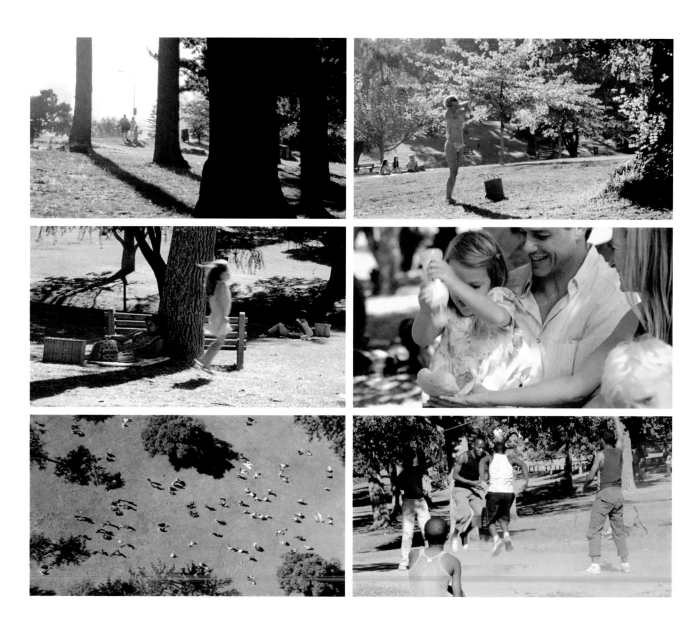

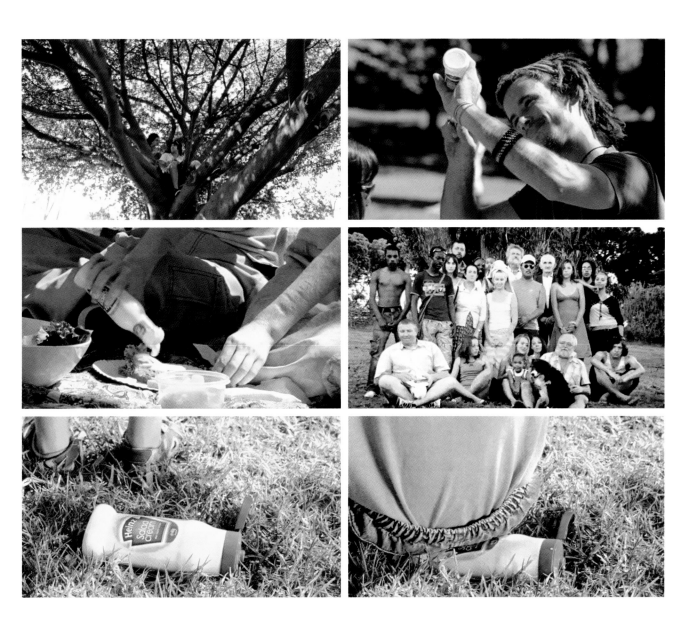

TITLE: Lifeguard. **CLIENT:** Unilever Bestfoods. **PRODUCT:** Marmite. **AGENCY:** BMP DDB. **COUNTRY:** United Kingdom. **YEAR:** 2003. **CREATIVE DIRECTOR:** Joanna Wenley, Jeremy Craigen. **COPYWRITER:** Adam Tucker. **ART DIRECTOR:** Justin Tindall. **PRODUCTION COMPANY:** Partizan. **PRODUCER:** James Tomkinson. **DIRECTOR:** Dominic Murphy.

A lifeguard is eating a Marmite sandwich on the beach. Suddenly he sees a man drowning and rushes in to rescue him. Back on the shore he gives him mouth-to-mouth resuscitation. The swimmer recovers and gives the lifeguard a big smoochy kiss. He loves Marmite. /// Ein Rettungsschwimmer isst am Strand ein Marmite-Sandwich. Plötzlich sieht er einen ertrinkenden Mann, wirft sich ins Wasser und bringt ihn an den Strand zurück. Nach der Rettung gibt er ihm eine Mund-zu-Mund-Beatmung. Der Schwimmer erholt sich und küsst den Rettungs-schwimmer. Er liebt Marmite! /// Un maître nageur est en train de manger un sandwich au Marmite. Soudain, il voit un homme qui se noie et court le sauver. Une fois revenus sur la plage, il lui fait du bouche-à-bouche pour le ranimer. Le nageur reprend conscience et l'embrasse langoureusement. Il adore le Marmite.

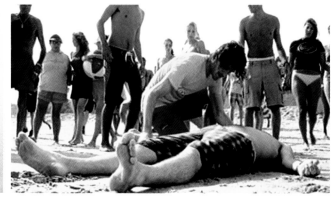

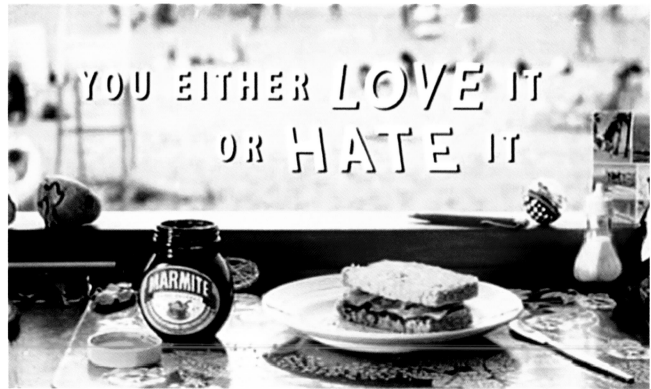

FEATURED ON THE DVD **TITLE:** The Blob. **CLIENT:** Unilever Bestfoods. **PRODUCT:** Marmite. **AGENCY:** DDB London. **COUNTRY:** United Kingdom. **YEAR:** 2005. **COPYWRITER:** Sam Oliver. **ART DIRECTOR:** Shishir Patel. **PRODUCTION COMPANY:** The Sweet Shop. **PRODUCER:** Tony Whyman. **DIRECTOR:** Steve Ayson. **AWARDS:** Cannes Lions (Bronze).

A giant blob of Marmite goes on the rampage in a small town. People flee screaming. Suddenly a woman runs away from her boyfriend and dives into the blob. Soon others plunge in. The end titles read: "You either love it or hate it!" /// Ein Riesenklecks Marmite wütet in einer kleinen Stadt. Die Leute ergreifen schreiend die Flucht. Plötzlich läuft eine Frau von ihrem Freund weg und taucht in den Klecks ein. Bald folgen ihr auch andere. Der Schlusstitel lautet: „Entweder Sie mögen es oder Sie hassen es!" /// Un énorme blob de Marmite saccage une petite ville. Les gens s'enfuient en hurlant. Soudain, une femme se sépare de son compagnon et court plonger dans le blob. D'autres la suivent bientôt. Le générique de fin affiche : « Soit vous détestez, soit vous adorez ! »

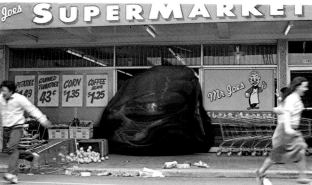

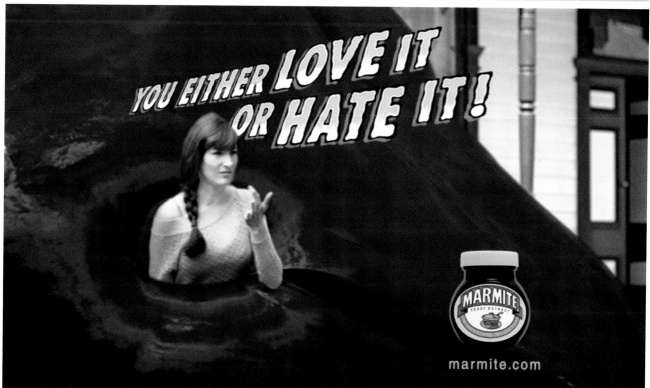

FEATURED ON THE DVD **TITLE:** Choir. / Intro. **CLIENT:** Pot Noodle. **PRODUCT:** Pot Noodle. **AGENCY:** Mother London. **COUNTRY:** United Kingdom. **YEAR:** 2006. **PRODUCTION COMPANY:** Epoch Films. **PRODUCER:** Rob Godbold. **DIRECTOR:** Stacy Wall.

This spot celebrates Pot Noodle as a source of energy. In the heart of the Welsh Valleys, a choir sings while miners extract noodles from the pits below. /// Dieser Werbespot feiert Pot Noodle als Energiequelle. Im Herzen der walisischen Täler singt ein Chor, während Bergarbeiter Nudeln aus der Grube holen. Der Slogan lautet: „Pot Noodle. Das Heizöl Großbritanniens, nicht wahr?" /// Ce spot vante les mérites de Pot Noodle comme source d'énergie. Dans les entrailles des vallées du Pays de Galles, un choeur chante pendant que des mineurs extraient des nouilles dans la mine. Le slogan s'affiche : « Pot Noodle. Le combustible de la Grande-Bretagne, n'est-il pas ? »

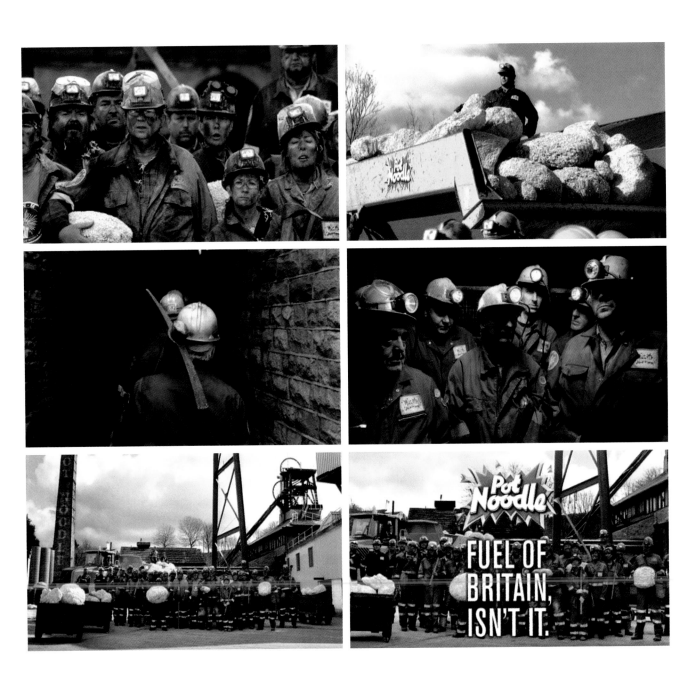

This spoof documentary shows Pot Noodle miners as they work tirelessly to extract the 'Jewel of the Welsh Empire'. /// Dieser ulkige dokumentarische Spot zeigt die Bergarbeiter von Pot Noodle, die unermüdlich versuchen, die „Juwelen des walisischen Empires" zu gewinnen. /// Cette parodie de documentaire montre des mineurs de Pot Noodle travailler sans relâche pour extraire le « joyau de l'Empire gallois ».

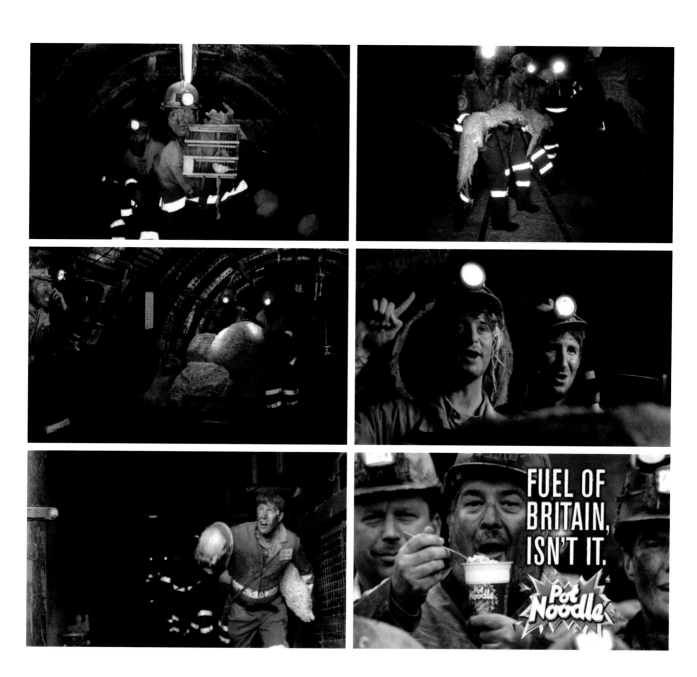

FEATURED ON THE DVD **TITLE:** T-Rex. **CLIENT:** BC Dairy Foundation. **PRODUCT:** Milk. **AGENCY:** DDB Canada. **COUNTRY:** Canada. **YEAR:** 2005. **CREATIVE DIRECTOR:** Alan Russell. **COPYWRITER:** James Lee. **ART DIRECTOR:** Dean Lee. **PRODUCTION COMPANY:** Zanita Films. **PRODUCER:** Seamus Byrne. **DIRECTOR:** Ruairí Robinson.

Curiosity kills the caveman in this wonderfully whacky take on evolution, which demonstrates how "It's always been survival of the fittest." /// In dieser wundervoll schrulligen Interpretation der Evolution bringt den Höhlenmenschen seine Neugier ums Leben. Auch hier gilt: „Der Stärkere überlebt – immer!" /// La curiosité cause la perte de l'homme des cavernes dans cette vision merveilleusement loufoque de l'évolution qui fait la démonstration de la survie du plus fort.

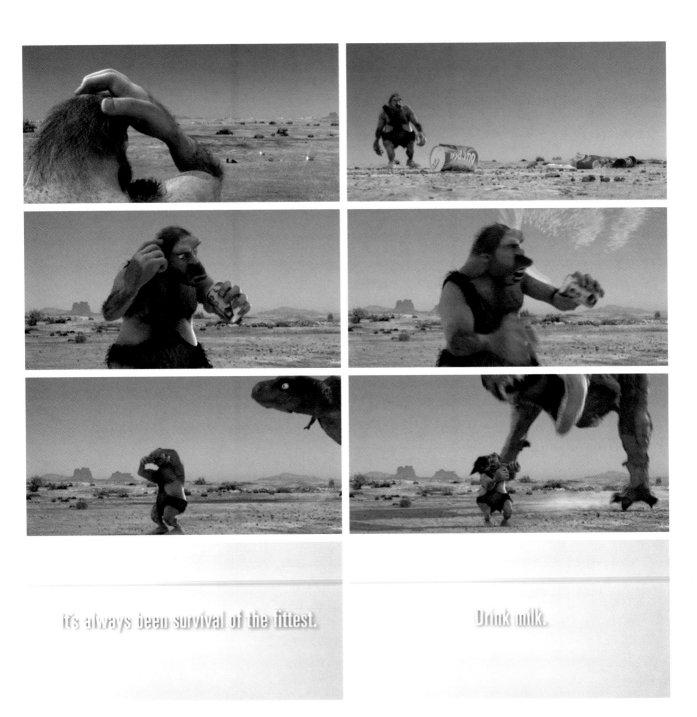

It's always been survival of the fittest.

Drink milk.

TITLE: Birthday. CLIENT: California Milk Processor Board. PRODUCT: Milk. AGENCY: Goodby, Silverstein & Partners. COUNTRY: USA. YEAR: 2003. CREATIVE DIRECTOR: Jeffrey Goodby, Rich Silverstein. COPYWRITER: Colin Nissan. ART DIRECTOR: Sean Farrell. PRODUCTION COMPANY: Biscuit Filmworks. PRODUCER: Scott Craig, Karen O'Brien. DIRECTOR: Noam Murro. AWARDS: Cannes Lions (Gold).

In this eerie spot a young boy has supernatural powers. He uses them to avoid a series of accidents on the way to a birthday party. Once there he warns the others not to eat the cake. They ignore his advice. A frightened woman bursts in with an empty milk carton. /// In diesem unheimlichen Spot verfügt ein kleiner Junge über übernatürliche Kräfte. Er benutzt sie, um auf dem Weg zu einer Geburtstagsparty eine Reihe von Unfällen zu verhindern. Auf der Party warnt er die anderen Gäste davor, den Kuchen zu essen, aber sie ignorieren seine Ratschläge. Eine erschrockene Frau platzt mit einer leeren Milchpackung herein. /// Dans ce spot à l'atmosphère inquiétante, un jeune garçon utilise ses pouvoirs surnaturels pour éviter une série d'accidents sur le chemin d'une fête d'anniversaire. Une fois arrivé, il avertit les autres invités de ne pas manger le gâteau. Ils décident d'ignorer son conseil. Une femme paniquée fait irruption avec un brick de lait vide.

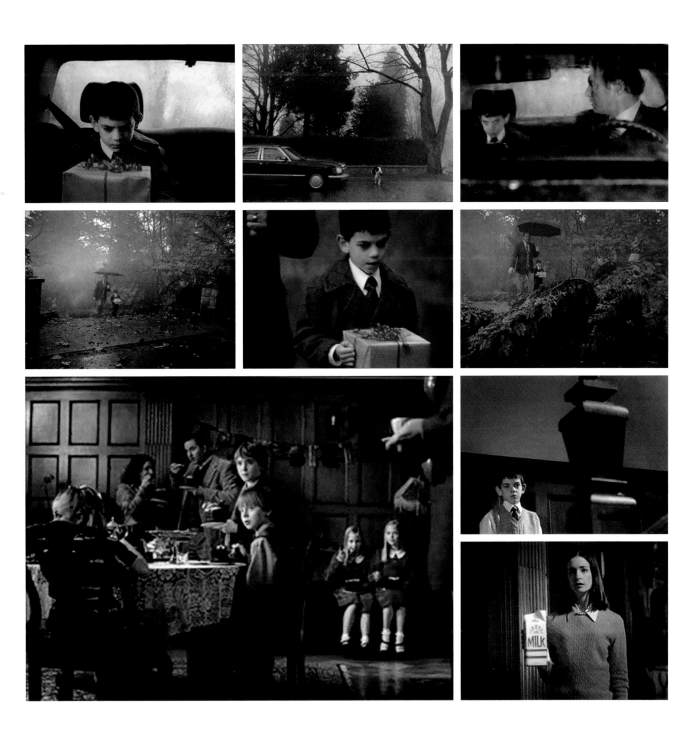

TITLE: Afro. CLIENT: Cadbury. PRODUCT: Cadbury Boost. AGENCY: Arnold Australia. COUNTRY: Australia. YEAR: 2005. CREATIVE DIRECTOR: Jay Furby. COPYWRITER: Jay Furby. EXECUTIVE PRODUCER: Lynette Gordon. PRODUCTION COMPANY: The Sweet Shop. DIRECTOR: Kezia Barnett.

A hip black dude walks down the street showing off his extra-large afro. Down at the barber shop, Jesse coifs a hairstyle while a queue of people wait. He takes a break with a bar of Cadbury's Boost. The product is shown on screen. The hip street dude arrives at the barber shop. His hair has grown into a giant afro. The spot closes with the Boost Highland Fling. /// Ein schicker schwarzer Typ geht die Straße entlang und prahlt mit seiner riesigen Afro-Frisur. Im Friseurladen stylt Jesse die Frisur eines Kunden, während sich eine Warteschlange bildet. Er macht eine Pause und genießt seinen Cadbury Boost-Riegel. Das Produkt wird in Großaufnahme gezeigt. Der schicke Typ erreicht den Friseurladen. Seine Haare sind zu einer gigantischen Afro-Frisur gewachsen. Der Werbespot endet mit dem Boost Highland Fling. /// Un Noir branché parade sa coiffure afro surdimensionnée dans la rue. Dans le salon de coiffure, Jesse finit de peigner un client pendant que d'autres font la queue. Il prend une pause avec une barre de Cadbury's Boost. Le produit est montré à l'écran. Le type branché arrive au salon. Sa coiffure afro est devenue énorme. Le spot se termine par le « lancer écossais de Boost ».

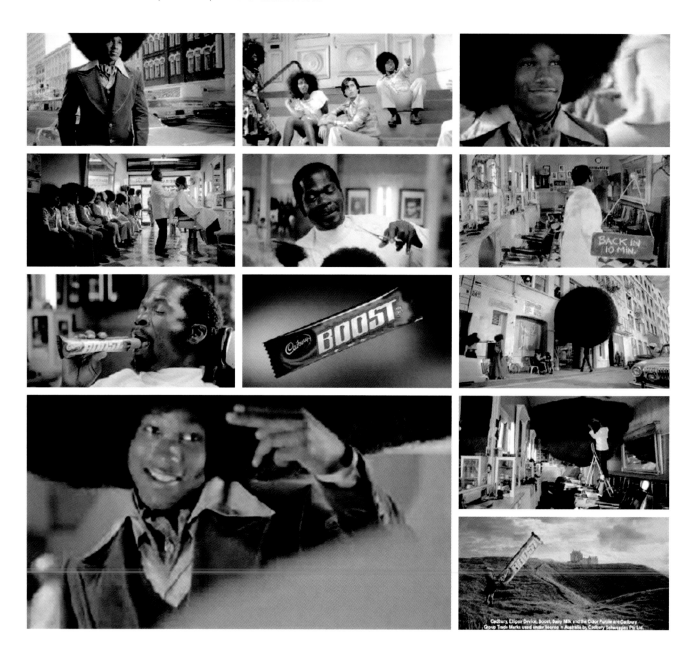

TITLE: Leak. CLIENT: Masterfoods. PRODUCT: Skittles Sweets. AGENCY: TBWA\Chiat\Day. COUNTRY: USA. YEAR: 2006. EXECUTIVE CREATIVE DIRECTOR: Gerry Graf. CREATIVE DIRECTOR: Scott Vitrone, Ian Reichenthal. COPYWRITER: Ian Reichenthal. ART DIRECTOR: Scott Vitrone. PRODUCTION COMPANY: MJZ. PRODUCER: Scott Kaplan. DIRECTOR: Tom Kuntz.

A plumber is called in to a guy's home. His ceiling is leaking Skittles candy. The plumber drills two handle bars into the ceiling, pulls out a small man from his tool bag and suspends him on the bars. The small man hangs there collecting Skittles in his mouth. Job done. /// Ein Mann bestellt einen Klempner in sein Haus. Durch seine Zimmerdecke sickern Skittles-Kaudragees. Der Klempner bringt zwei Haltegriffe an der Decke an, holt ein Männchen aus seiner Werkzeugtasche und hängt es an die Haltegriffe. Das Männchen hängt dort oben und fängt die Skittles mit seinem Mund auf. Aufgabe gelöst! /// Un plombier est appelé chez quelqu'un pour un plafond qui a une fuite de Skittles. Le plombier fixe deux poignées au plafond, sort un petit homme de son sac à outils et le suspend aux poignées. Le petit homme reste accroché là et les Skittles tombent dans sa bouche. Problème résolu.

HEALTH, BEAUTY, AND SEX

MIGUEL ANGEL FURONES
CHAIRMAN OF PUBLICIS GROUPE MEDIA FOR IBERIA

Miguel Angel Furones is president of Leo Burnett Latin America as well as chairman of Publicis Groupe Media for Spain and Portugal (Iberia). He previously served as the worldwide creative director of Leo Burnett. The founder of Vitruvio Leo Burnett, a Spanish agency that has been recognized on various occasions as Agency of the Year within the expansive Leo Burnett network, Miguel Angel has also presided over the judging panels on numerous international festivals. During his career he has published several books on advertising, in addition to poetry and short stories.

There is a word between health and beauty which is never used as openly: Sex. But this secret word is present (and at the same time hidden) in nearly all the campaigns in this area.

HEALTH IS A SOLID, SEX IS A LIQUID, AND BEAUTY IS A GAS.

Health is elated, explicit, brazen. It is the clothes on the body when the body has no clothes. Beauty is suggestive, ambiguous, magnetic. It is music and perfume. It is consenting, provocative,

Miguel Angel Furones ist Präsident von Leo Burnett Lateinamerika und Chairman der Publicis Groupe Media für Spanien und Portugal (Iberia). Zuvor war er Worldwide Creative Director von Leo Burnett. Er gründete Vitruvio Leo Burnett, eine spanische Agentur, die innerhalb des weltweiten Netzwerks von Leo Burnett mehrmals als Agentur des Jahres ausgezeichnet wurde, und trat außerdem bei zahlreichen internationalen Festivals als Vorsitzender der Jury in Erscheinung. Neben mehreren Büchern über Werbung hat er auch Gedichte und Kurzgeschichten veröffentlicht.

Zwischen Gesundheit und Schönheit gibt es ein Wort, das nie ausgesprochen wird: Sex. Doch dieses heimliche Wort verbirgt sich in fast allen Kampagnen dieser Kategorie.

GESUNDHEIT IST WIE DER FESTE, SEX WIE DER FLÜSSIGE UND SCHÖNHEIT WIE DER GASFÖRMIGE AGGREGATZUSTAND.

Gesundheit macht sich klar und deutlich bemerkbar, ohne Gnade. Sie kleidet unseren Körper, selbst wenn er nackt ist. Schönheit ist verlockend, facettenreich, betörend. Sie ist Musik und Parfüm. Sie verleiht jene magnetische Anziehungskraft, die jeder bewundert und begehrt. Aus dem Blickwinkel der Gesundheit sehen wir uns selbst. Aus dem Blickwinkel der Schönheit sehen uns die anderen. Gesundheit ist objektiv. Schönheit ist subjektiv.

In dieser Welt der Widersprüche kreieren Werbeschaffende Marken, die in einer einzigartigen und frustrierenden Wirklichkeit verankert sind: Fast jeder

Miguel Angel Furones est président de Leo Burnett Amérique latine, ainsi que directeur général de Publicis Groupe Media pour la péninsule ibérique. Il a été le directeur de la création de Leo Burnett Worldwide. Fondateur de Vitruvio Leo Burnett, une agence espagnole maintes fois reconnue « Agence de l'année » au sein du vaste réseau Leo Burnett, Miguel Angel a également présidé les jurys de nombreux festivals internationaux. Tout au long de sa carrière, il a publié de nombreux ouvrages à propos la publicité, ainsi que des recueils de poèmes et des nouvelles.

Entre la santé et la beauté, il existe un mot que l'on ne prononce jamais : le sexe. Mais ce mot secret est présent (et caché) dans presque toutes les campagnes de cette catégorie.

LA SANTÉ EST SOLIDE, LE SEXE EST LIQUIDE, ET LA BEAUTÉ EST GAZEUSE.

La santé est exubérante, explicite et insolente. C'est le vêtement du corps lorsque le corps n'a pas de vêtement. La beauté est suggestive, ambiguë, magnétique. Elle est musique et parfum. C'est l'attraction consentie, provoquée, poursuivie. La santé, c'est pour se voir soi-même. La beauté, c'est pour que les autres nous voient. La santé est objective. La beauté est subjective.

Dans cet univers de paradoxes, les créatifs publicitaires bâtissent des marques ancrées dans une réalité unique et démoralisante : presque tout le monde aimerait être quelqu'un d'autre. Ou du moins, posséder quelque chose de ce quelqu'un. Ses yeux, ses cheveux,

persecuted attraction. Health is looking at yourself. Beauty is being looked at by others. Health is objective. Beauty is subjective.

In this universe of paradoxes creative advertisers build brands based on a single, irrefutable reality: nearly every one of us would like to be another person. Or at least have something from someone else. Their eyes, their hair, their style, their bottom. But as we can't have we try, at least, to imitate.

This is a category of imitation. Unlike other categories in which the advertising language is more conceptual and discursive, in Health&Beauty the adverts show more than they demonstrate. They do not try to convince us because they know that captivating us is enough.

It is interesting that this is the category which uses most models — because the word model is exactly this: a reference, a paradigm, an icon to copy.

Although the seduction techniques of advertising have become more sophisticated over the years, in this category the most primitive and childlike of them still prevail: the image of a top model letting us know she uses this cream, this shampoo, this perfume. That simple, without rhetoric, without creativity, at least in the sense which advertisers specializing in other categories give to this last word.

Luckily things are changing, and here is this book to prove it. More and more these days health means knowledge, sex fun, and beauty culture. And in this field, advertising is able to work with subtle little details, producing new ideas which are fresher and more suggestive, directed at the intelligence of the consumer instead of at their frustrations.

möchte gern ein anderer sein. Oder wenigstens etwas von diesem anderen besitzen. Seine Augen, seine Haare, seinen Hintern. Aber da wir diese Merkmale nicht besitzen können, versuchen wir, sie zu imitieren.

Die Kategorie Schönheit & Gesundheit wird von der Imitation beherrscht. Im Unterschied zu anderen Kategorien, in denen der Werbediskurs konzeptioneller und rationaler geführt wird, bauen die Werbespots dieser Kategorie eher auf Illusionen als auf Fakten. Sie wollen nicht überzeugen, sondern faszinieren.

Es verwundert nicht, dass in dieser Kategorie die meisten Models zum Einsatz kommen. Models sind Identifikationsfiguren, Vorbilder, Ikonen, an denen sich jeder orientieren kann.

Auch wenn die Verführungsmethoden der Werbung im Laufe der Zeit immer raffinierter geworden sind, ist die vorherrschende Vorgehensweise in dieser Kategorie so primitiv und simpel wie eh und je: Wir bekommen ein weibliches (oder männliches) Supermodel zu sehen, das uns mitteilt, welche Creme, welches Shampoo oder welches Parfüm es benutzt. Eine denkbar einfache Methode, die jede Sprachgewandtheit und Kreativität vermissen lässt. Zumindest nicht in dem Sinne, wie Kreativität verstanden wird, wenn von der Werbung in den anderen Kategorien die Rede ist.

Glücklicherweise ändern sich die Dinge gerade, wie dieses Buch eindrucksvoll belegt. In wachsendem Maße wird Gesundheit zu einer Frage der Erkenntnis, Sex zu einer Frage des Vergnügens und Schönheit zu einer Frage der Kultur. Hier bietet sich der Werbung eine Spielwiese mit einer Fülle von Möglichkeiten. Die neuen Ideen sind origineller und interessanter, weil sie zunehmend an den Intellekt des Verbrauchers appellieren, statt sich seiner Frustration zu bedienen.

ses fesses. Mais comme nous ne pouvons pas posséder ces caractéristiques, nous essayons de les imiter.

Dans cette catégorie, l'imitation est reine. À la différence d'autres catégories dans lesquelles le discours publicitaire est plus conceptuel et plus rationnel, pour la Santé-Beauté les publicités montrent plus qu'elles ne démontrent. Elles n'essaient pas de nous convaincre, parce qu'il suffit de nous fasciner.

Il faut remarquer que c'est dans cette catégorie que l'on utilise le plus de mannequins, de « modèles ». Un modèle, c'est une référence, un paradigme, une icône à suivre.

Bien que les techniques de séduction de la publicité se soient raffinées au cours du temps, dans cette catégorie la technique prédominante est toujours la plus primitive et la plus puérile qui soit : l'image d'une superbe femme (ou d'un homme) qui nous apprend qu'elle utilise telle crème, tel shampooing, tel parfum. C'est aussi simple que cela. Pas de rhétorique, pas de créativité. Du moins pas au sens que l'on donne à ce dernier terme lorsque l'on parle de la publicité des autres catégories.

Par chance, et ce livre le démontre, tout cela est en train de changer. Chaque jour davantage, la santé devient connaissance, le sexe devient plaisir et la beauté devient culture. La publicité trouve là un terrain de jeu aux nuances beaucoup plus riches. Avec de nouvelles idées, plus originales et plus intéressantes, qui s'adressent à l'intelligence du consommateur et non plus à ses frustrations.

002

HEALTH & BEAUTY

TITLE: Coinage. **CLIENT:** Unilever. **PRODUCT:** AXE Deodorant. **AGENCY:** Lowe Bull, Johannesburg. **COUNTRY:** South Africa. **YEAR:** 2006. **PRODUCTION COMPANY:** Egg Films. **PRODUCER:** Chloe Saunders. **DIRECTOR:** Brent Harris. **AWARDS:** Cannes Lions (Bronze).

In this funny ad a couple of young buddies perform some amazing party tricks by bouncing coins into jars and glasses. This game continues until the screen goes black and the words "Get a girlfriend" appear. The spot closes with a shot of a young dude spraying himself with axe with two chicks at his side. /// In diesem lustigen Werbespot zeigen ein paar Kerle einige erstaunliche Partytricks, bei denen sie Münzen in Krüge und Gläser hüpfen lassen. Dieses Spiel setzt sich fort, bis der Bildschirm schwarz wird und die Worte „Such dir eine Freundin" erscheinen. In der Schlussszene besprüht sich ein junger Mann mit Axe und hat dabei zwei hübsche Mädchen an seiner Seite. /// Dans cette publicité hilarante, deux copains font des tours époustouflants en faisant rebondir des pièces de monnaie dans des pots et des verres. Ce jeu continue jusqu'à ce que l'écran devienne noir et que les mots « Trouvez-vous une copine » apparaissent. Le spot se termine par l'image d'un jeune homme qui se vaporise avec de l'Axe, flanqué de deux filles.

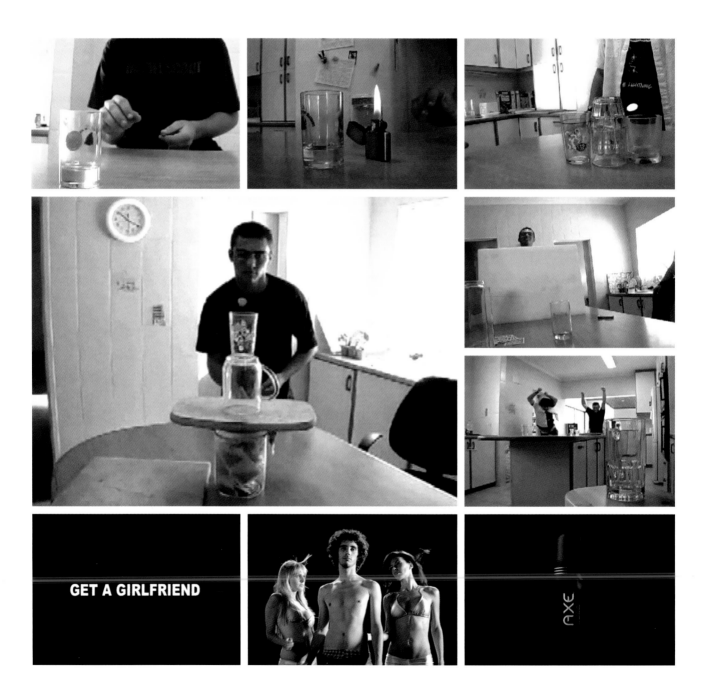

TITLE: No. CLIENT: Unilver. PRODUCT: Lynx 24-7 Deodorant. AGENCY: Vega Olmos Ponce/APL. COUNTRY: Argentina. YEAR: 2004. COPYWRITER: Analia Rios. ART DIRECTOR: Ricardo Armentamno. PRODUCTION COMPANY: La Banda Films. PRODUCER: Roberto Carsillo. DIRECTOR: Jose Antonio Prat. AWARDS: Cannes Lions (Bronze).

This spot features a young guy and his girlfriend happily in various scenes. They seem happily in love, though every time he leans over to ask her something, she simply says "No!" It seems even the cool fragrance of Axe can't help him out. /// Dieser Spot zeigt einen jungen Mann und seine Freundin in verschiedenen schönen Szenen. Sie scheinen glücklich verliebt zu sein, obwohl die Freundin jedes Mal einfach „Nein!" sagt, wenn er sich zu ihr beugt und etwas fragt. Es scheint, dass nicht einmal der frische Duft von Axe ihm helfen kann. /// Ce spot montre plusieurs scènes de la vie d'un jeune homme et de sa compagne. Ils semblent heureux et amoureux, mais chaque fois qu'il se penche pour lui demander quelque chose, elle répond simplement « Non ! » Apparemment, même le parfum d'Axe ne peut rien faire pour lui.

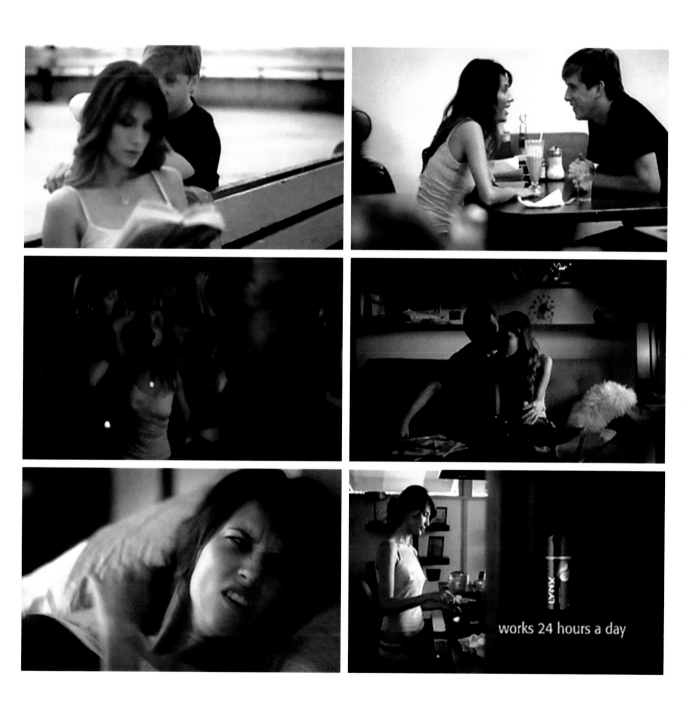

works 24 hours a day

TITLE: Getting Dressed. **CLIENT:** Unilever. **PRODUCT:** Lynx 24-7 Deodorant. **AGENCY:** Bartle Bogle Hegarty. **COUNTRY:** United Kingdom. **YEAR:** 2004. **CREATIVE DIRECTOR:** Rosie Arnold. **COPYWRITER:** Nick Gill. **PRODUCTION COMPANY:** Small Family Business. **PRODUCER:** Sally Humphries. **DIRECTOR:** Ringan Ledwidge. **AWARDS:** Cannes Lions (Gold).

This spot gets the message across with a play on time. A young couple wake up in bed. They start getting dressed and find their clothes all over the city. They finally arrive back at the supermarket they met at hours before. They take their trolleys and part. /// Dieser Werbespot vermittelt seine Botschaft über rückwärts laufende Zeit. Ein junges Paar wacht zusammen im Bett auf. Sie beginnen, sich anzuziehen und finden ihre Kleidung in der ganzen Stadt verstreut wieder. Schließlich kommen sie in dem Supermarkt an, in dem sie sich einige Stunden zuvor getroffen hatten. Sie nehmen ihre Einkaufswagen und trennen sich. /// Ce spot transmet son message en inversant le cours de la narration. Un jeune couple se réveille dans un lit. Ils commencent à s'habiller et trouvent leurs vêtements éparpillés dans toute la ville. Leur périple se termine au supermarché où ils s'étaient rencontrés quelques heures plus tôt. Ils prennent leurs chariots et se séparent.

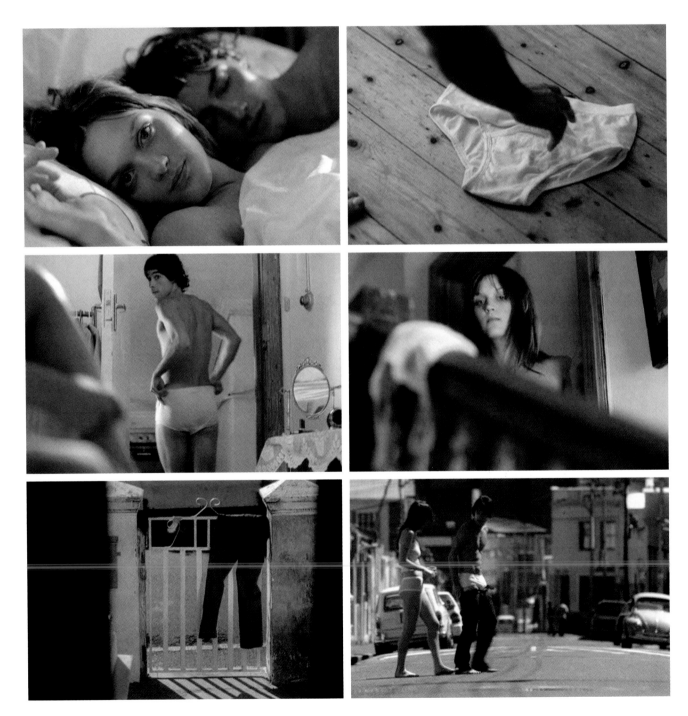

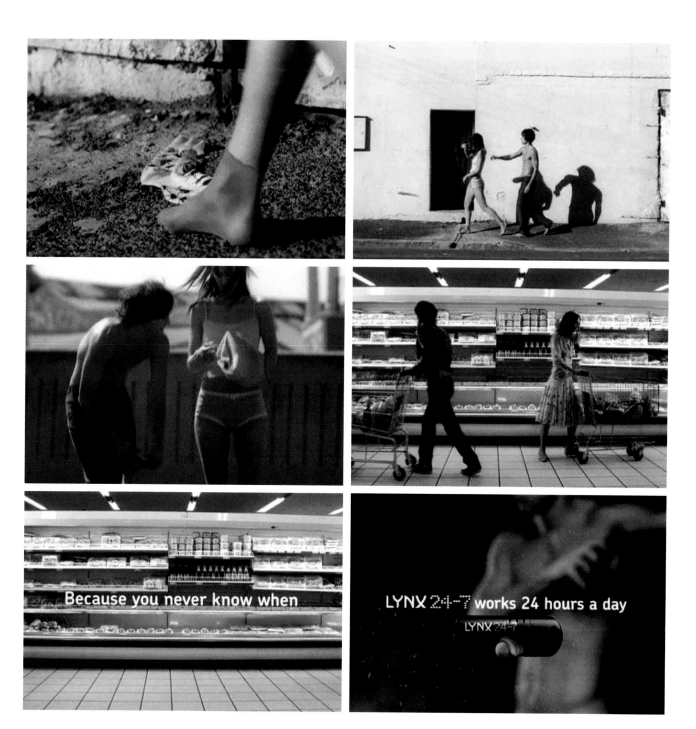

TITLE: LynxJet Corporate. **CLIENT:** Unilever. **PRODUCT:** Lynx Body Spray. **AGENCY:** Lowe Hunt, Sydney. **COUNTRY:** Australia. **YEAR:** 2006. **CREATIVE DIRECTOR:** Lionel Hunt, Adam Lance. **COPYWRITER:** Adam Lance, Michael Canning, Howard Collinge. **ART DIRECTOR:** Simone Brandse, Dejan Rasic. **PRODUCTION COMPANY:** Plaza Films. **PRODUCER:** Darren Bailey, Lisa Cordukes, Charna Henry. **DIRECTOR:** Nick Reynolds. **AWARDS:** Cannes Lions (Bronze).

"Imagine a level of comfort never before experienced in air travel…" The LynxJet campaign offers the epitome of every male frequent flyer's daydream: a bevy of beautiful stewardesses to cater for every need; an in-flight entertainment system that includes live pillow fighting or spanking. /// „Stellen Sie sich einen Komfort vor, den Sie bei Flugreisen noch nie zuvor erlebt haben…" Die LynxJet-Kampagne bietet den Inbegriff der Tagträume jedes männlichen Vielfliegers: Ein Schwarm schöner Stewardessen, die alle Wünsche erfüllen, und ein Unterhaltungsprogramm während des Fluges mit heißen Kissenschlachten oder Po-Versohlen. /// « Imaginez un confort jamais vu dans les voyages aériens… » La campagne Lynxjet propose la quintessence du rêve de tout voyageur masculin : une armée d'hôtesses de l'air sculpturales prêtes à satisfaire tous ses besoins, et un système de divertissement à bord qui comprend des batailles d'oreillers ou des séances de fessée en direct.

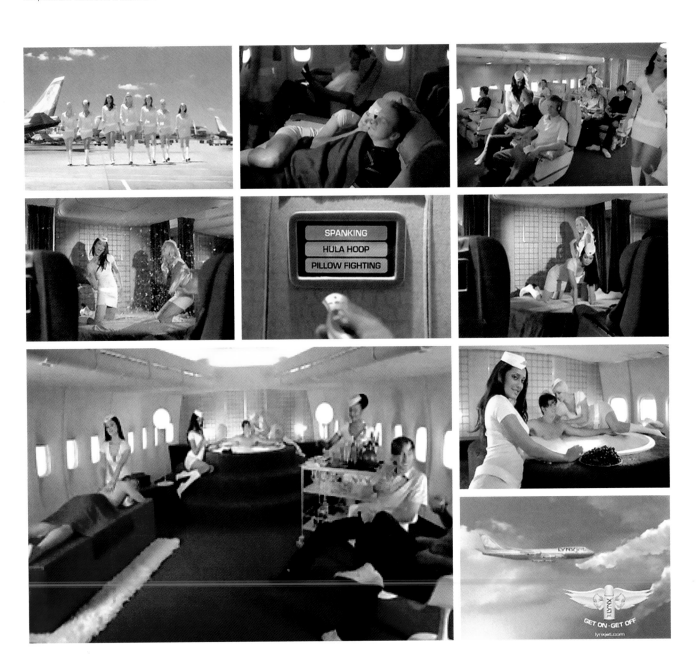

TITLE: Stunt City. CLIENT: Unilever. PRODUCT: Rexona Sure for Men Deodorant. AGENCY: Lowe London. COUNTRY: United Kingdom. YEAR: 2005. CREATIVE DIRECTOR: Ed Morris. COPYWRITER: Geoff Smith. ART DIRECTOR: Simon Butler. PRODUCTION COMPANY: Stink. PRODUCER: Nick Landon. DIRECTOR: Ivan Zacharias. AWARDS: Cannes Lions (Gold).

The scene is 'Stunt City', a place where all those death defying Hollywood action stunts are part of normal everyday life. The apt Rexona slogan here reads: "Over the top protection, for under the arms." /// Diese Szene spielt in „Stunt City", einem Ort, an dem todesmutige Hollywood Action-Stunts zum Alltag gehören. Der passende Rexona-Slogan heißt hier: „Überragender Schutz auch unter den Armen." /// Le décor est « Stunt City », la ville des cascades, où tous les cascadeurs d'Hollywood bravent la mort au quotidien. Le slogan de Rexona annonce : « Une protection vraiment à toute épreuve, pour les aisselles ».

TITLE: Sandwich. CLIENT: SSL International. PRODUCT: Durex Condoms. AGENCY: McCann Erickson Manchester. COUNTRY: United Kingdom. YEAR: 2008. CREATIVE DIRECTOR: Dave Price. COPYWRITER: Neil Lancaster. ART DIRECTOR: Dave Price. AGENCY PRODUCER: Neil Armstrong. EDITOR: Matthew Felstead, Greg Willcox. DIRECTOR: Simon Cheek.

A girl arrives home to find her boyfriend making tea for her parents, who decided to drop in unexpectedly. The girlfriend turns white when he tells her he found a cucumber in the fridge to make the sandwiches. The tagline appears over a close-up of a cucumber skin, "Isn't it time you bought a vibrator? Buy online at durex.co.uk." /// Eine junge Frau kommt nach Hause. Dort macht ihr Freund gerade Tee für ihre Eltern, die unerwartet zu Besuch gekommen sind. Die junge Frau wird blass, als ihr Freund ihr erzählt, dass er eine Salatgurke im Kühlschrank gefunden und damit die Sandwichs garniert hat. Der Slogan erscheint über der Nahaufnahme einer Gurkenschale: „Wird es nicht Zeit, einen Vibrator zu kaufen? Kaufen Sie online bei durex. co.uk." /// A son retour chez elle, une jeune fille trouve son fiancé en train de préparer le thé pour ses parents, qui leur ont rendu visite à l'improviste. Elle blêmit lorsqu'elle l'entend dire qu'il a préparé les sandwichs avec un concombre trouvé dans le frigo. Le message s'affiche sur un gros plan de peau de concombre : « N'est-il pas temps de vous payer un vibromasseur ? Achetez on-line sur durex.co.uk. »

FEATURED ON THE DVD **TITLE:** Barber. **CLIENT:** SSL International. **PRODUCT:** Durex Condoms. **AGENCY:** McCann Erickson Italy. **COUNTRY:** Italy. **YEAR:** 2004. **CREATIVE DIRECTOR:** Federiaca Ariagno, Giorgio Natale. **COPYWRITER:** Francesca Pagliarini. **ART DIRECTOR:** Gaetano Del Pizzo. **PRODUCTION COMPANY:** Mercurio Cinematografica. **PRODUCER:** Luca Fanfani. **DIRECTOR:** Bosi + Sironi. **AWARDS:** Cannes Lions (Bronze).

Two old men wait their turn in a barber shop. Suddenly one of them starts moaning and writhing in his chair. He convulses and falls silent. Both the barber and customer look around. The barber continues cutting in silence while the embarrassed, moaning man composes himself. The caption appears, "Durex Performa. Delay your climax." /// Zwei ältere Männer warten bei einem Herrenfriseur darauf, bis sie an der Reihe sind. Plötzlich beginnt einer von ihnen zu stöhnen und sich in seinem Stuhl zu winden. Er zuckt und bleibt schließlich still sitzen. Der Friseur und der andere Kunde schauen ihn erstaunt an. Der Friseur schneidet schweigend weiter, während sich der Mann verlegen wieder beruhigt. Der folgende Titel erscheint: „Durex Performa. Delay your climax" (zögere deinen Höhepunkt hinaus). /// Deux hommes âgés attendent leur tour chez le coiffeur. Soudain, l'un d'eux commence à gémir et à se tordre dans sa chaise. Il a une contraction finale, puis se tait. Le coiffeur et le client regardent autour d'eux. Le coiffeur continue de couper en silence, pendant que l'homme qui gémissait, embarrassé, se donne une contenance. Le spot se termine par ces mots : « Durex Performa. Retardez votre orgasme. »

FEATURED ON THE DVD **TITLE:** Elevator. **CLIENT:** SSL International. **PRODUCT:** Durex Condoms. **AGENCY:** McCann Erickson Italy. **COUNTRY:** Italy. **YEAR:** 2004. **CREATIVE DIRECTOR:** Federica Ariagno, Giorgio Natale. **COPYWRITER:** Francesca Pagliarini. **ART DIRECTOR:** Gaetano Del Pizzo. **PRODUCTION COMPANY:** Filmmaster. **PRODUCER:** Karim Bartoletti. **DIRECTOR:** Dario Piana. **AWARDS:** Cannes Lions (Bronze).

A man and a woman walk into an office elevator. Suddenly the man has an orgasm. As he does the woman glances over her shoulder curiously. /// Ein Mann und eine Frau betreten den Aufzug in einem Bürogebäude. Plötzlich hat der Mann einen Orgasmus. Während er seinen Höhepunkt hat, schaut die Frau neugierig über ihre Schulter. /// Un homme et une femme entrent dans un ascenseur dans un immeuble de bureaux. Soudain, l'homme a un orgasme. La femme regarde derrière elle avec curiosité.

FEATURED ON THE DVD **TITLE:** Swimming Pool. **CLIENT:** SSL International. **PRODUCT:** Durex Condoms. **AGENCY:** McCann Erickson Italy. **COUNTRY:** Italy. **YEAR:** 2004. **CREATIVE DIRECTOR:** Federica Ariagno, Giorgio Natale. **COPYWRITER:** Francesca Pagliarini. **ART DIRECTOR:** Gaetano Del Pizzo. **PRODUCTION COMPANY:** Mercurio Cinematografica. **PRODUCER:** Luca Fanfani. **DIRECTOR:** Bosi + Sironi. **AWARDS:** Cannes Lions (Bronze).

This clever visual play conveys the message that Durex Performa delay orgasm. A man is swimming alone in a pool. He begins to get aroused. As he reaches the handle rails he climaxes and glances down at himself. /// Dieses raffinierte visuelle Spiel vermittelt die Botschaft, dass Durex Performa den Orgasmus verzögert. Ein Mann schwimmt allein in einem Schwimmbecken. Dabei wird er immer erregter. Als er den Beckenrand erreicht, hat er seinen Höhepunkt und blickt an sich herunter. /// Ce jeu visuel ingénieux explique que Durex Performa retarde l'orgasme. Un homme nage seul dans une piscine. Il commence à s'exciter. Au moment où il attrape la poignée, il jouit et baisse les yeux.

This humorous ad opens with a guy waking up with a hangover. As he stands up he falls flat on the floor and starts crawling across the room. Resting his head on the toaster he manages to reach the fridge door. The clip ends with a bottle of Hang Hangover Reliever. /// In diesem humorvollen Werbespot wacht ein Mann auf und hat einen Kater. Als er aufstehen will, stürzt er zu Boden und beginnt, durch den Raum zu kriechen. Indem er seinen Kopf auf den Toaster stützt, schafft er es, die Kühlschranktür zu erreichen. Der Clip endet mit dem Bild einer Flasche *Hang*-Schmerzmittel gegen Kater. /// Un homme se réveille avec la gueule de bois. Il se lève, et tombe de tout son long sur le sol puis commence à ramper dans la chambre. Il arrive à atteindre le réfrigérateur en reposant sa tête sur le grille-pain. Le spot finit par une image d'une bouteille de Hangover Reliever (remède anti-gueule de bois) de Hang.

FEATURED ON THE DVD **TITLE:** Jinxed. **CLIENT:** Kimberly-Clark. **PRODUCT:** Kleenex Tissues. **AGENCY:** JWT Brasil. **COUNTRY:** Brazil. **YEAR:** 2005. **CREATIVE DIRECTOR:** Atila Francucci, Fernando Nobre, João Linneu. **COPYWRITER:** João Caetano Brasil. **ART DIRECTOR:** Keka Morelle. **PRODUCTION COMPANY:** Ad Studio. **DIRECTOR:** Jarbas Agnelli. **AWARDS:** Cannes Lions (Gold).

An animated sequence of words and pictures tells the story of Stuart Sutcliffe, the original bass player in The Beatles. He left just before the band topped the charts. The ad ends with a box of Kleenex tissues and the sound of a cry. /// Eine animierte Abfolge aus Wörtern und Bildern erzählt die Geschichte von Stuart Sutcliffe, dem ursprünglichen Bassisten der Beatles. Er verließ die Band, kurz bevor diese die Charts stürmte. Der Werbespot endet mit dem Bild einer Packung Kleenex-Taschentücher und dem Geräusch von Weinen. /// Une séquence d'animation raconte avec des mots et des images l'histoire de Stuart Sutcliffe, le premier bassiste des Beatles. Il quitta le groupe juste avant que le succès n'arrive. Le spot finit avec l'image d'une boîte de Kleenex, et des bruits de sanglots.

TITLE: Bird. CLIENT: Altana. PRODUCT: Neosaldina. AGENCY: Fischer America. COUNTRY: Brazil. YEAR: 2006. EXECUTIVE CREATIVE DIRECTOR: Sax So Funny. CREATIVE DIRECTOR: Jader Rossetto, Flavio Casarotti. COPYWRITER: Gustavo Diehl. ART DIRECTOR: Ricardo Big Passos. PRODUCER: Rachel Folino, Fernanda Sousa. PRODUCTION COMPANY: Farofa Filmes. DIRECTOR: Alvaro Beck. AWARDS: Cannes Lions (Bronze).

In a serene static shot a small bird lands on a window ledge and sings. A few seconds later a shot is fired and the bird disappears in a puff of feathers. The following titles appear: "Everything is a pain with a headache." /// In einer ruhigen statischen Kameraeinstellung landet ein kleiner Vogel auf einem Fensterbrett und singt. Einige Sekunden später wird ein Schuss abgegeben, und der Vogel verschwindet in einer Wolke aus Federn. Dann erscheinen die Worte „Bei Kopfschmerzen nervt einfach alles." /// Un plan statique plein de sérénité montre un petit oiseau qui atterrit sur le bord d'une fenêtre et se met à chanter. Quelques secondes plus tard, un coup de feu est tiré et l'oiseau disparaît dans une volée de plumes. Les mots suivants apparaissent : « Quand on a mal à la tête, tout devient insupportable ».

TITLE: Marathon. **CLIENT:** Libero. **PRODUCT:** Up&Go. **AGENCY:** Forsman & Bodenfors. **COUNTRY:** Sweden. **YEAR:** 2006. **COPYWRITER:** Jonas Enghage. **ART DIRECTOR:** Kim Cramer. **PRODUCTION COMPANY:** Anders Skog Films. **PRODUCER:** Asa Jansson, Magnus Kennhed. **DIRECTOR:** Anders Skog. **AWARDS:** Cannes Lions (Bronze).

It's marathon day. The water sponges are prepared. The crowds line up along the streets. As the runners appear they reveal themselves as toddlers. The spectators cheer. "The new Up&Go has arrived. Drier, thinner and faster than ever." /// Es ist Marathon-Tag, und alle Wasserschwämme sind schon vorbereitet. Die Menschen finden sich massenweise am Straßenrand ein. Als die Läufer erscheinen, entpuppen sie sich als Kleinkinder. Die Zuschauer jubeln. „Die neue Up&Go ist da. Trockener, dünner und schneller als je zuvor." /// C'est jour de marathon. Les éponges humides sont prêtes. La foule de spectateurs se met en place le long des rues. Les coureurs apparaissent, et l'on voit qu'il s'agit de bébés tout juste en âge de marcher. Les spectateurs les acclament. « La nouvelle Up&Go est arrivée. Plus sèche, plus fine et plus rapide que jamais. »

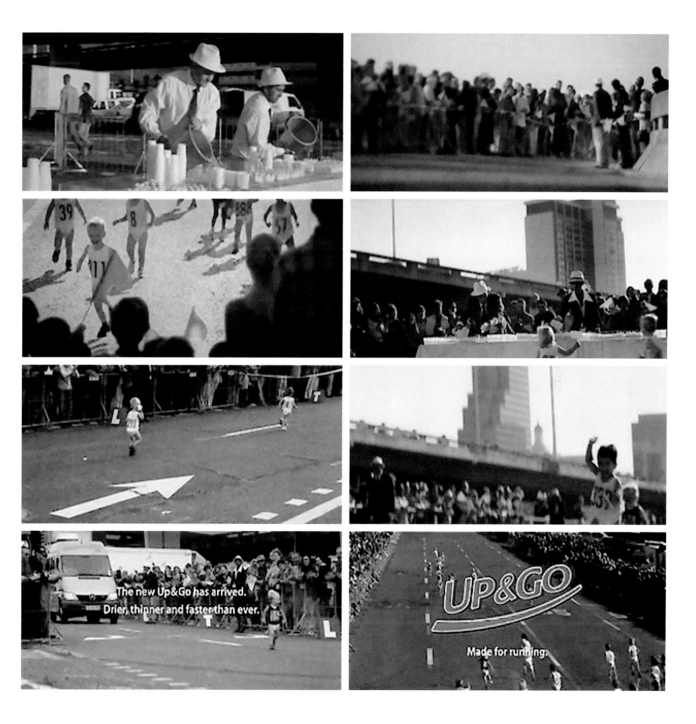

FEATURED ON THE DVD **TITLE:** Stairs. **CLIENT:** Procter & Gamble. **PRODUCT:** Pampers. **AGENCY:** Del Campo Nazca Saatchi & Saatchi. **COUNTRY:** Argentina. **YEAR:** 2005. **CREATIVE DIRECTOR:** Chavo Demilio. **COPYWRITER:** Gastón Bigio, Pablo Gil. **ART DIRECTOR:** Sebastián Garin, Jonathan Gurvit. **PRODUCTION COMPANY:** Pioneer. **PRODUCER:** Flora Fernandez Marengo. **DIRECTOR:** Luciano Pocadminsky. **AWARDS:** Cannes Lions (Silver).

This spot reveals the impact a parental decision can have on a child's future. The clip opens with a mother shouting "No!" when her toddler walks towards the stairs. In the subsequent scenes, the toddler, now a grown man is seen standing at the feet of various stairs unable to walk up them. /// Dieser Werbespot zeigt, welche Auswirkungen elterliche Entscheidungen auf die Zukunft eines Kindes haben können. In der Anfangsszene ruft eine Mutter jedes Mal „Nein!", wenn ihr Kleinkind in Richtung Treppe läuft. In den folgenden Szenen sieht man das Kind, nun als erwachsenen Mann, am Fuße verschiedener Treppen stehen. Er ist nicht in der Lage, die Stufen hinaufzugehen. /// Ce spot révèle l'importance qu'une décision parentale peut avoir pour l'avenir d'un enfant. Il commence avec une mère qui crie « Non ! » lorsque son bébé va vers les escaliers. Dans les scènes suivantes, on voit le bébé devenu adulte debout au pied d'un escalier, incapable de les monter.

FEATURED ON THE DVD **TITLE:** Lullaby. **CLIENT:** Procter & Gamble. **PRODUCT:** Pampers. **AGENCY:** Del Campo Nazca Saatchi & Saatchi. **COUNTRY:** Argentina. **YEAR:** 2006. **CREATIVE DIRECTOR:** Gastón Bigio, Sebastián Garín, Pablo Gil. **PRODUCTION COMPANY:** Compania Cinematografica. **PRODUCER:** Jamón del Mar. **DIRECTOR:** Javier Blanco.

This spot shows the ultimate comfort of Pampers Nappies. A baby sleeps peacefully as different sounds, including a dripping tap, a car alarm and ticking clock make up the chorus of a baby lullaby. /// Dieser Werbespot zeigt, wie bequem die Windeln von Pampers sind. Ein Baby schläft friedlich, während verschiedene Geräusche wie ein tropfender Wasserhahn, eine Autoalarmanlage und eine tickende Uhr zu einem Wiegenlied verschmelzen. /// Ce spot montre à quel point les couches Pampers sont confortables. Un bébé dort paisiblement pendant que différents bruits, notamment un robinet qui fuit, une alarme de voiture et le tic-tac d'une horloge, forment la mélodie d'une berceuse.

FEATURED ON THE DVD **TITLE:** Love Story 1. / Love Story 2. **CLIENT:** Smooth-E. **PRODUCT:** Smooth-E Baby Face Foam. **AGENCY:** Jeh United Ltd. **COUNTRY:** Thailand. **YEAR:** 2006. **CREATIVE DIRECTOR:** Jureeporn Thaidumrong. **COPYWRITER:** Jureeporn Thaidumrong. **ART DIRECTOR:** Jureeporn Thaidumrong. **PRODUCTION COMPANY:** Phenomena. **PRODUCER:** Angsana Premprasert, Sumalee Tantrapongsatorn. **DIRECTOR:** Thanonchai Sornsriwichai. **AWARDS:** Cannes Lions (Gold).

The first of this four part ad campaign introduces the central characters. Joom is a tough teenage girl with bad acne. Her palm reader pharmacist tells her that her soulmate has a centipede tattooed on his arm. She sees him in the park, but he likes someone else. Joom takes her friend Yae to the pharmacist to demand a solution. She's told bluntly that she needs to be more pretty and gentle, like Smooth-E Babyface Foam. /// Der erste Spot dieser vierteiligen Werbekampagne stellt die Hauptfiguren vor. Joom ist ein taffer Teenager mit schlimmer Akne. Ihre Apothekerin, die aus der Hand lesen kann, verrät ihr, dass jemand ihr Seelenverwandter sei, der eine Tätowierung in Form eines Tausendfüßlers auf dem Arm hat. Sie sieht einen solchen jungen Mann im Park, doch der steht auf ein anderes Mädchen. Joom nimmt ihren Freund Yae mit zur Apothekerin und fragt nach einer Lösung. Ihr wird ganz unverblümt gesagt, dass sie hübscher und sanfter werden müsste – so wie Smooth-E Babyface Foam. /// Le premier spot de cette campagne en quatre parties présente les personnages principaux. Joom est une adolescente dure à cuire avec un problème d'acné. Sa pharmacienne, qui lit dans les lignes de la main, lui annonce que son âme sœur a une marque en forme de mille-pattes sur le bras. Elle le voit dans le parc, mais il aime quelqu'un d'autre. Joom emmène son ami Yae chez la pharmacienne pour exiger une solution. Elle s'entend répondre brutalement qu'il faut qu'elle soit plus jolie et plus douce, comme Smooth-E Babyface Foam.

Joom decides to take drastic action. She uses Smooth-E Babyface Foam and has a makeover, whilst dreaming she's married to Ake. Suddenly she has a change of heart. In a bizarre twist Ayo, her pharmacist friend, reveals that she's a transsexual. Love encouraged her to change. Joom meets Ake at the park. He walks past her. The other girl is also there. Suddenly, Ake picks a flower and gives it to Joom … /// Joom entschließt sich, harte Maßnahmen zu ergreifen. Sie benutzt Smooth-E Babyface Foam und verändert sich grundlegend, während sie davon träumt, mit Ake verheiratet zu sein. Plötzlich hat sie einen Sinneswandel. In einer skurrilen und unerwarteten Wendung offenbart ihr Ayo, die Apothekerin und Freundin, dass sie eine Transsexuelle sei. Die Liebe hätte sie zu dieser drastischen Veränderung ermutigt. Joom trifft Ake im Park. Er geht an ihr vorüber. Auch das andere Mädchen ist dabei. Plötzlich pflückt Ake eine Blume und überreicht sie Joom … /// Joom décide de prendre le taureau par les cornes. Elle utilise Smooth-E Babyface Foam et se soumet à un changement de look, tout en rêvant d'être la femme d'Ake. Mais elle hésite. C'est alors qu'Ayo, son amie pharmacienne, lui révèle qu'elle est une transsexuelle, et que c'est l'amour qui l'a encouragée à changer. Joom va voir Ake au parc. Il passe à côté d'elle. L'autre fille est là aussi. Soudain, Ake cueille une fleur et la donne à Joom …

FEATURED ON THE DVD **TITLE:** Love Story 3. / Love Story 4. **CLIENT:** Smooth-E. **PRODUCT:** Smooth-E Baby Face Foam. **AGENCY:** Jeh United Ltd. **COUNTRY:** Thailand. **YEAR:** 2006. **CREATIVE DIRECTOR:** Jureeporn Thaidumrong. **COPYWRITER:** Jureeporn Thaidumrong. **ART DIRECTOR:** Jureeporn Thaidumrong. **PRODUCTION COMPANY:** Phenomena. **PRODUCER:** Angsana Premprasert, Sumalee Tantrapongsatorn. **DIRECTOR:** Thanonchai Sornsriwichai. **AWARDS:** Cannes Lions (Gold).

Ake and Joom are in love, but wherever they go someone keeps throwing a bottle at Ake's head. As they walk down the street, two bullies who appear in every spot begin taunting them. Joom turns to Ake for help, but he runs away. Ayo comforts Joom by telling her that Ake is just "like a pimple," and Smooth-E Babyface Foam "removes all pimples." Joom picks up a remote and freezes Ayo. She wonders who saved her from the gang. /// Ake und Joom sind ein Paar, doch egal, wohin sie gehen, irgendjemand wirft Ake eine Flasche an den Kopf. Während sie die Straße hinuntergehen, werden sie von zwei Kerlen schikaniert, die in jedem Werbespot auftauchen. Joom dreht sich hilfesuchend zu Ake um, doch dieser sucht das Weite. Ayo tröstet Joom und sagt ihr, dass Ake nur „wie ein Pickel" ist und dass Smooth-E Babyface Foam „alle Pickel entfernt". Joom nimmt eine Fernbedienung und lässt Ayo erstarren. Sie fragt sich, wer sie vor der Bande gerettet hat. /// Ake et Joom sont amoureux, mais partout où ils vont quelqu'un lance une bouteille en plastique à la tête d'Ake. Ils marchent tous les deux dans la rue, et deux brutes qui apparaissent dans chaque spot commencent à les provoquer. Joom compte sur Ake pour l'aider, mais il prend ses jambes à son cou, et Joom s'évanouit. Ayo console Joom en lui disant qu'Ake est « comme un bouton », et Smooth-E Babyface Foam « élimine tous les boutons ». Joom prend une télécommande et met Ayo en pause. Elle se demande qui l'a sauvée de la bande.

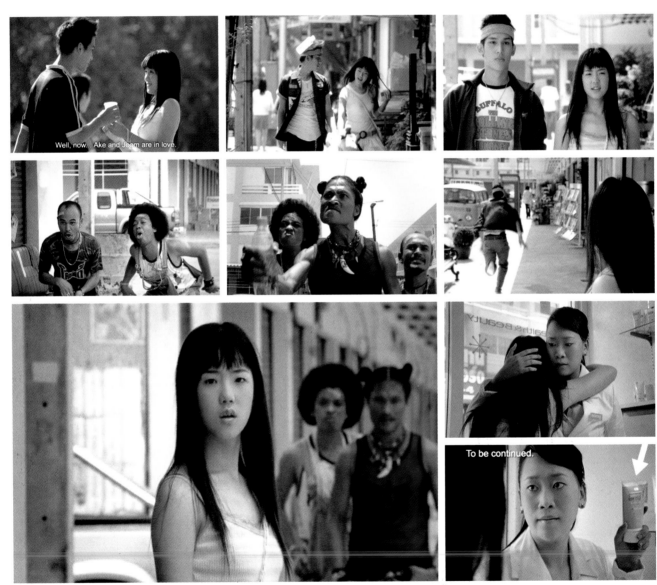

Ayo reveals that after Joom had fainted, her friend Yae came to rescue her. Joom goes to Yae who is sitting alone on a bench in the park. She thanks him and realises that he loves her. He admits it then denies it. Joom playfully punches his shoulder. Yae shrieks in pain as the camera reveals a long stitch… in the shape of a centipede. The series flashes to Joom and Yae's wedding then flashes back over the series. /// Ayo verrät Joom, dass ihr Freund Yae ihr zu Hilfe kam, als sie ohnmächtig wurde. Joom geht zu Yae, der allein auf einer Bank im Park sitzt. Sie dankt ihm und begreift, dass er sie liebt. Er gibt es zunächst zu, bestreitet es dann wieder. Joom gibt ihm einen spielerischen Klaps auf die Schulter. Yae schreit vor Schmerz auf, während die Kamera eine lange genähte Wunde auf seiner Haut preisgibt… in der Form eines Tausendfüßlers. Der Film springt zur Hochzeit von Joom und Yae über und zeigt dann Rückblicke aus der gesamten Serie. /// Ayo révèle à Joom qu'après qu'elle se soit évanouie, c'est son ami Yae qui l'a sauvée. Joom va voir Yae, qui est tout seul sur un banc dans le parc. Elle le remercie et réalise qu'il est amoureux d'elle. Il le reconnaît, puis nie tout en bloc. Joom lui donne un petit coup sur l'épaule pour plaisanter. Yae grimace de douleur, et la caméra révèle une longue cicatrice avec des points de suture… en forme de mille-pattes! Un flash nous transporte au mariage de Joom et Yae avant de revenir à l'histoire.

After you fainted, Yae came and helped you.

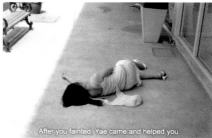
After you fainted, Yae came and helped you.

He would do anything for the one he loves.

Non-Ionic, Soap free…

FEATURED ON THE DVD **TITLE:** Tattoo. / Knitting Pattern. **CLIENT:** Procter & Gamble. **PRODUCT:** Tampax Tampons. **AGENCY:** Leo Burnett USA. **COUNTRY:** USA. **YEAR:** 2006. **CREATIVE DIRECTOR:** Becky Swanson, Reed Collins, Jill Bohannan. **COPYWRITER:** Jen Faust. **ART DIRECTOR:** Reed Collins. **PRODUCTION COMPANY:** Smuggler. **DIRECTOR:** Happy.

Tampax give women the choice of keeping their periods private or advertising the fact. One suggestion would be a temporary tattoo. /// Tampax lässt Frauen die Wahl, ihre Periode für sich zu behalten oder sie an die große Glocke zu hängen. Ein Vorschlag wäre eine vorübergehende Tätowierung! /// Tampax laisse les femmes décider si elles veulent que leurs règles soient une affaire privée, ou publique. Elles peuvent par exemple se faire un tatouage temporaire.

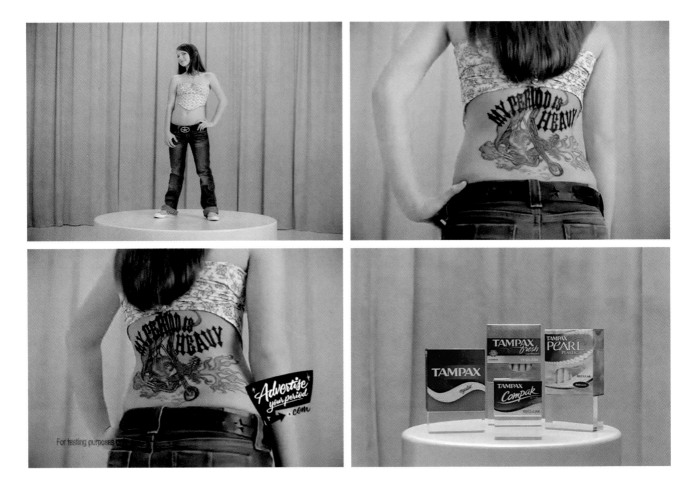

A girl appears smiling on a revolving platform. She's holding her pet dog who's wearing a pink knitted sweater, which has on it the words 'mommy's menstruating'. Ladies can keep their periods private with Tampax, or advertise it to the world. /// Eine Frau erscheint lächelnd auf einer sich drehenden Bühne. Sie hält ihren Hund auf dem Arm, der einen rosa Strickpullover mit der Aufschrift „Frauchen hat ihre Tage" trägt. Frauen können mit Tampax ihre Periode für sich behalten oder sie der ganzen Welt mitteilen. /// Une jeune femme souriante apparaît sur une plateforme tournante. Elle tient son chien dans les bras, et il porte un pull rose avec les mots « ma maîtresse a ses règles ». Avec Tampax, les femmes peuvent garder leurs règles secrètes, ou bien les crier sur tous les toits.

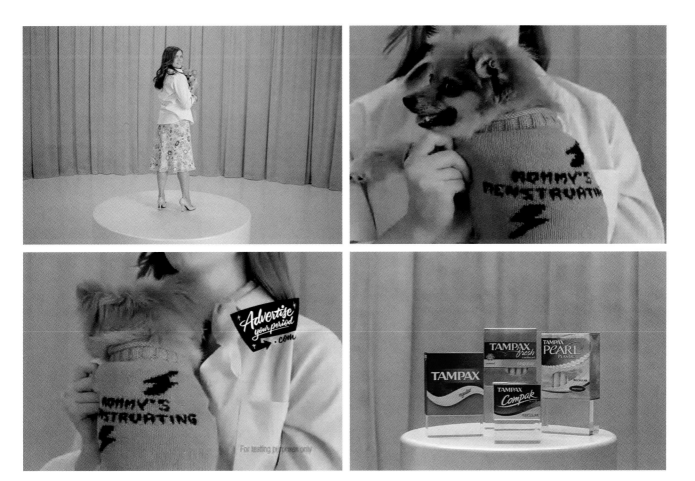

Timotei's Camomile and Henna campaign pits a blonde against a brunette in the battle of the stereotypes. In the first spot a blonde raises the brunettes' argument that they have more inner beauty. To which the blonde asks, "Then why don't you peel yourself?" /// Timotei's Kamille- und Henna-Kampagne zeigt eine Blondine und eine Brünette im Kampf der Stereotypen. Im ersten Spot widerspricht eine Blondine der Behauptung der Brünetten, dass diese mehr innere Schönheit hätten. Dazu fragt die Blondine: „Warum schälst du dich dann nicht?" /// La campagne Camomille et Henné de Timotei oppose une blonde et une brune dans une bataille des stéréotypes. Dans le premier spot, une blonde reprend l'argument des brunes selon lequel elles auraient une plus grande beauté intérieure. La blonde demande : « Si c'est vrai, pourquoi vous ne vous épluchez pas ? »

"Blondes have more fun alright," explains this young brunette; "if you tell them something funny they'll laugh at least three times. Once – when you tell them the story. Again, once you've explained the punchline … and the third time once they've understood it." /// „Blondinen haben mehr Spaß, das stimmt", erklärt diese junge Brünette. „Wenn Sie ihnen etwas Lustiges erzählen, lachen sie mindestens dreimal. Einmal, wenn sie die Geschichte hören. Zum zweiten Mal, nachdem ihnen die Pointe erklärt wurde … und zum dritten Mal, wenn sie die Pointe verstanden haben." /// « C'est bien vrai que les blondes savent s'amuser », explique cette jeune brune, « si vous leur racontez une histoire drôle elles vont rire au moins trois fois. Une fois lorsque vous leur racontez l'histoire. Une fois lorsque vous leur expliquez pourquoi c'est drôle … et la troisième lorsqu'elles finissent par comprendre. »

TITLE: Golf. / Office. **CLIENT:** Pfizer Canada. **PRODUCT:** Viagra. **AGENCY:** TAXI Canada. **COUNTRY:** Canada. **YEAR:** 2005. **CREATIVE DIRECTOR:** Zak Mroueh. **COPYWRITER:** Irfan Khan. **ART DIRECTOR:** Ron Smrczek. **PRODUCTION COMPANY:** The Partners Film Company. **PRODUCER:** Gigi Realini, Link York. **DIRECTOR:** Joachim Back. **AWARDS:** Cannes Lions (Gold).

Two old buddies are playing golf. One drops an awesome put. As his friend congratulates him, the other says, "That's nothing, this morning I…." Suddenly his voice is masked by a tone and a Viagra logo blocks out his lips. The slogan reads: "Talk to your doctor." /// Zwei alte Kumpel spielen Golf. Einem gelingt ein großartiger Putt. Als ihm sein Freund gratuliert, sagt der andere: „Das ist gar nichts, heute Morgen habe ich…" Plötzlich wird seine Stimme mit einem Ton überdeckt, und ein Viagra-Logo verdeckt seine Lippen. Der Slogan lautet: „Sprechen Sie mit Ihrem Arzt." /// Deux vieux copains jouent au golf. L'un d'eux fait un putt époustouflant. Son ami le félicite, et l'autre dit : « Et encore, ce n'est rien, ce matin j'ai … » Soudain sa voix est couverte par un bip et sa bouche est cachée par le logo Viagra. Le slogan s'affiche : « Parlez-en à votre médecin ».

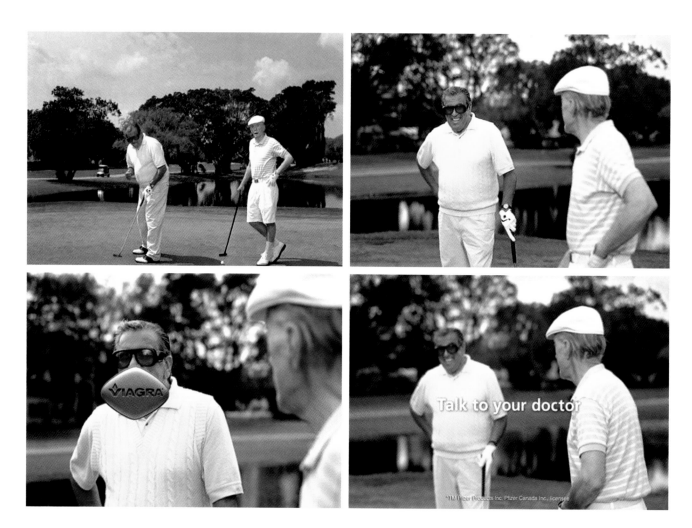

The setting is an office suite. Three colleagues go into the break room for a coffee. One man says to the other. "You're looking good. You been working out?" The other guy responds, "No …" before his answer is blocked out by a tone. The female worker smiles nervously and says, "Bravo!" /// Der Werbespot spielt in einem Büro. Drei Kollegen gehen auf einen Kaffee in den Pausenraum. Ein Mann sagt zu einem anderen: „Du siehst gut aus. Treibst du im Moment Sport?" Der andere antwortet: „Nein …", bevor seine Antwort mit einem Ton überdeckt wird. Die weibliche Kollegin lächelt nervös und sagt: „Bravo!" /// L'action se déroule dans des bureaux. Trois collègues vont prendre un café dans la salle de pause. L'un dit à un autre : « Tu as l'air en forme. Tu fais du sport en ce moment ? » L'autre répond : « Non … » mais un bip rend sa réponse inaudible. La femme sourit nerveusement et lâche : « Bravo ! »

FEATURED ON THE DVD **TITLE:** Savana. **CLIENT:** Johnson & Johnson Inc. **PRODUCT:** Reactine. **AGENCY:** JWT Rome. **COUNTRY:** Italy. **YEAR:** 2006. **CREATIVE DIRECTOR:** Chips Hardy, Pietro Maestri, Paolo Ronchi. **COPYWRITER:** Alfredo Ruggieri. **ART DIRECTOR:** Pierfranco Fedele. **PRODUCTION COMPANY:** Mercurio Productions. **PRODUCER:** Benedetta Arnaldi. **DIRECTOR:** Max Rocchetti. **AWARDS:** Cannes Lions (Bronze).

"I've been living in the savannah for a few years and I know how fast an allergy attack can be," says a South African park ranger. He is oblivious to the bizarre chase that is happening behind him. /// „Ich lebe schon seit einigen Jahren in der Savanne und weiß, wie schnell eine Allergie zuschlagen kann", sagt ein südafrikanischer Parkaufseher. Von der grotesken Jagd hinter ihm bekommt er nichts mit. /// « J'ai vécu plusieurs années dans la savane, et je sais que les allergies peuvent attaquer sans prévenir », raconte un gardien de parc sud-africain. Il ne remarque même pas la drôle de poursuite qui se déroule derrière lui.

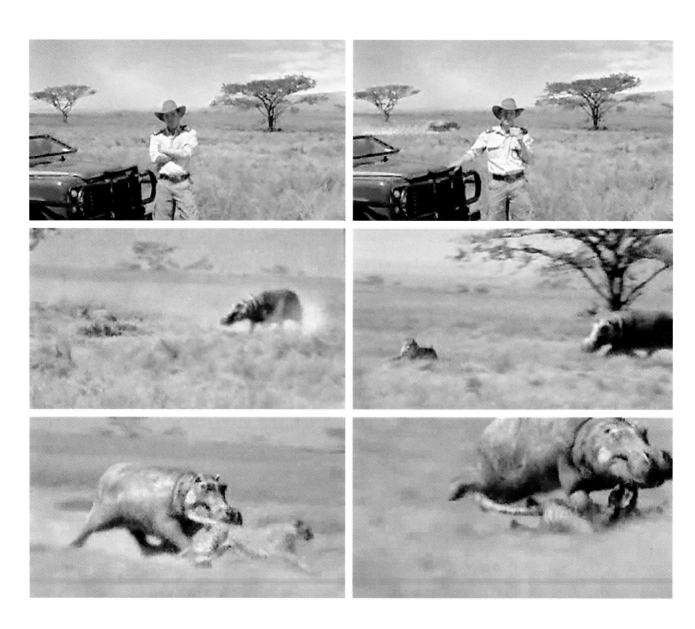

TITLE: Breathing. CLIENT: O Boticário. PRODUCT: Zaad – Perfume for men. AGENCY: Almap BBDO. COUNTRY: Brazil. YEAR: 2008. CREATIVE DIRECTOR: Dulcidio Caldeira, Luiz Sanches. COPYWRITER: Renato Simões, Bruno Prosperi. ART DIRECTOR: Renato Simões, Bruno Prosperi. PRODUCTION COMPANY: O2 Filmes. DIRECTOR: Paola Siqueira.

A beautiful girl tries to break up with her boyfriend. She looks into the camera and says, "I don't love you any more," as she breathes out. As she inhales the alluring fragrance of Zaad for Men she says, "I love you." Following each negative exhalation she professes her love again with each inhalation. /// Ein schönes Mädchen versucht, mit ihrem Freund Schluss zu machen. Sie schaut in die Kamera und sagt „Ich liebe dich nicht mehr", während sie ausatmet. Als sie jedoch den verführerischen Duft von Zaad for Men einatmet, sagt sie „Ich liebe dich". Nach jedem Ausatmen gesteht sie ihm während des Einatmens erneut ihre Liebe. /// Une jolie fille s'efforce de rompre avec son petit ami. Elle regarde la caméra et dit : « Je ne t'aime plus, » en expirant. Mais lorsqu'elle inspire, elle inhale le séduisant parfum de Zaad for Men et murmure, « Je t'aime. » Après chaque expiration négative, elle déclare à nouveau son amour à chaque inspiration.

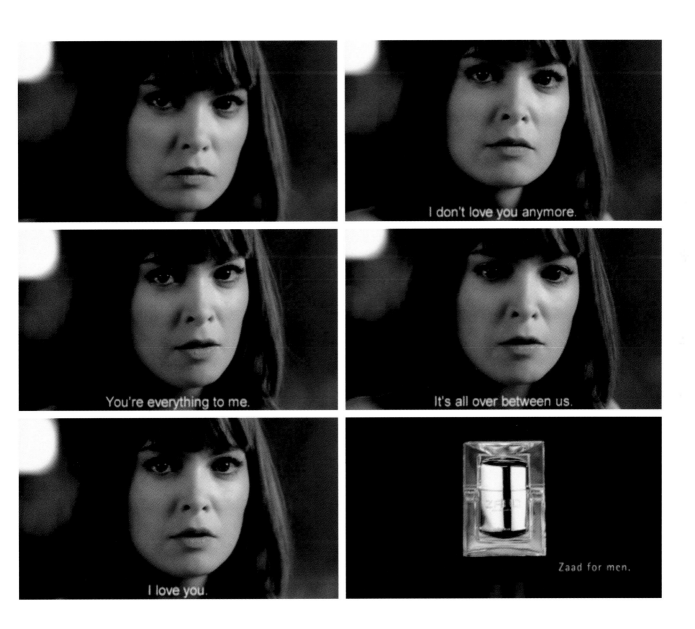

HOME CARE, GREAT SPOTS

GUSTAVO REYES
EXECUTIVE CREATIVE DIRECTOR OF EURO RSCG, BUENOS AIRES

Gustavo Reyes obtained his bachelors degree in visual arts at La Plata University and a further degree in art direction at the Escuela Superior de Creativos Publicitarios. He started working in the advertising industry as a freelance graphic designer in 1989. During the course of his career he has held many creative directorship posts in some of the most prestigious advertising agencies in Argentina, such as Publicis, TBWA, Cravero Lanis Euro RSCG, and Ogilvy & Mather. Gustavo is currently the general executive creative director of Euro RSCG Buenos Aires. He has extensive experience directing national, regional, and international accounts such as Seagram, Budweiser, Brahma, Sprite, Fanta, Campari, Unilever Best Foods, Kraft Foods, Grupo Clarín, Carrefour, Bayer, Nivea, and Wal-Mart. Gustavo's talent and work has been recognized throughout his career with a string of international festival awards to his name, including five Cannes Lions Print, two Cannes Lions TV, two Silver and one Bronze at the Clio Awards, not to mention 54 Gold Awards at the New York Festival, amongst others.

Gustavo Reyes hat einen Bachelor in Visual Arts der Universität von La Plata und einen weiteren Abschluss in Art Direction der Escuela Superior de Creativos Publicitarios. Er begann 1989 seine Tätigkeit in der Werbebranche als selbständiger Grafikdesigner. Im Laufe seiner Karriere arbeitete er als Creative Director in einigen der renommiertesten Agenturen Argentiniens, darunter Publicis, TBWA, Cravero Lanis Euro RSCG und Ogilvy & Mather. Derzeit ist er General Executive Creative Director von Euro RSCG Buenos Aires. Er hat umfangreiche Erfahrungen in der Leitung regionaler, nationaler und internationaler Accounts wie Seagram, Budweiser, Brahma, Sprite, Fanta, Campari, Unilever Best Foods, Kraft Foods, Grupo Clarín, Carrefour, Bayer, Nivea und Wal-Mart. Für sein Talent und seine Arbeit wurde er bereits auf einer Reihe von internationalen Festivals mit Preisen ausgezeichnet: Er erhielt unter anderem fünf Cannes Lions in der Kategorie Print, zwei Cannes Lions in der Kategorie TV, zweimal Silber sowie einmal Bronze bei den Clio Awards und 54 Gold Awards beim New York Festival.

Gustavo Reyes präsentiert nachfolgend eine Auswahl der besten TV-Spots der letzten Jahre und erklärt zugleich, warum er sich für diese Kandidaten entschieden hat:

Energizer „Yard Sale"
Dieser TV-Spot präsentiert den Geist der Jugend und das wahre Leben auf den Straßen, wobei er beides mit den realistischen Elementen eines Dokumentarfilms verknüpft. Seine Struktur überrascht und fasziniert durch die Gegensätzlichkeit der Charaktere und durch

Gustavo Reyes a obtenu sa licence d'Arts plastiques à l'université de La Plata, ainsi qu'un diplôme en direction artistique à l'Escuela Superior de Creativos Publicitarios. Il a démarré dans le monde de la publicité en 1989 en travaillant comme graphiste indépendant. Au cours de sa carrière, il a occupé de nombreux postes de directeur de la création dans quelques-unes des agences publicitaires les plus prestigieuses d'Argentine, telles que Publicis, TBWA, Cravero Lanis, Euro RSCG et Ogilvy & Mather. Gustavo est actuellement directeur exécutif général de la création chez Euro RSCG Buenos Aires. Il a une grande expérience de la direction de la création pour le compte de clients nationaux, régionaux et internationaux, tels que Seagram, Budweiser, Brahma, Sprite, Fanta, Campari, Unilever Best Foods, Kraft Foods, Grupo Clarín, Carrefour, Bayer, Nivea et Wal-Mart. Le talent et le travail de Gustavo ont été reconnus tout au long de sa carrière par une ribambelle de prix internationaux, parmi lesquels cinq Lions à Cannes catégorie « Print », deux Lions catégorie « TV », deux Clios d'argent et un Clio d'or, sans oublier 54 médailles d'or au New York Festival, entre autres.

Gustavo Reyes vous propose ci-dessous une sélection des meilleurs spots télévisés de ces dernières années. Il explique également les raisons derrière ses choix :

Energizer « Yard Sale »
Ce spot jeune d'esprit dévoile la réalité de la rue avec un réalisme digne d'un documentaire. Sa structure est surprenante et intrigante à la fois, grâce au contraste des personnages et à la manière intelligente

Below is a selection of what Gustavo Reyes considers to be the best TV commercials of the last years, with his own comments on why they were selected:

Energizer "Yard Sale"
This film presents the spirit of youth and the reality of the streets, combining them with a documentary-like realism. Its structure is both surprising and intriguing, thanks to the contrast of the characters and the intelligent and realistic manner in which the product's attributes are displayed. This makes it ordinary yet intellectually aspirational.

Velvet "Soft Factory"
This film promotes the company's philosophical values by referencing the product's sensory attributes in a funny, entertaining, and almost ironic way that makes it attractive to the viewer. It surprises and stands out from typical paper commercials.

Vim "The Prisoner"
This commercial presents the metaphor of the woman as slave to household chores. The deceit at the beginning, which leads to having to clean the bathroom, evinces a change in philosophy: "The important thing is to be with your kids; it is not worth spending time cleaning the bathroom." It is fresh and ironic and also offers a twist by switching from drama to comedy.

P&G Cheer "Is This Black?"
This is an appealing interactive commercial where the viewer's attention is drawn by the challenge and its simple and effective solution. These kinds of ideas provide immediate results and a satisfactory experi-

die intelligente wie auch realistische Weise, mit der die Eigenschaften des Produkts präsentiert werden. Dadurch wirkt der Werbespot gewöhnlich, fesselt jedoch zugleich auf intellektueller Ebene.

Velvet „Soft Factory"
Dieser TV-Spot präsentiert die philosophischen Werte des Unternehmens, indem er in witziger, unterhaltsamer und geradezu ironischer Weise auf die sensorischen Eigenschaften des Produkts Bezug nimmt. Das macht ihn für den Zuschauer attraktiv. Dieser TV-Spot überrascht und hebt sich nicht zuletzt dadurch von typischen Toilettenpapier-Werbungen ab.

Vim „The Prisoner"
Dieser TV-Spot zeigt die Metapher der Frau als Sklavin ihres Haushaltes. Die anfängliche Täuschung – die Mutter sitzt nicht wirklich hinter Gittern, sondern ist in ihrem Zwang gefangen, die Badewanne blitzblank putzen zu müssen – lässt einen Wandel der Philosophie erkennen: Wichtig ist, seinen Kindern Zeit zu widmen, statt seine Zeit damit zu verbringen, das Bad zu reinigen. Ein frischer und ironischer Ansatz, der zudem durch die überraschende Wendung vom Drama zur Komödie überzeugt.

P&G Cheer „Is This Black?"
Diese ansprechende interaktive Werbung gewinnt die Aufmerksamkeit des Betrachters, indem zunächst ein Problem und anschließend dessen einfache und effektive Lösung präsentiert werden. Ideen dieser Art liefern unmittelbare Ergebnisse und verschaffen dem Betrachter ein befriedigendes Erlebnis. Eine sehr simple und zugleich intelligente Methode, die Produktionskosten niedrig zu halten.

et réaliste de présenter les qualités du produit. Cela lui donne un caractère ordinaire mais intellectuellement suggestif.

Velvet « Soft Factory »
Ce spot défend les valeurs philosophiques de la société, en dressant la liste des avantages sensoriels du produit de manière amusante, divertissante et presque ironique, qui rend le produit attrayant aux yeux du spectateur. Le film surprend et se détache des publicités pour papier courantes.

Vim « The Prisoner »
Ce film publicitaire met en scène une femme qui est esclave des tâches ménagères. La tromperie du début, qui conduit à l'obligation de nettoyer la salle de bain, annonce un changement de philosophie : « Le plus important, c'est de passer du temps avec ses enfants et non pas de nettoyer la salle de bain. » Original et ironique, ce spot offre un rebondissement, en passant de la tragédie à la comédie.

P&G Cheer « Is This Black? »
Ce spot interactif et séduisant attire l'attention du spectateur sur le défi et sa solution simple et efficace. Ce genre d'idées procure des résultats immédiats et une expérience satisfaisante pour le spectateur. C'est un moyen simple et intelligent de maintenir les coûts de production au plus bas.

Reynolds « Milk »
Le choix des décors et le réalisme du jeu des acteurs rend ces deux spots publicitaires particulièrement intéressants. Le recours à un contexte dramatique rend la démonstration de l'utilisation de ce produit éton-

ence for the viewer. It's a very simple and intelligent method of keeping production costs down.

Reynodls "Milk"

What makes these two films special are the selection of the settings and the realism of the acting. The use of a dramatic context turns a product demonstration that could have otherwise been predictable and boring into something tense and intriguing. By referencing the competition's imitations and strategic inefficiencies, the second commercial adds to the strengths of the first film and displays the product's superiority.

Sylvania "Cockroach"

This commercial resorts to humor about a religious subject, which is prevalent not only in its milieu but is also important to the rest of the world. The reincarnation is funny, and it is a subject that everyone can relate to. It is fun, surprising, and offers an intriguing idea.

Hornbach "Fluginsektenvernichter"

The strength of these types of campaigns is that they take the age-old gimmick of having viewers adopt the product and make it popular in everyday life. Add to it a communication style that's unique and distinctive to the brand, and the effects can last long after the launch of the campaign.

Calgon "Jesus"

This is a groundbreaking film that's a bit over the top and exaggerated, but its quality of production does not make it any less attractive. Due to the religious controversy it generated, it made an impact on the general public and gained notoriety.

Milwaukee "Pit Stop"

This is a meaningless exaggeration, surprising and hard to believe, but it clearly displays the product's attributes. Since it is neither pretentious nor snobby, it is funny and effective because the actors' surprise works at all times. The clumsy way in which the actors are depicted from the very beginning creates a comedy that allows viewers to forget about the silliness of the script.

Reynolds „Milk"

Was diese beiden TV-Spots so einzigartig macht, ist die Auswahl der Szenarien und der Realismus der Darstellung. Der dramatische Kontext verwandelt eine Produktvorführung, die ansonsten vorhersagbar und langweilig hätte sein können, in eine spannende und faszinierende Angelegenheit. Durch die Bezugnahme auf die Nachahmungsversuche und strategische Ineffizienz der Mitbewerber unterstreicht der zweite Werbefilm die Stärken des ersten TV-Spots und stellt die Überlegenheit des Produkts überzeugend dar.

Sylvania „Cockroach"

Dieser thailändische TV-Spot bezieht sich in humorvoller Weise auf ein religiöses Thema, das nicht nur für die dortige, größtenteils buddhistische Bevölkerung, sondern auch für den Rest der Welt von Bedeutung ist. Die Reinkarnation, ein Thema, mit dem sich jeder identifizieren kann, wird hier auf amüsante Weise in Szene gesetzt. Ein witziger und überraschender Werbefilm, der mit einer originellen Idee überzeugt.

Hornbach „Fluginsektenvernichter"

Die Stärke dieser Art von Kampagnen liegt darin, dass sie sich der altbekannten Werbemasche bedienen, den Betrachter das Produkt adoptieren zu lassen und es im alltäglichen Leben populär zu machen. Wird dies durch einen Kommunikationsstil ergänzt, der auf einzigartige und unverwechselbare Weise mit der Marke verbunden ist, kann die Wirkung noch lange nach dem Start der Kampagne anhalten.

Calgon „Jesus"

Zugegeben: Dieser bahnbrechende TV-Spot ist ein wenig übertrieben und an der Grenze, doch macht ihn die Qualität seiner Produktion besonders attraktiv. Berühmt und berüchtigt wurde er vor allem dadurch, dass er eine religiöse Kontroverse auslöste und so die Aufmerksamkeit einer breiten Öffentlichkeit erregte.

Milwaukee „Pit Stop"

Dieser TV-Spot übertreibt gnadenlos: Am Ende bleibt ein überraschter Zuschauer zurück, der seinen Augen nicht traut. Zugleich präsentiert er jedoch ganz klar die Eigenschaften des Produkts. Er ist dabei weder anmaßend noch überheblich. Seine witzige Wirkung ver-

nante et captivante, alors qu'elle aurait pu être prévisible et ennuyeuse. En dressant la liste des imitations et de l'inefficacité stratégique de la concurrence, le second film donne davantage d'intensité au premier et met en exergue la supériorité du produit.

Sylvania « Cockroach »

Ce spot publicitaire a recours à l'humour sur un sujet religieux, qui est présent à la fois dans son milieu et dans le reste du monde. La réincarnation est drôle et c'est un sujet auquel tout le monde peut s'identifier. Il s'agit d'un spot amusant, étonnant et intrigant.

Hornbach « Fluginsektenvernichter »

La force de ce type de campagnes réside dans le recours à un moyen ancestral consistant à ce que le spectateur adopte le produit et le rende populaire dans la vie de tous les jours. Ajoutez-y un style de communication unique et propre à la marque et le résultat peut continuer de faire effet bien après le lancement de la campagne.

Calgon « Jesus »

Ce film novateur, quelque peu tiré par les cheveux et démesuré, est remarquable pour la qualité de sa production. Grâce à la controverse religieuse qu'il a provoquée, ce spot a eu une grande répercussion sur le grand public et le produit a gagné en notoriété.

Milwaukee « Pit Stop »

Ce spot est une exagération dépourvue de sens, insolite et difficile à croire, mais il a le mérite de présenter clairement les attributs du produit. Comme il n'est ni prétentieux ni affecté, le film est drôle et efficace, notamment grâce à la surprise que créent les acteurs. La maladresse avec laquelle les acteurs sont dépeints depuis le départ rend le film comique et permet aux spectateurs d'oublier l'absurdité du scénario.

Dulux « One Endangered Species »

Cette publicité emploie subtilement un lieu commun et le dévoile sous un autre jour afin de le rendre plus attrayant. Le spectateur perçoit les problèmes d'un point de vue différent, ce qui les rend plus pertinents. La réalisation est esthétiquement agréable et la gentillesse des enfants est manifeste. Le film aborde un

Dulux "One Endangered Species"

This commercial subtly takes something that's commonplace and shows it in a different light in order to make it more appealing. It makes the viewer see the problems from a different perspective and therefore makes them more relevant. Its execution is visually pleasing, and the children's friendliness is tender and comes across clearly. It addresses a subject that is always relevant to those who have kids, and it communicates the benefits of the product brilliantly.

Skil "Harvest Moon" + "Project"

The contrast between the two characters helps to point out how useful and convenient the product can be for users of all ages. The ad shows how people who are reluctant to give up their old habits shouldn't use their reluctance as an excuse to disregard the product's benefits. Whether you're old fashioned or modern, there are benefits for everyone.

Electrolux "Melons"

This commercial is interesting because of its sheer madness. It draws the viewer's attention by having all of the supermarket employees trying to do something different with the products. The acting is quite funny, and the ingenious way in which the product is presented is what helps set it apart. It is funny and attractive.

Brandt "Three Films Campaign"

A realistic execution. The fake acting and the people's reaction is both creative and intelligent. Its cinematographic style is very smooth and helps give the brand a unique personality.

Trane "Panda"

This film presents a bizarre approach, which is justified by the conceptual resolution. A surreal situation unfolds from an institutional message to highlight the importance and value the brand places on the free maintenance service of its equipment. The result is achieved with an air of controversy and with no ties to the segment.

Dulux "Plasticine"

It is interesting to see how in a few seconds viewers can be moved by the animated figures and the tender-

dankt er dem Überraschungsmoment eine Technik, die einfach immer funktioniert. Die Darsteller agieren am Anfang schwerfällig und langsam, was einen sehr wirkungsvollen Kontrast zum schnellen Überraschungsgag am Ende erzeugt. Diese unterhaltsame Komödie lässt den Zuschauer vergessen, wie schwach das Drehbuch eigentlich ist.

Dulux „One Endangered Species"

Dieser Werbefilm nimmt auf subtile Weise etwas ganz Gewöhnliches und zeigt es in einem neuen Licht, um es attraktiver zu machen. Dadurch sieht der Zuschauer die Probleme aus einer anderen Perspektive, und plötzlich haben sie für ihn mehr Relevanz. Die Ausführung ist visuell sehr ansprechend, und das liebenswerte Wesen der Kinder kommt klar herüber. Der Film spricht ein Thema an, das für alle Eltern von Bedeutung ist, und kommuniziert zugleich in brillanter Weise die Vorteile des Produkts.

Skil „Harvest Moon" + „Project"

Der Kontrast zwischen den beiden Charakteren unterstreicht, dass dieses Produkt Vorteile für Nutzer aller Altersgruppen bietet. Der Werbefilm verdeutlicht, dass sogar Menschen, die alte Gewohnheiten nicht aufgeben wollen, trotzdem von den Vorteilen des Produkts profitieren können. Egal ob jemand eine altmodische oder moderne Einstellung hat, dieses Produkt ist auf jeden Fall von großem Nutzen.

Electrolux „Melons"

Dieser Werbefilm ist völlig verrückt, und das macht ihn so interessant. Er fesselt die Aufmerksamkeit des Zuschauers dadurch, dass alle Supermarktangestellten versuchen, mit den Produkten etwas anderes zu machen. Die Darsteller verleihen diesem TV-Spot seinen Witz, und die erfinderische Art der Produktpräsentation macht ihn außergewöhnlich. Ein lustiger und ansprechender Werbefilm.

Brandt „Three Films Campaign"

Das Besondere an diesen Werbefilmen ist ihre Mischung aus Realitätsnähe und Komik. Die Art und Weise, wie die verschiedenen Figuren agieren und reagieren, wurde kreativ und intelligent inszeniert. Der konsequent durchgeführte kinematografische

sujet qui interpelle toujours ceux qui ont des enfants et communique à merveille les avantages du produit.

Skil « Harvest Moon » + « Project »

Le contraste entre les deux personnages aide à souligner l'utilité et la commodité du produit pour les consommateurs de tous âges. Dans ce spot, on voit que ceux qui se refusent à se défaire de leurs vieilles habitudes ne devraient pas utiliser leur réticence pour ignorer les avantages du produit. Vieux jeu ou moderne, chacun peut y trouver son compte.

Electrolux « Melons »

C'est la folie pure et simple de ce spot qui le rend si intéressant. L'attention du spectateur est attirée par le fait que tous les employés du supermarché font quelque chose de différent avec les produits. Le jeu des acteurs est amusant et l'ingéniosité avec laquelle le produit est présenté contribue efficacement à le mettre en valeur. C'est un film drôle et séduisant.

Brandt « Three Films Campaign »

Une exécution réaliste. L'interprétation postiche et la réaction des gens sont à la fois créatives et intelligentes. Le style cinématographique employé est très réussi et il contribue à donner à la marque une personnalité unique.

Trane « Panda »

Ce film présente une approche étrange, justifiée par la résolution conceptuelle. Une situation surréaliste découle d'un message institutionnel afin de souligner l'importance et la valeur que la marque donne au service d'entretien gratuit de son équipement. Le résultat est atteint sur fond de controverse et sans aucun lien avec le public ciblé.

Dulux « Plasticine »

Il est intéressant de voir comment, en quelques secondes, le spectateur peut s'émouvoir devant des personnages animés et la tendresse qu'ils dégagent. Avec la gorge tranchée, on s'aperçoit à quel point on peut devenir obsessionnel lorsque l'on décore sa maison. Il s'agit d'une grande idée, communiquée avec clarté.

ness that they display. The cutting of the throat shows just how obsessive one can get when decorating one's house. It is a great idea that is clearly communicated.

Fevicol "Bus"

A brilliant idea represented through a typical portrayal of India and its customs. It has the necessary element of surprise, turning a product demonstration into a memorable commercial.

Husqvarna "Portraits"

This is the kind of film that makes us reflect on how people judge each other and stereotype one another. It clearly shows how symbolic the memory of some celebrities can be, all supported by a romantic and very personal aesthetic that makes the product's attributes stand out.

Sealy "Boy"

This ad uses exaggeration to poke fun at a segment of the market that doesn't get with the times and upgrade its products. This way of presenting the product's attributes is commonly used by other brands, yet this commercial differentiates itself through its use of humor.

Ansatz trägt dazu bei, der Marke eine einzigartige Persönlichkeit zu verleihen.

Trane „Panda"

Dieser Werbefilm präsentiert einen bizarren Ansatz, der durch die konzeptionelle Durchführung gerechtfertigt wird. Eine zunächst völlig surreal erscheinende Situation löst sich am Ende mit einer überzeugenden logischen Erklärung auf. Die Werbebotschaft vermittelt wirkungsvoll Bedeutung und Wert, die die Marke dem kostenlosen Service für ihre Produkte beimisst, und das hohe Engagement, mit dem dieser Service geleistet wird.

Dulux „Plasticine"

Das Interessante an diesem Werbespot ist, dass er die Aufmerksamkeit des Zuschauers aus dem Stand mit einem Szenario fesselt, bei dem eine Familie aus animierten Knetfiguren eine tragende Rolle spielt. Das Abreißen des Kopfes soll illustrieren, wie besessen man werden kann, wenn man seine eigenen vier Wände renoviert. Eine originelle Idee, die klar kommuniziert wird.

Fevicol „Bus"

Eine brillante Idee, die mithilfe eines typischen Porträts des indischen Alltagslebens vermittelt wird. Der TV-Spot endet mit dem elementaren Überraschungsmoment, das aus einer Produktvorführung eine originelle Werbung macht.

Husqvarna „Portraits"

Dieser Werbefilm lässt uns über die Neigung der Menschen nachdenken, einander zu beurteilen und nach Stereotypen zu kategorisieren. Er verdeutlicht, welchen symbolischen Wert die Erinnerung an manche Berühmtheiten haben kann, unterstützt durch eine romantische und sehr persönliche Ästhetik, die die Eigenschaften des Produkts in den Vordergrund rückt.

Sealy „Boy"

Diese Werbung nutzt das Mittel der Übertreibung, um sich über ein Marktsegment lustig zu machen, das nicht mit der Zeit geht und seine Produkte erneuert. Auch andere Marken präsentieren die Eigenschaften ihrer Produkte auf diese Art, doch diese Werbung unterscheidet sich von den anderen durch ihren Humor.

Fevicol « Bus »

Une idée brillante représentée au moyen d'un portrait typique de l'Inde et de ses coutumes. Le film comporte l'élément de surprise indispensable, qui fait de la démonstration de l'utilisation du produit un spot publicitaire mémorable.

Husqvarna « Portraits »

Voici le genre de spot qui nous fait réfléchir sur la manière dont les gens se jugent les uns les autres et tendent à stéréotyper, et qui dévoile le symbolisme de la mémoire de certaines célébrités. Tout cela filmé sur fond d'esthétique romantique et personnelle qui donne plus d'intensité aux qualités du produit.

Sealy « Boy »

Ce spot a recours à l'exagération pour se moquer d'un segment de marché qui n'est pas à la page et n'actualise pas ses produits. Cette manière de présenter les attributs du produit est souvent employée par d'autres marques, mais ce film se distingue par son utilisation de l'humour.

"THE STRENGTH OF THESE TYPES OF CAMPAIGNS IS THAT THEY TAKE THE AGE-OLD GIMMICK OF HAVING VIEWERS ADOPT THE PRODUCT AND MAKE IT POPULAR IN EVERYDAY LIFE."

„DIE STÄRKE DIESER ART VON KAMPAGNEN LIEGT DARIN, DASS SIE SICH DER ALTBEKANNTEN WERBEMASCHE BEDIENEN, DEN BETRACHTER DAS PRODUKT ADOPTIEREN ZU LASSEN UND ES IM ALLTÄGLICHEN LEBEN POPULÄR ZU MACHEN."

« LA FORCE DE CE TYPE DE CAMPAGNES RÉSIDE DANS LE RECOURS À UN MOYEN ANCESTRAL CONSISTANT À CE QUE LE SPECTATEUR ADOPTE LE PRODUIT ET LE RENDE POPULAIRE DANS LA VIE DE TOUS LES JOURS. »

003

HOME CARE & HYGIENE

TITLE: Oven. / Fridge. **CLIENT:** Brandt. **PRODUCT:** Brandt Home Appliances. **AGENCY:** CLM BBDO Paris. **COUNTRY:** France. **YEAR:** 2000. **CREATIVE DIRECTOR:** Fred Raillard, Farid Mokart. **COPYWRITER:** Fred Raillard, Farid Mokart. **ART DIRECTOR:** Fred Raillard, Farid Mokart. **PRODUCTION COMPANY:** Quad Productions. **DIRECTOR:** Remy Belvaux. **AWARDS:** CLIO Awards, New York Festivals of Advertising, Cannes Lions.

All appears well at the dinner party as the wife collects the plates and walks into the kitchen. She opens the oven door and jumps on it in a sudden fit of rage. Her husband rushes in. "That's it," shouts the wife, "I can't take it. I've had enough!" She storms out. The slogan appears on screen, "She wants a Brandt." /// Alles scheint bei dem Abendessen mit Freunden in Ordnung zu sein. Die Gastgeberin sammelt die Teller ein und trägt sie in die Küche. Sie öffnet die Backofentür und springt in einem plötzlichen Wutanfall darauf. Ihr Ehemann eilt herbei. „Mir reicht es", brüllt die Ehefrau, „ich kann es nicht mehr aushalten. Ich hab's satt!" Sie stürmt aus der Küche. Der Slogan „Sie will einen Brandt" erscheint auf dem Bildschirm. /// Le dîner semble aller comme sur des roulettes. Madame ramasse les assiettes et pénètre dans la cuisine. Elle ouvre la porte du four et, soudain, saute dessus à pieds joints avec rage. Le mari se précipite. « Ça suffit, » hurle-t-elle, « Je n'en peux plus. J'en ai assez ! » Et elle sort brusquement de la pièce. Le slogan s'affiche sur l'écran : « Elle veut un Brandt. »

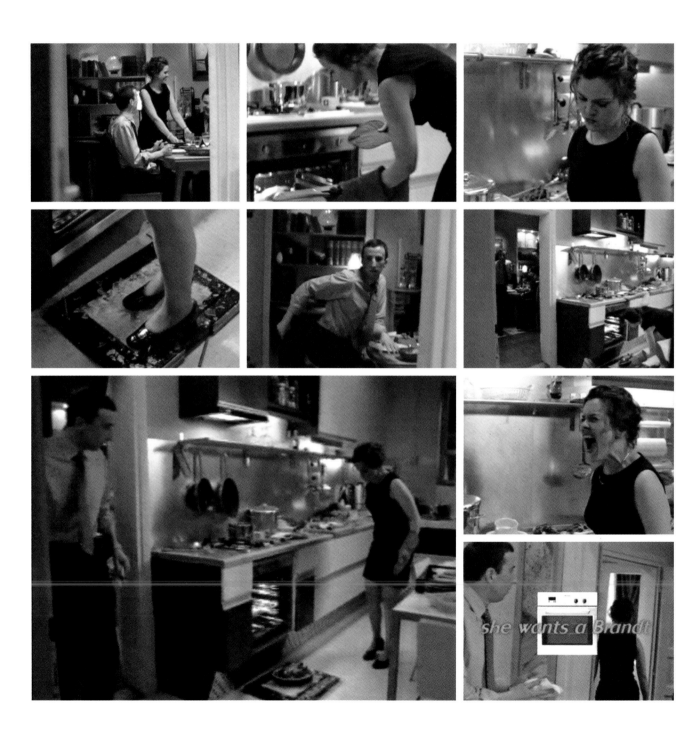

A guy opens the fridge, picks up a bottle of water and then kicks the door in. His girlfriend hears the noise and rushes downstairs. "What happened?" she asks. "I don't know," replies the man. "I was going to ask you the same thing." He looks at her in denial. "What? I didn't do it." The caption fades up, "He wants a Brandt." /// Ein junger Mann öffnet den Kühlschrank, nimmt eine Flasche Wasser heraus und tritt dann die Kühlschranktür aus den Angeln. Seine Freundin hört den Lärm und eilt die Treppe hinunter. „Was ist passiert?", fragt sie. „Ich weiß nicht", antwortet ihr Freund. „Ich wollte dich gerade das Gleiche fragen." Er schaut sie unschuldig an. „Was? Ich war das nicht." Der folgende Slogan erscheint: „Er will einen Brandt." /// Un homme ouvre le frigo, y prend une bouteille d'eau puis se met à donner des coups de pieds dans la porte. Au bruit, sa petite amie accourt. « Que s'est-il passé ? » demande-t-elle. « Je ne sais pas, » répond l'homme. « J'allais te demander la même chose. » Il la regarde d'un air de dénégation. « Quoi ? C'est pas moi qui ai fait ça. » La légende s'affiche, « Il veut un Brandt. »

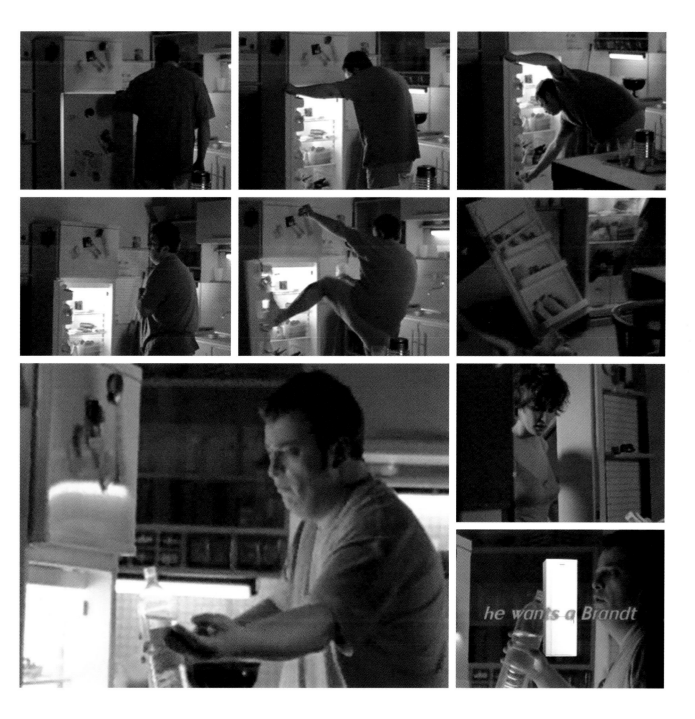

TITLE: Jesus. CLIENT: Reckitt Benckiser Austria. PRODUCT: Calgon detergent/softener. AGENCY: Fahrnholz & Junghanns & Raetzel Werbeagentur. COUNTRY: Germany. YEAR: 2004. CREATIVE DIRECTOR: Hans Fahrnholz. COPYWRITER: Hondo. ART DIRECTOR: Florian Scherzer. PRODUCTION COMPANY: Vivafilm. PRODUCER: Andreas Grassl, Stephan Loesebrink. DIRECTOR: Hondo.

The spot opens with a Jesus-like figure – back turned to the camera – walking on a lake of water. The words "Hard Water?" appear on screen. The shot cross fades to reveal a box of Aqua Pro Calgon, half buried on a sandy shore. The titles "Water softener – Protects your washing machine" close the ad. /// Der Werbespot zeigt eine Jesus-ähnliche Figur von hinten, die über das Wasser eines Sees geht. Die Worte „Ist Ihr Wasser hart?" erscheinen auf dem Bildschirm. Die Kamera blendet zu einer Packung Calgon AquaPro über, die halb vergraben am sandigen Ufer zu sehen ist. Der Schlusstitel „Wasserenthärter – schützt Ihre Waschmaschine" beendet den Werbespot. /// Le spot commence par un personnage qui ressemble à Jésus (le dos tourné à la caméra) et marche à la surface d'un lac. Les mots « Votre eau est calcaire? » apparaissent à l'écran. Un fondu enchaîné montre une boîte de Calgon AquaPro à moitié enterrée dans le sable. Le spot se conclut par les mots : « Adoucit l'eau, protège votre machine à laver ».

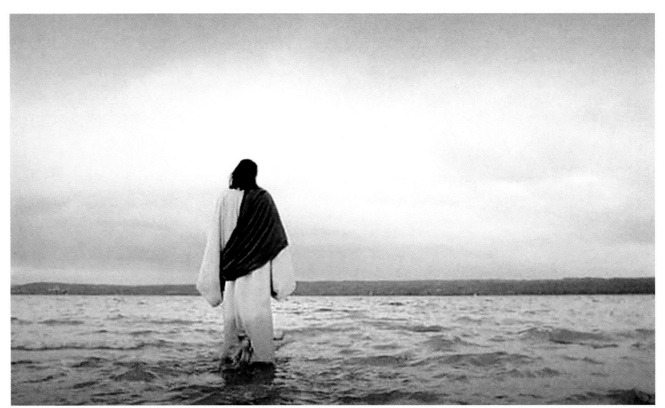

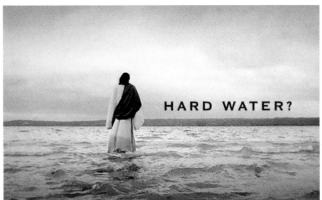

TITLE: Bulldozer. CLIENT: Procter & Gamble. PRODUCT: Crest. AGENCY: Saatchi & Saatchi New York. COUNTRY: USA. YEAR: 2008. EXECUTIVE CREATIVE DIRECTOR: Gerry Graf. CREATIVE DIRECTOR: Kerry Keenan, Alison Gragnano. COPYWRITER: Nathan Frank. ART DIRECTOR: Dan Lucey. PRODUCTION COMPANY: Station Film. EXECUTIVE PRODUCER: Tom Rossano. DIRECTOR: Harold Einstein.

Three young boys stop beside a bulldozer in their playground. One boy asks the driver what he is doing. He explains that he is going to knock down their playground to build a noisy power station. The tagline appears, "You can say anything with a smile." The spot closes with the Crest logo and the caption, "Healthy, beautiful smiles for life." /// Drei Jungen bleiben neben einem Bulldozer stehen, der sich auf ihrem Spielplatz befindet. Einer der Jungen fragt den Fahrer, was er dort machen wird. Der Fahrer erklärt, dass er den Spielplatz abreißt, um ein neues Elektrizitätswerk darauf zu bauen, das viel Lärm machen wird. Der Slogan „Mit einem Lächeln kannst du alles sagen" erscheint. Der Werbespot endet mit dem Logo von Crest und den Zeilen „Gesundes, schönes Lächeln ein ganzes Leben lang". /// Sur un terrain de jeux, trois gamins s'arrêtent à côté d'un bulldozer. L'un d'eux demande au conducteur ce qu'il fait. Tout sourire, celui-ci répond qu'il va démolir leur terrain de jeux pour construire à la place une bruyante centrale électrique. L'accroche apparaît : « On peut tout dire avec le sourire. » Le spot s'achève sur le logo de Crest, avec cette légende : « Des sourires sains et beaux, pour la vie. »

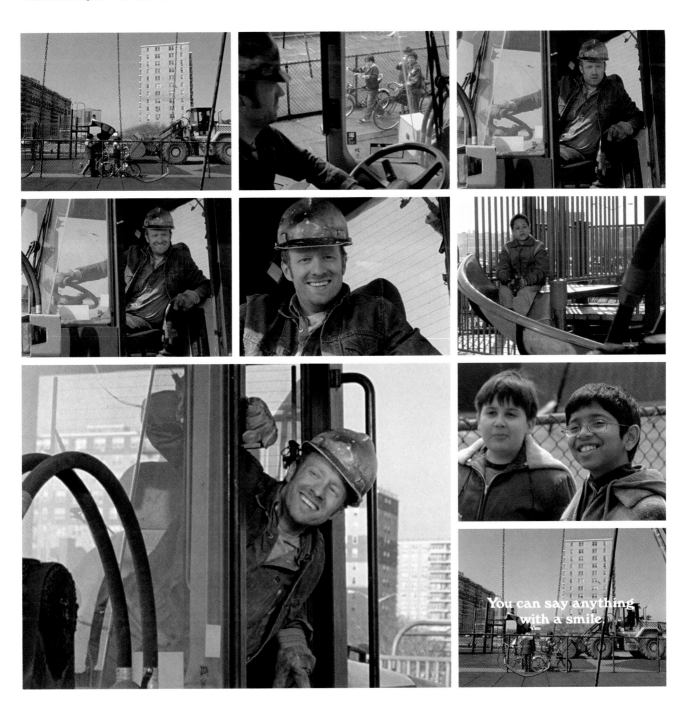

TITLE: Plasticine. **CLIENT:** ICI. **PRODUCT:** Dulux Paint. **AGENCY:** Abbott Mead Vickers BBDO. **COUNTRY:** United Kingdom. **YEAR:** 2002. **CREATIVE DIRECTOR:** Peter Souter. **COPYWRITER:** Nick Worthington. **ART DIRECTOR:** Paul Brazier. **PRODUCTION COMPANY:** Outsider. **PRODUCER:** Jason Kemp. **DIRECTOR:** Paul Gay. **AWARDS:** Cannes Lions (Shortlist).

An animation opens with three colored plasticine figures enjoying a cup of tea in their house. The camera pulls back showing it is a children's model set. A teacher walks past carrying her books. She turns and stops, then pulls off the red figure's head. The two plasticine figures try to model a new head for their friend, while the teacher is seen painting her walls in the plasticine red. "You find the color, we'll match it." /// In einer Animation genießen drei farbige Figuren aus Knetmasse in ihrem Haus eine Tasse Tee. Die Kamera zoomt heraus und zeigt, dass es sich um ein Modellhaus in einer Schule handelt. Eine Lehrerin geht vorbei. Sie bleibt stehen, dreht sich um und zieht der roten Figur den Kopf ab. Die beiden anderen Figuren versuchen, ihrem Freund einen neuen Kopf zu modellieren, während die Lehrerin zu sehen ist, wie sie ihre Wände in dem Rot-Ton der Knetmasse streicht. „Sie finden die Farbe, wir passen sie an." /// Ce petit film d'animation commence par trois figurines en plasticine qui boivent une tasse de thé dans leur maison. La caméra recule, et l'on voit qu'il s'agit d'un décor en miniature pour enfants. Une institutrice qui porte des livres passe à côté. Elle se retourne, s'arrête, puis arrache la tête de la figurine rouge. Les deux autres figurines essaient de faire une nouvelle tête pour leur amie, et l'on voit l'institutrice peignant ses murs de la même couleur rouge que celle de la figurine dont elle avait arraché la tête. « Trouvez la couleur, nous la reproduirons. »

TITLE: Yard Sale. **CLIENT:** Energizer Canada. **PRODUCT:** Energizer MAX Batteries. **AGENCY:** DDB Canada. **COUNTRY:** Canada. **YEAR:** 2004. **CREATIVE DIRECTOR:** Neil McOstrich. **COPYWRITER:** Neil McOstrich, Andrew Simon. **ART DIRECTOR:** William Hammond, Marketa Krivy. **PRODUCTION COMPANY:** Untitled. **PRODUCER:** James Davis. **DIRECTOR:** Curtis Wehfritz. **AWARDS:** Cannes Lions (Shortlist).

The power of Energizer Max batteries is demonstrated in this funny spot. A young skateboarder with headphones stops by a yard sale and buys a little doll figurine. He pays the old lady and skates off. As he turns the corner of the street, he pulls out the Energizer batteries and throws the doll into the bush. /// Die Kraft von Energizer Max-Batterien wird in diesem lustigen Werbespot gezeigt. Ein junger Skateboarder mit Kopfhörern hält bei einem Garagenflohmarkt an und kauft eine kleine Puppe. Er gibt der alten Dame den Kaufpreis und rollt davon. Hinter der nächsten Straßenecke nimmt er die Energizer-Batterien heraus und wirft die Puppe beiseite. /// Ce spot hilarant montre l'efficacité des piles Energizer Max. Un jeune skateboarder qui porte un casque à écouteurs s'arrête devant quelqu'un qui vend de la brocante et achète une petite figurine. Il paie la vieille dame et s'en va en skateboard. Dès qu'il a passé le coin de la rue, il retire les piles Energizer de la figurine et la jette dans un buisson.

TITLE: Sticky. / Melons. CLIENT: Electrolux. PRODUCT: Electrolux Liberation Fridges. AGENCY: Bartle Bogle Hegarty. COUNTRY: United Kingdom. YEAR: 2001. CREATIVE DIRECTOR: John O'Keeffe. COPYWRITER: Alex Grieve. ART DIRECTOR: Adrian Rossi. PRODUCTION COMPANY: Godman. PRODUCER: Philippa Thomas. DIRECTOR: Kevin Thomas. AWARDS: Cannes Lions (Shortlist).

The scene is an empty supermarket with fully stocked shelves. A solitary water melon rolls across an aisle. A second melon clatters down the aisle. The shot cuts to show two store workers playing bowls with a lemon as the jack. The tagline "Make fewer trips to the supermarket" appears. Electrolux fridges keep foods fresher for longer. /// Der Werbespot zeigt einen leeren Supermarkt mit vollen Regalen. Eine einzelne Wassermelone rollt einen Gang entlang. Eine zweite Wassermelone kullert hinterher. Die Kameraeinstellung zeigt zwei Mitarbeiter des Supermarktes, die Bowling mit einer Zitrone als Ziel spielen. Die Worte „Gehen Sie nicht so oft in den Supermarkt" erscheinen. Na klar: Electrolux-Kühlschränke halten Nahrungsmittel länger frisch. /// L'action se déroule dans un supermarché vide, avec les rayons débordants de provisions. Une pastèque solitaire roule dans une allée. Une deuxième pastèque fait de même. La caméra montre que deux employés du supermarché sont en train de jouer aux boules, avec un citron qui fait office de cochonnet. La phrase « Allez moins souvent au supermarché » apparaît. Les réfrigérateurs Electrolux conservent les aliments plus longtemps.

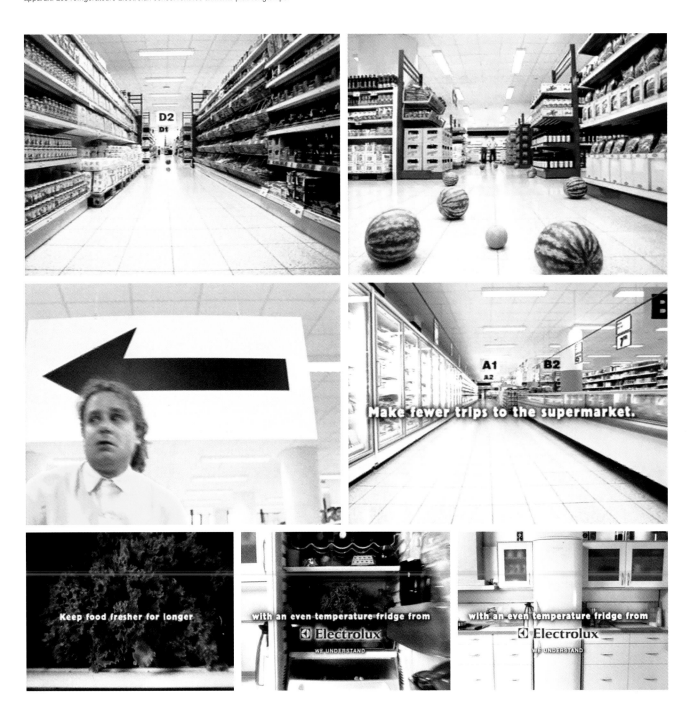

Our empty supermarket workers amuse themselves by sticking tape to their faces in the shape of beards, moustaches and armpit hair. Electrolux's "even temperature refrigerators keep food fresher for longer, so you don't have to visit the supermarket too often." /// Unsere Mitarbeiter im leeren Supermarkt vergnügen sich damit, sich gegenseitig Klebeband in Form von Kinnbärten, Schnauzbärten und Achselhaaren anzukleben. Der Slogan von Electrolux: „Gleichmäßig kühlende Kühlschränke halten Nahrungsmittel länger frisch, und Sie brauchen nicht so oft zum Supermarkt." /// Les employés du supermarché vide s'occupent en se faisant des barbes, des moustaches ou des poils sous les bras avec du ruban adhésif. « Les réfrigérateurs à température constante d'Electrolux conservent les aliments plus longtemps, pour que vous n'ayez pas besoin d'aller au supermarché trop souvent. »

TITLE: Bus. CLIENT: Pidilite Industries. PRODUCT: Fevicol Adhesive. AGENCY: Ogilvy & Mather. COUNTRY: India. YEAR: 2002. CREATIVE DIRECTOR: Piyush Pandey. ART DIRECTOR: Arab Iqbal, Khai Meng Tham. PRODUCTION COMPANY: Highlight Films. DIRECTOR: Prasoon Pandey. AWARDS: Cannes Lions (Silver).

The scene is India. The camera pans out to reveal dozens of passengers hanging precariously onto the sides and roof of an old bus as it dips and bounces along a dusty track. The spot closes showing the bus driving off into the distance. The rear banner ad reads, "Fevicol – The Ultimate Adhesive." /// Der Werbespot spielt in Indien. Die Kamera zeigt Dutzende von Passagieren, die sich unsicher an den Seiten und auf dem Dach eines alten Busses festklammern, der eine staubige Straße entlang rumpelt. In der Schlussszene verschwindet der Bus in der Ferne. Das Werbeplakat am Heck des Busses lautet „Fevicol – der ultimative Haftkleber." /// L'action se déroule en Inde. Le mouvement de la caméra montre des dizaines de passagers qui s'accrochent aux flancs et sur le toit d'un vieux bus qui cahote sur une route poussiéreuse. Le spot se termine par une image du bus qui s'éloigne. À l'arrière, une bannière annonce : « Fevicol, l'adhésif suprême ».

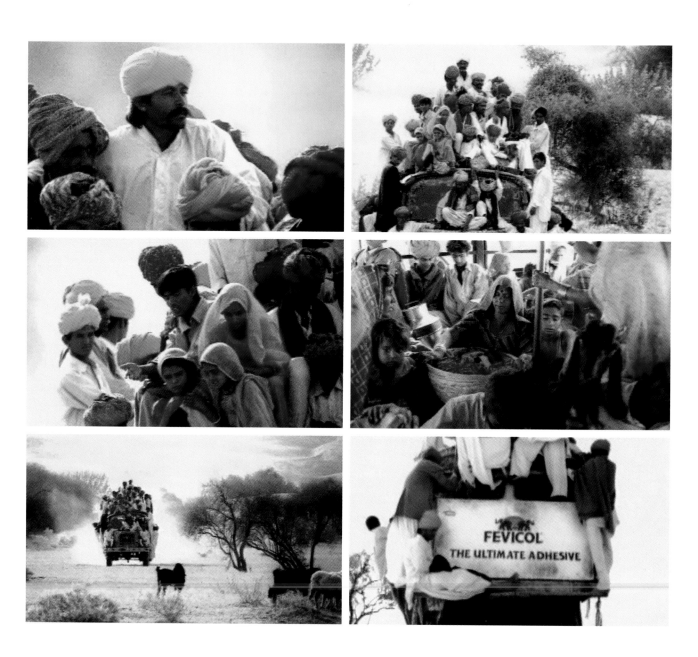

TITLE: Galerie de Portraits. CLIENT: Husqvarna. PRODUCT: Husqvarna Garden Machinery. AGENCY: Euro RSCG – Gregoire Blachere Huard & Roussel. COUNTRY: France. YEAR: 1998. CREATIVE DIRECTOR: Pascal Gregoire. COPYWRITER: Stephane Xiberras. ART DIRECTOR: Hughes Pinguet, Jean-Loup Seuret. PRODUCTION COMPANY: Les Telecreateurs. PRODUCER: Arnaud Moria. DIRECTOR: Frederic Rey, Bertrand Mandico.

This delightful animation shows some famous faces losing their beards and moustaches, including Karl Marx and Charlie Chaplin. Titles of Husqvarna's range of garden machinery appear; lawnmowers, weed cutters and chainsaws. The spot closes with a headless portrait of Louis XVI. /// Diese wunderbare Animation zeigt einige berühmte Gesichter, darunter auch Karl Marx und Charlie Chaplin, wie sie ihre Bärte und Schnurrbärte verlieren. Die Überschriften der Gartengerät-Reihe von Husqvarna erscheinen: Rasenmäher, Unkrautschneider und Kettensägen. Der Werbespot endet mit einem kopflosen Porträt von Ludwig XVI. /// Cette belle animation montre des personnages célèbres perdant leurs barbes et leurs moustaches, notamment Karl Marx et Charlie Chaplin. Les noms des appareils d'entretien du jardin de Husqvarna apparaissent à l'écran : tondeuses, motoculteurs et tronçonneuses. Le spot se termine par un portrait de Louis XVI, sans la tête.

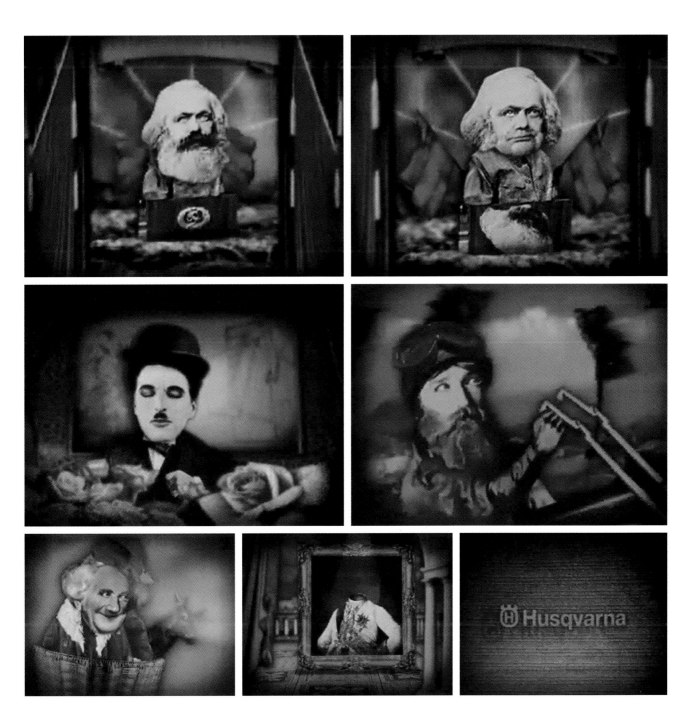

TITLE: BBQ. / Highrise. **CLIENT:** Reckitt Benckiser. **PRODUCT:** Harpic Toilet Bleach. **AGENCY:** Euro RSCG. **COUNTRY:** Australia. **YEAR:** 2007. **EXECUTIVE CREATIVE DIRECTOR:** Sound Reservoir. **ART DIRECTOR:** Katrina Mercer. **COPYWRITER:** Chris Johnson. **PRODUCER:** Susannah Phillips. **DIRECTOR:** Dave Klaiber.

A guy stumbles out of an outside toilet holding his blinded eyes. He stubs his toe on a beer cooler before burning himself on the grill. A voiceover warns, "Beware the brilliance of Harpic White & Shine…". The spot closes with the caption, "What does your loo say about you?" /// Ein Mann stolpert aus einem Klohäuschen und hält sich die Hände vor seine geblendeten Augen. Er stößt sich den Zeh an einer Kühlbox und verbrennt sich schließlich an einem Grillrost. Eine Hintergrundstimme warnt: „Vorsicht vor dem Glanz von Harpic White & Shine…". Der Werbespot endet mit dem Slogan „Was sagt dein Klo über dich?"/// Littéralement aveuglé par la blancheur des toilettes de jardin dont il sort, un homme trébuche contre une glacière avant de se brûler au grill du barbecue. Une voix off lance cet avertissement « Attention à l'éclat de Harpic White & Shine… ». Le spot s'achève sur cette légende : « Que disent vos toilettes de vous ? »

A man in a suit walks out of a WC blinded by a dazzling white light. He slips on a remote control before falling out of a high-rise balcony. /// Ein Mann in einem Anzug verlässt die Toilette, geblendet von einem grellen weißen Licht. Er rutscht auf einer Fernbedienung aus und fällt über den Balkon aus dem Hochhaus. /// Un homme en complet blanc sort des toilettes, aveuglé par une éclatante lumière blanche. Il glisse sur une télécommande avant de tomber d'un très haut balcon.

FEATURED ON THE DVD **TITLE:** Mosquito Killer. / Paving Stones. **CLIENT:** Hornbach. **PRODUCT:** Hornbach Home improvement superstores. **AGENCY:** Heimat. **COUNTRY:** Germany. **YEAR:** 2005. **CREATIVE DIRECTOR:** Guido Heffels, Jürgen Vossen. **COPYWRITER:** Hornbach Intern, Thomas Winkler. **ART DIRECTOR:** Tim Schneider. **PRODUCTION COMPANY:** Hermann Vaske's Emotional Network. **PRODUCER:** Hermann Vaske, Jennifer Feist. **DIRECTOR:** Hermann Vaske. **AWARDS:** Cannes Lions (Bronze).

An avant-garde slant to this ad shows Blixa Bargeld, lead singer of German industrial techno band Einstürzende Neubauten reciting a passage from the Hornbach DIY supplement. /// In einer avantgardistischen Kameraeinstellung zeigt dieser Werbespot Blixa Bargeld, Sänger der deutschen Industrial Techno-Band Einstürzende Neubauten, wie er eine Textpassage aus dem Katalog des Hornbach-Baumarkts vorträgt. /// Cette publicité avant-gardiste montre Blixa Bargeld, le chanteur du groupe allemand de techno industrielle Einstürzende Neubauten, récitant un passage du supplément de bricolage de Hornbach.

Blixa Bargeld,
leadsinger of the
industrial techno band
Collapsing New Buildings,
reads the DIY Catalogue
of the Hornbach
Home Improvement Superstore

blixa bargeld liest hornbach

mosquito killer with UV-bulb

quality tested

painless and hygienic

Hornbach

Home Improvement Superstore

German rock musician and former guitarist of the group Nick Cave and the Bad Seeds, Blixa Bargeld, reads a listing for paving stones in the Hornbach DIY catalogue. /// Hier wird wieder Blixa Bargeld gezeigt, früher Gitarrist bei Nick Cave and the Bad Seeds, der eine Liste über Pflastersteine aus dem Katalog des Hornbach-Baumarkt vorliest. /// On retrouve ici Blixa Bargeld, ancien guitariste de Nick Cave and the Bad Seeds, lisant une liste de dalles du catalogue de bricolage de Hornbach.

Blixa Bargeld,
leadsinger of the
industrial techno band
Collapsing New Buildings,
reads the DIY Catalogue
of the Hornbach
Home Improvement Superstore

FEATURED ON THE DVD **TITLE:** Boy. **CLIENT:** Sealy. **PRODUCT:** Sealy Mattress. **AGENCY:** Leo Burnett Mexico. **COUNTRY:** Mexico. **YEAR:** 2001. **CREATIVE DIRECTOR:** Tony Hidalgo. **COPYWRITER:** Simon Bross. **ART DIRECTOR:** Ruben Bross. **PRODUCTION COMPANY:** Garcia Bross y Asociados. **PRODUCER:** Simon Bross. **DIRECTOR:** Simon Bross **AWARDS:** Cannes Lions (Silver).

A split screen shows two identical bedrooms. On one side a boy bounces on his bed, labelled "Other". He then jumps across the screen and onto the "Sealy" mattress. He falls asleep immediately. /// Ein geteilter Bildschirm zeigt zwei identische Schlafzimmer. Auf der einen Seite springt ein Junge auf seinem Bett herum, das mit „Andere" beschriftet ist. Dann hüpft der Junge über den Bildschirm und auf die „Sealy" Matratze. Er schläft sofort ein. /// Un écran divisé en deux panneaux montre deux chambres identiques. D'un côté, un garçon saute sur son lit, identifié comme « Autre ». Puis il saute à travers l'écran et atterrit sur le matelas « Sealy ». Il s'endort immédiatement.

FEATURED ON THE DVD **TITLE:** Pit Stop. **CLIENT:** Atlas Copco Tools. **PRODUCT:** Milwaukee Eletric Drill. **AGENCY:** Leo Burnett Denmark. **COUNTRY:** Denmark. **YEAR:** 2004. **CREATIVE DIRECTOR:** Claus Møllebro. **ART DIRECTOR:** Claus Møllebro. **PRODUCTION COMPANY:** DNA Moving Pictures. **DIRECTOR:** Per Dreyer. **AWARDS:** Cannes Lions (Shortlist).

A race car pulls into the pit lane. Two mechanics begin to change the tyre. Suddenly the car flips over, proving that Milwaukee Heavy Duty power tools are tough enough for any job. /// Ein Rennwagen hält in der Boxengasse. Zwei Mechaniker beginnen, den Reifen zu wechseln. Plötzlich dreht sich der Wagen um sich selbst und liefert damit den Beweis, dass die Hochleistungswerkzeuge von Milwaukee für jede Arbeit stark genug sind. /// Une voiture de course se dirige vers le stand. Deux mécaniciens commencent à changer un pneu. Soudain, la voiture se retourne, démontrant que les outils professionnels de Milwaukee sont assez puissants pour n'importe quelle tâche.

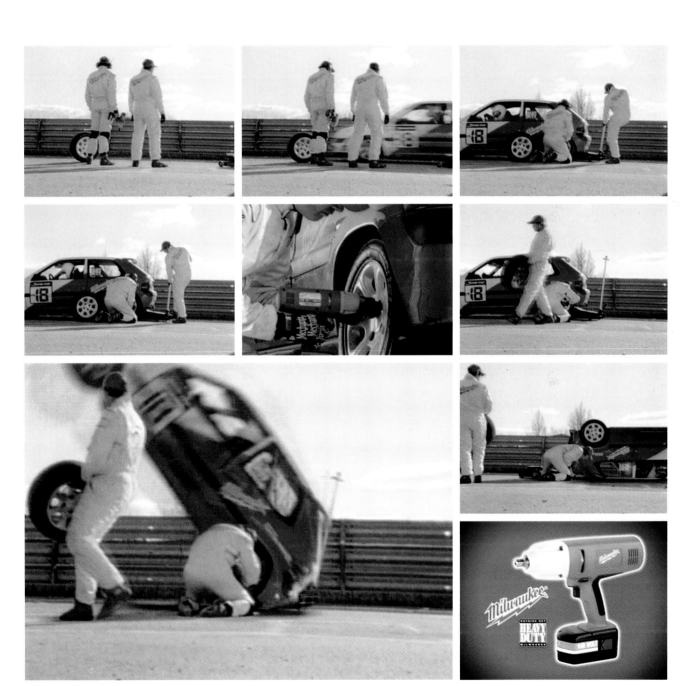

TITLE: Harvest Moon. / Project. CLIENT: Robert Bosch Tool Corporation. PRODUCT: Skil X-drive Drill. AGENCY: TAXI Canada. COUNTRY: Canada. YEAR: 2005. CREATIVE DIRECTOR: Zak Mroueh. COPYWRITER: Pete Breton. ART DIRECTOR: Dave Douglass. PRODUCTION COMPANY: Reginald Pike. PRODUCER: Jennifer Walker. DIRECTOR: The Perlorian Brothers.

Deep in the heart of Transylvania, an old village woman prepares for the Harvest Moon. She opens her Skil power tool case and describes its contents, including her Skil X Drive, power charger, garlic and chicken's feet. The voiceover says, "Just because vampires and werewolves are coming doesn't mean my home shouldn't look nice." /// Tief im Herzen von Transsylvanien bereitet sich eine alte Frau in einem Dorf auf das Erntefest vor. Sie öffnet ihren Elektro-Werkzeugkasten von Skil und beschreibt dessen Inhalt, darunter ihren Skil X Drive, den Power Charger, Knoblauch und Hühnerfüße. Aus dem Off kommen die Worte: „Nur weil Vampire und Werwölfe kommen, heißt das nicht, dass mein Zuhause nicht schön aussehen soll." /// Au fin fond de la Transylvanie, une vieille villageoise se prépare pour la pleine lune. Elle ouvre sa boîte à outils Skil et décrit son contenu : sa perceuse Skil X Drive et son chargeur, de l'ail et des pattes de poulet. La voix off déclare : « Ce n'est pas parce que les vampires et les loups-garous sont à l'affût que je vais négliger mon intérieur ».

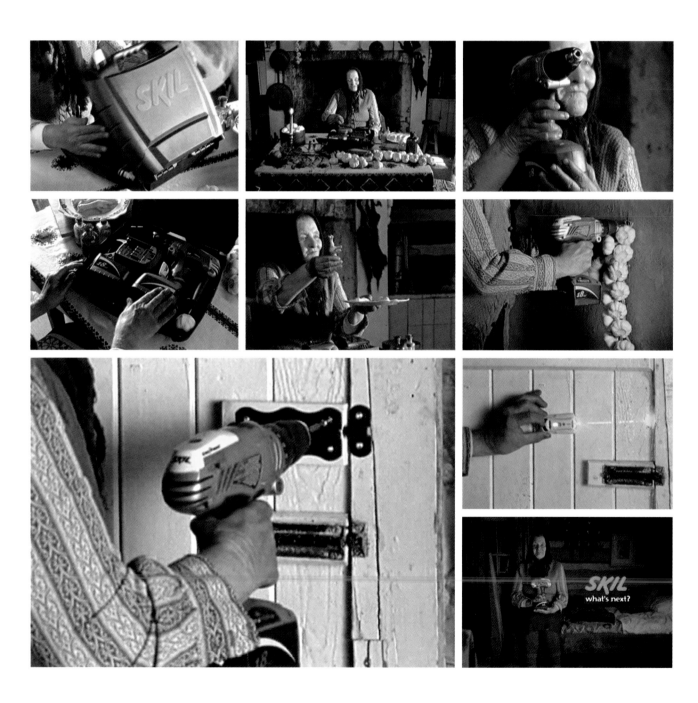

"Life on the farm is very busy," says an old village woman, "When I'm not fixing, I'm building." She explains how her Skil X Drive helps her with her projects. The spot shows her building a set of wings out of wood and cloth. It ends with her standing by the lake wearing her wings. /// „Das Leben auf einem Bauernhof ist voller Arbeit", sagt die alte Bauersfrau. „Wenn ich nichts repariere, dann baue ich was zusammen." Sie erklärt, wie ihr der Skil X Drive bei ihren Projekten hilft. Der Werbespot zeigt sie beim Anfertigen eines Flügelpaares aus Holz und Stoff. In der Schlussszene steht sie am See und trägt ihre Flügel. /// « On est toujours occupé, dans une ferme », déclare une vieille villageoise. « Quand je ne suis pas en train de réparer quelque chose, je construis autre chose. » Elle explique que sa perceuse Skil X Drive lui est très utile pour ses projets. Le spot la montre en train de construire des ailes avec du bois et du tissu. La dernière image la montre portant ses ailes au bord d'un lac.

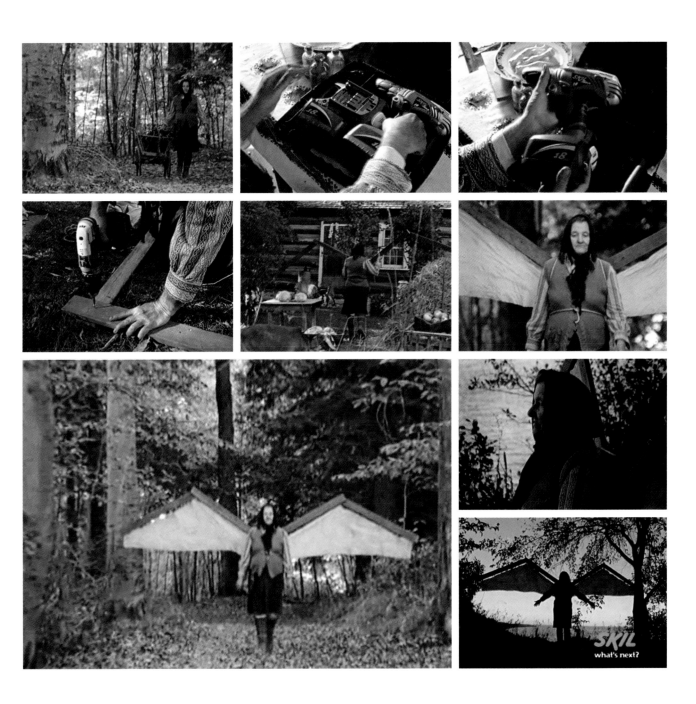

TITLE: Milk 1. / Milk 3. **CLIENT:** Newell Rubbermaid Group. **PRODUCT:** Reynolds Pens. **AGENCY:** BBDO Bangkok. **COUNTRY:** Thailand. **YEAR:** 2003. **CREATIVE DIRECTOR:** Suthisak Sucharittanonta. **COPYWRITER:** Kitti Chaiyaporn, Suthisak Sucharittanonta, Rudeewan Tohtong. **ART DIRECTOR:** Kitti Chaiyaporn, Nirun Summalertphun. **PRODUCTION COMPANY:** Phenomena. **DIRECTOR:** Thanonchai Sornsrivichai.

An angry husband is sitting at the kitchen table writing. He touches his empty glass and shouts to his wife, "Where's my milk?" The wife brings him a can of milk. The husband stabs it open with his pen and lets it pour into the glass. The spot ends with a pen on the screen and the slogan, "As tough as life – Reynolds." /// Ein aufgebrachter Ehemann sitzt am Küchentisch und schreibt. Er greift nach seinem leeren Glas und schreit seine Frau an: „Wo ist meine Milch?" Die Ehefrau bringt ihm eine Dose Milch. Der Ehemann öffnet die Dose, indem er mit seinem Stift hineinsticht, und lässt die Milch ins Glas fließen. Die Schlussszene zeigt auf dem Bildschirm einen Stift und den Slogan „So hart wie das Leben – Reynolds". /// Un mari mécontent écrit, assis à la table de la cuisine. Il touche son verre vide et crie à sa femme : « Où est mon lait ? » Elle lui apporte une boîte de lait. Pour l'ouvrir, il la poinçonne avec son stylo, et la laisse se vider dans le verre. Le spot se termine par l'image d'un stylo et le slogan : « Dur comme la vie – Reynolds ».

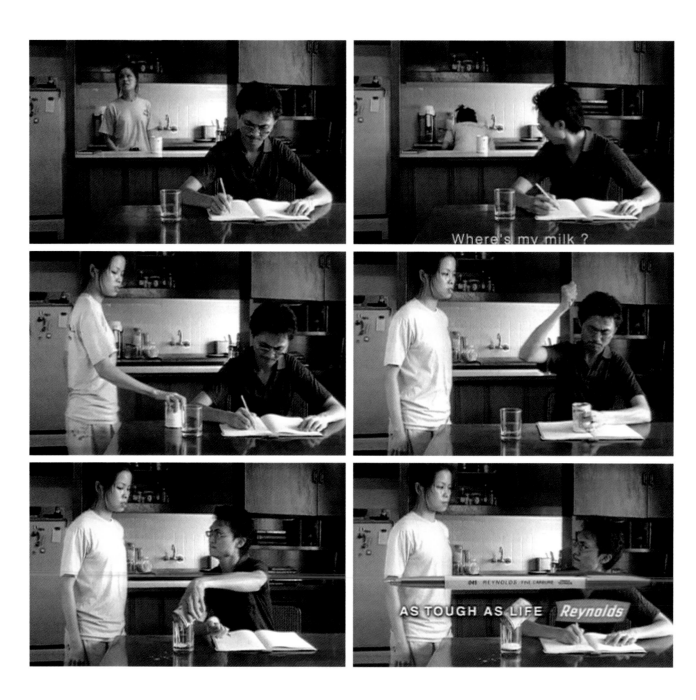

Once again, the angry husband shouts at his wife to bring him milk. She slams the can on the table. He tries to pierce it with his pen but isn't successful. A big red circle appears on screen with the words, "Beware of Imitations." The wife puts another can on the table. This time the husband pierces the lid and the milk streams into the air. "This is the true one." /// Wieder schreit der aufgebrachte Ehemann seine Frau an, sie solle ihm Milch bringen. Sie knallt die Milchdose auf den Tisch. Er versucht, die Dose mit seinem Stift zu durchstechen, doch er hat keinen Erfolg. Auf dem Bildschirm erscheint ein großer roter Kreis mit den Worten „Vorsicht vor Imitationen." Die Ehefrau stellt ihm eine andere Milchpackung auf den Tisch. Dieses Mal durchsticht der Ehemann den Deckel, und die Milch schießt in die Luft. „Das ist der echte Stift." /// Encore une fois, le mari mécontent crie à sa femme de lui apporter du lait. Elle abat violemment la boîte sur la table. Il essaie de la percer avec son stylo, mais n'y arrive pas. Un grand cercle rouge apparaît à l'écran avec les mots « Méfiez-vous des imitations ». La femme pose une autre boîte de lait sur la table. Cette fois le mari perce le couvercle, et le lait jaillit. « C'est le bon ».

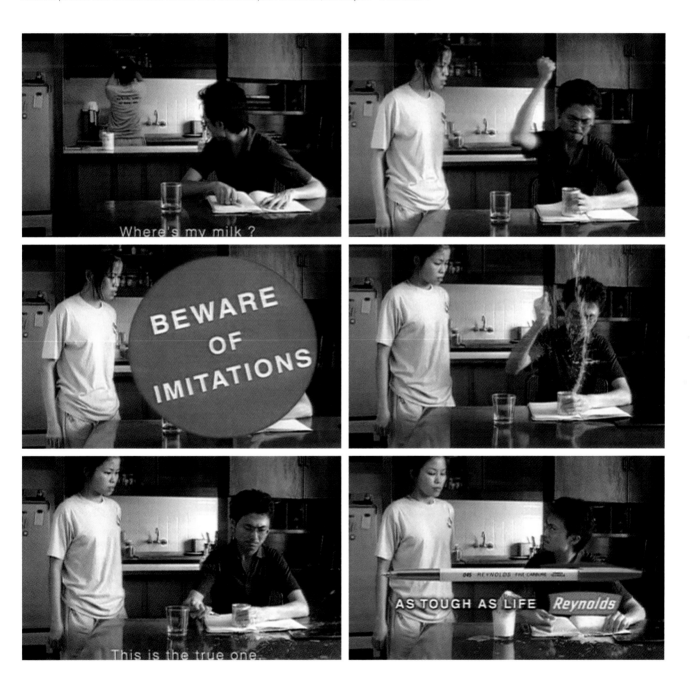

FEATURED ON THE DVD **TITLE:** Gecko. / Cockroach. **CLIENT:** Sylvania. **PRODUCT:** Sylvania Light Bulb. **AGENCY:** Saatchi & Saatchi Thailand. **COUNTRY:** Thailand. **YEAR:** 2004. **CREATIVE DIRECTOR:** Jureeporn Thaidumrong. **COPYWRITER:** Kittinan Sawasdee, Jureeporn Thaidumrong. **ART DIRECTOR:** Supon Khaotong. **PRODUCTION COMPANY:** Phenomena. **PRODUCER:** Piyawan Mungkung. **DIRECTOR:** Thanonchai Sornsriwichai.

A young lady is taking a bath. A Gecko on the wall calls out to her. It is a reincarnation of her husband. The widow starts screaming and throwing things at the lizard. The spot closes showing a box of Sylvania light bulbs – an important investment to avoid being born a lesser being. /// Eine junge Frau nimmt ein Bad. Ein Gecko an der Wand spricht sie an – er ist ihr wiedergeborener Ehemann. Die Witwe beginnt, den Gecko anzuschreien und Gegenstände nach ihm zu werfen. Die Schlussszene des Werbespots zeigt eine Packung mit Sylvania-Glühbirnen – eine wichtige Investition, um zu vermeiden, als niedrigere Lebensform wiedergeboren zu werden. /// Une jeune femme prend un bain. Un gecko qui se trouve sur le mur l'appelle. Il s'agit de son mari, réincarné en gecko. La veuve commence à crier et à lui jeter des objets. Le spot se termine par l'image d'une boîte d'ampoules Sylvania, un investissement essentiel pour éviter de se réincarner en une forme de vie inférieure.

Two cockroaches are having an argument. A female yells at a male and starts chasing him away. The male starts shouting back at her. When she realises she's not a human but a cockroach she starts screaming more. The moral of the ad is that to avoid being a lesser being is to buy Sylvania light bulbs. /// Zwei Kakerlaken streiten sich. Eine weibliche Kakerlake schreit eine männliche Kakerlake an und versucht, sie fortzujagen. Das Männchen brüllt zurück. Als das Weibchen erkennt, dass sie kein Mensch, sondern eine Kakerlake ist, schreit sie noch lauter. Die Moral dieses Werbespots lautet: Kaufe Sylvania-Glühbirnen, dann besteht keine Gefahr, als niedrigere Lebensform wiedergeboren zu werden. /// Deux cafards se disputent. La femelle crie après son mâle et commence à le chasser. Le mâle lui répond en criant. Lorsqu'elle réalise qu'elle n'est pas une humaine, elle se met à crier encore plus. La morale de cette publicité est que, pour éviter de se réincarner en une forme de vie inférieure, il faut acheter des ampoules Sylvania.

FEATURED ON THE DVD TITLE: Walk. **CLIENT:** Sylvania. **PRODUCT:** Sylvania Mini-Lynx Spiral Light. **AGENCY:** Saatchi & Saatchi Thailand. **COUNTRY:** Thailand. **YEAR:** 2005. **CREATIVE DIRECTOR:** Jureeporn Thaidumrong. **COPYWRITER:** Wiparat Nantananontchai. **ART DIRECTOR:** Thana Rittirajcomporn, Tawatchai Suknipitapong. **PRODUCTION COMPANY:** Matching Studio. **PRODUCER:** Surayut Sritrakul. **DIRECTOR:** Suthon Petchsuwan.

A stereo blasts out techno music in an apartment. Suddenly the neighbours start shouting and banging on the wall. A teenage male walks across the room and switches the map off. The neighbours shout "Thank You!" /// In einem Apartment dröhnt Techno-Musik aus einer Stereoanlage. Plötzlich beginnen die Nachbarn zu rufen und an die Wand zu klopfen. Ein Teenager geht durch den Raum und schaltet die Lampe aus. Die Nachbarn rufen „Danke!" /// Dans un appartement, de la musique techno joue à plein tube sur la stéréo. Soudain, les voisins se mettent à crier et à marteler sur le mur. Un adolescent traverse la pièce et éteint la lampe. Les voisins crient « Merci ! »

TITLE: Red. **CLIENT:** Taubmans. **PRODUCT:** Taubmans Paint. **AGENCY:** Y&R Sydney. **COUNTRY:** Australia. **YEAR:** 2001. **CREATIVE DIRECTOR:** Shaun Branagan. **COPYWRITER:** Shaun Branagan. **ART DIRECTOR:** Pete Buckley. **PRODUCTION COMPANY:** Blue Sky Films. **PRODUCER:** Sandy Macauley. **DIRECTOR:** Jason Wingrove.

A young couple walk into their bedroom while the decorators are painting the walls red. Lust ridden by the rich colour the two fall on the bed and start making love. The voiceover says, "Colours can change the way you feel." The two old painters smile at each other and hold hands. /// Ein junges Paar geht in das Schlafzimmer, während Maler dort die Wände rot streichen. Durch die satte Wandfarbe lustvoll erregt, fallen die beiden aufs Bett und beginnen, sich zu lieben. Der Sprecher sagt: „Farben können Ihre Gefühle verändern." Die beiden alten Anstreicher lächeln und schütteln sich die Hände. /// Un jeune couple entre dans la chambre pendant que les décorateurs sont en train de peindre les murs en rouge. La beauté de la couleur leur cause une attaque de désir sexuel. Ils se laissent tomber sur le lit et commencent à faire l'amour. Commentaire de la voix off : « Les couleurs peuvent influencer les sentiments ». Les deux vieux peintres se sourient et se tiennent la main.

TITLE: Dog. CLIENT: Tefal. PRODUCT: Tefal Cookware. AGENCY: Publicis Conseil. COUNTRY: France. YEAR: 2006. CREATIVE DIRECTOR: Olivier Altmann. COPYWRITER: Bruno Delhomme. ART DIRECTOR: Andrea Leupold. PRODUCTION COMPANY: Premiere Heure. PRODUCER: Jerôme Rucki. DIRECTOR: Emmanuel Bellegarde. AWARDS: Cannes Lions (Shortlist).

A man tries to cram a frying pan into one of his kitchen cupboards, already jammed with plates and pots. As he slams the door shut the pan handle goes through the wall and sticks out of a painting of a dog on the other side. A woman stops playing the piano and looks in surprise. At her side is the dog in the painting, which whimpers and glances at his tail. /// Ein Mann versucht, eine Pfanne in den Küchenschrank zu quetschen, der bereits zum Bersten voll mit Tellern und Töpfen ist. Als er die Tür zuschlägt, bricht der Pfannengriff durch die Wand und ragt auf der anderen Seite aus einem Gemälde mit einem Hund heraus. Eine Frau hört auf, Klavier zu spielen, und schaut überrascht auf. An ihrer Seite sitzt der Hund aus dem Gemälde, winselt und schaut auf seinen Schwanz. /// Un homme essaie de faire entrer une poêle dans l'un des placards de sa cuisine, déjà encombré de plats et de pots. Il claque la porte, et la poignée de la poêle traverse le mur et ressort à travers le portrait d'un chien accroché de l'autre côté. Dans la pièce, une femme qui jouait du piano s'arrête et lève les yeux, surprise. Le chien du portrait est à ses pieds. Il pousse un cri plaintif et regarde sa queue.

Short of space?

Tefal

Tefal
Ideas you can't live without.

www.tefal.com

TITLE: Panda. CLIENT: Trane Inc. PRODUCT: Trane Air Conditioning. AGENCY: TBWA\Thailand. COUNTRY: Thailand. YEAR: 2004. CREATIVE DIRECTOR: Unnop Chanpaibool. COPYWRITER: Kittikorn Kamolprempiya. ART DIRECTOR: Satit Jantawiwat. PRODUCTION COMPANY: Matching Studio. PRODUCER: Taweechai Ngampati. DIRECTOR: Suthon Petchsuwan. AWARDS: Cannes Lions (Shortlist).

Two pandas are seen playing in an indoor zoo. While the other sleeps, a man breaks out of his panda suit and tends to the Trane Pacific air conditioning unit. /// In einem Zoo sieht man zwei Pandabären beim Spielen in einem Innengehege. Während der eine schläft, schlüpft der andere Panda aus seinem Kostüm und streckt sich nach der Klimaanlage von Trane Pacific aus. /// Deux pandas sont en train de jouer dans un zoo couvert. Pendant que l'autre dort, un homme sort la tête de son costume de panda et procède à l'entretien du climatiseur Trane Pacific.

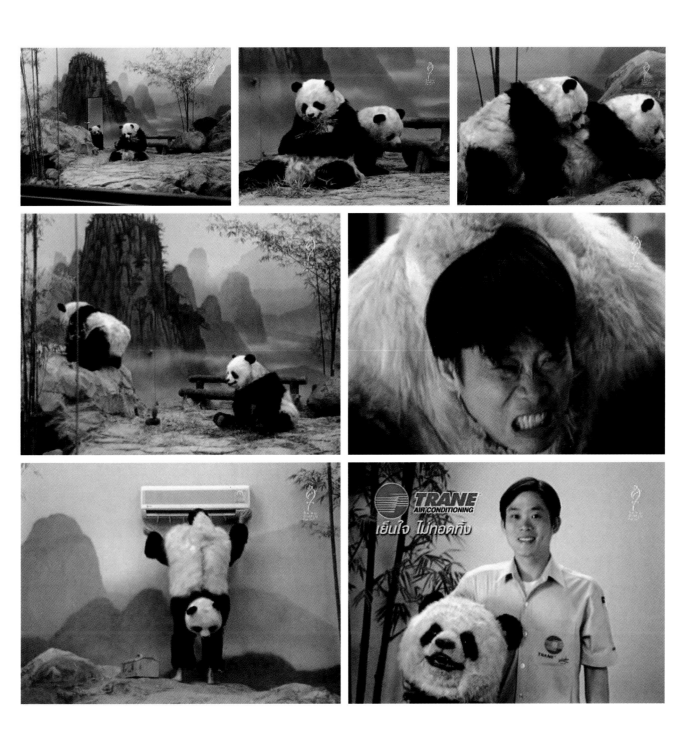

TITLE: Factory. CLIENT: Velvet. PRODUCT: Velvet Toilet Tissue. AGENCY: Fallon London. COUNTRY: United Kingdom. YEAR: 2004. CREATIVE DIRECTOR: Andy McLeod, Richard Flintham. COPYWRITER: Ed Edwards. ART DIRECTOR: Dave Masterman. PRODUCTION COMPANY: Epoch Films. PRODUCER: Rob Godbold. DIRECTOR: Stacy Wall. AWARDS: Cannes Lions (Bronze).

A factory scene shows workers in a variety of scenes demonstrating the ultimate softness of Velvet toilet tissues. They ride their bikes and jump off balconies into crates of Velvet. /// Der Werbespot zeigt in verschiedenen Szenen Fabrikarbeiter, wie sie die ultimative Weichheit von Velvet-Toilettenpapier demonstrieren. Sie fahren auf Fahrrädern oder springen von einem Balkon in Kisten voller Velvet. /// Dans un décor industriel, plusieurs scènes montrent la douceur extrême du papier toilette Velvet. Les travailleurs sautent en moto depuis les balcons et atterrissent sur des tas de Velvet.

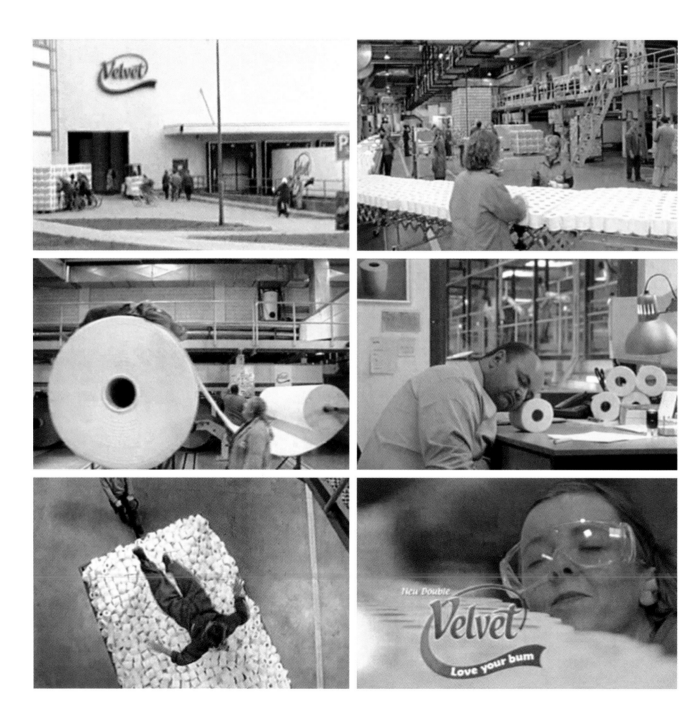

TITLE: Prison Visitor. **CLIENT:** Unilever. **PRODUCT:** Vim Cream Cleanser. **AGENCY:** Zig. **COUNTRY:** Canada. **YEAR:** 2004. **CREATIVE DIRECTOR:** Elspeth Lynn, Lorriane Tao. **COPYWRITER:** Aaron Starkman. **ART DIRECTOR:** Stephen Leps. **PRODUCTION COMPANY:** Reginald Pike. **PRODUCER:** Bridget Flynn. **DIRECTOR:** The Perlorian Brothers. **AWARDS:** Cannes Lions (Gold).

The spot opens with a close up of a young girl visiting her mother in prison. The two place their hands on the glass screen. The following shot reveals the mother is actually scrubbing the bath behind the shower screen. Vim's slogan appears, "Spend less time cleaning." /// Der Werbespot beginnt mit der Nahaufnahme eines Mädchens, das scheinbar seine Mutter im Gefängnis besucht. Die beiden legen ihre Hände auf die Glaswand zwischen ihnen. Die folgende Szene zeigt die Mutter, wie sie die Wanne hinter der gläsernen Duschabtrennung schrubbt. Vims Slogan erscheint: „Verbringen Sie nicht so viel Zeit mit Putzen." /// Le spot commence par le gros plan d'une fillette qui rend visite à sa mère en prison. Elles plaquent leurs mains sur la paroi en verre. Le plan suivant révèle qu'en fait la mère est en train de nettoyer la salle de bain, et qu'elle se trouve derrière la cloison de la douche. Le slogan de Vim apparaît : « Passez moins de temps à faire le ménage ».

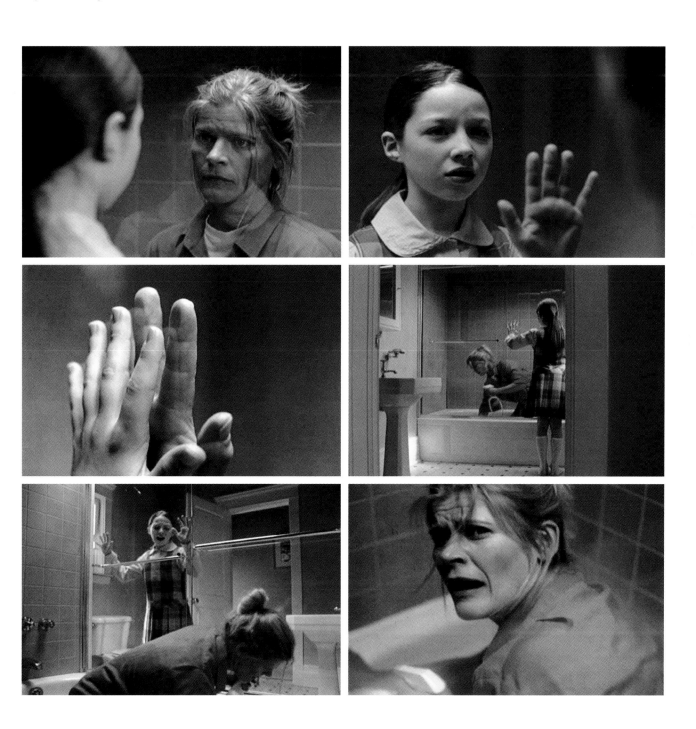

004

MISCELLANEOUS

TITLE: Kiki. **CLIENT:** Versele-Laga Premium Petfood. **PRODUCT:** Bento Cronen Light. **AGENCY:** LG&F. **COUNTRY:** Belgium. **YEAR:** 2006. **CREATIVE DIRECTOR:** Christophe Ghewy, Paul Wauters. **COPYWRITER:** Eric Piette. **ART DIRECTOR:** Benoit Hilson. **PRODUCTION COMPANY:** T42 Films. **PRODUCER:** Stephanie Deleuze. **DIRECTOR:** Geoffroy Enthoven. **AWARDS:** Cannes Lions (Bronze).

An old lady stands on the beach calling to her dog, "Kiki? Kiki?" With no response she presses the wind button on her lead handle. Suddenly her small dog is yanked back and disappears into the handle. Only the fluffy tail shows. The ad ends with a dog bowl and a bag of Bento Kronen Light on the beach. /// Eine alte Dame steht am Strand und ruft ihren Hund. Da keine Reaktion erfolgt, drückt sie auf den Knopf zum Aufspulen der Hundeleine. Plötzlich wird ihr kleiner Hund zurückgezerrt und verschwindet im Griff. Nur der flauschige Schwanz ist noch zu sehen. Der Werbespot endet mit einem Hundenapf und einer Packung Bento Kronen Light auf dem Strand. /// Une vieille dame est sur la plage, et appelle son chien : « Kiki ? Kiki ? » Le chien ne réagissant pas, elle appuie sur le bouton qui rembobine la laisse. Le petit chien est entraîné avec une telle force qu'il disparaît dans la poignée de la laisse. On n'en voit plus que la queue. La dernière image est un bol pour chien et un sac de Bento Kronen Light sur la plage.

FEATURED ON THE DVD **TITLE:** Prank Call. **CLIENT:** Golden Star Gifts & Stationery. **PRODUCT:** BIC Permanent Marker. **AGENCY:** McCann Erickson Singapore. **COUNTRY:** Singapore. **YEAR:** 2005. **CREATIVE DIRECTOR:** Ng Tian It. **COPYWRITER:** Gayle Lim. **ART DIRECTOR:** Teng Run Run. **PRODUCTION COMPANY:** Rushes Network. **PRODUCER:** Susan Tan. **DIRECTOR:** Melvin Mak. **AWARDS:** Cannes Lions (Silver).

An old woman receives a phone call while having her tea at home. She slowly shuffles to answer it and is disgusted to hear it is a prank call. A flashback reveals why she has been receiving calls for so many years. The final shot reveals a Bic Permanent Marker, "Since 1945." /// Eine alte Dame erhält einen Anruf, während sie zu Hause Tee trinkt. Sie schlurft langsam zum Telefon, um das Gespräch anzunehmen, und ist empört, dass es sich wieder um einen Scherzanruf handelt. Eine Rückblende enthüllt, warum sie schon seit so vielen Jahren diese Anrufe erhält. Die Schlussszene zeigt einen Bic Permanent Marker: „Seit 1945." /// Une vieille femme reçoit un coup de téléphone pendant qu'elle est en train de prendre le thé chez elle. Elle va répondre en marchant avec difficulté, et est écœurée de découvrir qu'il s'agit d'une farce. Un flash-back explique pourquoi elle reçoit ce genre d'appels depuis tant d'années. La dernière image montre un feutre Bic Permanent, « Depuis 1945 ».

TITLE: Shower. CLIENT: EPA. SERVICE: EPA – Pan-American School of Art & Design. AGENCY: Almap BBDO. COUNTRY: Brazil. YEAR: 2008. CREATIVE DIRECTOR: Luis Sanches. COPYWRITER/ART DIRECTOR: Gustavo Sarkis, Wilson Mateos, Marcos Medeiros. PRODUCTION COMPANY: Lux Filmes. PRODUCER: Lux Filmes. DIRECTOR: Beto Salatini.

The spot follows the quirky exploits of a young guy who cannot hold down a normal job as he can only come up with ideas in the shower. Eventually he discovers art college and gives up showering completely, to the suffering of his classmates. The ad closes with the logo for the Pan-American School of Art & Design. /// Der Werbespot folgt den schrulligen Heldentaten eines jungen Mannes, der keiner normalen Arbeit nachgehen kann, da er nur unter der Dusche gute Ideen hat. Schließlich entdeckt er die Kunsthochschule und duscht überhaupt nicht mehr, zum Leidwesen seiner Mitstudenten. Der Werbespot endet mit dem Logo der Pan-American School of Art & Design. /// Le spot suit les exploits inattendus d'un jeune garçon qui ne peut s'astreindre à un travail normal car il n'a d'idées que sous la douche. Ayant découvert par hasard les beaux-arts, il abandonne les douches pour toujours, au grand désespoir de ses camarades de classe. La pub se conclut sur le logo de la Pan-American School of Art & Design.

TITLE: City Lights. **CLIENT:** Perfetti Van Melle. **PRODUCT:** Happydent White Chewing. **AGENCY:** McCann Erickson Mumbai. **COUNTRY:** India. **YEAR:** 2008. **CREATIVE DIRECTOR:** Prasoon Joshi. **PRODUCTION COMPANY:** Equinox Films. **DIRECTOR:** Ram Madhvani.

A young boy races to work at the Sultan's palace. He arrives at nightfall and positions himself at the centre of a human chandelier. He quickly sticks a piece of gum into his mouth and a bright light shines from his teeth. The spot ends showing the Happydent brand and the tagline, "The teeth whitening gum." /// Ein Junge eilt zur Arbeit in den Palast des Sultans. Er kommt bei Einbruch der Dunkelheit an und nimmt seinen Platz in der Mitte eines aus Menschen gebildeten Kronleuchters ein. Er steckt sich schnell ein Kaubonbon in den Mund, und ein helles Licht erstrahlt von seinen Zähnen. Der Werbespot endet mit dem Markenzeichen von Happydent und dem Slogan „Das Zahnweiß-Kaubonbon." /// Un jeune garçon se hâte sur le chemin du palais du Sultan, où il travaille. Il y arrive à la tombée du jour et prend place au centre d'un chandelier humain. Il se colle rapidement une dragée de chewing-gum dans la bouche et ses dents s'illuminent d'un éclatant sourire. Le spot s'achève sur la marque Happydent, avec cette accroche « Le chewing-gum qui blanchit les dents. »

FEATURED ON THE DVD **TITLE:** "Know Where You Stand" – Berlin / Normandy. **CLIENT:** A&E Television Networks. **SERVICE:** The History Channel. **AGENCY:** Ground Zero, Los Angeles. **COUNTRY:** USA. **YEAR:** 2004. **EXECUTIVE CREATIVE DIRECTOR:** Court Crandall. **COPYWRITER:** Tom O'Connor. **ART DIRECTOR:** Jeff Lable. **PRODUCTION COMPANY:** A52. **EXECUTIVE PRODUCER:** Darcy Parsons. **PRODUCER:** Jacques Arnaud, Serge Fournier (Franco-American Films – Normandy), Kirsten Sohrauer (Shorts Prod. Film & Video – Berlin), Louise Simon (Filmchicks Inc. – USA).

This poignant commercial shows a man walking across a Berlin street talking into his mobile phone. Faded images and sounds of the Berlin wall being knocked down seamlessly appear in the background. The title "Know where you stand" appears, followed by The History Channel logo. /// Dieser ergreifende Werbespot zeigt einen Mann, der eine Straße in Berlin entlang läuft und in sein Handy spricht. Verblasste Bilder und Geräusche vom Abbruch der Berliner Mauer sind im Hintergrund zu sehen und zu hören. Die Überschrift „Wissen, wo man steht" erscheint, gefolgt vom History-Channel-Logo. /// Cette publicité très émouvante montre un homme qui marche dans une rue de Berlin tout en parlant au téléphone. Des images et des sons de la chute du mur de Berlin se superposent à l'arrière-plan actuel. Le slogan « Sachez où vous vous trouvez » apparaît, suivi du logo de History Channel.

This moving spot for The History Channel's "Know where you stand" campaign shows a mother and daughter digging for shells on a Normandy beach. Original footage and sounds of the D-Day landings are overlaid to fit the exact location. /// Dieser Werbespot für die Kampagne „Wissen, wo man steht" des History Channels zeigt, wie eine Mutter und ihre Tochter an einem Strand in der Normandie nach Muscheln suchen. Originales Filmmaterial und Geräusche der Landungen der Alliierten überlagern den Spot, um den Standort zu verdeutlichen. /// Ce spot poignant pour la campagne « Sachez où vous vous trouvez » de History Channel montre une mère et une fille qui cherchent des coquillages sur une plage en Normandie. Des séquences vidéo et audio du débarquement se superposent à l'endroit où elles se trouvent.

FEATURED ON THE DVD TITLE: "Know Where You Stand" – Hindenburg. CLIENT: A&E Television Networks. SERVICE: The History Channel. AGENCY: Ground Zero, Los Angeles. COUNTRY: USA. YEAR: 2004. EXECUTIVE CREATIVE DIRECTOR: Court Crandall. COPYWRITER: Tom O'Connor. ART DIRECTOR: Jeff Lable. PRODUCTION COMPANY: A52. EXECUTIVE PRODUCER: Darcy Parsons. PRODUCER: Jacques Arnaud, Serge Fournier (Franco-American Films – Normandy), Kirsten Sohrauer (Shorts Prod. Film & Video – Berlin), Louise Simon (Filmchicks Inc. – USA).

A man walks his dog across a field. Newsreel footage and sound recordings of the Hindenburg Airship disaster appear around him in the original location of the crash. /// Ein Mann führt seinen Hund über ein Feld. Wochenschau-Filmmaterial und Tonaufnahmen der Katastrophe, als das Luftschiff Hindenburg abstürzte, erscheinen um ihn herum – hier am Originalschauplatz des Unglücks. /// Un homme promène son chien dans un champ. Des séquences filmées à l'époque pour les informations apparaissent autour de lui et montrent la catastrophe du dirigeable Hindenburg, à l'endroit exact de l'accident.

FEATURED ON THE DVD TITLE: Words. CLIENT: National Geographic. SERVICE: National Geographic Channel. AGENCY: Devilfish. COUNTRY: United Kingdom. YEAR: 2006. CREATIVE DIRECTOR: Richard Holman. COPYWRITER: Alan & Sandy Cinnamond. DIRECTOR: Chris Turner, Sam Tootal, Samuel Christopher. AWARDS: Cannes Lions (Bronze).

National Geographic's "Think Again" campaign cleverly uses words to stimulate the target audience. The spot shows a close-up of a computer screen. A keyboard can be heard clicking as words appear on the screen with letters in completely the wrong order. /// Die Kampagne „Think Again" von National Geographic benutzt geschickt Wörter, um das Interesse des Zielpublikums zu erwecken. Der Werbespot zeigt einen Bildschirm in Großaufnahme. Man hört das Klicken einer Tastatur, während auf dem Bildschirm Wörter erscheinen, deren Buchstaben völlig falsch angeordnet sind. /// La campagne « Think again » (Réfléchissez) de National Geographic fait une utilisation ingénieuse des mots pour stimuler son public cible. Le spot montre un écran d'ordinateur en gros plan. On entend le cliquetis du clavier, et des mots apparaissent à l'écran avec les lettres dans le mauvais ordre.

TITLE: Train. CLIENT: Norsk Hydro ASA. SERVICE: Hydro. AGENCY: DDB Oslo. COUNTRY: Norway. YEAR: 2008. COPYWRITER: Torbjørn Kvien Madsen. ART DIRECTOR: Martin R. Thorsen. PRODUCTION COMPANY: Motion Blur. PRODUCER: Richard Patterson. DIRECTOR: Roenberg.

A group of young kids appear to be welding a metal apparatus on a railway track. Finally they evacuate the track as a high-speed train approaches. Suddenly the train launches skyward on a metal loop the kids have created. The tagline fades up, "There are many engineers. We can't wait till they grow up." The ad ends showing the Hydro logo. /// Eine Gruppe Kinder erscheint, die eine metallene Vorrichtung auf Bahngleisen zusammenschweißen. Als sich ein Hochgeschwindigkeitszug nähert, verlassen die Kinder die Gleise. Plötzlich schießt der Zug himmelwärts – auf einem Looping aus Metall, den die Kinder gebaut haben. Der Slogan erscheint: „There are many young engineers. We can't wait till they grow up" (Es gibt viele Ingenieure. Wir können es kaum erwarten, bis sie erwachsen sind). Der Werbespot endet mit dem Logo von Hydro. /// Des enfants semblent être en train de souder un assemblage en métal sur une voie de chemin de fer. Ils évacuent les rails à l'approche d'un train qui arrive à grande vitesse. Soudain le train s'élance vers le ciel sur la boucle en métal que les enfants ont construite. Le slogan apparaît : « Il y a beaucoup d'ingénieurs. Nous avons hâte qu'ils grandissent. » Le spot se termine par le logo Hydro.

FEATURED ON THE DVD TITLE: Mother. / Child. CLIENT: L'Equipe. PRODUCT: L'Equipe Sports Newspaper. AGENCY: DDB Paris. COUNTRY: France. YEAR: 2005. CREATIVE DIRECTOR: Alexandre Hervé, Sylvain Thirache. COPYWRITER: Céline Landa. ART DIRECTOR: Benjamin Marchal. PRODUCTION COMPANY: Soixan7e Quin5e. PRODUCER: Greg Panteix. DIRECTOR: Jonathan Herman. AWARDS: Cannes Lions (Gold).

A husband returns home from work and sits on his living room sofa. Suddenly his wife comes in and shrieks in fright. The husband quickly picks up his copy of *L'Equipe's* sport pages. The wife calms down and remarks, "Oh honey, it's you!" The end slogan reads, "Everyday. Every Sport." /// Eine Ehemann kommt von der Arbeit nach Hause und setzt sich im Wohnzimmer aufs Sofa. Plötzlich kommt seine Frau herein und kreischt erschreckt auf. Der Ehemann nimmt schnell seine *L'Equipe*-Sportbeilage hoch. Die Frau beruhigt sich und sagt beiläufig: „Ach, du bist es, Schatz!" Der Schluss-Slogan lautet „Jeden Tag. Jeder Sport." /// Un mari rentre chez lui après le travail et s'assoit sur le canapé du salon. C'est alors que sa femme entre dans la pièce et hurle d'effroi. L'homme se dépêche de prendre les pages sportives de l'Équipe. La femme se calme aussitôt : « Ah, chéri, c'est toi ! » Le slogan s'affiche : « Tous les jours. Tous les sports. »

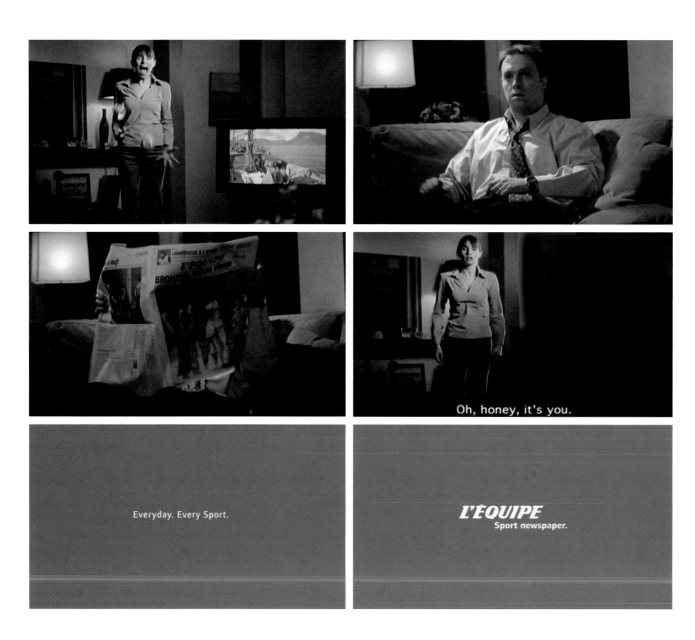

A man walks into his son's bedroom while he is sleeping. The son wakes up, turns around and recoils in horror. He starts screaming for his mother. Suddenly the father picks up his copy of *L'Equipe's* sport supplement. The son sighs with relief and says, "Oh, it's you dad." /// Ein Mann geht in das Schlafzimmer seines schlafenden Sohnes. Der Sohn wacht auf, dreht sich um und schreckt voller Entsetzen zurück. Er beginnt, nach seiner Mutter zu rufen. Plötzlich nimmt der Vater seine L'Equipe-Sportbeilage auf. Der Sohn seufzt erleichtert auf und sagt: „Oh, du bist es, Papa." /// Un homme entre dans la chambre de son fils endormi. L'enfant se réveille, se retourne et recule d'horreur. Il hurle et appelle sa mère. Le père se dépêche de faire mine de lire son exemplaire du journal sportif l'Équipe. L'enfant soupire de soulagement et dit : « Ah, papa, c'est toi ».

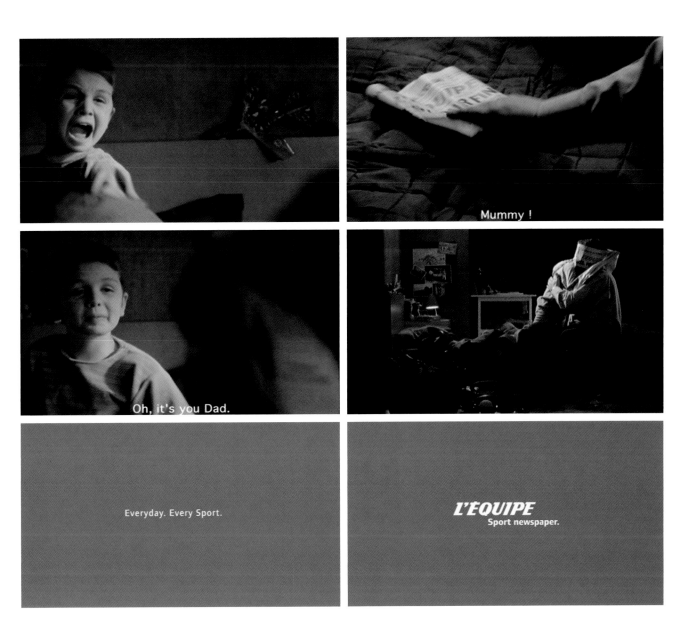

FEATURED ON THE DVD TITLE: Screams. / Bird. **CLIENT:** Parque de la Costa. **PRODUCT:** Parque de la Costa. **AGENCY:** Del Campo Nazca Saatchi & Saatchi. **COUNTRY:** Argentina. **YEAR:** 2003. **CREATIVE DIRECTOR:** Chanel Basualdo, Chavo D'emilio. **COPYWRITER:** Gastón Bigio. **ART DIRECTOR:** Jonathán Gurvit. **PRODUCTION COMPANY:** Nunchaku. **DIRECTOR:** Nicolás Kaacov. **AWARDS:** Cannes Lions (Gold).

The clip opens showing a rollercoaster attendant waiting for the carriages to arrive back to the platform. A crowd can be heard screaming in the background. The rollercoaster arrives empty. The next shot reveals the screaming crowd waiting to get in behind the turnstiles. Parque de la Costa's slogan closes the spot, "Boomerang, our new rollercoaster. Dare to ride it?" /// Der Werbeclip zeigt den Bediensteten einer Achterbahn, der auf die Rückkehr der Wagen an der Einstiegsrampe wartet. Im Hintergrund ist eine schreiende Menschenmenge zu hören. Die Achterbahn kommt leer an. In der nächsten Szene ist die schreiende Menschenmenge zu sehen, die darauf wartet, hinter das Drehkreuz zu gelangen. Der Spot endet mit dem Slogan von Parque de la Costa: „Boomerang, unsere neue Achterbahn. Trauen Sie sich?" /// Le spot s'ouvre sur l'image d'un employé du parc qui attend que les wagons des montagnes russes arrivent à la plateforme. On entend des gens qui hurlent. Les wagons arrivent vides. Le plan suivant révèle que les gens qui hurlent sont derrière les tourniquets, et attendent leur tour. Le slogan du Parque de la Costa conclut le spot : « Boomerang, nos nouvelles montagnes russes. Oserez-vous monter ? »

A young man lies having an operation in a hospital. As the surgeons work on him, a small bird suddenly flies out of his chest. The spot cuts to the man hours before. He's riding the Parque de la Costa's Boomerang rollercoaster, screaming with his mouth wide open. /// Ein junger Mann wird gerade im Krankenhaus operiert. Da fliegt plötzlich ein kleiner Vogel aus seiner Brust. Der Werbespot zeigt eine Rückblende, in dem der junge Mann einige Stunden zuvor zu sehen ist. Er fährt mit der Boomerang-Achterbahn im Parque de la Costa und schreit mit weit geöffnetem Mund. /// Un jeune homme est en train de subir une opération dans un hôpital. Pendant que les chirurgiens travaillent, un petit oiseau s'envole de son torse. Un flash-back nous ramène quelques heures plus tôt dans la vie du jeune homme. Il est dans un wagon des montagnes russes du Parque de la Costa, et crie la bouche grande ouverte.

TITLE: Kitchen. / Room. CLIENT: Photoespaña. SERVICE: PHE02 International Festival of Photography and Visual Arts. AGENCY: SCPF. COUNTRY: Spain. YEAR: 2003. CREATIVE DIRECTOR: Toni Segarra. COPYWRITER: Glauco Ciasca. ART DIRECTOR: Javier Donada. PRODUCTION COMPANY: Porlacara Productions. PRODUCER: Glauco Ciasca, Javier Donada, Bet Roig-Serra, Tanit Plana. AWARDS: Cannes Lions (Silver).

A woman walks into her kitchen and starts chopping vegetables. The camera angle is from her viewpoint. In the centre of the screen is a static photograph of a woman's face. In the background the woman's son is heard saying, "Mum, I'm going." /// Eine Frau geht in ihre Küche und beginnt, Gemüse zu schneiden. Die Kamera nimmt ihren Blickwinkel ein. In der Mitte des Bildschirms ist die statische Fotografie eines Frauengesichts zu sehen. Im Hintergrund hört der Zuschauer den Sohn der Frau sagen: „Mama, ich gehe jetzt." /// Une femme entre dans sa cuisine et commence à hacher des légumes. Le spectateur voit les images depuis son point de vue. La photo d'un visage féminin reste cependant immobile au centre de l'écran. On entend la voix du fils de la femme qui dit : « Maman, j'y vais ».

A man is lying on top of his bed in his short; a photograph of a pregnant woman sticking her finger up remains in the middle of the screen. The man's girlfriend or wife is seen putting her top on at the foot of the bed. She crawls up to him, rests her head on his chest and asks, "What's on your mind?" /// In diesem kurzen Werbespot liegt ein Mann auf seinem Bett. In der Mitte des Bildschirms ist eine Fotografie von einer schwangeren Frau zu sehen, die ihren Finger in die Höhe streckt. Die Freundin oder Ehefrau des Mannes zieht am Fuß des Bettes ihr Oberteil an. Sie kriecht zu ihm, legt ihren Kopf auf seine Brust und fragt: „An was denkst du gerade?" /// Un homme est allongé sur son lit. La photographie d'une femme enceinte qui fait un doigt d'honneur reste au centre de l'écran. On voit la compagne de l'homme au pied du lit, en train de mettre son t-shirt. Elle grimpe sur le lit, pose sa tête sur son torse et lui demande : « À quoi tu penses ? »

TITLE: Banana. / Bottle. **CLIENT:** Times Newspaper. **PRODUCT:** Times Newspaper. **AGENCY:** Rainey Kelly Campbell Roalfe, Y&R. **COUNTRY:** United Kingdom. **YEAR:** 2003. **CREATIVE DIRECTOR:** Robert Campbell, Mark Roalfe.
COPYWRITER: Mike Boles. **ART DIRECTOR:** Jerry Hollens. **PRODUCTION COMPANY:** Gorgeous Enterprises. **PRODUCER:** Paul Rothwell. **DIRECTOR:** Chris Palmer. **AWARDS:** Cannes Lions (Silver).

A simple banana appears on a plate. This evocative spot shows the global impact a simple piece of fruit can have; from being an object of humour, racism and sexism. The ad closes with *The Times* logo and the slogan, "Are you missing what's important?" /// Eine einfache Banane erscheint auf einem Teller. Dieser aufrüttelnde Werbespot zeigt die globale Bedeutung einer einfachen Frucht: von einem Objekt des Humors über Rassismus bis hin zum Sexismus. Der Werbespot endet mit dem Logo der *Times* und dem Slogan: „Verpassen Sie das, was wichtig ist?" /// Une simple banane sur une assiette apparaît à l'écran. Ce spot évocateur montre l'impact global que peut avoir un simple fruit, qui peut être un objet humoristique, raciste ou sexiste. La publicité se termine par le logo du Times et le slogan « Êtes-vous en train de rater quelque chose d'important ? »

The power of everyday objects is profoundly demonstrated here with the example of a bottle. A voiceover explains the various uses of the ordinary bottle from feeding a child with milk to throwing a petrol bomb or numbing the pain of life through alcoholism. /// Die Kraft des alltäglichen Objekts wird hier hintergründig am Beispiel einer Flasche demonstriert. Die Stimme des Sprechers erklärt, wie unterschiedlich eine gewöhnliche Flasche verwendet werden kann: vom Füttern eines Kindes mit Milch über das Werfen einer Benzinbombe bis zum Betäuben des Lebensschmerzes durch Alkohol. /// Le pouvoir d'évocation des objets quotidiens est démontré magistralement dans ce spot, avec l'exemple d'une bouteille. Une voix off explique les différentes utilisations que l'on peut faire d'une bouteille ordinaire, comme donner du lait à un enfant, envoyer un cocktail Molotov ou noyer ses problèmes dans l'alcoolisme.

TITLE: Fleas. **CLIENT:** Purina. **PRODUCT:** Purina Tratto Dog Shampoo. **AGENCY:** Publicis Salles Norton. **COUNTRY:** Brazil. **YEAR:** 2004. **CREATIVE DIRECTOR:** Tião Bernardi, Luciano Santos. **COPYWRITER:** Sérgio Franco. **ART DIRECTOR:** Henrique Del Lama, Luciano Santos. **PRODUCTION COMPANY:** Lobo Filmes. **PRODUCER:** Lobo Films. **DIRECTOR:** Nando Cohen. **AWARDS:** Cannes Lions (Silver).

Names of dog breeds randomly fill a blank screen, with dog sounds in the background. Suddenly a hand slams down a bottle of Purina Tratto dog shampoo in front of the words. All the dots over the 'i' letters start dropping like fleas. **///** Namen von Hunderassen füllen wahllos einen schwarzen Bildschirm, während im Hintergrund Hundegebell zu hören ist. Plötzlich knallt eine Hand eine Flasche Purina Tratto Hundeshampoo vor die Worte. Alle Punkte über den Buchstaben „i" fallen herunter wie tote Flöhe. **///** Des noms de races de chiens remplissent l'écran blanc, et l'on entend des aboiements. Soudain, une main abat une bouteille de shampoing Purina Tratto devant les mots. Tous les points des « i » tombent comme des puces mortes.

– Pointer

:iler – Pinscher – Dalmatian – Labrador Retriever – Perdiguero
– Fila Brasileiro – Manchester Terrier
– Chihuahua – Chinese Imperial Chin – Mastiff – Cocker Spaniel
Collie – Bichon Frisé – Pointer
 – Golden Retriever – American Eskimo
 – Chinook – Fox Terrier
Pumi – Kishu – Lithuanian Hound – Basenji
r – Italian Greyhound – Anatolian Mastiff
 – Porcelaine – Rottweiler – Saint Bernard – Fi

:iler – Pinscher – Dalmatian – Labrador Retriever – Per
– Eskimo Dog – Fila Brasileiro – Manchester Terrier
– Chihuahua – Chinese Imperial Chin – Mastiff –
Collie – Bichon Frisé – Irish Setter – Billy –
Puli – Golden Retriever – Ha im Pins kimo
Akita – Hawaiian Poi Dog – Chinook – Terrier
– Pumi – Kishu – Lithu – Papillon
r – Italian Greyhound Mastiff –
in – Affenpinscher – aint Bernard – Fi

TITLE: No Jam. **CLIENT:** Advance Agro. **PRODUCT:** Double A Quality Paper. **AGENCY:** JWT Singapore. **COUNTRY:** Singapore. **YEAR:** 2002. **CREATIVE DIRECTOR:** Norman Tan. **ART DIRECTOR:** Benson Toh, Norman Tan. **PRODUCTION COMPANY:** Film Factory. **DIRECTOR:** Oceanic Chan. **AWARDS:** Cannes Lions (Shortlist).

A photocopier seamlessly churns out copies of a piece of paper with a slice of toast on it. This continues for a few seconds until the words "No Jam" appear on the screen. The spot closes showing the product while a voiceover says, "Double A paper is the smoothest paper to go into and come out of your photocopier." /// Ein Kopiergerät wirft am laufenden Band Kopien aus, die eine Scheibe Toast zeigen. Dies setzt sich einige Sekunden fort, bis auf dem Bildschirm die Worte „No Jam" erscheinen (doppeldeutig: keine Marmelade, aber auch: kein Papierstau). Die Schlussszene zeigt das Produkt und ein Sprecher sagt: „Double A Papier ist das weichste Papier, das in Ihren Kopierer eingezogen und ausgegeben wird." /// Une photocopieuse éjecte sans s'arrêter des copies d'une feuille de papier avec une tranche de pain grillé. Cela continue pendant quelques secondes, puis les mots « Pas de blocage papier » apparaissent. Le spot se termine par une image du produit, avec une voix off qui déclare « Le papier Double A est le papier le plus lisse qui entrera et sortira de votre photocopieuse ».

NEW MEDIA IDEAS

BILL WRIGHT & ANDREW KELLER
VICE-PRESIDENT & CREATIVE DIRECTOR OF CRISPIN PORTER + BOGUSKY
VICE-PRESIDENT & EXECUTIVE CREATIVE DIRECTOR OF CRISPIN PORTER + BOGUSKY

Since joining Crispin Porter + Bogusky in 1995, Bill has contributed on just about every account that's ever walked through the agency's doors. The list includes Miller Beer, MINI, IKEA, Virgin Atlantic Airways, Schwinn, Giro Helmets, Burger King, Volkswagen, The Golf Channel, AND1 basketball shoes, and the "Truth" anti-smoking account. Bill started his career as a copywriter at Ogilvy & Mather, cutting his teeth on accounts such as Shell Oil and Compaq computers. Prior to that, he graduated with a journalism degree from the University of Missouri. His work has been recognized by the One Show, *Communication Arts*, *Archive* magazine, the Clios, the Kelly Awards, Cannes, the London International Advertising Awards, the Radio Mercury Awards, and the CBS television program *World's Greatest Commercials*.

Andrew Keller joined Crispin Porter + Bogusky in 1998 as a creative director. Since that time he has played a lead role in the US launch of the MINI, the turnaround of Burger King and the revitalization of the Volkswagen brand. Andrew has received many accolades for his work and was recently named the second most awarded creative director in the world by *Creativity* magazine (right under his boss, Alex Bogusky). Andrew's contributions to the

Seit seinem Einstieg 1995 bei Crispin Porter + Bogusky hat Bill mit nahezu jedem Kunden der Agentur zusammengearbeitet. Zu den Accounts, die er betreut hat, zählen unter anderem Miller Beer, MINI, IKEA, Virgin Atlantic Airways, Schwinn, Giro Helmets, Burger King, VW, The Golf Channel, AND1 Basketballschuhe und die Anti-Raucher-Kampagne „Truth". Bill begann seine Karriere als Texter bei Ogilvy & Mather, wo er sich die Zähne an Accounts wie Shell Oil und Compaq Computer ausbiss. Zuvor machte er einen Abschluss in Journalismus an der University of Missouri. Seine Arbeiten fanden Anerkennung in den Publikationen von One Show, *Communication Arts*, *Archive* Magazine, bei den Clios, den Kelly Awards, in Cannes, bei den London International Advertising Awards, den Radio Mercury Awards und in der CBS Fernsehsendung *World's Greatest Commercials*.

Andrew Keller kam 1998 als Creative Director zu Crispin Porter + Bogusky. Er hatte eine führende Rolle beim US-Launch des MINI, bei der Turnaround-Kampagne für Burger King und der Wiederbelebung der Marke Volkswagen. Andrew erhielt zahlreiche Auszeichnungen für seine Arbeit und erschien kürzlich in der vom Magazin *Creativity* erstellten Liste der weltweit am häufigsten ausgezeichneten Kreativdirektoren auf Platz zwei (gleich hinter seinem Boss Alex Bogusky). Andrews Input zur kreativen Leitung der Agentur trug entscheidend dazu bei, dass Crispin Porter + Bogusky viermal die Auszeichnung „Agentur des Jahres" des Magazins *Creativity* von Advertising Age erhielt und zudem sowohl von *Adweek* als auch von *Shoot* zur „Agentur des Jahres" gekürt wurde. Als Executive Creative

Depuis qu'il est entré chez Crispin Porter + Bogusky en 1995, Bill a apporté sa contribution à quasiment tous les clients qui sont passés par l'agence. La liste comprend Miller Beer, MINI, IKEA, Virgin Atlantic Airways, Schwinn, Giro Helmets, Burger King, VW, The Golf Channel, les chaussures de basket AND1 et la campagne anti-tabac « Truth ». Bill a démarré sa carrière en tant que rédacteur publicitaire chez Ogilvy & Mather, en se faisant les dents sur des clients comme Shell Oil et les ordinateurs Compaq. Auparavant, il avait obtenu un diplôme de journalisme à l'Université du Missouri. Son travail a été reconnu par One Show, *Communication Arts*, la revue *Archive*, les Prix Clios, les Prix Kelly, Cannes, les London International Advertising Awards, les Prix Radio Mercury et l'émission télévisée de la CBS *World's Greatest Commercials*.

Andrew Keller est entré chez Crispin Porter + Bogusky en 1998 en tant que directeur de la création. Depuis lors, il a joué un rôle phare dans le lancement américain de la MINI, le revirement de Burger King et la revitalisation de la marque Volkswagen. Andrew a décroché de nombreux prix pour son travail et a récemment été nommé deuxième directeur de la création le plus primé au monde par la revue *Creativity* (juste après son patron, Alex Bogusky). Les apports d'Andrew à la direction de la création de l'agence ont joué un rôle majeur chez Crispin Porter + Bogusky, qui a été nommée « Agence de l'année » par *Adweek* et *Shoot* magazine et à quatre reprises par la revue *Creativity* d'Advertising Age. En tant que directeur exécutif de la création, il supervise toutes les activités du service et a mené des

creative direction of the agency have played a major role in Crispin Porter + Bogusky being named "Agency of the Year" four times by Advertising Age's *Creativity* magazine, as well as "Agency of the Year" by both *Adweek* and *Shoot* magazine. As Executive Creative Director he oversees the activities of the entire department and has also spearheaded campaigns for Volkswagen, Burger King, Virgin Atlantic Airways, Gap, Coca-Cola Zero, and Sprite.

T: What do you think is the current trend in the area you judged?

AK: Making them a part of the conversation that pop culture is having.
BW: This is a pretty conservative category that is historically marked by comparatively "safe" advertising. Retailers and especially financial services have been content to humbly present their case and not rock the boat too much. So it seems as the category gets more crowded and more cluttered, the companies within it are seeing the need (and the benefit) to be more engaging and impactful with their TV [spots].

T: What are your top 3 spots from the entire selection, and can you explain their importance?

AK: Geico, eBay, Burger King's – "Wake up with the King." People talked about those spots. They were so relevant you couldn't ignore them. eBay was sort of backwards. It already had talk value. These spots made me feel smart for using it, or dumb for not. They really activated the sensation for the mainstream.

Director ist er für die gesamte Kreativabteilung verantwortlich und hat bereits Kampagnen für Volkswagen, Burger King, Virgin Atlantic Airways, Gap, Coca-Cola Zero und Sprite geleitet.

T: Welchen aktuellen Trend sehen Sie in dem Bereich, den Sie beurteilt haben?

AK: Sie zu einem Teil des Gesprächs zu machen, das gerade in der Popkultur abläuft.
BW: Das ist eine ziemlich konservative Kategorie, die historisch durch vergleichsweise „sichere" Werbung geprägt ist. Der Einzelhandel und insbesondere Finanzdienstleister geben sich damit zufrieden, die Werbung für ihre Produkte bescheiden zu gestalten und dabei auf Nummer sicher zu gehen. Diese Kategorie wird anscheinend immer überfüllter und enger, sodass die Unternehmen in ihr allmählich erkennen, dass sie originellere und wirkungsvollere TV-Werbung für ihre Produkte machen müssen (und davon profitieren können).

T: Was sind Ihre 3 Top-TV-Spots der gesamten Auswahl? Können Sie ihre Bedeutung erläutern?

AK: Geico, eBay, Burger King – „Wake up with the King". Die Leute haben über diese Spots geredet. Sie waren so auffällig, dass man sie einfach nicht ignorieren konnte. Bei eBay lief es irgendwie rückwärts; es hatte bereits Talk Value. Diese Spots gaben mir das Gefühl, dass es clever war, diese Produkte zu benutzen, und dumm, es nicht zu tun. Sie haben wirklich das Bedürfnis geweckt, dem Mainstream zu folgen.

campagnes pour Volkswagen, Burger King, Virgin Atlantic Airways, Gap, Coca-Cola Zero et Sprite.

T : D'après vous, quelle est la nouvelle tendance dans la catégorie pour laquelle vous avez fait partie du jury ?

AK : Les films cherchent à entrer dans le dialogue à l'œuvre dans la culture pop
BW : Il s'agit d'une catégorie plutôt conservatrice, qui a toujours prôné un type de publicité « peu risquée ». Détaillants et services financiers en particulier se sont contentés de vendre humblement leurs produits sans trop jouer les trouble-fête. Il semblerait que plus la catégorie croît et prend de l'ampleur, plus les sociétés qui y figurent s'aperçoivent de la nécessité (et des avantages à tirer) de films publicitaires plus engageants et plus marquants.

T : Quels sont vos trois spots préférés de la sélection et comment expliquez-vous leur importance ?

AK : Geico, eBay, et le film « Wake up with the King » de Burger King. Ces spots ont fait beaucoup de bruit. Ils étaient si pertinents qu'il était impossible de passer outre. Le spot d'eBay avait une touche rétro. Il a beaucoup fait parler de lui. Ces films vous donnent l'impression d'être intelligent si vous consommez le produit et stupide dans le cas contraire. Ils ont vraiment fait sensation auprès du grand public.

T : En quoi consiste la beauté d'un spot publicitaire comparé à un autre support ?

T: What is the beauty of commercial film versus other media?

AK: It's what people think of as advertising. So they talk about it. So if your goal is to be a part of the conversation, TV is a great place to start. The Internet is growing its potential to do this but in a different way. You talk about TV because you assume others know what you know—like the weather. You talk about the Internet because you assume others don't know and you will look smart for knowing—gossip. Both are powerful.

BW: I really love the Comcast "Pyramid" spot. By way of explanation, there was a game show on American TV called *The $20,000 Pyramid*, hosted by Dick Clark. And this spot used archival footage from that show and overdubbed the audio to make it appear as if all the questions were about Comcast services. So it's a lot of very dry, factual material, but they did it in a way that really made me pay attention. It's an American tradition to hate your cable company but Comcast seems to have found a way to be liked. And they had the best tagline of the year too: "It's Comcastic!"

T: What are the limitations today, with the Internet and mobiles, etc?

AK: The content competition is massive. How do you beat nudity, profanity and violence when it's not an option for branded content? And the content bar is so low that consumers are learning to ignore it at a faster rate. While at the same time new media ideas are used up as soon as they are invented and then discarded. You have to move fast.

T: Was ist das Schöne am Werbefilm im Vergleich zu anderen Medien?

AK: Es ist das, was die Leute sich unter Werbung vorstellen. Also reden sie darüber. Wenn man also das Ziel hat, zum Gesprächsthema zu werden, ist TV-Werbung das ideale Mittel. Das Internet hat diesbezüglich ebenfalls wachsendes Potenzial, aber es läuft anders ab. Übers Fernsehen redet man, weil man annimmt, dass die anderen wissen, was man selbst weiß — wie beim Wetter zum Beispiel. Übers Internet redet man, weil man annimmt, dass die anderen nicht wissen, was man selbst weiß, und weil man sich damit wichtig machen kann — das hat eher was von Klatsch und Tratsch. Beides sind mächtige Tools.

BW: Was ich wirklich liebe, ist der „Pyramiden"-Spot von Comcast. Es gab im US-Fernsehen mal eine Gameshow namens *Die 20.000-Dollar-Pyramide*, die von Dick Clark moderiert wurde. Für den Werbespot wurde Archivmaterial aus dieser Show benutzt und das Audiomaterial synchronisiert. Dadurch entstand der Eindruck, als ob alle Fragen sich auf den Service von Comcast beziehen. Das Archivmaterial aus der Show war eigentlich ziemlich dröge, aber sie haben es auf eine Weise aufgepeppt, die mich wirklich zum Hinschauen brachte. Eigentlich hat es in Amerika Tradition, dass jeder sein Kabelunternehmen hasst, aber bei Comcast scheinen sie einen Weg gefunden haben, sich beliebt zu machen. Und obendrein hatten sie den besten Slogan des Jahres: „It's Comcastic!"

T: Welche Grenzen gibt es heute, in Anbetracht von Internet, Mobiltelefonen usw.?

AK: Der Content-Wettbewerb ist knallhart. Wie soll man bei Nacktbildern, Vulgärem und Gewalt gegensteuern, wenn Branded Content die Verwendung solcher Inhalte bei einer Marke nicht erlaubt? Zudem lernen die Verbraucher, Content-Werbung immer häufiger und schneller zu ignorieren. Gleichzeitig sind neue Medienideen inzwischen schon in dem Moment veraltet, wo sie erfunden werden. Man muss wirklich schnell sein.

AK : Le spot est l'idée que les gens se font de la publicité. Alors, ils en parlent. Si votre but est d'entrer dans les conversations, la télévision est le meilleur point de départ. Le potentiel de l'Internet croît, mais différemment. On parle de la télévision comme si tout le monde avait vu la même chose, comme la météo par exemple. À l'inverse, on parle de l'Internet comme si personne n'avait pu voir la même chose, avec un air de supériorité (commérages). Les deux sont des médias très puissants.

BW : J'adore le spot « Pyramid » de Comcast. Je m'explique. Il y avait un jeu télévisé américain qui s'appelait *The $20,000 Pyramid*, animé par Dick Clark. Pour le spot, ils ont pris des images d'archives de l'émission et les ont doublées de telle sorte que toutes les questions se rapportent aux services Comcast. Beaucoup de matériel sobre, factuel, mais la transportation a vraiment attiré mon attention. Aux États-Unis, il est courant d'exécrer son fournisseur de télévision câblée, mais Comcast a réussi à se faire apprécier. Et ils ont trouvé le meilleur slogan de l'année : « C'est comcastique ! »

T : Quelles limites posent l'Internet et la téléphonie mobile aujourd'hui ?

AK : La concurrence en termes de contenus est énorme. Comment battre la nudité, la vulgarité ou la violence lorsque ces contenus ne sont pas acceptables pour une marque ? Par ailleurs, le niveau des contenus est si bas que les consommateurs apprennent à en faire abstraction de plus en plus vite. Parallèlement, les idées concernant les nouveaux médias sont consommées dès qu'elles sont trouvées, puis elles sont immédiatement écartées. Il faut être très rapide.

"THE CONTENT COMPETITION IS MASSIVE. HOW DO YOU BEAT NUDITY, PROFANITY AND VIOLENCE WHEN IT'S NOT AN OPTION FOR BRANDED CONTENT?"

„DER CONTENT-WETTBEWERB IST KNALLHART. WIE SOLL MAN BEI NACKTBILDERN, VULGÄREM UND GEWALT GEGENSTEUERN, WENN BRANDED CONTENT DIE VERWENDUNG SOLCHER INHALTE BEI EINER MARKE NICHT ERLAUBT?"

« LA CONCURRENCE EN TERMES DE CONTENUS EST ÉNORME. COMMENT BATTRE LA NUDITÉ, LA VULGARITÉ OU LA VIOLENCE LORSQUE CES CONTENUS NE SONT PAS ACCEPTABLES POUR UNE MARQUE ? »

005

SERVICE & RETAILERS

TITLE: Roddick vs Pong. **CLIENT:** American Express. **SERVICE:** American Express Credit Cards. **AGENCY:** Ogilvy & Mather New York. **YEAR:** 2005. **CREATIVE DIRECTOR:** Terry Finley, Chris Mitton. **COPYWRITER:** Chris Lisick. **ART DIRECTOR:** John LaMacchia. **PRODUCTION COMPANY:** Smuggler. **EXECUTIVE PRODUCER:** Brian Carmody, Patrick Milling Smith. **PRODUCER:** Cheryl Gackstetter. **DIRECTOR:** Stylewar.

This ad features Tennis star Andy Roddick against 'Pong', the white block from the early TV video game. As Roddick desperately tries to beat his opponent, he resorts to delivering an underhand serve. Roddick's voiceover announces, "My life is about finding a way to win. That's why my card is American Express." /// Dieser Werbespot zeigt Tennis-Star Andy Roddick gegen „Pong", den weißen Klotz aus dem früheren Videospiel. Als Roddick verzweifelt versucht, seinen Gegner zu schlagen, greift er auf einen Unterhand-Schlag zurück. Roddicks Synchronstimme verkündet: „In meinem Leben geht es darum, einen Weg zu finden, mit dem ich gewinnen kann. Deshalb ist meine Kreditkarte American Express." /// Cette publicité met en scène la star du tennis Andy Roddick, jouant contre « Pong », la brique blanche du tout premier jeu vidéo de tennis. Roddick essaie désespérément de battre son adversaire, et finit par avoir recours à un service sournois. En voix off, il déclare : « Je trouve toujours un moyen de gagner. C'est pour cela que ma carte est une American Express ».

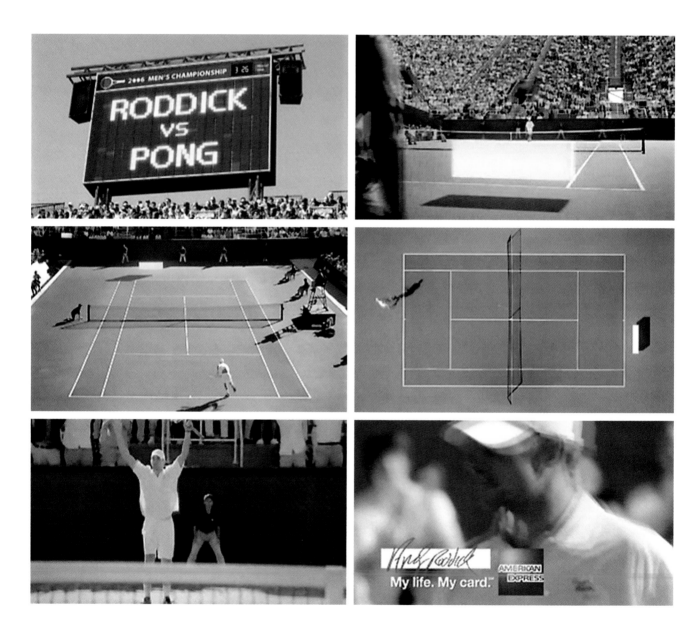

TITLE: Surprise Dinner. CLIENT: Ameriquest Mortgage Company. SERVICE: Ameriquest Mortgage. AGENCY: DDB Los Angeles. COUNTRY: USA. YEAR: 2005. ART DIRECTOR: Feh Tarty. CREATIVE DIRECTOR: Helen Cote. COPYWRITER: Patrick McKay. EXECUTIVE CREATIVE DIRECTOR: Mark Monteiro. PRODUCTION COMPANY: MJZ. EXECUTIVE PRODUCER: Lisa Rich, David Zander. PRODUCER: Vanessa McAdam. DIRECTOR: Craig Gillespie. AWARDS: Super Bowl, One Show (Gold), CLIO Awards (Silver), AICP, Cannes Lions (Bronze), ANDY Awards (Bronze), Addy (Gold).

A man returns home with plans to surprise his girlfriend with a romantic dinner. He arranges flowers on the table and begins to cook in the kitchen. Unfortunately, his cat decides to tip the dinner all over the floor. As the guy scrambles to clean the mess up, his girlfriend walks in. She is shocked to see him holding the cat in one hand with a kitchen knife in the other." /// Ein Mann kommt nach Hause und plant, seine Freundin mit einem romantischen Abendessen zu überraschen. Er arrangiert Blumen auf dem Tisch und beginnt, in der Küche zu kochen. Leider stößt seine Katze das Abendessen um, das auf dem Boden landet. Als der Mann auf dem Boden kniet, um die Sauerei zu beseitigen, kommt seine Freundin herein. Schockiert sieht sie, wie er mit der einen Hand die Katze festhält und in der anderen ein Küchenmesser hat. /// Un homme rentre chez lui avec l'intention de surprendre sa compagne avec un dîner romantique. Il décore la table avec des fleurs et commence à cuisiner. Malheureusement, le chat décide de renverser le dîner par terre. Alors que l'homme essaie tant bien que mal de nettoyer, sa compagne arrive dans la pièce, et reste stupéfaite de le voir tenant le chat dans une main et un couteau de cuisine dans l'autre.

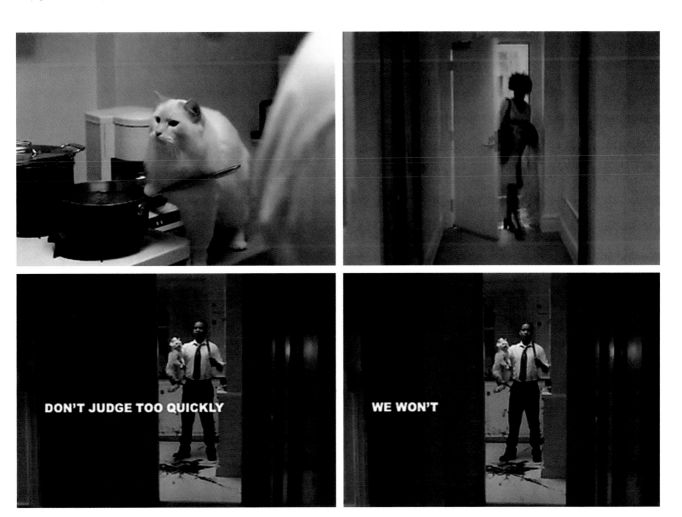

TITLE: Hold Up. **CLIENT:** Ameriquest Mortgage Company. **SERVICE:** Ameriquest Mortgage. **AGENCY:** DDB Los Angeles. **COUNTRY:** USA. **YEAR:** 2005. **ART DIRECTOR:** Feh Tarty. **CREATIVE DIRECTOR:** Helen Cote. **COPYWRITER:** Patrick McKay. **EXECUTIVE CREATIVE DIRECTOR:** Mark Monteiro. **PRODUCTION COMPANY:** MJZ. **EXECUTIVE PRODUCER:** Lisa Rich, David Zander. **PRODUCER:** Vanessa McAdam. **DIRECTOR:** Craig Gillespie. **AWARDS:** Super Bowl, One Show (Gold), CLIO Awards (Silver), AICP, Cannes Lions (Bronze), ANDY Awards (Bronze), Addy (Gold).

A man wearing a Bluetooth headset walks into a minimart while having a phone conversation with a work colleague. "I hate to tell you this, but you're getting robbed," he says. In a panic the shop owner turns around and sprays the customer with pepper spray before whacking him with a baseball bat, His co-worker appears with a stun rod. /// Ein Mann mit einem Bluetooth-Headset betritt einen kleinen Laden, während er mit einem Arbeitskollegen telefoniert. „Ich hasse es, dir das sagen zu müssen, aber du wirst ausgeraubt", sagt er. In Panik dreht sich der Ladenbesitzer um, besprüht den Kunden mit Pfefferspray und zieht ihm schließlich mit einem Baseballschläger eins über. Sein Mitarbeiter erscheint mit einem Elektroschocker. /// Un homme qui porte une oreillette Bluetooth entre dans une épicerie. Il est en plein milieu d'une conversation avec un collègue. « Je suis désolée de te le dire, mais tu te fais voler », dit-il. Pris de panique, le propriétaire du magasin se retourne et l'asperge de gaz lacrymogène avant de lui donner un grand coup avec une batte de base-ball. Son collègue arrive avec une matraque paralysante.

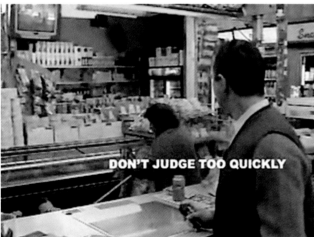
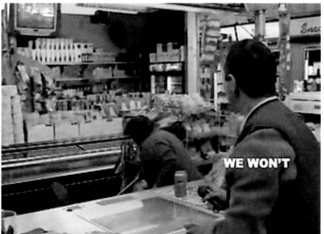

TITLE: Concert. CLIENT: Ameriquest Mortgage Company. SERVICE: Ameriquest Mortgage. AGENCY: DDB Los Angeles. COUNTRY: USA. YEAR: 2006. EXECUTIVE CREATIVE DIRECTOR: Mark Monteiro. CREATIVE DIRECTOR: Helene Cote. COPYWRITER: Josh Fell. ART DIRECTOR: Sarah Bates. PRODUCTION COMPANY: MJZ. PRODUCER: Vanessa McAdam. DIRECTOR: Craig Gillespie. AWARDS: Cannes Lions (Silver).

A group of teenage girls are on their way to a party. The driver's daughter asks him to pull over at a drug store. The father calls his daughter back to hand her some money. A police car arrives with full beams on. The spot freezes with the stunned father holding a bill in his hand. The caption reads, "Don't judge too quickly, we won't!" /// Eine Gruppe Teenager ist auf dem Weg zu einer Party. Die Tochter des Fahrers bittet ihren Vater, bei einer Apotheke anzuhalten. Der Vater ruft seine Tochter zurück, um ihr Geld zu geben. Ein Polizeiwagen mit Blaulicht trifft ein. Der Werbespot zeigt ein Standbild mit dem verblüfften Vater, der einen Geldschein in seiner Hand hält. Die Bildüberschrift lautet: „Urteilen Sie nicht zu früh, denn wir werden es nicht tun!" /// Des adolescentes se font accompagner à une fête. La fille du conducteur lui demande de s'arrêter à une pharmacie. Elle descend, et le père la rappelle, pour lui donner de l'argent. Une voiture de police arrive, toutes lumières allumées. Une image arrêtée montre le père stupéfait, un billet à la main. Le sous-titre déclare : « Ne jugez pas trop rapidement, nous ne le ferons pas non plus ! »

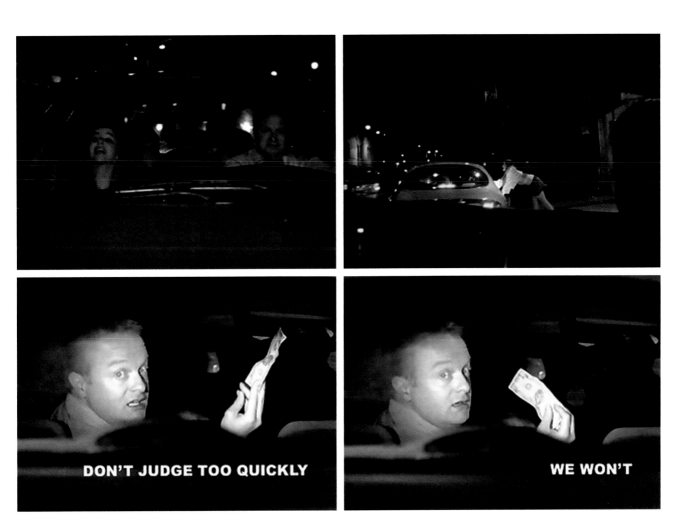

TITLE: Robbery. / Twister. **CLIENT:** Bangkok Insurance. **SERVICE:** Bangkok Insurance. **AGENCY:** Creative Juice G1, Bangkok. **COUNTRY:** Thailand. **YEAR:** 2006. **CREATIVE DIRECTOR:** Prangthip Praditpong, Thirasak Tanapatanakul. **COPYWRITER:** Prangthip Praditpong, Nutchanun Chiaphanumas. **ART DIRECTOR:** Jon Chalermwong, Kittitat Larppitakpong, Thirasak Tanapatanakul. **PRODUCTION COMPANY:** Phenomena Film Production. **PRODUCER:** Chuthrat Chingduang. **DIRECTOR:** Thanonchai Sornsriwichai. **AWARDS:** CLIO Awards (Gold), One Show (Silver), Cannes Lions (Gold).

A CCTV camera shows a man walking into a jewellery shop. He pulls out a gun and starts screaming at the sales assistants and customers. Panic ensues and the man fires his gun in the air. The bullet ricochets off several surfaces before hitting the man in his foot. He drops the gun and hops his getaway. The Bangkok Insurance punch line reads, "Probability = 0.0000001 %." /// Eine Videoüberwachungskamera zeigt einen Mann, der ein Juweliergeschäft betritt. Er zieht eine Pistole und brüllt die Verkäufer und Kunden des Geschäfts an. Panik entsteht, und der Mann feuert mit seiner Pistole in die Luft. Die Kugel prallt an verschiedenen Oberflächen ab und trifft den Mann schließlich in den Fuß. Er lässt seine Waffe fallen und ergreift hüpfend die Flucht. Die Pointe der Bangkok Insurance lautet „Wahrscheinlichkeit = 0.0000001 %". /// Une caméra de surveillance montre un homme qui entre dans une bijouterie. Il sort un pistolet et commence à hurler des ordres aux vendeurs et aux clients. Les gens paniquent, et l'homme tire un coup de feu en l'air. La balle rebondit sur plusieurs surfaces avant de toucher l'homme au pied. Il laisse tomber son pistolet et se sauve à cloche-pied. Le mot de la fin de Bangkok Insurance : « Probabilité = 0,0000001 % »

In this zany spot, a raging tornado is caught on tape by a family as it devastates their home. In a highly improbable freak of nature, the twister swirls past rebuilding the house exactly as it had been, down to the last roof tile. /// In diesem verrückten Werbespot filmt eine Familie einen tobenden Tornado, der gerade ihr Heim verwüstet. In einer sehr unwahrscheinlichen Laune der Natur wirbelt der Tornado an dem Haus vorbei und baut es genauso auf, wie es vorher war – bis auf den letzten Dachziegel. /// Dans ce spot loufoque, une famille enregistre sur vidéo la tornade qui est en train de détruire leur maison. Par un hasard incroyable, le tourbillon repasse sur la maison et remet tous les objets en place, jusqu'à la moindre tuile du toit.

TITLE: Wheel. CLIENT: Bangkok Insurance. SERVICE: Bangkok Insurance. AGENCY: Creative Juice G1, Bangkok. COUNTRY: Thailand. YEAR: 2006. CREATIVE DIRECTOR: Prangthip Praditpong, Thirasak Tanapatanakul. COPYWRITER: Prangthip Praditpong, Nutchanun Chiaphanumas. ART DIRECTOR: Jon Chalermwong, Kittitat Larppitakpong, Thirasak Tanapatanakul. PRODUCTION COMPANY: Phenomena Film Production. PRODUCER: Chuthrat Chingduang. DIRECTOR: Thanonchai Sornsriwichai. AWARDS: CLIO Awards (Gold), One Show (Silver), Cannes Lions (Gold).

The scene is a busy highway. A wheel comes off a car and starts an amazing journey as it ping pongs off various vehicles before bouncing off a lamp post and rolling back into the wheel arch of the car it came off. /// Die Szene dieses Werbespots spielt auf einer verkehrsreichen Fernstraße. Ein Rad löst sich von einem Auto und beginnt eine unglaubliche Reise, während der es von verschiedenen Fahrzeugen abprallt, von einem Laternenmast zurückgeworfen wird und wieder in den Radkasten zurückrollt, aus dem es gekommen ist. /// L'action se déroule sur une autoroute encombrée. Une roue se détache d'une voiture et entreprend une trajectoire incroyable en rebondissant sur plusieurs véhicules, puis sur un lampadaire, et retourne prendre sa place sur la voiture d'où elle était venue.

TITLE: I Understand. **CLIENT:** CareerBuilder. **SERVICE:** CareerBuilder.com. **AGENCY:** Cramer-Krasselt. **COUNTRY:** USA. **YEAR:** 2006. **CREATIVE DIRECTOR:** Marshall Ross. **COPYWRITER:** Bill Dow. **ART DIRECTOR:** Justin Bucktrout. **PRODUCTION COMPANY:** Hungry Man. **PRODUCER:** Ben Latimer. **DIRECTOR:** Bryan Buckley. **AWARDS:** Super Bowl, Cannes Lions (Bronze).

An office worker surrounded by monkeys apologizes to his caller and explains that he works "with a bunch of monkeys." The scene changes to his caller's office. She is surrounded by donkeys. She responds to the man, "I totally understand. I work with a bunch of jackasses." CareerBuilder.com offers better prospects for jobseekers. /// Ein von Schimpansen umgebener Büroangestellter entschuldigt sich bei seiner Anruferin und erklärt, dass er „mit einer Horde Affen" arbeite. Die Szene wechselt in das Büro der Anruferin. Sie ist von Eseln umgeben. Sie antwortet dem Büroangestellten: „Ich verstehe Sie sehr gut. Ich arbeite mit einer Horde von Eseln." CareerBuilder.com bietet Arbeitssuchenden bessere Perspektiven. /// Un employé de bureau entouré de chimpanzés s'excuse auprès de la personne avec qui il parle au téléphone et lui explique qu'il « travaille avec une bande de singes ». Le bureau de l'autre personne apparaît à l'écran. Elle est entourée d'ânes. Elle répond : « Je comprends tout à fait. Je travaille avec des ânes. » CarrerBuilder.com propose de meilleures perspectives aux chercheurs d'emploi.

TITLE: Celebration. **CLIENT:** CareerBuilder. **SERVICE:** CareerBuilder.com. **AGENCY:** Cramer-Krasselt. **COUNTRY:** USA. **YEAR:** 2006. **CREATIVE DIRECTOR:** Marshall Ross. **COPYWRITER:** Bill Dow. **ART DIRECTOR:** Justin Bucktrout. **PRODUCTION COMPANY:** Hungry Man. **EXECUTIVE PRODUCER:** Kevin Byrne. **PRODUCER:** Ben Latimer. **DIRECTOR:** Bryan Buckley. **AWARDS:** Super Bowl, Cannes Lions (Bronze).

The office monkeys are having a party. Their human colleague walks in and turns the music off. He turns the sales chart upside down and tries to explain that their sales figures are actually down and not up. The monkey boss switches the music back on and turns the chart upside down again. The guy shrugs and reluctantly joins in the celebration. /// Die Büroaffen feiern eine Party. Ihr menschlicher Kollege betritt den Raum und schaltet die Musik aus. Er dreht das Bild mit dem Umsatzdiagramm um und versucht zu erklären, dass die Umsätze der Firma eigentlich zurückgehen und nicht steigen. Der Affenchef schaltet die Musik wieder an. Der Mann zuckt mit den Schultern und feiert schließlich widerstrebend mit. /// Les singes de bureau font la fête. Leur collègue humain entre dans la pièce et éteint la musique. Il retourne le graphique des ventes et essaie de leur expliquer que les chiffres sont à la baisse, et non à la hausse comme ils le croyaient. Le singe-chef remet la musique. L'homme hausse les épaules et se joint à la fête à contrecœur.

TITLE: Pointer. CLIENT: CareerBuilder. SERVICE: CareerBuilder.com. AGENCY: Cramer-Krasselt. COUNTRY: USA. YEAR: 2006. CREATIVE DIRECTOR: Marshall Ross. COPYWRITER: Bill Dow. ART DIRECTOR: Justin Bucktrout. PRODUCTION COMPANY: Hungry Man. EXECUTIVE PRODUCER: Kevin Byrne. PRODUCER: Ben Latimer. DIRECTOR: Bryan Buckley. AWARDS: Super Bowl, Cannes Lions (Bronze).

Our junior executive is trying to give a slide presentation to his monkey colleagues. However, they are more interested in aggravating him by playing with their screen pointers. He turns around and tries to refocus their attention, but they're having too much fun pointing at his trousers. /// Unser Büroangestellter versucht, vor seinen Affenkollegen eine Präsentation mit einem Overheadprojektor zu halten. Sie sind jedoch mehr daran interessiert, ihn zu stören, indem sie mit ihren Laser-Pointern spielen. Er dreht sich um und versucht, ihre Aufmerksamkeit zu erlangen, doch sie haben zu viel Spaß daran, mit den Laser-Pointern auf seine Hose zu zielen. /// Notre jeune cadre essaie de faire une présentation devant ses collègues singes. Mais au lieu d'écouter, ils préfèrent l'agacer avec leurs pointeurs lumineux. Il se retourne et essaie d'attirer leur attention, mais ils sont trop occupés à pointer vers son pantalon.

TITLE: Pregnancy. **CLIENT:** Cingular. **SERVICE:** Cingular Wireless. **AGENCY:** BBDO New York / BBDO Atlanta. **COUNTRY:** USA. **YEAR:** 2008. **CHIEF CREATIVE OFFICERS:** David Lubars, Bill Bruce. **EXECUTIVE CREATIVE DIRECTOR:** Susan Credle. **COPYWRITER:** Chris Maiorino. **ART DIRECTOR:** Linda Honan. **PRODUCTION COMPANY:** Smuggler. **PRODUCER:** Nicole Lundy. **DIRECTOR:** Chris Smith.

A woman calls her husband to tell him she is pregnant. As he waves his arms in celebration the sound is muted. The screen cuts to white showing the caption, "Switch to the network with the fewest dropped calls." The woman's excitement gradually turns to disdain. The ad closes with the Cingular logo and the tagline, "Raising the bar." /// Eine Frau ruft ihren Mann an, um ihm mitzuteilen, dass sie schwanger ist. Als er vor Freude seine Arme hochwirft, wird der Ton ausgeblendet. Der Bildschirm wird weiß und zeigt die folgenden Zeilen: „Wechsele zum Mobilfunkanbieter mit den wenigsten unterbrochenen Gesprächen." Die Nervosität der Frau verwandelt sich langsam in Geringschätzigkeit. Der Werbespot endet mit dem Logo von Cingular und dem Slogan „Raising the bar." /// Une jeune femme appelle son mari pour lui annoncer qu'elle est enceinte. La communication se coupe au moment où, fou de joie, il agite les bras dans tous les sens. L'écran passe au blanc avec cette légende : « Rejoignez le réseau qui compte le moins de communications coupées. » L'exaltation de la jeune femme tourne au mépris. La pub prend fin sur le logo de Cingular, avec cette accroche « Mettons la barre plus haut. »

TITLE: Vegas. **CLIENT:** Cingular. **SERVICE:** Cingular Wireless. **AGENCY:** BBDO New York / BBDO Atlanta. **COUNTRY:** USA. **YEAR:** 2008. **CHIEF CREATIVE OFFICERS:** David Lubars, Bill Bruce. **EXECUTIVE CREATIVE DIRECTOR:** Susan Credle. **COPYWRITER:** Dan Rollman. **ART DIRECTOR:** Linda Honan. **PRODUCTION COMPANY:** Smuggler. **PRODUCER:** Nicole Lundy. **DIRECTOR:** Chris Smith.

A young woman is standing in the middle of Las Vegas with her boyfriend. She calls her mother who is at home ironing. Jokingly, the mother tells her daughter not to get married. Suddenly the call is dropped and the mother fears the worst. Finally she says, "Jennifer, don't make the same mistake I made." The Spot closes with the Cingular logo. /// Eine junge Frau steht mit ihrem Freund mitten in Las Vegas. Sie ruft ihre Mutter an, die gerade zuhause bügelt. Die Mutter sagt scherzhaft zu ihrer Tochter, sie solle bloß nicht heiraten. Plötzlich ist die Verbindung unterbrochen, und die Mutter befürchtet das Schlimmste. Schließlich sagt sie: „Jennifer, mach nicht den gleichen Fehler, den ich gemacht habe." Der Werbespot endet mit dem Logo von Cingular. /// Plantée avec son petit ami au beau milieu d'une rue de Las Vegas, une jeune fille passe un coup de fil à sa mère, chez elle en train de repasser. En plaisantant, celle-ci lui dit de ne pas se marier. Soudain, la communication est coupée et la mère, qui se met à craindre le pire, finit par lancer "Jennifer, ne fais pas la même bêtise que moi." Le spot s'achève sur le logo de Cingular.

TITLE: Thelma and Norma. CLIENT: Citibank. SERVICE: Citi Identity Theft Solutions. AGENCY: Fallon Minneapolis. COUNTRY: USA. YEAR: 2006. EXECUTIVE CREATIVE DIRECTOR: Kerry Feuerman. CREATIVE DIRECTOR: Steve Driggs. COPYWRITER: James Bray. ART DIRECTOR: Steve Driggs. HEAD OF PRODUCTION: Brian DiLorenzo. PRODUCTION COMPANY: Thomas Thomas. EXECUTIVE PRODUCER: Jenny Gadd. PRODUCER: Ted Knutson. DIRECTOR: Kevin Thomas.

Two old ladies are drinking tea together. Their voices are overdubbed with two hillbilly biker crooks, who are laughing about the motorcycles they've bought with the ladies' stolen money. A caption appears on screen with the words, "Thelma and Norma – Identity Theft Victims." /// Zwei alte Damen trinken zusammen Tee. Ihre Stimmen werden von den Stimmen eines Motorradfahrers und eines Gauners ersetzt, die darüber lachen, wie sie von den alten Damen Geld gestohlen und davon neue Motorräder gekauft haben. Auf dem Bildschirm erscheinen die Worte „Thelma und Norma – Opfer eines Identitätsdiebstahls." /// Deux grand-mères prennent le thé ensemble. Leurs voix ont été remplacées par celle de deux escrocs mal dégrossis qui se tapent les cuisses en pensant aux motos qu'ils ont achetées avec l'argent volé aux deux femmes. Un sous-titre apparaît : « Thelma et Norma, victimes d'usurpation d'identité ».

TITLE: Outfit. **CLIENT:** Citibank. **SERVICE:** Citi Identity Theft Solutions. **AGENCY:** Fallon Minneapolis. **COUNTRY:** USA. **YEAR:** 2003. **GROUP CREATIVE DIRECTOR:** John Matejczyk. **CREATIVE DIRECTOR:** Steve Driggs. **COPYWRITER:** Ryan Peck. **ART DIRECTOR:** Steve Driggs, Steve Sage. **PRODUCTION COMPANY:** Thomas Thomas. **EXECUTIVE PRODUCER:** Phillipa Thomas. **PRODUCER:** Rob van de Weteringe. **DIRECTOR:** Kevin Thomas.

A man sits in his living room and starts talking to camera. His voice is overdubbed with a woman's. She gloats on how she emptied his checking account and spent his money at the mall. After a few seconds a title appears on screen with the words, "Jake B. Identity Theft Victim." Citibank offer free identity theft solutions with every card. /// Ein Mann sitzt in seinem Wohnzimmer und beginnt, in die Kamera zu sprechen. Seine Stimme wird durch die Stimme einer Frau ersetzt. Sie brüstet sich damit, wie sie sein Bankkonto geleert und sein Geld im Einkaufszentrum ausgegeben hat. Nach wenigen Sekunden erscheinen auf dem Bildschirm die Worte: „Jake B., Opfer eines Identitätsdiebstahls." Citibank bietet bei jeder Karte kostenlose Lösungen zur Unterbindung des Identitätsdiebstahls. /// Un homme assis dans son salon commence à parler en face de la caméra. Ce n'est pas sa voix que l'on entend, mais celle d'une femme. Elle se vante d'avoir vidé le compte bancaire de l'homme et d'avoir dépensé son argent dans les magasins. Après quelques secondes, un sous-titre apparaît à l'écran : « Jake B., victime d'usurpation d'identité ». Citibank offre à ses clients détenteurs d'une carte des solutions gratuites contre l'usurpation d'identité.

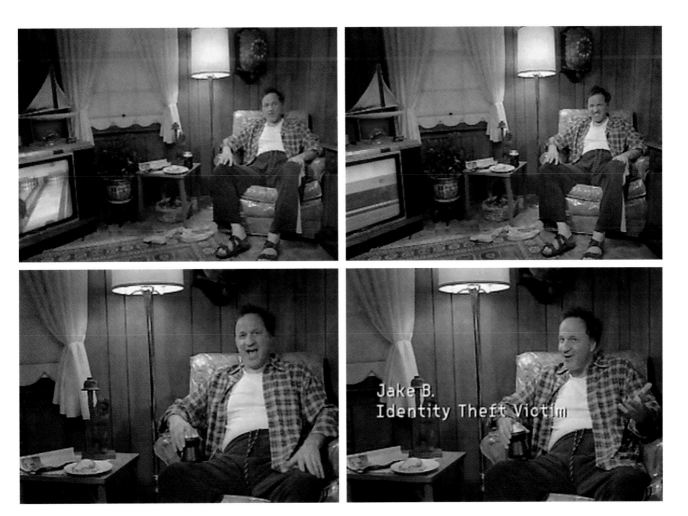

TITLE: Anthem. CLIENT: eBay. SERVICE: eBay. AGENCY: BBDO New York. COUNTRY: USA. YEAR: 2006. SENIOR CREATIVE DIRECTOR: Kara Goodrich. CREATIVE DIRECTOR: David Lubars, Bill Bruce, Greg Hahn, James Clunie. COPYWRITER: Kara Goodrich, Greg Hahn. ART DIRECTOR: James Clunie. PRODUCTION COMPANY: MJZ. DIRECTOR: Fredrik Bond. AWARDS: Cannes Lions (Shortlist).

eBay's "it" campaign reaches a climax with this spot, showing all the things that "it" can be. The end caption reads, "Whatever 'it' is, you can get it on eBay." /// Die „Es"-Kampagne von eBay erreicht mit diesem Werbespot ihren Höhepunkt. Der Spot zeigt all die Dinge, die „Es" sein können. Die abschließende Überschrift lautet: „Was auch immer ‚Es' ist, Sie bekommen es bei eBay." /// La campagne « ça » d'eBay atteint son point culminant avec ce spot qui montre tout ce que « ça » peut être. Le titre de fin s'affiche : « Quoi que ce soit, ça s'achète sur eBay ».

TITLE: Spokesman Teaser. CLIENT: eBay. SERVICE: eBay. AGENCY: BBDO New York. COUNTRY: USA. YEAR: 2006. CREATIVE DIRECTOR: David Lubars, Bill Bruce, Greg Hahn. COPYWRITER: Tom Christmann. ART DIRECTOR: Scott Kaplan. PRODUCTION COMPANY: MJZ. DIRECTOR: Fredrik Bond.

In this episode of eBay's simple yet effective promotional campaign, the "it" spokesman describes the infinite number of qualities the "it" product has. "it" can cook, vacuum and even store music. /// In dieser Episode der einfachen, aber wirkungsvollen Werbekampagne von eBay beschreibt der „Es"-Sprecher die unendliche Anzahl von Eigenschaften, die das Produkt „Es" hat. „Es" kann kochen, staubsaugen und sogar Musik speichern. /// Dans cet épisode de la campagne promotionnelle simple mais efficace d'eBay, le porte-parole du « ça » décrit les infinies qualités du produit « ça ». « Ça » peut cuire, aspirer la poussière et même enregistrer de la musique.

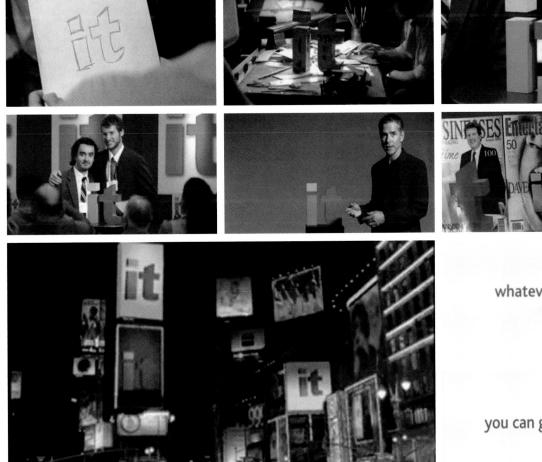

whatever **it** is

you can get **it** on
ebY

TITLE: Cube. **CLIENT:** eBay France. **SERVICE:** eBay. **AGENCY:** BETC Euro RSCG. **COUNTRY:** France. **YEAR:** 2008. **CREATIVE DIRECTOR:** Stéphane Xiberras. **COPYWRITER:** Olivier Apers. **ART DIRECTOR:** Hugues Pinguet. **PRODUCTION COMPANY:** COSA. **EXECUTIVE PRODUCERS:** Julien Pasquier, Julien Rigoulot. **DIRECTOR:** Denis Thybaud.

A white cube spins against a white background. A caption suddenly appears, "eBay is putting this ad space up for auction." Seconds later another caption pops up, "Come on TV and advertise the item you are selling on eBay." A voiceover announcement follows, "Hurry up! The auction has already started. See you at eBay.fr." /// Ein weißer Würfel dreht sich vor einem weißen Hintergrund. Plötzlich erscheint die Überschrift „eBay gibt diese Werbefläche zur Auktion frei." Sekunden später erscheint eine weitere Überschrift: „Komm ins Fernsehen und werbe für dein Produkt bei eBay." Eine Hintergrundstimme folgt mit den Worten: „Beeil dich! Die Auktion hat schon angefangen. Wir sehen uns bei eBay.fr." /// Un cube blanc tourne sur fond blanc. Une légende s'affiche soudain : « eBay met cet espace aux enchères. » Quelques secondes plus tard, une deuxième phrase apparaît : « Passez à la TV et faites la pub de l'objet que vous vendez sur eBay. » Une annonce en voix off suit : « Dépêchez-vous ! Les enchères ont déjà commencé. Rendez-vous sur eBay.fr. »

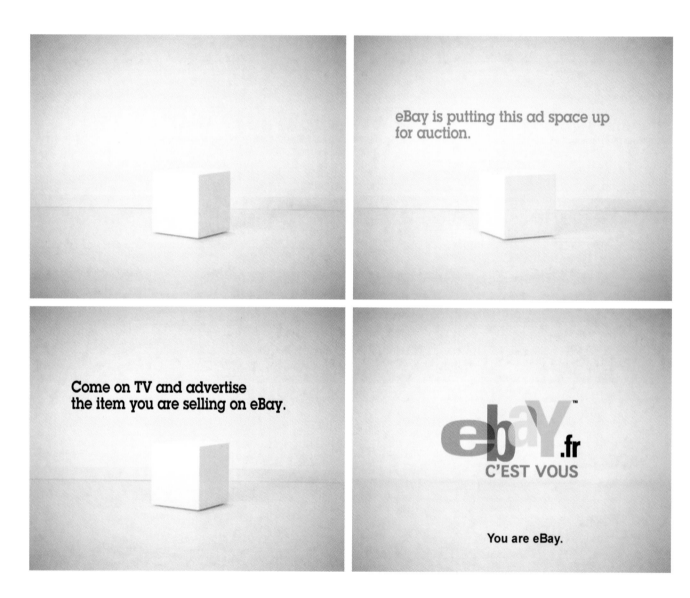

TITLE: Stick. CLIENT: FedEx. SERVICE: FedEx. AGENCY: BBDO New York. COUNTRY: USA. YEAR: 2006. CHIEF CREATIVE OFFICER: Bill Bruce, David Lubars. CREATIVE DIRECTOR: Eric Silver. COPYWRITER: Jim LeMaitre. ART DIRECTOR: Jonathan Mackler. PRODUCTION COMPANY: Partizan Entertainment. PRODUCER: Elise Greiche. DIRECTOR: Traktor. AWARDS: Super Bowl, One Show, AICP, Cannes Lions (Bronze).

A caveman ties a bone to a pterodactyl and sets it free. Suddenly it is eaten by another dinosaur. Dismayed the man returns to his cave. He tells his caveman boss that the parcel didn't make it. When the boss asks him if he used FedEx, the other replies, "No," and gets fired… "But FedEx doesn't exist yet," protests the caveman. He walks out miserably and kicks a little pterodactyl before being crushed by a giant dinosaur's foot. /// Ein Höhlenbewohner bindet einen Knochen an eine Flugechse und lässt sie frei. Plötzlich wird sie von einem anderen Dinosaurier gefressen. Der Mann kehrt bestürzt in seine Höhle zurück. Er teilt seinem Höhlen-Boss mit, dass das Paket nicht gesendet werden konnte. Als der Boss fragt, ob er FedEx benutzt hätte, antwortet der andere „Nein" und wird gefeuert… „Aber es gibt doch noch gar kein FedEx," protestiert der Höhlenbewohner. Er verlässt unglücklich die Höhle und gibt einer kleinen Flugeidechse einen Tritt, bevor er durch den Fuß eines Riesendinosauriers zerquetscht wird. /// Un homme des cavernes attache un os à la patte d'un ptérodactyle puis le laisse s'envoler. Mais le volatile se fait dévorer par un dinosaure. Consterné, l'homme retourne dans la caverne. Il dit à son chef que le colis n'est pas arrivé à bon port. Lorsque son chef lui demande s'il est passé par FedEx, il répond que non, et se fait renvoyer… « Mais FedEx n'existe pas encore ! » proteste-t-il. Frustré, il sort et donne un coup de pied à un petit dinosaure, juste avant de se faire écraser par un dinosaure géant.

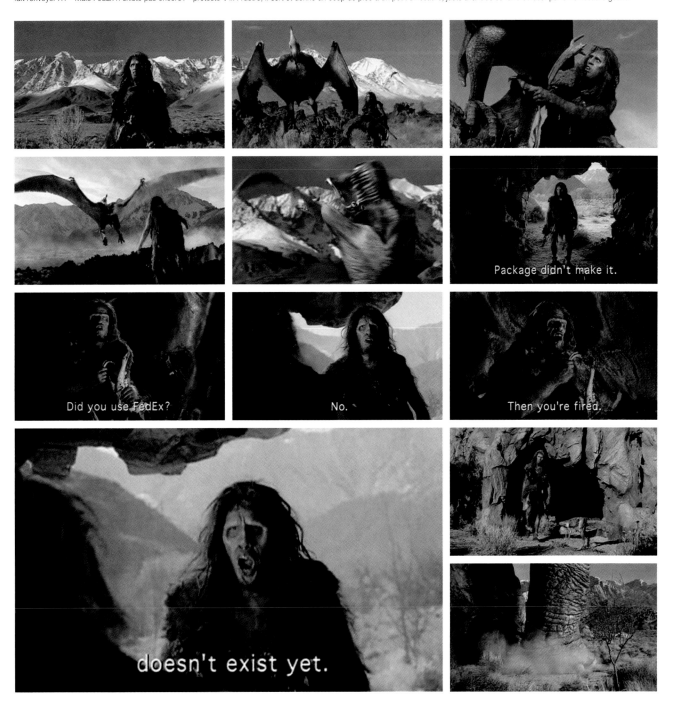

TITLE: Pigeons. CLIENT: FedEx. SERVICE: FedEx. AGENCY: BBDO New York. COUNTRY: USA. YEAR: 2008. CHIEF CREATIVE OFFICERS: David Lubars, Bill Bruce. EXECUTIVE CREATIVE DIRECTOR: Eric Silver. COPYWRITER: Reuben Hower. ART DIRECTOR: Gerard Caputo. PRODUCTION COMPANY: MJZ. EXECUTIVE PRODUCERS: Elise Greiche. DIRECTOR: Tom Kuntz.

A corporate executive tours his company mailroom to discover that the entire freight operation relies upon carrier pigeons; and for the 'big stuff' they have big pigeons. As one giant pigeon flies off, it drops a crate on the city street below where all mayhem ensues. Having witnessed enough, the executive calmly remarks to his junior, "Let's switch to FedEx." /// Der Firmenchef besichtigt die Poststelle seines Unternehmens und stellt fest, dass der gesamte Versand über Brieftauben erfolgt. Für die schweren Sachen werden große Brieftauben eingesetzt. Als eine riesige Brieftaube startet, lässt sie eine Kiste auf die Straße der Stadt unter sich fallen, wo augenblicklich Chaos ausbricht. Nachdem er genug gesehen hat, bemerkt der Firmenchef gelassen zu seinem Assistenten: „Lasst uns zu FedEx wechseln." /// Passant en revue les expéditions de son entreprise, un cadre découvre que toutes les opérations de messagerie y sont exécutées par des pigeons voyageurs ; pour les ‹ gros trucs ›, on utilise de gros pigeons. Justement, un pigeon géant prend son vol et laisse tomber une caisse dans une rue de la ville, y déclenchant un énorme grabuge. Le cadre, qui en a assez vu, lance calmement à son adjoint : « Adressons-nous à FedEx. »

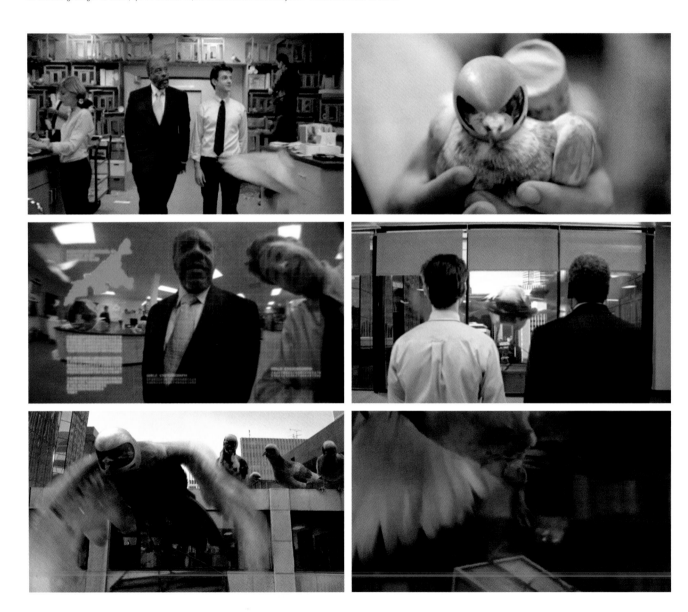

TITLE: Apology. / Insult. **CLIENT:** GEICO. **SERVICE:** Geico Car Insurance. **AGENCY:** Martin Agency. **COUNTRY:** USA. **YEAR:** 2004. **CREATIVE DIRECTOR:** Steve Bassett. **COPYWRITER:** Joe Lawson. **ART DIRECTOR:** Noel Ritter. **PRODUCTION COMPANY:** Furlined. **EXECUTIVE PRODUCER:** Adam Bloom. **PRODUCER:** Brad Powell. **DIRECTOR:** Speck, Gordon.

"It's so easy to use Geico.com a caveman can do it," announces a commercial announcer on a film set. "Not cool!" shouts a caveman boom operator, as he storms off the lot. A voice-over closes the spot with "15 minutes could save you 15 % or more on car insurance." /// „Es ist so einfach, Geico.com zu benutzen – das kann sogar ein Höhlenmensch", erklärt der Werbesprecher eines Filmsets. „Unverschämtheit!" ruft der Höhlenmensch-Tontechniker und rauscht wutentbrannt davon. Ein Sprecher schließt den Werbespot mit den Worten „Mit 15 Minuten sparen Sie 15 % oder mehr bei Ihrer Autoversicherung ein." /// « Geico.com est tellement facile à utiliser que même un homme des cavernes pourrait le faire », déclare un annonceur sur le plateau de tournage d'une publicité. « C'est pas sympa ! » crie un perchiste des cavernes en quittant le plateau. Une voix off conclut avec ces mots : « 15 minutes pourraient pour économiser 15 % ou plus sur votre assurance voiture » /// « Geico.com est tellement facile à utiliser que même un homme des cavernes pourrait le faire », déclare un annonceur sur le plateau de tournage d'une publicité. « C'est pas sympa ! » crie un perchiste des cavernes en quittant le plateau. Une voix off conclut avec ces mots : « 15 minutes pourraient pour économiser 15 % ou plus sur votre assurance voiture ».

As an apology for his onscreen insult, the ad announcer takes the cavemen film crew members to dinner. He manages to appease one, whilst the other is still hurt and decides he doesn't have an appetite. /// Als Entschuldigung für seine Beleidigung auf dem Bildschirm lädt der Werbesprecher die Mitglieder des Höhlenmenschen-Filmteams zum Abendessen ein. Es gelingt ihm, einen zu besänftigen, während der andere immer noch gekränkt ist und behauptet, keinen Hunger zu haben. /// Pour se faire pardonner son insulte, l'annonceur invite au restaurant les membres de l'équipe de tournage qui sont des hommes des cavernes. Il arrive à apaiser l'un d'eux, mais l'autre est toujours vexé et décide que cette histoire lui a coupé l'appétit.

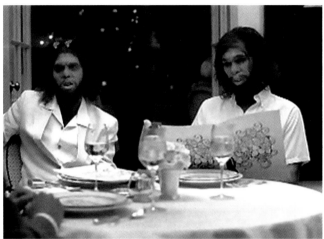

GEICO
1-800-947-AUTO

geico.com

TITLE: Aviator. **CLIENT:** JCPenney. **SERVICE:** JCPenney. **AGENCY:** Saatchi & Saatchi New York. **COUNTRY:** USA. **YEAR:** 2008. **CHIEF CREATIVE OFFICER:** Tony Granger. **CREATIVE DIRECTOR:** Michael Long, Kerry Keenan. **COPYWRITER:** Sara Rose. **ART DIRECTOR:** Lea Ladera. **PRODUCTION COMPANY:** MJZ, Los Angeles. **EXECUTIVE PRODUCER:** Lisa Margulis. **DIRECTOR:** Fredrik Bond.

A young girl watches a truck drive past with a load of Christmas trees on it and a huge billboard of Santa Claus. Teased by the neighbourhood bully, she starts building something, which catches the attention of the whole neighbourhood. Finally, she unveils a big space rocket. As she launches the North Pole Voyager, a caption appears, "Today's the day to believe… Happy Holidays." /// Ein kleines Mädchen beobachtet einen Lastwagen, der mit einer Ladung Weihnachtsbäume und einer riesigen Plakatwand in Form des Weihnachtsmannes vorbeifährt. Sie wird von dem Nachbarjungen geärgert und beginnt, etwas zu bauen, was die Aufmerksamkeit der gesamten Nachbarschaft weckt. Schließlich enthüllt sie eine große Weltraumrakete. Als sie ihre Rakete North Pole Voyager startet, erscheint der Text „Heute ist der Tag zu glauben… Schöne Ferien." /// Une petite fille regarde passer un vieux camion plein de sapins de Noël, flanqué d'un grand panneau représentant un Père Noël. Malgré les taquineries des petites brutes du quartier, elle commence à construire quelque chose, suscitant la curiosité de tout le monde. Finalement, elle dévoile un grand vaisseau spatial. Tandis qu'elle lance son Voyageur du Pôle Nord, une légende s'affiche « C'est aujourd'hui qu'il faut y croire… Bonnes vacances. »

TITLE: Commentators EURO 2008. CLIENT: MasterCard. SERVICE: MasterCard Credit Cards. AGENCY: McCann Erickson London. COUNTRY: United Kingdom. YEAR: 2008. EXECUTIVE CREATIVE DIRECTORS: Brian Fraser, Simon Learman. CREATIVE DIRECTOR: Jason Stewart. COPYWRITER: Jonny Skinner. ART DIRECTOR: Ben Brazier. PRODUCTION COMPANY: MJZ, Los Angeles. DIRECTOR: Ulf Johansson.

A soccer stadium's commentary boxes are full of screaming reporters. Various actions, from one announcer spilling coffee on his laptop to another doing a salsa dance, are accompanied by on-screen price tags. The spot closes with two microphone shields morphing into the MasterCard logo. The tagline reads, "There are some things that money can't buy. For everything else there's MasterCard." /// Die Pressekabinen eines Fußballstadions sind voller schreiender Reportern. Verschiedene Aktionen, z.B. ein Kommentator, der Kaffee über seinen Laptop verschüttet, oder ein anderer, der Salsa tanzt, werden auf dem Bildschirm mit Preisschildern versehen. Am Ende des Spots verwandeln sich zwei Mikrofon-Schilder in das Logo von MasterCard. Der Slogan lautet: „Einige Dinge kann man nicht mit Geld kaufen. Für alles andere gibt es MasterCard." /// Les box de presse du stade de foot sont bourrés de commentateurs sportifs en délire. Plusieurs actions, notamment un reporter qui renverse du café sur son ordinateur portable, ou un autre qui danse la salsa, sont soulignées à l'écran par une légende en annonçant leur prix. Le spot s'achève sur deux micros qui se transforment graduellement en logo Mastercard. Légende : « Il y a des choses que l'argent ne peut acheter. Pour tout le reste, il y a MasterCard. »

TITLE: Chair. / Tissue. **CLIENT:** Rabobank. **SERVICE:** RaboPlus. **AGENCY:** The Furnace Sydney. **COUNTRY:** Australia. **YEAR:** 2008. **COPYWRITER:** Sean Birk. **ART DIRECTOR:** Chad MacKenzie. **PRODUCTION COMPANY:** The Sweet Shop. **PRODUCER:** Lynnette Gordon. **DIRECTOR:** Mark Lever.

A new arrival at Affluents Anonymous is ushered in to pull up a chair. The screen changes to a caption, "7.80 % on call savings and no minimal balance." A voiceover announces the benefits of helping yourself "to market leading savings rate from Australia's safest bank." The RaboBank logo appears followed by a closing shot of the guest dragging an antique sofa across the room. /// Ein Neuankömmling bei den Anonymen Reichen wird gebeten, einen Stuhl zu holen und sich mit in den Kreis zu setzen. Der Bildschirm wechselt zu den Zeilen „7,80% für Sparanlagen auf Abruf und kein Mindestguthaben." Eine Hintergrundstimme erklärt die Vorteile, welche die „marktführenden Sparzinssätze der sichersten Bank Australiens" mit sich bringen. Das RaboBank-Logo erscheint, gefolgt von einer letzten Einstellung auf den Gast, der ein antikes Sofa durch den Raum zerrt. /// Un nouveau venu aux réunions des Opulents Anonymes est invité à approcher une chaise. L'écran affiche la phrase suivante « 7,80 % d'intérêts sur les dépôts à vue et pas de dépôt minimum. » Une voix off vante les bénéfices de faire appel « à la banque d'épargne la plus sûre d'Australie. » Le logo de RaboBank apparaît, suivi d'un gros plan de l'invité, qui traîne un canapé ancien à travers la pièce.

At the Affluents Anonymous meeting, one tearful member sobs, "It's just hard being this wealthy. People have started to stare." He is offered a tissue which is actually a 100-dollar bill from a silver dispenser. A caption appears, "7.80 % pa on call. No fees." A voiceover announces, "Help Yourself… to Australia's safest bank… and you too could have money problems." /// Beim Treffen der Anonymen Reichen schluchzt ein Mitglied unter Tränen: „Es ist wirklich schwer, so wohlhabend zu sein. Die Leute starren mich neuerdings an." Ihm wird ein Taschentuch aus einer silbernen Spenderdose angeboten, das in Wirklichkeit eine 100-Dollar-Note ist. Folgende Überschrift erscheint auf dem Bildschirm: „7,80% p.a. auf Abruf. Keine Gebühren." Eine Hintergrundstimme sagt: „Bedienen Sie sich … bei der sichersten Bank Australiens … und auch Sie könnten Geldprobleme haben." /// Lors d'une réunion des Opulents Anonymes, un membre pleurniche : « C'est vraiment dur d'être aussi riche. Les gens vous regardent de travers maintenant. » On lui tend un mouchoir dans une boîte en argent : c'est en fait un billet de 100 dollars. Un message s'affiche : « 7,80 % par an. Sans frais. » Une voix off annonce "Faites appel… à la banque la plus sûre d'Australie… et vous pourrez vous aussi avoir des problèmes d'argent. »

TITLE: Together. / Launch. **CLIENT:** Rabobank. **SERVICE:** RaboPlus. **AGENCY:** The Furnace Sydney. **COUNTRY:** Australia. **YEAR:** 2008. **COPYWRITER:** Sean Birk. **ART DIRECTOR:** Chad MacKenzie. **PRODUCTION COMPANY:** The Sweet Shop. **PRODUCER:** Lynnette Gordon. **DIRECTOR:** Mark Lever.

At the luxurious Affluents Anonymous clinic, a group of rich guests engage in a spot of group bonding therapy. "You too may be overwhelmed by wealth when you help yourself to leading wholesale managed funds," explains a voiceover. /// In der luxuriösen Beratungsstelle für Anonyme Reiche wirkt eine Gruppe reicher Gäste an einem Spot für therapeutisches Umarmen mit. „Auch Sie können vom Wohlstand überwältigt werden, wenn Sie bei führenden Anlagefonds im Großhandel zugreifen", erklärt eine Stimme aus dem Off. /// Dans une luxueuse clinique des Opulents Anonymes, un groupe de riches clients prend part à une thérapie de groupe. « Vous aussi vous serez accablé par l'opulence lorsque vous ferez appel aux fonds les mieux gérés du marché interbancaire, » explique une voix off.

Another session is taking place at Affluents Anonymous. A rich guest shares his angst at being judged by his wealth. "So what if I collect Superyachts," he confesses nonchalantly, "they're not even that big." As the rest of the group applaud their member's openness one woman falls over with the weight of the gold chains she is wearing. /// Bei den Anonymen Reichen findet eine weitere Sitzung statt. Ein reicher Gast berichtet von seiner Angst, anhand seines Reichtums beurteilt zu werden. „Was macht es schon, wenn ich Superyachten sammle", bekennt er lässig. „Sie sind nicht einmal besonders groß." Während der Rest der Gruppe ihrem Mitglied für seine Offenheit Beifall spendet, fällt eine Frau durch das Gewicht ihrer Goldkette hin, die sie um den Hals trägt. /// Une autre séance se déroule aux Opulents Anonymes. Un riche client partage son angoisse d'être jugé sur sa richesse. « Je collectionne les grands yachts, et alors ? » confesse-t-il nonchalamment, « ils ne sont pas si gros que ça en plus. » Tandis que le reste du groupe applaudit la franchise de ce membre, une femme se lève et tombe en avant, entraînée par le poids des chaînes d'or qu'elle porte au cou.

TITLE: Locker Room. **CLIENT:** Sprint/Nextel. **SERVICE:** Sprint/Nextel Mobile. **AGENCY:** TBWA\Chiat\Day New York. **COUNTRY:** USA. **YEAR:** 2006. **CREATIVE DIRECTOR:** Gerry Graf. **COPYWRITER:** Harold Einstein. **ART DIRECTOR:** Harold Einstein, Gerry Graf. **PRODUCTION COMPANY:** Hungry Man. **EXECUTIVE PRODUCER:** Steve Orent. **PRODUCER:** Nathy Aviram, Kevin Byrne. **DIRECTOR:** Bryan Buckley. **AWARDS:** Cannes Lions (Shortlist), Super Bowl, AICP.

Two guys in a locker room try to outwit each other by describing the features on their Sprint phones. Finally, one breaks the deadlock by telling the other about his crime deterrent feature and challenges his opponent to try to take his wallet. As the reaches for it, the other one throws his phone in his face and knocks him down. /// Zwei Männer in einem Umkleideraum versuchen, sich gegenseitig zu überflügeln, indem sie die Eigenschaften ihrer Sprint-Handys beschreiben. Schließlich setzt einer noch einen drauf und erzählt dem anderen, dass sein Handy Verbrechen abschrecken könnte. Er fordert seinen Gegner auf zu versuchen, seine Geldbörse zu nehmen. Als dieser danach greift, wirft ihm der andere sein Handy ins Gesicht und schlägt ihn nieder. /// Deux hommes dans un vestiaire rivalisent en décrivant les fonctions de leurs téléphones Sprint. L'un d'eux finit par prendre l'avantage en disant qu'il a une fonction qui décourage le vol, et défie l'autre d'essayer de prendre son portefeuille. Lorsque son adversaire tend la main pour le prendre, il lui jette son téléphone à la tête et le met à terre.

Live TV
Wireless music downloads
Email
Crime deterrent

Sprint
Together with NEXTEL

1-800-Sprint-1

TITLE: Wants/Needs Swim. **CLIENT:** Target. **SERVICE:** Target Stores. **AGENCY:** Peterson Milla Hooks. **COUNTRY:** USA. **YEAR:** 2005. **CREATIVE DIRECTOR:** David Peterson. **COPYWRITER:** Nate Morley. **ART DIRECTOR:** Thomas Ambrose. **PRODUCTION COMPANY:** Epoch Films. **PRODUCER:** Aldo Hertz. **DIRECTOR:** Matthew Badger.

Clever animation combines a variety of people in sporting and fun activities using a broad range of products available at Target Stores. The closing slogan reads, "Expect More. Pay Less." /// Eine Vielzahl von Menschen nutzt in dieser raffinierten Animation ein breites Angebot von Produkten aus dem Sport- und Spaßbereich, die in Target-Filialen verfügbar sind. Der Endslogan lautet: „Erwarte mehr. Zahle weniger." /// Cette animation ingénieuse montre toutes sortes de personnes menant des activités sportives et de loisir avec de nombreux produits en vente dans les magasins Target. Le slogan de la fin : « Demandez plus. Payez moins. »

TITLE: Bridge. **CLIENT:** Travelers Group. **SERVICE:** Travelers Insurance. **AGENCY:** Fallon Minneapolis. **COUNTRY:** USA. **YEAR:** 2006. **CREATIVE DIRECTOR:** Todd Riddle. **COPYWRITER:** Dean Buckhorn. **ART DIRECTOR:** Dean Hanson. **HEAD OF PRODUCTION:** Brian DiLorenzo. **PRODUCTION COMPANY:** Biscuit Filmworks. **EXECUTIVE PRODUCER:** Shawn Lacy Tessaro. **PRODUCER:** Sherry Baumgart, Jay Veal. **DIRECTOR:** Noam Murro.

In an age of 'evolving risks', this spot addresses the prudence of taking out Travelers Insurance. A young man invents a flying machine and jumps off a bridge to prove his invention works. All the villagers cheer, except one old man who knows he can't swim. /// In einem Zeitalter der „neuen Risiken" nimmt sich dieser Werbespot die Umsicht zum Abschluss von Reiseversicherungen zum Thema. Ein junger Mann erfindet eine Flugmaschine und springt von einer Brücke, um zu beweisen, dass seine Erfindung funktioniert. Alle Dorfbewohner jubeln, außer einem alten Mann, der weiß, dass der junge Mann nicht schwimmen kann. /// À une époque où « les risques changent », ce spot démontre qu'il est prudent de prendre une assurance Travelers. Un jeune homme invente une machine volante et saute du haut d'un pont pour prouver que son invention fonctionne. Les villageois l'applaudissent, sauf un vieil homme qui sait qu'il ne sait pas nager.

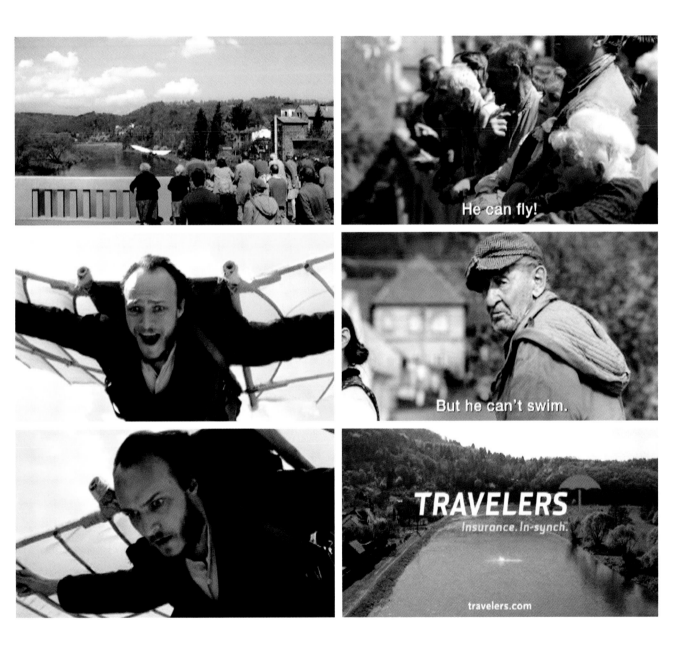

TITLE: We're All Snowflakes. **CLIENT:** Virgin Mobile. **SERVICE:** Virgin Mobile. **AGENCY:** Fallon New York. **COUNTRY:** USA. **YEAR:** 2004. **EXECUTIVE CREATIVE DIRECTOR:** Ari Merkin. **CREATIVE DIRECTOR:** Wayne Best. **COPYWRITER:** Adam Alshin. **ART DIRECTOR:** Marcus Woolcott. **PRODUCER:** Zarina Mak. **DIRECTOR:** Tom, Mike Kuntz, Maguire.

To celebrate Virgin Mobile's special K9 package offer with no contractual obligations, the Chrismahanukwanzakah team join together to sing a festive jingle. The voiceover closes with, "It's a holiday for all of us." /// Um das besondere Angebot von Virgin Mobile zu feiern – das K9-Paket ohne Vertragsbindung –, versammelt sich das Chrismahanukwanzakah-Team und singt eine festliche Werbemelodie. Der Sprecher schließt mit den Worten: „Dies ist ein Feiertag für uns alle." /// Pour fêter le pack spécial K9 de Virgin Mobile, sans obligation contractuelle, l'équipe de Chrismahanukwanzakah se rassemble pour chanter un air festif. La voix off conclut par : « C'est la fête pour tout le monde ».

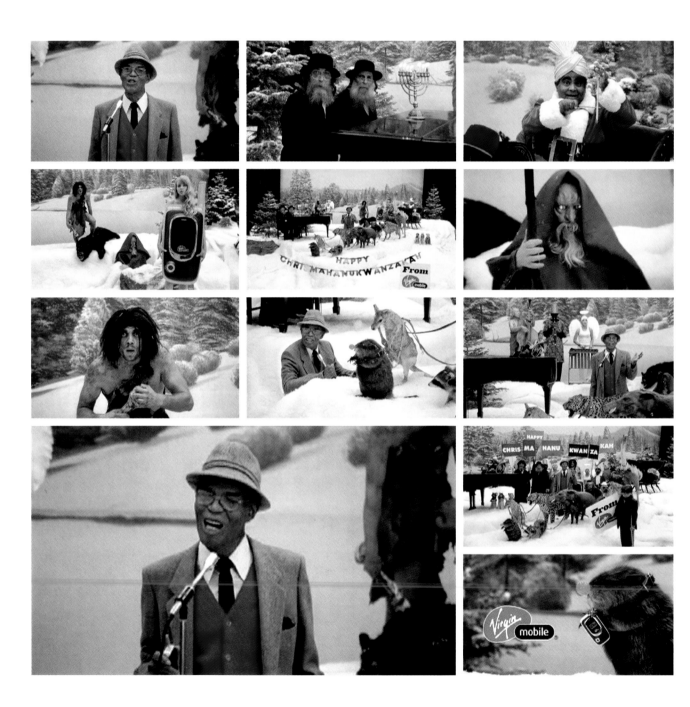

FEATURED ON THE DVD TITLE: Gay. **CLIENT:** Vodafone. **SERVICE:** Vodafone Mobile **AGENCY:** JWT London. **COUNTRY:** United Kingdom. **YEAR:** 2006. **CREATIVE DIRECTOR:** Nick Bell. **COPYWRITER:** Richard Baynham. **ART DIRECTOR:** Ian Gabaldoni. **PRODUCTION COMPANY:** Outsider, USA. **PRODUCER:** Garfield Kempton. **DIRECTOR:** David Lodge. **AWARDS:** CLIO Awards (Silver), One Show (Gold/Silver), Cannes Lions (Silver).

A son calls his father on his mobile and says, "Dad, I'm gay." The father simply answers, "Excellent!" and switches his phone off. A red screen appears and a voiceover announces, "Sometimes life's more than a three minute conversation. Talk for up to 60 minutes, pay for just 3 with Vodafone." /// Ein Sohn ruft seinen Vater auf dessen Handy an und sagt: „Papa, ich bin schwul." Der Vater antwortet nur „Großartig!" und legt dann auf. Ein roter Bildschirm erscheint, und ein Sprecher sagt: „Manchmal braucht man im Leben mehr als nur ein 3-Minuten-Gespräch. Sprechen Sie mit Vodafone bis zu 60 Minuten und bezahlen Sie nur 3." /// Un fils appelle son père sur son téléphone mobile et lui annonce : « Papa, je suis gay ». Le père se contente de répondre : « Excellent ! » et raccroche. Un écran rouge apparaît et une voix off déclare : « Certaines conversations méritent plus de 3 minutes. Avec Vodafone, parlez jusqu'à 60 minutes et payez seulement 3 minutes ».

FEATURED ON THE DVD **TITLE:** Son. **CLIENT:** Vodafone. **SERVICE:** Vodafone Mobile **AGENCY:** JWT London. **COUNTRY:** United Kingdom. **YEAR:** 2006. **CREATIVE DIRECTOR:** Nick Bell. **COPYWRITER:** Richard Baynham. **ART DIRECTOR:** Ian Gabaldoni. **PRODUCTION COMPANY:** Outsider, USA. **PRODUCER:** Garfield Kempton. **DIRECTOR:** David Lodge. **AWARDS:** CLIO Awards (Silver), One Show (Gold/Silver), Cannes Lions (Silver).

"I'm not your dad," says a man to his teenage son on a mobile phone. "That's alright," replies the son. The conversation ends. To highlight the notion many have of mobile phone costs, Vodafone encouraged consumers with a special offer of 60 minutes for the price of 3. /// „Ich bin nicht dein Vater", sagt ein Mann am Handy zu seinem Sohn im Teenageralter. „Das ist in Ordnung", antwortet der Sohn. Das Gespräch ist beendet. Um das Problem herauszustellen, das viele Menschen mit den hohen Kosten ihres Mobiltelefons haben, ermutigt Vodafone seine Kunden mit dem besonderen Angebot von 60 Minuten zum Preis von 3. /// « Je ne suis pas ton père », annonce un père à son fils adolescent sur son téléphone mobile. « C'est pas grave », répond le fils. La conversation prend fin. Pour déraciner l'idée que beaucoup d'usagers ont des coûts de la téléphonie mobile, Vodafone a encouragé les consommateurs avec une offre spéciale de 60 minutes pour le prix de 3.

Talk for 60 minutes, pay for 3.

vodafone™

TEXT 6 22 55

FEATURED ON THE DVD **TITLE:** Pregnant. **CLIENT:** Vodafone. **SERVICE:** Vodafone Mobile. **AGENCY:** JWT London. **COUNTRY:** United Kingdom. **YEAR:** 2006. **CREATIVE DIRECTOR:** Nick Bell. **COPYWRITER:** Richard Baynham. **ART DIRECTOR:** Ian Gabaldoni. **PRODUCTION COMPANY:** Outsider, USA. **PRODUCER:** Garfield Kempton. **DIRECTOR:** David Lodge. **AWARDS:** CLIO Awards (Silver), One Show (Gold/Silver), Cannes Lions (Silver).

A girl calls her father to tell him she's pregnant. "Oops!" he replies before switching his mobile off. This short spot conveys the absurdity of trying to condense an important or emergency call into an abrupt message. /// Ein Mädchen ruft ihren Vater an und sagt ihm, sie sei schwanger. „Ups!" antwortet er, bevor er sein Handy ausschaltet. Dieser kurze Werbespot vermittelt, wie absurd der Versuch ist, einen wichtigen Anruf oder einen Notfall in eine kurze Nachricht zu quetschen. /// Une fille appelle son père pour lui annoncer qu'elle est enceinte. « Oups ! » répond-il avant de raccrocher. Ce court spot explique qu'il est absurde d'essayer de condenser un appel important ou urgent dans un message brutal.

TITLE: Running Man. CLIENT: Visa. SERVICE: Visa Credit Cards. AGENCY: Saatchi & Saatchi London. COUNTRY: United Kingdom. YEAR: 2004. CREATIVE DIRECTOR: Kate Stanners. COPYWRITER: Dave Henderson. ART DIRECTOR: Richard Denney. PRODUCTION COMPANY: Partizan . DIRECTOR: Antoine Bardou-Jacquet.

A man clutching a Visa card runs naked through a desert flat. The viewer sees him running through various landscapes. Along the way he manages to find all the necessary clothing and transport to get him to his city destination – his own church wedding. The tagline reads, "Visa flows." /// Ein Mann läuft nackt durch eine flache Wüste und hält eine Visa Card fest in seiner Hand. Der Zuschauer sieht ihn durch verschiedene Gegenden laufen. Auf seinem Weg gelingt es ihm, all die nötige Kleidung und Transportmittel zu finden, die ihn in einer Stadt zum gewünschten Ziel bringen – in die Kirche, wo seine eigene Hochzeit stattfindet. Der Slogan lautet „Visa fließt." /// Nu, carte Visa en main, un homme traverse en courant une étendue désertique. Le spectateur le voit courir à travers plusieurs paysages. Chemin faisant, il parvient à trouver les vêtements et les moyens de transport nécessaires pour arriver à destination – à l'église, pour son propre mariage. En conclusion, ces mots : « Visa circule. »

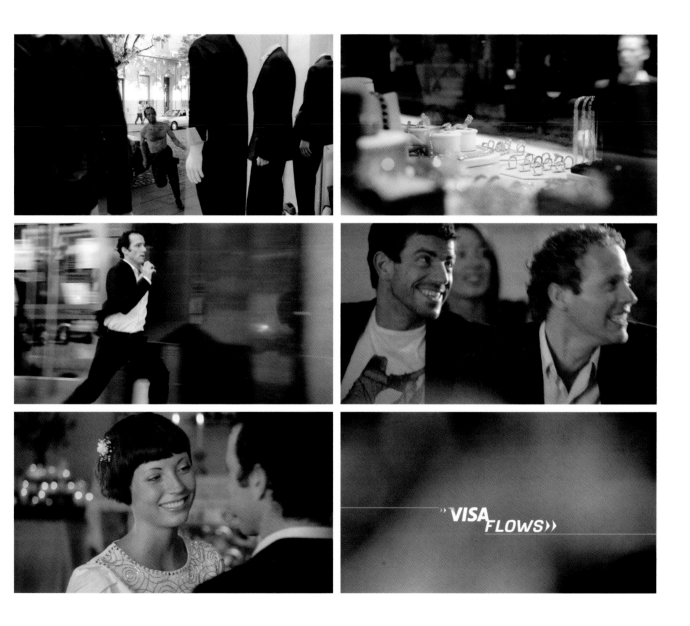

SOCIAL ADVERTISING

JUREEPORN THAIDUMRONG
FOUNDER / EXECUTIVE CREATIVE DIRECTOR OF JEH UNITED BANGKOK

Jureeporn has many years of extensive experience in the advertising business. She is one of Thailand's and, indeed, Asia's leading creatives, with an impressive track record at Leo Burnett, Y&R, Results Advertising (the second agency of Ogilvy & Mather) and Saatchi & Saatchi Bangkok. She has won awards at numerous international and regional shows, including Cannes, D&AD, Clio, Young Guns, The One Show, London International, New York Festival, Asian Advertising Awards, Asia Pacific AdFest, AWARD Australia, etc. In 2005, she established JEH United, the independent creative power-house in Thailand. In 2006, JEH United's Smooth E Baby Face Foam campaign "The Love Story" swept through award shows across the world, netting a Gold Lion at Cannes and Best of Show at both Media's Spikes (Asian Advertising Awards) and Asia Pacific AdFest. Jureeporn ended the year 2006 by receiving the industry honor of being voted Asia Pacific's "Creative of the Year" Award.

Jureeporn verfügt über langjährige umfangreiche Erfahrungen in der Werbebranche. Sie zählt zu den führenden Kreativen Thailands und ganz Asiens. Im Laufe ihrer Karriere machte sie unter anderem Station bei Leo Burnett, Y&R, Results Advertising (gehört zu Ogilvy & Mather) und Saatchi & Saatchi Bangkok. Auf zahlreichen internationalen und regionalen Werbefestivals hat sie bereits Preise gewonnen, einschließlich Cannes, D&AD, Clio, Young Guns, The One Show, London International, New York Festival, Asian Advertising Awards, Asia Pacific AdFest und AWARD Australia. 2005 gründete sie JEH United, inzwischen eine der renommiertesten unabhängigen Werbeagenturen Thailands. 2006 räumte JEH United mit der Kampagne „The Love Story" für die Gesichtspflege Smooth E Baby Face Foam weltweit zahlreiche Preise ab, darunter einen Gold Lion in Cannes und die Auszeichnung „Best of Show" bei den Spike Awards (Asian Advertising Awards) sowie beim Asia Pacific AdFest. Ende 2006 wurde Jureeporn mit dem renommierten „Asia Pacific Creative of the Year" Award geehrt.

T: Inwieweit unterscheidet sich Ihrer Meinung nach die Wirkung von TV-Werbung im Vergleich zu anderen Medien?

JT: Im Gegensatz zu anderen Massenmedien wie Radio oder Plakat erreicht Werbung im Fernsehen das Publikum auf mehreren Ebenen gleichzeitig (Bilder, Ton, Worte, Stimmung usw.). TV-Werbung hat oft eine ähnliche Wirkung wie Kinowerbung oder virale Werbung via Computer oder Mobiltelefon. Was

Jureeporn a de nombreuses années d'expérience dans le domaine de la publicité. Elle est l'un des meilleurs créateurs de Thaïlande et d'Asie, et a eu un parcours impressionnant chez Leo Burnett, Y&R, Results Advertising (la deuxième agence d'Ogilvy & Mather) et Saatchi & Saatchi Bangkok. Elle a remporté de nombreux prix nationaux et internationaux, notamment à Cannes, D&AD, Clio, Young Guns, The One Show, London International, New York Festival, Asian Advertising Awards, AdFest Asie-Pacifique, AWARD Australia, etc. En 2005, elle a fondé JEH United, le temple de la création indépendante en Thaïlande. En 2006, la campagne « Smooth E Baby Face Foam (The Love Story) » de son agence JEH United a décroché une foule de récompenses dans le monde entier, dont un Lion d'or à Cannes et le prix « Best of Show » de Media Spikes (Asian Advertising Awards) et d'AdFest Asie-Pacifique. Jureeporn a achevé l'année 2006 en beauté : ses pairs lui ont décerné le prix du Créateur de l'année pour l'Asie-Pacifique.

T : Selon vous, en quoi la télévision touche-t-elle les gens différemment des autres médias ?

JT : Un film publicitaire télévisé a des points de contact avec le public (visuels, sonores, verbaux, relatifs au ton, etc.) que les autres médias de masse tels que la presse, la radio ou les panneaux d'affichage n'ont pas. Il peut avoir un impact similaire à celui d'un spot projeté au cinéma, ou d'une vidéo virale sur ordinateur ou sur téléphone portable, mais il aura toujours un certain impact social, un effet bouche-à-oreille unique lors de

T: How do you think TV impacts on people differently from other media?

JT: A TV commercial ("TVC") has touchpoints with the audience (visuals, sound, words, mood, etc.), unlike print, radio, billboard and other mass media. It can have a slightly similar impact to cinema ads and viral ads on computers or mobiles, but a TVC still has a classic way of creating social impact, called "Talk of the Town", within its first launch. The difference between a TV ad and a cinema or viral ads is that at its launch a TVC can be seen by millions of consumers at a time, while cinema ads and viral ads can be seen by just one person or a relatively small group of people. In Thailand, there is a phenomenon where consumers sometimes concentrate on TVCs instead of TV shows or soap operas, and Thai consumers often chat with their colleagues and friends about a TVC they watched last night. A viral ad would absolutely not have this kind of impact (at least not overnight). So, I think TVCs still have more impact on people than other kinds of media.

T: What are the best three commercials you have ever seen?

JT: It is hard to decide because there are many TVCs I like. Here are some of my favorite TVCs of all time: 1) IKEA "Lamp" (Crispin Porter + Bogusky) made me feel like I was hit in the face every time I watched it. 2) Honda "Cog" (Wieden+Kennedy, UK) made me jealous that they (the creatives) could do that before I could. 3) Budweiser "Wazzup" (DBB Chicago). This is the biggest change in creative thinking for the TVC. They brought a new way of thinking to the conventional TVC.

TV-Werbung jedoch nach wie vor einzigartig macht, ist die Fähigkeit, auf Anhieb eine gesellschaftliche Wirkung zu erzeugen, das klassische „Talk of the Town"-Phänomen. Der Unterschied zwischen einer TV-Werbung und einer Kinowerbung oder viraler Werbung besteht darin, dass ein TV-Spot bei seiner Ausstrahlung von Millionen Verbrauchern gleichzeitig gesehen werden kann, während ein Kino-Spot oder ein viraler Werbespot nur relativ kleine Gruppen oder Einzelpersonen erreicht. In Thailand kommt es recht häufig vor, dass Verbraucher nicht so sehr auf TV-Shows oder Seifenopern achten, sondern vielmehr auf die TV-Werbung, und oft unterhalten sich thailändische Verbraucher mit ihren Kollegen und Freunden über eine TV-Werbung, die sie am Abend zuvor gesehen haben. Eine virale Werbung hätte auf keinen Fall so eine Wirkung (zumindest nicht über Nacht). Daher glaube ich, dass TV-Werbung nach wie vor einen größeren Einfluss auf Leute hat als andere Arten von Medien.

T: Was sind die besten drei Werbespots, die Sie je gesehen haben?

JT: Das ist schwer zu sagen, weil es so viele TV-Spots gibt, die mir gefallen. Hier sind einige meiner absoluten TV-Lieblingsspots: 1) IKEA „Lamp" (Crispin Porter + Bogusky). Jedes Mal, wenn ich diesen Spot sah, hatte ich das Gefühl, einen Schlag ins Gesicht zu bekommen. 2) Honda „Cog" (Wieden+Kennedy, UK). Da wurde ich neidisch, dass diese Kreativen mir zuvor kamen. 3) Budweiser „Wazzup" (DBB Chicago). Das ist der größte Wandel im kreativen Denken für TV-Werbung. Sie haben die konventionelle TV-Werbung um einen neuen Denkansatz bereichert.

son lancement. La différence entre un film publicitaire télévisé et un spot projeté au cinéma ou une vidéo virale est que le premier pourra tout de suite être vu par des millions de consommateurs en même temps, alors qu'au cinéma, ou avec un film viral, il ne peut être vu que par une seule personne ou un seul groupe de personnes à la fois. En Thaïlande, il y a tout un phénomène autour des films publicitaires. Parfois, les consommateurs sont plus intéressés par eux que par les émissions et les séries, et ils parlent souvent avec leurs collègues du film publicitaire qu'ils ont vu le soir précédent. Une vidéo virale n'aurait absolument pas ce type d'impact (en tout cas, pas en une nuit). Alors je pense que les spots télévisés ont plus d'effet sur les gens que les autres types de média.

T : Quels sont les 3 meilleurs spots télévisés que vous ayez jamais vus ?

JT : Il y en a tellement qui me plaisent, c'est difficile de choisir. Voici quelques-uns de mes spots télévisés préférés : 1) IKEA « Lamp » (Crispin Porter + Bogusky) — chaque fois que je le voyais, j'avais l'impression de recevoir une gifle. 2) Honda « Cog » (Wieden+Kennedy, Royaume-Uni) — ce spot m'a rendue jalouse parce qu'ils (les créatifs) l'ont fait avant moi. 3) Budweiser « Wazzup » (DDB Chicago) — ce spot représente le plus grand changement en termes de pensée créative pour les films publicitaires télévisés. Ils ont introduit une nouvelle manière de penser pour les spots conventionnels.

T : Quels sont les 3 meilleurs spots télévisés que vous avez réalisés ?

T: What are the best three commercials you have done?

JT: This is also very hard to decide. I don't really feel that I have done my best commercial yet. But if I have to choose, I would select these commercials: 1) Smooth E Babyface Foam "The Love Story Campaign." I like this campaign because it changed the face of cosmetic advertising. When you have a challenging client, it is worth it to work hard so the results come out great. 2) Thai Health Promotion Foundation "Stop Drinking, Stop Poverty." You may not understand this commercial outside Thailand, but it had wide impact on Thai citizens of every social class. 3) Sylvania "Light Man." I think it was a new way of communication six or seven years ago. The German wind energy commercial, "Power of Wind" (EPURON), which won a Cannes Gold Lion this year (2007), used the same way of thinking as the "Light Man" commercial. Let me pick one more commercial I like: SPY Wine Cooler "DJ". There's nothing too special about it, I just like it.

T: Using advertising for social causes can really drive a lot of awareness. How do you think they have contributed in the social and political field in recent decades?

JT: In the realm of social causes and public awareness messages, I've seen many great ads from many organizations such as WWF, Greenpeace, Amnesty, etc., in every medium all over the world. But in the political field I don't see much advertising of any value. However, in previous decades there were some famous campaigns in America and the UK. The two areas seem very separate to me.

T: How do you see film on the Internet competing with TV?

JT: There are plenty of these kinds of media in the form of video clips. I've seen both cheap production values and very expensive production values. The advantage of commercials on the Internet is that there is no time limit and you don't have to worry about censorship. You're free to do whatever you want and

T: Was sind die besten drei Werbespots, die Sie selbst gemacht haben?

JT: Das ist ebenfalls eine sehr schwierige Entscheidung. Ich habe eigentlich noch gar nicht das Gefühl, schon den besten Werbespot gemacht zu haben. Aber wenn ich wählen muss, dann würde ich diese Werbespots nehmen: 1) Smooth E Babyface Foam „The Love Story". Ich mag diese Kampagne, weil sie das Gesicht der Kosmetikwerbung verändert hat. Wenn man einen Kunden mit sehr hohen Ansprüchen hat, lohnt es sich, hart zu arbeiten, denn dann kommt man zu tollen Ergebnissen. 2) Thai Health Promotion Foundation „Stop Drinking, Stop Poverty". Diese Werbung versteht man außerhalb von Thailand vielleicht nicht, aber auf die thailändische Bevölkerung hatte sie quer durch alle Gesellschaftsschichten einen großen Einfluss. 3) Sylvania „Light Man". Vor sechs oder sieben Jahren war das eine ganz neue Art der Kommunikation. Die deutsche Windenergie-Werbung „Power of Wind" (EPURON), die dieses Jahr (2007) einen Goldenen Löwen in Cannes gewann, beruht auf dem gleichen Denkansatz wie die „Light Man"-Werbung. Und lassen Sie mich noch einen Werbespot nennen, den ich mag: SPY Wine Cooler „DJ". Er ist nicht wirklich außergewöhnlich, er gefällt mir einfach nur.

T: Der Einsatz von Werbung zur Bekämpfung sozialer Probleme kann wirklich viel Aufmerksamkeit schaffen. Welchen Beitrag hat Werbung Ihrer Ansicht nach in den letzten Jahrzehnten im sozialen und politischen Bereich geleistet?

JT: Im Bereich soziale Problemstellungen und öffentliche Aufmerksamkeitskampagnen habe ich viele großartige Werbungen von zahlreichen Organisationen wie WWF, Greenpeace, Amnesty usw. gesehen, die weltweit in allen Medien präsentiert wurden. Aber im politischen Bereich sehe ich kaum Werbung mit Wert. Es gab in früheren Jahrzehnten jedoch einige berühmte Kampagnen in Amerika und Großbritannien. Diese zwei Bereiche erscheinen mir jedenfalls sehr unterschiedlich.

JT : Là aussi, c'est un choix très difficile. Je crois que je n'ai pas encore fait mon meilleur spot. Mais si je dois choisir, je sélectionne les films suivants : 1) Smooth E Babyface Foam « The Love Story » — j'aime cette campagne parce qu'elle a révolutionné la publicité dans le secteur des cosmétiques. Lorsqu'on a un client très exigeant, cela vaut la peine de travailler dur pour obtenir des résultats excellents. 2) Fondation thaïlandaise de promotion de la santé « Arrêtez l'alcool, arrêtez la pauvreté » - on peut ne pas comprendre ce spot en dehors de la Thaïlande, mais il a eu un grand impact sur les Thaïlandais de toutes les classes sociales. 3) Sylvania « Light Man » - Je pense que cette forme de communication était nouvelle il y a six ou sept ans. Le film publicitaire allemand sur l'énergie éolienne « Power of Wind » (EPURON), qui a remporté un Lion d'or à Cannes cette année (2007) utilisait le même mode de pensée que le spot « Light Man ». Enfin, permettez-moi de choisir un dernier spot — SPY Wine Cooler « DJ ». Il n'a rien de vraiment spécial, mais je l'aime bien.

T : La publicité a vraiment un grand potentiel de sensibilisation aux causes sociales. Selon vous, quelle a été sa contribution aux domaines du social et de la politique ces dernières années ?

JT : Dans le domaine des messages relatifs aux causes sociales et à la sensibilisation du public, j'ai vu beaucoup de très bons spots faits par de nombreuses organisations telles que WWF, Greenpeace, Amnesty, etc., et ce sur tous les supports et partout dans le monde. Mais pour ce qui est de la politique, je n'ai pas vu beaucoup d'exemples dignes d'intérêt. Lors des décennies précédentes, il y a pourtant eu quelques campagnes à succès aux États-Unis et au Royaume-Uni. Les deux domaines me semblent complètement séparés.

T : Selon vous, comment les films sur Internet concurrencent-ils la télévision ?

JT : Il y a abondance de ces types de films, sous forme de clips vidéo. J'ai vu des productions à petit budget et des productions à très gros budget. Sur

not be restricted. This is much different from TVCs that have limited time for airing (only 10, 20 or 30 seconds) or censorship issues. So, a commercial on the Internet is easier to make, and because there is no boundary it is very hard to make it profound and interesting. When people watch the commercial on computers or mobile phones, the commercial may be easily rejected if it is dull or not interesting enough. However, it looks like everybody believes that the TVC will disappear in the near future. It will be replaced by the Internet. But I think in Thailand it may take a longer time to happen.

T: What are the biggest challenges to create a strong message, and generate reaction, for a social campaign?

JT: First of all, the commercial itself has to convince people to feel that the message it contains is directly relevant to their own lives. They have to feel that they are a part of it and have responsibilities to fix the problem, or at least feel like they want to give support to anyone who is trying to solve the problem. A social campaign will not be effective if it is just information that is dryly given to people. The creative has to find an insight relevant to everyone in society to make the commercial effective with the public. Also, the commercial should be presented in a way that everyone can participate in the problem and emphasize how people can act on it (i.e. make a phone call/donate money, etc.).

T: How do you see the integration of these media, especially for social causes where you can advertise on TV and raise funds with online donations?

JT: This is a good part of the Internet in that it helps boost support for social cause campaigns. The integration of these media can increase commercial effectiveness. Beside donation advantages, another Internet benefit is that it is a strong information source. Now, JEH United is producing the "Sufficiency Economic Theory Campaign." We plan to launch a TVC to promote this theory but the theory itself is very complicated, as it has so many con-

T: Wie konkurrieren Werbefilme im Internet Ihrer Meinung nach mit TV-Werbung?

JT: Diese Art der Werbung erscheint häufig in Form von Videoclips. In diesem Bereich habe ich schon sehr billig, aber auch sehr teuer produzierte Werbung gesehen. Der Vorteil von Internetwerbung besteht darin, dass es kein Zeitlimit gibt und man sich keine Gedanken über Zensur machen muss. Man hat mehr Freiheiten und ist nicht so eingeschränkt. Bei TV-Werbung ist es ganz anders, da gibt es Grenzen in Bezug auf die zeitliche Länge (z.B. 10, 20 oder 30 Sekunden) und auch mehr Vorschriften in Bezug auf Inhalt und Gestaltung. Internetwerbung ist also an sich leichter zu machen, aber weil es keinerlei Beschränkungen gibt, ist es sehr schwer, sie effizient zu platzieren und interessant zu gestalten. Wenn jemand eine Werbung auf einem Computer- oder Handybildschirm sieht, kann er sie sofort wegklicken, wenn sie ihm langweilig oder schlecht gemacht erscheint. Trotzdem scheinen alle davon überzeugt zu sein, dass die TV-Werbung schon bald der Vergangenheit angehören und durch die Internetwerbung verdrängt werden wird. Ich glaube jedoch, dass es in Thailand etwas länger dauern wird, bis es soweit ist.

T: Welches sind die größten Herausforderungen bei der Schaffung einer starken, Aufmerksamkeit und Reaktionen erzeugenden Botschaft für eine soziale Kampagne?

JT: Zunächst ist es wichtig, dass die Werbung selbst den Menschen auf überzeugende Weise das Gefühl vermittelt, dass die Botschaft in der Werbung eine direkte Relevanz für ihr eigenes Leben hat. Sie müssen das Gefühl bekommen, dass ihr eigenes Handeln wichtig ist und dass sie für die Lösung des Problems mit verantwortlich sind, oder sie müssen zumindest den Wunsch verspüren, anderen Menschen Unterstützung zu geben, die versuchen, das Problem zu lösen. Eine soziale Kampagne wird keine Wirkung zeigen, wenn sie den Menschen Informationen nur auf rein sachliche Art vermittelt. Der Kreative muss einen Ansatzpunkt finden, der für jedes Mitglied der Gesellschaft relevant ist, damit die Werbung eine Wirkung auf die Öffentlichkeit hat. Außerdem

Internet, l'avantage est qu'il n'y a aucune limite de temps et que l'on n'a pas à se soucier de la censure. On peut faire tout ce qu'on veut sans subir de restrictions. À la télévision, c'est très différent, car les spots ont une durée limitée (seulement 10, 20 ou 30 secondes) et peuvent être soumis à la censure. Il est donc plus facile de faire un film publicitaire pour Internet, et comme il n'y a aucune limite il est très difficile de le rendre profond et intéressant. Lorsque les gens regardent un spot sur un ordinateur ou sur un téléphone portable, ils n'ont aucune difficulté à le rejeter s'il est insipide ou qu'il manque d'intérêt. Malgré cela, il semble que tout le monde pense que les spots télévisés disparaîtront dans un avenir proche, et qu'ils seront remplacés par Internet. Mais je pense que pour la Thaïlande cela prendra peut-être un peu plus de temps.

T : Quels sont les problèmes les plus difficiles à résoudre pour créer un message fort et générer une réaction, dans le cadre d'une campagne sociale ?

JT : Tout d'abord, le film publicitaire lui-même doit faire comprendre aux gens que le message concerne directement leur propre vie. Il faut qu'ils sentent qu'ils font partie du problème et qu'ils ont la responsabilité de le résoudre, ou tout au moins qu'ils veuillent aider quiconque essaie de le résoudre. Une campagne sociale n'aura aucun effet si elle se contente de livrer aux gens des informations brutes. Pour que le spot agisse sur le public, les créatifs doivent trouver un angle qui interpellera tous les membres de la société. Le spot doit également être présenté de sorte que tout le monde puisse participer à la résolution du problème et sache quoi faire (par ex. téléphoner, faire un don, etc.).

T : Que pensez-vous de l'intégration de ces médias, en particulier pour les causes sociales pour lesquelles on peut faire de la publicité télévisée et collecter des fonds au travers de fondations sur Internet ?

JT : C'est un bon côté de l'Internet, car cela aide à renforcer l'efficacité des campagnes pour les causes sociales. L'intégration de ces médias peut augmen-

texts. So, we use online media to help give more information and examples.

T: How do you see advertising on TV these days? What changes do you see?

JT: Nowadays I don't see many interesting TVCs. In some countries such as Japan, the USA, the UK or Canada, etc., I can't separate a viral ad from a TV ad. As for the latest Cannes Lions Grand Prix TV award, I am very confused how a viral ad like the "Evolution" ad for Dove was judged in the TV category. In Thailand, I still see some fresh and original ideas in TVCs. At this moment in time, everyone around the world seems to be so interested in digital media and may think that TVCs are already out of fashion, so no one is trying to develop them. Let me ask then, "Shouldn't we try to make better TVCs any more?"

T: Can you tell us about your creative process?

JT: It is nothing unusual. I believe that great creative work is developed from a great creative brief. So here we try to get involved with the client before the brief is out. The reason for doing this is that we don't want creative work to be just a commercial that responds to a mediocre brief.

T: Is storytelling changing with more videos appearing on the Internet?

JT: I think it has a direct effect. The billions of video clips we watch on the Internet absolutely affect the thinking of the creatives who design TVCs. Lastly, I agree that film or TVCs may disappear in the near future just like many advertising gurus expect, or they may change to become just a direct sales tool. I feel great to have had an opportunity to create many TVCs. I'm proud of every commercial I've done. In my opinion, no matter how weird or crazy a viral ad is, it can't be as cool as a TVC for the reason that, with the limitations of time and censorship, a TVC can still create such a huge effect after its first launch to the public. I'm so sick and tired of watching video clips on the Internet today. There are so many that I can't find the value in them.

sollte die Werbung auf eine Weise präsentiert werden, die deutlich macht, dass jeder zur Lösung des Problems beitragen kann, und wie dieser Beitrag zur Problemlösung aussehen könnte (z. B. einen Anruf tätigen, Geld spenden usw.).

T: Wie sehen Sie die Integration dieser Medien, insbesondere bei sozialen Themen, für die man im Fernsehen Werbung machen und per Internet Spenden generieren kann?

JT: Einer der Vorteile des Internets liegt darin, dass es dazu beiträgt, die Effizienz sozialer Kampagnen zu steigern. Die Integration dieser Medien kann die kommerzielle Effektivität erhöhen. Abgesehen von der Möglichkeit der Online-Spenden bietet das Internet zudem den Vorteil, dass es eine mächtige Informationsquelle ist. JEH United produziert gerade eine Kampagne mit dem Arbeitstitel „Sufficiency Economic Theory Campaign", eine Kampagne über die Theorie der sogenannten „Selbstgenügsamen Ökonomie". Wir planen den Launch eines TV-Spots, um Werbung für diese Theorie zu machen, aber die Theorie an sich ist sehr schwierig zu erklären, weil sie so viele Aspekte hat. Deshalb nutzen wir auch Online-Medien, um zusätzliche Informationen und Beispiele zu geben.

Wie sehen Sie die heutige TV-Werbung? Welche Veränderungen sehen Sie?

JT: In der heutigen TV-Werbung sehe ich nicht viele interessante Spots. In manchen Ländern wie etwa Japan, USA, Großbritannien oder Kanada kann ich einen viralen Werbespot kaum von einem TV-Spot unterscheiden. Bei der Verleihung des letzten Grand Prix bei den Film Lions in Cannes war ich sehr überrascht darüber, dass ein viraler Film wie der Spot „Evolution" für Dove eine so hohe Auszeichnung in der Kategorie „Film" erhalten konnte. In Thailand kann ich noch immer einige neue und originelle Ideen in der TV-Werbung entdecken. Im Moment scheinen weltweit alle ein so riesiges Interesse an digitalen Medien zu haben; viele denken vielleicht, dass der TV-Werbefilm schon längst aus der Mode ist, und das könnte wiederum der Grund dafür sein, dass niemand versucht,

ter l'efficacité commerciale. Outre les avantages en matière de dons, Internet est aussi une très bonne source d'informations. En ce moment, JEH United produit une campagne sur la « théorie de la suffisance économique ». Nous prévoyons de lancer un spot télévisé pour promouvoir cette théorie, mais la théorie en elle-même est très compliquée, car elle repose sur des contextes très variés. Nous avons donc recours à Internet pour donner aux gens de plus amples informations et des exemples.

T : Que pensez-vous de la publicité télévisée en ce moment ? Quels changements voyez-vous ?

JT : Je ne vois pas beaucoup de spots intéressants à la télévision en ce moment. Dans certains pays, comme le Japon, les États-Unis, le Royaume-Uni ou le Canada, je ne fais pas la différence entre une publicité virale et un film publicitaire télévisé. En ce qui concerne le dernier Grand prix des Lions de Cannes pour la télévision, je ne comprends pas pourquoi une publicité virale telle que le film « Évolution » de Dove a concouru dans la catégorie TV. En Thaïlande, je vois encore quelques idées originales et innovantes dans les spots télévisés. En ce moment, tout le monde aux quatre coins du globe semble s'intéresser aux supports numériques et penser que les spots télévisés sont dépassés. Personne n'essaie de les développer. Alors permettez-moi de poser la question : « Ne doit-on plus essayer de faire de bons spots télévisés ? »

T : Pouvez-vous nous parler de votre processus de création ?

JT : Il n'a rien d'étrange. Je pense qu'un bon travail de création commence par une vision claire de la part du client. C'est pourquoi nous essayons de beaucoup communiquer avec le client avant qu'il ne rédige ses directives. Nous ne voulons pas que le travail de création se solde par un spot qui répond à des directives médiocres.

T : L'apparition de plus en plus de vidéos sur Internet a-t-elle changé la façon de raconter des histoires ?

« POUR QUE LE SPOT AGISSE SUR LE PUBLIC, LES CRÉATIFS DOIVENT TROUVER UN ANGLE QUI INTERPELLERA TOUS LES MEMBRES DE LA SOCIÉTÉ. »

dieses Medium weiter zu entwickeln. Da stelle ich die Frage: „Sollten wir gar nicht mehr versuchen, bessere TV-Werbefilme zu machen?"

T: Können Sie uns etwas über Ihren Kreativprozess erzählen?

JT: Daran ist nichts Ungewöhnliches. Ich glaube, dass die Grundlage für gute kreative Arbeit ein gutes kreatives Briefing ist. Wir versuchen also, die Zusammenarbeit mit dem Kunden bereits zu beginnen, bevor wir sein Briefing bekommen. Wir machen das, weil wir nicht wollen, dass kreative Arbeit bloß in einer mittelmäßigen Werbung mündet, die auf einem mittelmäßigen Briefing basiert.

T: Beobachten Sie vor dem Hintergrund der zunehmenden Anzahl von Videos, die im Internet erscheinen, Veränderungen beim Storytelling?

JT: Meines Erachtens hat das direkte Auswirkungen. Die Milliarden von Videoclips, die im Internet zu sehen sind, haben auf jeden Fall einen Einfluss auf die Denkweise der Kreativen, die TV-Werbung kreieren. Letztendlich schließe ich mich der Vorhersage vieler Werbegurus an, dass Film- oder TV-Werbung in naher Zukunft entweder ganz verschwindet oder aber sich zu einem Direktverkaufstool entwickelt. Ich bin froh darüber, dass ich die Chance hatte, viele TV-Spots zu kreieren. Ich bin stolz auf jeden Werbespot, den ich gemacht habe. Meiner Meinung nach wird kein viraler Werbespot – egal wie originell oder witzig er sein mag – einem TV-Spot jemals das Wasser reichen können, denn obwohl es bei TV-Werbung das Problem begrenzter Spotlängen und rechtlicher Vorschriften gibt, lässt sich bisher mit keinem anderen Medium auf einen Schlag eine solch große Werbewirksamkeit erzielen wie mit einem TV-Spot. Ich habe inzwischen wirklich die Nase voll davon, mir Videoclips im Internet anzusehen. Es gibt einfach zu viele, und das macht sie für mich wertlos.

JT : Je pense que cela a un effet direct. Les millions de clips vidéo que nous regardons sur Internet influencent énormément la façon de penser des créatifs qui font les spots télévisés. Enfin, je pense qu'effectivement les spots télévisés peuvent disparaître dans un avenir proche, comme de nombreux gourous de la publicité le prévoient. Ils peuvent aussi devenir un simple outil de vente directe. Je suis vraiment ravie d'avoir eu l'occasion de créer de nombreux films publicitaires pour la télévision. Je suis fière de tous ceux que j'ai réalisés. À mon avis, quel que soit le degré d'étrangeté ou de folie d'un film viral, il ne pourra jamais être aussi efficace qu'un spot télévisé car, malgré les limites de temps et la censure, un spot télévisé peut quand même avoir un effet énorme sur le public lors de son lancement. J'en ai vraiment assez de regarder des clips vidéos sur Internet. Il y en a tellement que je n'arrive pas à leur trouver de l'intérêt.

006

SOCIAL & POLITICAL

TITLE: Sugar Baby Love. **CLIENT:** AIDES. **SERVICE:** AIDS Awareness. **AGENCY:** TBWA\Paris. **COUNTRY:** France. **YEAR:** 2006. **CREATIVE DIRECTOR:** Erik Vervroegen. **COPYWRITER:** Veronique Sels. **ART DIRECTOR:** Eve Roussou. **PRODUCTION COMPANY:** Crossroads Films. **PRODUCER:** Claude Fayolle. **DIRECTOR:** Wilfred Brimo. **AWARDS:** Cannes Lions (Silver).

This animated tale tells the story of a young boy, who realizes he is gay and grows up in search of his true love. Graphically charting the trials and tribulations of his sexuality and relationships, he finally finds his dream. The moral of the story is, "Live long enough to find the right one. Protect yourself." /// Dieser animierte Werbespot erzählt die Geschichte eines Jungen, der erkennt, dass er schwul ist. Er wächst auf und sucht nach seiner wahren Liebe. Nach den anschaulichen Darstellungen seiner Versuche und Enttäuschungen in Sachen Sexualität und Beziehungen findet er schließlich seinen Traumpartner. Die Moral der Geschichte ist: „Lebe lang genug, um den Richtigen zu finden. Schütze dich." /// Ce conte animé raconte l'histoire d'un petit garçon qui réalise qu'il est homosexuel. Il grandit et cherche l'amour de sa vie. Il a plusieurs expériences sexuelles et romantiques décevantes avant que son rêve devienne enfin réalité. La morale de l'histoire : « Vivez assez longtemps pour trouver le bon. Protégez-vous ».

TITLE: Vibrators. **CLIENT:** AIDES. **SERVICE:** AIDS Awareness. **AGENCY:** TBWA\Paris. **COUNTRY:** France. **YEAR:** 2005. **CREATIVE DIRECTOR:** Erik Vervroegen. **COPYWRITER:** Véronique Sels, Erik Vervroegen. **ART DIRECTOR:** Erik Vervroegen. **PRODUCTION COMPANY:** Wanda Productions. **AWARDS:** Cannes Lions (Gold).

This highly imaginative computer animation tells the story of a young girl as she journeys sexually into womanhood. Often sad and hilarious, the viewer traces her safe sex exploits until she finally discovers true love. /// Diese sehr einfallsreiche Computeranimation erzählt die Geschichte eines jungen Mädchens, wie sie sich zur Frau entwickelt. Mal traurig oder vergnügt verfolgt der Zuschauer ihre Erfahrungen beim Safe Sex, bis sie schließlich die wahre Liebe findet. Der Schlussslogan lautet: „Lebe lang genug, um den Richtigen zu finden. Schütze dich." /// Cette animation numérique très créative raconte l'histoire d'une petite fille et son parcours au fur et à mesure qu'elle devient une femme. Le spectateur suit ses aventures sexuelles tristes et drôles, jusqu'à ce qu'elle finisse par trouver le véritable amour. Le spot se termine par ces mots : « Vivez assez longtemps pour trouver le bon. Protégez-vous ».

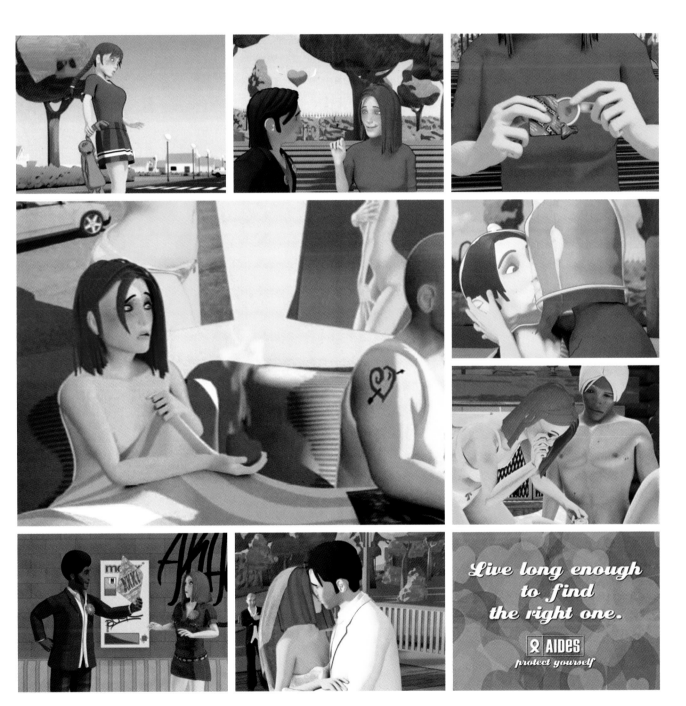

TITLE: Village. **CLIENT:** AIDES. **SERVICE:** AIDS Awareness. **AGENCY:** TBWA\Paris. **COUNTRY:** France. **YEAR:** 2004. **CREATIVE DIRECTOR:** Erik Vervroegen. **COPYWRITER:** Ghislaine De Germont. **ART DIRECTOR:** Marianne Fonferrier. **PRODUCTION COMPANY:** Suburban Films, Hamster Publicite. **DIRECTOR:** Miles Goodall. **AWARDS:** Cannes Lions (Silver).

A group of African children are playing in the countryside. A boy suddenly sees something approaching and alerts the other children. They quickly run back to the village to warn the people. Everyone deserts the streets in panic. The threat turns out to be nothing more than an old man. /// Eine Gruppe afrikanischer Kinder spielt in einer ländlichen Umgebung. Ein Junge sieht plötzlich etwas, das sich der Gruppe nähert, und warnt die anderen Kinder. Sie laufen schnell zurück ins Dorf und alarmieren die Dorfbewohner. Alle Menschen verlassen panisch die Straßen. Die Bedrohung entpuppt sich schließlich als alter Mann. Die folgenden Worte erscheinen auf dem Bildschirm: „Die durchschnittliche Lebenserwartung in Afrika beträgt 47 Jahre. Bald schon wird niemand mehr wissen, wie ein alter Mensch überhaupt aussieht." /// Des enfants africains jouent dans la nature. Soudain, un garçon voit quelque chose approcher et alerte les autres enfants. Ils courent au village prévenir les gens. Tout le monde déserte les rues, la panique règne. La menace n'était en fait qu'un vieil homme. Les mots suivants apparaissent à l'écran : « En Afrique, l'espérance de vie moyenne est de 47 ans. Bientôt, plus personne ne saura à quoi ressemble une personne du troisième âge. »

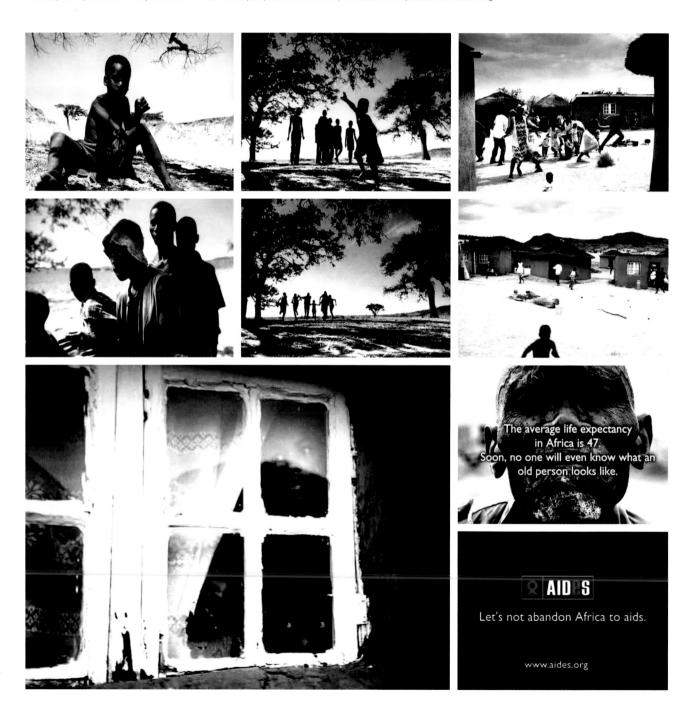

The average life expectancy in Africa is 47. Soon, no one will even know what an old person looks like.

AIDES

Let's not abandon Africa to aids.

www.aides.org

FEATURED ON THE DVD **TITLE:** Children. **CLIENT:** UNICEF. **SERVICE:** UNICEF. **AGENCY:** Saatchi & Saatchi. **COUNTRY:** Hong Kong. **YEAR:** 2000. **CREATIVE DIRECTOR:** Daniel Lim. **COPYWRITER:** Daniel Lim, Wu Jiang Xue. **ART DIRECTOR:** Vincent Pang. **PRODUCTION COMPANY:** Visual Impact. **PRODUCER:** Wu La La. **DIRECTOR:** Lee Wei Ren.

A sequence of scenes show people working in different jobs – jobs that will one day be performed by today's children. The final scene shows a teacher giving a lesson in a classroom. The spot ends with the words, "All they need is a chance to grow up like yours." /// Eine Folge von Filmszenen zeigen Menschen, die in verschiedenen Berufen arbeiten – Berufe, die eines Tages von den Kindern von heute ausgeübt werden. In der Schlussszene unterrichtet ein Lehrer in einem Klassenraum. Der Werbespot endet mit den Worten: „Sie brauchen nur die Chance, so aufzuwachsen wie Ihre Kinder. /// Plusieurs scènes montrent des gens dans l'exercice de plusieurs métiers, des métiers qui seront un jour exercés par les enfants d'aujourd'hui. La dernière scène montre un instituteur en train d'enseigner à sa classe. Le spot finit par les mots : « Tout ce dont ils ont besoin, c'est d'une chance de grandir, comme celle que vous avez eue ».

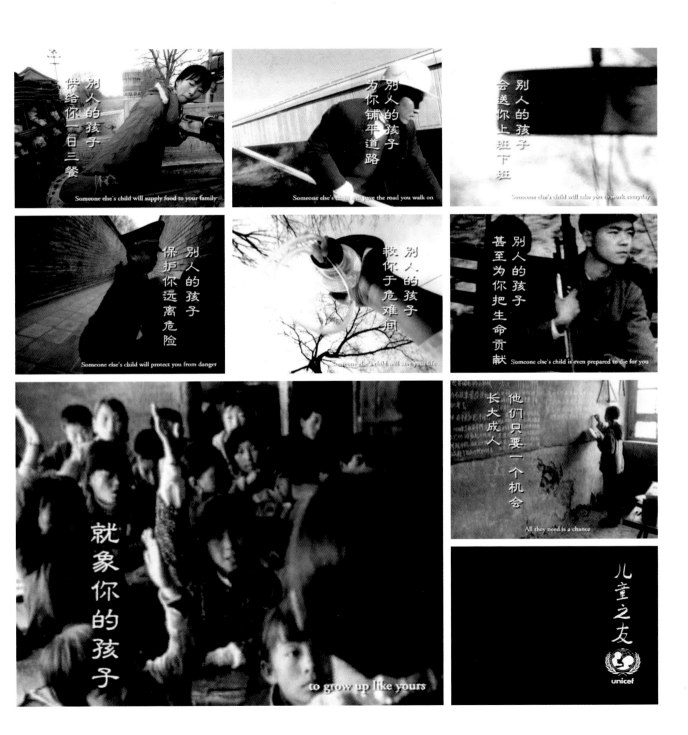

FEATURED ON THE DVD **TITLE:** Cartoon. **CLIENT:** NSPCC – National Society for the Prevention of Cruelty to Children. **SERVICE:** Anti-child Abuse. **AGENCY:** Saatchi & Saatchi London. **COUNTRY:** United Kingdom. **YEAR:** 2002.
CREATIVE DIRECTOR: David Droga. **COPYWRITER:** Howard Willmott. **ART DIRECTOR:** Duncan Marshall. **PRODUCTION COMPANY:** Gorgeous Enterprises, Passion Pictures. **DIRECTOR:** Frank Budgen, Russell Brooke. **AWARDS:**
Cannes Lions (Gold).

A man walks into his home to find his cartoon character son sitting and watching television. Slapstick cartoon music adds an eerie effect as the father inflicts horrific injuries to the animated boy. In one final act of graphic violence the father throws his son downstairs. The camera pulls back to reveal a real life unconscious child. "Real children don't bounce back." /// Ein Mann kommt nach Hause und findet seinen Sohn als Trickfilmfigur vor dem Fernseher sitzen. Der Vater fügt dem animierten Jungen schreckliche Verletzungen zu, und die Slapstick-Musik steigert den schaurigen Effekt noch zusätzlich. In einer letzten Handlung voller übersteigerter Gewalt wirft der Vater seinen Sohn die Treppe hinunter. Die Kamera fährt zurück und zeigt ein echtes bewusstloses Kind. „Echte Kinder kommen nicht wieder auf die Beine." /// Un homme rentre chez lui et trouve son fils en dessin animé assis devant la télévision. La musique comique renforce le sinistre de l'action, pendant que le père inflige des coups terribles au garçon en dessin animé. Dans un dernier accès de violence, le père jette son fils dans les escaliers. La caméra recule et révèle le corps inanimé d'un enfant de chair et d'os. « Les vrais enfants ne rebondissent pas. »

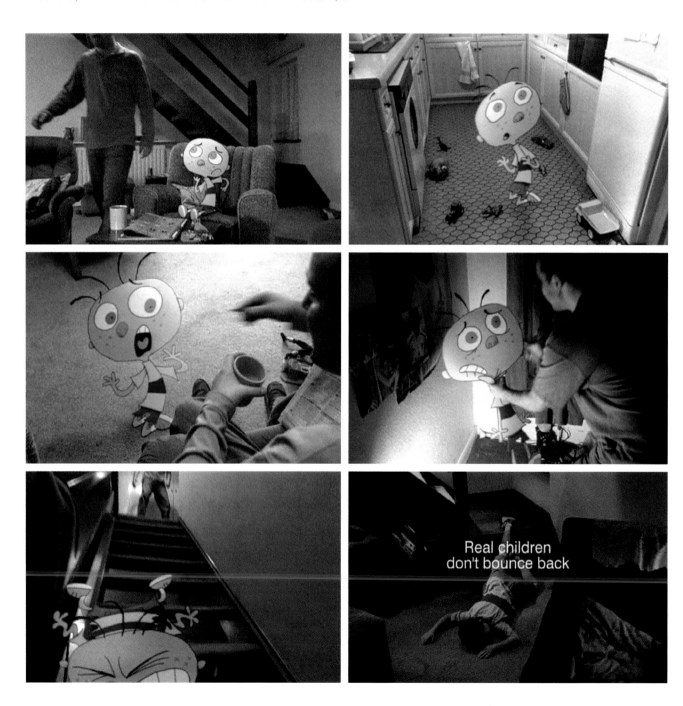

FEATURED ON THE DVD **TITLE:** Can't Look. **CLIENT:** NSPCC – National Society for the Prevention of Cruelty to Children. **SERVICE:** Anti-child Abuse. **AGENCY:** Saatchi & Saatchi London. **COUNTRY:** United Kingdom. **YEAR:** 1999. **CREATIVE DIRECTOR:** Matt Ryan, John Pallant. **COPYWRITER:** Kes Gray. **ART DIRECTOR:** Dennis Willison. **PRODUCTION COMPANY:** Malcolm Venville. **PRODUCER:** Daniel Todd. **DIRECTOR:** Malcolm Venville. **AWARDS:** Cannes Lions (Gold).

This profound spot shows a variety of well-known children's characters and heroes covering their eyes in various rooms as scenes of child abuse are heard in the background. The closing caption shows the NSPCC logo with the phrase, "Cruelty to children must stop. FULL STOP." /// Dieser tiefgründige Werbespot zeigt eine Reihe von bekannten Kinderfiguren und -helden, die in verschiedenen Räumen ihre Augen bedecken, während im Hintergrund zu hören ist, wie offensichtlich Kinder misshandelt werden. Die Schlussszene zeigt das NSPCC-Logo mit dem Satz „Grausamkeit gegenüber Kindern muss aufhören. Ganz." /// Ce spot profond montre plusieurs personnages et héros du monde des enfants qui se couvrent les yeux dans des pièces diverses pendant que l'on entend des scènes de mauvais traitements à l'arrière-plan. La dernière image montre le logo de la NSPCC (Société nationale de prévention de la cruauté envers les enfants) et la phrase : « La cruauté envers les enfants doit cesser. UN POINT C'EST TOUT. »

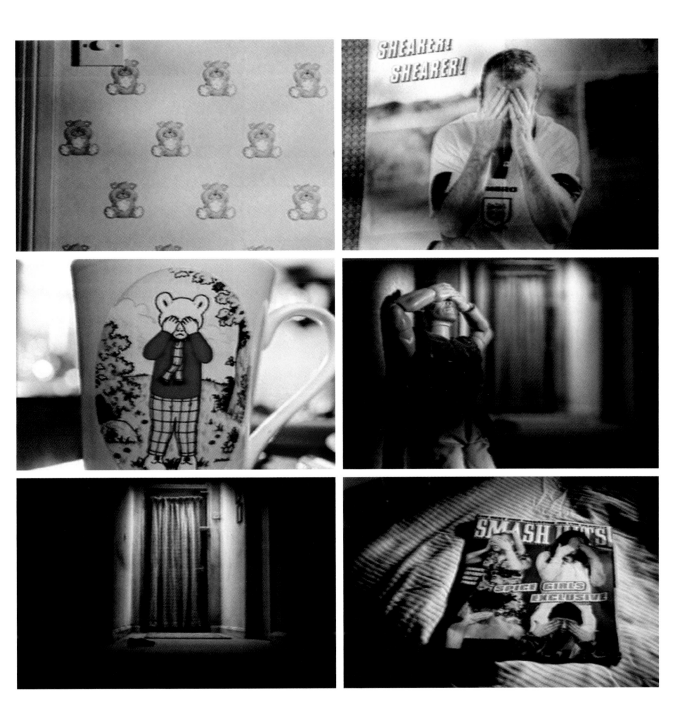

TITLE: Dad. CLIENT: BC SPCA – British Columbia Society for the Prevention of Cruelty to Animals. SERVICE: Pet Adoption. AGENCY: DDB Canada. COUNTRY: Canada. YEAR: 2004. CREATIVE DIRECTOR: Alan Russell. COPYWRITER: Paul Little. ART DIRECTOR: Lara Palmer. PRODUCTION COMPANY: Circle Productions, Hungry Man. PRODUCER: Howard Dancyger. DIRECTOR: David Shane. AWARDS: Cannes Lions (Gold).

The scene is a lakeshore. A young boy is playing 'catch' with his dad. All of a sudden the dad launches the ball into the lake and yells for the boy to go and get it, as if he were a dog. The titles fade up, "Some things you can only do with a pet." The screen fades to black and the slogan reads, "BC SPCA – Adopt soon." /// Dieser Werbespot spielt am Ufer eines Sees. Ein kleiner Junge spielt mit seinem Vater Ball. Plötzlich wirft der Vater den Ball in den See und ruft dem Jungen zu, dass er ihn holen soll, als wäre er ein Hund. Die Zeile „Manche Dinge können Sie nur mit einem Haustier machen." erscheint. Der Bildschirm wird schwarz, und der Slogan lautet: „BC SPCA – Adoptieren Sie ein verlassenes Haustier." /// L'action se déroule au bord d'un lac. Un jeune garçon est en train de jouer à la balle avec son père. Soudain, le père lance la balle dans le lac et crie à son fils d'aller la chercher, comme s'il s'agissait d'un chien. Les mots suivants apparaissent : « Il y a certaines choses que vous ne pouvez faire qu'avec un animal. L'écran devient noir, et le slogan s'affiche : « BC SPCA – Adoptez vite ».

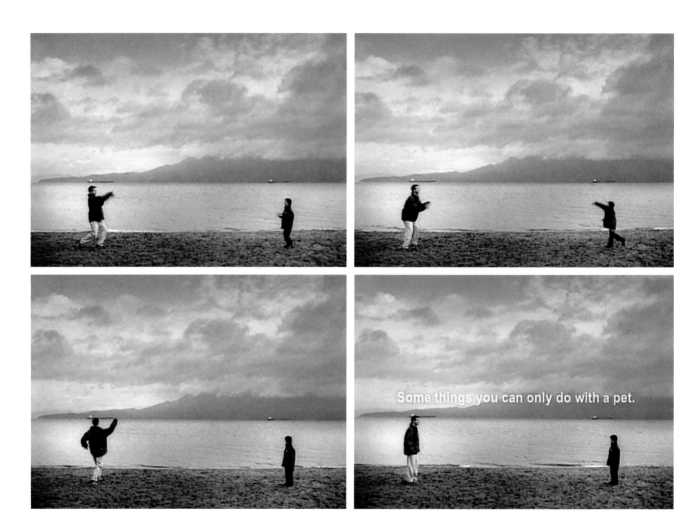

TITLE: Husband. CLIENT: BC SPCA – British Columbia Society for the Prevention of Cruelty to Animals. SERVICE: Pet Adoption. AGENCY: DDB Canada. COUNTRY: Canada. YEAR: 2004. CREATIVE DIRECTOR: Alan Russell. COPYWRITER: Paul Little. ART DIRECTOR: Lara Palmer. PRODUCTION COMPANY: Circle Productions, Hungry Man. PRODUCER: Howard Dancyger. DIRECTOR: David Shane. AWARDS: Cannes Lions (Gold).

A woman opens her kitchen fridge to get a snack. Her husband creeps up behind her and cuddles her from behind. "Who's my chubby one?" He starts patting her stomach as if she's a dog. She turns around and gives him a stern look, "Don't do that!" The titles fade up, "Some things you can only do with a pet." The screen fades to black and the slogan reads, "BC SPCA – Adopt soon." /// Eine Frau öffnet die Kühlschranktür, um sich einen Snack herauszuholen. Ihr Mann schleicht sich von hinten an sie heran und drückt sie mit den Worten „Wo ist denn mein Moppelchen?" an sich. Er beginnt ihren Bauch zu tätscheln, als wäre sie ein Hund. Sie dreht sich um und wirft ihm einen ernsten Blick zu: „Lass das!" Die Worte „Manche Dinge können Sie nur mit einem Haustier machen." erscheinen. Der Bildschirm wird schwarz, und der Slogan lautet: „BC SPCA – Adoptieren Sie ein verlassenes Haustier." /// Une femme ouvre son réfrigérateur à la recherche d'un en-cas. Son mari se faufile derrière elle et la prend dans ses bras. « C'est qui ma pépette ? » Il commence à lui tapoter le ventre comme si elle était une chienne. Elle se retourne et le regarde sévèrement : « Ne fais pas ça ! » Les mots suivants apparaissent : « Il y a certaines choses que vous ne pouvez faire qu'avec un animal ». L'écran devient noir, et le slogan s'affiche : « BC SPCA – Adoptez vite ».

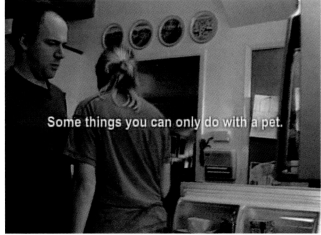

FEATURED ON THE DVD **TITLE:** Alzheimers. **CLIENT:** Instituto de Apoio à Criança. **SERVICE:** Anti-child abuse. **AGENCY:** Leo Burnett Lisbon. **COUNTRY:** Portugal. **YEAR:** 2006. **CREATIVE DIRECTOR:** Fernando Bellotti. **COPYWRITER:** Fernando Bellotti, R. Corsaro. **ART DIRECTOR:** Fernando Bellotti, P. Arêas. **PRODUCTION COMPANY:** Republika Filmes. **PRODUCER:** Regina Costa. **DIRECTOR:** Carlos Manga Junior. **AWARDS:** Cannes Lions (Gold).

A woman visits her elderly mother in an Alzheimer's clinic. She doesn't recognize her and thinks the nurse is her aunt. The old lady then mutters that she wants to be hidden under the bed, and says, "My father should be here soon". The slogan simply reads, "An abused child never forgets." /// Eine Frau besucht ihre alte Mutter in einer Alzheimer-Klinik. Die Mutter erkennt sie nicht und denkt, dass die Krankenschwester ihre Tante ist. Die alte Dame murmelt dann, dass sie unter dem Bett versteckt werden will und sagt: „Mein Vater ist gleich hier." Der Slogan lautet einfach: „Ein missbrauchtes Kind vergisst nie." /// Une femme visite sa mère dans une clinique pour malades atteints d'Alzheimer. Cette dernière ne la reconnaît pas, et croit que l'infirmière est sa tante. Elle murmure qu'elle veut qu'on la cache sous le lit et dit : « Mon père va bientôt rentrer ». Le slogan déclare simplement : « Un enfant maltraité n'oublie jamais ».

TITLE: Whale. **CLIENT:** Japan Advertising Council. **SERVICE:** Children's Foundation Appeal. **AGENCY:** Dentsu. **COUNTRY:** Japan. **YEAR:** 2002. **CREATIVE DIRECTOR:** Akira Kagami. **PRODUCTION COMPANY:** Dentsu Tec. **PRODUCER:** Hidehiko Kawasaki. **DIRECTOR:** Masahiro Takata. **AWARDS:** Cannes Lions (Silver).

A teacher instructs her class to draw anything they want. One boy keeps filling sheet after sheet of paper with black crayon. Worried, his teacher visits the boy's parents, who in turn take him to see a psychiatrist. By chance they put the sheets together and realise he has created a full size whale. The caption reads, "How can you encourage a child? Use your imagination. Support the Children's Foundation." /// Eine Lehrerin gibt ihren Schülern die Aufgabe, ein Bild nach ihren Wünschen zu malen. Ein Junge bemalt einen Bogen Papier nach dem anderen mit seinem schwarzen Stift. Beunruhigt besucht die Lehrerin die Eltern des Jungen, die ihn wiederum einem Psychiater vorstellen. Zufällig legen sie die Papierbögen zusammen und erkennen, dass der Junge einen Wal in Lebensgröße geschaffen hat. Der Slogan lautet: „Wie können Sie ein Kind bestärken? Benutzen Sie Ihre Vorstellungskraft. Unterstützen Sie die Children's Foundation." /// Une institutrice demande à ses élèves de dessiner ce qu'ils veulent. Un petit garçon remplit des dizaines de feuilles de papier de crayon noir. L'institutrice, inquiète, rend visite aux parents de l'enfant, qui l'emmènent voir un psychiatre. Par pur hasard, ils assemblent les feuilles et réalisent qu'il a dessiné une baleine grandeur nature. Les mots suivants apparaissent : « Comment pouvez-vous encourager un enfant ? Faites marcher votre imagination. Soutenez la Fondation pour l'enfance ».

TITLE: Execution / Peepshow. **CLIENT:** Nobody's Children Foundation/Nask. **SERVICE:** Safer Internet Academy Program. **AGENCY:** McCann Erickson Polska. **COUNTRY:** Poland. **YEAR:** 2008. **CREATIVE DIRECTOR:** Iwona Kluszczynska, Wojtek Dagiel. **COPYWRITER:** Robert Olszewski, Blanka Lipinska, Magda Komorek. **ART DIRECTOR:** Blanka Lipinska. **PRODUCTION COMPANY:** Dynamo Films, Warsaw. **PRODUCER:** Mira Klajnberg, Pawel Mrowka. **DIRECTOR:** Frank Vroegop.

A blindfolded man is being dragged along by armed soldiers. Just as the commander signals to the firing squad to shoot, he notices a young boy with a baseball cap standing nearby eating chips. When asked what he is doing there, the young boy replies, "I'm surfing the net." The spot closes with a black screen and the caption, "Care about surfing children." /// Ein Mann mit verbundenen Augen wird von bewaffneten Soldaten einen Weg entlang gezerrt. Gerade als der Befehlshaber dem Exekutionskommando das Signal zum Schießen gibt, bemerkt er einen kleinen Jungen mit Baseballkappe, der in der Nähe steht und Chips isst. Als er den Jungen fragt, was er dort macht, antwortet dieser: „Ich surfe im Internet." Der Werbespot endet mit einem schwarzen Bildschirm und dem Text „Achten Sie darauf, wo Ihre Kinder surfen." /// Des soldats armés traînent un homme aux yeux bandés. Juste au moment où il va donner au peloton l'ordre de tirer, l'officier remarque un enfant coiffé d'une casquette de baseball, qui observe la scène en mangeant des chips. Interrogé sur la raison de sa présence en ces lieux, le gamin répond : « Je surfe sur Internet. » Le spot conclut sur un écran noir avec ces mots « Attention aux enfants qui surfent. »

This poignant spot warns of the dangers of explicit content that children are exposed to on the Internet. A stripper performs a provocative dance at a peepshow. Suddenly she turns and sees that she is being watched by a young girl. "What are you doing here girly?" asks the surprised woman. "I'm surfing the net," replies the child. /// Dieser ergreifende Werbespot warnt vor den Gefahren, denen Kinder im Internet beim Betrachten bestimmter Websites ausgesetzt sind. Eine Stripperin tanzt provokativ in einer Peepshow. Plötzlich dreht sie sich um und sieht, dass sie von einem kleinen Mädchen beobachtet wird. „Was machst du hier, Kleine?" fragt die überraschte Frau. „Ich surfe im Internet", antwortet das Kind. /// Ce spot émouvant met en garde contre les dangers des contenus explicites auxquels les enfants sont exposés sur Internet. Une stripteaseuse exécute une danse provocante dans un peep-show. Soudain, elle se retourne et voit qu'une petite fille la regarde. « Qu'est-ce que tu fais ici, petite ? » demande-t-elle, surprise. « Je surfe sur Internet » répond l'enfant.

FEATURED ON THE DVD **TITLE:** Girl. / Boy. **CLIENT:** Pediatric Cardiac Surgery Foundation. **SERVICE:** Pediatric Cardiac Surgery Foundation. **AGENCY:** Leo Burnett Thailand. **COUNTRY:** Thailand. **YEAR:** 2006. **CREATIVE DIRECTOR:** Keeratie Chaimoungkalo, Sompat Trisadikun. **COPYWRITER:** Keeratie Chaimoungkalo, Noranit Yasopa. **ART DIRECTOR:** Sompat Trisadikun. **PRODUCTION COMPANY:** Open Up. **PRODUCER:** Phatcharin Tarnpornsree. **DIRECTOR:** Montri Lerdsuwan-sri. **AWARDS:** Cannes Lions (Shortlist).

A young girl comes into shot as she walks along a narrow street. She crouches down and takes out some food. A group of puppies run up to her to receive their treats. A caption appears on the screen with the words, "She has a good heart, because someone with a good heart gave it to her." The spot closes with a close up of the girl smiling as she shows her surgery scars. /// Ein junges Mädchen tritt ins Bild und läuft eine enge Straße entlang. Sie hockt sich hin und packt Futter aus. Eine Gruppe junger Hunde läuft zu ihr hin, um ihre Leckerbissen zu bekommen. Auf dem Bildschirm erscheinen die Worte: „Sie hat ein gutes Herz, weil jemand mit einem guten Herzen ihr es gegeben hat." Der Spot endet mit der Nahaufnahme des Mädchens, das lächelnd seine Operationsnarben zeigt. /// Une petite fille marche dans une rue étroite. Elle se baisse et sort de la nourriture. Des chiots courent vers elle pour recevoir ses présents. Les mots suivants apparaissent à l'écran : « Elle a bon cœur, parce que quelqu'un qui avait bon cœur lui a donné le sien ». Le spot se termine par une image de la fillette, souriante, qui montre les cicatrices de son opération.

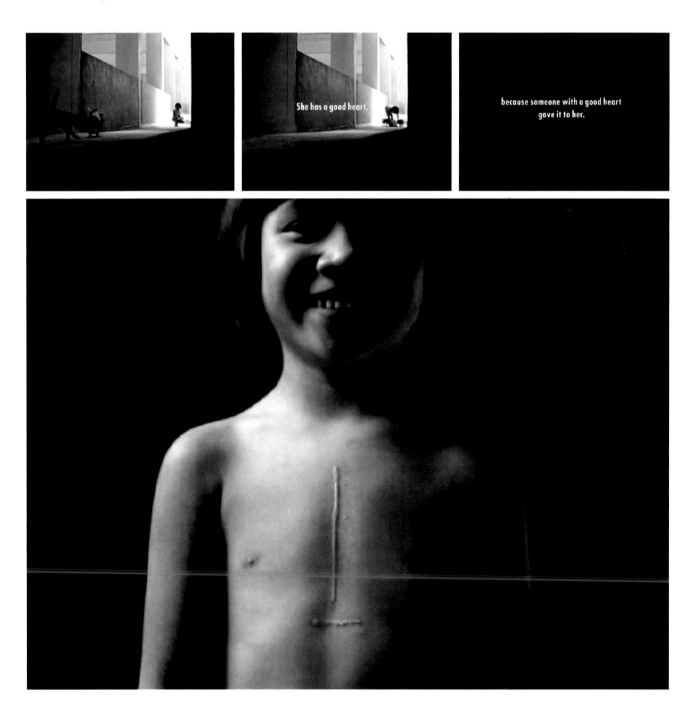

An old lady sits begging on a bridge as the city-goers pass by. Only one young boy stops to give her some change. A caption fades up, "He has a good heart … because someone with a good heart gave it to him." The ad closes with the smiling young boy showing his heart transplant scars. /// Eine alte Frau sitzt bettelnd auf einer Brücke, während die Passanten an ihr vorbeigehen. Nur ein kleiner Junge bleibt stehen und gibt ihr etwas Kleingeld. Die folgende Überschrift erscheint: „Er hat ein gutes Herz … weil jemand mit einem guten Herzen es ihm gegeben hat." Der Spot endet mit dem lächelnden Jungen, der die Narben seiner Herztransplantation zeigt. /// Assise sur un pont, une vieille dame demande l'aumône aux passants. Seul un petit garçon lui donne quelques pièces. Une légende s'affiche « Il a bon cœur … parce que quelqu'un qui avait bon cœur lui a donné le sien. » La pub se termine par une image de l'enfant, souriant, qui montre les cicatrices de son opération.

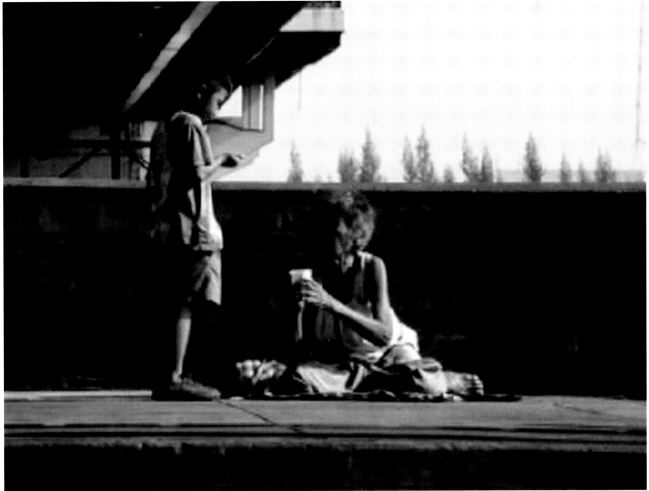

TITLE: One In Four. CLIENT: Womankind Worldwide. SERVICE: Womankind Day Appeal. AGENCY: Rainey Kelly Campbell Roalfe Y&R. COUNTRY: United Kingdom. YEAR: 2002. CREATIVE DIRECTOR: Mike Boles, Jerry Hollens. COPYWRITER: Mike Boles. ART DIRECTOR: Jerry Hollens. PRODUCTION COMPANY: Thomas Thomas. PRODUCER: Philippa Thomas. DIRECTOR: Kevin Thomas. AWARDS: Cannes Lions (Silver).

A man counts aloud the number of women he passes down the street. Every fourth woman he passes is either verbally abused or assaulted by him. A voiceover announces that "one in four women in the UK will suffer violent abuse by men." As the man passes another third woman he enters his house. The voiceover continues, " … usually it's behind closed doors." The tagline reads, "Buy a white ribbon for Womankind day." /// Ein Mann zählt laut die Frauen, denen er auf der Straße begegnet. Jede vierte Frau, an der er vorbeigeht, wird von ihm verbal angegriffen oder beleidigt. Ein Sprecher sagt, dass „in Großbritannien eine von vier Frauen gewaltsamen Missbrauch durch Männer erfährt." Nachdem der Mann wieder an einer dritten Frau vorbeigegangen ist, betritt er sein Haus. Der Sprecher fährt fort, „ … gewöhnlich hinter geschlossenen Türen." Der Slogan lautet: „Kauf ein weißes Band für den Frauenwelt-Tag." /// Un homme compte à voix haute le nombre de femmes qu'il croise dans la rue. Chaque fois qu'il arrive à quatre, il l'agresse verbalement ou physiquement. Une voix off annonce : « En Grande-Bretagne, une femme sur quatre sera agressée par un homme ». L'homme rentre chez lui, son compte vient d'arriver à trois. La voix off continue : « … cela se passe souvent dans l'intimité du foyer ». Ces mots apparaissent : « Achetez un ruban blanc pour la journée des femmes ».

FEATURED ON THE DVD TITLE: Prison. **CLIENT:** Pedestrian Council of Australia. **SERVICE:** Anti-Drink Driving Message. **AGENCY:** Saatchi & Saatchi Australia. **COUNTRY:** Australia. **YEAR:** 2001. **CREATIVE DIRECTOR:** Michael Newman. **COPYWRITER:** Jay Furby. **ART DIRECTOR:** Jay Furby. **PRODUCTION COMPANY:** Silverscreen Productions. **PRODUCER:** Scott McBurnie. **DIRECTOR:** David Gaddie. **AWARDS:** Cannes Lions (Gold).

Mark "Chopper" Read, Australia's infamous murderer, describes the injuries he received from inmates during his 23 years behind bars. Chopper says, "If you drink and drive and kill someone, you'd better pray to God you don't go to prison." /// Der berüchtigte australische Mörder Mark „Chopper" Read beschreibt, welche Verletzungen ihm seine Zellengenossen während seiner 23 Jahre hinter Gittern zugefügt haben. Chopper sagt: „Wenn Sie trinken und Auto fahren und jemanden töten, beten Sie besser zu Gott, dass Sie nicht ins Gefängnis müssen." /// Mark « Chopper » Read, un assassin tristement célèbre en Australie, décrit les blessures qui lui ont été infligées par des détenus au cours des 23 ans qu'il a passés en prison. Il conclut par : « Si vous conduisez en état d'ivresse et que vous tuez quelqu'un, il ne vous reste plus qu'à prier pour ne pas aller en prison ».

MARK 'CHOPPER' READ

A KILLER IS A KILLER

DON'T DRINK AND DRIVE

PEDESTRIAN COUNCIL OF AUSTRALIA

FEATURED ON THE DVD TITLE: Delay. CLIENT: Thai Health Promotion Foundation. SERVICE: Anti-drink driving. AGENCY: Saatchi & Saatchi Thailand. COUNTRY: Thailand. YEAR: 2004. CREATIVE DIRECTOR: Jureeporn Thaidumrong. ASSOCIATE CREATIVE DIRECTOR: Thana Rittirajcomporn. COPYWRITER: Prasert Vijitpawan, Wiparat Nantananontchai. ART DIRECTOR: Thayavee Nithipitigan. PRODUCTION COMPANY: Phenomena. PRODUCER: Piyawan Mungkung. DIRECTOR: Thanonchai Sornsriwichai.

"Expect your body to respond 40 % slower when you drink," announce a voiceover as a man empties an entire bottle of spirits into an overflowing glass. A sequence of clips show the man's delayed reactions, culminating with him running over a child in his car. A few seconds later the words, "Drink; Don't Drive" appear on a black screen. We hear a car screech to a halt. /// „Wenn Sie Alkohol getrunken haben, reagiert Ihr Körper bis zu 40 % langsamer", erklärt ein Sprecher, während ein Mann eine ganze Flasche Alkohol in ein überlaufendes Glas entleert. Eine Folge von Filmclips zeigt die verzögerten Reaktionen des Mannes, was dazu führt, dass er mit seinem Auto ein Kind überfährt. Auf einem schwarzen Bildschirm erscheinen einige Sekunden später die Worte „Trinken; Nicht fahren". Wir hören die Bremsen eines Wagens kreischen, bis der Wagen zum Stillstand kommt. /// « Votre corps réagit 40 % moins vite lorsque vous avez bu », annonce une voix off pendant qu'un homme vide toute une bouteille d'alcool dans un verre qui déborde. Une série de clips montre ses réactions ralenties, jusqu'au moment où il renverse un enfant avec sa voiture. Quelques secondes plus tard, les mots « Si vous buvez, ne conduisez pas » apparaissent sur un écran noir. On entend le crissement des freins d'une voiture.

FEATURED ON THE DVD **TITLE:** Bar Fight. **CLIENT:** Thai Health Promotion Foundation. **SERVICE:** Anti-alcohol Abuse. **AGENCY:** Saatchi & Saatchi Thailand. **COUNTRY:** Thailand. **YEAR:** 2004. **CREATIVE DIRECTOR:** Jureeporn Thaidumrong. **COPYWRITER:** Prasert Vijitpawan, Krai Klittikorn. **ART DIRECTOR:** Supon Khaotong, Nuntawat Chaipornkaew. **PRODUCTION COMPANY:** Phenomena. **PRODUCER:** Piyawan Mungkung. **DIRECTOR:** Thanonchai Sornsriwichai.

The spot opens in a busy downtown bar. Two guys are seen wrapping bottles with cushions and gluing their table and chairs together. After some time the drunken men get embroiled in a fight. Thanks to their foresight, no bottles, chairs or tables get smashed. /// Der Werbespot zeigt eine gut gefüllte Bar in der Innenstadt. Zwei Männer umwickeln Flaschen mit Schaumstoff und kleben ihre Tische und Stühle zusammen. Nach einiger Zeit fangen die betrunkenen Männer eine Prügelei an. Dank ihrer Voraussicht werden dabei keine Flaschen, Stühle oder Tische zertrümmert. /// L'action se déroule dans un bar très fréquenté dans le centre d'une ville. On voit deux hommes en train d'envelopper des bouteilles avec des coussins et de coller leur table et leurs chaises. Quelque temps plus tard, ils sont ivres et se retrouvent mêlés à une bagarre. Grâce à leur prévoyance, les bouteilles, les tables et les chaises s'en sortent sans aucun dégât.

FEATURED ON THE DVD **TITLE:** Domestic Violence. **CLIENT:** Thai Health Promotion Foundation. **SERVICE:** Anti-alcohol Abuse. **AGENCY:** Saatchi & Saatchi Thailand. **COUNTRY:** Thailand. **YEAR:** 2004. **CREATIVE DIRECTOR:** Jureeporn Thaidumrong. **COPYWRITER:** Prasert Vijitpawan, Krai Klittikorn. **ART DIRECTOR:** Supon Khaotong, Nuntawat Chaipornkaew. **PRODUCTION COMPANY:** Phenomena. **PRODUCER:** Piyawan Mungkung. **DIRECTOR:** Thanonchai Sornsriwichai.

A hen pecked husband turns his punchbag into an effigy of his wife before storming out. A few hours later he is drunk at a bar with his friend. His wife rings his mobile phone and the pair start yelling at each other. He rushes home and we can hear punches and screams. The shot cuts to the husband taking his anger out on his punchbag. The closing caption reads, "How well do you handle your drinking?" /// Ein geplagter Ehemann wandelt seinen Boxsack in das Ebenbild seiner Frau um, bevor er aus dem Haus stürmt. Wenige Stunden später betrinkt er sich mit seinem Freund in einer Bar. Seine Frau ruft ihn auf seinem Handy an, und das Paar fängt an, sich anzubrüllen. Er eilt nach Hause, und Schläge und Schreie sind zu hören. Die Kamera zeigt den Ehemann, der seine Wut an seinem Boxsack auslässt. Der Schlussslogan lautet: „Wie gut haben Sie Ihr Trinken im Griff?" /// Un mari harcelé transforme son sac de boxe en effigie de sa femme avant de sortir. Quelques heures plus tard, il se saoule dans un bar avec un ami. Sa femme l'appelle sur son mobile et les cris fusent. Il rentre chez lui, et l'on entend des coups et des cris. Le mari apparaît à l'image, il est en train de décharger sa colère sur son sac de boxe. Le spot se conclut par les mots suivants : « Savez-vous vous contrôler lorsque vous buvez ? »

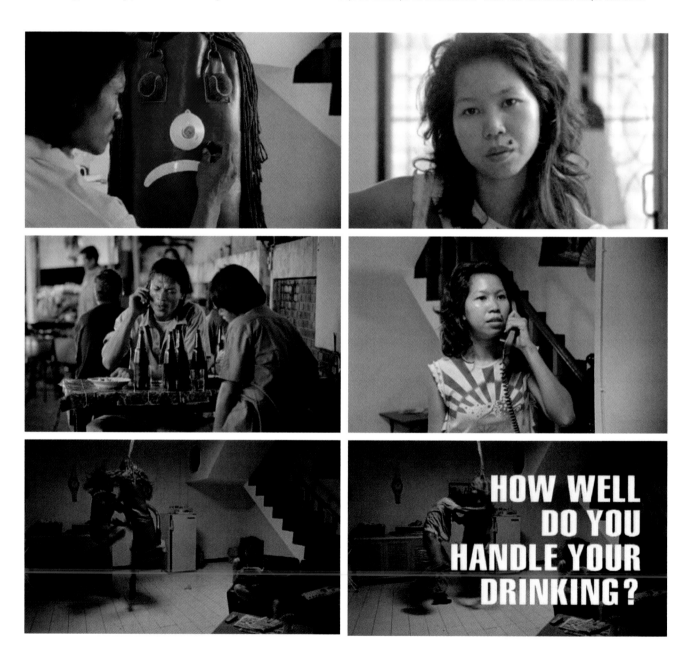

TITLE: Sexual Harassment. **CLIENT:** Thai Health Promotion Foundation. **SERVICE:** Anti-alcohol Abuse. **AGENCY:** Saatchi & Saatchi Thailand. **COUNTRY:** Thailand. **YEAR:** 2004. **CREATIVE DIRECTOR:** Jureeporn Thaidumrong. **COPYWRITER:** Prasert Vijitpawan, Krai Klittikorn. **ART DIRECTOR:** Supon Khaotong, Nuntawat Chaipornkaew. **PRODUCTION COMPANY:** Phenomena. **PRODUCER:** Piyawan Mungkung. **DIRECTOR:** Thanonchai Sornsriwichai.

An office worker distributes fly swatters to girls sitting at table in a pub. He and his friend then proceed to get blind drunk at the bar. A few hours later the guy starts sexually harassing the girls, who suddenly realise the purpose of the fly swatters. /// Ein Büroangestellter verteilt Fliegenklatschen an junge Frauen, die in einer Kneipe an den Tischen sitzen. Er und sein Freund betrinken sich daraufhin an der Bar. Einige Stunden später beginnt er, die Frauen sexuell zu belästigen, denen plötzlich der Zweck der Fliegenklatschen klar wird. /// Un employé de bureau distribue des tapettes à mouches à plusieurs jeunes femmes assises dans un pub. Puis lui et ses amis vont se saouler au comptoir. Quelques heures plus tard, l'homme se met à harceler sexuellement les jeunes femmes, qui comprennent maintenant l'utilité des tapettes à mouches.

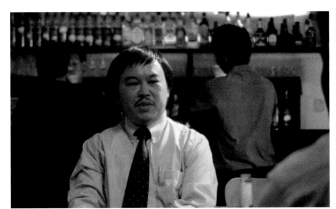 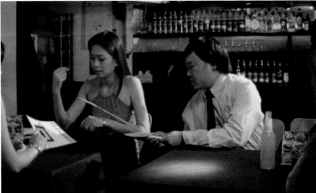

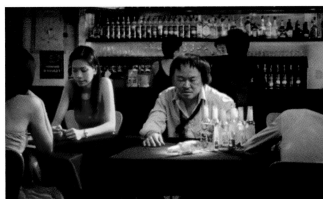

 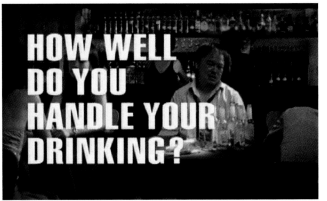

FEATURED ON THE DVD TITLE: Eyes. CLIENT: Fundação SOS Mata Atlantica. SERVICE: Atlantic Forest Preservation Program. YEAR: 2001. AGENCY: F/Nazca Saatchi & Saatchi. COUNTRY: Brazil. CREATIVE DIRECTOR: Fábio Fernandes, Eduardo Lima. COPYWRITER: Fábio Fernandes, Eduardo Lima, Victor Sant'Anna. PRODUCTION COMPANY: Zero Filmes. DIRECTOR: Sergio Amon.

A short series of images of eyes flash on the screen, as a deep voiceover announces, "I-SAW-WHAT-YOU-DID-WITH-A-CHAINSAW!" A tagline follows with the words, "Nature sees but it can't do anything." A final image flashes on screen showing two eye shapes in a tree branch. The voiceover closes with, "EYE SAW!" /// Eine kurze Bildfolge von Augen erscheint auf dem Bildschirm, während eine tiefe Sprecherstimme sagt: „I-SAW-WHAT-YOU-DID-WITH-A-CHAINSAW!" Ein Slogan folgt mit den Worten: „Die Natur sieht es, doch sie kann nichts tun." Ein letztes Bild erscheint auf dem Bildschirm und zeigt zwei Augen in Form eines Baumstammes. Der Sprecher beendet den Werbespot mit: „EYE SAW!" /// Une courte série d'images d'yeux défile à l'écran pendant qu'une voix grave annonce : « J'AI-VU-CE-QUE-TU-AS-FAIT ! » Puis les mots suivants apparaissent : « La nature voit, mais ne peut rien faire. » La dernière image montre deux formes d'yeux dans une branche d'arbre. La voix off conclut par « J'AI VU ! »

TITLE: Two Ways. CLIENT: Greenpeace. SERVICE: Climate Change Awareness. YEAR: 2008. AGENCY: Almap BBDO. COUNTRY: Brazil. CREATIVE DIRECTOR: Marcello Serpa. COPYWRITER/ART DIRECTOR: Renato Simões, Wilson Mateos, Bruno Prosperi, Marcos Medeiros. PRODUCTION COMPANY: Vetor Zero. DIRECTOR: Nando Cohen.

This endearing 3-D animation gives two extreme examples of how to combat global climate change. Either become President and "convince other countries to stop polluting the planet." Or, more simply, "only use fluorescent bulbs." The ad closes with the Greenpeace logo and website address. /// Diese liebenswerte 3-D-Animation zeigt zwei extreme Beispiele für den Kampf gegen die globale Klimaerwärmung. Entweder sollte man Präsident werden und „andere Länder davon überzeugen, den Planeten nicht weiter zu verschmutzen". Oder viel einfacher: „Benutze nur Energiesparlampen." Der Spot endet mit dem Logo und der Website von Greenpeace. /// Cette attachante animation 3-D propose deux manières radicales de combattre le réchauffement climatique global. Soit devenir président et « convaincre d'autres pays d'arrêter de polluer la planète. » Soit, plus simplement, « d'utiliser uniquement des ampoules fluorescentes. » La pub s'achève sur le logo de Greenpeace et l'adresse de son site Web.

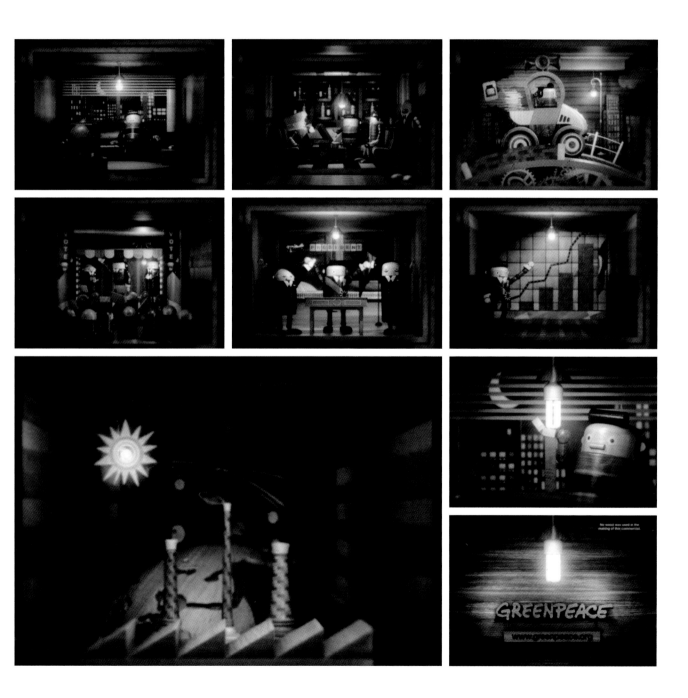

TITLE: Focus on the positive. **CLIENT:** Florida Department of Health. **SERVICE:** Anti-smoking campaign. **AGENCY:** Crispin Porter + Bogusky. **COUNTRY:** USA. **YEAR:** 2002. **CREATIVE DIRECTOR:** Alex Bogusky. **COPYWRITER:** Bob Cianfrone. **ART DIRECTOR:** Paul Keister. **PRODUCTION COMPANY:** Oil Factory. **DIRECTOR:** Gareth Francis. **AWARDS:** Cannes Lions (Gold).

A group of young activists with a hidden camera walk into the offices of a tobacco manufacturer. When they question the executive, he bursts into a song, and the scene becomes a full-scale musical. The chorus, "Stay focused on the positive" sounds out as the ad changes scenes to a hospital operating theatre and mortuary. /// Eine Gruppe junger Aktivisten betritt mit einer versteckten Kamera das Bürogebäude eines Tabakherstellers. Als sie den Geschäftsführer befragen, beginnt dieser zu singen, und die Szene verwandelt sich in ein richtiges Musical. Der Chor singt: „Konzentrieren Sie sich auf das Positive", wird jedoch ausgeblendet, als die Szene in den Operationssaal eines Krankenhauses und in eine Leichenhalle wechselt. /// Un groupe de jeunes activistes armés d'une caméra cachée entre dans les bureaux d'un fabricant de cigarettes. Ils interrogent le directeur, qui se met à chanter, et le film se transforme en une véritable comédie musicale. Le refrain « Concentrez-vous sur le positif » résonne pendant que le décor change et devient un hôpital puis une morgue.

TITLE: Artery. **CLIENT:** British Heart Foundation. **SERVICE:** Anti-smoking message. **AGENCY:** Euro RSCG London. **COUNTRY:** United Kingdom. **YEAR:** 2004. **CREATIVE DIRECTOR:** Nick Hastings. **COPYWRITER:** Liz Whiston. **ART DIRECTOR:** Dave Shelton. **PRODUCTION COMPANY:** Large. **PRODUCER:** Johnnie Frankle. **DIRECTOR:** Daniel Kleinman. **AWARDS:** Cannes Lions (Silver).

A group of friends are enjoying a drink in a pub. As some of the friends begin to smoke, a thick, fatty puss oozes from the tips of their cigarettes. The narrator, a guy sitting at the bar, explains how "… our hearts can't work properly if our arteries are clogged up." He encourages smokers that there are different ways of giving up. /// Eine Gruppe von Freunden trinkt zusammen in einer Kneipe. Als einige zu rauchen beginnen, quillt dicker Eiter aus den Spitzen ihrer Zigaretten. Der Sprecher, ein anderer Mann in der Kneipe, erklärt, dass „… unsere Herzen nicht richtig arbeiten können, wenn die Arterien verstopft sind." Er ermutigt Raucher, dass es verschiedene Möglichkeiten gibt, das Rauchen aufzugeben. Der Werbespot endet mit dem Logo der British Heart Foundation und der Notruf-Telefonnummer sowie mit dem Slogan: „Wir helfen Ihnen, mit dem Rauchen aufzuhören, bevor Sie völlig verstopft sind." /// Des amis boivent un verre dans un pub. Certains commencent à fumer, et un pus épais et gras suinte du bout de leurs cigarettes. Le narrateur, un homme assis au bar, explique que « notre cœur ne peut pas fonctionner correctement si nos artères sont bouchées ». Il encourage les fumeurs à s'arrêter de fumer grâce à l'une des nombreuses méthodes qui sont à leur disposition. La publicité se conclut avec le logo de la British Heart Foundation et le numéro d'une ligne d'assistance, ainsi que le sous-titre : « Nous vous aiderons à arrêter avant que vos artères ne soient complètement bouchées ».

TITLE: Marie. **CLIENT:** INPES – National Institute for Prevention and Health Education. **SERVICE:** Anti-smoking message. **AGENCY:** FCB Paris **COUNTRY:** France. **YEAR:** 2004. **CREATIVE DIRECTOR:** Thomas Stern. **COPYWRITER:** Dominique Marchand. **ART DIRECTOR:** Jean Michel Alirol. **PRODUCTION COMPANY:** Partizan Midi Minuit Me. **PRODUCER:** Suzanne Hormain, Florence Le Theuff. **DIRECTOR:** The Elvis. **AWARDS:** ANDY Awards (Bronze), CLIO Awards (Bronze), Cannes Lions (Silver).

The ad shows different rooms in a house filled with piles of cigarettes. A voiceover announces how many tens of thousands of cigarettes Marie has smoked since moving into the house. The spot finally reveals that Marie is only 7 years old. /// Der Werbespot zeigt verschiedene Räume in einem Haus, in denen sich Unmengen von Zigarettenschachteln stapeln. Ein Sprecher teilt dem Zuschauer mit, wie viele Zehntausende von Zigaretten Marie schon geraucht hat, seit sie in dieses Haus gezogen ist. Schließlich wird deutlich, dass Marie erst 7 Jahre alt ist. Der Schlussslogan lautet: „Wenn Sie rauchen, dann rauchen auch Nichtraucher." /// Cette publicité montre plusieurs pièces dans une maison remplie de piles de cigarettes. Une voix off annonce combien de dizaines de milliers de cigarettes Marie a fumées depuis qu'elle est arrivée dans cette maison. Le plan final révèle que Marie n'a que 7 ans. La conclusion suivante s'affiche : « Lorsque vous fumez, les non-fumeurs fument aussi ».

TITLE: War. CLIENT: Unimed. SERVICE: Anti-Smoking Campaign. AGENCY: F/Nazca Saatchi & Saatchi. COUNTRY: Brazil. YEAR: 2007. CREATIVE DIRECTOR: Fábio Fernandes, Eduardo Lima. COPYWRITER: Eduardo Lima, Ricardo Jones. ART DIRECTOR: Airton Camignani. PRODUCTION COMPANY: Tribbo Post. DIRECTOR: Luiz Adriano, Airton Carmignani, Ricardo Jones.

An animated sequence shows the breakout of war resulting in a nuclear bomb exploding. Upon closer inspection the viewer sees that the animation is made up of thousands of cigarette tips packed tightly together. An animated caption reveals the words, "Smoking Kills More." The spot closes with the Unimed logo and the tagline, "The best health plan is living." /// Eine animierte Bildfolge zeigt den Ausbruch eines Krieges, der in der Explosion einer Atombombe endet. Bei genauerem Hinsehen sieht der Zuschauer, dass die Animation aus Tausenden, eng zusammengepressten Zigarettenspitzen aufgebaut ist. Ein animierter Schriftzug mit den Worten „Rauchen tötet mehr" erscheint. Der Spot endet mit dem Unimed-Logo und dem Slogan „Der beste Gesundheitsplan ist Leben." /// Une séquence animée montre le début d'une guerre et l'explosion d'une bombe atomique. Un examen plus attentif permet au spectateur de voir que l'animation est faite de milliers de cigarettes serrées les unes contre les autres. Une légende animée révèle les mots « Fumer tue davantage. » Le sport s'achève sur le logo d'Unimed et sur la phrase « Le meilleur plan sanitaire consiste à vivre. »

FEATURED ON THE DVD **TITLE:** Camera Phone. **CLIENT:** DfT – Department of Transport. **SERVICE:** Teenage Road Safety Message. **AGENCY:** Leo Burnett UK. **COUNTRY:** United Kingdom. **YEAR:** 2006. **CREATIVE DIRECTOR:** Jim Thornton. **COPYWRITER:** Angus Macadam, Paul Jordan. **ART DIRECTOR:** Angus Macadam, Paul Jordan. **PRODUCTION COMPANY:** Gorgeous. **PRODUCER:** Rupert Smythe. **DIRECTOR:** Chris Palmer. **AWARDS:** Cannes Lions (Gold).

To send a clear and simple road safety message to youngsters, this spot was filmed entirely on a mobile phone camera. It shows a group of young teenage friends joking and pulling faces to the camera on a sidewalk. One of them walks straight into the road and is hit by an oncoming car. The slogan is simple, "55 teenagers a week wished they'd given the road their full attention." /// Um Jugendlichen eine klare und einfache Botschaft zum Thema Sicherheit auf der Straße zu vermitteln, wurde dieser Spot gänzlich mit einer Handykamera gefilmt. Der Film zeigt eine Gruppe junger Teenager, die auf dem Gehweg vor der Kamera herumalbern und Grimassen ziehen. Einer der Teenager läuft direkt auf die Straße und wird von einem Auto erfasst. Der Slogan ist einfach: „Pro Woche wünschen sich 55 Teenager, dass sie auf der Straße richtig aufgepasst hätten." /// Pour envoyer aux jeunes un message clair sur la sécurité routière, ce spot a été entièrement filmé sur un téléphone mobile. Il montre un groupe d'adolescents sur un trottoir, ils plaisantent et font des grimaces à la caméra. L'un d'eux marche dans la rue et est renversé par une voiture qui arrivait. Le slogan est simple: « Chaque semaine, 55 adolescents regrettent amèrement de ne pas avoir fait attention à la route ».

55 teenagers a week wish they'd given the road their full attention.

THINK!

TITLE: Lucky. **CLIENT:** DfT – Department of Transport. **SERVICE:** Road Safety. **AGENCY:** Abbott Mead Vickers BBDO. **COUNTRY:** United Kingdom. **YEAR:** 2005. **CREATIVE DIRECTOR:** Paul Belfor, Nigel Roberts. **COPYWRITER:** Mary Wear. **ART DIRECTOR:** Andy McKay. **PRODUCTION COMPANY:** Academy Films. **PRODUCER:** Laura Kaufman. **DIRECTOR:** Walter Stern. **AWARDS:** Cannes Lions (Silver).

A young girl is lying mangled against a tree. Her voiceover says, "If you hit me at 40mph there's around an 80 % chance I'll die." The viewer sees the girl's limbs straighten and her injuries disappear. She is dragged back into the middle of the road. Suddenly her eyes open and she awakens with a gasp. "Hit me at 30mph and there's around an 80 % chance I'll live." /// Ein kleines Mädchen liegt verdreht an einem Baum. Ihre Synchronstimme sagt: „Wenn du mich mit 40 mph (65 km/h) anfährst, liegt die Wahrscheinlichkeit bei 80 %, dass ich sterbe." Der Zuschauer sieht, wie sich die Glieder des Mädchens begradigen und ihre Verletzungen verschwinden. Sie wird zurück in die Mitte der Straße gezogen. Plötzlich öffnet sie ihre Augen und erwacht mit einem Keuchen. „Wenn du mich mit 30 mph (50 km/h) anfährst, liegt die Wahrscheinlichkeit bei 80 %, dass ich überlebe." /// Une fillette gravement blessée est allongée au pied d'un arbre. Elle nous parle en voix off : « Si vous me renversez à 40 mph (65 km/h), j'ai environ 80 % de chances de mourir. » On voit alors ses membres se réparer et ses blessures disparaître. Son corps inconscient retourne au milieu de la route. Soudain ses yeux s'ouvrent et elle se réveille en prenant une inspiration profonde. « Si vous me renversez à 30 mph (50 km/h), j'ai environ 80 % de chances de vivre. »

TITLE: Curtain Airbags. **CLIENT:** TAC – Transport Accident Commission. **SERVICE:** Curtain Airbags. **AGENCY:** The Furnace, Sydney. **COUNTRY:** Australia. **YEAR:** 2007. **CREATIVE DIRECTOR:** Rob Martin Murphy. **COPYWRITER:** Rob Martin Murphy. **ART DIRECTOR:** Rob Martin Murphy. **PRODUCTION COMPANY:** EXIT Films, Melbourne. **EXECUTIVE PRODUCER:** Jane Liscombe. **DIRECTOR:** Glendyn Ivin.

This spot shows a woman with a speech impediment explaining the benefits of curtain airbags in cars. "I knew nothing about curtain airbags before my accident, "she says. "Now I'm an expert." The closing titles read, "Demand curtain airbags in your next car," followed by the "How safe is your car" campaign slogan. /// Dieser Werbespot zeigt eine Frau mit einer Sprachbehinderung, die die Vorteile von Kopfairbags in Fahrzeugen erklärt. „Ich wusste vor meinem Unfall nichts über Kopfairbags", sagt sie. „Jetzt bin ich Expertin." Die abschließende Überschrift lautet: „Verlangen Sie in Ihrem nächsten Auto Kopfairbags", gefolgt von dem Slogan der Kampagne „Wie sicher ist Ihr Auto?" /// Dans ce spot, une femme qui a des difficultés à s'exprimer explique les avantages des airbags rideaux. « J'ignorais tout des airbags rideaux avant mon accident » dit-elle. « Maintenant, je suis une experte. » La phrase de conclusion s'affiche « Exigez des airbags rideaux dans votre prochaine voiture », suivie du slogan de la campagne « Votre voiture est-elle sûre ? ».

TITLE: Speed. **CLIENT:** Thai Health Promotion Foundation. **SERVICE:** Anti-speeding campaign. **AGENCY:** BBDO Bangkok. **COUNTRY:** Thailand. **YEAR:** 2006. **CREATIVE DIRECTOR:** Suthisak Sucharittanonta, Nikrom Kulkosa, Vasan Wangpaitoon. **COPYWRITER:** Suthisak Sucharittanonta, Juntiga Nasunee, Wirat Charoenwiwatchai. **ART DIRECTOR:** Nikrom Kulkosa, Vasan Wangpaitoon, Aniruth Assawanapanon. **PRODUCTION COMPANY:** Phenomena. **PRODUCER:** Angsana Premprasert. **DIRECTOR:** Thanonchai Sornsrivichai. **AWARDS:** Cannes Lions (Shortlist).

A boy and a girl are recklessly speeding on their motorcycle. They overtake a truck only to see another truck coming head on. Just before impact the scene freezes. The boy and girl dismount to consider their limited options. Finally they choose to try to make it through a narrow gap between the two trucks. The scene resumes and ends in disaster. The message is simple, "Don't Speed." /// Ein junger Mann und eine junge Frau rasen unbekümmert auf ihrem Motorrad die Straße entlang. Sie überholen einen LKW und sehen zu spät, dass ihnen ein anderer LKW frontal entgegen kommt. Kurz vor dem Aufprall ist ein Standbild der Szene zu sehen. Sie steigen ab und überlegen sich ihre eingeschränkten Möglichkeiten. Schließlich beschließen sie, sich durch eine Lücke zwischen den beiden LKWs zu quetschen. Die Filmszene setzt sich fort und endet katastrophal. Die Nachricht ist einfach: „Nicht rasen." /// Deux jeunes gens à mobylette roulent imprudemment à toute allure. Ils doublent un camion et se retrouvent devant un autre camion qui arrive en sens inverse. La scène se fige juste avant l'impact. Ils descendent de la moto pour réfléchir à leurs options, limitées. Ils décident finalement d'essayer de passer dans l'espace étroit entre les deux camions. L'action reprend, et finit en désastre. Le message est simple : « Ralentissez ».

TITLE: Unconditional. **CLIENT:** CAPP – Companion Animal Placement Program. **SERVICE:** Pet Adoption. **AGENCY:** Suburban Advertising. **COUNTRY:** USA. **YEAR:** 1998. **CREATIVE DIRECTOR:** Eric Aronin, Dave Laden. **COPYWRITER:** Eric Aronin, John Wagner. **ART DIRECTOR:** Dave Laden. **PRODUCTION COMPANY:** Partizan Entertainment. **PRODUCER:** Scott Siegal. **DIRECTOR:** Paul Goldman. **AWARDS:** Cannes Lions (Gold).

A man comes home and undresses. His dog watches as the man dresses up as a woman, puts on a wig and makeup and prepares to go out. The caption fades up, "That's the great thing about pets. They really don't care. Adopt today." /// Ein Mann kommt nach Hause und zieht sich aus. Sein Hund beobachtet, wie sein Herrchen sich als Frau verkleidet, eine Perücke anzieht, Makeup aufträgt und sich zum Ausgehen fertig macht. Der Slogan erscheint: „Das ist das Wunderbare an Haustieren. Es ist ihnen wirklich egal. Nehmen Sie heute ein verwaistes Haustier auf." /// Un homme rentre chez lui et se déshabille. Son chien le regarde pendant qu'il s'habille en femme, met une perruque, se maquille et se prépare à sortir. Les mots suivants apparaissent : « C'est ce qui est bien avec les animaux de compagnie. Ça leur est vraiment égal. Adoptez dès aujourd'hui. »

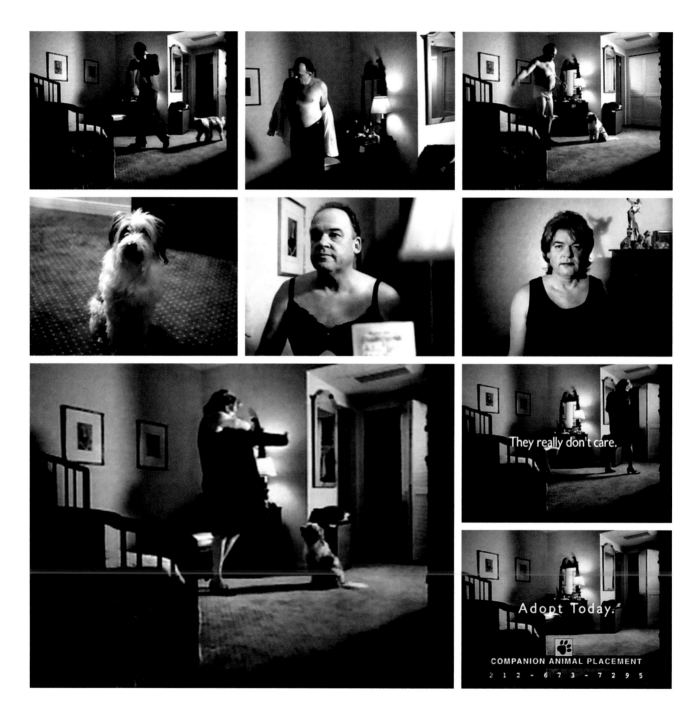

TITLE: Killing Death. **CLIENT:** Mexican Red Cross. **SERVICE:** Humanitarian Aid Fundraiser. **AGENCY:** Saatchi & Saatchi Mexico. **COUNTRY:** Mexico. **YEAR:** 2006. **CREATIVE DIRECTOR:** Jose Arce, Fernando Iyo. **COPYWRITER:** Jose Arce, Fernando Iyo. **ART DIRECTOR:** Ivan Carrasco, Veronica Medina, Fernando Carrera. **PRODUCTION COMPANY:** Cyberfilms. **DIRECTOR:** Javier Gutierrez. **AWARDS:** Cannes Lions (Silver).

This engaging animation shows the grim reaper being cheated as various people are saved by the Red Cross. /// Diese einnehmende Animation zeigt den Sensenmann, der sich betrogen fühlt, weil verschiedene Menschen durch das Rote Kreuz gerettet wurden. Die Schlussszene zeigt das Logo des mexikanischen Roten Kreuzes mit dem Slogan: „Macht Happy Ends zur Wirklichkeit." /// Cette animation captivante montre comment plusieurs personnes sauvées par la Croix-Rouge arrivent à tromper la Mort. La dernière image montre le logo de la Croix-Rouge mexicaine, avec le slogan « Nous créons des fins heureuses ».

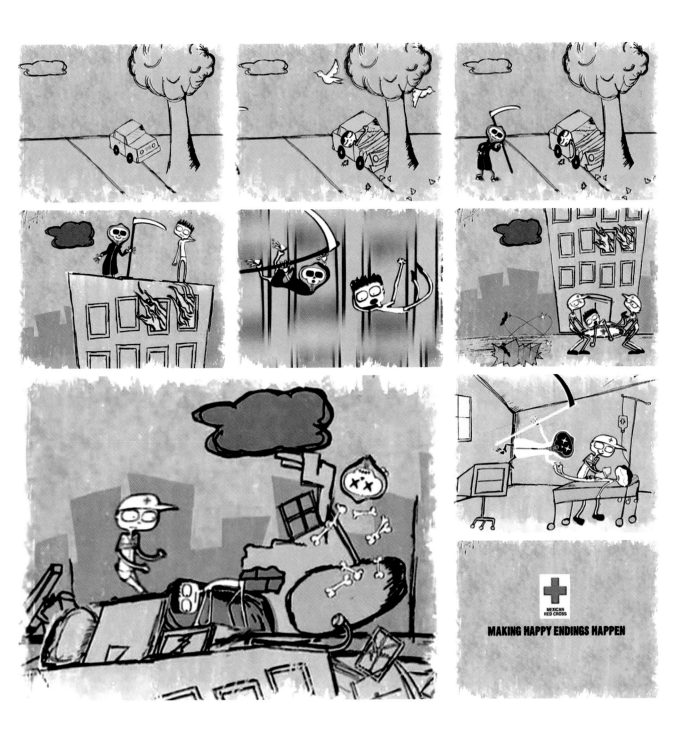

TITLE: Different. CLIENT: Special Olympics. SERVICE: Special Olympics. AGENCY: JWT London. COUNTRY: United Kingdom. YEAR: 2001. CREATIVE DIRECTOR: Jaspar Shelbourne. COPYWRITER: Jonathan John. ART DIRECTOR: Nick Wootton. PRODUCTION COMPANY: H30 Films. PRODUCER: Steve Ackhurst. DIRECTOR: Charles Hendley. AWARDS: Cannes Lions (Gold).

A man with Down's Syndrome talks to camera. As if he is being discriminated, he says, "People look at you. They stare ... They make you feel different ... " Suddenly he adds, "It's fantastic!" The slogan appears, "Special Olympics. Be a part of it." The spot closes with the man being cheered on as he proudly wears his medal. /// Ein Mann mit Down-Syndrom spricht in die Kamera. Als wäre er diskriminiert worden, sagt er: „Die Leute schauen dich an. Sie starren ... Sie geben dir das Gefühl, anders zu sein ... " Plötzlich fügt er hinzu „Es ist fantastisch!" Der Slogan erscheint: „Special Olympics. Sei ein Teil davon." Der Werbespot endet mit dem Mann, der bejubelt wird, während er stolz seine Medaille trägt. /// Un homme atteint de trisomie 21 parle face à la caméra. Il semble parler de la discrimination qu'il subit au quotidien : « Les gens vous regardent. Ils vous fixent ... Ils vous font sentir différent ... » Soudain il ajoute : « C'est fantastique ! » Le slogan s'affiche : « Jeux paralympiques. Participez. » Le spot se termine par une séquence de l'homme arborant fièrement sa médaille, porté aux nues par la foule.

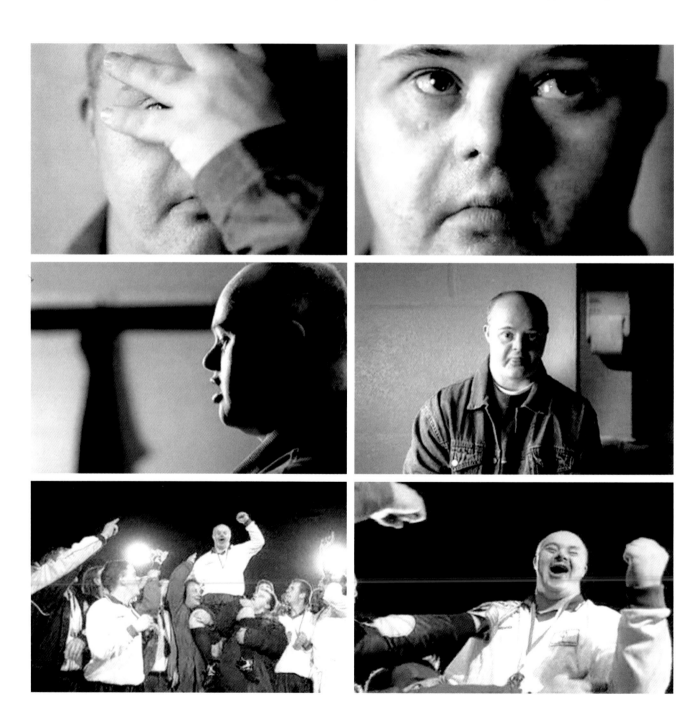

FEATURED ON THE DVD **TITLE:** Blind Man. **CLIENT:** Thai Health Promotion Foundation. **SERVICE:** Goodness. **AGENCY:** Jeh United Ltd. **COUNTRY:** Thailand. **YEAR:** 2006. **CREATIVE DIRECTOR:** Jureeporn Thaidumrong. **COPYWRITER:** Wuthisak Anankaporn, Suwit Ekudompong, Setthar Keawngamdee. **ART DIRECTOR:** Dutsanee Emnuwattana, Nat Promdhep, Wicha Horthamanan. **PRODUCTION COMPANY:** Phenomena. **DIRECTOR:** Thanonchai Sornsriwichai.

The spot opens with the close up of a smiling man wearing sunglasses. As the spot cuts to shots of a crowded city, a voiceover describes a beautiful vision the man is having. "What makes him see such a beautiful image?" The next shot reveals the man is blind and is being led through the streets with a smiling younger man. "Kindness makes a better world" reads the slogan. /// Der Werbespot beginnt mit der Großaufnahme eines lächelnden Mannes, der eine Sonnenbrille trägt. Als die Kamera eine überfüllte Stadt zeigt, beschreibt ein Sprecher das schöne Bild, das der Mann sieht. „Warum sieht er solch wunderschöne Dinge?" Das nächste Bild lässt erkennen, dass der Mann blind ist und von einem lächelnden jüngeren Mann durch die Straßen geführt wird. „Freundlichkeit führt zu einer besseren Welt" lautet der Slogan. /// Le spot commence par le gros plan d'un homme souriant qui porte des lunettes de soleil. Pendant que la caméra montre une ville pleine de gens, une voix off décrit la vision magnifique que l'homme en a. « Pourquoi voit-il une si belle image ? » L'image suivante révèle que l'homme est aveugle, et qu'il est guidé par un jeune homme souriant. « La gentillesse embellit le monde », déclare le slogan.

It is often said.....

this man is given the vision of a green grass field,

an exquisite rainbow over the majestic mountain range,

And kids are running around blissfully next to a pristine creek,

What makes him see this wonderful image?

FEATURED ON THE DVD **TITLE:** Mouse Trap. / Madam. **CLIENT:** EPPO – Energy Policy and Planning Office. **SERVICE:** Energy Conservation. **AGENCY:** Saatchi & Saatchi Thailand. **COUNTRY:** Thailand. **YEAR:** 2005. **CREATIVE DIRECTOR:** Jureeporn Thaidumrong. **COPYWRITER:** Wiparat Nantananontchai. **ART DIRECTOR:** Thana Rittirajcomporn, Tawatchai Suknipitapong. **PRODUCTION COMPANY:** Phenomena. **PRODUCER:** Piyawan Mungkung. **DIRECTOR:** Thanonchai Sornsrivichai. **AWARDS:** Cannes Lions (Gold).

Mr. Energy explains how keeping within a 90 km/h driving speed can save energy. To illustrate this point, we see a young driver who is slamming his foot on the gas like an idiot. He runs out of petrol and screeches into the filling station. He gets out and steps on a mouse trap, set earlier by Mr. Energy. The maniac finally sees the error of his ways. /// Mr. Energy erklärt, wie eine konstante Fahrgeschwindigkeit von 90 km/h Energie sparen kann. Als Veranschaulichung sehen wir einen jungen Fahrer, der das Gaspedal wie ein Idiot durchtritt. Er fährt den Tank leer und kommt mit quietschenden Reifen an der Tankstelle an. Er steigt aus dem Fahrzeug und tritt in eine Mausefalle, die Mr. Energy vorher aufgestellt hat. Der verrückte Fahrer sieht schließlich sein Fehlverhalten ein. /// M. Énergie explique que si l'on ne dépasse pas les 90 km/h on économise de l'énergie. Pour illustrer cette idée, on voit un jeune conducteur qui appuie à fond sur l'accélérateur comme un idiot. Il manque d'essence et arrive en grinçant dans une station-service. Il sort et marche sur un piège à souris que M. Énergie avait posé là. Le maniaque de la vitesse comprend enfin qu'il était dans l'erreur.

It's our responsibility to take care and fix this.

So don't forget. Drive within 90.

ไทยช่วยไทย ลดใช้พลังงาน

Help your country save energy!

At a service station a wealthy woman complains about the high cost of petrol. Suddenly Mr. Energy arrives and offers a unique energy saving scheme for her to try. He opens her trunk to discover it is loaded with luxury items. He blows a whistle and a crowd of people rush to unload the loot. The car's suspension rises as Mr. Energy announces to camera, "Please remember – No excess baggage." /// An einer Tankstelle beschwert sich eine wohlhabende Frau über die hohen Benzinkosten. Plötzlich erscheint Mr. Energy und bietet ihr an, ein einzigartiges Energiesparprogramm auszuprobieren. Er öffnet ihren Kofferraum und entdeckt, dass dieser voll beladen mit Luxusartikeln ist. Er bläst in eine Trillerpfeife, und eine Menschenmenge leert den Kofferraum in Windeseile. Man sieht, wie sich die Autoaufhängung wieder erhöht, als Mr. Energy vor der Kamera erklärt: „Bitte denken Sie dran: Keine übermäßigen Lasten." /// Dans une station-service, une femme riche se plaint du prix de l'essence. M. Énergie arrive soudain et lui propose d'essayer un programme original pour économiser l'énergie. Il ouvre son coffre, rempli de produits de luxe. Il donne un coup de sifflet et une foule de gens arrivent en courant pour s'emparer du butin. La suspension de la voiture remonte et M. Énergie déclare face à la caméra : « N'oubliez pas : pas d'excédents de bagages ».

FEATURED ON THE DVD **TITLE:** Oil. / Lost Money. **CLIENT:** EPPO – Energy Policy and Planning Office. **SERVICE:** Energy Conservation. **AGENCY:** Saatchi & Saatchi Thailand. **COUNTRY:** Thailand. **YEAR:** 2005. **CREATIVE DIRECTOR:** Jureeporn Thaidumrong. **COPYWRITER:** Wiparat Nantananontchai. **ART DIRECTOR:** Thana Rittirajcomporn, Tawatchai Suknipitapong. **PRODUCTION COMPANY:** Phenomena. **PRODUCER:** Piyawan Mungkung. **DIRECTOR:** Thanonchai Sornsrivichai. **AWARDS:** Cannes Lions (Gold).

A guy is foul mouthing a gas station attendant over the rising price of petrol. Mr. Energy pops up and slams a piece of fruit into the driver's mouth before explaining how much more expensive petrol is elsewhere in the world. The driver thinks that as fuel is so much cheaper he can afford to continue wasting it. Mr. Energy stops him in his tracks by producing a huge size fruit. /// Ein Mann beschwert sich beim Angestellten der Tankstelle über die steigenden Benzinpreise. Mr. Energy taucht auf und steckt dem Fahrer blitzschnell eine Frucht in den Mund, bevor er ihm erklärt, wie viel teurer der Treibstoff überall auf der Welt ist. Der Fahrer denkt nun, dass er es sich leisten kann, Benzin weiterhin zu verschwenden, da es so viel günstiger ist. Mr. Energy stoppt ihn, indem er eine riesige Frucht produziert. /// Un homme est désagréable avec l'employé de la station-service à cause du prix du carburant. M. Énergie arrive et fourre un fruit dans la bouche du conducteur puis explique que l'essence est beaucoup plus chère dans d'autres pays. Le conducteur pense que puisque l'essence est moins chère il peut se permettre de continuer à la gaspiller. M. Énergie l'arrête net en brandissant un fruit énorme.

Do you realize that while we're paying 21 Baht for a liter,

ไทยช่วยไทย ลดใช้พลังงาน

Help your country save energy!

A driver is baffled when he doesn't have any money at the gas station. Mr. Energy appears and explains why he is out of pocket. Visual humour is used to highlight the economic and environmental burden of gas guzzling vehicles for ordinary motorists. /// Ein Fahrer stellt an der Tankstelle perplex fest, dass er kein Geld hat. Mr. Energy erscheint und erklärt ihm, warum er pleite ist. In dem Werbespot wird sehr anschaulicher Humor verwendet, um die ökonomischen und ökologischen Belastungen spritfressender Fahrzeuge für gewöhnliche Autofahrer aufzuzeigen. /// Un conducteur est fort désappointé de se trouver sans un sou devant la pompe d'une station service. M. Énergie arrive et lui explique pourquoi il a les poches vides. L'humour visuel sert ici à mettre en lumière le fardeau économique et environnemental que représentent les véhicules très gourmands en essence pour les automobilistes ordinaires.

WEARING BEAUTY

GRAHAM FINK
EXECUTIVE CREATIVE DIRECTOR OF M&C SAATCHI

Graham's entrance into the advertising industry was slightly unconventional. After applying for a job at CDP (then London's top creative hot shop), Graham was told they were looking for a candidate with more experience. Unwilling to accept rejection, a determined Graham returned the following day dressed up as an old man, an audacious move that got him the job. In 1995, Graham began directing commercials and music videos at the Paul Weiland film company. A year later he became the youngest ever president of D&AD. As a true Renaissance man, Graham's award-winning photography has been used in many advertising campaigns including Sony PlayStation's "Blood" and "Mental Wealth" poster campaigns. He also directed (Z), a short film commissioned by David Puttnam for the Millennium, which was shortlisted at BAFTA. In 2001, he launched a conceptual production company called *thefinktank*. In 2005, Graham became creative director at M&C Saatchi. Over the years, Graham has collected a bag of awards for his work including: Gold Lions, D&AD Pencils and Gold British Television Arrows, amongst a host of others. Together with his creative partner, Deirdre Allen, Graham runs a free, public access project called the artschool.

Grahams Einstieg in die Werbebranche war eher ungewöhnlich. Als er sich für einen Job bei CDP bewarb (damals Londons Top-Kreativschmiede), sagte man ihm, dass ein Kandidat mit mehr Erfahrung gesucht wird. Graham war jedoch nicht bereit, dieses Nein zu akzeptieren, und kam am nächsten Tag wieder, diesmal als Opa verkleidet. Diese Idee verschaffte ihm schließlich den Job. 1995 begann Graham als Regisseur von Werbefilmen und Musikvideos bei der Paul Weiland Film Company. Ein Jahr später wurde er zum bis dato jüngsten Präsidenten des D&AD ernannt. Grahams preisgekrönte Arbeiten fanden Eingang in zahlreiche Werbekampagnen, darunter die Plakatkampagnen „Blood" und „Mental Wealth" für Sony PlayStation. Zudem führte er Regie beim Kurzfilm (Z), der von David Puttnam für die Jahrtausendwende in Auftrag gegeben wurde und für die er eine Shortlist-Nominierung bei den BAFTA Awards erhielt. 2001 gründete er eine konzeptionelle Produktionsgesellschaft mit dem Namen *thefinktank*. Seit 2005 ist er Creative Director bei M&C Saatchi. Im Laufe der Jahre konnte Graham für seine Arbeiten zahlreiche Preise einheimsen, darunter Gold Lions, D&AD Pencils und Gold British Television Arrows. Zusammen mit seiner kreativen Partnerin Deirdre Allen leitet Graham „the artschool", ein freies öffentliches Kunstschulprojekt.

Die meisten Werber würden alles dafür geben, für eine Sportmarke zu arbeiten, denn dann könnten sie endlich zeigen, zu welchen Spitzenleistungen ihre kreative Power sie antreibt. Einige der besten Arbeiten der Werbegeschichte stammen aus diesem Bereich. Der

Graham est entré dans le monde de la publicité d'une façon quelque peu originale. Après avoir posé sa candidature pour un poste chez CDP (qui était alors le centre de la créativité londonienne), Graham se vit répondre qu'ils cherchaient un candidat possédant davantage d'expérience. Graham, déterminé à ne pas se laisser faire, se présenta le jour suivant déguisé en vieil homme. Son audace lui valut le poste. En 1995, Graham commença à réaliser des films publicitaires et des vidéos musicales pour la société de production de Paul Weiland. Un an plus tard, il devint le président le plus jeune de l'histoire de D&AD. Graham est un homme aux talents multiples, et ses photographies primées ont été utilisées dans de nombreuses campagnes de publicité, et notamment pour les campagnes d'affichage « Blood » et « Mental Wealth » de la PlayStation de Sony. Il a également réalisé (Z), un court-métrage que David Puttnam avait commandé pour le millénaire, et qui a été présélectionné par la BAFTA. En 2001, il mit sur pied une société de production conceptuelle appelée *thefinktank*. Graham est devenu directeur de la création chez M&C Saatchi en 2005. Au cours des années, Graham a décroché une multitude de récompenses, notamment des Lions d'or, des Crayons de D&AD et des Flèches d'or de la télévision britannique, entre autres nombreux prix. Graham dirige avec sa partenaire créative, Deirdre Allen, un projet gratuit et ouvert au public, appelé artschool.

La plupart des créatifs donneraient leur bras droit pour travailler sur une marque de sport, qui leur donnerait l'occasion de déchaîner leur puissance de feu créatrice. Quelques-unes des meilleures créa-

Most creative people would give their right arm to work on a sports brand, where they would have a real chance to unleash their pure creative firepower. Some of the best work in advertising history has been done in this area and the path is laden with lions, pencils, arrows and other gongs all coated in a magnificent golden color. It just takes that Midas touch to pick them up along the way. It's no coincidence that athletes also have to be at the top of their game to win gold medals: overcoming fear, prejudice and finding the pure self-belief needed to conquer the seemingly impossible. In fact, "Just Do It" is probably the greatest end line of them all. It perfectly captures the philosophy of not only Nike, but the quintessential nature of all things great.

The Nike brand uniquely combines creativity, philosophy, psychology, discipline, and freedom. No wonder this breeds some amazing work.

IF A CREATIVE TEAM HAVE BEEN INSPIRED ENOUGH TO WRITE A GREAT SCRIPT, THEY NEED TO FIND A GREAT DIRECTOR TO BRING IT TO LIFE. NO PROBLEM HERE. THE WORLD'S BEST QUEUE UP TO GET THEIR HANDS ON THEM.

Add a sprinkling of magic dust from Ronaldinho, Ronaldo, Beckham or Michael Jordan and Co, a fantastic music track (more often than not a classical piece from one of the greatest composers of all time), and you have a stunning end result.

Going through the reels of work done in this sector over the last 5 years or so (some of which I've in-

Pfad der Sportwerbung ist mit Lions, Pencils, Arrows und anderen goldenen Lorbeeren gepflastert. Es braucht nur einen Glücksgriff, um dieses Gold zu ernten. Sportler haben viel mit Werbern gemeinsam. Auch sie müssen Spitzenleistungen vollbringen, um die begehrten Goldmedaillen zu gewinnen: Sie müssen ihre Ängste überwinden, gegen Widersacher kämpfen und fest an sich selbst glauben, um das schier Unmögliche zu erreichen. Von allen berühmten Slogans illustriert „Just Do It" dies wahrscheinlich am besten. Er ist nicht nur die perfekte Verkörperung der Philosophie von Nike, sondern auch vom Wesen der Größe an sich.

Die Marke Nike vereint auf beispiellose Weise Kreativität, Philosophie, Psychologie, Disziplin und Freiheit. Sie bietet den idealen Nährboden für fantastische Arbeit.

WENN EINEM INSPIRIERTEN KREATIVTEAM EIN GROSSARTIGES SCRIPT GELUNGEN IST, MUSS ES ANSCHLIESSEND EINEN REGISSEUR FINDEN, DER DIESER VISION LEBEN EINHAUCHT. DAS IST KEIN PROBLEM. DIE BESTEN DER WELT WERDEN DAFÜR SCHLANGE STEHEN.

Dazu eine Prise Magie von Ronaldinho, Ronaldo, Beckham oder Michael Jordan, eine fesselnde musikalische Untermalung (oft ein klassisches Stück von einem der größten Komponisten aller Zeiten), und fertig ist das Zauberkunststück.

Als ich mir die Arbeiten ansah, die während der letzten fünf Jahre in diesem Bereich entstanden (einige davon sind in diesem Buch zu finden), stieg wahre

tions de l'histoire de la publicité appartiennent à ce domaine, et le chemin est jonché de lions, crayons, flèches et autres médailles baignées d'une belle couleur dorée. Celui qui a le don de tout transformer en or n'a qu'à se baisser pour les ramasser. Pour gagner des médailles d'or, les athlètes aussi doivent être en pleine forme : dépasser la peur et les préjugés et trouver la confiance en soi inaltérable nécessaire pour conquérir l'impossible. D'ailleurs, « Just Dot It » est probablement le meilleur slogan de tous. Il représente parfaitement non seulement la philosophie de Nike, mais aussi la quintessence de la grandeur.

La marque Nike est une alliance unique de créativité, de philosophie, de psychologie, de discipline et de liberté. On ne s'étonne pas que cela puisse donner naissance à un travail brillantissime.

SI UNE ÉQUIPE DE CRÉATIFS A TROUVÉ L'INSPIRATION POUR ÉCRIRE UN BON SCRIPT, IL LUI FAUT TROUVER UN BON RÉALISATEUR POUR LUI DONNER VIE. AUCUN PROBLÈME. LA CRÈME DE LA CRÈME FAIT LA QUEUE POUR TRAVAILLER AVEC EUX.

Ajoutez un peu de poudre de perlimpinpin à la Ronaldinho, Beckham ou Michael Jordan et compagnie, une bande sonore fantastique (le plus souvent, une œuvre classique signée par l'un des plus grands compositeurs de tous les temps), et vous obtiendrez un résultat stupéfiant.

En regardant les vidéos de ce qui a été réalisé dans ce domaine ces 5 dernières années (et dont j'ai inclus quelques exemples dans cet ouvrage), je me

cluded in this book) my soul filled with joy and I wished my name was on some of these gems.

Over the years technology has played a large part in commercials and as it becomes ever more sophisticated there will be limitless tools at our disposal. We'll certainly need them, as the challenges get even tougher, the ideas get done and the analogies fast run out. But I am optimistic. I think we should be inspired to go even further in our thinking and visit unexplored and dangerous creative lands. In order to do this I think we could learn a thing or two from the world of fashion.

TAKE ANY FASHION MAGAZINE AND YOU'LL FIND IT FULL OF FRIVOLOUS, FICKLE, ABSTRACT OR METAPHYSICAL IMAGERY. TO THE HARDCORE AD-MAN THERE'S NO IDEA. BUT GREAT FASHION DESIGNERS AND PHOTOGRAPHERS TAP INTO AN EMOTION, A FEELING, A DREAM.

The best of these thoughts I call iconic whims. It's about a spirit that runs through your veins. You can't describe it. It's just there. Now if you can capture this essence in an apparel ad, you're on to a winner.

Levi's is probably the best example, doing for the apparel category what Nike has done for sports. They make it seem effortless, but this only comes from an innate understanding of not just the brand but the subtle world of moods and senses.

The Gap spots for example, whilst not having the greatest idea in the world, make you feel better after you've watched them and capture the spirit of the brand perfectly. When they first appeared, they were unlike anything on TV; modern, uplifting and brutally simple.

Or take Diesel, inviting you to join a crazy colorful world where anything can happen. From a semiotic viewpoint the language is surreal; evil often being good, lovers becoming heroes. The codes used are the antithesis of Levi's and it's this self-belief of the brand that exudes from the rectangular catwalk, otherwise known as your flat screen.

Freude in mir hoch, und ich bedauerte nur, dass keines dieser Goldstücke aus meiner Schmiede stammte.

Moderne Technologie hat in der Werbung schon immer eine wichtige Rolle gespielt, und je weiter sie sich entwickelt, desto grenzenloser werden unsere Möglichkeiten. Wir werden auch in Zukunft auf sie angewiesen sein, denn die Herausforderungen, vor denen wir stehen, werden immer größer. Ideen werden immer schneller umgesetzt, und Analogien sind rasch passé. Doch ich bin optimistisch. Wir sollten nichts unversucht lassen, um in unserer Vorstellungskraft noch weiter zu gehen und bisher unbekannte, gefährliche Kreativwelten zu erforschen. Damit uns das gelingt, sollten wir die Welt der Mode als Inspirationsquelle nutzen.

IN JEDEM MODEMAGAZIN FINDEN SICH BILDERWELTEN IN HÜLLE UND FÜLLE, OB TRIVIAL, SCHILLERND, ABSTRAKT ODER METAPHYSISCH. DER EINGEFLEISCHTE WERBER WIRD BEI DIESEM ANBLICK FRAGEN: WO IST DIE IDEE DAHINTER? ABER DIE GROSSEN MODEDESIGNER UND MODEFOTOGRAFEN HALTEN SICH NICHT LANGE MIT DIESER FRAGE AUF. SIE FOLGEN IHRER INTUITION, GEBEN EINEM GEFÜHL NACH, EINER EINGEBUNG, EINEM TRAUM.

Die besten dieser Intuitionen sind für mich Geniestreiche mit Kultcharakter. Es geht um eine Art von Spiritualität, die dich durchströmt und inspiriert. Es lässt sich nicht beschreiben. Es ist einfach da. Wenn man es schafft, diese Essenz in einer Werbung für Mode einzufangen, steht man schon fast ganz oben auf der Siegertreppe.

Levi's ist wahrscheinlich das beste Beispiel: Sie haben in der Kategorie Mode das erreicht, was Nike in der Kategorie Sport gelungen ist. Es sieht so einfach aus – doch das erreicht man nur, wenn man nicht nur ein Gespür für die Marke, sondern auch für die subtile Welt der Gefühle und Stimmungen hat.

suis senti plein d'allégresse et j'aurais aimé avoir été l'auteur de quelques-uns de ces bijoux.

Au cours des années, la technologie a joué un grand rôle dans les films publicitaires. Avec les perfectionnements dont elle fera l'objet, nous disposerons d'outils à la puissance sans limites. Nous en aurons d'ailleurs grand besoin, car les défis à relever sont de plus en plus compliqués, les idées déjà réalisées doivent être remplacées par des idées neuves et les analogies se démodent vite. Mais je suis optimiste. Je pense que nous devrions trouver l'inspiration pour pousser plus avant notre pensée et visiter des terrains créatifs inexplorés et sauvages. Pour ce faire, je pense que nous pourrions prendre exemple sur le monde de la mode.

PRENEZ N'IMPORTE QUEL MAGAZINE DE MODE ET VOUS LE TROUVEREZ REMPLI D'IMAGES FRIVOLES, CAPRICIEUSES, ABSTRAITES OU MÉTAPHYSIQUES. POUR LE PUBLICISTE PUR ET DUR, IL N'Y A PAS D'IDÉES. MAIS LES GRANDS CRÉATEURS ET PHOTOGRAPHES DE MODE PUISENT DANS UNE ÉMOTION, UN SENTIMENT, UN RÊVE.

J'appelle les meilleures de ces pensées des lubies emblématiques. C'est un esprit qui coule dans vos veines. Vous ne pouvez pas le décrire, mais c'est là. Si vous réussissez à capturer cette essence dans un film publicitaire pour des vêtements, vous ne pouvez que gagner.

Levi's en est sans doute le meilleur exemple, et a fait pour la catégorie des vêtements ce que Nike a fait pour le sport. Cela peut sembler tout naturel, mais cela ne vient que d'une compréhension innée non seulement de la marque, mais aussi de tout un monde subtil d'humeurs et de ressentis.

Les spots de Gap, par exemple, ne sont pas bâtis sur la meilleure idée au monde, mais après les avoir vus vous vous sentez mieux, et ils représentent parfaitement l'esprit de la marque. Lorsqu'ils sont apparus pour la première fois, ils ne ressemblaient à rien de ce que l'on voyait alors à la télévision. Ils étaient modernes, stimulants et d'une simplicité brutale.

So, as much as I think the idea is King, the spirit also needs to be free. Look hard and you'll see a link between Sports advertising and Apparel: both need more than an idea, they need a dream. In other words, if you want to do something really different don't let the idea get in the way.

Den TV-Spots von Gap beispielsweise liegt sicher nicht die brillanteste Idee zugrunde, doch wenn man sie gesehen hat, fühlt man sich besser. Sie haben die Essenz der Marke auf perfekte Weise eingefangen. Als sie zum ersten Mal gezeigt wurden, waren sie völlig anders als die übrigen TV-Spots; sie waren modern, machten gute Laune und beruhten letztendlich auf einer wirklich sehr simplen Idee.

Ein anderes Beispiel sind die TV-Spots für Diesel, die den Betrachter dazu einladen, an einer verrückten bunten Welt teilzuhaben, in der alles möglich ist. Aus semiotischer Perspektive ist die Sprache surreal; das Böse ist oft gut, Liebende werden zu Helden. Die verwendeten Codes bilden eigentlich den totalen Gegensatz zu dem, wofür Levi's steht. Es ist diese absolute Selbstsicherheit der Marke, die uns da vom rechteckigen Catwalk, der auch Fernsehbildschirm genannt wird, entgegen springt.

So sehr ich auch glaube, dass für uns Kreative die „Big Idea" das große Ziel ist, so sehr bin ich auch davon überzeugt, dass unser Geist frei sein muss. Wenn Sie genau hinsehen, werden Sie eine Verbindung zwischen Werbung für Sport und Werbung für Mode erkennen: Beide brauchen mehr als eine Idee: Sie brauchen einen Traum! Mit anderen Worten: Wenn Sie etwas wirklich Besonderes erschaffen wollen, vertrauen Sie nicht nur auf Ideen, sondern vor allem auf Ihre Intuition.

Ou bien prenez Diesel, qui vous invite à entrer dans un monde fou et coloré où tout est possible. D'un point de vue sémiotique, le langage est surréaliste, les méchants sont les gentils, les amants deviennent des héros. Les codes utilisés sont l'antithèse de ceux de Levi's et c'est cette confiance de la marque qui émane du podium rectangulaire, j'ai nommé l'écran plat de votre télévision.

Je crois fermement que l'idée est reine, mais l'esprit doit aussi être libre. Regardez bien, et vous verrez un lien entre les publicités de sport et de vêtements : les deux ont besoin de davantage qu'une idée, il leur faut un rêve. En d'autres termes, si vous voulez faire quelque chose de véritablement différent, ne laissez pas l'idée devenir un obstacle.

007

SPORTS & APPAREL

TITLE: Ball. **CLIENT:** adidas. **PRODUCT:** adidas. **AGENCY:** 180 Communications. **COUNTRY:** The Netherlands. **YEAR:** 2004. **COPYWRITER:** Chuck McBride, John Hunt. **ART DIRECTOR:** Chuck McBride. **PRODUCTION COMPANY:** Smuggler NY. **DIRECTOR:** David Frankham. **AWARDS:** CLIO Awards (Silver).

This advert reveals the inspiration of sport on a poor young boy who roams the streets of his city collecting plastic bags. Once he has collected enough he takes them to a derelict space where he ties them together to make a football. The slogan fades up with the words, "Forever Sport." /// Dieser Spot verdeutlicht, welche Inspiration der Sport einem armen Jungen geben kann. Er streunt durch die Straßen seiner Stadt und sammelt Plastiktüten. Sobald er genug zusammen hat, bringt er sie zu einer brach liegenden Freifläche, wo er sie zusammenbindet und einen Fußball daraus macht. Der Slogan „Forever Sport" erscheint. /// Ce spot montre que le sport est une source d'inspiration pour un jeune garçon pauvre qui erre dans les rues de sa ville en ramassant des sacs en plastique. Une fois qu'il en a assez, il les emmène dans un endroit abandonné, où il les attache ensemble pour faire un ballon de football. Le slogan suivant apparaît : « Le sport pour toujours ».

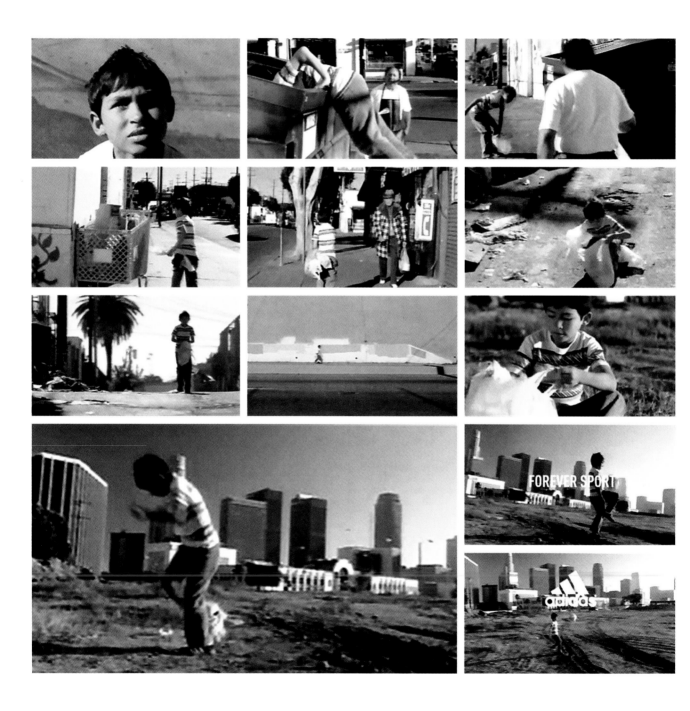

TITLE: Wake Up Call. **CLIENT:** adidas. **PRODUCT:** adidas. **AGENCY:** 180 Communications. **COUNTRY:** The Netherlands. **YEAR:** 2003. **EXECUTIVE CREATIVE DIRECTOR:** Peter McHugh. **ASSOCIATE CREATIVE DIRECTOR:** Andy Fackrell. **ART DIRECTOR:** Andy Fackrell. **PRODUCTION COMPANY:** Park Pictures. **EXECUTIVE PRODUCER:** Jackie Kelman Bisbee. **PRODUCER:** Deannie ONeil. **DIRECTOR:** Lance Acord. **AWARDS:** CLIO Awards (Bronze/Silver), ANDY Awards (Silver), AICP, Cannes Lions (Gold).

A blonde woman is woken up with the sound of banging. In the courtyard below her apartment a team of Chinese women footballers, all wearing Adidas jerseys, perform an amazing set of synchronized ball skills. The blonde woman and her Adidas clad team-mates congregate outside and nonchalantly watch the impressive display. The tagline reads, "FIFA Woman's World Cup 2003. Forever Sport." /// Eine blonde Frau wird von knallenden Geräuschen geweckt. Im Innenhof unterhalb ihrer Wohnung spielt ein chinesisches Frauenfußballteam. Die Spielerinnen tragen Trikots von Adidas und zeigen eine erstaunliche Reihe von synchronisierten Tricks mit ihren Bällen. Die blonde Frau und ihre in Adidas gekleideten Mannschafts-Kameradinnen versammeln sich draußen und beobachten lässig die beeindruckende Vorführung. Der Slogan lautet: „Weltmeisterschaft der Frauen FIFA 2003. Forever Sport." /// Une femme blonde est réveillée par des bruits de coups. En bas de son appartement, dans la cour, une équipe de footballeuses chinoises qui portent toutes des maillots Adidas se livrent à une véritable démonstration de dextérité synchronisée au ballon. La femme blonde et les autres membres de son équipe, toutes habillés en Adidas des pieds à la tête, se rejoignent pour regarder nonchalamment ce spectacle impressionnant. Les mots suivants apparaissent : « Coupe du monde féminine FIFA 2003. Le sport pour toujours. »

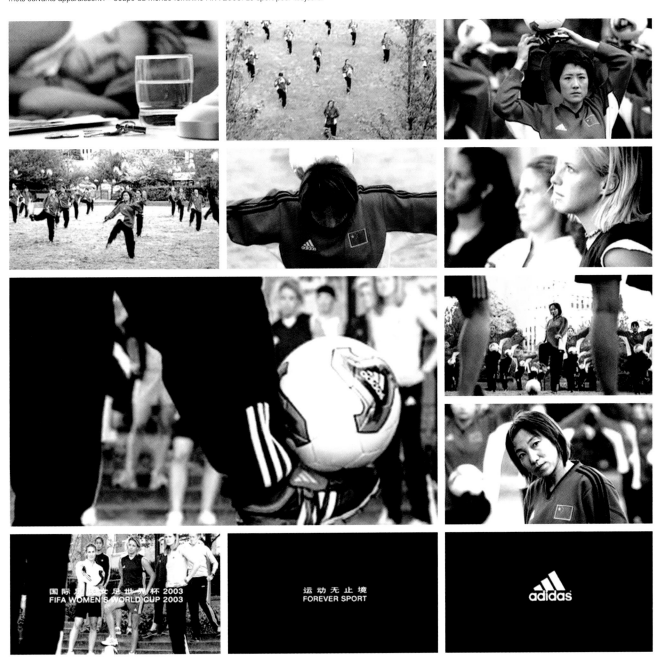

TITLE: Laila. **CLIENT:** adidas. **PRODUCT:** adidas. **AGENCY:** 180 Amsterdam. **COUNTRY:** The Netherlands. **YEAR:** 2004. **CREATIVE DIRECTOR:** Peter McHugh (180 Amsterdam), Lee Clow (TBWA\Worldwide). **COPYWRITER:** Richard Bullock. **ART DIRECTOR:** Dean Maryon. **PRODUCTION COMPANY:** Park Pictures. **PRODUCER:** Jackie Kelman Bisbee, Deannie O'neil. **DIRECTOR:** Lance Acord. **AWARDS:** Cannes Lions (Gold).

Using innovative CGI and editing, this spot combines original footage of boxing legend Muhammad Ali fighting his own daughter, three-times boxing champion, Laila. She provides the voiceover, "Impossible isn't a fact. It's an opinion." /// Durch computergenerierte Bilder und spezielle Bearbeitungstechniken verbindet dieser Werbespot originales Filmmaterial der Boxlegende Muhammad Ali, wie er gegen seine eigene Tochter kämpft: die dreifache Boxmeisterin Leila. Sie spricht auch in diesem Werbespot und sagt: „Unmöglich ist keine Tatsache. Es ist eine Meinung." /// Grâce à des techniques innovantes d'images de synthèse, ce spot utilise des séquences d'époque de la légende de la boxe Mohamed Ali pour le montrer se battant contre sa fille Leila, trois fois championne du monde. Elle dit en voix off : « L'impossible n'est pas un fait. C'est une opinion ».

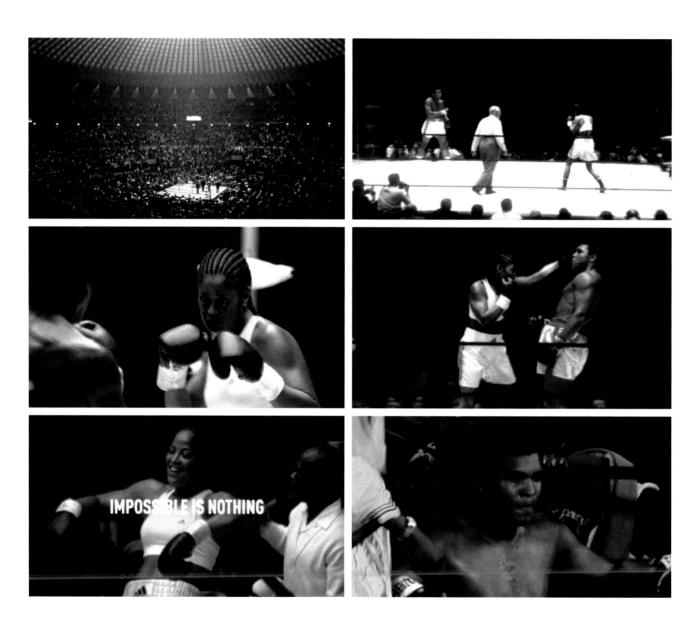

TITLE: Hello Tomorrow. **CLIENT:** adidas. **PRODUCT:** adidas. **AGENCY:** TBWA\Chiat\Day San Francisco. **COUNTRY:** USA. **YEAR:** 2005. **CREATIVE DIRECTOR:** Lee Clow. **COPYWRITER:** Chuck McBride. **ART DIRECTOR:** Joe Kayser. **PRODUCTION COMPANY:** MJZ. **EXECUTIVE PRODUCER:** Jeff Scruton, Jennifer Golub, David Zander. **PRODUCER:** Vince Landay. **DIRECTOR:** Spike Jonze. **AWARDS:** Cannes Lions (Gold), CLIO Awards (Silver), One Show (Bronze), AICP.

A man wakes up in bed. As he sits up his Adidas-1 trainers fit themselves onto his feet. He then goes on a dreamlike walk through various scenes, his Adidas-1s illuminating his path with each step. Finally he ends up back in bed and the tagline appears with the words, "World's first intelligent shoe…Impossible is nothing." /// Ein Mann wacht in seinem Bett auf. Als er aufsteht, streifen sich seine Adidas-1-Turnschuhe von selbst über seine Füße. Er geht nun traumgleich durch verschiedene Szenen, und seine Adidas-1-Schuhe lassen seinen Weg bei jedem Schritt aufleuchten. Schließlich befindet er sich wieder in seinem Bett, und der Slogan „Der erste intelligente Schuh der Welt…Unmöglich ist nichts." erscheint. /// Un homme se réveille. Il s'assoit au bord du lit, et ses tennis viennent toutes seules sur ses pieds. On le suit dans un jogging onirique à travers plusieurs scènes où ses Adidas-1 éclairent son chemin à chaque pas. Il finit par retrouver son lit et les mots suivants concluent le spot : « La première chaussure intelligente…Impossible n'est rien ».

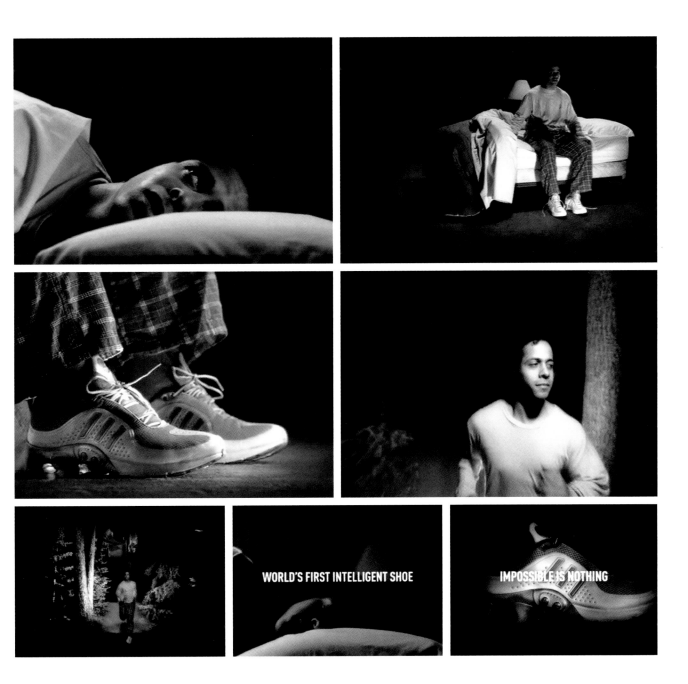

TITLE: Carry. CLIENT: adidas. PRODUCT: adidas. AGENCY: TBWA\Chiat\Day San Francisco. COUNTRY: USA. YEAR: 2004. CREATIVE DIRECTOR: Chuck McBride. COPYWRITER: Scott Duchon. ART DIRECTOR: Geoffrey Edwards. PRODUCTION COMPANY: Biscuit Filmworks EXECUTIVE PRODUCER: Shawn Lacy Tessaro. PRODUCER: Jennifer Golub. DIRECTOR: Noam Murro. AWARDS: One Show (Gold), CLIO Awards (Gold/Silver), AICP, Cannes Lions (Bronze).

In this clever ad NBA star Kevin Garnett has "got the whole world in his hands." The spot opens with Kevin, wearing Adidas shoes, as he picks up his friend and carries him on his shoulders. Soon others climb on board until he is carrying dozens on his back. /// In diesem intelligenten Spot hat NBA-Star Kevin Garnett „die ganze Welt in seiner Hand". Man sieht Kevin, der Schuhe von Adidas trägt, während er seinen Freund abholt und ihn auf seinen Schultern trägt. Bald klettern auch andere dazu, bis er schließlich Dutzende auf seinem Rücken trägt. /// Dans cette publicité astucieuse, la star de la NBA Kevin Garnett a « le monde entier dans le creux de sa main ». Le spot commence par une image de Kevin, chaussé en Adidas, qui soulève un ami et le porte sur son dos. Puis d'autres grimpent aussi, jusqu'à ce qu'il ait des dizaines de gens sur les épaules.

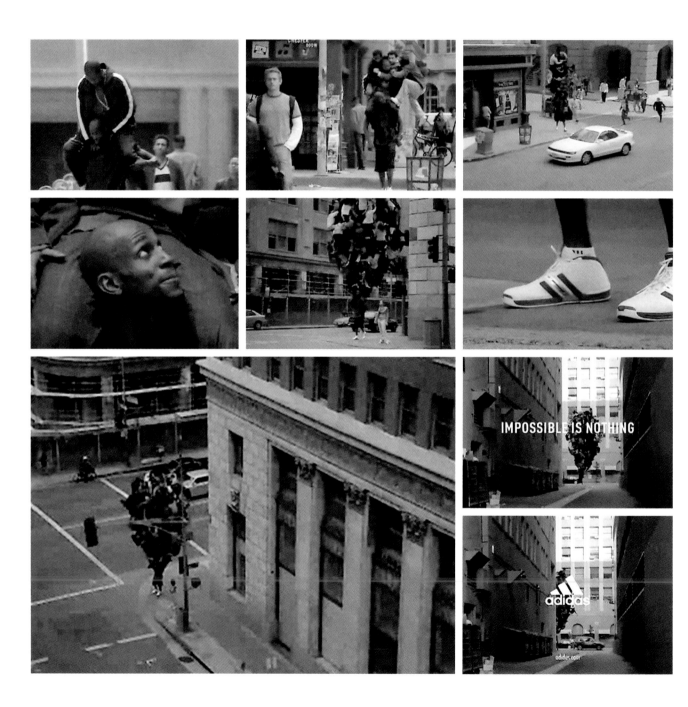

TITLE: Last Man Standing. CLIENT: adidas. PRODUCT: adidas. AGENCY: 180 Amsterdam. COUNTRY: The Netherlands. YEAR: 2005. EXECUTIVE CREATIVE DIRECTOR: Andy Fackrell. CREATIVE DIRECTOR: Stuart Brown. ART DIRECTOR: Stuart Brown. PRODUCTION COMPANY: Small Family Business. PRODUCER: Sally Humphries. DIRECTOR: Ringan Ledwidge. AWARDS: Eurobest Awards (Silver).

The New Zealand All-Adidas wearing All Blacks rugby football team enjoy a friendly training session together with Adidas stars from the rest of the world. The slogan reads, "Impossible is Nothing." /// Das neuseeländische All Blacks Rugby-Team, ganz in Adidas gekleidet, genießt eine freundliche Trainingseinheit mit anderen Adidas-Stars aus der ganzen Welt. Der Slogan lautet: „Unmöglich ist nichts". /// L'équipe de rugby néo-zélandaise des All Blacks, entièrement habillée en Adidas, est en pleine session amicale d'entraînement avec des stars Adidas du monde entier. Le slogan s'affiche : « Impossible n'est rien ».

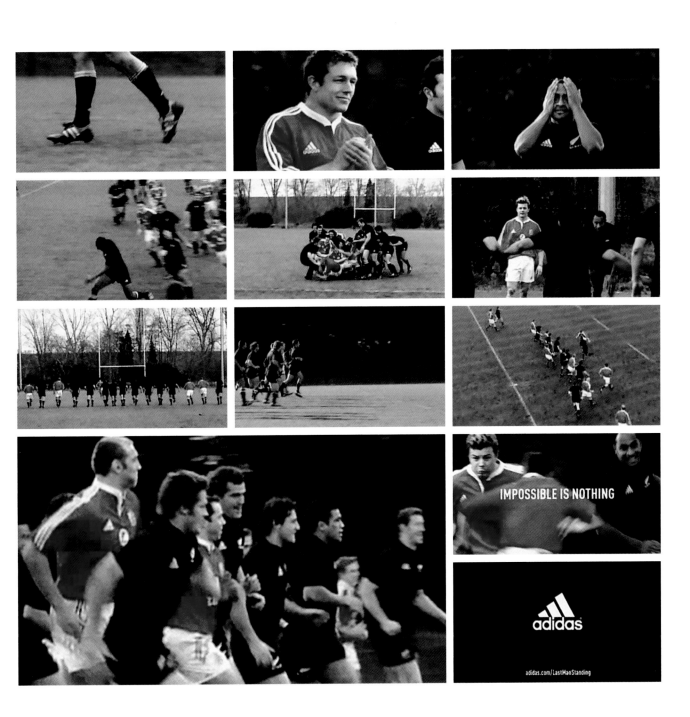

TITLE: Pool. CLIENT: Nike. PRODUCT: Nike. AGENCY: Wieden+Kennedy Portland. COUNTRY: USA. YEAR: 2006. CREATIVE DIRECTOR: Mike Folino, Steve Luker, Jim Riswold. COPYWRITER: Brandon Davis, Kevin Garnett, Stacy Wall. ART DIRECTOR: Jayanta Jenkins. PRODUCTION COMPANY: Epoch Films. EXECUTIVE PRODUCER: Jerry Solomon. PRODUCER: Marc Marrie. DIRECTOR: Stacy Wall.

An athlete is training in a swimming pool at a luxury villa. The team coach father lounges in the shade, berating his lazy sons. One of them cannonball's into the pool, splashing the father and the swimmer's Nike trainers. Pretty boy son number 3 is standing on the high diving board with white suit and perfectly styled Afro haircut. Suddenly he jumps off performing a perfect freestyle Olympic dive. /// Ein Athlet trainiert im Schwimmbecken einer luxuriösen Villa. Der Trainer und Vater ruht im Schatten aus und beschimpft seine faulen Söhne. Einer der Söhne wirft sich in den Pool und bespritzt dabei seinen Vater und die Nike-Sportschuhe des Schwimmers. Der hübsche Sohn Nummer 3 steht auf dem hohen Sprungbrett. Er trägt einen weißen Anzug, und sein Afro-Look ist perfekt gestylt. Plötzlich springt er ab und führt einen perfekten olympischen Freestyle-Sprung vor. /// Un athlète s'entraîne dans la piscine d'une villa de luxe. Le père entraîneur est allongé à l'ombre et critique la paresse de ses fils. L'un d'eux saute dans la piscine et éclabousse le père et les chaussures de sport Nike du nageur. Le troisième fils est un dandy. Il se tient sur le plongeoir le plus élevé, en costume blanc, avec une coupe afro impeccable. Soudain, il exécute un plongeon olympique parfait.

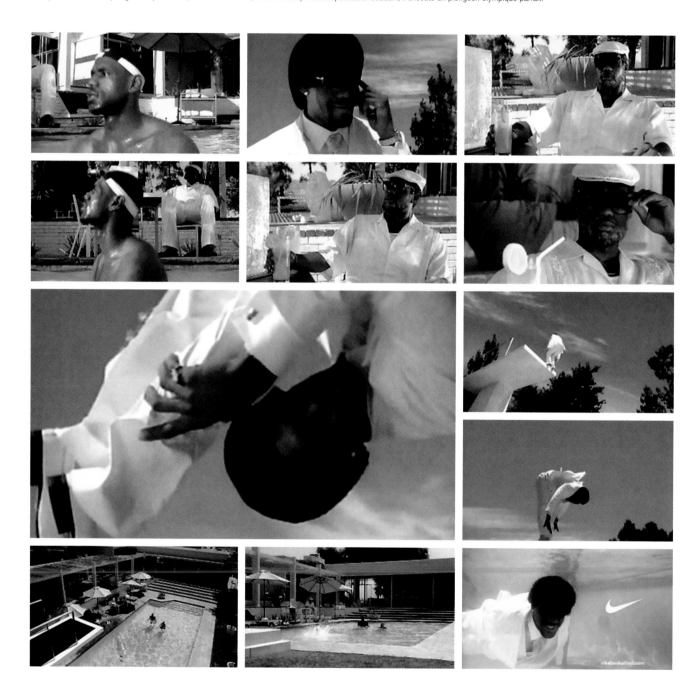

FEATURED ON THE DVD TITLE: Airvolution. CLIENT: Nike. PRODUCT: Nike Foot Locker. AGENCY: Wieden+Kennedy Amsterdam. COUNTRY: The Netherlands. YEAR: 2006. EXECUTIVE CREATIVE DIRECTOR: Al Moseley, John Norman. CREATIVE DIRECTOR: Alvaro Sotomayor, Mark Hunter. COPYWRITER: John Cross. ART DIRECTOR: Anders Stake. PRODUCTION COMPANY: Digital Domain. EXECUTIVE PRODUCER: Tom Dunlap, Elissa Singstock. PRODUCER: Laura Christie. DIRECTOR: Brad Parker.

This punchy animation shows the "Airvolution" of the Nike Air trainer as to reincarnates into various styles. "Footlocker – Join the evolution." /// Diese ausdrucksstarke Animation zeigt die „Airvolution" der Nike Air-Sportschuhe, die in verschiedene Formen wiedergeboren werden. „Footlocker – Verbinde dich mit der Evolution." /// Cette animation pleine d'énergie montre l'« airvolution » de la chaussure Nike Air, qui reprend différents styles passés. « Footlocker – Rejoignez l'évolution. »

TITLE: Frozen Moment. **CLIENT:** Nike. **PRODUCT:** Nike Basketball. **AGENCY:** Wieden+Kennedy Portland. **COUNTRY:** USA. **YEAR:** 1996. **COPYWRITER:** Jamie Barrett. **ART DIRECTOR:** Larry Frey. **PRODUCTION COMPANY:** Propaganda Films. **DIRECTOR:** Jonathan Glazer.

NBA legend Michael Jordan appears on TV in slow motion. As he prepares for a slam dunk, time slows down for all those watching the game: a group of people running on treadmills in a gym slow down, while a shaving man slows down as his wash basin overflows. The spot ends with the 'Air Jordan' logo on a black screen. /// Die NBA-Legende Michael Jordan erscheint in Zeitlupe im Fernsehen. Als er sich auf einen Slam Dunk vorbereitet, verlangsamt sich auch die Zeit für all die Personen, die sich das Spiel anschauen: Eine Gruppe von Menschen läuft langsamer, die sich im Fitness-Studio auf Laufbändern befinden, und ein Mann rasiert sich langsamer, während sein Waschbecken überläuft. Der Werbespot endet mit dem Logo von „Air Jordan" auf einem schwarzen Bildschirm. /// La légende de la NBA, Michael Jordan, apparaît ici au ralenti. Pendant qu'il se prépare à faire un slam dunk, le temps ralentit pour tous ceux qui regardent le match : des gens qui courent sur des tapis de course dans un gymnase ralentissent, et un homme qui se rase ralentit également, et son lavabo déborde. Le spot se termine avec le logo « Air Jordan » sur fond noir.

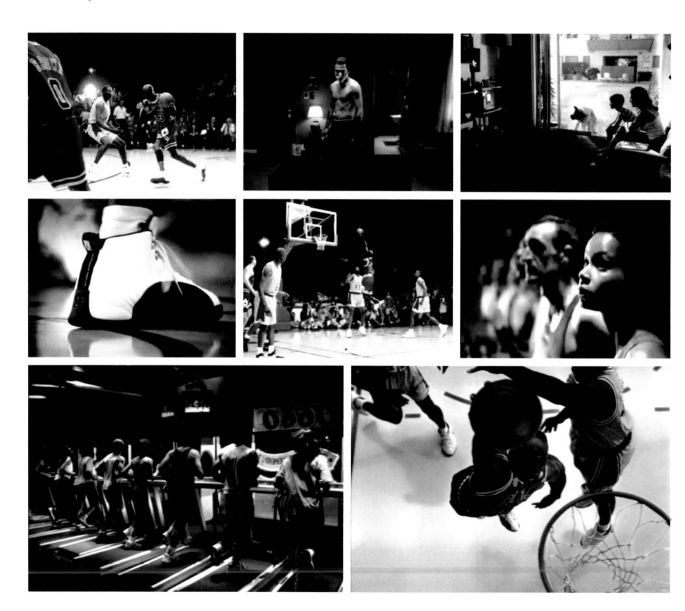

FEATURED ON THE DVD **TITLE:** Musical Chairs. **CLIENT:** Nike. **PRODUCT:** Nike P.L.A.Y. **AGENCY:** Wieden+Kennedy Amsterdam. **COUNTRY:** The Netherlands. **YEAR:** 2004. **CREATIVE DIRECTOR:** Carlos Bayala, Paul Shearer. **COPYWRITER:** Carlo Cavallone. **ART DIRECTOR:** Alvaro Sotomayor. **PRODUCTION COMPANY:** Partizan UK. **PRODUCER:** Philippa Smith. **DIRECTOR:** Ulf Johansson.

An NBA game is in progress. In the audio booth a technician is playing musical chairs on his electric organ. Suddenly he stops and all hell breaks loose as the players, spectators and staff rush around the stadium to try and find the nearest seat. Finally it's down to one player and one spectator. The player grabs the last seat to a big cheer. Nike's Play logo appears. /// Ein NBA-Spiel ist gerade im Gang. Bei der Tontechnik spielt ein Techniker die Musik zur „Reise nach Jerusalem" auf seinem Keyboard. Plötzlich stoppt er, und überall bricht Chaos aus, als Spieler, Zuschauer und Personal hastig versuchen, im Stadion den nächsten Platz zu finden. Schließlich sind nur noch ein Spieler und ein Zuschauer übrig. Der Zuschauer schnappt sich unter lautem Beifall den letzten Sitz. Das Logo von Nike Play erscheint. /// Un match de la NBA est en train de se jouer. Dans la cabine de son, un technicien est en train de jouer l'air des chaises musicales sur son orgue électrique. Il s'arrête et c'est la panique : les joueurs, les spectateurs et les employés du stade courent partout et essaient de trouver un siège. Il ne reste plus qu'un joueur et un spectateur. C'est le spectateur qui arrive à s'asseoir sur le dernier siège, à la grande joie du public. Le logo Play de Nike s'affiche.

FEATURED ON THE DVD TITLE: Joga Bonito: Heart (Rooney). CLIENT: Nike. PRODUCT: Nike Football. AGENCY: Wieden+Kennedy Amsterdam. COUNTRY: The Netherlands. YEAR: 2006. EXECUTIVE CREATIVE DIRECTOR: Al Moseley, John Norman. CREATIVE DIRECTOR: Mark Hunter, Alvaro Sotomayor. CREATIVE: Rachid Ahouyek, Jon Burden, Carlo Cavallone, Johan Dahlqvist, Joe Staples. PRODUCTION COMPANY: Smith & Jones. PRODUCER: Phillipa Smith. DIRECTOR: Ulf Johansson.

A host of Manchester United Football Club legends assemble for this spot as part of Nike's 'Joga Bonito' (Play Beautifully) campaign. On the training field, Eric Cantona opens the spot for 'Joga TV'. "I had heart", he says, "and I know, without heart, you cannot play." Wayne Rooney ignores his coach's instructions as he tries to play goalkeeper and striker at the same time. /// Eine Schar von Fußball-Legenden des Manchester United Football Clubs versammeln sich für diesen Werbespot, der Teil der Nike-Kampagne „Joga Bonito" (Spiel schön) ist. Auf dem Trainingsplatz eröffnet Eric Cantona den Werbespot für „Joga TV". „Ich hatte Herz," sagt er, „und ich weiß, dass man ohne Herz nicht spielen kann." Wayne Rooney ignoriert die Anweisungen seines Trainers und versucht, gleichzeitig Torwart und Stürmer zu sein. /// Plusieurs joueurs légendaires du Manchester United Football Club se sont retrouvés pour ce spot réalisé dans le cadre de la campagne « Joga Bonito » (Jouez beau) de Nike. Sur le terrain d'entraînement, c'est Éric Cantona qui ouvre le spot pour « Joga TV ». « J'avais du cœur », dit-il, « et je sais que, sans cœur, on ne peut pas jouer ». Wayne Rooney ignore les instructions de son entraîneur et essaie de jouer comme gardien et buteur à la fois.

FEATURED ON THE DVD **TITLE:** Joga Bonito: Joy (Ronaldinho). **CLIENT:** Nike. **PRODUCT:** Nike Football. **AGENCY:** Wieden+Kennedy Amsterdam. **COUNTRY:** The Netherlands. **YEAR:** 2006. **EXECUTIVE CREATIVE DIRECTOR:** Al Moseley, John Norman. **CREATIVE DIRECTOR:** Mark Hunter, Alvaro Sotomayor. **CREATIVE:** Carlo Cavallone, Johan Dahlqvist, Joe Staples. **PRODUCTION COMPANY:** Smith & Jones. **PRODUCER:** Phillipa Smith. **DIRECTOR:** Ulf Johansson.

Joga TV's legendary host, Eric Cantona runs a tape in the video suite to remind the viewer of "how it should be." The video tape shows a very young and as yet undiscovered Ronaldinho playing in an indoor school tournament. His natural skills already visible are intercut with shots of him today. Cantona close the spot with a word of advice, "Never grow up my friends." /// Joga TV's legendärer Gastgeber, Eric Cantona, zeigt ein Video, um die Zuschauer daran zu erinnern, „wie es sein sollte." Das Video zeigt einen sehr jungen und noch unentdeckten Ronaldinho, der in einem Schulturnier Hallenfußball spielt. Seine bereits sichtbaren natürlichen Fertigkeiten werden mit Aufnahmen aus der heutigen Zeit kombiniert. Cantona beendet den Spot mit folgendem Ratschlag: „Werdet nie erwachsen, meine Freunde." /// Le présentateur légendaire de Joga TV, Éric Cantona, lance une vidéo pour rappeler au spectateur « comment cela devrait être ». La bande montre Ronaldinho alors qu'il n'était qu'un petit garçon et n'avait pas encore été découvert, jouant dans un championnat de football en salle inter-écoles. Son talent naturel est déjà bien visible, et les séquences sont entrecoupées d'images d'aujourd'hui. Cantona conclut le spot avec un conseil : « Ne grandissez jamais, mes amis ».

TITLE: Angry Chicken. CLIENT: Nike. PRODUCT: Nike Presto. AGENCY: Wieden+Kennedy Portland. COUNTRY: USA. YEAR: 2002. CREATIVE DIRECTOR: Carlos Bayala, Susan Hoffman. COPYWRITER: Mike Byrne. ART DIRECTOR: Danielle Flagg. PRODUCTION COMPANY: Partizan Entertainment. PRODUCER: Jennifer Smieja. DIRECTOR: Traktor.

A man jumps out of an apartment balcony and starts free running throughout a city. However, he is being followed … by an angry chicken. The runner tries to outwit the chicken with various stunts and eventually wins. The spot closes as the Nike Presto logo appears. /// Ein Mann springt von dem Balkon seines Apartments und fängt an, im Free-Running-Stil die Stadt zu durchqueren. Er wird jedoch verfolgt … von einem wütenden Huhn. Der Läufer versucht, das Huhn durch verschiedene Kunststücke auszutricksen, und gewinnt schließlich. Am Ende des Spots erscheint das Logo von Nike Presto. /// Un homme saute depuis un balcon et commence à courir en free-running à travers la ville. Il est poursuivi par … un poulet en colère. Le coureur essaie tous ses trucs pour semer le poulet, et finit par réussir. Le spot se termine avec le logo Nike Presto.

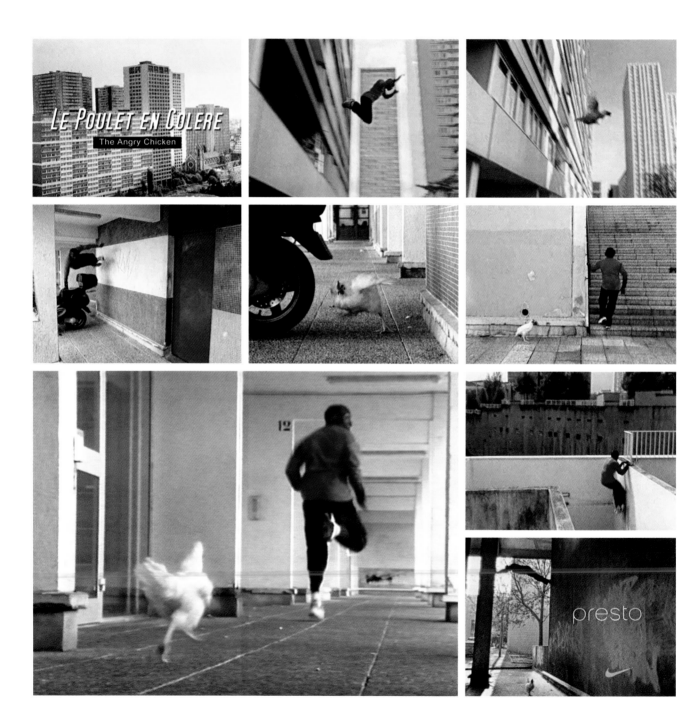

FEATURED ON THE DVD **TITLE:** Puddles. **CLIENT:** Nike. **PRODUCT:** Nike. **AGENCY:** Wieden+Kennedy Amsterdam. **COUNTRY:** The Netherlands. **YEAR:** 2002. **CREATIVE DIRECTOR:** Paul Shearer. **COPYWRITER:** Paul Shearer, Carlo Cavallone. **ART DIRECTOR:** Rachid Ahouyek. **PRODUCTION COMPANY:** Outsider UK. **PRODUCER:** John Madsen. **DIRECTOR:** Dom & Nic. **AWARDS:** BTAA (Bronze), One Show, Cannes Lions (Silver).

As a woman prepares for her run in a park, a male runner runs through a puddle and splashes her with water. This triggers off a slapstick race between the two as they use any means to spray each other. Both are finally caught out as a bus speeds through a huge street puddle, thoroughly showering them. Inside the coach, members of the Manchester United Football team look out of the windows to see the show. /// Während sich eine Frau auf ihren Lauf im Park vorbereitet, rennt ein männlicher Läufer durch eine Pfütze und bespritzt sie mit Wasser. Dies löst ein witziges Rennen zwischen den beiden Läufern aus, die jede sich bietende Möglichkeit nutzen, sich gegenseitig zu bespritzen. Beide werden schließlich von einem Bus erwischt, der durch eine riesige Straßenpfütze fährt und sie gründlich abduscht. Im Bus schaut das Team von Manchester United aus dem Fenster und sieht sich die Vorstellung an. /// Une femme se prépare à courir dans le parc lorsqu'un coureur passe sur une flaque et l'éclabousse. Cela déclenche une course poursuite comique pendant laquelle ils essaient de s'éclabousser par tous les moyens. Ils finissent par se faire surprendre par un car qui passe sur une énorme flaque dans la rue et leur fait prendre une douche. À l'intérieur du car, des membres de l'équipe du Manchester United Football regardent la scène à travers les vitres.

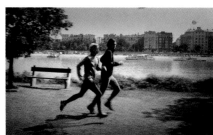

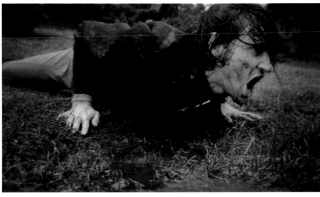
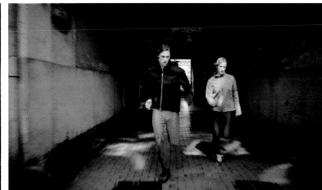

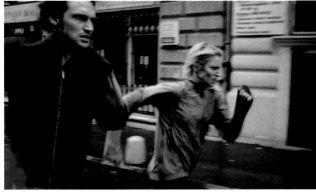

TITLE: Tennis Instructor. **CLIENT:** Nike. **PRODUCT:** Nike. **AGENCY:** Wieden+Kennedy Portland. **COUNTRY:** USA. **YEAR:** 2004. **CREATIVE DIRECTOR:** Hal Curtis, Mike Byrne. **COPYWRITER:** Alberto Ponte. **ART DIRECTOR:** Bill Karow. **PRODUCTION COMPANY:** Gorgeous. **PRODUCER:** Heather Kojima. **DIRECTOR:** Chris Palmer.

In a tennis club locker room a group of teenage girls excitedly await the arrival of their hunky instructor. As they all try to outplay each other to impress him, he's astounded by their performances and begins to see visions of tennis ace Serena Williams all around him. Nike's tagline reads, "You're faster than you think." /// Im Umkleideraum eines Tennisclubs wartet eine Gruppe weiblicher Teenager aufgeregt auf die Ankunft ihres hübschen Trainers. Sie versuchen alle, sich gegenseitig zu übertrumpfen, um ihn zu beeindrucken. Er ist verblüfft über ihre Leistungen und beginnt, um sich herum nur die Visionen von Tennis-As Serena Williams zu sehen. Nikes Slogan lautet: „Du bist schneller, als du denkst." /// Dans les vestiaires d'un club de tennis, des adolescentes attendent avec excitation leur professeur, un véritable apollon. Sur le court, elles essaient toutes de l'impressionner. Il est époustouflé par leurs performances et commence à voir la star du tennis Serena Williams partout. Le spot se conclut par ces mots : « Vous êtes plus rapide que vous ne le pensez ».

TITLE: Shade Running. **CLIENT:** Nike. **PRODUCT:** Nike P.L.A.Y. **AGENCY:** Wieden+Kennedy Portland. **COUNTRY:** USA. **YEAR:** 2001. **CREATIVE DIRECTOR:** Hal Curtis, Dan Wieden. **COPYWRITER:** Mike Byrne. **ART DIRECTOR:** Andy Fackrell, Monica Taylor. **PRODUCTION COMPANY:** Anonymous Content. **DIRECTOR:** Frank Budgen.

A female athlete runs through a city on a sunny day. However, she manages to manoeuvre herself to stay in the shade at all times. Finally, she pauses for rest in an alley and a window reflects sunlight on her Nike running shoe. The Nike Play logo appears with the caption, "Shade Running". /// Eine Athletin läuft an einem sonnigen Tag durch eine Stadt. Sie schafft es aber, dabei die ganze Zeit im Schatten zu bleiben. Schließlich legt sie in einer Nebenstraße eine Pause ein. Ein Fenster reflektiert das Sonnenlicht auf ihre Nike-Laufschuhe. Das Nike Play-Logo erscheint mit der Überschrift: „Schattenlaufen". /// Une athlète court dans la ville par une belle journée ensoleillée, mais arrive à toujours rester à l'ombre. Elle finit par s'arrêter dans une ruelle pour se reposer, et une fenêtre réfléchit de la lumière sur sa chaussure de course Nike. Le logo Nike Play apparaît avec les mots « Shade Running ».

TITLE: The Blob. CLIENT: Reebok. PRODUCT: Reebok. AGENCY: Lowe Lintas & Partners London. COUNTRY: United Kingdom. YEAR: 2000. CREATIVE DIRECTOR: Charles Inge. COPYWRITER: Brian Turner. ART DIRECTOR: Micky Tudor. PRODUCTION COMPANY: Partizan Entertainment. PRODUCER: Anthony Falco. DIRECTOR: Traktor.

A man is chased through a city by a giant belly. He finally outwits the huge blob by hanging off a bridge as the belly on a motorcycle falls into the river below. The camera zooms into the sole of the dangling man's Reebok running shoe, which reads, "Lose the beer belly." /// Ein Mann wird von einem riesigen Bauch durch die Stadt gejagt. Er überlistet ihn schließlich, indem er sich von einer Brücke hängen lässt, während der Bauch auf einem Motorrad in den Fluss darunter stürzt. Die Kamera zeigt eine Nahaufnahme der Reebok-Schuhsohlen, die der von der Brücke baumelnde Mann trägt. Dort stehen die Worte „Weg mit dem Bierbauch". /// Un homme est poursuivi dans toute la ville par un ventre géant. Il finit par se montrer plus malin que la grande masse immonde. Il s'accroche à un pont et le ventre, juché sur une moto, tombe dans la rivière. La caméra zoome sur la semelle de ses chaussures de course Reebok, où l'on peut lire : « Perdez votre ventre de buveur de bière ».

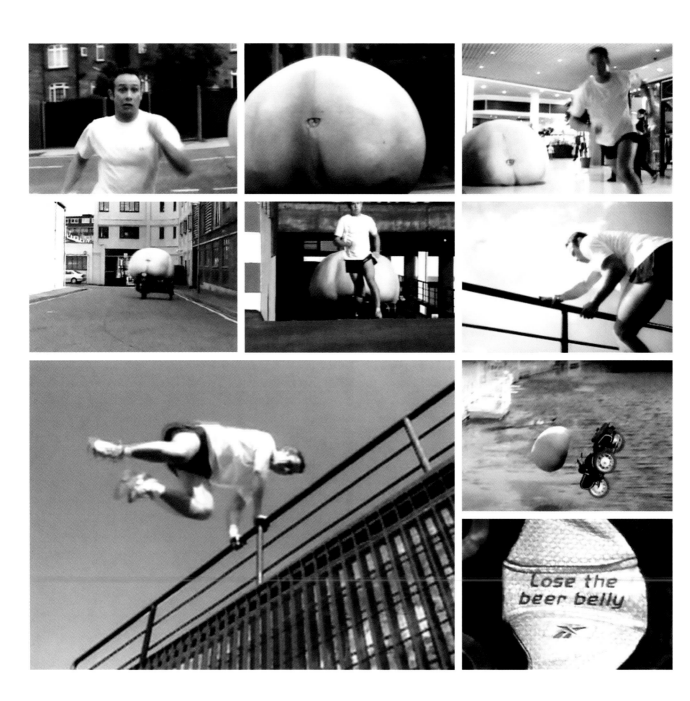

TITLE: Sofa. **CLIENT:** Reebok. **PRODUCT:** Reebok. **AGENCY:** Lowe Lintas & Partners London. **COUNTRY:** United Kingdom. **YEAR:** 2001. **CREATIVE DIRECTOR:** Paul Weinberger. **COPYWRITER:** Tony Barry. **ART DIRECTOR:** Vince Squibb. **PRODUCTION COMPANY:** Gorgeous. **PRODUCER:** Paul Rothwell. **DIRECTOR:** Frank Budgen.

A man wearing Reebok trainers is lying on his sofa watching TV. When his show ends he switches the box off and prepares to set out for the gym. Suddenly, he is attacked by his sofa. The man tries to escape and finally struggles free when the sofa gets wedged in his apartment door. /// Ein Mann in Reebok-Sportschuhen liegt auf seinem Sofa und schaut Fernsehen. Als der Film zu Ende ist, schaltet er den Fernseher aus und will los zum Fitness-Studio. Plötzlich wird er von seinem Sofa angegriffen. Der Mann versucht zu entkommen und kann sich schließlich befreien, als sich das Sofa in der Türöffnung verkeilt. /// Un homme qui porte des chaussures de sport Reebok est allongé sur son canapé devant la télévision. L'émission se termine, il éteint l'appareil et se prépare à aller au gymnase. Soudain, son canapé l'attaque. Il essaie de s'échapper et finit par se dégager lorsque le canapé se retrouve coincé dans la porte d'entrée.

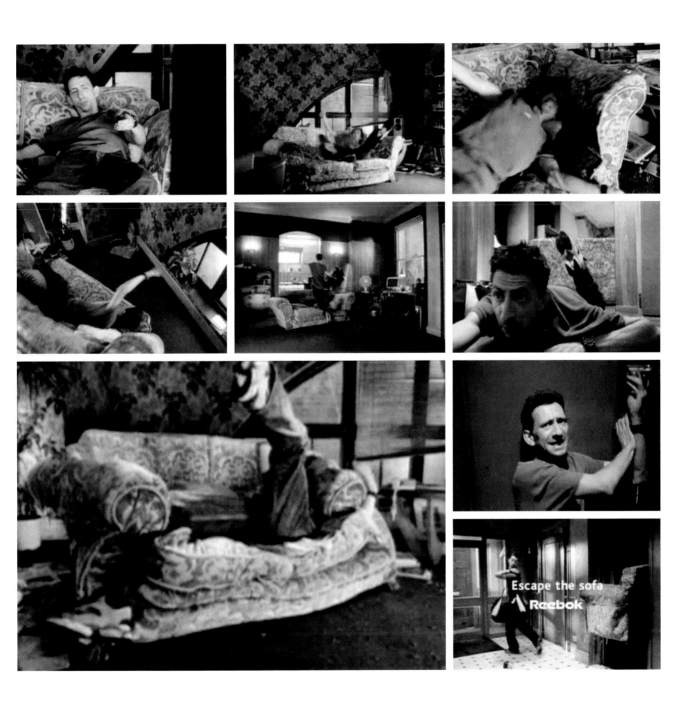

TITLE: Terry Tate – Office Linebacker. **CLIENT:** Reebok. **PRODUCT:** Reebok. **AGENCY:** Arnell Group Worldwide. **COUNTRY:** USA. **YEAR:** 2003. **CREATIVE DIRECTOR:** Peter Arnell. **COPYWRITER:** Rawson Thurber. **ART DIRECTOR:** Peter Arnell. **PRODUCTION COMPANY:** Hypnotic. **PRODUCER:** Gary Bryman, Steve Hein, Jason Mercer. **DIRECTOR:** Rawson Thurber. **AWARDS:** CLIO Awards (Bronze), AICP, Cannes Lions (Gold), AICE (Winner Comedy).

Terry Tate, Office Linebacker has been assigned to streamline the workforce at Felcher & Sons. Ron Felcher, CEO of Felcher & Sons proudly explains how Reebok's dynamic solution has improved his company's efficiency. /// Der Büro-Linebacker Terry Tate wurde ausgewählt, um die Belegschaft von Felcher & Sons zu rationalisieren. Ron Felcher erklärt als Vorstand von Felcher & Sons stolz, wie Reeboks dynamische Lösung die Produktivität seiner Firma verbessert hat. /// Terry Tate, défenseur de football américain, a été engagé pour contrôler la productivité des employés chez Felcher & Sons. Ron Felcher, le directeur général, explique fièrement que cette solution de Reebok a amélioré les résultats de l'entreprise.

TITLE: Terry Tate – On the Field. CLIENT: Reebok. PRODUCT: Reebok. AGENCY: Arnell Group Worldwide. COUNTRY: USA. YEAR: 2003. CREATIVE DIRECTOR: Peter Arnell. PRODUCTION COMPANY: Hypnotic. PRODUCER: Steve Hein, Jason Mercer. DIRECTOR: Rawson Thurber.

A big league soccer games is interrupted when a male streaker runs across the pitch. Suddenly, he's taken out with a flying tackle from Reebok's Terry Tate, Office Linebacker. /// Ein Oberligaspiel wird unterbrochen, als ein männlicher Flitzer über das Fußballfeld läuft. Plötzlich wird er durch einen stürmischen Angriff von Terry Tate, dem Büro-Linebacker von Reebok, außer Gefecht gesetzt. /// Un grand match de football est interrompu par un plaisantin qui traverse le terrain en courant, nu comme un ver. Soudain, il est fauché par un tacle puissant du défenseur de Reebok, Terry Tate.

TITLE: Dynamite Surfing. **CLIENT:** Quiksilver Denmark. **PRODUCT:** Quiksilver. **AGENCY:** Saatchi & Saatchi Copenhagen. **COUNTRY:** Danmark. **YEAR:** 2007. **CREATIVE DIRECTOR:** Simon Wooller. **COPYWRITER/ART DIRECTOR:** Simon Wooller, Lasse Bækbo Hinke, Rasmus Petersen. **PRODUCTION COMPANY:** www.sisomo.dk. **EXECUTIVE PRODUCER:** Anna-Marie Elkjær. **DIRECTOR:** Jonas Arnby.

This fast-paced ad follows a group of urban guerrilla surfers as they prepare for a highly unusual stunt. They throw a stick of dynamite into a city river, allowing one of the group members to ride the artificial wave. The Quicksilver surfing brand logo closes the spot with the tagline, "Original Thinking." /// Dieser rasante Spot folgt einer Gruppe städtischer Guerilla-Surfer, die sich auf ein höchst ungewöhnliches Kunststück vorbereiten. Sie werfen eine Stange Dynamit in den Fluss der Stadt und lassen ein Gruppenmitglied auf der künstlichen Welle surfen. Der Werbespot endet mit dem Logo der Quicksilver Surfing-Marke und dem Slogan „Original Thinking." /// Cette pub au rythme trépidant suit un groupe de surfeurs qui, à la manière de guérilleros urbains, préparent une cascade des plus insolites. Ils jettent un bâton de dynamite dans la rivière de la ville, permettant ainsi à l'un d'eux de se mesurer à une vague artificielle. Le logo de la marque d'équipements de surf Quicksilver met fin au spot, avec cette accroche « Penser original. »

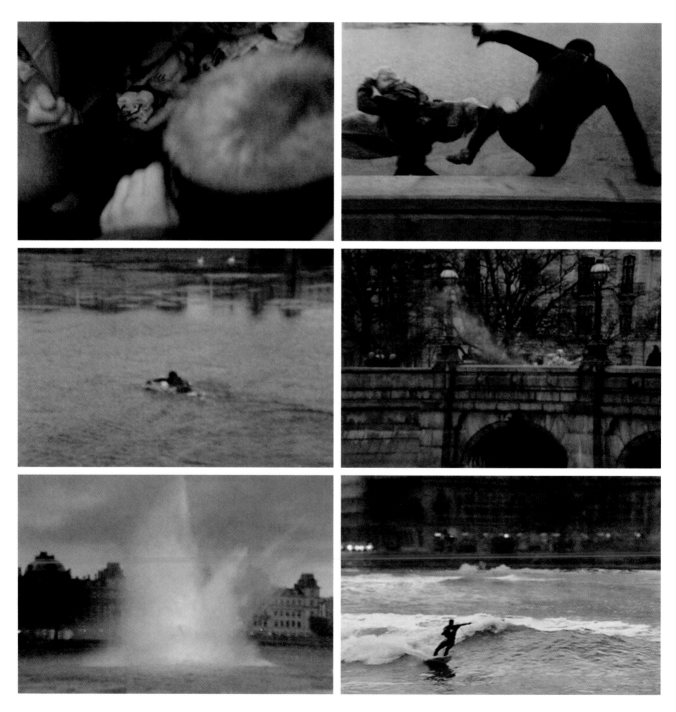

TITLE: Balls. **CLIENT:** Jockey. **PRODUCT:** Jockey Underwear. **AGENCY:** Arnold Australia. **COUNTRY:** Australia. **YEAR:** 2005. **CREATIVE DIRECTOR:** Jay Furby. **COPYWRITER:** Jay Furby. **ART DIRECTOR:** Jay Furby, Ross McGarver. **PRODUCTION COMPANY:** Curious Film. **PRODUCER:** Matt Noonan. **DIRECTOR:** Darryl Ward.

Various scenes show balls and ball-shaped objects, from sports balls to fruit, being discarded, kicked, knocked about and fried. A blue screen intercuts with the slogan, "You only get one pair ... Treat them well." The spot closes with the Jockey Recut Y-Front logo. /// Verschiedene Szenen zeigen jeweils paarweise Bälle und ballförmige Objekte, von Sportbällen bis hin zu Früchten, die geworfen, getreten, umhergestoßen und gebraten werden. Ein blauer Bildschirm erscheint mit dem Slogan „Du hast nur ein Paar ... behandle es gut." Der Spot endet mit dem Logo von Jockey Recut Y-Front. /// Des boules ou des objets en forme de boule, depuis des ballons jusqu'à des fruits, se succèdent à l'écran, lancés, frappés, heurtés et même frits. Un écran bleu s'interpose, avec le slogan « Vous n'en avez qu'une paire ... Traitez-les bien. » Le spot s'achève par le logo de Jockey Recut Y-Front.

TITLE: We don't pay sports stars – Beyond Reason. **CLIENT:** Skins. **PRODUCT:** Skins Spotswear. **AGENCY:** The Furnace, Sydney. **COUNTRY:** Australia. **YEAR:** 2005. **CREATIVE DIRECTOR:** Rob Martin Murphy. **COPYWRITER:** Rob Martin Murphy **ART DIRECTOR:** Paul Fenton. **PRODUCTION COMPANY:** The Sweet Shop, NZ. **EXECUTIVE PRODUCER:** Michael Ritchie. **DIRECTOR:** Jess Bluck.

This spot uses the delicate theme of race to highlight the natural physical prowess of black people. Various black athletes explain how they attribute their strengths and athleticism from a racial and historical viewpoint. /// Dieser Werbespot arbeitet mit dem heiklen Thema der ethnischen Herkunft, um die natürlichen physischen Fähigkeiten farbiger Menschen herauszustellen. Verschiedene farbige Athleten erklären, wie sie ihre Stärke und athletische Form von einem ethnischen und historischen Standpunkt herleiten. /// Ce spot exploite la délicate question raciale pour vanter les prouesses physiques naturelles de la population noire. Plusieurs athlètes de couleur s'expriment, expliquant leurs aptitudes et leurs performances d'un point de vue racial et historique.

TITLE: We don't pay sports stars – Jump. CLIENT: Skins. PRODUCT: Skins Spotswear. AGENCY: The Furnace, Sydney. COUNTRY: Australia. YEAR: 2005. CREATIVE DIRECTOR: Rob Martin Murphy. PRODUCTION COMPANY: The Sweet Shop, NZ. PRODUCER: Sharlene George. DIRECTOR: Melanie Bridge.

A voiceover launches into an angry tirade against all those sports stars who get paid too much and are out of touch with reality. The spot closes with a footballer kicking a ball wearing Skins 'bioacceleration technology' sportswear. The spot closes with the Skins logo and website address. /// Eine Hintergrundstimme lässt eine wütende Tirade gegen all jene Spitzensportler los, die zu viel Geld verdienen und damit den Sinn für die Realität verlieren. Der Spot endet mit einem Fußballer, der einen Ball tritt und die ‚Bioacceleration Technology Sportswear' von Skins trägt. Schließlich werden das Logo und die Webadresse von Skins eingeblendet. /// Une voix off exaspérée se lance dans une tirade contre ces étoiles du sport system qu'on surpaye et qui perdent tout contact avec la réalité. Le spot s'achève sur un footballeur en train de shooter : il porte un équipement ‹ bioacceleration technology › de Skins. Suit le logo de Skins et l'adresse de son site Web.

TITLE: Kylie. **CLIENT:** Agent Provocateur. **PRODUCT:** Agent Provocateur. **AGENCY:** CDP. **COUNTRY:** UK. **YEAR:** 2001. **CREATIVE DIRECTOR:** Andy Amadeo, Mick Mahoney. **PRODUCTION COMPANY:** Another Film Company. **PRODUCER:** Anthony Falco. **DIRECTOR:** Steve Reeves. **AWARDS:** BTAA.

An old woman sits in a big padded red room. Kylie Minogue walks on set and states that, "Agent Provocateur is the most erotic lingerie in the world. And with your help … we can prove it." After a provocative ride on a big red padded poof, a hot and flustered Kylie asks all the men in the audience to stand up. After a silence the old lady shrieks with laughter, "Didn't think you would be able to." /// Eine alte Frau sitzt in einem großen, roten, ausgepolsterten Raum. Kylie Minogue erscheint in der Szene und erklärt, dass „Agent Provocateur die erotischsten Dessous der Welt sind. Und mit Ihrer Hilfe … können wir das beweisen." Nach einem provokativen Ritt auf einem großen roten Sitzkissen bittet eine erhitzte und nervöse Kylie alle Männer im Publikum darum, aufzustehen. Nach kurzer Stille kreischt die alte Dame vor Lachen: „Ich hätte nicht gedacht, dass du das schaffst." /// Une vieille femme est assise dans une grande pièce rouge capitonnée. Kylie Minogue apparaît à l'écran et déclare : « Agent Provocateur est la lingerie la plus érotique au monde. Et avec votre aide … nous pouvons le prouver ». Après un tour torride sur une machine à rodéo capitonnée de velours rouge, Kylie, reprend son souffle et demande aux hommes du public de se lever. Après quelques secondes de silence, la vieille femme rit à gorge déployée : « Je savais bien que vous ne pourriez pas ».

TITLE: Catwalk. CLIENT: Clarks PRODUCT: Clarks AGENCY: St Lukes, London. COUNTRY: United Kingdom. YEAR: 2003. PRODUCTION COMPANY: HSI/Venus/Mars. DIRECTOR: Paul Hunter.

The scene is an haute couture fashion show. A variety of ordinary people walk down the catwalk, from a man flipping burgers on a barbeque to a woman carrying her trash into a wheelie bin. The audience roars with approval. For the closing shot, all the ordinary models join together to savour the applause. The slogan reads, "Clarks – Life's one long catwalk." /// Die Szene dieses Werbespots zeigt eine Haute Couture-Modenschau. Verschiedene, aber ganz normale Menschen gehen den Laufsteg entlang: ein Mann, der Burger auf einem Grill wendet, oder eine Frau, die ihren Müll zur Tonne trägt. Das Publikum spendet tosenden Beifall. In der Schlussszene versammeln sich alle gewöhnlichen Models und genießen den Applaus. Der Slogan lautet: „Clarks – Das Leben ist ein einziger langer Laufsteg." /// L'action se déroule à un défilé de haute couture. Des personnes ordinaires de différents horizons défilent sur le podium, depuis un homme qui retourne des steaks sur un barbecue jusqu'à une femme qui met ses ordures dans une poubelle. Le public pousse des cris d'approbation. La dernière image montre tous les mannequins ordinaires qui se rejoignent sur le podium pour savourer les applaudissements. Le slogan s'affiche : « Clarks – La vie est un grand défilé ».

TITLE: Little Rock 1873. **CLIENT:** Diesel. **PRODUCT:** Diesel Jeans. **AGENCY:** Paradiset DDB, Stockholm. **COUNTRY:** Sweden. **YEAR:** 1996. **CREATIVE DIRECTOR:** Jakob Nelson. **COPYWRITER:** Linus Kaslsson. **ART DIRECTOR:** Joakim Jonason. **PRODUCER:** Paul Dulaney. **PRODUCTION COMPANY:** Partizan Midi Minuit. **DIRECTOR:** Traktor. **AWARDS:** Grand Prix Cannes Lions.

Diesel Historical Moments present Little Rock, 1873. A righteous young cowboy puts his jeans on and kisses his wife goodbye. In another room a greasy bad guy leaves his ugly showgirl and goes on the rampage. Outside the street clears and the bad guy and good guy come face to face. They draw their guns and the bad guy shoots the other dead. The punch line reads, "For successful living: Diesel." /// Historische Momente von Diesel zeigt Little Rock im Jahre 1873. Ein rechtschaffener junger Cowboy zieht seine Jeans an und gibt seiner Frau einen Abschiedskuss. In einem anderen Raum verlässt ein schmutziger Bösewicht sein hässliches Revuegirl und randaliert. Draußen leert sich die Straße, während sich Bösewicht und guter Cowboy gegenübertreten. Sie ziehen ihre Waffen, und der Bösewicht erschießt den anderen. Die Pointe lautet: „Für ein erfolgreiches Leben: Diesel." /// Les Moments historiques de Diesel présentent Little Rock, 1873. Un jeune cow-boy vertueux met son jean et dit au revoir à sa femme en l'embrassant. Ailleurs, un méchant crasseux quitte une fille de joie hideuse et part se livrer à ses activités criminelles. Dehors, la rue est vide, et le méchant et le justicier se retrouvent face à face. Ils dégainent et le méchant tue l'autre. Le slogan s'affiche : « Pour une vie de succès : Diesel. »

TITLE: Boy Scouts. **CLIENT:** Diesel. **PRODUCT:** Diesel Jeans. **AGENCY:** Paradiset DDB, Stockholm. **COUNTRY:** Sweden. **YEAR:** 1996. **CREATIVE DIRECTOR:** Jakob Nelson. **COPYWRITER:** Linus Kaslsson. **ART DIRECTOR:** Joakim Jonason. **PRODUCTION COMPANY:** Partizan Midi Minuit. **PRODUCER:** Paul Dulaney. **DIRECTOR:** Traktor.

It's 5 a.m. in the mono village. A bugle announces roll call and the boy scouts do their morning exercises. The scout leader blows his whistle and the group congregate for a First Aid lesson in mouth to mouth resuscitation. A pretty boy bully makes his way to the head of the queue. To his horror he discovers his model is an old man. "For successful living: Diesel jeans and workwear." /// Es ist 5 Uhr morgens im Pfadfinderlager. Ein Signalhorn kündigt den Morgenappell an, und die Pfadfinder machen ihre morgendlichen Übungen. Der Leiter ruft die Gruppe mit seiner Trillerpfeife zu einer Erste-Hilfe-Übung in Mund-zu-Mund-Beatmung. Ein grober Kerl, der gerne schüchterne Jungs ärgert, drängelt sich nach vorn und sichert sich seinen Platz am Anfang der Warteschlange. Zu seinem Schrecken stellt er fest, dass sein Modell ein alter Mann ist. „Für ein erfolgreiches Leben: Diesel Jeans und Arbeitskleidung." /// Il est 5 heures du matin dans le camp des scouts. Le clairon sonne et les boys scouts font leurs exercices matinaux. Le chef scout donne un coup de sifflet et le groupe se rassemble pour écouter une leçon de premiers secours, le bouche-à-bouche. Un beau garçon sûr de lui passe devant tous les autres. Il réalise avec horreur que le cobaye est un vieil homme. « Pour une vie de succès : jeans et vêtements de travail Diesel ».

TITLE: No Jeans. **CLIENT:** Diesel. **PRODUCT:** Diesel Jeans. **AGENCY:** Paradiset DDB, Stockholm. **COUNTRY:** Sweden. **YEAR:** 1997. **CREATIVE DIRECTOR:** Joakim Jonason. **COPYWRITER:** Jacob Nelson. **ART DIRECTOR:** Joakim Jonason. **PRODUCTION COMPANY:** Partizan Midi Minuit. **PRODUCER:** Richard Ulfvengren. **DIRECTOR:** Traktor.

Set in the turmoil of North Korean life, a young man leaves his abusive home in search of work. He sets off on his bike with the neighbour's daughter, but when they arrive at the employment office he is denied entry for wearing jeans. Distraught, he prepares to jump off a bridge. A young woman yells at him to stop. She too is wearing jeans. They jump together – only to end up in an open truck full of sacks. /// Die Szene spielt im Getümmel des Lebens in Nordkorea. Ein junger Mann verlässt sein Heim, in dem er nur ausgenutzt wird, um sich Arbeit zu suchen. Zusammen mit der Nachbarstochter macht er sich per Fahrrad auf den Weg, doch als die beiden bei der Arbeitsvermittlung ankommen, wird ihm der Zutritt verwehrt, da er Jeans trägt. Verzweifelt macht er sich daran, von einer Brücke zu springen. Eine junge Frau ruft ihm zu, dass er warten soll. Auch sie trägt Jeans. Sie springen zusammen – nur um auf der Ladefläche eines Lastwagens mit Säcken zu landen. /// Dans le climat instable de la Corée du Nord, un jeune homme maltraité par ses parents quitte son foyer à la recherche d'un travail. Il part sur son vélo avec la fille du voisin, mais lorsqu'ils arrivent à l'agence pour l'emploi on lui refuse l'entrée parce qu'il porte un jean. Désespéré, il se prépare à sauter du haut d'un pont. Une jeune femme lui crie d'arrêter. Elle aussi porte un jean. Ils sautent ensemble, et atterrissent dans la remorque pleine de sacs d'un camion.

DIESEL®
FOR SUCCESSFUL LIVING

TITLE: Oil Klash Klash. **CLIENT:** Diesel. **PRODUCT:** Diesel Jeans. **AGENCY:** KesselsKramer Amsterdam. **COUNTRY:** The Netherlands. **YEAR:** 2003. **CREATIVE DIRECTOR:** Lorenzo de Rita. **COPYWRITER:** Johan Kramer. **ART DIRECTOR:** Johan Kramer. **PRODUCTION COMPANY:** Stink. **PRODUCER:** Jacqueline Kouwenberg. **DIRECTOR:** Johan Kramer.

In a petrol dry country people resort to pushing each other's cars. A young man meets a girl and jumps into her car. They start kissing. Oblivious to their car rolling down a street they continue kissing. They crash through a market square, where a wrestling match is taking place. A wrestler ends up on the roof as they crash into a post, which begins to gush out oil. The village cheers. /// In einem Land ohne Benzin behelfen sich die Menschen damit, gegenseitig ihre Autos zu schieben. Ein junger Mann trifft ein Mädchen und springt in ihr Auto. Sie beginnen, sich zu küssen. Sie achten nicht darauf, wo ihr Auto hinrollt, und küssen sich weiter. Sie brettern durch einen Marktplatz, wo gerade ein Ringkampf stattfindet. Ein Ringer landet auf dem Autodach, während sie auf einen Pfosten treffen, aus dem plötzlich Öl fließt. Das ganze Dorf jubelt. /// Dans un pays sans pétrole, les gens poussent les voitures. Un jeune homme rencontre une jeune fille et saute dans sa voiture. Ils commencent à s'embrasser. Ils continuent sans se rendre compte que la voiture est en train de dévaler la rue. Ils arrivent avec grand fracas sur une place de marché où se tient un match de lutte. L'un des lutteurs se retrouve sur le toit de la voiture, qui s'écrase sur un poteau. Du pétrole jaillit du trou. Tout le village pousse des hourras.

TITLE: Odyssey. **CLIENT:** Levi's. **PRODUCT:** Levi's Engineered Jeans. **AGENCY:** Bartle Bogle Hegarty. **COUNTRY:** United Kingdom **YEAR:** 2002. **CREATIVE DIRECTOR:** Stephen Butler. **COPYWRITER:** Anthony Goldstein. **ART DIRECTOR:** Gavin Lester. **PRODUCTION COMPANY:** Academy Films. **PRODUCER:** Nick Morris. **DIRECTOR:** Jonathan Glazer. **AWARDS:** AICP, Cannes Lions (Gold), LIAA, ANDY.

This beautifully surreal spot shows a man wearing Levis as he runs and crashes through a long series of rooms. A woman wearing Levis appears doing the same. For a moment the two runners notice each other and walk side by side. The pair crash through brick wall and sprint vertically along the trunks of two long trees before leaping into orbit. The slogan reads, "Freedom to Move." /// Dieser schöne surreale Werbespot zeigt einen Mann in Levis-Jeans, der durch aufeinander folgende Räume rennt. Eine Frau, die ebenfalls eine Levis trägt, kommt hinzu und rennt mit. Für einen Moment nehmen sich die beiden gegenseitig wahr und laufen Seite an Seite. Das Paar bricht durch eine Ziegelmauer und sprintet vertikal an zwei hohen Baumstämmen hoch, bevor es schließlich in den Orbit springt. Der Slogan lautet: „Bewegungsfreiheit." /// Dans ce magnifique spot surréel, un homme qui porte un Levis court à travers une longue série de pièces, en passant à travers les murs. Une femme qui porte également un Levis apparaît, elle est train de faire la même chose. Pendant un moment, les deux coureurs se rendent compte de la présence de l'autre, et marchent côte à côte. Ils passent à travers un mur de briques, sprintent le long des troncs de deux grands arbres, et sautent dans l'espace. Le slogan s'affiche : « La liberté de bouger ».

TITLE: Twist. **CLIENT:** Levi's. **PRODUCT:** Levi's Engineered Jeans. **AGENCY:** Bartle Bogle Hegarty. **COUNTRY:** United Kingdom. **YEAR:** 2001. **CREATIVE DIRECTOR:** Russell Ramsey. **COPYWRITER:** Mark Hunter, Claudia Southgate. **ART DIRECTOR:** Tony McTear, Verity Fenner. **PRODUCTION COMPANY:** Outsider Films. **PRODUCER:** Andy Gulliman. **DIRECTOR:** Dom & Nic. **AWARDS:** Cannes Lions (Gold), ANDY Awards, CLIO Awards (Silver), AICP, Creative Circle Award (Gold).

A group of youths head off for the drive-in. They can all twist and bend their limbs into impossible positions. Finally they start pulling their arms and heads off. As they drive off a dog picks up a missing hand and chases their car down the street. The tagline reads, "Twisted to fit." /// Eine Gruppe Jugendlicher fährt zum Drive-In. Sie alle können ihre Glieder in unmögliche Positionen krümmen und verbiegen. Schließlich beginnen sie, ihre Arme und Köpfe abzunehmen. Als sie davonfahren, schnappt sich ein Hund eine vergessene Hand und jagt dem Auto hinterher. Der Slogan lautet: „Twisted to fit." /// Un groupe de jeunes va au drive-in. Ils arrivent tous à tordre leurs membres et à leur faire prendre des positions impossibles. Puis ils commencent à détacher leurs bras et leurs têtes. Ils repartent, un chien ramasse une main égarée et poursuit leur voiture. Le slogan s'affiche : « Levis, des jeans techniques ».

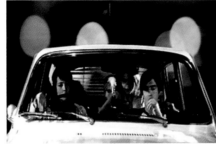

TITLE: Hispanic. **CLIENT:** Levi's. **PRODUCT:** Levi's 501 Anti-fit Jeans. **AGENCY:** Bartle Bogle Hegarty. **COUNTRY:** United Kingdom. **YEAR:** 2004. **CREATIVE DIRECTOR:** Stephen Butler. **COPYWRITER:** Nick Gill. **ART DIRECTOR:** Stephen Butler. **PRODUCTION COMPANY:** Omaha Pictures. **PRODUCER:** Nerine Soper. **DIRECTOR:** Speck, Gordon.

Two guys are hanging out on a street corner mocking each other's taste in jeans. One guy wearing tight brown jeans ridicules his buddy for his ripped low cut Levi 501s; but before he can say another word he rips his own jeans pocket. The tagline appears with the words, "501 jeans with Anti-fit." /// Zwei junge Männer hängen an der Straßenecke herum und verspotten gegenseitig ihren Modegeschmack bei Jeans. Einer der Männer trägt eine enge braune Jeans und verhöhnt seinen Kumpel wegen dessen zerrissener Low-Cut Levi 501s, doch bevor er noch ein weiteres Wort sagen kann, zerreißt er die Tasche seiner eigenen Jeans. Der Slogan erscheint mit den Worten: „501 Jeans mit Anti-fit." /// Au coin d'une rue, deux hommes se moquent de leurs goûts respectifs en matière de jeans. L'un des deux, qui porte un jean marron serré, tourne son copain en ridicule à cause de son Levis 501 déchiré et qui tombe sur ses hanches. Le slogan apparaît : « Le jean 501 avec Anti-fit ».

TITLE: Bike. CLIENT: Levi's. PRODUCT: Levi's 501 Anti-fit Jeans. AGENCY: Bartle Bogle Hegarty. COUNTRY: United Kingdom. YEAR: 2004. CREATIVE DIRECTOR: Marc Shillum. COPYWRITER: Toby Allen. ART DIRECTOR: Jim Hilson. PRODUCTION COMPANY: Academy Films. PRODUCER: Sally Campbell. DIRECTOR: Nick Gordon. AWARDS: BTAA (Gold/Silver), APA 50.

A young dude on a mountain bike spots a beautiful girl on roller skates. At first she refuses his offer of a ride. Gradually, his comedy charms her when he wiggles his backside and almost crashes into a tree. He finally manages to win her over and she grabs on to his Levis 501 Anti-fit jeans. /// Ein junger Typ auf einem Mountainbike entdeckt ein schönes Mädchen auf Roller Skates. Er bietet ihr die Mitfahrt an, doch sie lehnt zunächst ab. Nach und nach findet sie es aber doch bezaubernd, wie lustig er ist, als er mit seinem Hinterteil wackelt und fast in einen Baum kracht. Schließlich kriegt er sie doch herum, dass sie sich an seiner Levis 501 Anti-fit Jeans festhält und ziehen lässt. /// Un jeune en mountain bike repère une fille magnifique en rollers. Il lui propose de la remorquer, mais elle refuse. Ses pitreries commencent à la séduire lorsqu'il se trémousse du bas du dos et manque de s'écraser contre un arbre. Il finit par la conquérir, et elle s'accroche à son jean Levis 501 Anti-fit.

TECH BRANDS

SIMON LEARMAN & BRIAN FRASER
EXECUTIVE CREATIVE DIRECTORS OF McCANN LONDON

Simon Learman and Brian Fraser have created some of the best-loved campaigns for Guinness, Volkswagen, Sony, Budweiser, Vodafone, Philips, Reuters, Heinz, and UPS. They have won all the top industry awards, and they became joint executive creative directors of McCann London in January 2006, after stints at Saatchi & Saatchi, Ogilvy and DDB (BMP).

What is it about technology and gadgets that makes us so fickle? Do we view tech brands in the same way as fashion brands? Or, is the latest technical innovation simply an affordable substitute for that car we always wanted? One thing is certainly true: as consumers, we can't embrace the very latest kit without rejecting all that came before. Obsolescence is built in.

Hey, this isn't something the advertising fraternity started. It's called "progress." We all know that the latest BMW has a far superior computing capacity to the first space shuttle's. So change is good.

Then again, what about the mountains of unwanted TVs, refrigerators and computers that litter our planet? Surely they will force us to reconsider our cavalier attitude to replacing goods. Carbon footprints could start to factor in our appreciation of technology

Simon Learman und Brian Fraser haben einige der populärsten Kampagnen für Guinness, Volkswagen, Sony, Budweiser, Vodafone, Philips, Reuters, Heinz und UPS kreiert. Sie haben alle wichtigen Preise der Branche gewonnen. Nach Stationen bei Saatchi & Saatchi, Ogilvy und DDB (BMP) kamen sie im Januar 2006 gemeinsam als Executive Creative Directors zu McCann London.

Warum haben wir bei Technologie und technischen Geräten eigentlich diese Wegwerfmentalität? Sind für uns Tech-Marken genauso wie Fashion-Marken? Oder ist die neueste technische Erfindung nur ein erschwinglicher Ersatz für das Luxusauto, das wir schon immer haben wollten, uns aber nicht leisten können? Eines steht fest: Als Konsumenten können wir das allerneueste Gerät nur dann annehmen, wenn wir alles, was es davor gab, fortan total ablehnen. Die Veralterung ist quasi eingebaut.

Das ist aber nicht der Werbung zuzuschreiben. Das nennt man „Fortschritt". Wir alle wissen, dass der neueste BMW über ein weitaus besseres Computersystem verfügt als das erste Space Shuttle. Veränderung ist also gut.

Aber wohin mit den Bergen von alten Fernsehern, Kühlschränken und Computern, die unseren Planeten vermüllen? Vielleicht sollten wir allmählich beginnen, unsere lockere Wegwerfhaltung zu überdenken. Das Problem des ökologischen Fußabdrucks könnte bei unserer Wertschätzung von Technologie-Marken eine zunehmende Rolle spielen. Denn die Herstellung von Produkten mit einer Relevanz für unser Leben ist eine ständige Herausforderung.

Neue Technologien sind zunächst immer fremd. Sie beeinflussen jedoch nachhaltig unsere Interaktion

Simon Learman et Brian Fraser ont créé quelques-unes des campagnes les plus appréciées du public pour Guinness, Volkswagen, Sony, Budweiser, Vodafone, Philips, Reuters, Heinz et UPS. Ils ont remporté toutes les grandes récompenses du secteur de la publicité, et ils sont devenus codirecteurs exécutifs de la création chez McCann Londres en janvier 2006, après avoir travaillé chez Saatchi & Saatchi, Ogilvy et DDB (BMP).

Pourquoi sommes-nous si volages lorsqu'il s'agit de technologie et de gadgets ? Est-ce que nous voyons les marques de produits technologiques de la même façon que nous voyons les marques de mode ? Ou bien la dernière innovation technique est-elle simplement un substitut abordable pour cette voiture que nous avons toujours voulu acheter ?

Une chose est sûre : en tant que consommateurs, nous ne pouvons pas accueillir les nouveautés sans rejeter tout ce qu'il y avait avant. L'obsolescence est incluse dans le produit.

Mais ce n'est pas la publicité qui a inventé cet état de fait. C'est ce que l'on appelle le « progrès ». Nous savons tous que l'ordinateur de bord de la dernière BMW est bien plus puissant que celui de la première navette spatiale. Le changement a donc du bon.

Mais alors, que faire des montagnes de télévisions, de réfrigérateurs et d'ordinateurs indésirables qui encombrent notre planète ? Elles nous forceront sans doute à reconsidérer notre attitude cavalière quant au remplacement des objets. L'empreinte carbone pourrait commencer à peser son poids dans notre opinion sur les marques de produits technologiques. Fabriquer des produits qui ont leur place dans la vie des gens est un défi permanent.

brands, because making products relevant to people's lives is a constant challenge.

Technology is alien to the human experience. It affects the way we interact with the world. Technology defines change, so we have to help consumers understand how and where it fits in. A brand must tell us how it can make a positive effect on our daily lives.

In building a relationship with consumers, brands must also understand the wider social context. For centuries, the world's great artists defined popular culture. MTV changed all that. Its montage style of editing promoted a collision of sound and image. People are now so much more aware, and certainly visually demanding.

THE LIMITATIONS OF THE MEDIUM ARE ANOTHER CONSIDERATION. HOW DO YOU DEMONSTRATE A LIFE-LIKE PICTURE WHEN MOST OF THE VIEWING PUBLIC IS WATCHING YOUR COMMERCIAL ON A WONKY TELLY?

Fortunately, using hyperbole and getting lateral are advertising conventions that are widely accepted. Which is just as well. Describing sensory experiences is tough. Think about it. How do you go about demonstrating the quality of sound, the vibrancy of color, or how well a product reproduces your world?

But technology by its very nature is, well, technical. So we have chosen a selection of spots that show a range of solutions to the perennial problem: explaining geeky stuff and making it sexy.

Hewlett Packard makes the assertion that power and control can be in the hands of the masses.

mit der Welt. Technologie definiert Veränderung, also müssen wir den Verbrauchern helfen zu verstehen, wie und wo sie in ihrem Leben Sinn macht.

Worin besteht bei einer Marke ihr positiver Effekt auf unser tägliches Leben? Um eine Beziehung zu Verbrauchern aufzubauen, muss eine Marke auch den gesellschaftlichen Zusammenhang begreifen. Unsere Kultur wurde jahrhundertelang von den großen Künstlern der Welt geprägt – bis MTV kam. Der MTV-Stil – schnelle Schnitte und permanente Musikuntermalung – hat die Kollision von Ton und Bild vorangetrieben. Inzwischen sind die Leute wesentlich aufmerksamer und haben visuell höhere Ansprüche.

DIE GRENZEN DES MEDIUMS SIND EIN GANZ ANDERES THEMA. WIE PRÄSENTIERT MAN EIN NATURGETREUES BILD, WENN DIE MEISTEN ZUSCHAUER DEN TV-SPOT AUF EINEM KÜMMERLICHEN FERNSEHSCHIRM SEHEN?

Glücklicherweise sind Querdenken und Übertreibungen in der Werbung allgemein akzeptiert. Das hat Vorteile. Sinnliche Erfahrungen zu beschreiben, ist schwer. Denken Sie mal darüber nach. Wie machen Sie Dinge wie Soundqualität oder Farbbrillanz begreiflich? Wie können Sie überzeugend vermitteln, wie gut ein Produkt Ihre Welt reproduziert?

Technologie ist jedenfalls von Natur aus, nun ja, technisch. Deshalb haben wir uns für eine Auswahl von Spots entschieden, die Lösungen für das ewig gleiche Problem anbieten: Wie erkläre ich ein technisches Teil so, dass es sexy rüberkommt?

La technologie est étrangère à l'expérience humaine. Elle affecte la façon dont nous interagissons avec le monde. La technologie définit le changement, c'est pourquoi nous devons aider les consommateurs à comprendre sa place et son rôle.

Pour bâtir une relation avec leurs consommateurs, les marques doivent également comprendre le contexte social dans son ensemble. Pendant des siècles, ce sont les grands artistes qui ont défini la culture populaire. MTV a changé tout cela. Le style de montage de la chaîne a encouragé la collision du son et de l'image. Les gens sont maintenant beaucoup plus sensibles à ce genre de choses, et en tout cas plus exigeants visuellement.

IL FAUT ÉGALEMENT TENIR COMPTE DES LIMITES DU SUPPORT. COMMENT TRANSMETTRE UNE IMAGE PLEINE DE VIE LORSQUE LA PLUPART DES SPECTATEURS REGARDENT VOTRE FILM PUBLICITAIRE SUR UNE TÉLÉVISION MÉDIOCRE ?

Heureusement, l'hyperbole et la pensée latérale sont des conventions largement acceptées dans le domaine de la publicité. Ce qui est tout aussi bien. Il est difficile de décrire des expériences sensorielles. Pensez-y. Comment transmettre la qualité du son, la brillance de la couleur, ou la façon dont un appareil reproduit votre monde ?

Mais la technologie est, par nature, technique. Eh oui ! C'est pourquoi nous avons sélectionné des spots apportant plusieurs solutions à l'éternel pro-

One of their clever spots shows the computer cursor as protagonist. It's a very literal and direct display of control. By illustrating how HP help in the fight against crime we can begin to appreciate their role in the modern world.

Apple also understands the importance of humanizing their brand. By placing the consumer experience at the heart of their communication they give their brand a true voice and make it immediately accessible. The brilliant iPod and iTunes campaigns use the lessons learnt by the MTV generation. Iconic advertising promises a direct, visceral connection with music: unfettered emotion. Perhaps it's more a victory for style over content, but we're certainly not going to knock it.

Apple's inspired "Mac meets PC" campaign works differently to make the brand look friendly. They cleverly characterize the personalities of the respective products through well-chosen actors. Guess who's cooler?

TECHNOLOGY CAN ALLOW US TO REJECT A LESS THAN PERFECT WORLD.

Olympus show us how specters such as red-eyed babies, distorted dogs and tourists with cropped heads can all be eradicated by the flick of a button. They too offer a sense of empowerment by providing a solution to man's constant struggle to master technology. And we're all happy to suspend disbelief because we know it's only advertising. So we also accept that Sony's "ultra" power zoom can shrink continents. And that their night vision camera can make night appear just like day. Conversely, we accept the Panasonic campaign that tells of a faltering piano recital learnt from a skipping CD. These are all good examples of extreme claims that simply illustrate a point.

Interestingly, because we afford consumers an opportunity to glimpse a hyperreality, we have to constantly strive to create an even more surprising and challenging canvas. The advent of virtual reality and gaming has blurred the distinction between what's real and what is technically feasible.

Hewlett-Packard stellt die Behauptung auf, dass Macht und Kontrolle in die Hände der Massen gelangen können. In einem ihrer cleveren Spots ist der Protagonist ein Computercursor. Das ist eine direkte Demonstration von Kontrolle. Sie illustriert, wie HP den Kampf gegen das Verbrechen unterstützt – was es uns ermöglicht, die Rolle von HP in der modernen Welt endlich schätzen zu lernen.

Auch Apple hat begriffen, wie wichtig es ist, sich von der menschlichen Seite zu zeigen. Indem sie das Erleben des Verbrauchers in den Mittelpunkt ihrer Werbung stellen, machen sie die Kommunikation dem Verbraucher sofort zugänglich. Die brillanten Kampagnen für iPod und iTunes machen sich die Erfahrungen der MTV-Generation zunutze. Werbung mit Kultcharakter baut oft auf die direkte, emotional bewegende Wirkung von Musik: Sie vermittelt pures Gefühl. Vielleicht siegt hier Stil über Inhalt, aber das nehmen wir gern in Kauf.

Die „Mac meets PC"-Kampagne von Apple arbeitet dagegen anders; sie soll der Marke ein freundliches Gesicht geben. Die Persönlichkeiten beider Produkte werden von klug ausgewählten Schauspielern dargestellt. Raten Sie mal, wer cooler ist.

TECHNOLOGIE ERMÖGLICHT UNS, EINE NICHT PERFEKTE WELT EINFACH AUSZUBLENDEN.

Olympus zeigt uns, dass wir unerwünschte Bildeffekte wie rote Augen mit einem Knopfdruck löschen können, um nur solche Bilder zu speichern, die uns schön und erinnerungswert erscheinen. Auch Olympus schenkt dem Betrachter das Gefühl von Kontrolle – so kann der ständige Kampf gegen die Tücken der Technik endlich gewonnen werden. Und wir sind bereit, alles zu schlucken, denn wir wissen ja: Es ist nur Werbung. Deshalb akzeptieren wir auch, dass der „Ultra"-Powerzoom von Sony Kontinente schrumpfen kann. Und dass die Nachtbildkamera von Sony die Nacht zum Tag machen kann. Das sind gute Beispiele für Werbespots, die zu extremen Mitteln greifen, um ganz simple Dinge zu verdeutlichen.

Indem wir Verbrauchern die Chance geben, den Blick auf eine Hyperrealität zu werfen, legen wir die Latte immer höher: Der nächste Spot muss noch ori-

blème : expliquer des détails techniques et les rendre irrésistibles.

Hewlett Packard affirme que les masses peuvent prendre le pouvoir. L'un de leurs spots les plus intelligents a comme vedette le curseur d'un ordinateur. C'est une démonstration de contrôle très directe. En montrant comment HP peut contribuer à la lutte contre le crime, cette entreprise aide le public à apprécier son rôle dans le monde moderne.

Apple comprend aussi qu'il est important d'humaniser sa marque. En plaçant le consommateur et l'expérience qu'il a des produits au centre de sa communication, cette entreprise donne à sa marque une véritable voix, et la rend immédiatement accessible. Les brillantes campagnes pour l'iPod et iTunes utilisent les leçons apprises par la génération MTV. Ces publicités emblématiques promettent une connexion directe et viscérale avec la musique : une émotion pure. Il s'agit peut-être d'une victoire du style sur le contenu, mais nous n'allons pas nous en plaindre.

La campagne « Mac meets PC » fonctionne différemment et rend la marque sympathique. La personnalité des produits est représentée par des acteurs bien choisis. Devinez qui est le plus cool ?

LA TECHNOLOGIE PEUT NOUS AIDER À SUPPRIMER LES IMPERFECTIONS DE NOTRE MONDE.

Olympus nous montre comment les bébés aux yeux rouges, les chiens déformés et les touristes aux têtes coupées peuvent disparaître en appuyant sur un bouton. Ils donnent au consommateur un sentiment de contrôle en apportant une solution à la lutte permanente de l'homme pour la maîtrise de la technologie. Nous sommes contents de faire semblant d'y croire, car nous savons que ce n'est que de la publicité. C'est pourquoi nous ne nous formalisons pas lorsque Sony nous dit que son zoom « ultra » peut faire rapetisser les continents, ou que son appareil photo équipé de vision nocturne peut nous faire voir la nuit comme en plein jour. Ce sont tous de bons exemples d'affirmations extrêmes qui ne servent en fait que d'illustrations.

Ce qui est intéressant, c'est que comme nous donnons aux consommateurs l'occasion d'entrevoir une hyperréalité, nous devons constamment nous ef-

CONSUMERS ARE NOW EMPOWERED TO DEFINE AND CONTROL THEIR OWN PERSONAL REALITY. IT'S AS IF THEY'VE CROSSED SOME METAPHYSICAL DIVIDE. IT'S KINDA SPOOKY.

So tech brands have become intermediaries, or facilitators. Guys like Xbox, PlayStation and PSP allude to a sensory explosion that goes beyond a hitherto human experience. Xbox and PlayStation invite us to participate in a richer life-affirming quest. By way of contrast, PSP launched by revealing their brand logo as some brutal organic life force that must be embraced. But where do we go from here?

Interestingly, Sony reversed the strategic trend when they launched the Bravia. Sure "Balls" and "Paint" are radical ideas. But rather than encourage us to enter an idealized world, they demonstrate the impact of the brand on our own very real world. Here metaphor allows us to appreciate the quality of the product without being held back by the medium.

Sony's solid brand credentials removed the need to make a highly technical claim. This frees up the process, and promotes a highly visceral execution. At the end of the day, it's all about human insight — being able to make a connection between brand and consumer.

It's no coincidence that these two very simple and truly memorable pieces of communication came from a highly confident brand. This is advertising that doesn't just break out of the category but redefines the whole industry.

Damn! We wish we'd done them.

gineller werden. Virtuelle Realität und Computerspiele lassen die Grenze zwischen dem, was real und was technisch machbar ist, verschwimmen.

VERBRAUCHER SIND JETZT IN DER LAGE, IHRE EIGENE PERSÖNLICHE REALITÄT ZU DEFINIEREN UND ZU KONTROLLIEREN. ES SCHEINT, ALS HÄTTEN SIE EINE METAPHYSISCHE GRENZE ÜBERSCHRITTEN. DAS IST SCHON ZIEMLICH GRUSELIG.

Tech-Marken sind zu Vermittlern geworden. Xbox, PlayStation und PSP ermöglichen eine Explosion der Sinne, die alle bisherigen Erfahrungsgrenzen sprengt. Xbox und PlayStation laden uns dazu ein, an einer reicheren, lebensbejahenden Erfahrung teilzuhaben. Im Gegensatz dazu gestaltete PSP seinen Launch mit einem Markenlogo in Gestalt einer brutalen organischen Lebenskraft, der keiner entkommen kann. Doch wie geht es weiter?

Sony kehrte den Trend mit dem Launch von Bravia um. Natürlich sind „Balls" und „Paint" radikale Ideen. Doch statt uns zu ermuntern, eine idealisierte Welt zu betreten, illustrieren diese Werbefilme den Einfluss der Marke auf unsere eigene, reale Welt. Hier ermöglicht uns eine Metapher, die Qualität des Produktes wertzuschätzen, ohne vom Medium zurückgehalten zu werden.

Dank der Glaubwürdigkeit der Marke Sony konnte auf die Notwendigkeit eines hochtechnischen Claims verzichtet werden. Dadurch wurde der gestalterische Prozess freier, was eine auf emotionaler Ebene sehr ansprechende Ausführung ermöglichte. Letztlich dreht sich alles um das Verstehen des menschlichen Verhaltens — um die Fähigkeit, eine Verbindung zwischen Marke und Verbraucher zu schaffen.

Es ist kein Zufall, dass diese sehr simplen und dennoch bemerkenswerten Werbungen von einer sehr selbstbewussten Marke stammen. Das ist Werbung, die nicht einfach nur aus der Kategorie ausbricht, sondern die gesamte Branche neu definiert.

Schade, dass sie nicht von uns gemacht wurde.

forcer de créer des effets de plus en plus surprenants et compliqués. L'avènement de la réalité virtuelle et des jeux virtuels a atténué la limite entre ce qui est réel et ce qui est faisable techniquement.

LES CONSOMMATEURS PEUVENT MAINTENANT DÉFINIR ET CONTRÔLER LEUR PROPRE RÉALITÉ PERSONNELLE. C'EST COMME S'ILS AVAIENT TRAVERSÉ UNE SORTE DE FRONTIÈRE MÉTAPHYSIQUE. ÇA FAIT UN PEU PEUR.

Les marques de produits technologiques sont donc devenues des intermédiaires. La Xbox, la PlayStation et la PSP font allusion à une explosion sensorielle qui dépasse toute expérience humaine connue. La Xbox et la PlayStation nous invitent à participer à une vie plus riche et plus intense. La PSP, en revanche, a présenté son logo comme une forme de vie organique brutale qu'il faut prendre à bras-le-corps. Mais quelle suite donner à tout cela ?

Sony a inversé la tendance pour le lancement de la Bravia. Bien sûr, les spots « Balls » et « Paint » sont des idées radicales. Mais au lieu de nous encourager à pénétrer dans un monde idéalisé, ils montrent l'impact de la marque sur notre propre monde, notre vrai monde. Ici, la métaphore nous permet d'apprécier la qualité du produit sans être gênés par le support.

La réputation solide de Sony lui évite d'avoir à faire des affirmations sur sa qualité technique. Cela donne une certaine liberté et permet une réalisation très viscérale. En fin de compte, il s'agit de perception humaine, d'établir un lien entre la marque et le consommateur.

Ces deux œuvres de communication, très simples et vraiment mémorables, émanent d'une marque très sûre d'elle. Ce n'est pas une coïncidence. C'est de la publicité qui ne se contente pas d'être originale, mais redéfinit tout le secteur publicitaire.

Bon sang ! Nous aurions aimé en être les auteurs.

008

TECHNOLOGY & EQUIPMENT

TITLE: Virus. CLIENT: Apple Inc. PRODUCT: Get a Mac. AGENCY: TBWA\Chiat\Day Los Angeles. COUNTRY: USA. YEAR: 2006. COPYWRITER: Jason Sperling. ART DIRECTOR: Scott Trattner. PRODUCTION COMPANY: Epoch Films. DIRECTOR: Phil Morrison.

Apple's Get a Mac campaign consists of a series of spots featuring two guys in conversation as personifications of a PC and Mac. Each spot is designed to extol the creative benefits of using Mac over PC through affectionate one-upmanship and humorous dialogue. /// Die Apple-Kampagne Get a Mac besteht aus einer Serie von Spots mit zwei sich unterhaltenden Männern. Der Ältere personifiziert einen PC, der Jüngere einen Mac. Indem sie einander auszustechen versuchen und durch humorvolle Dialoge stellt jeder Spot die kreativen Vorteile heraus, wenn man mit einem Mac statt einem PC arbeitet. /// La campagne Get a Mac d'Apple est constituée d'une série de spots où deux hommes incarnent un PC et un Mac. Chaque spot souligne les avantages créatifs du Mac par rapport au PC grâce à des dialogues pleins d'humour où les deux rivaux essaient de se surpasser l'un l'autre.

TITLE: City. CLIENT: Apple Inc. PRODUCT: iPod + iTunes. AGENCY: TBWA\Chiat\Day. COUNTRY: USA. YEAR: 2006. CHIEF CREATIVE OFFICER: Lee Clow. EXECUTIVE CREATIVE DIRECTOR: Duncan Milner. CREATIVE DIRECTOR: Eric Grunbaum. ASSOCIATE CREATIVE DIRECTOR: Alain Briere. COPYWRITER: Dirk Henelmann, Ryan Waite. ART DIRECTOR: Philipp Borchardt, Jamin Duncan. PRODUCTION COMPANY: Logan. DIRECTOR: Logan.

A computer animation shows a city being built entirely of thumbnailed album covers. All the covers finally get sucked into an iPod. "1,000 songs in your pocket. iPod + iTunes." /// Eine Computeranimation zeigt eine Stadt, die völlig aus Miniaturbildern von Album-Covern besteht. Alle Cover werden schließlich in einen iPod eingesaugt. Der Slogan lautet: „1.000 Songs in deiner Tasche. iPod + iTunes." /// Une animation numérique montre une ville entièrement constituée de miniatures de couvertures d'albums. Toutes les couvertures finissent par être aspirées à l'intérieur d'un iPod. Le slogan s'affiche : « 1 000 chansons dans votre poche. iPod + iTunes ».

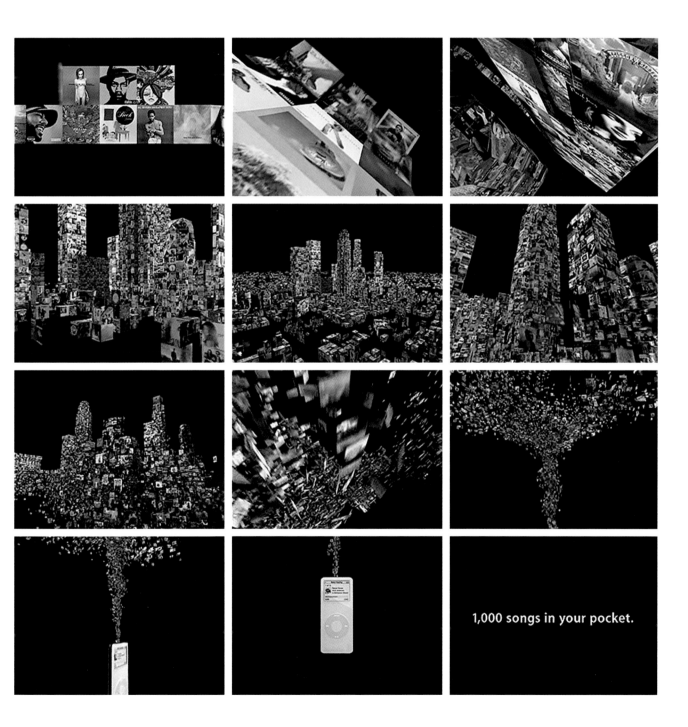

TITLE: The Band. CLIENT: Apple Inc. PRODUCT: iPod + iTunes. AGENCY: TBWA\Chiat\Day. COUNTRY: USA. YEAR: 2005. CREATIVE DIRECTOR: Duncan Milner, Eric Grunbaum. ART DIRECTOR: Susan Alinsangan.
PRODUCTION COMPANY: Anonymous Content. EXECUTIVE PRODUCER: Lisa Margulis. DIRECTOR: Mark Romanek. AWARDS: Cannes Lions (Shortlist).

Rock supergroup U2 perform their song "Vertigo" as silhouettes against a variety of brightly coloured backdrops. Silhouetted dancers move and jump around listening to their distinctively white coloured iPods. The spot ends with the titles, "Vertigo by U2 … iPod + iTunes," followed by the Apple logo. /// Die Rockgruppe U2 spielt als Silhouette vor wechselnden, leuchtenden Farben ihren Song „Vertigo". Silhouetten von Tänzern bewegen sich und springen umher, während sie ihre unverwechselbaren weißen iPods hören. Der Werbespot endet mit der Überschrift „Vertigo von U2 … iPod + iTunes," gefolgt von dem Apple-Logo. /// Le supergroupe de rock U2 joue la chanson « Vertigo » et apparaît sous forme de silhouettes sur des fonds aux couleurs vives. Des silhouettes de danseurs qui portent des iPods blancs se déhanchent en rythme. Le spot se termine par ces mots : « Vertigo de U2 … iPod + iTunes », suivis du logo d'Apple.

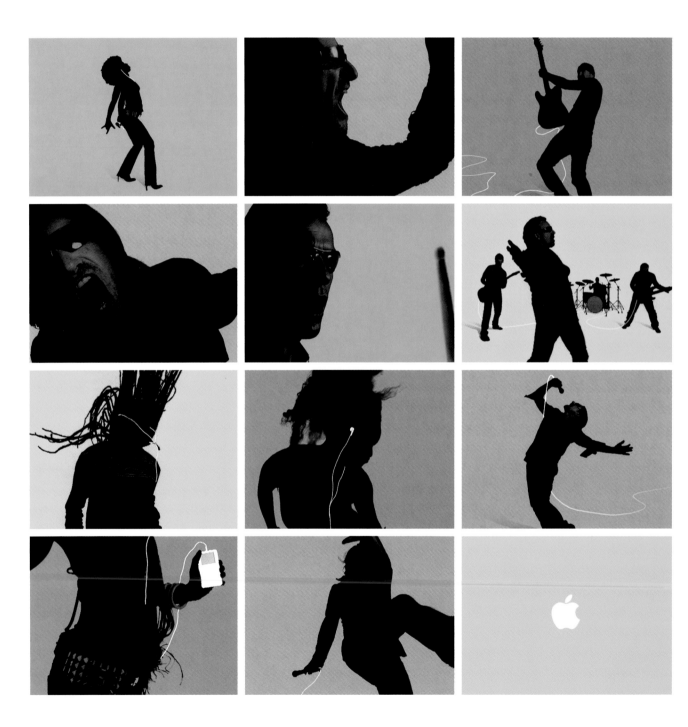

TITLE: Dance. CLIENT: Apple Inc. PRODUCT: iPod + iTunes. AGENCY: TBWA\Chiat\Day. COUNTRY: USA. YEAR: 2004. CREATIVE DIRECTOR: Lee Clow, Duncan Milner, Eric Grunbaum. COPYWRITER: Tom Kraemer. ART DIRECTOR: Susan Alinsangan. PRODUCTION COMPANY: @radical.media. DIRECTOR: Dave Meyers. AWARDS: Cannes Lions (Bronze).

Various dancers appear as silhouettes against different coloured backgrounds, wearing white iPods. The spot is intercut with simple taglines, "iPod … Mac or PC," followed by the Apple logo. /// Verschiedene Tänzer erscheinen als Silhouetten vor einem Hintergrund mit unterschiedlichen Farben. Sie tragen weiße iPods. In den Spot wird der einfache Slogan „iPod … Mac oder PC" zwischengeschnitten, gefolgt von dem Apple-Logo. /// Plusieurs danseurs apparaissent sous forme de silhouettes portant des iPods blancs sur des fonds de différentes couleurs. Le spot est entrecoupé des simples mots : « iPod … Mac ou PC », suivis du logo Apple.

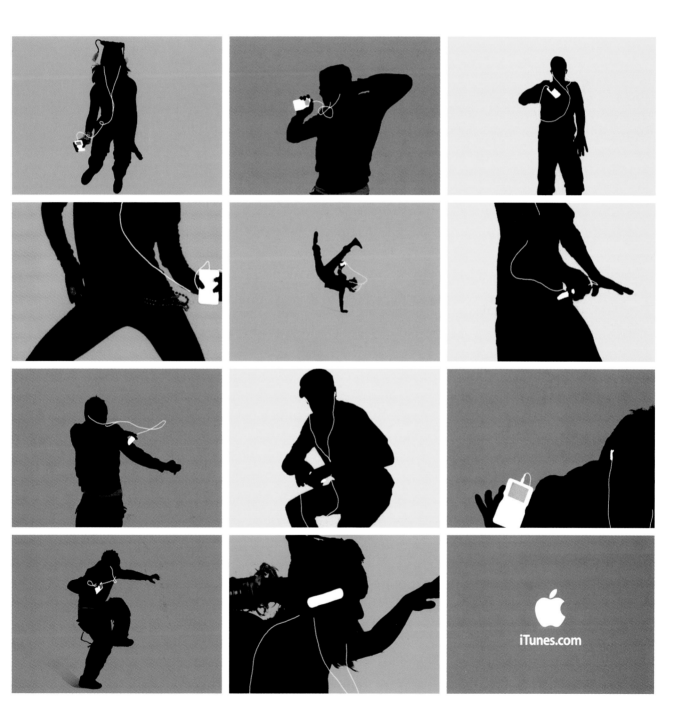

TITLE: Poodle. CLIENT: Fujifilm Corporation. PRODUCT: Fujifilm. AGENCY: Publicis New York. COUNTRY: USA. YEAR: 2002. CREATIVE DIRECTOR: Jim Basirico, Mark Bernath. ART DIRECTOR: Jim Basirico. PRODUCTION COMPANY: Hungry Man. PRODUCER: Mary Ann Kurasz. DIRECTOR: Bryan Buckley. AWARDS: Cannes Lions (Bronze).

A guy is standing in an apartment elevator. His beautiful neighbour walks in carrying her poodle. The guy looks on wishfully as the woman playfully kisses her dog. He rushes out to a pet store and snaps a poodle with his Fuji Camera. Next time in the elevator the guy tries to impress the girl with his photo printed T-Shirt of his dead poodle named Mitch. The spot closes with the slogan, "Do you speak Fuji?" /// Ein Mann steht im Aufzug eines Wohnhauses, als seine schöne Nachbarin mit ihrem Pudel auf dem Arm einsteigt. Der Mann schaut sehnsüchtig zu, als die Frau spielerisch ihren Hund küsst. Er eilt in eine Zoohandlung und fotografiert mit seiner Fuji-Kamera einen Pudel. Beim nächsten Treffen im Aufzug versucht der Mann, die Nachbarin mit seinem Foto-T-Shirt zu beeindrucken, das seinen verstorbenen Pudel namens Mitch zeigt. Der Werbespot endet mit dem Slogan: „Sprechen Sie Fuji?" /// Un homme se tient dans l'ascenseur de son immeuble. Sa superbe voisine entre avec son caniche dans les bras. Elle embrasse son chien d'un air joueur, et l'homme contemple la scène avec envie. Il va directement dans un magasin d'animaux et prend un caniche en photo avec son appareil Fuji. Plus tard, dans le même ascenseur, il essaie d'impressionner sa voisine avec son t-shirt qui porte une photo de son caniche décédé, Mitch. Le spot se termine par ce slogan : « Parlez-vous Fuji ? »

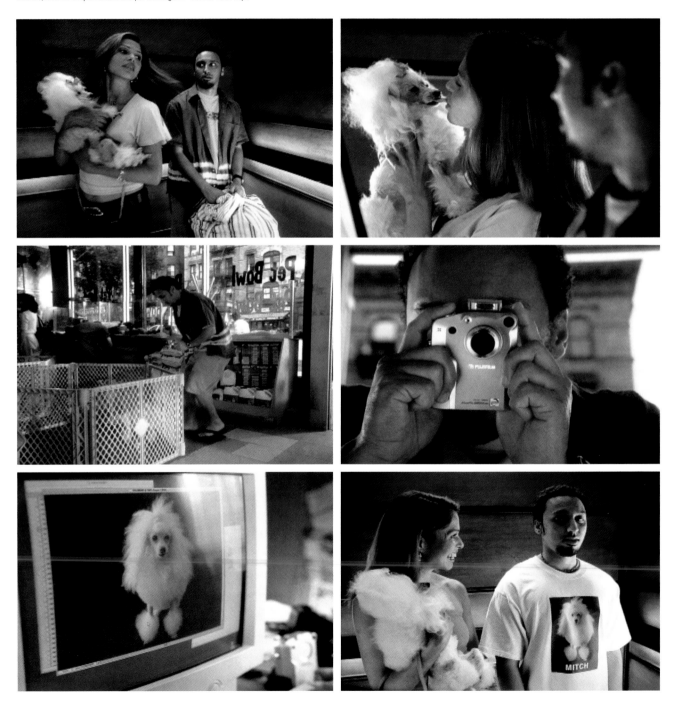

TITLE: Digital Crime Fighting. CLIENT: Hewlett-Packard. PRODUCT: Hewlett-Packard. AGENCY: Goodby, Silverstein & Partners. COUNTRY: USA. YEAR: 2003. CREATIVE DIRECTOR: Steve Luker, Steve Simpson. COPYWRITER: Matt Elhardt. ART DIRECTOR: Joel Clement. PRODUCTION COMPANY: MJZ. PRODUCER: Clarissa Troop, Nell Jordan. DIRECTOR: Frederik Bond. AWARDS: Cannes Lions (Bronze).

Three men are having a conversation around a table in a closed bar. Suddenly, as if by magic, a computer cursor appears and flings one of the men across the table. As onlookers watch in stunned silence, the cursor throws him out of the bar and drags him along a street and into a waiting police van. A voiceover announces, "Using HP mobile technology to get information quickly and easily, the world's police forces now fight crime digitally." /// Drei Männer sitzen an einem Kneipentisch und reden. Plötzlich erscheint wie durch Zauberei der Mauszeiger eines Computers und schleudert einen der Männer über den Tisch. Während die anderen Gäste verblüfft verstummen, reißt der Mauszeiger den Mann vom Tisch weg, schleift ihn aus der Bar die Straße entlang und wirft ihn in ein wartendes Polizeifahrzeug. Ein Sprecher sagt: „Auf der ganzen Welt bekämpft die Polizei das Verbrechen nun digital … durch die Verwendung der Mobiltechnologie von HP bekommt sie schnell und einfach Informationen." /// Trois hommes sont en pleine conversation autour d'une table dans un bar fermé. Soudain, un curseur d'ordinateur apparaît comme par magie et bouscule l'un des hommes. Devant l'assistance stupéfaite, le curseur le jette dehors et le traîne jusqu'à un car de police qui attendait dans la rue. Une voix off annonce : « Grâce à la technologie mobile d'HP, les forces de police du monde entier ont accès aux informations plus rapidement et plus facilement, et livrent au crime un combat numérique ».

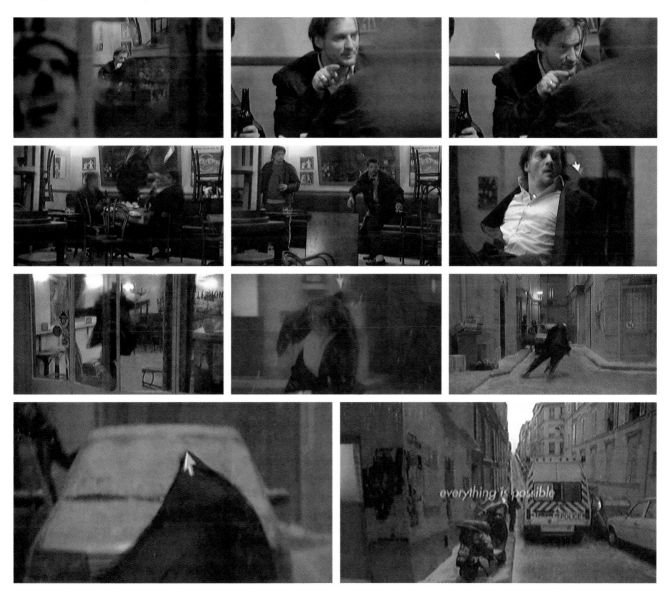

TITLE: Evil Daughter. CLIENT: LG Electronics. PRODUCT: LG Plasma TV. AGENCY: Euro RSCG Next. COUNTRY: Australia. YEAR: 2007. EXECUTIVE CREATIVE DIRECTOR: Take 2/Greg Crittenden. COPYWRITER: Emma Den-Ouden. ART DIRECTOR: Patrycja Lukjanow. AGENCY PRODUCER: Mardi Palmer. DIRECTOR: Jonathan Nyquist. PRODUCER: Rona Lewis.

A man sits down to watch a rock concert on TV. He notices something in the crowd and grabs the TV remote. A black screen appears with the caption, "Pause and rewind live TV." He reaches over for a photograph and realises it is his daughter. A voiceover announces, "Change the way you watch TV." As his daughter takes her T-shirt off, the spot cuts to reveal the LG Plasma with built in DVR. /// Ein Mann schaut sich im Fernsehen ein Rock-Konzert an. Ihm fällt im Publikum jemand auf, und er greift zur Fernbedienung. Der Bildschirm wird schwarz, und die Worte „Life-Fernsehen anhalten und zurückspulen" erscheinen. Er nimmt ein gerahmtes Foto in die Hand, auf dem seine Tochter zu erkennen ist – mit dem gleichen T-Shirt wie auf dem Bildschirm. Eine Off-Stimme sagt: „Die neue Art des Fernsehens." Als die Tochter ihr T-Shirt auszieht, wechselt die Bildeinstellung auf den LG Plasma mit integriertem Digitalvideorekorder. /// Un homme assis devant la télévision regarde un concert de rock. Il remarque quelque chose dans la foule et saisit la télécommande. Un écran noir apparaît avec les mots : « Mettez en pause et rembobinez la télé en direct ». Il se penche pour prendre une photo et se rend compte qu'il s'agit de sa fille. Une voix annonce : « Changez votre façon de regarder la télé ». Pendant que sa fille enlève son t-shirt à l'écran, la caméra révèle le téléviseur LG Plasma avec DVR intégré.

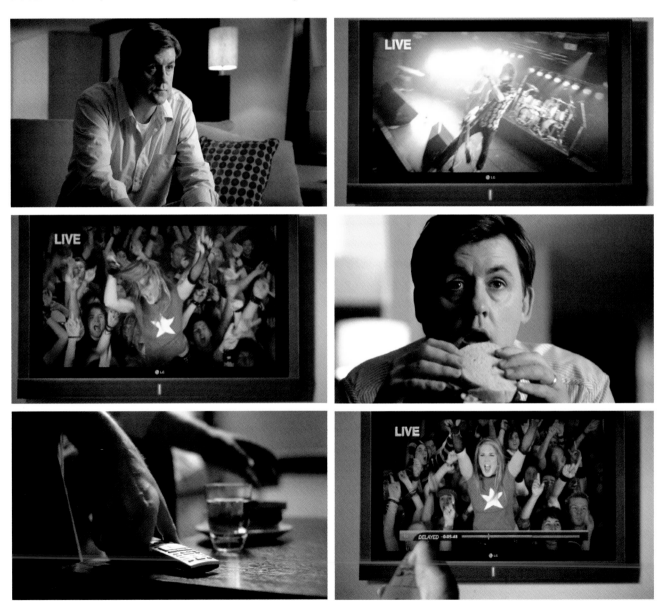

TITLE: Blurry Boy. / Distorted Dog. **CLIENT:** Olympus Europe. **PRODUCT:** Olympus Digital Camera. **AGENCY:** Springer & Jacoby International. **COUNTRY:** The Netherlands. **YEAR:** 2005. **CREATIVE DIRECTOR:** Aris Theophilakis, Murray White. **COPYWRITER:** Murray White, Sharon Cleary. **ART DIRECTOR:** Chris Pugmire. **PRODUCTION COMPANY:** Tony Petersen Film, Biscuit Filmworks. **PRODUCER:** Mandy Kothe. **DIRECTOR:** Noam Murro. **AWARDS:** Cannes Lions (Gold).

An old lady returns home to find her daughter reading a book. Walking around the room is the figure of a blurry boy. The mother looks at him with disdain. "What's he still doing here?" she asks her daughter. "He reminds me of happy times," replies the daughter. The mother scornfully remembers her husband from 35 years ago. He too was blurry. The closing caption reads, "Would you save or delete a blurry boy? What you choose to remember – Olympus." /// Eine alte Dame kommt nach Hause und sieht, wie ihre Tochter ein Buch liest. Die Figur eines verschwommenen Jungen geht im Raum umher. Die Mutter sieht ihn verächtlich an und fragt die Tochter: „Was macht der denn noch hier?" „Er erinnert mich an glückliche Zeiten", antwortet diese. Die Mutter erinnert sich voll Verachtung an ihren Ehemann vor 35 Jahren. Auch er war verschwommen. Die abschließende Überschrift lautet: „Würden Sie einen verschwommenen Jungen speichern oder löschen? Wählen Sie Ihre Erinnerungen – Olympus." /// Une femme rentre chez elle et trouve sa fille en train de lire un livre. Un jeune homme flou se tient dans la pièce. La mère le regarde avec dédain. « Qu'est-ce qu'il fait encore là ? » demande-t-elle à sa fille. « Il me rappelle de bons moments », répond-elle. La mère évoque avec dédain son mari il y a 35 ans. Lui aussi était flou. Les mots suivants concluent le spot : « Faut-il enregistrer ou effacer un garçon flou ? Les souvenirs que vous choisissez – Olympus ».

A woman is having a cup of tea in her girlfriend's kitchen. Suddenly she sees something which horrifies her. A dog with a huge distorted head sits down. A moment later two more distorted dogs appear in the doorway. The woman starts looking very anxious. Her friend looks forlorn as she tries to calm her down, " … it really is going to be alright." The tagline appears, "Would you save or delete distorted dogs?" /// Eine Frau trinkt in der Küche ihrer Freundin eine Tasse Tee. Plötzlich wird sie in Angst und Schrecken versetzt: Vor ihr setzt sich ein Hund mit einem gewaltig verzerrten Kopf hin. Kurz darauf erscheinen zwei weitere verzerrte Hunde an der Tür. Die Frau schaut sich ängstlich um, aber die Freundin wirkt verlassen und sehnsüchtig. Sie will sie mit den Worten „ … es ist wirklich ganz in Ordnung" beruhigen. Der Slogan erscheint: „Würden Sie verzerrte Hunde speichern oder löschen?" /// Une femme boit une tasse de café dans la cuisine d'une amie. Soudain elle voit quelque chose qui l'horrifie : un chien avec une énorme tête déformée, qui s'assied devant elle. Quelques instants plus tard, deux autres chiens déformés arrivent dans le couloir. La femme s'angoisse de plus en plus. Son amie semble résignée, et elle essaie de la calmer : « … tout ira bien ». Le slogan apparaît : « Faut-il enregistrer ou effacer des chiens déformés ? »

TITLE: Cropped Tourists / Red-Eyed Baby. **CLIENT:** Olympus Europe. **PRODUCT:** Olympus Digital Camera. **AGENCY:** Springer & Jacoby International. **COUNTRY:** The Netherlands. **YEAR:** 2005. **CREATIVE DIRECTOR:** Aris Theophilakis, Murray White. **COPYWRITER:** Murray White, Sharon Cleary. **ART DIRECTOR:** Chris Pugmire. **PRODUCTION COMPANY:** Tony Petersen Film, Biscuit Filmworks. **PRODUCER:** Mandy Kothe. **DIRECTOR:** Noam Murro. **AWARDS:** Cannes Lions (Gold).

A guy gets a knock on his apartment door. He looks through the peep hole and recoils at the sight of two tourists with cropped heads. "You promised to mail us that photo from the Eiffel Tower," yells the tourist wife. The guy in the apartment tries in vain to get rid of them and hides under his duvet. The cropped tourists sit in vigil as they continue to shout and bang on his front door. The closing slogan reads, "Would you delete or email cropped tourists?" /// Ein Mann hört ein Klopfen an seiner Wohnungstür. Er schaut durch das Guckloch und schreckt zurück, als er zwei Touristen mit angeschnittenen Köpfen sieht. „Sie haben uns versprochen, das Foto vom Eiffelturm zu schicken", schreit die Touristin. Der Mann versucht vergeblich, sie loszuwerden, und versteckt sich unter seiner Bettdecke. Die Touristen mit den angeschnittenen Köpfen halten vor der Wohnungstür Wache und rufen und klopfen weiter. Der Schlussslogan lautet: „Würden Sie abgeschnittene Touristen löschen oder per E-Mail versenden?" /// Un homme entend qu'on frappe à sa porte. Il regarde par l'œilleton et recule à la vue de deux touristes aux têtes coupées. « Vous aviez promis de nous envoyer cette photo de la tour Eiffel » crie la femme. Dans l'appartement, l'homme essaie en vain de se débarrasser d'eux et se cache sous les draps. Les touristes mal cadrés s'assoient tout en continuant de crier et de frapper à la porte. Les mots suivants apparaissent : « Faut-il effacer ou envoyer par e-mail des touristes mal cadrés ? »

A husband comes home from work. He looks in the bedroom and is horrified to see a baby with red eyes. He goes into the kitchen and pleads with his wife, "I told you … that freaks me out. I don't want it in here. Can you get rid of it?" Annoyed, the wife marches into the bedroom. Picks up the child and hides it away in the wardrobe. An Olympus camera appears on screen with the tagline, "Would you save or delete a red-eyed baby?" /// Ein Ehemann kommt von der Arbeit nach Hause. Er schaut in das Schlafzimmer und sieht dort mit Entsetzen ein Baby mit roten Augen. Er geht in die Küche und fleht seine Frau an: „Ich habe es dir doch schon gesagt … das macht mich ganz fertig. Ich will es hier nicht haben. Kannst du es loswerden?" Genervt marschiert seine Frau ins Schlafzimmer, nimmt das Baby und versteckt es im Kleiderschrank. Eine Olympus-Kamera erscheint auf dem Bildschirm mit dem Slogan: „Würden Sie ein Baby mit roten Augen speichern oder löschen?" /// Un mari rentre chez lui après le travail. Il jette un coup d'œil dans la chambre et la vue d'un bébé aux yeux rouges le met mal à l'aise. Il va dans la cuisine et se plaint à sa femme : « Je te l'ai déjà dit … ça me dérange. Je ne veux pas le voir là. Tu ne peux pas t'en débarrasser ? » Sa femme soupire, va dans la chambre, soulève le bébé et le cache dans un placard. Un appareil photo Olympus apparaît avec les mots : « Faut-il enregistrer ou effacer un bébé aux yeux rouges ? »

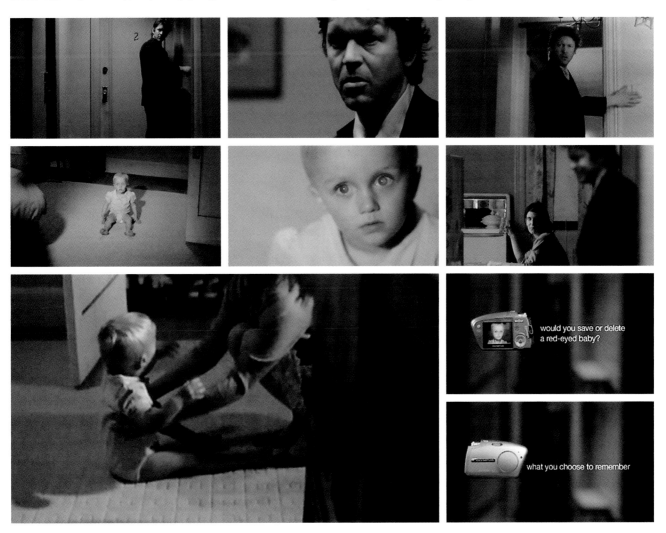

FEATURED ON THE DVD TITLE: Lion. **CLIENT:** Olympus. **PRODUCT:** Olympus Digital Camera. **AGENCY:** Saatchi & Saatchi Australia. **COUNTRY:** Australia. **YEAR:** 2004. **CREATIVE DIRECTOR:** David Nobay. **COPYWRITER:** Scott Nowell. **ART DIRECTOR:** Justin Drape. **PRODUCTION COMPANY:** Luscious International. **PRODUCER:** Susie Douglas. **DIRECTOR:** Damien Toogood. **AWARDS:** Cannes Lions (Bronze).

A group of tourists are on safari in Africa. A man frames a lion in the viewfinder of his Olympus digital camera. He accidentally pushes the zoom button and it appears as though the lion is rushing towards him at close range. He bolts up with a shriek of fear, shocking the rest of the group in the safari truck. The next shot reveals the lion is quite a distance from the vehicle. The man tries to compose himself. A voiceover announces, "Get closer without getting closer." /// Eine Gruppe von Touristen macht in Afrika eine Safari. Ein Mann stellt den Bildsucher seiner Olympus-Digitalkamera auf einen Löwen ein. Er drückt versehentlich auf die Zoom-Taste, und es scheint, als ob der Löwe aus nächster Nähe auf ihn zuläuft. Mit einem Schrei fährt er zurück und versetzt den Rest der Safari-Gruppe in Angst und Schrecken. Die nächste Einstellung zeigt den Löwen, der sich in einem beträchtlichen Abstand zum Fahrzeug befindet. Der Mann versucht, sich zu beruhigen. Ein Sprecher sagt: „Kommen Sie näher, ohne näherzukommen." /// Des touristes font un safari en Afrique. Un homme cadre un lion sur l'écran de son appareil photo numérique Olympus. Il appuie sans le vouloir sur le bouton du zoom, et le lion semble courir vers lui et se rapprocher dangereusement. Il bondit et pousse un cri de terreur, et affole les autres passagers de la jeep. Le plan suivant révèle que le lion se tient en fait à une bonne distance du véhicule. L'homme essaie de se redonner une contenance. La voix off déclare : « Rapprochez-vous sans vous rapprocher ».

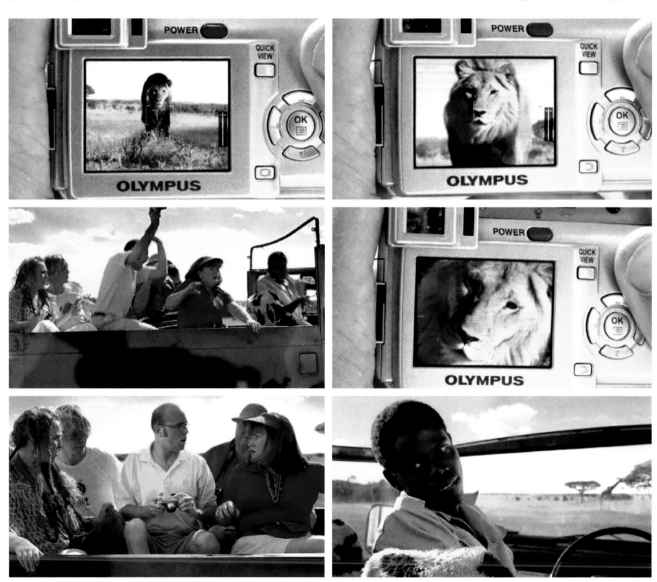

TITLE: Tokyo. **CLIENT:** Sagem. **PRODUCT:** Sagem MY X5-2. **AGENCY:** Publicis Conseil. **COUNTRY:** France. **YEAR:** 2005. **CREATIVE DIRECTOR:** Olivier Altmann. **COPYWRITER:** Guilhem Arnal. **ART DIRECTOR:** Robin de Lestrade. **PRODUCTION COMPANY:** Soixan7e Quin5e. **PRODUCER:** Emmanuel Guiraud. **DIRECTOR:** Johan Renck. **AWARDS:** Cannes Lions (Bronze).

A man takes a photo of a toilet in a public convenience with his Sagem MYX5-2 phone camera. He then goes from place to place snapping various images. We then see him on board a plane and arriving in Tokyo. He stops some girls and shows them the toilet photo on his mobile phone screen. They giggle and point him to the nearest convenience. The spot closes with a shot of the Sagem MYX5-2 and the slogan, "Sagem. Simply smart." /// Ein Mann fotografiert mit seinem Sagem MYX5-2-Handy eine öffentliche Toilette. Er nimmt dann an verschiedenen Orten weitere Bilder auf. Schließlich sehen wir ihn an Bord eines Flugzeugs gehen und in Tokio ankommen. Er hält einige Mädchen an und zeigt ihnen das Foto von der Toilette auf dem Handy-Bildschirm. Sie kichern und weisen ihm den Weg zur nächsten öffentlichen Toilette. Der Spot endet mit einem Bild des Sagem MYX5-2 und dem Slogan: „Sagem. Einfach intelligent." /// Un homme prend des toilettes en photo dans un lieu public avec son téléphone Sagem MYX5-2. Puis il va prendre d'autres photos à plusieurs endroits différents. On le voit ensuite prendre l'avion et arriver à Tokyo. Il aborde des jeunes filles et leur montre la photo des toilettes sur l'écran de son téléphone. Elles gloussent et lui indiquent par gestes les toilettes les plus proches. Le spot se termine par une image du Sagem MYX5-2 et le slogan : « Sagem. Simplement intelligent. »

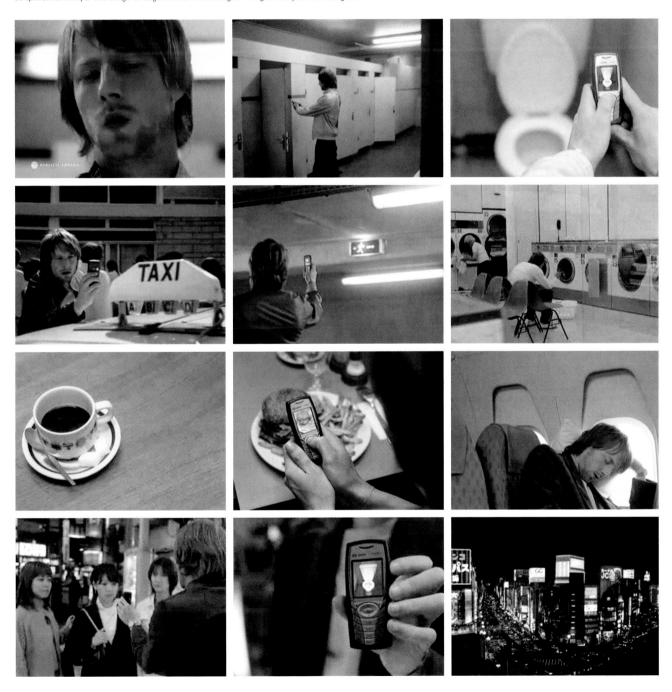

TITLE: Squished Concert. / Squished Locker Room. **CLIENT:** RCA. **PRODUCT:** RCA Scenium. **AGENCY:** Publicis New York. **COUNTRY:** USA. **YEAR:** 2006. **EXECUTIVE CREATIVE DIRECTORS:** Howard Wilmott, Duncan Marshall. **CREATIVE DIRECTOR/ART DIRECTOR:** Michael Long. **COPYWRITER:** Brian Platt, Joshua Greenspan. **PRODUCTION COMPANY:** Czar US. **DIRECTOR:** Lionel Goldstein.

A famous rock band performs on a TV show with hilarious results. All the figures appear tightly pressed against a screen. The visual gag is revealed at the end as the camera pulls back to show that the characters are all squashed to fit into "the world's thinnest flat screen TV … The HD Scenium Profile Series." /// In diesem witzigen Werbespot ist eine berühmte Rockband in einer Fernsehshow zu sehen. Alle Figuren scheinen fest gegen einen Bildschirm gepresst zu sein. Erst am Ende wird der Gag sichtbar, als die Kamera zurückfährt und zeigt, dass alle Figuren zusammengequetscht wurden, damit sie in „den dünnsten Flachbildschirmfernseher der Welt" hineinpassen: „… die HD Scenium Profile Serie." /// Un célèbre groupe de rock donne un show télévisé, avec des résultats hilarants. Tous les personnages se retrouvent serrés contre un écran. A la fin, le gag visuel est dévoilé lorsque la caméra recule, montrant que les personnages ont été écrasés pour tenir dans « L'écran plat le plus mince du monde … La série HD Scenium Profile. »

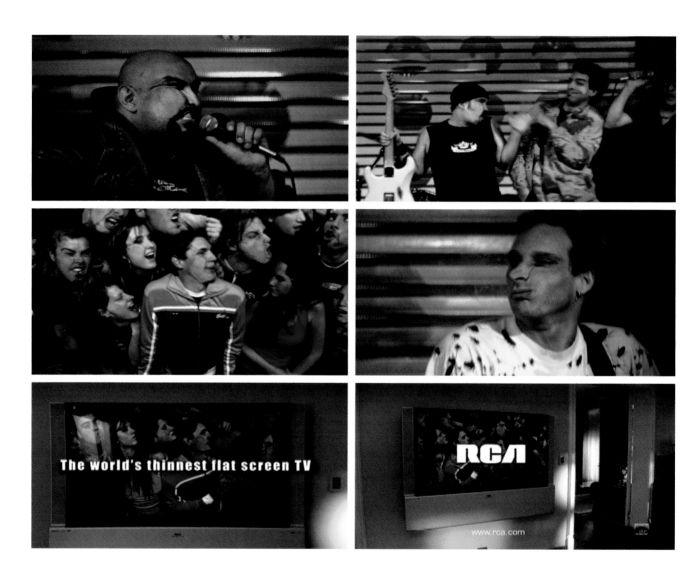

The big football match reveals some hilarious scenes. All the players appear completely squashed against a screen. The locker room interviews show an array of flat, distorted faces. The punchline reveals the ad's visual play. Of course, it could only be RCA's HD Scenium Profile Series…"the world's thinnest flat screen TV." /// In dem großen Fußballspiel werden einige urkomische Szenen gezeigt. Alle Spieler scheinen völlig gegen einen Bildschirm gepresst zu sein. Bei den Interviews im Umkleideraum sieht der Zuschauer eine Reihe von flachen und deformierten Gesichtern. Die Pointe besteht aus dem visuellen Gag des Spots. Natürlich kann es sich nur um die HD Scenium Profile Serie von RCA handeln… „den dünnsten Flachbildschirmfernseher der Welt." /// Le grand match de foot est ponctué de scènes hilarantes. Tous les joueurs finissent scotchés contre un écran. Dans les vestiaires aussi, ce n'est qu'une suite de visages aplatis et déformés. Avec la phrase de conclusion, on comprend le motif de ce jeu optique. Bien sûr, il ne pouvait s'agir que de la série HD Scenium Profile de RCA… « L'écran plat le plus mince du monde. »

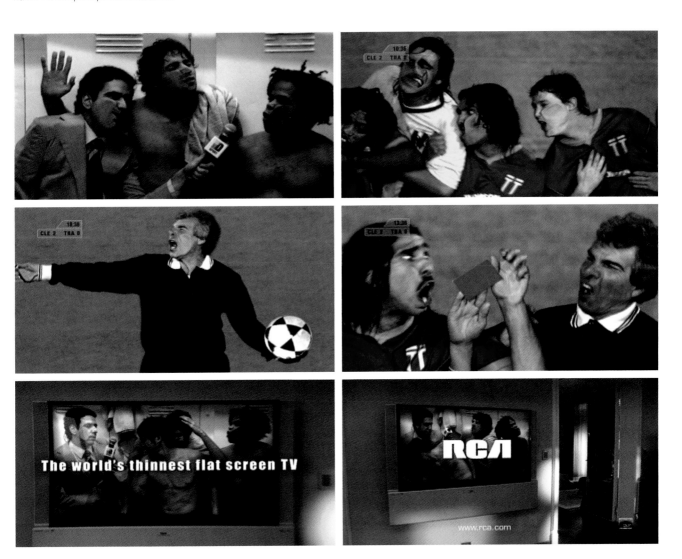

TITLE: Face of the future. **CLIENT:** Siemens. **PRODUCT:** Siemens Xelibri Mobile Phones. **AGENCY:** Mother. **COUNTRY:** United Kingdom. **YEAR:** 2003. **CREATIVE DIRECTOR:** Mark Waites, Robert Saville. **COPYWRITER/ART DIRECTOR:** Cecilia Dufils, Markus Bjurman, Darren Bailes, Al Maccuish. **PRODUCTION COMPANY:** Partizan. **PRODUCER:** Traktor. **DIRECTOR:** Traktor. **AWARDS:** Cannes Lions (Silver).

In a futuristic nightmare, a guy decides to commit a crime by dancing in public. He escapes an identity parade and flees the country with his ghetto-blaster dog. Arriving on a paradise island he hits the music on his Siemens Xelibri phone. The spot closes with a screenshot of the Xelibri range of handsets and the caption, "That's so tomorrow!" /// In einem futuristischen Albtraum beschließt ein Mann, sich strafbar zu machen, indem er in der Öffentlichkeit tanzt. Weil er gemeinsam mit seinem Ghettoblaster-Hund aus dem Land flieht, entgeht er einer polizeilichen Gegenüberstellung. Er erreicht eine paradiesische Insel und spielt Musik auf seinem Siemens Xelibri Handy. Der Werbespot endet mit einer Einstellung auf die Auswahl von Xelibri-Kopfhörern und den Zeilen „Das ist total zukunftsmäßig!" /// Cauchemar futuriste : un jeune homme décide de commettre un délit en dansant en public. Il échappe à une séance d'identification et parvient à quitter le pays en avion, en compagnie de son ghetto-blaster travesti en chien. Arrivé dans une île paradisiaque, il met la musique à pleins pots sur son portable Siemens Xelibri. Le spot finit par une image de la gamme de portables Xelibri, avec pour légende « That's so tomorrow! » (C'est tellement demain).

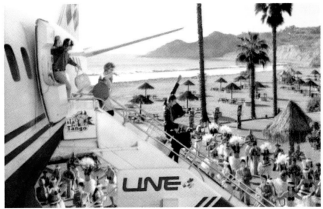

TITLE: Balls. CLIENT: Sony. PRODUCT: Sony Bravia Television. AGENCY: Fallon London. COUNTRY: United Kingdom. YEAR: 2005. EXECUTIVE CREATIVE DIRECTOR: Richard Flintham. CREATIVE DIRECTOR: Andy McLeod, Juan Cabral. COPYWRITER: Juan Cabral. ART DIRECTOR: Juan Cabral. PRODUCTION COMPANY: MJZ. PRODUCER: Nicky Barnes, Charlie Gatsky, Nell Jordan. DIRECTOR: Nicolai Fuglsig. AWARDS: CLIO Awards (Gold/Silver), ANDY Awards (Silver), One Show (Merit), D&AD (Yellow Pencil), Cannes Lions (Gold).

This beautiful spot shows thousands of brightly coloured balls bouncing down a steep street. The spot closes with the slogan, "Colour like no other." /// Dieser schöne Spot zeigt Tausende von Bällen in strahlenden Farben, die eine steile Straße hinabhüpfen. Der Spot endet mit dem Slogan: „Farben wie keine anderen." /// Ce spot superbe montre des milliers de balles de couleurs vives qui dévalent une rue en pente. Le spot se termine par ce slogan : « La couleur comme jamais ».

TITLE: Paint. **CLIENT:** Sony. **PRODUCT:** Sony Bravia Television. **AGENCY:** Fallon London. **COUNTRY:** United Kingdom. **YEAR:** 2005. **EXECUTIVE CREATIVE DIRECTOR:** Peter Raeburn. **CREATIVE DIRECTOR:** Juan Cabral, Richard Flintham. **PRODUCER:** Nicky Barnes, Simon Cooper. **DIRECTOR:** Jonathan Glazer. **AWARDS:** CLIO Awards (Gold/Silver), ANDY Awards (Silver), One Show (Merit), D&AD (Yellow Pencil), Cannes Lions (Gold).

A housing estate erupts in a symphony of vivid colours. Jets of coloured paints stream out of high rise blocks like an array of fireworks, which culminate into a vibrant crescendo. The spot closes with paint falling like rain. The slogan, "Colour like no other" appears followed by an image of the Sony Bravia television. /// Aus einer Wohnanlage bricht eine Symphonie aus lebhaften Farben hervor. Bunte Farbstrahlen schießen wie ein Feuerwerk aus hohen Gebäuden und gipfeln in einem pulsierenden Crescendo. Der Spot endet mit Farbe, die wie Regen herunterfällt. Der Slogan „Farben wie keine anderen" erscheint, gefolgt von einem Bild des Sony Bravia Fernsehgeräts. /// Un quartier résidentiel éclate en une symphonie de couleurs vives. Des jets de peinture jaillissent des immeubles comme des feux d'artifice, dans un crescendo coloré qui finit en apothéose. Dans le dernier plan, la peinture tombe comme de la pluie. Le slogan « La couleur comme jamais », apparaît, suivi de l'image d'une télévision Sony Bravia.

FEATURED ON THE DVD **TITLE:** Matchstick. **CLIENT:** Sony. **PRODUCT:** Sony Handycam. **AGENCY:** Saatchi & Saatchi India. **COUNTRY:** India. **YEAR:** 2004. **CREATIVE DIRECTOR:** Emmanuel Upputuru, Prasad Raghavan. **COPYWRITER:** Emmanuel Upputuru. **ART DIRECTOR:** Prasad Raghavan. **PRODUCTION COMPANY:** Like Minded People. **PRODUCER:** Prasad Raghavan. **DIRECTOR:** Prasad Raghavan, Emmanuel Upputuru. **AWARDS:** Cannes Lions (Shortlist).

The scene is a large hallway in a house. A phone is ringing continuously on a table. The sound of a match being struck is heard in the background. A boy slowly descends the stairs carrying the lit match. As he answers the phone the screen cuts to black. The slogan appears, "Super NightShot Handycam." /// Die Szene zeigt die große Diele eines Hauses. Auf einem Tisch klingelt ständig ein Telefon. Im Hintergrund hört man das Geräusch eines anbrennenden Streichholzes. Ein Junge kommt langsam die Treppe hinunter und hält das brennende Streichholz. Als er den Hörer abnimmt, wird der Bildschirm schwarz. Der Slogan „Super NightShot Handycam" erscheint. /// L'action se déroule dans la spacieuse entrée d'une maison. Un téléphone sonne sans arrêt sur une table. On entend le craquement d'une allumette à l'arrière-plan. Un garçon portant l'allumette allumée descend lentement les escaliers. Il décroche le téléphone, et l'écran devient noir. Les mots suivants concluent le spot : « Super NightShot Handycam ».

FEATURED ON THE DVD TITLE: Night Watchman. CLIENT: Sony. PRODUCT: Sony Handycam. AGENCY: Saatchi & Saatchi India. COUNTRY: India. YEAR: 2004. CREATIVE DIRECTOR: Emmanuel Upputuru, Prasad Raghavan. COPYWRITER: Emmanuel Upputuru. ART DIRECTOR: Prasad Raghavan. PRODUCTION COMPANY: Like Minded People. PRODUCER: Prasad Raghavan. DIRECTOR: Prasad Raghavan, Emmanuel Upputuru. AWARDS: Cannes Lions (Bronze).

A man comes into view waving a flashlight and tapping the ground with a stick. As he comes closer it becomes apparent that he is a night watchman doing the rounds. The image appears clear as day. The spot cuts to the closing slogan, "Super NightShot Handycam." /// Ein Mann kommt in Sicht, der eine Taschenlampe schwenkt und den Boden vor sich mit einem Stock abtastet. Während er näherkommt, wird offensichtlich, dass es sich um einen Nachtwächter auf einer Kontrollrunde handelt. Das Bild erscheint klar wie am Tage. Der Werbespot endet mit dem Slogan: „Super NightShot Handycam." /// Un homme arrive à l'image en brandissant une torche et en frappant le sol avec un bâton. Il se rapproche, et l'on se rend compte qu'il s'agit d'un gardien de nuit qui fait sa ronde. L'image est claire comme en plein jour. L'image passe au slogan de fin : « Super NightShot Handycam ».

TITLE: Egg Master. **CLIENT:** Sony. **PRODUCT:** Sony PlayStation 3. **AGENCY:** TBWA\Chiat\Day Los Angeles. **COUNTRY:** USA. **YEAR:** 2006. **CREATIVE DIRECTOR:** Brett Craig. **COPYWRITER:** Patrick Almaguer. **ART DIRECTOR:** Blake Kidder. **PRODUCTION COMPANY:** MJZ. **PRODUCER:** Anh-Thu Le. **DIRECTOR:** Rupert Sanders.

In a white room a PlayStation 3 console sits quietly while its controller hovers. A dozen eggs slowly roll to the other side. In a sudden movement the controller flings the eggs against the wall. Instantly they burst out of the wall as a flock of black ravens. The closing caption reads, "Sixaxis Wireless Controller – Play Beyond." /// In einem weißen Raum steht bewegungslos eine PlayStation 3 Konsole, deren Steuerung in der Luft schwebt. Ein Dutzend Eier rollt langsam über den Boden zur anderen Seite des Raumes. Mit einer plötzlichen Bewegung schleudert die Steuerung die Eier gegen die Wand. Sofort brechen sie als Schwarm schwarzer Raben aus der Wand hervor. Der abschließende Slogan lautet: „Sixaxis Wireless Controller – Play Beyond." /// Dans une pièce blanche, une console de PlayStation 3 se tient tranquillement, sa manette de contrôle en suspension au-dessus d'elle. Une douzaine d'œufs roulent doucement à l'autre bout de la pièce. Soudainement, la manette lance les œufs contre le mur. Instantanément, ils se brisent, laissant échapper un vol de corbeaux noirs. Le phrase de clôture s'affiche : « Sixaxis Wireless Controller – Play Beyond. »

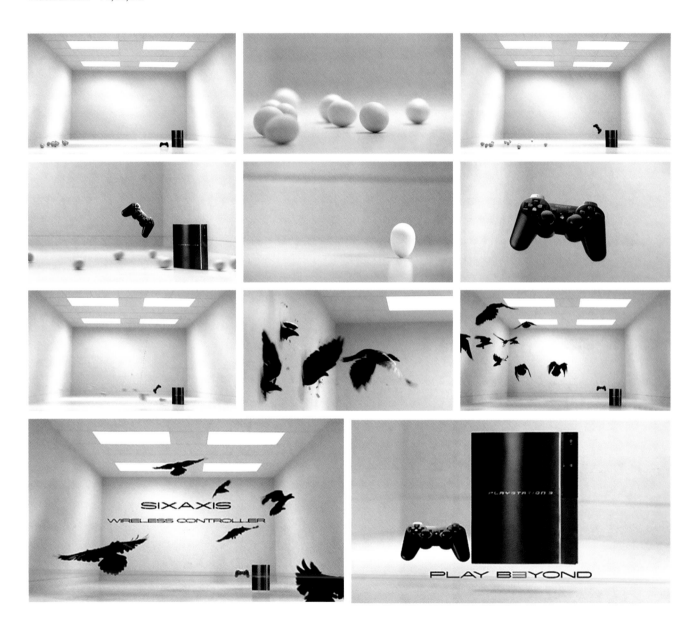

TITLE: Rubik's. **CLIENT:** Sony. **PRODUCT:** PlayStation 3. **AGENCY:** TBWA\Chiat\Day Los Angeles. **COUNTRY:** USA. **YEAR:** 2006. **CREATIVE DIRECTOR:** Brett Craig. **COPYWRITER:** Patrick Almaguer. **ART DIRECTOR:** Blake Kidder. **PRODUCTION COMPANY:** MJZ. **PRODUCER:** Anh-Thu Le. **DIRECTOR:** Rupert Sanders.

In a white room a PlayStation 3 asserts its intelligence over the Rubik's Cube. First it levitates the cube and solves the combination. Suddenly the cube explodes, showering each wall in perfect colour. The caption fades up, "Cell processor: Smarter." A PlayStation 3 appears in a close-up with the tagline, "Play Beyond." /// In einem weißen Raum erprobt eine PlayStation 3 ihre Intelligenz an einem Rubik-Zauberwürfel. Zunächst lässt sie den Würfel frei schweben und löst seine Kombination. Plötzlich explodiert der Würfel und bedeckt jede Wand mit perfekten Farbtönen. Die Zeilen „Cell Processor: Smarter" Erscheinen, dann in einer Naheinstellung eine PlayStation 3 mit dem Slogan „Play Beyond." /// Dans une pièce blanche, une PlayStation 3 teste son intelligence sur un Rubik's Cube. Elle fait tout d'abord léviter le cube, puis en résout la combinaison. Soudain, le cube explose, et chacun des murs s'agrémente d'une couleur. La légende s'affiche « Processeur Cell : Plus intelligent. » Une PlayStation 3 apparaît en gros plan, avec l'accroche « Play Beyond. »

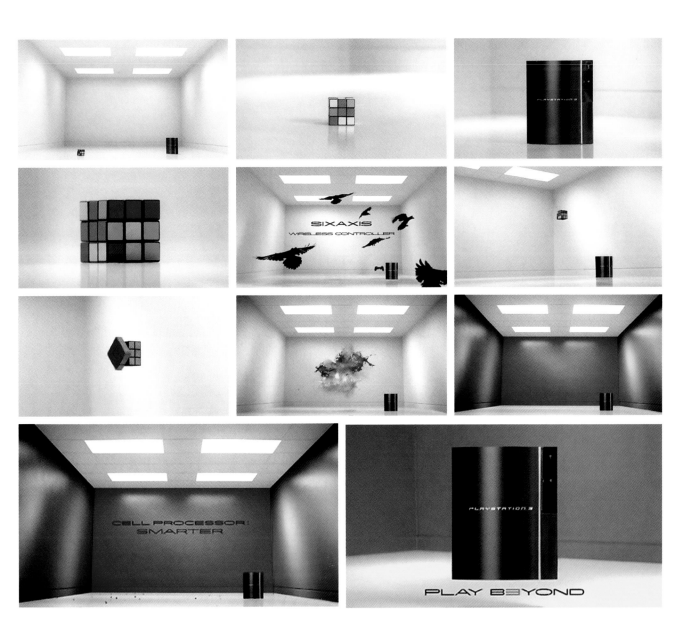

TITLE: Day in the Life. **CLIENT:** Sony. **PRODUCT:** Sony PlayStation Portable. **AGENCY:** TBWA\London. **YEAR:** 2005. **COPYWRITER:** James Gilham, Simon Hardy, Tony McTear, Danny Brooke Taylor. **ART DIRECTOR:** James Gilham, Simon Hardy, Tony McTear, Danny Brooke Taylor. **PRODUCTION COMPANY:** RSA. **PRODUCER:** Diane Croll, Kate Taylor. **DIRECTOR:** Alex Rutterford. **AWARDS:** CLIO Awards (Gold), ANDY Awards (Bronze).

A modern geometrical sculpture explodes to life in a gallery. The clustered object begins a surreal, fast paced journey across a cityscape. As two young men are seen playing with their Sony PlayStation PSPs on a bus, the abstract shape suddenly crashes into their window and splits into two. Now two clusters commence battle. They fall off a crane and into a pool of foam. The spot ends with a brief shot of the shape being pressure washed on an assembly line. /// In einer Galerie erwacht eine moderne geometrische Figur zum Leben. Sie beginnt eine surreale und rasante Reise durch eine Stadt. Zwei junge Männer spielen im Bus mit ihren Sony PlayStation PSPs, als die Figur plötzlich durchs Fenster bricht und sich in zwei Teile splittet. Die beiden Objekte beginnen einen Kampf. Sie fallen von einem Kran in einen schaumgefüllten Swimmingpool. Der Spot endet mit einer kurzen Einstellung auf die Figur, die auf einem Montageband mit Hochdruck gereinigt wird. /// Une sculpture géométrique moderne prend vie dans une galerie. Cet objet commence un voyage surréel et effréné dans un paysage urbain. Deux jeunes sont en train de jouer sur leur Sony PlayStation PSP dans un bus lorsque la forme abstraite passe à travers leur fenêtre et se divise en deux morceaux, qui commencent à se battre. Ils tombent d'une grue et atterrissent dans une piscine de mousse. Le spot se termine par une brève séquence qui montre la forme en train d'être nettoyée à pression sur une chaîne d'assemblage.

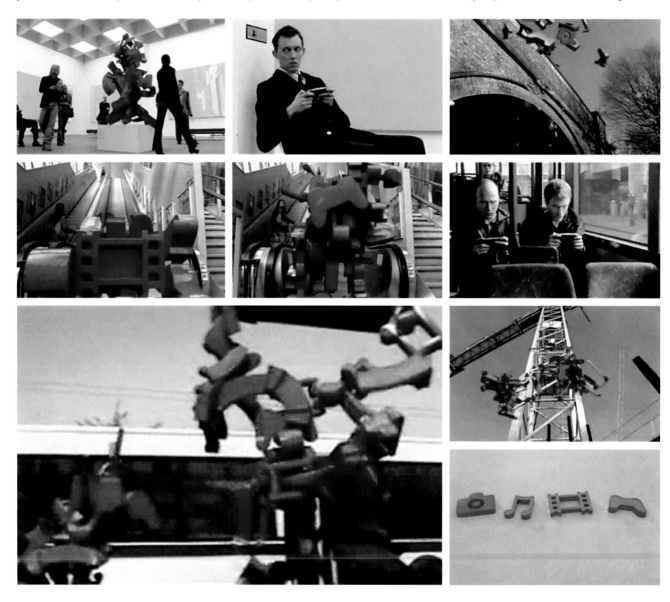

TITLE: Xbox Ear Tennis. **CLIENT:** Microsoft. **PRODUCT:** Xbox Game Console. **AGENCY:** Bartle Bogle Hegarty. **COUNTRY:** United Kingdom. **YEAR:** 2003. **COPYWRITER:** Adam Chiappe. **ART DIRECTOR:** Mathew Saunby.
PRODUCTION COMPANY: Blink Productions, Czar/Belgium. **PRODUCER:** James Studholme, Ellen De Waele. **DIRECTOR:** Lionel Goldstein. **AWARDS:** Cannes Lions (Gold).

The scene opens at a major ping pong tournament. This cuts to a sequence of shots following a star Chinese ping pong champion who uses his huge paddle-shaped ears as his bat. /// Diese Szene zeigt ein bedeutendes Tischtennis-Turnier. Die Kamera verfolgt die rasante Schlagfolge eines chinesischen Tischtennisstars, der seine riesigen schaufelförmigen Ohren als Schläger benutzt. /// L'action se déroule lors d'un grand tournoi de ping-pong. On voit alors une série de scènes où une star du ping-pong chinois joue avec ses énormes oreilles en forme de raquettes.

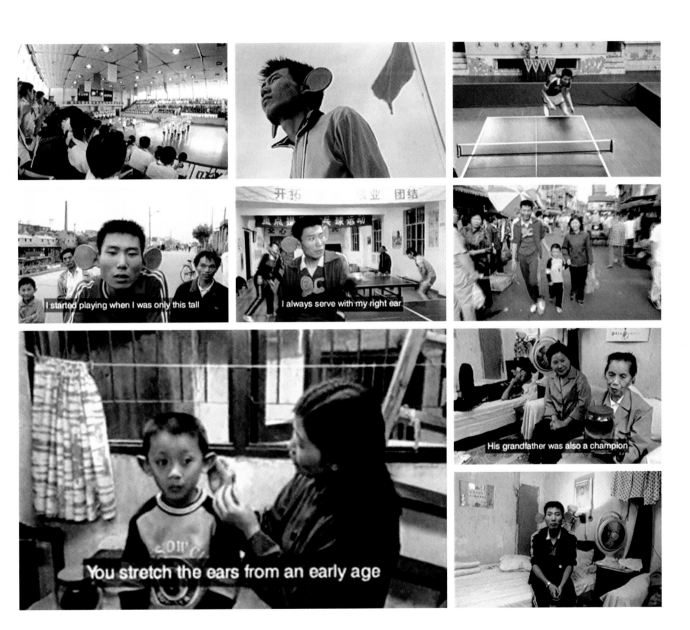

TITLE: Champagne. **CLIENT:** Microsoft. **PRODUCT:** Xbox Game Console. **AGENCY:** Bartle Bogle Hegarty. **COUNTRY:** United Kingdom. **YEAR:** 2002. **CREATIVE DIRECTOR:** John Hegarty. **COPYWRITER:** Fred & Farid. **ART DIRECTOR:** Fred & Farid. **PRODUCTION COMPANY:** Spectre. **PRODUCER:** Johnnie Frankel. **DIRECTOR:** Daniel Kleinman. **AWARDS:** Cannes Lions (Gold).

A woman is giving birth in hospital. With a sudden yelp her baby jettisons out of her and flies out of the window like a rocket. Using brilliant postproduction techniques, we see the baby grow into a boy and age in mid flight. The man continues to yell as he speeds through his life, before finally diving down into a cemetery and crashing into a grave. The slogan reads, "Life is short. Play more. Xbox." /// Eine Frau bekommt im Krankenhaus ein Baby. Mit einem gellenden Schrei schießt das Baby aus ihr heraus und fliegt wie eine Rakete aus dem Fenster. Durch brillante Nachbearbeitungstechniken sehen wir, wie das Baby während des Fluges zu einem Jungen wird und schließlich altert. Der Mann schreit weiter, während er durchs Leben rast. Er landet schließlich auf einem Friedhof und kracht in ein Grab. Der Slogan lautet: „Das Leben ist kurz. Spiel mehr. Xbox." /// Une femme est en train d'accoucher à l'hôpital. Dans un cri soudain, son bébé sort d'elle comme une fusée et est éjecté par la fenêtre. Grâce à des techniques de postproduction de pointe, on voit le bébé grandir et vieillir, toujours en plein vol. L'homme continue à crier et sa vie passe à toute vitesse. Il finit par tomber en piqué vers un cimetière et s'écrase dans sa tombe. Le slogan déclare : « La vie est courte. Jouez plus. Xbox ».

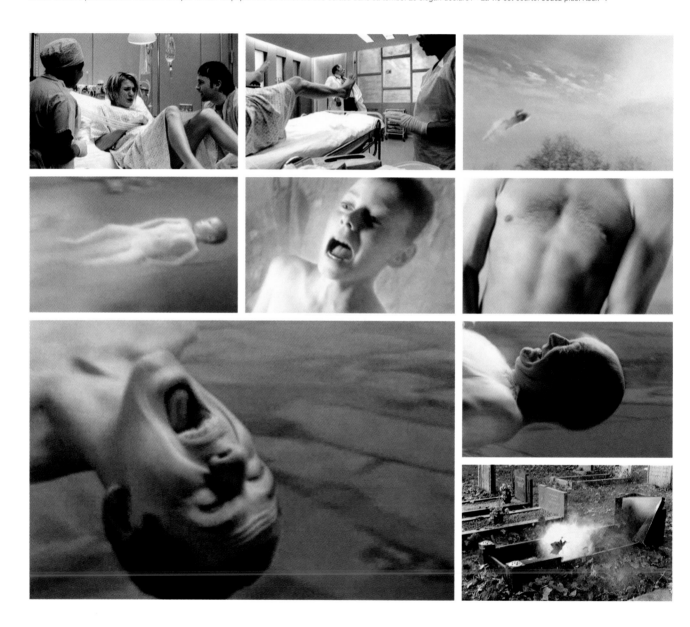

TITLE: Rock Band. **CLIENT:** Microsoft. **PRODUCT:** Xbox 360 "Rock Band". **AGENCY:** McCann Erickson London. **COUNTRY:** United Kingdom. **YEAR:** 2008. **EXECUTIVE CREATIVE DIRECTORS:** Brian Fraser, Simon Learman. **COPYWRITER:** Cameron Mitchell. **ART DIRECTOR:** Elliot Harris. **PRODUCTION COMPANY:** Smith & Jones Films. **DIRECTOR:** Ulf Johansson.

A rock band performs at a big arena. All hell breaks loose as the crowd climb up on the stage to perform in seamless rotation whilst following the Xbox 360 Live game on laptops. The tagline fades up, "Start a band … Rock the world … Rock Band." The spot closes with a close-up of a laptop and the Xbox 360 Live logo. /// Auf einer großen Bühne spielt eine Rockband. Die Hölle bricht los, als die Zuschauer auf die Bühne klettern und wild über die Bühne fegen, während sie auf Laptops der Xbox 360 Live folgen. Der Slogan „Gründe eine Band … Rock die Welt … Rockband" erscheint. Der Werbespot endet mit einer Naheinstellung auf einen Laptop und dem Xbox 360 Live-Logo. /// Un groupe de rock donne un concert dans une grande salle. La folie s'empare des lieux quand des membres de l'assistance montent sur scène et, prenant la place des musiciens, s'y succèdent à l'infini, tout en suivant le jeu Xbox 360 Live sur des ordinateurs portables. La légende s'affiche « Start a band … Rock the world … Rockband. » Le sport prend fin sur un gros plan du portable et le logo de Xbox 360 Live.

TITLE: Diorama. CLIENT: Microsoft. PRODUCT: Xbox 360 "Halo 3". AGENCY: McCann Erickson San Francisco. COUNTRY: USA. YEAR: 2008. CREATIVE DIRECTORS: Scott Duchon, Geoff Edwards, John Patroulis. COPYWRITER: Mat Bunnell. ART DIRECTOR: Tim Stier, Nate Able. PRODUCTION COMPANY: MJZ, Los Angeles. DIRECTOR: Rupert Sanders.

The camera weaves through a diorama of an epic fantasy battle frozen in time. Finally, one alien soldier's helmet lights up as he lifts his head. The spot cuts to a black screen with the word, "Believe," followed by the Halo 3 and Xbox Live logos. /// Die Kamera schlängelt sich durch das Diorama einer epischen Fantasieschlacht, die völlig erstarrt ist. Schließlich leuchtet der Helm eines außerirdischen Soldaten auf, als dieser seinen Kopf hebt. Der Spot endet mit einem schwarzen Bildschirm und dem Wort „Glaube", gefolgt von den Logos von *Halo 3* und Xbox Live. /// La caméra se promène sur la reconstitution d'un champ de bataille imaginaire épique, comme figé dans le temps. Finalement, un soldat extra-terrestre bouge la tête et une lumière s'allume dans son casque. Un écran noir prend la suite, avec le mot « Croyez, » après quoi les logos de Halo 3 et Xbox Live s'affichent.

FEATURED ON THE DVD **TITLE:** Mad World. **CLIENT:** Microsoft. **PRODUCT:** Xbox 360 "Gears of War" . **AGENCY:** McCann Erickson San Francisco. **COUNTRY:** USA. **YEAR:** 2007. **EXECUTIVE CREATIVE DIRECTOR:** John McNeil, Rob Bagot. **CREATIVE DIRECTOR:** Geoff Edwards, Scott Duchon. **COPYWRITER:** Mat Bunnell. **ART DIRECTOR:** Nate Able. **AGENCY PRODUCER:** Hannah Murray. **PRODUCTION COMPANY:** Anonymous Content. **DIRECTOR:** Joseph Kosinski. **AWARDS:** Cannes Lions (Silver), CLIO Awards (Bronze).

Using state of the art computer animation, this spot follows the movements of a lone soldier as he runs through the wreckage of a desolate cityscape at night. Finally, he does battle with a predatory alien. The ad closes with the game title "Gears of War" and the Xbox 360 logo. /// Unter Anwendung modernster Computeranimation verfolgt dieser Spot einen Soldaten, der bei Nacht durch die Trümmer einer verlassenen Stadt läuft. Schließlich kämpft er gegen einen gefährlichen Außerirdischen. Der Spot endet mit dem Spieltitel „Gears of War" und dem Xbox 360-Logo. /// Ce spot utilise une animation de synthèse dernier cri pour nous faire suivre les déplacements d'un soldat solitaire qui court dans une ville en ruine, la nuit. Il finit par engager le combat avec un extra-terrestre prédateur. La publicité se conclut avec le titre du jeu, « Gears of War » et le logo Xbox 360.

THE LOVE
FOR SPEED

BOB ISHERWOOD
WORLDWIDE CREATIVE DIRECTOR OF SAATCHI & SAATCHI

Australian-born Bob Isherwood is Worldwide Creative Director of Saatchi & Saatchi. In a career spanning over 35 years in the advertising industry, Bob's work has been well documented in many books and endorsed by the industry's most prestigious national and international award shows. He won Australia's first Gold Lion for Cinema at Cannes, and is among the few people to have won the British Design and Art Directors Gold Award for Advertising. Bob has been elected to the Clio Hall of Fame in the US and named Australia's leading creative director. In 2001, he served as president of the Film and Press & Poster juries at Cannes. And in 2004 he was chairman of the Clio film jury.

In 1986 Bob joined Saatchi & Saatchi in Sydney. He was appointed creative director in 1988, chairman of the Worldwide Creative Board in 1995 and worldwide creative director in 1996. He believes passionately in the power of ideas to change the world. Appropriately, he is the driving force behind the Saatchi & Saatchi Award for World Changing Ideas. Under Bob's leadership, Saatchi & Saatchi's global network of 143 offices in 83 countries has consistently ranked among the top creative agencies in the world. Bob is

Der gebürtige Australier Bob Isherwood ist Worldwide Creative Director bei Saatchi & Saatchi. Seit 35 Jahren ist er in der Werbebranche erfolgreich. Bobs Arbeiten sind in zahlreichen Publikationen dokumentiert, und er wurde mit den renommiertesten nationalen und internationalen Werbepreisen ausgezeichnet. Unter anderem gewann er in Cannes für Australien den ersten Gold Lion in der Kategorie „Cinema" und zählt zu den wenigen Preisträgern des „British Design and Art Directors Gold Award for Advertising". Bob wurde in den USA mit dem „Clio Hall of Fame Award" und in Australien als führender Kreativdirektor geehrt. 2001 war er in Cannes Präsident der Jurys für die Kategorien „Film" sowie „Anzeigen & Plakate". 2004 war er Vorsitzender der Clio Filmjury.

1986 kam Bob zu Saatchi & Saatchi in Sydney. 1988 wurde er zum Creative Director ernannt, 1995 zum Chairman des Worldwide Creative Board und 1996 zum Worldwide Creative Director. Er glaubt leidenschaftlich daran, dass Ideen die Kraft besitzen, die Welt zu verändern. Deshalb ist er auch die treibende Kraft hinter dem „Saatchi & Saatchi Award for World Changing Ideas". Dank Bobs Leitung nimmt das globale Saatchi & Saatchi Netzwerk mit 143 Niederlassungen in 83 Ländern seit vielen Jahren eine Spitzenstellung in den internationalen Agentur-Rankings ein. Derzeit ist er in der weltweiten Zentrale von Saatchi & Saatchi in New York City im Einsatz.

„Transport" umfasst die Werbekategorie mit den weltweit höchsten Ausgaben: die Automobilindustrie.

Nach Schätzungen von Advertising Age belief

Né en Australie, Bob Isherwood est directeur de la création – monde chez Saatchi & Saatchi. Au cours d'une carrière de 35 ans dans le secteur de la publicité, le travail de Bob a été étudié dans de nombreux livres, et a remporté les récompenses nationales et internationales les plus prestigieuses du secteur. Il a gagné le premier Lion d'or australien pour le cinéma à Cannes, et fait partie des rares personnes qui se sont vu décerner le Gold Award de l'association British Design and Art Directors dans la catégorie publicité. Bob a été élu au Clio Hall of Fame aux États-Unis, et a été nommé le meilleur directeur de la création d'Australie. En 2001, il a été président du jury à Cannes pour la catégorie « Film and Press & Poster ». En 2004, il a été président du jury Clio pour la catégorie des films.

Bob est entré chez Saatchi & Saatchi à Sydney en 1986. Il a été nommé directeur de la création en 1988, président du comité de la création – monde en 1995, et directeur de la création – monde en 1996. Il croit passionnément que les idées peuvent changer le monde. C'est donc en toute logique qu'il est la force motrice derrière le prix Saatchi & Saatchi « World Changing Ideas ». Sous la direction de Bob, le réseau mondial de 143 bureaux dans 83 pays de Saatchi & Saatchi a constamment figuré parmi les meilleures agences créatives du monde. Bob est actuellement basé à New York, au siège mondial de Saatchi & Saatchi.

Le titre « Transports » comprend la catégorie qui dépense le plus en publicité : l'automobile.

Selon les calculs d'Advertising Age, les annonceurs y ont dépensé la bagatelle de 23 milliards de dollars.

currently based in Saatchi & Saatchi's worldwide headquarters in New York City.

"Transport" includes the world's highest spending advertising category: "Automotive."

Advertising Age's estimate is that, in 2005, advertisers lavished almost $23 billion on it.

This dwarfs the amount spent on basics, such as food, which had only an estimated amount of just over $8 billion spent on it.

Perhaps we can explain the massive investment in automobile advertising simply by noting that, in most economies, an automobile is the second biggest family purchase after a place to live.

BUT IF YOU FOLLOW THAT LOGIC, WHY DOESN'T HOUSING TOP THE ADVERTISING EXPENDITURE CHART? SO MUCH FOR LOGIC.

"Automotive" sits alongside airlines, trains, ships, motorcycles, bicycles and so on under the "Transport" umbrella.

But do we really think of our automobiles as "transport?" I don't think we view our automobiles in such a functional way at all.

Although an automobile is a stuck-together collection of metal, plastic, glass, rubber (and possibly wood and leather) components, we have complex, emotional relationships with these assemblies, and, moreover, we have complex, emotional reasons for buying particular marques and models.

Sure, if you ask someone for their checklist of purchase reasons, you'll get a pretty dull, worthy, rational collection. "Value for money"; "reliability"; "safety rat-

sich das Werbebudget in dieser Kategorie im Jahr 2005 auf fast 23 Milliarden US-Dollar.

Daneben wirken die Werbeausgaben für Nahrungsmittel mit einem Betrag von nur 8 Milliarden US-Dollar geradezu bescheiden.

Die massiven Investitionen der Automobilindustrie in Werbung lassen sich vermutlich am ehesten dadurch erklären, dass das Auto in den Privathaushalten der meisten Länder nach dem Haus- oder Wohnungskauf die zweitgrößte Ausgabe darstellt.

DOCH WENN MAN DIESER LOGIK FOLGT, STELLT SICH DIE FRAGE: WARUM STEHT DER IMMOBILIEN-SEKTOR AUF DER LISTE DER WERBEAUSGABEN NICHT GANZ OBEN? SOVIEL ZUR LOGIK.

Autos befinden sich also in der Kategorie „Transport" neben Flugzeugen, Zügen, Schiffen, Motorrädern, Fahrrädern und dergleichen.

Aber sehen wir unsere Autos wirklich als „Transportmittel"? Ich glaube nicht, dass wir unsere Autos überhaupt so funktional betrachten.

Obwohl ein Auto nichts weiter ist als ein zusammenmontiertes Etwas aus Metall, Kunststoff, Glas, Kautschuk, Holz, Leder und anderen Bestandteilen, haben wir eine komplexe, emotionale Bindung zu diesem Etwas. Mehr noch: Wir haben sogar komplexe, emotionale Gründe für den Kauf bestimmter Automarken und -modelle.

Wenn Sie einen Menschen gezielt nach seinen Kaufgründen fragen, wird er ihnen wahrscheinlich eine ziemlich rational, wenn nicht gar dröge klingende Liste nennen: „Preis-Leistungs-Verhältnis", „Zuverlässigkeit",

Par comparaison, la somme dépensée pour les produits de base, comme l'alimentation (estimée à un peu plus de 8 milliards de dollars), paraît bien faible.

Peut-être pouvons-nous expliquer les investissements massifs dans la publicité pour les voitures en remarquant simplement que, dans la plupart des économies, l'automobile occupe le second rang dans le budget des familles, juste après le logement.

MAIS SI L'ON SUIT CETTE LOGIQUE, POURQUOI LE LOGEMENT NE DÉPASSE-T-IL PAS L'AUTOMOBILE DANS LES DÉPENSES PUBLICITAIRES ? ADIEU LA LOGIQUE.

L'automobile est une catégorie que l'on trouve juste à côté des lignes aériennes, des trains, des bateaux, des motos, des vélos, etc., le tout rangé sous le titre de « Transports ».

Mais considérons-nous vraiment nos voitures comme un moyen de transport ? Je ne crois pas que la vision que nous en avons soit si fonctionnelle.

Bien que les voitures ne soient que des objets faits de métal, de plastique, de verre et de caoutchouc (et parfois aussi de bois et de cuir), nous avons avec elles des relations émotionnelles complexes. Nous avons de plus des raisons émotionnelles et complexes pour acheter une certaine marque et un certain modèle.

Bien sûr, si vous demandez à quelqu'un de vous expliquer son achat, vous obtiendrez une liste de raisons assez responsables, rationnelles et ennuyeuses : « rapport qualité-prix », « fiabilité », « sécurité », « dépréciation », « économies d'essence », « coûts d'entretien », « coffre spacieux », « visibilité », etc.

ing"; "depreciation"; "fuel economy"; "service costs"; "trunk space"; "visibility"; and so on and so on.

But catch the same respondent off-guard and you'll learn the truth.

"It does 0–60 in 5.6 seconds"; "I'll look good driving it"; "The guys at the golf club are going to be sooo impressed"; "The sound system is fantastic"; "Look at these low-profile tires"; and similar.

SO ARE WE REALLY JUST LOOKING FOR SOMETHING TO GET US FROM A TO B? OR ARE WE HOPING TO GET TO SOME OTHER PLACE COMPLETELY?

I think it's definitely the latter. And I think it's this recognition that leads to the best and most creative automobile advertising.

At the Cannes International Advertising Festival you can sit through about five hours of back-to-back entries in the automotive category.

The entries range from absolute stunners to absolute stinkers.

Fortunately, diamonds shine in mud.

Fresh, innovative, intelligent ideas engage viewers, not just at Cannes, but out here in the world.

The automobile spots I've chosen for this chapter fit this description.

They respect and entertain viewers. They don't presume that viewers are interested. Instead, they assume that viewers have hearts and brains.

They present brilliant, technical innovations in intriguing, imaginative ways.

And they major on feelings, not just on facts.

So that, afterwards, you can ask a viewer, "How do you feel about this product?" and not just, "What do you think about this product?"

There's a profound difference. However, it's simplistic to say, the best automobile spots just get the first step in the purchasing dance right, by creating a good feeling about the model on offer.

Advertisers can't sell their automobiles on the screen. What they can do is create a desire to learn more. They can also inspire the viewer to ask questions such as, "Wouldn't I look good driving that?"

If the answers are positive, the chances are the

„Sicherheitsaspekte", „Abschreibung", „Benzinsparen", „Servicekosten", „Laderaumvolumen", „Sichtbarkeit" und so weiter.

Wenn Sie denselben Menschen dagegen in ein unverfängliches Gespräch verwickeln, erfahren Sie seine wirklichen Gründe: „Er beschleunigt in 5,6 Sekunden von 0 auf 100", „Ich werde am Steuer richtig gut aussehen", „Den Typen vom Golfclub werden die Augen aus dem Kopf fallen", „Das Soundsystem ist der Hammer", „Schau dir diese Leichtmetallfelgen an" und so weiter.

GEHT ES UNS WIRKLICH NUR DARUM, MIT UNSEREM AUTO VON A NACH B ZU FAHREN? ODER HOFFEN WIR INSGEHEIM, DAMIT EINEN GANZ ANDEREN PLATZ ZU ERREICHEN?

Ich bin mir sicher, dass Letzteres der Fall ist. Und ich glaube, genau auf dieser Erkenntnis basiert die beste und kreativste Autowerbung.

Beim Cannes International Advertising Festival verbringt man fünf Stunden damit, sich Beiträge für die Kategorie „Autos" anzuschauen.

Unter den eingereichten Beiträgen findet sich alles, vom absoluten Überflieger bis zur totalen Niete.

Glücklicherweise leuchten Diamanten selbst noch im dicksten Schlamm ganz hell.

Frische, innovative, intelligente Ideen fesseln die Zuschauer, nicht nur in Cannes, sondern überall in der Welt.

Die Spots für Autowerbung, die ich für dieses Kapitel ausgesucht habe, entsprechen dieser Beschreibung.

Sie respektieren und unterhalten die Zuschauer. Sie setzen nicht einfach voraus, dass die Zuschauer interessiert sind. Stattdessen gehen sie davon aus, dass die Zuschauer über Verstand und Gefühl verfügen.

Sie präsentieren brillante technische Innovationen auf fantasievolle und fesselnde Art.

Und sie zählen nicht bloß Fakten auf, sondern appellieren zugleich an die Emotionen.

Jemanden, der solch einen Spot gesehen hat, kann man fragen: „Welches Gefühl haben Sie bei die-

Mais en creusant un peu, vous apprendrez la vérité.

« Elle monte à 100 en 5,6 secondes », « J'aurai fière allure au volant », « Mes copains du club de golf ne vont pas en revenir », « La sono est fantastique », « Regarde un peu ces pneus basse section », j'en passe et des meilleures.

ALORS, NE CHERCHONS-NOUS VRAIMENT QU'UN MOYEN D'ALLER DE A À B ? OU ESPÉRONS-NOUS NOUS ÉVADER VERS UN AUTRE AILLEURS ?

Je pense que la deuxième réponse est la bonne. Et je pense que les créateurs des meilleures publicités pour automobiles sont d'accord avec moi.

Au Festival international de la publicité de Cannes, on peut facilement voir cinq heures de films publicitaires sur les voitures les uns après les autres.

Les films en lice vont des plus brillants aux plus affligeants.

Heureusement, les diamants brillent aussi dans la boue.

Les spectateurs aiment les idées innovantes et intelligentes, pas seulement à Cannes, mais dans le reste du monde également.

Les spots automobiles que j'ai choisis pour ce chapitre correspondent à cette description.

Ils respectent les spectateurs et les divertissent. Ils ne présupposent pas que les spectateurs sont intéressés. Ils présupposent plutôt qu'ils ont un cœur et un cerveau.

Ils présentent des innovations techniques brillantes d'une façon intrigante et imaginative, et ils savent utiliser les sentiments, pas seulement les faits.

Après de tels films, vous pouvez demander au spectateur « Quel est votre sentiment à propos de ce produit ? », et pas seulement « Que pensez-vous de ce produit ? »

La différence est de taille. Cela peut sembler évident, mais les meilleurs spots automobiles ne font que donner une petite foulée d'avance dans la course à l'achat, en créant un sentiment positif à propos du modèle.

Les annonceurs ne peuvent pas vendre les voi-

viewer will want to ask more questions about the automobile.

A separate question at this point might be, why are there so many stinkers and so few stunners? To put it another way, why is so much of the $23 billion invested in mediocrity? Frankly, I don't know what the answer is, but I do know there's no excuse.

The creative opportunities are there. The understanding is there. The budgets are there. And the opportunities to be genuinely innovative are there too. I've included two examples: BMW's viral films from 2002, and the Toyota Yaris mobisodes campaign from 2006.

So far, and for obvious reasons, I've devoted a lot of words to automobiles.

THE FACT IS, NONE OF THE OTHER "TRANSPORT" CATEGORIES FIGURE IN ADVERTISING AGE'S 2005 REVIEW. AND THERE ISN'T AN AIRLINE IN ADVERTISING AGE'S LIST OF THE TOP 100 GLOBAL MARKETERS.

But happily, that doesn't mean there aren't outstanding advertising ideas in other "transport" categories.

One category wouldn't exist without automobiles, and springs directly from there. It's "road safety."

There's a long tradition of highly impactful (deliberate choice of word) advertising highlighting the perils associated with road travel.

And success in this, I would say, comes to those who do not preach.

THE MOST EFFECTIVE COMMUNICATIONS IN THIS AREA, AGAIN, RELY ON TREATING THE VIEWER, NOT AS SOME SLOW-WITTED MORON, BUT AS AN INTELLIGENT, SENSITIVE BEING. THEY SURPRISE AND THEY PROVOKE. AND THEY AVOID HYSTERIA IN FAVOUR OF POWERFUL UNDERSTATEMENT.

sem Produkt?" und nicht bloß: „Was denken Sie von diesem Produkt?"

Das ist ein bedeutender Unterschied. Es ist allerdings auch wahr, dass selbst die besten Spots für Autowerbung letztendlich nur das Kaufinteresse wecken können, indem sie ein gutes Gefühl in Bezug auf das angebotene Modell vermitteln.

Autos lassen sich zwar im Fernsehen bewerben, aber nicht übers Fernsehen verkaufen. TV-Werbung kann beim Zuschauer jedoch den Wunsch wecken, mehr über das Auto zu erfahren. TV-Werbung kann den Zuschauer auch dazu bringen, sich Fragen zu stellen wie „Würde ich am Steuer dieses Wagens nicht total gut aussehen?"

Wenn so eine Frage bejaht wird, stehen die Chancen gut, dass der Zuschauer mehr über das Auto wissen will.

Man könnte sich an diesem Punkt auch noch etwas anderes fragen: Warum gibt es eigentlich so viele Nieten und so wenige Überflieger? Oder anders ausgedrückt: Warum wird ein Großteil der 23 Milliarden US-Dollar in Mittelmäßigkeit investiert? Offen gestanden kenne ich die Antwort nicht. Ich weiß nur, dass es keine Entschuldigung dafür gibt.

Die kreativen Möglichkeiten sind da. Das Verständnis ist da. Die Budgets sind da. Und die Chancen, wirklich innovative Werbung zu kreieren, sind auch da. Zwei Beispiele habe ich ausgewählt: die viralen Spots für BMW von 2002 und die Mobisode-Kampagne für den Toyota Yaris von 2006.

Bisher bin ich hauptsächlich auf Autowerbung eingegangen.

TATSACHE IST, DASS IM 2005 REVIEW VON ADVERTISING AGE KEINE DER ANDEREN „TRANSPORT"-KATEGORIEN GENANNT WURDEN. IN DER LISTE DER TOP 100 GLOBAL MARKETERS VON ADVERTISING AGE FINDET SICH AUCH KEINE AIRLINE.

Doch zum Glück bedeutet dies nicht, dass es keine herausragenden Werbeideen in anderen „Transport"-Kategorien gibt.

tures par télévision interposée. Ce qu'ils veulent, c'est susciter le désir de se renseigner. Ils peuvent aussi amener le spectateur à se demander, par exemple, « N'aurai-je pas une allure fantastique au volant de cette voiture ? »

Si la réponse est positive, on peut supposer que le spectateur voudra se renseigner sur cette voiture.

Nous pouvons maintenant nous poser une tout autre question. Pourquoi y a-t-il autant de spots affligeants, et pourquoi les spots brillants sont-ils aussi rares ? En d'autres termes, pourquoi une part aussi importante de ces fameux 23 milliards de dollars finance-t-elle la médiocrité ? Franchement, je ne connais pas la réponse, mais je sais qu'il n'en existe aucune de valable.

Les opportunités de création sont là. La compréhension est là. Les budgets sont là. Et les occasions d'innover sont là aussi. J'ai inclus ici deux exemples : les films viraux de BMW, de 2002, et les mobisodes de la Toyota Yaris de 2006.

Jusqu'à maintenant, j'ai consacré une grande part de ce texte aux automobiles, pour des raisons évidentes.

D'AILLEURS, AUCUNE AUTRE CATÉGORIE DE « TRANSPORTS » NE FIGURE DANS LA LISTE D'ADVERTISING AGE POUR 2005, ET IL N'Y A PAS UNE SEULE LIGNE AÉRIENNE DANS LA LISTE DES 100 PLUS GRANDS ANNONCEURS D'ADVERTISING AGE.

Mais heureusement, cela ne signifie pas qu'il n'y ait pas d'excellentes idées de publicité parmi les autres catégories de transport.

L'une de ces catégories n'existerait pas sans les voitures, et en découle directement. C'est la sécurité routière.

Il existe une grande tradition de campagnes très impactantes (c'est un choix de mot délibéré) soulignant les risques associés à la route.

Et dans ce domaine, je dirais que le succès arrive à ceux qui ne prêchent pas.

Pour que la communication soit efficace, là encore, il faut traiter le spectateur non comme un imbé-

I'm also pleased to include three outstanding airline spots.

THESE THREE DO IT FOR ME, BECAUSE THEY DON'T RELY ON CRASS IMAGES OF SMILEY STEWARDESSES, WITH PERFECT HAIR AND TEETH, WHOSE COUNTRY OF ORIGIN IS ADLAND.

These three use charm, wit and observation to lead me to conclude that I'd seriously consider flying with all of them. It comes down to how the spots make me feel about spending my time, and with whom, at 38,000 feet.

After all, in transport, it's the communication ideas that inspire people to take a journey to somewhere they hadn't even thought about going, that are the most likely to succeed. It's the advertisers who recognize that function is a mere component. Because consumers tend to be driven by their hearts, with their minds in the passenger seat.

Eine Kategorie würde ohne Autos gar nicht existieren: „Straßensicherheit".

Es gibt eine lange Tradition von Werbespots, die per Schockwirkung die Gefahren des Straßenverkehrs verdeutlichen.

Ich würde sagen, in diesem Bereich sind diejenigen erfolgreich, die nicht predigen.

Auch in diesem Bereich zeichnen sich die besten Werbefilme dadurch aus, dass sie den Zuschauer nicht wie einen Idioten behandeln, sondern wie einen intelligenten und gefühlvollen Menschen. Sie überraschen und sie provozieren. Und sie setzen nicht auf übertriebene Effekte, sondern auf die Kraft des Understatements.

Ich freue mich, außerdem drei außergewöhnliche Werbespots für Airlines zu präsentieren.

DIESE DREI SPOTS HABEN MICH ÜBERZEUGT, WEIL SIE AUF DIE ÜBLICHEN BILDER VON LÄCHELNDEN FLUGBEGLEITERINNEN AUS DEM WERBEWUNDERLAND MIT PERFEKTER FRISUR UND PERFEKTEN ZÄHNEN VERZICHTEN.

Diese drei Spots haben mich auf charmante und witzige Art dazu gebracht, ernsthaft eine Flugbuchung bei jeder der drei Airlines in Erwägung zu ziehen. Für mich war entscheidend, welches Gefühl mir die Spots in Bezug darauf vermittelten, wie und mit wem ich meine Zeit in 11.000 Metern Höhe verbringe.

Beim Transport sind die Werbeideen mit den größten Erfolgschancen letztendlich diejenigen, die Menschen dazu inspirieren, an Orte zu reisen, die sie zuvor noch nie in Betracht gezogen haben. Solche Ideen stammen von Werbern, die erkannt haben, dass die Funktion nur eine Komponente ist. Denn der Verbraucher wird meist von seinen Gefühlen gesteuert, sein Verstand fährt auf dem Beifahrersitz mit.

cile lent à comprendre, mais comme un être intelligent et sensible. Ces films surprennent et provoquent. Ils évitent l'hystérie au profit de l'euphémisme plein de sens.

J'ai également le plaisir d'avoir sélectionné trois excellents spots de lignes aériennes.

CES TROIS SPOTS ME PLAISENT PARCE QU'ILS NE REPOSENT PAS SUR DE VULGAIRES IMAGES D'HÔTESSES SOURIANTES AUX CHEVEUX TROP COIFFÉS ET AUX DENTS TROP BLANCHES.

Ils utilisent le charme, l'astuce et l'observation pour m'amener à conclure que voler sur leurs lignes pourrait effectivement me plaire. Il s'agit en fin de compte de ce que ces spots m'évoquent sur la façon de passer mon temps, et avec qui, à 12 000 mètres au-dessus du plancher des vaches.

Après tout, dans le domaine des transports, les idées qui ont le plus de chances de fonctionner sont celles qui donnent envie d'aller quelque part où l'on n'avait pas pensé vouloir aller. Ce sont les annonceurs qui considèrent que la fonction n'est qu'un simple composant. Car les consommateurs ont tendance à conduire avec leur cœur, et avec leur esprit dans le siège du passager.

"AT THE CANNES INTERNATIONAL ADVERTISING FESTIVAL YOU CAN SIT THROUGH ABOUT FIVE HOURS OF BACK-TO-BACK ENTRIES IN THE AUTOMOTIVE CATEGORY."

„BEIM CANNES INTERNATIONAL ADVERTISING FESTIVAL VERBRINGT MAN FÜNF STUNDEN DAMIT, SICH BEITRÄGE FÜR DIE KATEGORIE ‚AUTOS' ANZUSCHAUEN."

« AU FESTIVAL INTERNATIONAL DE LA PUBLICITÉ DE CANNES, ON PEUT FACILEMENT VOIR CINQ HEURES DE FILMS PUBLICITAIRES SUR LES VOITURES LES UNS APRÈS LES AUTRES. »

009

TRANSPORT

TITLE: Beat The Devil. **CLIENT:** BMW. **PRODUCT:** BMW Hire Films. **AGENCY:** Fallon Minneapolis. **COUNTRY:** USA. **YEAR:** 2002. **CHIEF CREATIVE OFFICER:** David Lubars. **CREATIVE DIRECTOR:** David Lubars, Bruce Bildsten. **COPYWRITER:** David Carter, Greg Hahn, Vincent Ngo. **ART DIRECTOR:** David Carter, Tom Riddle. **PRODUCTION COMPANY:** RSA Films Inc. **PRODUCER:** Jules Daly, David Mitchell, Ridley Scott. **DIRECTOR:** Tony Scott. **AWARDS:** CLIO Awards (Gold), AICP (Advertising Excellence).

An ageing godfather of soul, James Brown, reveals how he sold his soul to the Devil and decides to renegotiate another 50 years of fame and fortune with a wager … a dragstrip at dawn. The spot ends with the Devil's neighbour complaining about the noise in his apartment. /// James Brown als alternder Godfather of Soul verrät, wie er dem Teufel seine Seele verkaufte und beschloss, bei einer Wette weitere 50 Jahre Reichtum und Ruhm auszuhandeln … durch ein Dragster-Rennen bei Sonnenaufgang. Der Spot endet mit dem Nachbarn des Teufels, der sich über den Lärm in der Nachbarwohnung beschwert. /// James Brown, pape finissant de la soul, révèle qu'il a vendu son âme au diable et décide de renégocier avec lui cinquante nouvelles années de succès et de fortune, en lui lançant un défi … un duel sur route à l'aube. Le spot s'achève sur l'image du voisin du diable, se plaignant du bruit dans l'appartement d'à côté.

TITLE: Hail. **CLIENT:** General Motors. **PRODUCT:** Chevrolet Luv Dmax Truck. **AGENCY:** McCann Erickson Bogota. **COUNTRY:** Colombia. **YEAR:** 2007. **EXECUTIVE CREATIVE DIRECTOR:** Samuel Estrada. **CREATIVE DIRECTOR:** Armando Rico. **COPYWRITER:** Armando Rico, Fernando Gómez. **ART DIRECTOR:** Cesar Meza, Camilo Cañizares. **AWARDS:** CLIO Awards (Shortlist), NY Festivals (Shortlist), The One Show (Merit Award), Cannes Lions (Bronze).

Using home video footage of "… the worst hailstorm ever seen in Colombia," the spot shows a resilient Chevrolet pick-up truck performing an amazing escape manoeuvre against the raging torrent of a flooded Bogota highway. The spot ends with an image of a new Chevrolet on a black screen with the tagline, "Make your own road," followed by the Chevrolet logo. /// Der Spot arbeitet mit Amateurvideos „… des schlimmsten Hagelsturms aller Zeiten in Kolumbien". Darin ist ein federnder Chevrolet Pickup zu sehen, dem ein erstaunliches Fluchtmanöver vor den reißenden Strom einer überfluteten Autobahn in Bogotá gelingt. Der Spot endet mit dem Bild eines neuen Chevrolets auf einem schwarzen Bildschirm mit dem Slogan „Schaff dir deine eigene Straße", gefolgt vom Chevrolet-Logo. /// Utilisant un film amateur du « … pire orage qu'ait jamais connu la Colombie », le spot montre un vaillant pick-up de Chevrolet qui, au terme d'une incroyable manœuvre, parvient à échapper au véritable torrent qu'est devenue l'autoroute de Bogota. Le spot s'achève par l'image d'une Chevrolet neuve, sur fond noir, avec la légende « Faites votre propre route, » suivie du logo de Chevrolet.

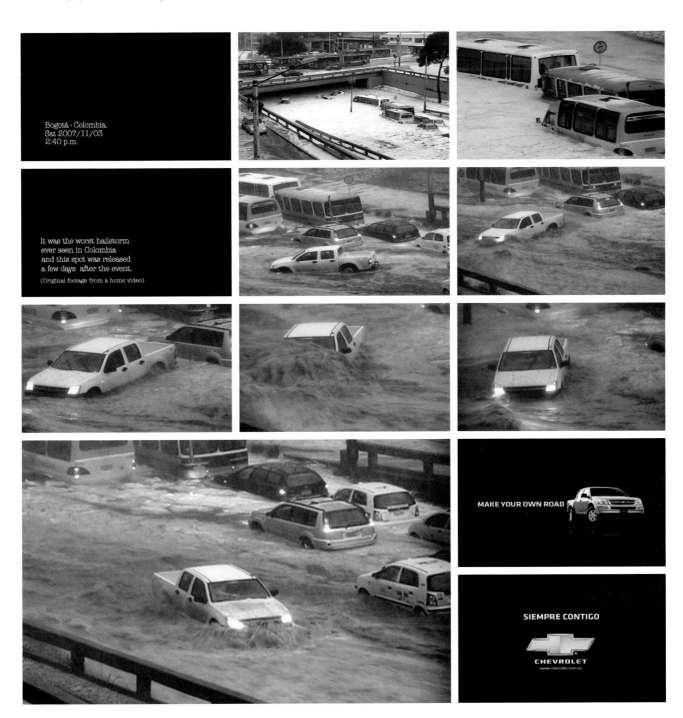

FEATURED ON THE DVD TITLE: Choir. CLIENT: Honda Motor. PRODUCT: Honda Civic. AGENCY: Wieden+Kennedy London. COUNTRY: United Kingdom. YEAR: 2006. PRODUCTION COMPANY: Partizan Midi Minuit Me. PRODUCER: Helen Whitely. DIRECTOR: Antoine Bardou Jacquet. AWARDS: CLIO Awards (Gold), AICP, Cannes Lions (Gold), One Show (Gold/Silver).

"This is what a Honda feels like," a voiceover announces. A close-up of an ignition button signals the cue for a highly imaginative vocal soundtrack. Inside an empty parking lot a choirmaster conducts his group to create all the sounds of a Honda Civic driving through different terrains and weather conditions. /// „So fühlt sich ein Honda an", sagt die Sprecherstimme. Die Nahaufnahme eines Zündschlosses gibt den Einsatz für einen sehr fantasievollen Chorgesang. Auf einem leeren Parkplatz dirigiert ein Chorleiter seinen Chor, der all die Geräusche eines Honda Civic nachahmt, wie dieser durch unterschiedliche Gelände- und Wetterbedingungen fährt. /// « Voici l'effet que fait une Honda », annonce une voix off. Le gros plan d'un bouton de démarrage donne le coup d'envoi d'une bande sonore vocale très créative. Dans un parking vide, un directeur de chorale fait reproduire à son groupe tous les sons d'une Honda Civic sur différents terrains et dans différentes conditions météorologiques.

FEATURED ON THE DVD **TITLE:** Cog. **CLIENT:** Honda Motor. **PRODUCT:** Honda Accord. **AGENCY:** Wieden+Kennedy London. **COUNTRY:** United Kingdom. **YEAR:** 2003. **CREATIVE DIRECTOR:** Tony Davidson, Kim Papworth. **COPYWRITER:** Ben Walker. **ART DIRECTOR:** Matt Gooden. **PRODUCTION COMPANY:** Partizan Midi Minuit Me. **PRODUCER:** Rob Steiner, James Thompkinson. **DIRECTOR:** Antoine Bardou Jacquet. **AWARDS:** Cannes Lions (Gold).

This ingenious spot illustrates the precision engineering and aesthetic excellence of the Honda Accord. A simple cog triggers a domino effect as various parts of a Honda Accord trigger each other off. The cycle completes with a brand new Accord rolling off a trailer. A voiceover adds, "Isn't it nice when things just work?" /// Dieser erfindungsreiche Spot verdeutlicht die präzise Ingenieurskunst und ästhetische Vortrefflichkeit des Honda Accord. Ein einfaches Zahnrad setzt einen Dominoeffekt in Gang, bei dem verschiedene Teile eines Honda Accord sich gegenseitig auslösen. Der Ablauf endet mit einem brandneuen Accord, der von einem Anhänger rollt. Ein Sprecher fügt hinzu: „Ist es nicht schön, wenn Dinge einfach funktionieren?" /// Ce spot ingénieux illustre la précision technique et l'excellence esthétique de la Honda Accord. Une simple roue dentée déclenche un effet domino entre différentes pièces d'une Honda Accord. Pour terminer le cycle, un modèle flambant neuf descend d'une plateforme. Une voix off ajoute : « N'est-ce pas agréable lorsque les choses fonctionnent ? »

FEATURED ON THE DVD TITLE: Everyday. **CLIENT:** Honda Motor. **PRODUCT:** Honda Civic. **AGENCY:** Wieden+Kennedy London. **COUNTRY:** United Kingdom. **YEAR:** 2004. **CREATIVE DIRECTOR:** Tony Davidson, Kim Papworth. **COPYWRITER:** Ben Walker, Sean Thompson. **ART DIRECTOR:** Matt Gooden. **PRODUCTION COMPANY:** Stink. **PRODUCER:** Nick Landon. **DIRECTOR:** Ivan Zacharias. **AWARDS:** Cannes Lions (Gold).

Starting with an alarm clock, a quick succession of close-up shots of everyday objects reveal a typical day in the life of a Honda Civic owner. Towards the end a voiceover asks the question, "Why is it that the better something does its job, the more we take it for granted?" The ad ends with the Honda logo and slogan, "The power of dreams." /// Beginnend mit einem Wecker zeigt eine schnelle Abfolge von Nahaufnahmen die alltäglichen Objekte, die einen typischen Tag im Leben eines Honda Civic-Fahrers ausmachen. Gegen Ende des Werbespots stellt ein Sprecher die Frage: „Je besser etwas funktioniert, desto mehr betrachten wir das als selbstverständlich. Warum ist das so?" Der Werbespot endet mit dem Logo von Honda und dem Slogan „Die Macht der Träume". /// Une succession rapide de plans rapprochés d'objets de la vie quotidienne illustre un jour dans la vie d'un propriétaire de Honda Civic, en commençant par un réveil. Vers la fin, la voix off demande : « Comment se fait-il que plus quelque chose fonctionne bien, moins on y fait attention ? » Le spot se termine par le logo Honda et ce slogan : « Le pouvoir des rêves ».

FEATURED ON THE DVD TITLE: Sense. CLIENT: Honda Motor. PRODUCT: Honda. AGENCY: Wieden+Kennedy London. COUNTRY: United Kingdom. YEAR: 2004. CREATIVE DIRECTOR: Tony Davidson, Kim Papworth. COPYWRITER: Kim Papworth, John Cherry. ART DIRECTOR: Tony Davidson, Tom Chancellor. PRODUCTION COMPANY: Gorgeous Enterprises. PRODUCER: Flora Fernandez. DIRECTOR: Peter Thwaites. AWARDS: Cannes Lions (Bronze).

Various sources of everyday power from escalators to street lamps sense human need and switch themselves on and off accordingly. "If things knew when they weren't being used, wouldn't they save a whole load of energy?" asks a voiceover. The spot closes with the letters IMA (Integrated Motor Assist) cross fading on screen. /// Verschiedene Energieverbraucher wie Rolltreppen oder Straßenlampen merken, wann die Menschen sie brauchen, und schalten sich dementsprechend an oder aus. „Wenn Dinge wüssten, wann sie nicht benutzt werden, würden sie dann nicht eine Menge Energie einsparen?" fragt eine Sprecherstimme. Der Werbespot endet mit einer Überblendung der Buchstaben IMA (Integrated Motor Assist) auf dem Bildschirm. /// Plusieurs sources d'énergie de la vie quotidienne, des escalators jusqu'aux lampadaires de la rue, captent les besoins des humains et s'allument ou s'éteignent en conséquence. « Si les objets pouvaient savoir quand ils ne sont pas utilisés, n'économiseraient-ils pas des quantités d'énergie ? », demande une voix off. Le spot se termine par les lettres IMA (Integrated Motor Assist – assistance moteur intégrée) en fondu enchaîné à l'écran.

FEATURED ON THE DVD **TITLE:** Grrr. **CLIENT:** Honda Motor. **PRODUCT:** Honda Diesel i-CTDi. **AGENCY:** Wieden+Kennedy London. **COUNTRY:** United Kingdom. **YEAR:** 2004. **CREATIVE DIRECTOR:** Tony Davidson, Kim Papworth, Michael Russoff, Sean Thompson. **PRODUCTION COMPANY:** Nexus Productions. **EXECUTIVE PRODUCER:** Chris O'Reilly. **PRODUCER:** Julia Parfitt. **DIRECTOR:** Smith & Foulkes. **AWARDS:** Cannes Lions (Grand Prix), CLIO Awards (Grand Clio/Gold), AICP (Advertising Excellence), ANDY Awards (Grandy), One Show (Best of Show/Gold), D&AD (Silver).

A couple of polluting diesel engines glide across a colourful, animated landscape. A voiceover starts singing a catchy song, "Can hate be good? Can hate be great?" as all the animated characters begin happily zapping away the engine intruders. A newer, cleaner Honda diesel engine appears and all the characters join in singing the chorus, "Hate something, change something, make something better." The spot closes with the slogan, "Honda, the power of dreams." /// Eine Reihe schmutziger Dieselmotoren gleiten durch eine farbenfroh animierte Landschaft. Aus dem Off wird der Ohrwurm „Kann Hass gut sein? Kann Hass großartig sein?" gesungen, während alle animierten Figuren damit beginnen, glücklich die umweltschädlichen Eindringlinge zu löschen. Ein neuerer und sauberer Dieselmotor von Honda erscheint, und alle Figuren singen gemeinsam im Chor: „Hass etwas, ändere etwas, verbessere etwas." Der Werbespot endet mit dem Slogan: „Honda, die Macht der Träume." /// Des moteurs diesel polluants volent dans un paysage de synthèse plein de couleurs. Une voix off commence à chanter une chanson entraînante : « La haine peut-elle être bonne ? La haine peut-elle être grande ? » pendant que tous les personnages de synthèse commencent à éliminer joyeusement les intrus. Un moteur tout neuf et tout propre de Honda apparaît et tous les personnages se mettent à chanter le refrain : « Détestez quelque chose, changez-la et améliorez-la ». Le spot se termine par ce slogan : « Honda, le pouvoir des rêves ».

TITLE: Gator. CLIENT: Land Rover. PRODUCT: Land Rover Freelander 4 Wheel Drive. AGENCY: Rainey Kelly Campbell Roalfe Y&R. COUNTRY: United Kingdom. YEAR: 2003. CREATIVE DIRECTOR: Mark Roalfe. COPYWRITER: Mike Boles. ART DIRECTOR: Jerry Hollens. PRODUCTION COMPANY: MJZ. PRODUCER: Line Postmyer. DIRECTOR: Fredrik Bond. AWARDS: Cannes Lions (Bronze).

An alligator startles passersby as it crawls along the sidewalk of a busy street. A man attracts its attention by making strange noises. He wrestles it and throws it down a manhole and into the sewer, before casually driving off in his Freelander. A tagline fades up, "Been anywhere interesting lately?" /// Ein Alligator erschreckt Passanten, weil er an einer belebten Straße auf dem Gehweg entlang kriecht. Ein Mann zieht seine Aufmerksamkeit auf sich, indem er merkwürdige Geräusche macht. Er ringt den Alligator nieder und wirft ihn durch einen Schacht in die Kanalisation, bevor er lässig mit seinem Freelander davonfährt. Ein Slogan erscheint: „Waren Sie letztens irgendwo, wo's interessant war?" /// Un alligator fait sursauter les passants en rampant le long du trottoir d'une rue animée. Un homme attire son attention en faisant des bruits étranges. Il se bat contre lui et le jette dans une bouche d'égout, avant de partir nonchalamment dans sa Freelander. Les mots suivants apparaissent : « Êtes-vous allé dans un endroit intéressant récemment ? »

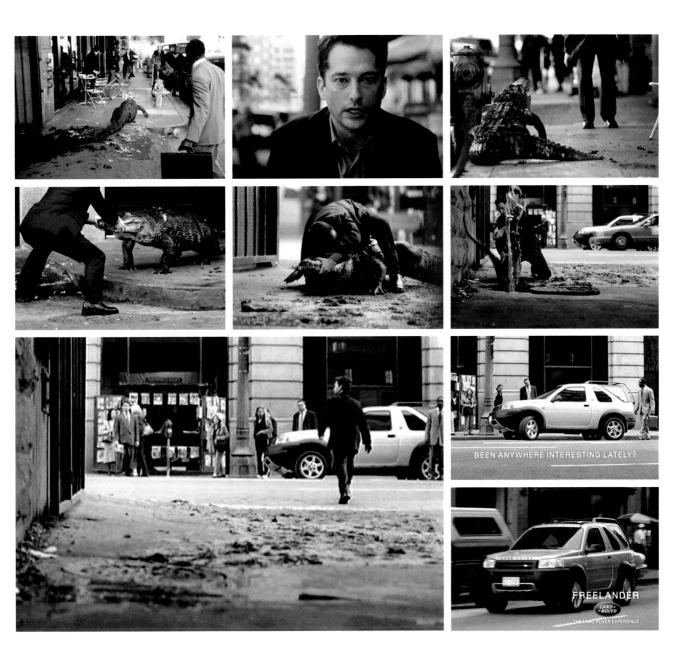

TITLE: Pop-Up. **CLIENT:** Lexus. **PRODUCT:** Lexus RX. **AGENCY:** Team One. **COUNTRY:** USA. **YEAR:** 2007. **CHIEF CREATIVE OFFICER:** Chris Graves. **GROUP CREATIVE DIRECTORS:** Jon Pearce, Gavin Lester. **COPYWRITER:** Dave Horton. **ART DIRECTOR:** Kevin R. Smith. **PRODUCTION COMPANY:** Smuggler. **DIRECTOR:** Stylewar.

A Lexus RX appears in a giant pop-up book as a voice-over narrates The Story of the Safest Accident, which turns out to be "the one that never happens." The ad closes with the Lexus logo on a black screen and the tagline, "The pursuit of perfection." /// Ein Lexus RX erscheint in einem riesigen Aufklappbuch, während eine Hintergrundstimme die *Geschichte des sichersten Unfalls* erzählt. Damit ist derjenige Unfall gemeint, „der nie passierte". Der Spot endet mit dem Logo von Lexus auf einem schwarzen Bildschirm und dem Slogan „Streben nach Perfektion." /// Une Lexus RX apparaît lorsque s'ouvre un livre géant, tandis qu'une voix raconte L'histoire de l'accident le plus sûr, qui s'avère être « celui qui n'a jamais eu lieu. » La pub finit sur le logo de Lexus, sur fond noir, et l'accroche « La quête de la perfection. »

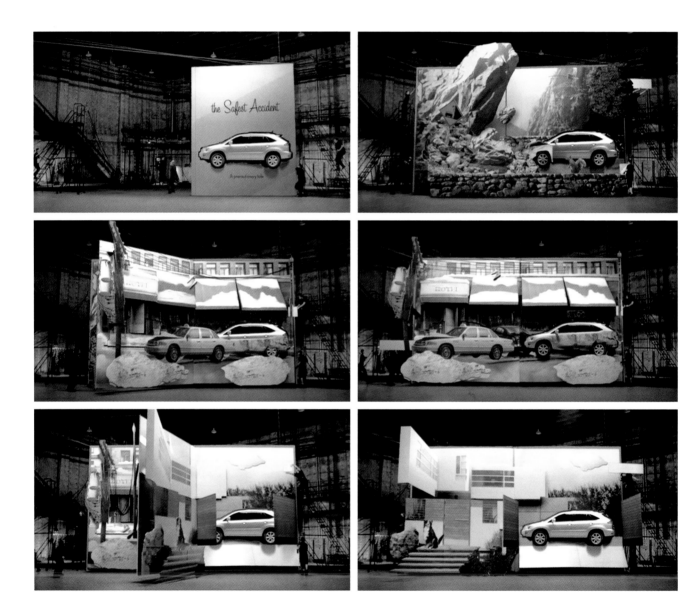

FEATURED ON THE DVD **TITLE:** Trucks. **CLIENT:** Lexus Australia. **PRODUCT:** Lexus LS430. **AGENCY:** Saatchi & Saatchi Australia. **COUNTRY:** Australia. **YEAR:** 2003. **CREATIVE DIRECTOR:** David Nobay. **COPYWRITER:** Scot Waterhouse. **ART DIRECTOR:** Steve Carlin. **PRODUCTION COMPANY:** Good Oil. **PRODUCER:** Ali Grant. **DIRECTOR:** Matt Murphy.

The setting is the Lexus testing sit in South Australia. A voiceover describes Lexus' almost obsessive commitment to safety, as a Lexus reverses at full speed between two oncoming lorries. The test demonstrates Lexus' new rear view camera facility to aid reversing. The spot cuts to black and closes with the Lexus badge and slogan, "The relentless pursuit of perfection." /// Der Werbespot zeigt das Testgelände von Lexus in Südaustralien. Ein Sprecher beschreibt das Besessenheit grenzende Engagement des Unternehmens in puncto Sicherheit. Ein Lexus fährt mit voller Geschwindigkeit rückwärts zwischen zwei entgegenkommenden Lastwagen hindurch. Der Test demonstriert die neue Rückfahrkamera des Fahrzeugs, die das Rückwärtsfahren erleichtert. Der Werbespot zeigt einen dunklen Bildschirm und endet mit dem Lexus-Emblem und dem Slogan „Kompromisslose Perfektion." /// L'action se déroule au centre de tests de Lexus en Australie du Sud. Une voix off décrit l'engagement presque obsessionnel de la marque envers la sécurité, pendant qu'une Lexus roule en marche arrière à pleine vitesse entre deux camions en marche. Le test montre que la nouvelle caméra de vision arrière de la voiture aide le conducteur pour la marche arrière. L'écran devient noir et le spot conclut avec le logo Lexus et le slogan : « La poursuite incessante de la perfection ».

FEATURED ON THE DVD TITLE: King Kong. CLIENT: Ford Sales & Service (Thailand). PRODUCT: Ford Ranger Open Cab. AGENCY: JWT Bangkok. COUNTRY: Thailand. YEAR: 2005. CREATIVE DIRECTOR: Pinit Chantaprateep. COPYWRITER: Wichian Thongsuksiri. ART DIRECTOR: Rungsun Suwannachitra, Taya Soonthonvipat. PRODUCTION COMPANY: Phenomena. PRODUCER: Piyawan Mungkung. DIRECTOR: Thanonchai Sornsrivichai. AWARDS: Cannes Lions (Gold).

A man relieves himself with his back turned to his Ford Ranger stocked with a consignment of bananas. Suddenly a giant ape's hand appears on the screen and picks up the vehicle. The ape's dad appears. "Stop playing. Go and eat your lunch," grunts the father ape. The shot cuts to a huge mountain of bananas. The child ape throws a tantrum and the father casually tosses the Ranger over his shoulder. It lands back unscathed next to the driver, who looks on in stunned amazement. /// Ein Mann erleichtert sich mit dem Rücken zum Ford Ranger, der mit einer Lieferung Bananen beladen ist. Plötzlich erscheint die Hand eines Riesenaffen auf dem Bildschirm und nimmt das Fahrzeug hoch. Der Vater des Affen taucht auf. „Hör auf zu spielen und geh zum Mittagessen", grunzt der Affenvater. Die Kamera zeigt einen gewaltigen Berg aus Bananen. Das Affenkind bekommt einen Wutanfall, und der Vater wirf den Ranger achtlos über die Schulter. Er landet unbeschädigt neben dem Fahrer, der in fassungslosem Staunen die Szene verfolgt. /// Un homme est en train de se soulager, le dos tourné vers sa Ford Ranger chargée de bananes. La main d'un singe géant apparaît soudain et soulève le véhicule. Le père du singe arrive et lui ordonne : « Arrête de jouer. Va déjeuner ». Une énorme montagne de bananes apparaît à l'écran. Le singe enfant pique une colère et le père lance nonchalamment la Ranger par-dessus son épaule. Elle atterrit sans une égratignure à côté de son conducteur stupéfait.

TITLE: Sounds of Summer. CLIENT: Mercedes-Benz. PRODUCT: Mercedes-Benz Convertibles. AGENCY: Springer & Jacoby. COUNTRY: Germany. YEAR: 2005. CREATIVE DIRECTOR: Till Hohmann, Axel Thomsen. COPYWRITER: Florian Kaehler, Florian Pagel. ART DIRECTOR: Justus V. Engelhardt, Tobias Gradert. PRODUCTION COMPANY: Sehsucht. PRODUCER: Andreas Coutsoumbelis. DIRECTOR: Ole Peters, Timo Schädel. AWARDS: Cannes Lions (Gold).

The sound of a car ignition is visualised through an audio graphic equaliser display, which changes into a fluid 3D sonic landscape of trees, lakes and horses. /// Das Geräusch der Zündung eines Automotors wird durch eine Equalizer-Anzeige visualisiert, die sich in eine fließende 3-D Schall-Landschaft aus Bäumen, Seen und Pferden verwandelt. Der Bildschirm wird schwarz, und der Slogan „Höre den Sommer – in einem Mercedes-Benz-Cabriolet" erscheint. /// Le son du démarrage d'une voiture est visualisé à travers un égaliseur graphique, qui se transforme en un paysage sonique fluide composé d'arbres, de lacs et de chevaux. L'écran devient noir et le slogan apparaît : « Écoutez l'été – dans une décapotable Mercedes-Benz ».

Hear the summer.
In a Mercedes-Benz convertible.

TITLE: Counterfeit Minis. **CLIENT:** BMW. **PRODUCT:** Mini Cooper. **AGENCY:** Crispin Porter + Bogusky Miami. **COUNTRY:** USA. **YEAR:** 2005. **EXECUTIVE CREATIVE DIRECTOR:** Alex Bogusky. **CREATIVE DIRECTOR:** Andrew Keller. **ASSOCIATE CREATIVE DIRECTOR:** Steve O'Connell. **COPYWRITER:** Rob Reilly, Franklin Tipton. **ART DIRECTOR:** Tiffany Kosel, Paul Stechschulte. **PRODUCTION COMPANY:** Hungry Man. **EXECUTIVE PRODUCER:** Steve Orent. **PRODUCER:** Matthew Bonin, David Rolfe, Rupert Samuel. **DIRECTOR:** Bryan Buckley. **AWARDS:** Cannes (Gold), CLIO Awards (Gold/Silver), One Show (Bronze), D&AD (Yellow Pencil).

In this spoof, reportage style ad, the Counter Counterfeit Commission issues a stark warning on the growing trade in counterfeit Mini Coopers. The spot shows the victims, criminals and types of fake Mini Coopers circulating the market. A voiceover announces, "Don't be fooled by imitations. Be certain your Mini is genuine." /// In diesem als Reportage getarnten Spot gibt die Kommission für den Kampf gegen Fälschungen die Warnung aus, dass der Handel mit gefälschten Mini Coopers immer mehr um sich greift. Der Spot zeigt Opfer, Fälscher und Exemplare dieser gefälschten Mini Cooper, die auf dem Markt im Umlauf sind. Ein Sprecher sagt: „Lassen Sie sich nicht von Imitationen täuschen. Achten Sie darauf, dass Ihr Mini das Original ist." /// Dans cette publicité qui parodie le style des reportages, la Commission anticontrefaçon publie un avertissement sévère sur le nombre croissant de fausses Mini Coopers. Le spot montre des victimes, des criminels et les types de fausses Mini Coopers qui circulent sur le marché. La voix off déclare : « Ne vous laissez pas abuser par les imitations. Vérifiez que votre Mini est authentique ».

TITLE: Fun. **CLIENT:** BMW Group Canada. **PRODUCT:** Mini Cooper. **AGENCY:** TAXI. **COUNTRY:** Canada. **YEAR:** 2004. **CREATIVE DIRECTOR:** Zak Mroueh. **COPYWRITER:** Terry Drummond. **ART DIRECTOR:** Alan Madill. **PRODUCTION COMPANY:** Untitled. **PRODUCER:** Peter Davis. **DIRECTOR:** Curtis Wehrfritz. **AWARDS:** Cannes Lions (Shortlist)

A mini pulls over with a police patrol car. A traffic patrolman gets out of the mini and walks back to his vehicle. As he hands the driver back his keys, he says, "I'll let you off with a warning this time." The spot cuts to black and reveals the Mini logo with the tagline, "2003 Car of the Year." /// Ein Mini stoppt am Straßenrand, hinter ihm eine Polizeistreife. Ein Verkehrspolizist steigt aus dem Mini und geht zu seinem Fahrzeug zurück. Als er dem Fahrer des Minis seinen Schlüssel zurückgibt, sagt er: „Diesmal verwarne ich Sie bloß." Schnitt, der Bildschirm wird schwarz und zeigt dann das Mini-Logo mit dem Slogan „Auto des Jahres 2003". /// Une Mini se range sur le côté de la route, avec une voiture de police. Un agent de police sort de la Mini et rejoint son véhicule. Il remet les clés de la Mini à son conducteur et lui dit : « Vous vous en tirez avec un avertissement, pour cette fois ». L'écran devient noir et le logo Mini apparaît avec ces mots : « Voiture de l'année 2003 ».

TITLE: The Sculptor. **CLIENT:** Peugeot. **PRODUCT:** Peugeot 206. **AGENCY:** Euro RSCG Mezzano Costantini Mignani. **COUNTRY:** Italy. **YEAR:** 2003. **CREATIVE DIRECTOR:** Roberto Greco, Giovanni Porro. **COPYWRITER:** Roberto Greco. **ART DIRECTOR:** Giovanni Porro. **PRODUCTION COMPANY:** Bandits. **PRODUCER:** Philippe Dupuy Mondel. **DIRECTOR:** Matthijs Van Heijningen. **AWARDS:** Cannes Lions (Gold).

An Indian guy drives his old banger against a wall and start reshaping it using an elephant and blow torch. He finally completes his sculpture the next day and as he proudly lowers his magazine cutting of Peugeot 206 advert, his battered lookalike is unveiled. The spot closes with the sculptor and his friends cruising around town at night. The screen cut's to the tagline, "Peugeot 206. Irresistible." /// Ein Inder fährt seine alte Kiste gegen eine Mauer und beginnt, sie mithilfe von Elefanten und Lötkolben umzugestalten. Am nächsten Tag hat er seine Skulptur schließlich fertig, und als er voller Stolz den Zeitungsausschnitt mit einer Werbung für den Peugeot 206 senkt, wird dahinter seine schäbige Nachahmung sichtbar. In der Schlussszene fährt der „Bildhauer" mit seinen Freunden bei Nacht in der Stadt umher. Der Bildschirm zeigt den Slogan „Peugeot 206. Unwiderstehlich". /// Un Indien écrase sa vieille guimbarde contre un mur et commence à la sculpter à l'aide d'un éléphant et d'un chalumeau. Le lendemain, il a fini sa sculpture. Il regarde une page de magazine avec la photo d'une Peugeot 206, et la baisse pour la comparer à son sosie cabossé. Dans la dernière séquence, le sculpteur et ses amis paradent en ville. Le slogan s'affiche à l'écran : « Peugeot 206. Irrésistible ».

TITLE: Toys. CLIENT: Peugeot. PRODUCT: Peugeot 407. AGENCY: BETC Euro RSCG. COUNTRY: France. YEAR: 2004. CREATIVE DIRECTOR: Rémi Babinet. COPYWRITER: Rémi Noël. ART DIRECTOR: Eric Holden. PRODUCTION COMPANY: Wanda Productions. PRODUCER: David Green. DIRECTOR: Philippe Andre. AWARDS: Cannes Lions (Gold).

Here is a city where all the cars are full size toys. There are big wind up cars, battery powered cars, wooden cars and paper cars. Enter the Peugeot 407, which glides effortlessly past all the broken down toy models. A neighbour puts his toy model back into a giant box and looks stunned as the 407 pulls into the driveway next door. The spot cuts to black and ends with the tagline, "Playtime is over." /// Der Spot zeigt eine Stadt voller Spielzeugautos, die so groß sind wie normale Autos. Da gibt es solche zum Aufziehen, batteriebetriebene Autos, Holzautos und Papierautos. Der Zuschauer sieht einen Peugeot 407, der mühelos an all den zusammengebrochenen Spielzeugmodellen vorbei gleitet. Ein Nachbar verstaut sein Spielzeugauto wieder in einem riesigen Behälter und schaut verblüfft zu, wie der 407 in die Einfahrt des Hauses einbiegt. Der Bildschirm wird schwarz, und der Spot endet mit dem Slogan „Die Zeit zum Spielen ist vorbei". /// Dans cette ville, toutes les voitures sont de grands jouets. Il y a de grandes voitures à manivelle, des voitures à piles, des voitures en bois et des voitures en carton. La Peugeot 407 fait son entrée et glisse sans effort au milieu des jouets cassés. Un voisin range sa voiture jouet dans une boîte géante et est stupéfait de voir la 407 se garer dans l'allée d'à côté. L'écran devient noir et le slogan s'affiche : « Fini de jouer ».

FEATURED ON THE DVD **TITLE:** Prisoner. **CLIENT:** Fiat. **PRODUCT:** Fiat Palio. **AGENCY:** Leo Burnett Brazil. **COUNTRY:** Brazil. **YEAR:** 2004. **CREATIVE DIRECTOR:** Ruy Lindenberg, Bruno Prosperi. **COPYWRITER:** Renato Simões. **ART DIRECTOR:** Bruno Prosperi. **PRODUCTION COMPANY:** Republica Filmes. **PRODUCER:** Fernando Carvalho. **DIRECTOR:** Carlos Manga Junior. **AWARDS:** Cannes Lions (Bronze).

An old man is preparing for his release from prison. Once outside, he walks past a brand new Fiat Palio in the street. The screen cuts to black and we hear the sound of breaking glass followed by a car alarm. The tagline reads, "The New Fiat Palio – Impossible to feel indifferent." /// Ein alter Mann bereitet sich auf seine Entlassung aus dem Gefängnis vor. Draußen geht er auf der Straße an einem brandneuen Fiat Palio vorbei. Der Bildschirm wird schwarz, und wir hören das Geräusch von splitterndem Glas, dann eine Auto-Alarmanlage. Der Slogan lautet „Der neue Fiat Palio. Völlig unmöglich, nicht interessiert zu sein". /// Un vieil homme se prépare à sortir de prison. Une fois dehors, il passe à côté d'une Fiat Palio toute neuve dans la rue. L'écran devient noir et l'on entend un bris de verre, suivi d'une alarme. Le slogan déclare : « La nouvelle Fiat Palio. Impossible d'être indifférent ».

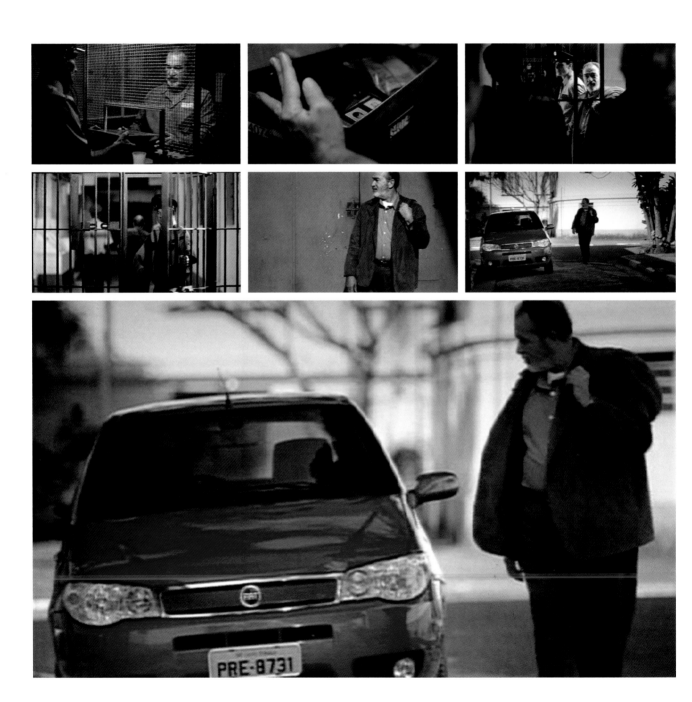

FEATURED ON THE DVD TITLE: Bugger. CLIENT: Toyota. PRODUCT: Toyota Hilux. AGENCY: Saatchi & Saatchi Sydney. COUNTRY: New Zealand. YEAR: 1999. CREATIVE DIRECTOR: David Nobay. COPYWRITER: David Ohana. ART DIRECTOR: Eron Broughton. AGENCY PRODUCER: Scott Mackenzie. PRODUCER: Bill Mulham. DIRECTOR: Andrew Murray. AWARDS: Cannes Lions (Gold).

In a funny sequence of mishaps, a farmer underestimates the strength of his Toyota Hilux. "Bugger!" he says, each time the Hilux shows its brute force. /// In einer lustigen Reihe von Missgeschicken unterschätzt ein Bauer immer, wie stark sein Toyota Hilux doch ist. „Mist!" sagt er jedes Mal, wenn der Hilux seine brachiale Kraft zeigt. Als er durch die Hügel davonfährt, erscheint der Slogan „Der neue kraftvollere Hilux. Er ist besser." /// Un fermier vit une série de mésaventures comiques parce qu'il sous-estime la puissance de sa Toyota Hilux. « Flûte ! », s'exclame-t-il chaque fois. Il part dans les collines au volant de la voiture, et le slogan apparaît : « La nouvelle Hilux, plus puissante. Encore meilleure ».

FEATURED ON THE DVD TITLE: Dog. / Old Man. **CLIENT:** Toyota Motor Corp. **PRODUCT:** Toyota Celica. **AGENCY:** Saatchi & Saatchi Los Angeles. **COUNTRY:** USA. **YEAR:** 2002. **EXECUTIVE CREATIVE DIRECTOR:** Steve Rabosky. **CREATIVE DIRECTOR:** Neal Foard, Doug Van Andel. **COPYWRITER:** Sherry Hawkins. **ART DIRECTOR:** Verner Soler. **AGENCY PRODUCER:** Elaine Adachi. **PRODUCTION COMPANY:** Independent. **EXECUTIVE PRODUCER:** Susanne Preissler. **DIRECTOR:** Chris Smith. **AWARDS:** Cannes Lion (Gold).

In a leafy neighbourhood, a brand new Celica is parked outside a house. The sound of a dog barking is heard. Suddenly, the dog runs out of the house, into the street and crashes straight into the back of the Celica with a thud. As the dog whimpers and walks away the slogan titles fade up – "Looks fast … The New Celica Action Package." /// In einer schönen grünen Wohngegend parkt ein brandneuer Celica vor einem Haus. Wir hören einen Hund bellen. Plötzlich rennt der Hund aus dem Haus auf die Straße und prallt mit einem dumpfen Aufschlag direkt gegen das Heck des Celica. Als der Hund winselnd wegläuft, erscheint der Slogan „Sieht schnell aus … Das neue Celica Action Package." /// Une Celica flambant neuve est garée devant une maison dans une rue bordée d'arbres. On entend un chien aboyer. Soudain, il sort de la maison à toute vitesse, court dans la rue et s'écrase sur l'arrière de la Celica avec un bruit sourd. Alors que le chien s'éloigne en gémissant, le slogan apparaît : « Elle a l'air rapide … La nouvelle Celica Action Package ».

A gleaming red Celica shows off its polished curves in a leafy street. An old man is walking by across the street. He stops and shouts "Slow down! This is a neighbourhood!" He then whispers, "Punk!" The tagline appears, "Looks fast … The New Celica Action Package." /// Ein glänzender roter Celica zeigt seine polierten Kurven unter Bäumen am Straßenrand. Ein alter Mann geht über die Straße. Er hält inne und ruft: „Fahr langsam! Das ist ein Wohnviertel!" Dann flüstert er: „Flegel!" Der Slogan erscheint: „Sieht schnell aus … Das neue Celica Action Package." /// Une Celica rouge flambant neuve fait étalage de ses courbes dans une rue bordée d'arbres. Un vieil homme passe de l'autre côté de la rue. Il s'arrête et crie : « Ralentissez ! C'est un quartier résidentiel ici ! » Puis il murmure : « Voyou ! » Le slogan s'affiche à l'écran : « Elle a l'air rapide … La nouvelle Celica Action Package ».

FEATURED ON THE DVD TITLE: Party Dress. **CLIENT:** Toyota GB. **PRODUCT:** Toyota Corolla. **AGENCY:** Saatchi & Saatchi London. **COUNTRY:** UK. **YEAR:** 2003. **CREATIVE DIRECTOR:** Cameron Harland. **COPYWRITER:** Mike Campbell. **ART DIRECTOR:** Colin Jones, Cameron Harland. **PRODUCTION COMPANY:** Outsider. **DIRECTOR:** Matthijs Van Heijningen. **PRODUCER:** Anna Hashmi.

A dad is walking along the sidewalk with his little girl, who is wearing a party dress. Suddenly a car drives across a puddle and sprays them with water. The angry father soon spots the culprit's car in a neighbouring car park. As he approaches the offending driver appears. He asks the driver, "Is this your car?" After a long pause, the driver replies, "Yes." The father then punches him in the face and walks off. The screen cuts to black with the following tagline, "Corolla. A car to be proud of." /// Ein Vater geht mit seiner kleinen Tochter eine Straße entlang. Das kleine Mädchen trägt ein Partykleid. Plötzlich fährt ein Auto durch eine Pfütze und bespritzt die beiden mit Wasser. Der wütende Vater entdeckt auf einem benachbarten Parkplatz das Auto des Schuldigen. Als er näher kommt, erscheint der Übeltäter. Der Vater fragt den Fahrer: „Ist das Ihr Auto?" Nach einer langen Pause antwortet der Fahrer mit „Ja". Der Vater verpasst ihm einen Faustschlag ins Gesicht und geht davon. Der Bildschirm wird schwarz und zeigt den Slogan: „Corolla. Ein Auto, auf das man stolz sein kann." /// Un père marche dans la rue avec sa petite fille, qui porte une robe de fête. Soudain, une voiture passe sur une flaque et l'asperge d'eau. Le père en colère repère la voiture dans un parking du quartier. Il se dirige vers elle, et voit le conducteur. Il lui demande : « C'est votre voiture ? » Après une longue pause, le conducteur répond : « Oui ». Le père lui envoie son poing dans la figure et s'en va. L'écran devient noir et le slogan s'affiche : « Corolla. Une voiture dont on est fier ».

FEATURED ON THE DVD **TITLE:** School. **CLIENT:** Toyota GB. **PRODUCT:** Toyota Corolla. **AGENCY:** Saatchi & Saatchi London. **COUNTRY:** UK. **YEAR:** 2002. **CREATIVE DIRECTOR:** John Wright. **COPYWRITER:** Jo Stafford. **ART DIRECTOR:** Brett Salmons, John Wright. **PRODUCTION COMPANY:** Outsider. **PRODUCER:** John Madsen. **DIRECTOR:** Dom & Nic.

A group of parents are waiting at a school gate. Suddenly, the home time bell rings and all the children rush out cheering. A girl waves goodbye to her friends and rushes to a blue Corolla. As she fastens her seatbelt, a woman driver turns around and asks, "Who are you?" The little girl gives her a menacing look and replies, "Just shut up and drive." The screen cuts to black with the slogan, "The new Corolla. A car to be proud of." /// Eine Gruppe Eltern wartet am Schuleingang. Plötzlich läutet die Schulglocke, und alle Kinder verlassen johlend das Schulgebäude. Ein Mädchen winkt zum Abschied ihren Freundinnen zu und eilt zu einem blauen Corolla. Als sie ihren Sicherheitsgurt schließt, dreht sich die Fahrerin um und fragt: „Wer bist du?" Das kleine Mädchen wirft ihr einen drohenden Blick zu und antwortet: „Halt einfach den Mund und fahr los." Der Bildschirm wird schwarz und zeigt den Slogan: „Der neue Corolla. Ein Auto, auf das man stolz sein kann." /// Un groupe de parents attend à la sortie de l'école. La sonnerie retentit et tous les enfants sortent en criant. Une petite fille dit au revoir à ses amis et court vers une Corolla bleue. Alors qu'elle est en train d'attacher sa ceinture, la conductrice se retourne et lui demande : « Qui es-tu ? » La petite fille lui lance un regard menaçant et répond : « Taisez-vous et démarrez ». L'écran devient noir et le slogan s'affiche : « La nouvelle Corolla. Une voiture dont on est fier ».

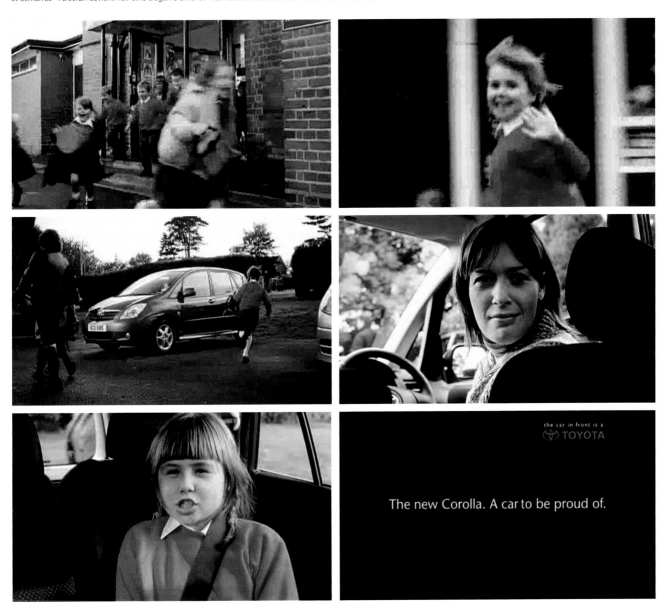

The new Corolla. A car to be proud of.

the car in front is a
TOYOTA

TITLE: Meteor. **CLIENT:** Toyota Motor Sales, USA. **PRODUCT:** Toyota Tacoma. **AGENCY:** Saatchi & Saatchi LA. **COUNTRY:** USA. **YEAR:** 2003. **EXECUTIVE CREATIVE DIRECTOR:** Harvey Marco. **CREATIVE DIRECTOR:** Steve Chavez. **COPYWRITER:** Greg Farley. **ART DIRECTOR:** Dino Spadavecchia. **DIRECTOR OF PRODUCTION:** Damian Stevens. **PRODUCER:** Mala Vasan. **PRODUCTION COMPANY:** Harvest Films. **DIRECTOR:** Baker Smith. **VISUAL EFFECTS:** Method Studios.

The spot opens on some friends as they tape their pals off-roading in a Toyota Tacoma. They notice a bright light in the sky which quickly reveals itself to be a meteor. It lands right on the Tacoma, knocking the friends back. They recover, only to find a smoking crater. That is, until the Tacoma emerges triumphantly intact and ready for more. The spot closes on the passenger thrusting his hand out the window in victory. /// Der Werbespot zeigt eine Gruppe von Freunden, die ihre Kumpels filmen, während diese in einem Toyota Tacoma über unebenes Gelände auf sie zufahren. Die Gruppe bemerkt ein helles Licht am Himmel. Es kommt rasend schnell näher und entpuppt sich als ein Meteor. Der Einschlag erfolgt genau auf dem Tacoma und die Freunde werden zu Boden geworfen. Sie rappeln sich wieder auf und finden einen rauchenden Krater vor, aus dem der Tacoma triumphierend und völlig intakt zum Vorschein kommt. Der Werbespot endet mit einer Einstellung auf den Beifahrer, der in siegreicher Pose seine Hand aus dem Fenster stößt. /// Le spot s'ouvre sur des gens qui filment leurs amis en train de faire du hors-route dans une Toyota Tacoma. Ils remarquent une lumière vive dans le ciel, qui se révèle rapidement être un météore. Il atterrit sur la Tacoma, et les gens qui filmaient sont renversés par le choc. Lorsqu'ils se relèvent, ils ne voient qu'un cratère fumant. Mais la Tacoma en émerge triomphalement, intacte et prête pour de nouvelles aventures. Le passager lève la main par la fenêtre en signe de victoire.

TITLE: Tundra. CLIENT: Toyota Motor Sales, USA. PRODUCT: Toyota Tundra. AGENCY: Saatchi & Saatchi LA. COUNTRY: USA. YEAR: 2003. EXECUTIVE CREATIVE DIRECTOR: Harvey Marco. CREATIVE DIRECTOR: Erich Funke. COPYWRITER: Ray Johnson. ART DIRECTOR: Gavin Milner. PRODUCER: Aris McGarry. PRODUCTION COMPANY: Anonymous Content – Culver City. DIRECTOR: Andrew Douglas.

The spot focuses on the speed and brake power of the Toyota Tundra pick-up truck as it performs a daredevil stunt in a canyon. The ad closes with a shot of the Toyota Tundra logo and an image of a new truck. /// Der Spot stellt die Geschwindigkeit und die Bremskraft des Toyota Tundra Pickup Transporters vor, der einen waghalsigen Stunt in einem Canyon zeigt. Er endet mit einer Einstellung auf das Toyota Tundra-Logo und dem Bild eines neuen Transporters. /// Le spot est centré sur la vitesse et la puissance de freinage du pick-up Tundra de Chevrolet, qui réalise une cascade diaboliquement audacieuse dans un canyon. Il prend fin sur le logo Tundra de Toyota et une image d'un nouveau pick-up truck.

FEATURED ON THE DVD **TITLE:** Chase. **CLIENT:** UMW Toyota Motor. **PRODUCT:** Toyota Unser. **AGENCY:** Saatchi & Saatchi. **COUNTRY:** Malaysia. **YEAR:** 2003. **CREATIVE DIRECTOR:** Erich Funke. **ART DIRECTOR:** Kelvin Leong. **COPYWRITER:** Craig Davis. **PRODUCTION COMPANY:** Carrot Films. **DIRECTOR:** Barney Chua.

An elevator door opens and two guys come face to face. The guy in the corridor recognizes the other one and makes a run for it. A chase ensues as the elevator guy pursues the other through an apartment block and into the car park below. The chased guy jumps into the back of a stationary Toyota Unser, but the elevator guy just manages to follow him in before he slams the door. After a pause, the elevator guy gets out of the car and radios his police chief, "Sir… I've lost him." /// Die Tür eines Aufzugs öffnet sich, und zwei Männer stehen sich gegenüber. Der Mann im Flur erkennt den anderen und ergreift die Flucht. Der Mann aus dem Aufzug jagt den anderen durch ein Mietswohngebäude bis in die Tiefgarage. Der Verfolgte springt auf die Rückbank eines geparkten Toyota Unser, doch sein Verfolger kann ihm gerade noch folgen, bevor er die Tür zuschlägt. Nach einer kurzen Pause steigt der Verfolger wieder aus dem Fahrzeug und funkt seinen Polizeichef an: „Sir… ich habe ihn verloren." /// La porte d'un ascenseur s'ouvre et deux hommes se retrouvent face à face. Celui du couloir reconnaît l'autre et part en courant. L'homme de l'ascenseur poursuit l'autre dans tout l'immeuble, puis dans le parking du sous-sol. L'homme pourchassé saute à l'arrière d'une Toyota Unser garée là, et l'autre arrive tout juste à l'y suivre avant qu'il ne claque la portière. Après une pause, l'homme de l'ascenseur, qui est en fait un policier, ressort de la voiture et appelle son supérieur par radio : « Monsieur… Il m'a semé ».

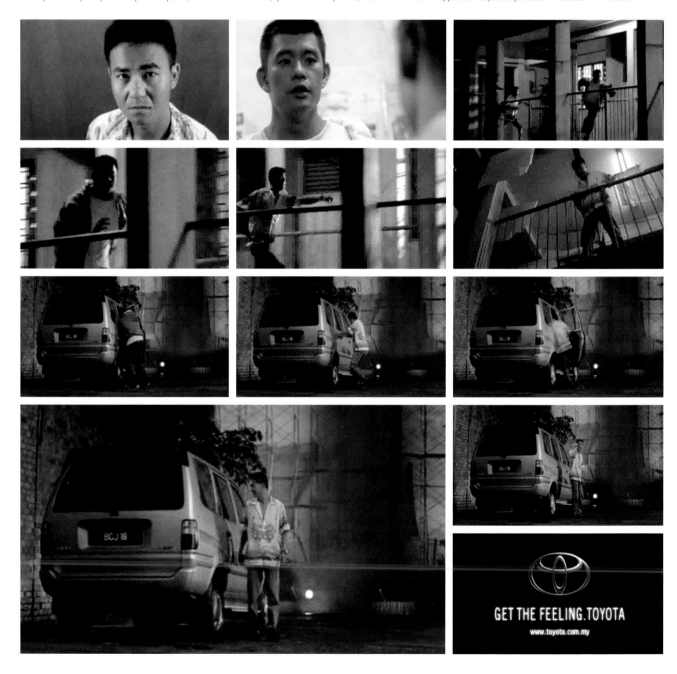

FEATURED ON THE DVD **TITLE:** Jogger. **CLIENT:** UMW Toyota Motor. **PRODUCT:** Toyota VIOS. **AGENCY:** Saatchi & Saatchi. **COUNTRY:** Malaysia. **YEAR:** 2005. **CREATIVE DIRECTOR:** Edmund Choe, Henry Yap. **COPYWRITER:** Primus Nair. **ART DIRECTOR:** Ong Kien Hoe. **PRODUCTION COMPANY:** Passion Pictures. **DIRECTOR:** Jamie Quah.

A jogger slows down as he sees a beautiful new Toyota Vios parked along a lakeshore. He approaches the car and touches it admiringly. We realise that the car is a cardboard cutout as it topples over. Suddenly, a giant lake monster springs out of the water and swipes the man in with a huge tentacle. Seconds later the monster's tentacle reappears and props the Vios cutout back up. The tagline fades up, "The irresistible Vios … You'll want one." /// Ein Jogger läuft langsamer, als er einen schönen neuen Toyota Vios am Rande eines Sees parken sieht. Er nähert sich dem Fahrzeug und berührt es bewundernd. Weil es umkippt, erkennt man, dass das Auto nur eine Attrappe aus Pappe ist. Plötzlich springt ein riesiges Seemonster aus dem Wasser und ergreift den Mann mit seinem gewaltigen Fangarm. Sekunden später erscheint der Fangarm des Monsters erneut und stellt die Papp-Attrappe des Vios wieder hin. Der Slogan erscheint mit den Worten: „Der unwiderstehliche Vios … Sie werden einen wollen." /// Un joggeur ralentit en voyant une superbe Toyota flambant neuve garée sur la rive d'un lac. Il s'approche de la voiture et la touche avec admiration. Mais la voiture n'est en fait qu'une photo imprimée sur un carton, et le carton se renverse. Un monstre géant jaillit aussitôt du lac et s'empare de l'homme avec son énorme tentacule. Quelques secondes plus tard, le tentacule ressort de l'eau et remet en place la photo de la Vios. Le slogan s'affiche à l'écran « L'irrésistible Vios … Vous en voudrez une ».

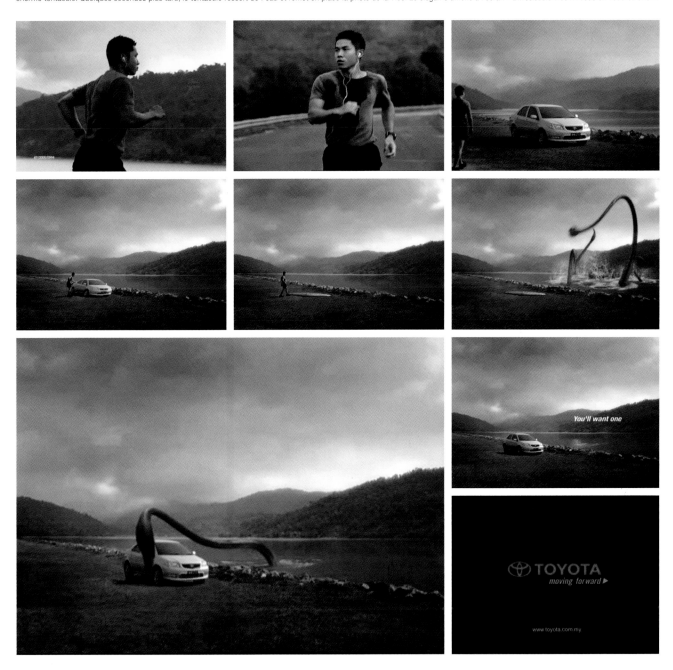

FEATURED ON THE DVD **TITLE:** Yaris vs Yaris 1. **CLIENT:** Toyota Motor Sales, USA. **PRODUCT:** Toyota Yaris. **AGENCY:** Saatchi & Saatchi Los Angeles. **COUNTRY:** USA. **YEAR:** 2006. **EXECUTIVE CREATIVE DIRECTOR:** tokyoplastic, 740 Sound. **CREATIVE DIRECTOR:** Steve Levit. **COPYWRITER:** Juan Bobillo, Conan Wang. **ART DIRECTOR:** Conan Wang, Juan Bobillo. **DIRECTOR OF INTEGRATED PRODUCTION:** Damian Stevens. **PRODUCER:** Jennifer Vogtmann. **TECHNICAL DIRECTOR:** James Boty. **ANIMATION DIRECTOR:** Chris Hill. **EXECUTIVE PRODUCER:** Jane Bolton.

Yaris vs. Yaris line up to race each other. The sedan cheats on the starting line by squirting the liftback's windscreen. A zany chase ensures as both cars conjure up every conceivable foil to outwit the other, from banana skins to flying tyre puncturing spike balls. At the end, the liftback gets even by spraying the sedan's windscreen, before they start their antics all over again. /// In der Yaris vs. Yaris-Kampagne stellen sich die beiden Modelle zum Rennen auf. Die Limousine schummelt an der Startlinie, indem sie die Windschutzscheibe der Fließhecklimousine bespritzt. Es folgt eine verrückte Jagd, in der sich beide Fahrzeuge jedes erdenkliche Hindernis in den Weg werfen – von Bananenschalen bis hin zu fliegenden Nagelkugeln, die die Reifen durchbohren. Am Ende holt die Fließhecklimousine auf, indem sie die Windschutzscheibe der Limousine bespritzt, und dann beginnt das Possenspiel von neuem. /// Les deux Yaris se mettent en position pour faire la course. La berline triche sur la ligne de départ en envoyant une giclée d'eau sur le pare-brise de la compacte. S'ensuit une course loufoque où chaque voiture a recours à tous les stratagèmes possibles pour gagner, depuis les peaux de banane jusqu'aux boules hérissées pour crever les pneus. La compacte réussit finalement à se venger en envoyant à son tour une giclée d'eau sur le pare-brise de la berline, et les deux voitures reprennent aussitôt leur manège.

FEATURED ON THE DVD **TITLE:** Yaris vs Yaris 2. / Yaris vs Yaris 3. **CLIENT:** Toyota Motor Sales, USA. **PRODUCT:** Toyota Yaris. **AGENCY:** Saatchi & Saatchi Los Angeles. **COUNTRY:** USA. **YEAR:** 2006. **EXECUTIVE CREATIVE DIRECTOR:** tokyoplastic, 740 Sound. **CREATIVE DIRECTOR:** Steve Levit. **COPYWRITER:** Juan Bobillo, Conan Wang. **ART DIRECTOR:** Conan Wang, Juan Bobillo. **DIRECTOR OF INTEGRATED PRODUCTION:** Damian Stevens. **PRODUCER:** Jennifer Vogtmann. **TECHNICAL DIRECTOR:** James Boty. **ANIMATION DIRECTOR:** Chris Hill. **EXECUTIVE PRODUCER:** Jane Bolton.

A giant spider made out of petrol cans is zapped down to size by the Yaris, which then runs it over. It then releases a pipe from its petrol cap and sucks up all the gas, before driving off with a burp. The tagline reads, "40 mpg rated." The spot closes with the Yaris splitting in to the sedan and liftback. /// Eine Riesenspinne aus Benzinkanistern wird vom Yaris zur Miniatur verkleinert und dann überfahren. Das Fahrzeug fährt aus dem Tankdeckel ein Rohr aus und saugt das gesamte Benzin auf, bevor es mit einem Rülpser davonfährt. Der Slogan lautet: „6 Liter auf 100 km." In der Schlussszene teilt sich die Yaris in Limousine und Fließhecklimousine auf. /// La Yaris fait rapetisser une araignée géante faite de barils de pétrole puis lui roule dessus. Un tuyau sort de son réservoir et elle aspire toute l'essence avant de repartir en faisant un petit rot. Le slogan s'affiche : « 6 litres aux 100 ». Sur la dernière image, la Yaris se divise en deux voitures, la berline et la compacte.

40 mpg rated

2007 EPA estimated highway mileage with 5-speed manual transmission. Actual mileage may vary

The Yaris liftback's trunk springs open to reveal its new secret weapon, a giant ball saw. In a dastardly move it cuts a circle around the standing sedan. In a reversal of fortune the liftback plunges down, leaving the sedan standing on a cylindrical plinth. /// Der Kofferraum der Yaris Fließhecklimousine springt auf und enthüllt ihre neue Geheimwaffe - eine riesige Säge. Heimtückisch sägt sie einen Kreis um die stehende Limousine. In einer Wendung des Schicksals fällt die Fließhecklimousine jedoch hinunter, während die Limousine auf einem zylinderförmigen Sockel stehen bleibt. /// Le coffre de la Yaris compacte s'ouvre et sa nouvelle arme secrète en jaillit, une scie circulaire. Dans un geste peu sportif, elle coupe un cercle tout autour de la berline. Mais la malchance s'en mêle et c'est la compacte qui plonge, la berline reste perchée sur un socle cylindrique.

TITLE: Sheet Metal. **CLIENT:** Saturn Corp. **PRODUCT:** Saturn. **AGENCY:** Goodby, Silverstein & Partners. **COUNTRY:** USA. **YEAR:** 2003. **CREATIVE DIRECTOR:** Jamie Barrett. **COPYWRITER:** Jamie Barrett. **ART DIRECTOR:** Mark Wenneker. **PRODUCTION COMPANY:** Biscuit Filmworks. **PRODUCER:** Jay Veal. **DIRECTOR:** Noam Murro. **AWARDS:** Cannes Lions (Gold).

Enter a world where people are cars. We see people jogging on highways, waiting in lanes at traffic lights and standing in parking lots. Towards the end a voiceover announces, "When we design cars we don't see sheet metal. We see the people that may one day drive them." The scene changes to a shot of three Saturn models, L, View and Ion. The voiceover closes with the line, "It's different in a Saturn." /// Wir sehen eine Welt, in der alle Menschen Autos sind. Da joggen Leute auf Autobahnen, warten an Ampeln in ihrer Fahrspur und stehen auf Parkplätzen. Gegen Ende des Spots sagt ein Sprecher: „Wenn wir Autos entwickeln, sehen wir nicht das Metall der Karosserie, sondern die Menschen, die eines Tages diese Autos fahren werden." Die Szene wechselt zu einem Bild der drei Saturn-Modelle L, View und Ion. Der Spot endet mit dem Satz: „Bei einem Saturn ist das anders." /// Entrez dans un monde où les gens sont des voitures. On les voit courir sur des autoroutes, patientant dans leurs voies respectives aux feux rouges, et immobiles dans les parkings. Vers la fin, la voix off annonce : « Lorsque nous concevons des voitures, nous ne voyons pas des feuilles de métal. Nous voyons les gens qui les conduiront ». L'écran montre alors une image de trois modèles de Saturn, L, View et Ion. La voix off conclut par ces mots : « C'est différent dans une Saturn ».

TITLE: Hide and Seek. **CLIENT:** Vauxhall Motors. **PRODUCT:** Corsa. **AGENCY:** Delaney Lund Knox Warren & Partners. **COUNTRY:** United Kingdom. **YEAR:** 2003. **CREATIVE DIRECTOR:** Gary Betts, Malcolm Green. **COPYWRITER:** Keith Bickel. **ART DIRECTOR:** Carlos Anuncibay. **PRODUCTION COMPANY:** Academy. **PRODUCER:** Simon Cooper. **DIRECTOR:** Frederic Planchon. **AWARDS:** Cannes Lions (Shortlist).

A set of Vauxhall Corsas decide to play Hide n Seek around a big city. They hide everywhere from shipping containers to supermarket aisles. The ad closes with the tagline, "Put the fun back into driving." /// Eine Gruppe Vauxhall Corsas spielt in einer großen Stadt Verstecken. Die Fahrzeuge verstecken sich überall: in Schiffscontainern und sogar in Supermarktgängen. Der Spot endet mit dem Slogan „Fahren soll wieder Spaß machen." Der Bildschirm wird schwarz und zeigt das Wort „Corsa", gefolgt von dem Vauxhall-Emblem. /// Plusieurs Vauxhall (Opel) Corsa décident de jouer à cache-cache dans une grande ville. Elles se cachent partout, depuis des containers de chargement jusqu'à des rayons de supermarché. La publicité conclut sur ces mots : « Retrouvez le plaisir de conduire ». L'écran devient noir et le mot « Corsa » apparaît, suivi du logo Vauxhall.

Put the fun back into driving.

TITLE: Bob Knight. / Heidi Klum. **CLIENT:** Volkswagen of America. **PRODUCT:** Volkswagen. **AGENCY:** Crispin Porter + Bogusky Miami. **COUNTRY:** USA. **YEAR:** 2008. **EXECUTIVE CREATIVE DIRECTOR:** Andrew Keller, Rob Reilly. **CREATIVE DIRECTOR:** Scott Linnen, Tony Calcao, Rob Strasberg. **COPYWRITER:** Scott Linnen, Dave Schiff (Omid Farhang: Coach Knight). **ART DIRECTOR:** Colin Kim, Alex Burnard (Tom Zukoski: Coach Knight). **PRODUCTION COMPANY:** The Directors Bureau. **DIRECTOR:** Roman Coppola.

Veteran basketball coach Bob Knight takes the hot seat in this instalment of VW Beetle's zany talk show. Knight plays down his sporting achievements as he mentions VW's 'Best Resale Value Brand 2008.' The haughty Beetle's sly remark that "at least one of us is winning a title this year" provokes Knight into throwing his chair to the ground as he storms off. /// Der altgediente Basketball-Trainer Bob Knight ist Gast bei dieser Fortsetzung der verrückten Talkshow von VW Beetle. Knight spielt seine sportlichen Errungenschaften herunter, als er den VW-Titel als ‚Marke mit dem besten Wiederverkaufswert 2008' erwähnt. Die durchtriebene Bemerkung „Wenigstens gewinnt einer von uns dieses Jahr einen Titel" des stolzen Beetle provoziert Knight derart, dass er seinen Stuhl umwirft und wutentbrannt abrauscht. /// L'entraîneur retraité Bob Knight est sur la sellette lors d'un talk show farfelu avec une coccinelle VW. Jouant la modestie quant à ses propres performances, Knight félicite VW d'avoir remporté le prix de la « marque ayant la meilleure valeur à la revente en 2008 ». La réplique ironique et hautaine de la coccinelle « Ça fait au moins quelqu'un qui aura remporté un titre cette année » provoque la colère de Knight, qui balance brutalement sa chaise par terre et quitte les lieux.

Supermodel Heidi Klum gets one over on the cheeky German Beetle in this episode of VW's *Das Auto* talk show. "German engineering is so sexy," she remarks as our VW host changes colour from black to red. "You're blushing," Klum jokes. The spot closes with the tagline, "Hot for German engineering," followed by the VW badge. /// In dieser Episode der VW-Talkshow Das Auto wischt das Supermodel Heidi Klum dem frechen deutschen Beetle eins aus. „Deutsche Ingenieurtechnik ist so sexy", bemerkt sie, während unser VW-Gastgeber seine Farbe von schwarz nach rot wechselt. „Du wirst ja ganz rot", scherzt Heidi Klum. Der Spot endet mit dem Slogan „Heiß auf deutsche Ingenieurtechnik", gefolgt vom VW-Emblem. /// La top-modèle Heidi Klum marque un point contre l'impertinente coccinelle dans cet épisode du talk show *Das Auto* de VW. « L'ingénierie allemande est tellement sexy » remarque-t-elle, tandis que notre VW passe du noir au rouge. « Vous rougissez » plaisante Heidi Klum. Le spot prend fin sur la phrase « On s'enflamme pour l'ingénierie allemande, » suivie du badge de VW.

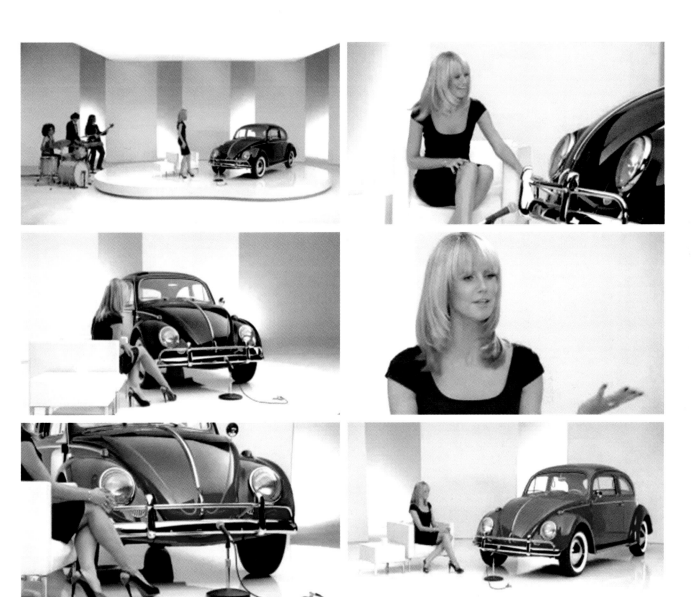

FEATURED ON THE DVD **TITLE:** Exorcist. / Shining. **CLIENT:** Volkswagen. **PRODUCT:** Volkswagen Fox. **AGENCY:** DDB Dusseldorf. **COUNTRY:** Germany. **YEAR:** 2006. **CREATIVE DIRECTOR:** Jennifer Shiman, Amir Kassaei, Eric Schoeffler. **COPYWRITER:** Tim Jacobs. **ART DIRECTOR:** Jennifer Shiman, Christian Brenner. **PRODUCTION COMPANY:** Angry Alien Productions. **PRODUCER:** James Strader. **DIRECTOR:** Jennifer Shiman. **AWARDS:** Cannes Lions (Silver).

"The Exorcist in 30 seconds," is a cartoon remake of the Oscar-winning horror classic. It's "Short and fun", exactly like the VW Fox. /// „Der Exorzist in 30 Sekunden" ist ein Trickfilm-Remake des mit dem Oscar ausgezeichneten Horror-Klassikers. Er ist „kurz und macht Spaß", genau wie der VW Fox. /// L'Exorciste en 30 secondes est un remake en dessin animé du classique de l'horreur oscarisé. C'est « court et amusant », exactement comme la nouvelle Fox VW.

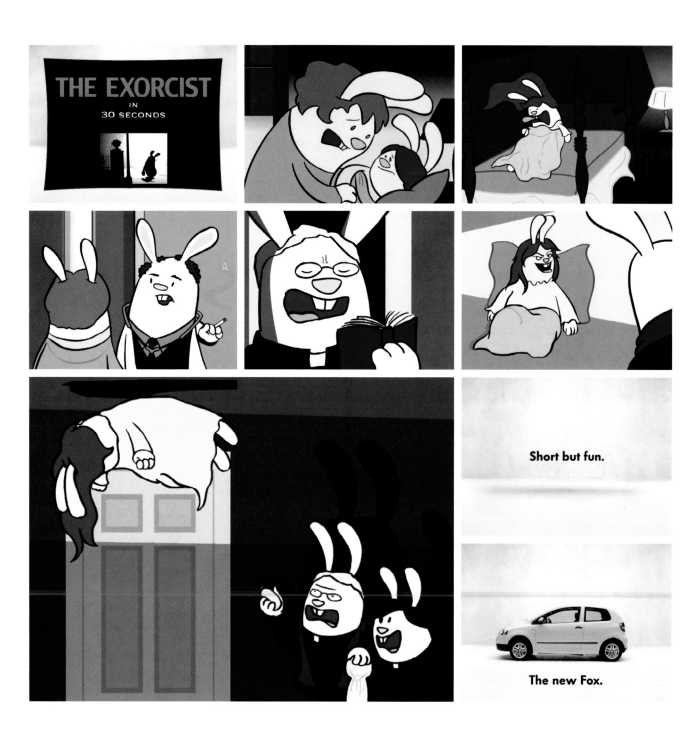

Stanley Kubrick's horror masterpiece is retold in the animated blockbuster, "The Shining in 30 Seconds." It's "Short and Fun", like the new VW Fox. /// Stanley Kubricks Meisterstück des Horrors wird in dem animierten Filmhit „Shining in 30 Sekunden" wiedererzählt. Er ist „kurz und macht Spaß" wie der neue VW Fox. /// Le chef-d'œuvre de l'horreur de Stanley Kubrick est raconté en dessin animé et en 30 secondes. C'est « court et amusant », comme la nouvelle Fox VW.

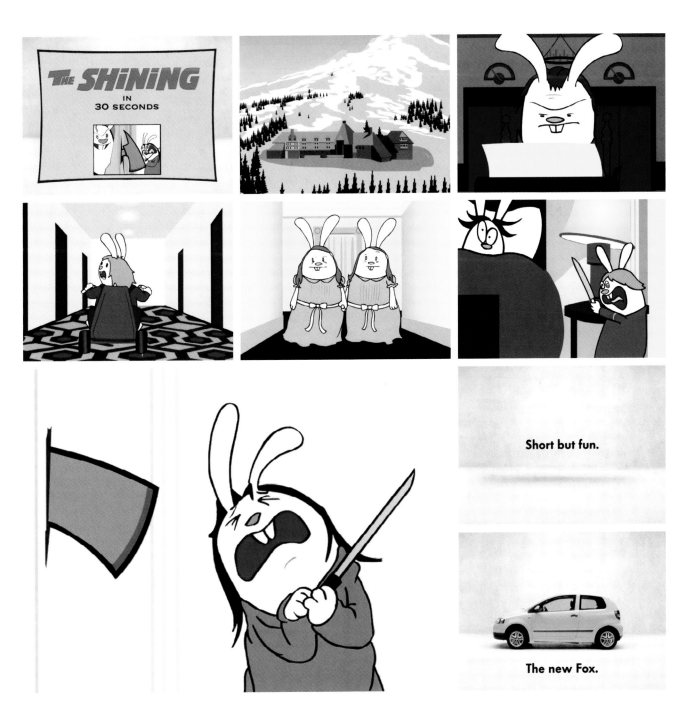

FEATURED ON THE DVD **TITLE:** Pulp Fiction. / Titanic. **CLIENT:** Volkswagen. **PRODUCT:** Volkswagen Fox. **AGENCY:** DDB Dusseldorf. **COUNTRY:** Germany. **YEAR:** 2006. **CREATIVE DIRECTOR:** Jennifer Shiman, Amir Kassaei, Eric Schoeffler. **COPYWRITER:** Tim Jacobs. **ART DIRECTOR:** Jennifer Shiman, Christian Brenner. **PRODUCTION COMPANY:** Angry Alien Productions. **PRODUCER:** James Strader. **DIRECTOR:** Jennifer Shiman. **AWARDS:** Cannes Lions (Silver).

A cartoon animation retells the Hollywood blockbuster "Pulp Fiction in 30 Seconds." The screen cuts to an empty white background with the tagline, "Short and fun." Suddenly the new VW Fox lands. /// Eine Trickfilm-Animation erzählt den Hollywood-Blockbuster „Pulp Fiction" in 30 Sekunden. Der Bildschirm zeigt einen leeren weißen Hintergrund mit der Überschrift „Kurz und macht Spaß." Plötzlich landet der neue VW Fox. /// Un dessin animé raconte l'histoire du film à succès Pulp Fiction en 30 secondes, L'écran devient tout blanc et les mots suivants s'affichent : « court et amusant ». Tout à coup, la nouvelle VW Fox atterrit.

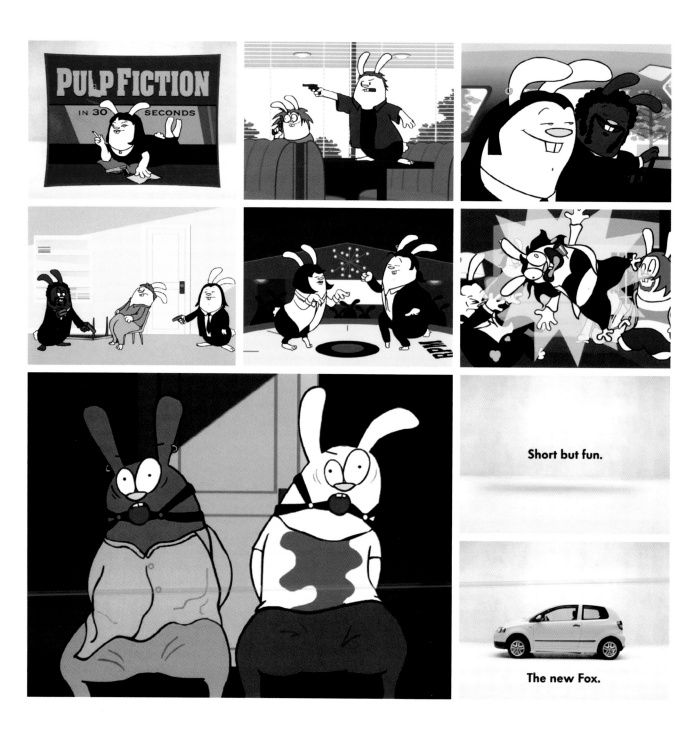

Just like the VW Fox, this 30-second animated version of the Oscar-winning epic movie Titanic is "Short but fun." /// Diese animierte 30-Sekunden-Version des mit vielen Oscars ausge-zeichneten Film-Epos Titanic ist genau wie der VW Fox – „kurz, aber voller Spaß." /// Tout comme la Fox de Volkswagen, ce remake animé du film oscarisé Titanic qui dure 30 secondes est « court et amusant ».#

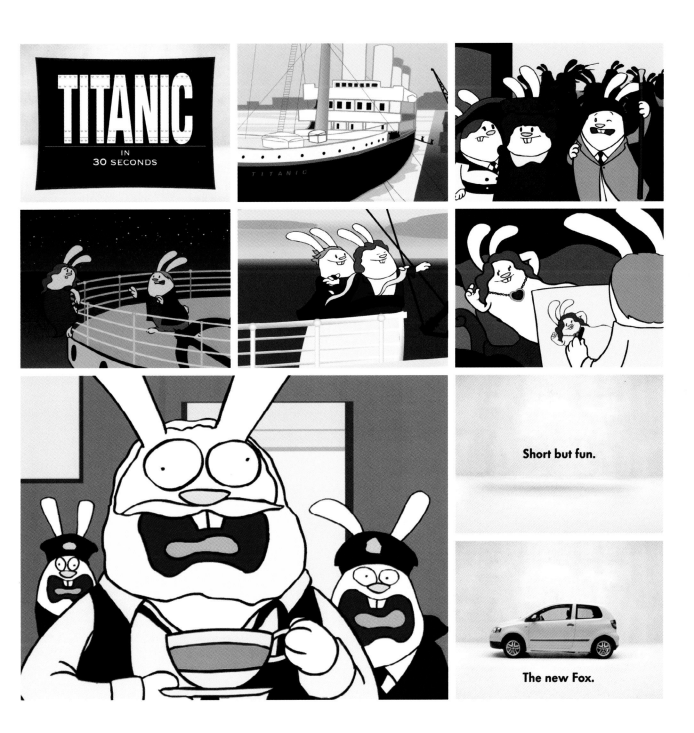

TITLE: Night Drive. **CLIENT:** Volkswagen. **PRODUCT:** Volkswagen Golf. **AGENCY:** DDB London. **COUNTRY:** United Kingdom. **YEAR:** 2008. **CREATIVE DIRECTOR:** Jeremy Craigen. **COPYWRITER:** Sam Oliver. **ART DIRECTOR:** Shishir Patel. **PRODUCTION COMPANY:** Independent, London. **PRODUCER:** Jay Veal, Richard Packer. **DIRECTOR:** Noam Murro.

A man drives his VW Golf through various cityscapes at night. In the background, Richard Burton narrates an excerpt from Under Milk Wood by Dylan Thomas. The screen fades to black to reveal the tagline, "When was the last time you just went for a drive?" The VW logo closes the spot. /// Ein Mann fährt mit seinem VW Golf bei Nacht durch verschiedene Stadtlandschaften. Aus dem Off spricht Richard Burton einen Abschnitt aus Under Milk Wood von Dylan Thomas. Der Bildschirm wird schwarz und zeigt den Slogan „Wann sind Sie das letzte Mal einfach nur Auto gefahren?" Das VW-Logo beendet den Spot. /// Au volant de sa VW Golf, un homme traverse une suite de paysages urbains nocturnes. En fond sonore, Richard Burton lit un extrait de Au bois lacté de Dylan Thomas. L'écran passe au noir, révélant la phrase « De quand date votre dernière promenade en voiture, juste pour le plaisir ? » Le logo de VW met fin au spot.

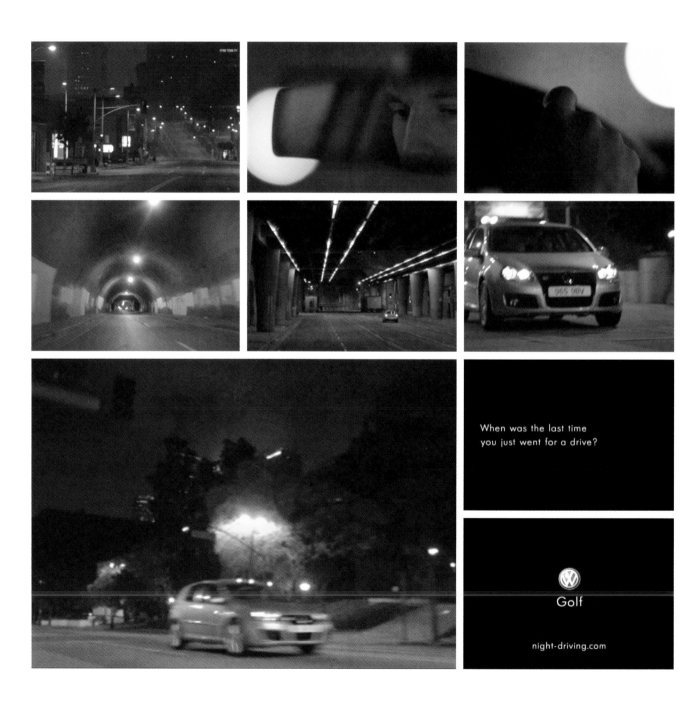

TITLE: Singin' In The Rain. CLIENT: Volkswagen. PRODUCT: Volkswagen Golf GTI. AGENCY: DDB London. COUNTRY: United Kingdom. YEAR: 2005. CREATIVE DIRECTOR: Jeremy Craigen. ART DIRECTOR: Steve Jones. COPYWRITER: Martin Loraine. DIRECTOR: NE-O. PRODUCER: Blake Powell. AGENCY PRODUCER: Richard Chambers. EDITING COMPANY: Marshall Street. SPECIAL EFFECTS: Alex Lovejoy, Christophe Damiano, MPC. MUSIC: Mint Royale. AWARDS: Cannes Lions (Bronze).

With the miracle of computer-generated imagery, Gene Kelly performs a modern electro version of the Hollywood classic, Singin' in the Rain. Kelly's character ends his dance next to a parked Volkswagen Golf GTI. The closing tagline reads, "The new Golf GTI. The original, updated." /// Durch das Wunder computergenerierter Bilder kann Gene Kelly eine moderne Version des Hollywood-Klassikers „Singin' in the Rain" zeigen. Kelly beendet seinen Tanz neben einem parkenden Golf GTI. Der Schlussslogan lautet „Der neue Golf GTI. Das Original, aktualisiert." /// Grâce au miracle des images de synthèse, Gene Kelly danse une version électronique moderne du classique hollywoodien Chantons sous la pluie. Son personnage finit sa danse à côté d'une Golf GTI Volkswagen garée. Le slogan s'affiche : « La nouvelle Golf GTI. L'originale, actualisée ».

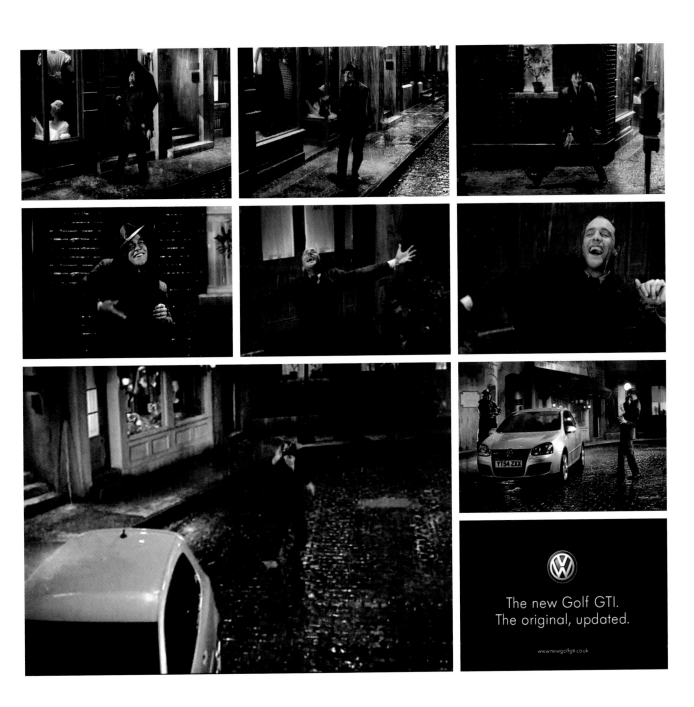

TITLE: Critique. / Like. **CLIENT:** Volkswagen of America. **PRODUCT:** Volkswagen Jena. **AGENCY:** Crispin Porter + Bogusky Miami. **COUNTRY:** USA. **YEAR:** 2006. **EXECUTIVE CREATIVE DIRECTOR:** Andrew Keller. **CREATIVE DIRECTOR:** Rob Strasberg. **COPYWRITER:** Tim Roper. **ART DIRECTOR:** Dave Clemans. **PRODUCTION COMPANY:** Epoch Films. **DIRECTOR:** Phil Morrison.

A series of spots show the sudden impact of a car crash with no injuries to the Volkswagen driver or passengers. In each final shot, the car rotates on a plinth showing its minimal damage. The tagline appears, "Safe Happens ...". /// Mehrere Bildfolgen zeigen die Auswirkungen eines plötzlichen Auffahrunfalls, bei dem weder Fahrer noch Beifahrer des Volkswagens Verletzungen davontragen. In jeder Abschlusseinstellung dreht sich das Fahrzeug auf einem Sockel und zeigt seine minimalen Beschädigungen. Der Slogan „Sicherheit passiert ...“ erscheint. /// Plusieurs spots montrent un accident entre deux voitures, dont une Volkswagen : ni le conducteur, ni les passagers de cette dernière ne sont blessés dans la collision. A la fin de chaque spot, la voiture tourne sur un socle : les dégâts ne sont pas importants. La légende s'affiche « La sécurité, ça peut arriver... »

Safe happens.

Government star ratings are part of the National Highway Traffic Safety Administration's (NHTSA's) New Car Assessment Program.(www.safercar.gov) All crashes are different and severe injuries can occur. Airbags do not deploy in all accidents. Always use safety belts and seat children in rear using appropriate restraint systems.

TITLE: Enjoy Everyday. CLIENT: Volkswagen. PRODUCT: Volkswagen Golf. AGENCY: DDB London. COUNTRY: United Kingdom. YEAR: 2007. EXECUTIVE CREATIVE DIRECTOR: Jeremy Craigen. CREATIVE DIRECTOR: Jeremy Craigen. COPYWRITER/ART DIRECTOR: Graeme Hall, Noah Regan. PRODUCTION COMPANY: OUTSIDER, London. PRODUCER: Zeno Campbell-Salmon. DIRECTOR: Scott Lyon.

A clever use of editing creates a rhythmic visual soundtrack to extol the everyday benefits of the VW Golf. The ad closes on a black screen with the VW badge and the tagline, "Golf. Enjoy the everyday." /// Durch raffinierte Filmbearbeitung wird ein visueller und rhythmischer Soundtrack geschaffen, der die täglichen Vorteile des VW Golfs zeigt. Der Spot endet mit einem schwarzen Bildschirm, auf dem das VW-Emblem und der Slogan „Golf. Genieße den Alltag" zu sehen ist. /// Une utilisation intelligente du montage permet ici de composer une bande-son rythmique exaltant les vertus quotidiennes de la Golf VW. La pub finit sur un écran noir, avec le badge de VW et cette phrase « Golf. Profitez du quotidien. »

TITLE: Bubble Boy. CLIENT: Volkswagen of America. PRODUCT: New Beetle Convertible. AGENCY: Arnold Worldwide. COUNTRY: USA. YEAR: 2003. CHIEF CREATIVE DIRECTOR: Ron Lawner. CREATIVE DIRECTOR: Alan Pafenbach. COPYWRITER: Joe Fallon. ART DIRECTOR: Don Shelford. PRODUCTION COMPANY: The Directors Bureau. PRODUCER: Oliver Fuselier. DIRECTOR: Mike Mills. AWARDS: Cannes Lions (Silver).

An alarm clock shows it's 7.30 am. In a quick succession of clips, intercut with multi-screen shots, we share a week in the life of Bill Briggs as he trudges through his monotonous corporate career. The spot ends with Bill walking across an office footbridge. He stops and gazes down admiringly as the camera pulls away. The taglines appear, "The New Beetle Convertible … Coming Soon … Drivers Wanted." /// Der Wecker steht auf 7:30 Uhr. Man sieht das Leben von Bill Briggs einer schnellen Abfolge von Filmclips und aufgeteilten Bildschirmansichten, wie er sich durch seine monotone Karriere schleppt. Am Ende des Spots geht Bill durch einen Gang, der zwei Gebäude verbindet, und schaut bewundernd durchs Fenster nach unten. Der Slogan „Der neue Beetle Cabriolet … kommt bald … Fahrer gesucht" erscheint. /// Il est 7h30. Une succession rapide de clips et d'écrans multiples nous fait partager une semaine de la vie de Bill Briggs et de sa carrière monotone au sein de son entreprise. Le spot se termine par une image de Bill traversant une passerelle pour piétons entre deux immeubles de bureaux. Il s'arrête et regarde vers le bas avec admiration pendant que la caméra recule. Les mots suivants apparaissent : « La nouvelle Coccinelle décapotable … Bientôt … On recherche des conducteurs ».

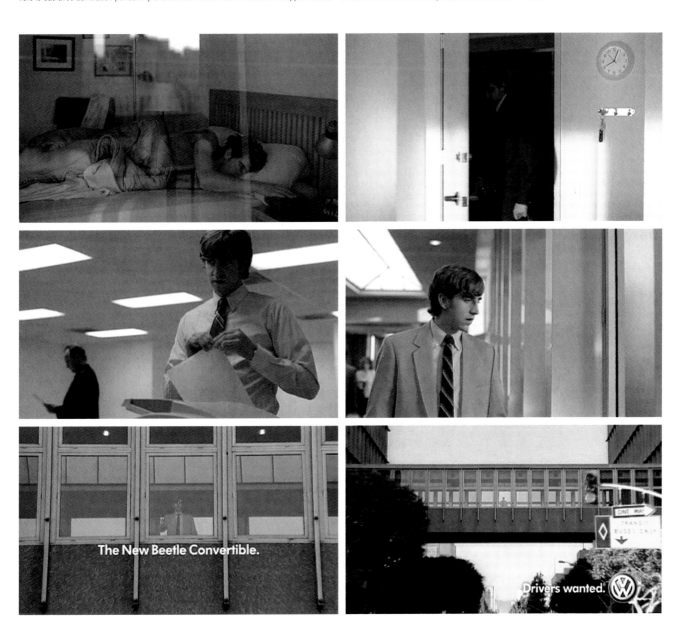

TITLE: Glasses. **CLIENT:** Volkswagen. **PRODUCT:** Volkswagen Trucks. **AGENCY:** Almap BBDO. **COUNTRY:** Brazil. **YEAR:** 2007. **CREATIVE DIRECTOR:** Dulcidio Caldeira, Luiz Sanches. **COPYWRITER/ART DIRECTOR:** Eduardo Andrietta, Marcus Kawamura. **PRODUCTION COMPANY:** Produtora Associados. **DIRECTOR:** Felipe Prado.

A pair of hands can be seen performing a three-cup shuffle using three upturned glasses on a white surface. A Volkswagen badge is clearly visible in one. A caption fades up, "Track it wherever it goes." The screen fades to black and the ad closes with the VW logo and the tagline, "Volksnet. The Volkswagen trucks tracking system." /// In diesem Spot schieben ein Paar Hände drei umgedrehte Gläser auf einer weißen Oberfläche schnell durcheinander. In einem der Gläser ist ein Volkswagen-Emblem klar zu erkennen. Ein Schriftzug mit den Worten „Verfolgen Sie den Weg, wohin er auch führt" erscheint. Der Bildschirm wird schwarz, und der Spot endet mit dem VW-Logo und dem Slogan „Volksnet. Das Volkswagen Transport-Überwachungssystem". /// Deux mains s'amusent à escamoter trois verres retournés sur une surface blanche. Un badge Volkswagen est clairement visible sous l'un d'eux. Une légende s'inscrit « Suivez-le où qu'il aille. » L'écran passe au noir et la pub s'achève sur le logo de VW, avec ce message « Volksnet. Le système de monitorage automobile de Volkswagen. »

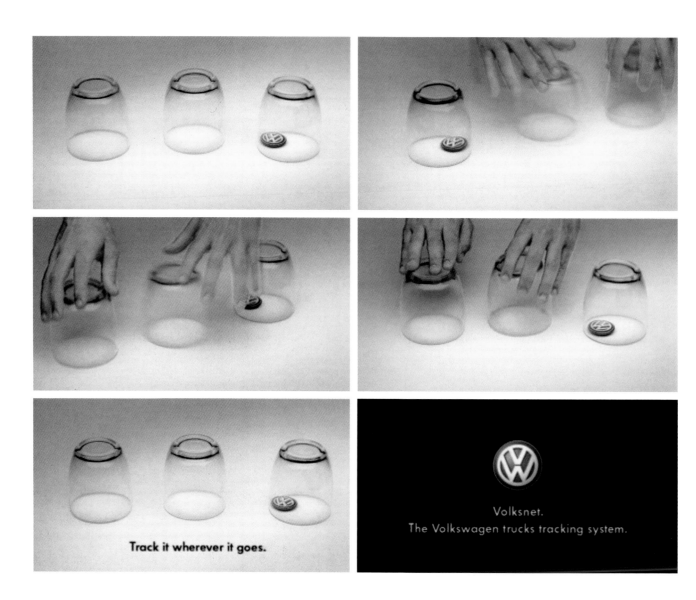

Track it wherever it goes.

Volksnet.
The Volkswagen trucks tracking system.

TITLE: Baby. CLIENT: Metro de Madrid. PRODUCT: Madrid Subway. AGENCY: McCann Erickson Madrid. COUNTRY: Spain. YEAR: 2007. EXECUTIVE CREATIVE DIRECTOR: Monica Moro. CREATIVE DIRECTOR: Raquel Martinez. COPYWRITER: Mónica Moro. ART DIRECTOR: Raquel Martinez. PRODUCTION COMPANY: Indio Films. PRODUCER: Fran Torres.

At a Christmas Party a baby boy sees a big cuddly toy ape under a Christmas tree on the other side of the room. He manages to manoeuvre his way through the crowds to reach the toy. The tagline fades up, "It's faster down below." The shot cuts to a speeding subway train and the words, "This Christmas, take the metro." /// Auf der Weihnachtsfeier entdeckt ein Kleinkind am anderen Ende des Raumes einen großen Plüschaffen unterm Weihnachtsbaum. Es gelingt ihm, seinen Weg durch die Menschenmenge zu finden und das Spielzeug zu erreichen. Der Slogan „Unten geht es schneller" erscheint. Die Einstellung wechselt zu einer anfahrenden U-Bahn und den Worten „Benutzen Sie diese Weihnachten die Metro". /// C'est la fête, le soir de Noël. Sous le sapin, à l'autre bout de la pièce, un bébé aperçoit un jouet qui lui plaît : un grand singe tout doux. Il se débrouille pour se frayer un chemin à travers la foule, et s'en saisit. La légende s'affiche « Par en dessous, ça va plus vite. » Apparaît alors l'image d'un métro en marche, avec ces mots « Ce Noël, prenez le métro. »

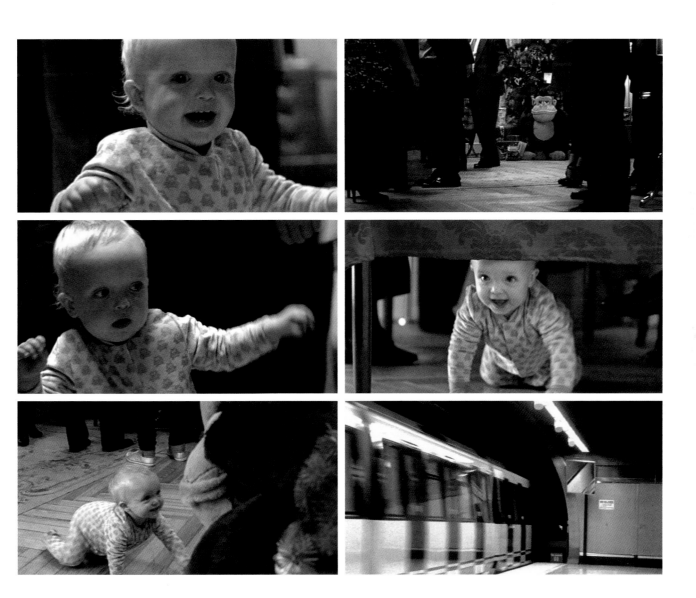

TITLE: Caterpillar. CLIENT: Gol Linhas Aéreas. PRODUCT: Gol Airlines. AGENCY: Almap BBDO. COUNTRY: Brazil. YEAR: 2007. CREATIVE DIRECTOR: Marcello Serpa, Cássio Zanatta. COPYWRITER/ART DIRECTOR: Gustavo Sarkis, Eduardo Andrietta, Renato Fernandes, Marcus Kawamura. PRODUCTION COMPANY: Vetor Zero. DIRECTOR: Nando Cohen.

This delightful animation, in the style of early 1930s black and white cartoons, shows a bustling city full of caterpillars as they emerge into butterflies to form a Technicolor aeroplane in the sky. A voiceover asks, "Isn't it great to find out you can fly?" The spot ends with the GOL logo and the tagline, "Here everyone can fly." /// Diese wunderbare Animation im Stil von Schwarz-Weiß-Cartoons der frühen 30er Jahre zeigt eine belebte Stadt voller Raupen, die sich in Schmetterlinge verwandeln und am Himmel ein buntes Flugzeug formen. Eine Hintergrundstimme fragt: „Ist es nicht großartig herauszufinden, dass man fliegen kann?" Der Spot endet mit dem GOL-Logo und dem Slogan „Hier kann jeder fliegen". /// Cette délicieuse animation, dans le style des dessins animés en noir et blanc du début des années trente, montre une ville laborieuse, pleine de chenilles qui se transforment en papillons, formant un avion multicolore dans le ciel. Une voix off demande « C'est chouette, non, de réaliser qu'on peut voler ? » Le spot prend fin sur le logo du GOL, avec cette accroche « Ici, tout le monde voler. »

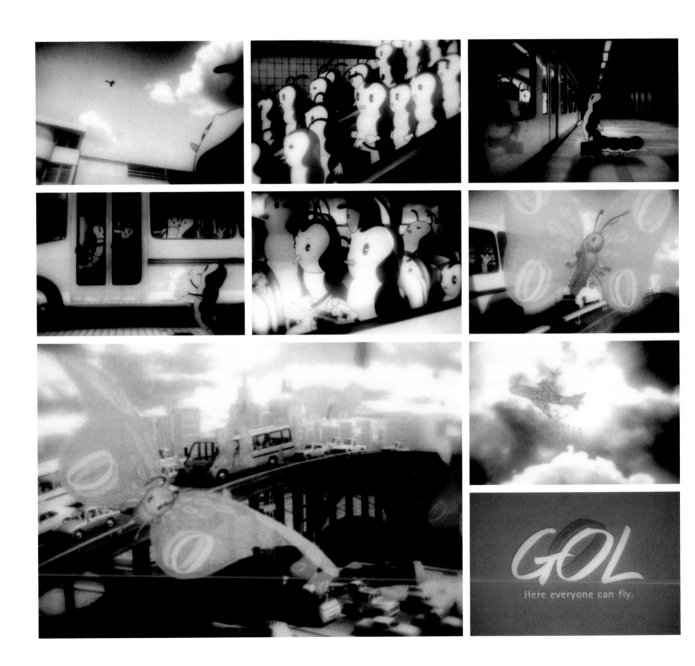

TITLE: New York Minute. **CLIENT:** American Airlines. **PRODUCT:** American Airlines. **AGENCY:** McCann Erickson London. **COUNTRY:** USA. **YEAR:** 2008. **EXECUTIVE CREATIVE DIRECTORS:** Brian Fraser, Simon Learman. **COPYWRITER:** Cameron Mitchell **ART DIRECTOR:** Elliot Harris. **PRODUCTION COMPANY:** MJZ. **DIRECTOR:** Rupert Sanders.

Actor James Gandolfini travels through New York City before arriving at an upmarket restaurant. A voiceover announces, "We've flown more New Yorkers than any other airline, and if we can keep them happy…" The spot ends with Gandolfini sitting in a first-class cabin. The screen cuts to the American Airlines logo and the tagline, "We know why you fly." /// Der Schauspieler James Gandolfini reist auf dem Weg zu einem vornehmen Restaurant durch New York. Eine Hintergrundstimme sagt: „Mit uns fliegen mehr New Yorker als mit jeder anderen Fluglinie, und wenn wir sie bei Laune halten können …" Der Spot endet mit einer Einstellung auf Gandolfini, der in einer Flugkabine der ersten Klasse sitzt. Der Bildschirm wechselt zum Logo der American Airlines und dem Slogan „Wir wissen, warum Sie fliegen". /// Après avoir traversé la ville de New York, l'acteur James Gandolfini s'attable dans un restaurant haut de gamme. Une voix off annonce : « Nous avons transporté plus de New-Yorkais qu'aucune autre compagnie aérienne, et si nous pouvons les contenter … » Le spot s'achève sur l'image de Gandolfini, assis dans une cabine de première classe. L'écran change, montrant le logo d'American Airlines et la phrase « Nous savons pourquoi vous prenez l'avion. »

TITLE: Love Story. **CLIENT:** Virgin Atlantic Airways. **SERVICE:** Virgin Atlantic Upper Class Suites. **AGENCY:** Net#Work BBDO. **COUNTRY:** South Africa. **YEAR:** 2005. **CREATIVE DIRECTOR:** Mike Schalit. **COPYWRITER:** John Davenport. **ART DIRECTOR:** Philip Ireland. **PRODUCTION COMPANY:** Velocity Films. **PRODUCER:** Helena Woodfine. **DIRECTOR:** Greg Grey. **AWARDS:** Cannes Lions (Silver).

A fat ugly man serenades his good looking partner in a bar. The romance ensues through a series of clips, culminating with a shot of the couple getting married at the altar. Suddenly the scene cuts to the cabin of an aircraft. The good looking man looks horrified as the fat passenger next to him sleeps on his shoulder. A voiceover announces, "If you wanted to sleep with him you would have married him." A shot of an upper class cabin appears as the voiceover continues, "Fly Virgin Atlantic Upper Class and get your own flat bed suite." The spot closes with the Virgin logo and slogan, "Virgin Atlantic – Upper Class Suite." /// Ein fetter, hässlicher Mann bringt seinem gutaussehenden Partner in einer Bar ein Ständchen. Die Romanze wird durch eine Reihe von Filmclips begleitet und findet ihren Höhepunkt in der Szene, in der das Paar vor dem Altar heiratet. Plötzlich wechselt die Szene in eine Flugzeugkabine. Der gutaus-sehende Mann schaut entsetzt auf den fetten Passagier neben ihm, der an seiner Schulter schläft. Ein Sprecher sagt: „Falls Sie mit ihm schlafen wollten, hätten sie ihn geheiratet." Das Bild einer Erste-Klasse-Kabine erscheint, während der Sprecher fortfährt: „Fliegen Sie Upper Class mit Virgin Atlantic und genießen Sie Ihre eigene Suite mit Flachbett." Der Spot endet mit

dem Virgin-Logo und dem Slogan „Virgin Atlantic – Upper Class Suite". /// Un homme gros et laid donne la sérénade à son séduisant partenaire dans un bar. On suit cette histoire d'amour à travers une série de scènes qui se termine par un mariage. On se retrouve soudain à l'intérieur d'un avion. L'homme séduisant est horrifié que son gros voisin soit en train de dormir sur son épaule. Une voix off dit : « Si vous aviez voulu dormir avec lui, vous l'auriez épousé ». La cabine Upper Class apparaît à l'écran et la voix continue : « Volez en Upper Class chez Virgin Atlantic et dormez dans votre propre lit dans un espace privé. Le logo Virgin conclut le spot avec les mots « Virgin Atlantic – Upper Class Suite ».

INDEX

AGENCIES

CLIENTS

DVD CONTENTS

ACKNOWLEDGEMENTS

This book is the result of a long process of research and consultation with leading professionals around the world, working to put together an outstanding compilation of great ads produced in the course of recent years. For anyone interested in inventive TV commercials, this book covers many of the best contemporary examples from around the world.

My first thanks as ever are due to Daniel Siciliano Bretas for his close working and hands-on approach, as well as to Andy Disl for the project design, Jutta Hendricks for fine work on the texts, and Christoph Krahl for his excellent work on the DVD.

Every chapter has been shaped as well by an invaluable input from top creative directors who all took the time to reflect on how they see advertising today, and specifically how they see the subject as it has been approached in this book. They are Chris Wall, David Apicella, Al Moseley, John Norman, Miguel Angel Furones, Gustavo Reyes, Bill Wright, Andrew Keller, Jureeporn Thaidumrong, Graham Fink, Simon Learman, Brian Fraser, and Bob Isherwood.

We also received an incredible amount of help from a large number of people at several agencies, including Nicola Weston, Richard Myers, Alicia Scuoch, Nam Sakamoto, Jocelyn Weiss, Stephen Sapka, Shannon Evans, Annamaria Marchesini, Sarah Taylor, Diane Merklinger, Meghan Schlicher, Megan Hofer, Cody Ryder, Tara Grote, Salita Sangarun, Sergio Mugnaini, Michelle Parks, Kerrie Finch, Heidi Dunleavy, Eva Gomez-Pallete, as well as numerous others in advertising agencies who helped us somehow in gathering information and materials for this publication.

Julius Wiedemann

IMPRINT

© 2009 TASCHEN GmbH
Hohenzollernring 53, D-50672 Köln
www.taschen.com

To stay informed about upcoming TASCHEN titles, please request our magazine at
www.taschen.com/magazine or write to TASCHEN, Hohenzollernring 53, D-50672
Cologne, Germany; contact@taschen.com; Fax: +49-221-254919. We will be
happy to send you a free copy of our magazine, which is filled with information
about all of our books.

Design: Sense/Net, Andy Disl and Birgit Eichwede, Cologne
and Daniel Siciliano Brêtas
Layout: Daniel Siciliano Brêtas
DVD Production, Editing, Sound: Christoph Krahl, Cologne

Editor: Julius Wiedemann
Editorial Coordination: Daniel Siciliano Brêtas and Jutta Hendricks
Spot Descriptions: Chris Mizsak

English Revision: Chris Allen
German Translation: Daniela Thoma (Equipo de Edición)
French Translation: Aurélie Daniel and Martine Joulia (Equipo de Edición)

Printed in China
ISBN: 978–3–8228–4029–0